Adobe Photoshop CS2 for Photographers

In memory of my mother Marjorie Evening

Adobe Photoshop CS2 for Photographers

A professional image editor's guide to the creative use of Photoshop for the Macintosh and PC

Martin Evening

AMSTERDAM • BOSTON • HEIDELBERG • LONDON • NEW YORK • OXFORD PARIS • SAN DIEGO • SAN FRANCISCO • SINGAPORE • SYDNEY • TOKYO Focal Press is an imprint of Elsevier

Focal Press An imprint of Elsevier Linacre House, Jordan Hill, Oxford OX2 8DP 30 Corporate Drive, Burlington MA 01803

First published 2005 Copyright © 2005, Martin Evening. All rights reserved

The right of Martin Evening to be identified as the author of this work has been asserted in accordance with the Copyright, Designs and Patents Act 1988

No part of this publication may be reproduced in any material form (including photocopying or storing in any medium by electronic means and whether or not transiently or incidentally to some other use of this publication) without the written permission of the copyright holder except in accordance with the provisions of the Copyright, Designs and Patents Act 1988 or under the terms of a licence issued by the Copyright Licensing Agency Ltd, 90 Tottenham Court Road, London, England W1T 4LP. Applications for the copyright holder's written permission to reproduce any part of this publication should be addressed to the publisher

Permissions may be sought directly from Elsevier's Science and Technology Rights Department in Oxford, UK: phone: (+44) (0) 1865 843830; fax: (+44) (0) 1865 853333; e-mail: permissions@elsevier.co.uk. You may also complete your request on-line via the Elsevier homepage (www.elsevier.com), by selecting 'Customer Support' and then 'Obtaining Permissions'

British Library Cataloguing in Publication Data

A catalogue record for this book is available from the British Library

Library of Congress Cataloguing in Publication Data

A catalogue record for this book is available from the Library of Congress

ISBN: 0 240 51984 1

For information on all Focal Press publications visit our website at: www.focalpress.com

Trademarks/Registered Trademarks

Brand names mentioned in this book are protected by their respective trademarks and are acknowledged

Printed and bound in Italy

Working together to grow libraries in developing countries www.elsevier.com | www.bookaid.org | www.sabre.org ELSEVIER BOOKADD International Sabre Foundation

Contents

Foreword	xxiii
Preface	XXV
Book and CD contents	xxvii
Photoshop for Photographers website	xxvii
Acknowledgments	xxviii

Chapter 1: What's New in Adobe Photoshop CS2

Bridge: The new file browser	2
Camera Raw	4
Vanishing Point	6
Image warping	7
Smart Objects	
32-bit support and Merge to HDR	9
Lens Correction	10
Noise Reduction	11
Smart Sharpen	12
Blur Filters	12
Red Eye removal	13
Spot healing brush	14
Interface and performance	14
Menu font size	14
Menu customization	14
Memory access limits increased	15
Changes to the Layers palette	
Automation	17
Scripting additions	17
Web Photo Gallery	18
Print with Preview dialog	
PDF saving	19
Overall impressions	

Chapter 2: The Work Space

Adaha Dridaa	00
Adobe Bridge	
The Bridge interface	
Custom work spaces in Bridge	
Opening and saving images	
When files won't open	
Save often	
Save As and Save a Copy	
The image document window	
Status display options	
Document Sizes	
Document Profile	
Document Dimensions	
Scratch Sizes	
Efficiency	
Timing	
Current Tool	31
Managing document windows	32
Rulers, Guides & Grid	33
'Snap to' behavior	33
The Photoshop palettes	34
Palette docking	35
Work space settings	
Navigator	
Info	
Histogram palette	
Tool Options bar	
Tool Presets	
Character	
Paragraph	
Brush tools in Photoshop	
Brushes palette	
Brushes palette options	
Styles	
Swatches	
Color	
Preset Manager	
Actions	
	43

History	49
Layers	50
Layer Comps	51
Layer Comps and Scripts	51
Channels	52
Paths	53
Tools palette	54
Easter eggs	55
Selection tools	
Modifier keys	
Lasso: freehand/polygon/magnetic	
Move tool	64
Layer selection using the move tool	64
Crop tool	
Trimming an image	
Crop presets	
Slicing tools	
The painting tools	68
Spot healing brush/Healing brush/Patch tool/Red eye tool	
Color replacement tool	
Brush	
Pencil	
Clone stamp/Pattern stamp	
History brush	
History brush and Snapshot	72
History and memory usage	73
Non-linear history	
Art history brush	
Eraser/Background eraser/Magic eraser	
The Extract command	
Gradients	
Noise gradients	
Paint bucket	
Focus: blur/sharpen/smudge	
Toning: dodge/burn/sponge	85
Magnetic pen tool	
Pen and path drawing	
Type tool	
Adding layer effects	87

Shape tools	88
Annotation tools	89
Eyedropper/color sampler	
Measure	
Navigation tools – hand and zoom	91
Foreground/Background colors	
Selection mode/Quick Mask mode	
Screen display	93
Jump to button	

Chapter 3: Configuring Photoshop

Buying a system	95
Operating environment	96
Choosing a display	97
Display calibration and profiling	
Calibrating hardware	
Do you want good color or just OK color?	104
Calibration without a budget	105
Visual display calibration for Mac OS X and PC	
Color management settings	109
Extras	110
Graphics tablets	110
Backing up image data	
Photoshop preferences	112
General preferences	112
File Handling	114
Display & Cursors	117
Transparency & Gamut	118
Units & Rulers	119
Guides, Grid & Slices	120
Plug-ins & Scratch Disks	120
RAM memory and scratch disks	122
Clearing the Photoshop memory	124
Memory & Image Cache	125
Type preferences	126
Bridge preferences	
Photoshop and Mac OS X	
Photoshop and Windows XP	
Operating System maintenance	

Chapter 4: Basic Image Adjustments

The histogram	
Levels adjustments	
Levels after a conversion	
Fine-tuning the endpoints	
Specular Highlights	
Preserving the highlight detail	
Cutouts against a white background	146
Brightness and contrast	
Mask adjustments with Brightness/Contrast	148
Curves adjustments	
Using Curves to improve contrast	151
Manipulating portions of a curve	153
Correcting shadow and highlight detail	154
Amount	154
Tonal Width	154
Radius	155
Color Correction	157
Midtone Contrast	157
Adjustment layers	
Multiple adjustment layers	
Blending mode adjustments	161
16 bits per channel support	164
16-bit and color space selection	
32 bits and High Dynamic Range	
Merge to HDR	
Cropping	
Selection-based cropping	
Perspective cropping	
Image rotation	
Canvas size	
Big data	
Image sharpening	
Sharpening solutions	
Capture sharpening	
Sharpening for output	
Unsharp Mask filter	
Amount	

Radius	
Threshold	
Edge sharpening	
Selective sharpening	
Luminance sharpening	
Third-party sharpening plug-ins	
Smart Sharpen filter	
Advanced Smart Sharpen mode	
High Pass filter edge sharpening	

Chapter 5: Color Correction

Arbitrary Map mode......204 Matching color and lighting across images......206

Chapter 6: Repairing an Image

Basic cloning methods	 219
Alternative history brush spotting technique	
Healing brush	
Better healing edges	
Spot healing brush	
Patch tool	
Healing brush strategies	
9 9	

Х

Accentuating the eyes	236
Adding lightness and contrast to the eyes	236
Repair work using a copied selection	238
Removing stray hairs	239
Roots coloring	240
Vanishing Point	241
Dodging and burning	244
Image noise and moiré	246
Luminosity blending	247
Reduce Noise filter	249
JPEG noise removal	249
Adding Noise	250
Other tools for retouching	251
Beauty retouching	252
Brush blending modes	252
Disguise your retouching	252
Portrait retouching	
Red eye correction	257

Chapter 7: Montage Techniques

Selections and channels	259
Selections	259
Quick Mask mode	
Modifying selections	261
Alpha channels	261
Selections, alpha channels and masks	263
Smoothing a selection	264
Expanding and shrinking selections	
Anti-aliasing and feathering	266
Smoother selection edges	266
Photoshop paths	267
Creating a path	
Drawing paths with the pen tool	268
Guidelines for drawing pen paths	
Rubber Band mode	270
Layers	271
Image layers	271
Shape layers	272

Text layers	272
Adjustment layers	
Layers palette controls	
Masking layers	275
Adding a layer mask	
Removing a layer mask	
Vector masks	
Working with multiple layers	
Layer group management	
Layer selection and linking	
Layer mask linking	
Layer locking	
Lock Transparent Pixels	
Lock Image Pixels	
Lock Layer Position	
Lock All	
Layer blending modes	
Normal	
Dissolve	
Darken	
Multiply	
Color Burn	
Linear Burn	
Lighten	
Screen	
Color Dodge	
Linear Dodge	
Overlay	
Soft Light	
Hard Light	
Vivid Light	
Linear Light	
Pin Light	
Hard Mix	
Difference	
Exclusion	
Hue	
Saturation	
Color	

Advanced blending options	290
Smart Objects	292
Placing a Camera Raw file as a Smart Object	
Transform commands	296
Numeric Transforms	299
Transforming selections and paths	299
Transforms and alignment	
Creating a montage	
Removing a matte color	
Cheating a mask	
Masking an object with a vector path	
Masking hair	
Clipping masks	
Extract command	
Exporting clipping paths	

Chapter 8: Darkroom Effects

Black and white from color	
Full color toning	
Solarization	
Duotone mode	
Infrared film simulation	
Cross-processing	
Lab Color effects	
Channel Mixer color adjustments	
Color overlays	
Hand coloring a photograph	
Gradient Map coloring	350
Adding a border to an image	351
Softening the focus	
5	

Chapter 9: Layer Effects

Layer Styles	354
Drop Shadow	
Inner Shadow	
Outer Glow and Inner Glow	
Bevel and Emboss	
Satin	
Gradient Overlay	
Pattern Overlay	
Color Overlay	
Stroke	
Applying layer styles to image layers	
Adding glows and shadows	
Layer effect contours	
Spot color channels	
, Adding type	

Chapter 10: Photoshop Filters

	Liquify	390
	Liquify tool controls	
	Reconstructions	
	Mask options	
	View options	
	Saving the mesh	
	Warp command	
L	ighting and rendering	
	Fibers filter	399
	Lighting Effects	399
	Clouds and Difference Clouds	
	Lens Flare	

Chapter 11: Digital Capture

Scanners	406
Drum scanners	406
Flatbed scanners	407
CCD scanners	407
What to look for in a scanner	408
Resolution	408
Dynamic range	409
Bit depth	410
Scanning software	413
Purchasing bureau scans	
Kodak Photo CD and Picture CD	414
Opening a Photo CD image	414
Digital cameras	
Comparing chips	416
Digital image structure	418
The sensor size	418
Making every pixel count	421
Chip performance	422
Memory cards	
Avoiding card failure	424
Camera response times	
Comparing sharpness	425
Scanning backs	

Digital workflows	
Raw versus JPEG	
From light to digital	
Raw is the digital negative	
Raw conversion software	
DNG file format	431
The DNG solution	432
Camera Raw in Photoshop CS2	434
Camera Raw in use	434
General controls for single file opening	436
General controls for multiple file opening	439
Image browsing with Camera Raw	440
Adjust panel controls	442
Digital exposure	444
Detail panel controls	446
Lens panel controls	448
Vignette control	449
Curve panel	
Calibrate panel controls	
Saving and applying Camera Raw settings	
Camera Raw black and white conversions	
Camera Raw cropping	
Multiple raw conversions of an image	459
Storage	
Pros and cons of going digital	462

Chapter 12: Resolution

Pixels versus vectors466Terminology466ppi: pixels per inch466lpi: lines per inch467dpi: dots per inch467Desktop printer resolution468Repro considerations468The relationship between ppi and lpi469Creating a new document471Altering the image size472Image interpolation473

Nearest Neighbor	473
Bilinear interpolation	
Bicubic interpolation	
Bicubic Smoother	
Bicubic Sharper	
Step interpolation	
Practical conclusions	

Chapter 13: Color Management

The need for color management	478
The way things were	478
RGB devices	
The versatility of RGB	481
Interpreting the color data	
Output-centric color management	
Profiled color management	
Color Management Modules	
The Profile Connection Space	
Choosing an RGB work space	488
Apple RGB	
sRGB IEC-61966-2.1	488
ColorMatch RGB	489
ProPhoto RGB	
Adobe RGB (1998)	
Profiling the display	
Calibration and profiling	491
Profiling the input	492
Profiling the output	
Photoshop color management interface	495
The Color Settings	
Color management policies	496
Profile mismatches and missing profiles	
Preserve embedded profiles	497
Convert to Working space	498
Color Management Off	499
Profile conversions	500
Convert to Profile	
Assign Profile	502

Profile mismatches	503
Saving a Color Setting	504
Reducing the opportunities for error	505
Working with Grayscale	508
Advanced Color Settings	509
Conversion options	510
Black Point Compensation	510
Use Dither (8-bit per channel images)	510
Rendering intents	510
Blend RGB colors using gamma	511
Desaturate monitor colors	511
Customizing the RGB and work space gamma	512
RGB to CMYK	513
CMYK setup	513
Creating a custom CMYK setting	513
Ink Colors	514
Dot gain	515
Advanced CMYK settings	516
Gray Component Replacement (GCR)	516
Undercolor Removal (UCR)	516
Undercolor Addition (UCA)	
Black generation	517
Choosing a suitable RGB work space	519
Rendering intents	
Perceptual	
Saturation (Graphics)	
Relative Colorimetric	
Absolute Colorimetric	
CMYK to CMYK	
Lab Color	
Info palette	525
Keeping it simple	

Chapter 14: Output for Print

526

xviii

The ideal inkjet	530
Photographic print quality	530
Image permanence	531
Inks and media	531
Third-party inks	532
Making a print	533
Online printing	533
Print with Preview: Output settings	534
Print with Preview: Color Management	535
Page Setup	536
Print with Preview	537
Print dialog settings	538
Building a custom printer profile	540
Printing a printer test target	540
Getting the most from your printer profiles	545
Soft proofing via the display	546
Display simulation options	548
Color proofing for press output	549
CMYK proofing with an inkjet	550
Simulation and rendering intents	
Proof simulation using Photoshop CS or older	
Proofing in Photoshop CS or older	551
PostScript printing	552
Printing via a RIP	553
Repro considerations	554
File formats	556
Photoshop native file format	557
PSB (Large Document Format)	
TIFF (Tagged Image File Format)	
EPS	560
DCS	561
Photoshop PDF	562
PDF security	
PICT	566

Chapter 15: Output for the Web

Sending images over the Internet	568
Email attachments	568
Uploading to a server	569
File formats for the Web	571
JPEG	571
Choosing the right compression type	573
JPEG 2000	575
GIF	576
Save for Web	577
GIF Save for Web	580
ZoomView Export	583
Adding a copyright watermark	
PNG (Portable Network Graphics)	585
Web Photo Gallery	
General	590
Banner	
Large Images	
Thumbnails	591
Custom Colors	
Security	591
Client feedback	
Information and feedback	
Adobe ImageReady CS2	593
The ImageReady interface	594
ImageReady layers	594
Jump to application	594
Image slicing	594
Slice content and optimization	
Animation	597

Chapter 16: Image Management

 The Bridge program
 601

 Rotating the thumbnails and preview
 603

 Arranging the Bridge contents
 604

 Customizing the panels and content area
 606

 Selecting a Bridge work space
 608

600

Working with multiple windows	610
Slideshow view	611
Folders panel	612
Favorites panel	612
Keywords panel	613
Image metadata	613
File Info metadata	614
Interpreting the metadata	615
Metadata in use	616
Metadata panel	617
Edit history log	
Image cache management	618
Managing images in Bridge	620
Image rating and labeling	621
Filtering and sorting images in Bridge	622
Image searches	623
Bridge automation	624
Renaming images	
Applying Camera Raw settings	
Bridge extras	626
The digital lightbox experience	626
Storage Media	630
Image protection	631
Fingerprint plug-ins	

Chapter 17: Automating Photoshop

Image Processor	645
Automated plug-ins	646
Crop and Straighten Photos	646
Fit Image	646
Contact Sheet II	647
Picture Package	648
Photomerge	
Using Photomerge to align images	
PDF Presentation	655
Photoshop Help	656
How To help files	
Export Transparent Image and Resize Image	
Let Photoshop take the strain	

Appendix

Index

659

Foreword

espite its name, Photoshop has not always been a welcome companion amongst the photography set. Much as assembly line automation was seen as the death knell for craftsmen and craftsmanship, at various times, Photoshop was seen as a threat against the skilled photographer. However, a change has recently taken place. Fueled primarily by the advent of digital SLRs with professional features offered at non-professional prices, the confluence of Photoshop and photography, particularly digital photography, has become a certainty. Photoshop is now accepted as a powerful tool in the photographer's arsenal.

But what are veteran shooters and those digital photographers newly minted to make of this brave new world? How can your wealth of darkroom experience be brought to bear on a computer screen and a mouse? Will the sterile environment of technology replace the comforting mess and sickly-sweet chemical smells of fixer and developer? Most importantly, how will you and your photography benefit from the new opportunities offered by Photoshop in its latest incarnation, Photoshop CS2?

Whether you are a long-time traditional film photographer, a newcomer to the 'tradigital' world, or a weekend snapshotter, this book has something to offer. From the broad coverage of the 'Photoshop ways' of performing traditional film and darkroom techniques to new techniques only possible using Photoshop, Martin takes you there and teaches everything step by step. This isn't another 'recipe' book that ignores your skilled eye and assumes all you want to do is paste your head on a supermodel's body. (Of course, Photoshop can do that, but if that is your goal, this is not the book for you.)

Martin understands the photographer's craft isn't always about the creative and artistic side of life. Rest assured, Martin covers the full spectrum of photographic tasks. Important aspects of the workflow of the film photographer moving to digital – scanning and image capture – usually ignored in most other books are covered in depth. Martin also tackles the usually mundane issue of image management within Photoshop CS2, showing how the new Adobe Bridge program can move you well beyond just a 'digital shoebox'.

Viewing Photoshop through the eyes of an experienced photographer takes specialized talent and skills. In this book, Martin effectively shares his experience and expertise both on photography and Photoshop in a thorough and balanced presentation. While this book is also an excellent general Photoshop reference, the focus here is always on photography.

Photoshop can be daunting, photography even more so. To have someone expertly versed in both, presenting his knowledge here in a clean and clear manner, is a real treat.

Marc Pawliger Director of Engineering, Digital Imaging Adobe Systems

Preface

Preface

e have all heard the expression 'a picture is worth a thousand words'. And this is as true now today as it has ever been. The information-rich world we live in is awash with photographs that are used in all sorts of ways: to communicate, educate, sell things, to remember special events by, or simply 'to create'. Ever since I first took an interest in photography I have always wanted to discover as much as I could about the photographic process so that I could perfect my craft skills and become a more creative photographer. For me, learning to use Photoshop represented an important continuation of that process. Making the transition from shooting film to shooting digitally has also been an interesting experience. And speaking as someone who got involved with digital imaging in the very early years, I have endured many frustrations with all the various bits of equipment and software programs. Yet Photoshop has proved to be an essential ally throughout. And not just for myself, but for millions of other users around the world. Without Photoshop, the digital imaging industry we know today just wouldn't be the same.

When I first started using Photoshop, it was a much simpler program to get to grips with compared to what we see today. Adobe Photoshop CS2 has evolved to provide photographers with all the tools they need. My aim is to provide you with a working photographer's perspective of what Photoshop CS2 can do and how you can make the most effective use of the program.

One of the main selling points of this book is that I work mostly as a professional studio photographer, running a busy photographic business close to the heart of London. On the days when I am not shooting or working on a production I use that time to study Photoshop, write articles and present seminars. And maybe that is one of the reasons why this series of Photoshop books has become so successful, because like you, I too had to learn all this stuff from scratch! I make no grandiose claims to have written the best book ever on the subject. I simply write from personal experience and aim to offer a detailed and comprehensive manual on the subject of digital photography and Photoshop, written by somebody who has first-hand professional experience and a close involvement with the people in San Jose who make the Adobe Photoshop program.

This book was initially aimed at intermediate to advanced users who, as the title suggests, were photographers. But it soon became apparent that all sorts of people were enjoying the book. Over the years I have adapted the content to satisfy the requirements of a broad readership. I still provide good, solid professional-level advice, but at the same time I try not to assume too much prior knowledge, and ensure that everything is explained as clearly and simply as possible.

The book, now into its sixth edition, has been sold worldwide and translated into at least six other languages. This latest edition has been thoroughly revised to ensure that you are provided with an updated account of everything that is new in Photoshop CS2. As the program has evolved over the years, the book content has had to undergo regular changes in order to reflect the new ways of working. The techniques shown here are based on the knowledge I have gained from working alongside some of the greatest Photoshop experts in the industry – people such as Jeff Schewe and Bruce Fraser, who are true Photoshop masters. And I've drawn on this information to provide you with the latest thinking of how to use Photoshop to its full advantage. So rather than me just tell you 'this is what you should do, because that's the way I do it', you will find frequent references to how the program works. And these discussions are often accompanied by diagrams that will help improve your understanding of the Photoshop CS2 program.

Book and CD contents

The book layout has been refined so that the contents are presented neatly within single or double-page spreads with the topic title clearly visible at the top of the page. The contents have been expanded to give even more coverage of basic and advanced Photoshop techniques.

The CD that comes with this book contains movie versions of many of the step-by-step techniques shown in this book. It is designed to run on Macintosh and PC systems and only requires you to install QuickTime on your computer in order to view them. If you should experience any problems running the disk, please always refer to the FAO section on the disk or on the website for guidance on how to configure your computer for optimum viewing. Educators may also be interested to know that the images used in the movies are provided on the CD, along with the relevant extracts from the book in PDF form (these are made available for you to share with your students). The CD also contains other information such as a summary listing of professional and semi-professional digital cameras, plus tables of all the Photoshop keyboard shortcuts.

You can access most of the images shown in this book, but not all of them. The reason for this is that some of the photographs, especially where models are featured in the picture, do have restricted usages that do not permit me to simply give them away. And some of the other images were kindly released by fellow photographers for use in the book only. So although there are quite a few pictures you can play with, you won't be able to access every photograph you see in this book.

Photoshop for Photographers website

There is a website set up to promote this book where you can find many active links (including those mentioned in the book) and help pages should you encounter problems running the movies from the CD:

www.photoshopforphotographers.com

Acknowledgments

I must first thank Andrea Bruno of Adobe Europe for her suggestion that I write a book about Photoshop aimed at photographers and thank you to all at Focal Press: Marie Hooper, Christina Donaldson, Margaret Denley, Georgia Kennedy, Lucy Lomas-Walker and Sheri Dean Allen. None of this would have got started without the founding work of Adam Woolfitt and Mike Laye who helped form the Digital Imaging Group (DIG) forum for UK digital photographers. The production of this book was done with the help of Gwilym Johnston, who compiled and authored the CD, Rod Wynne-Powell, who reviewed the final manuscript and provided help with technical advice and assistance, and Jason Simmons, who came up with the new book layout template and who designed the cover. Plus a big thank you to my ever helpful personal assistant, Lisa Tebbutt. I must give a special mention to fellow Photoshop alpha tester Jeff Schewe for all his guidance and help over the years (and wife Becky), not to mention the other members of the 'pixel mafia': Katrin Eismann, Bruce Fraser, Seth Resnick, Andrew Rodney and Mike Skurski.

Thank you also to the following clients, companies and individuals: Adobe Systems Inc., Neil Barstow, Steve Broback, Russell Brown, Steve Caplin, Kevin Connor, Chris Cox, Laurie Evans, Tom Fahey, Karen Gauthier, Greg Gorman, Gretag Macbeth, Mark Hamburg, Peter Hince, Thomas Holm, Ed Horwich, Carol Johnson, John Nack, Imacon, Thomas Knoll, MacUser, Macworld UK, Bob Marchant, Marc Pawliger, Pixl, Herb Paynter, Red or Dead Ltd, Eric Richmond, Addy Roff, Schwarzkopf Ltd, The Smithsonian Institution, Steve Snyder, Martin Soan, Tresemme, Gwyn Weisberg, Russell Williams, Mark Williford and What Digital Camera. And lastly, thanks to all my friends and family, and especially my late mother for all her love and encouragement and who was always so supportive and proud of my success.

Martin Evening, April 2005

Chapter 1

What's New in Adobe Photoshop CS2

hotoshop CS2 offers major new features that will truly be of benefit to photographers everywhere. This first chapter offers a quick guide to all the new major features that will be of interest to photographers. Let's start with the technical requirements: if you are a Macintosh user, Photoshop CS2 will only run using Mac OS X 10.2.8 or 10.3.0 through 10.3.4 (10.3.4 is recommended), and only a G3, G4 or G5 computer. If you are using a PC, you will need to use Windows 2000 (with Service Pack 3) or Windows XP operating systems running on an Intel Pentium class III or 4 processor. AMD processors are also compatible.

More than images

The Bridge program is a central component of the CS2 Adobe Creative Suite. It is designed so as to provide a navigational link between the separate CS2 programs (although you can use it to launch documents that were created in other applications as well). But Bridge is primarily a very useful image management tool for photographers.

Bridge automation

The Tools menu contains all the Automate commands that were previously in the File Browser. Photoshop automation tasks, such as building a Web Photo Gallery, can all be done directly from Bridge. And the Batch Rename feature has been improved to accommodate the requests of photographers who need to include things like the original filename into the renaming scheme. Plus it has the potential to restore the original filenames as well.

Scripts are also accessible from Bridge, so that you can automate images directly from the Bridge program. Simple scripts for open and save routines will make batch actions easier to create and run (see page 17).

Bridge: The new file browser

It may seem ironic, but the number one new feature in Photoshop CS2 is not what has been added, but rather what has been removed from the program. I am talking about the separation of the File Browser from Photoshop to become Adobe Bridge, which is a cross-application navigational program.

So why is this a good thing? Well, there are several reasons why Adobe did this. Firstly, the File Browser has always been a processor-hogging application within Photoshop itself and that was not a good state of affairs when you had the File Browser wanting to catalog and cache a whole bunch of files while you, the user, were wanting to get on with serious Photoshop work. Adobe Bridge is a central application that can be shared by all the Adobe Creative Suite applications. Bridge has its own menu options and keyboard shortcuts, making Bridge automation and navigation easier. These overall benefits can mean less disruption to your Photoshop workflow.

The Bridge interface is coming ever closer to matching the way we edit pictures on a light box. Bridge has several work space layout presets that you can customize according to your own way of working. You can also have multiple windows of Bridge open at once and this will enable you to view the contents of more than one folder at a time and each can be compacted to make these window views more manageable on the screen. And the folder management is made easier because you can drag and drop folders within Bridge just like you can in the System Finder/Explorer.

The thumbnails in the content area can be dynamically scaled in size and there is a choice of several layouts for presenting the image and document information. The Slideshow feature (see Figure 1.2) provides a nice clear viewing environment that can be configured to fill the whole screen or display a slideshow in its own window. And this comes complete with a set of basic editing controls for marking the images you like best. The overall rating system in Bridge is certainly more extensive, but also a lot simpler to utilize. You can use a (H). (ctrl). command to cumulatively add a star rating to an image and use (H), (ctrl), to cumulatively remove stars. This rating system makes it easier to concentrate more fully on making your image selections, plus you can apply color labels, which is a further aid to classifying and grouping images in Bridge.

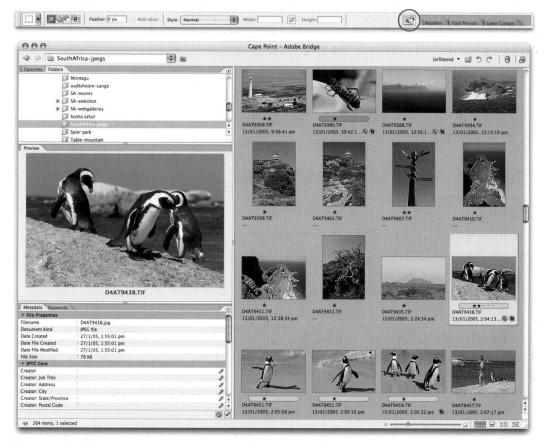

Figure 1.1 The File Browser has now become a separate application, called Bridge. The method of accessing the images remains unchanged. All you have to do is click the 'Launch Bridge' button (circled) in the Photoshop CS2 options bar to open the Bridge window interface shown here. Once Bridge is open you can perform all the usual File Browser type functions, but with added new features such as the ability to dynamically set the zoom size of the thumbnails, apply preset Bridge work space and thumbnail display configurations, including Filmstrip and Slideshow display modes.

Martin Evening Adobe Photoshop CS2 for Photographers

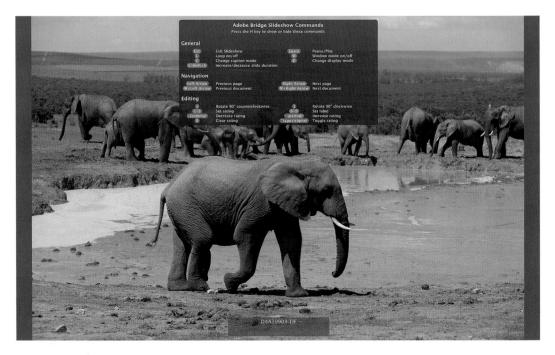

Figure 1.2 The new Bridge program includes a wonderful new slideshow viewer mode that will display images to fill the entire screen area. Once you have learnt the simple shortcut controls, it makes the reviewing and picture selection process a doddle.

Digital Negative (DNG) format

In September 2004, Adobe announced the introduction of the new Digital Negative (DNG) file format. This offers a new industry standard for the storage of raw camera data and the DNG raw data converter program is available for free download from the Adobe website. Support is now growing, and other applications such as Capture One, iView Media Pro and Extensis Portfolio all now support DNG. Any file that has been converted to the DNG format will be recognized in this and the last version of Photoshop CS and you can also now save files out of Camera Raw using the DNG file format.

Camera Raw

Camera Raw file processing is improved with a new updated version of the Camera Raw plug-in that now supports over 70 digital cameras. The Camera Raw 3.0 plug-in is configured by default to make automatic image adjustments that optimize your images until you decide to override these settings manually or apply a preset setting. Batch processing is easier and more logical, plus you can make extra editing decisions in Camera Raw such as straighten an image or apply a crop (which is not permanent and can be re-edited) and save multiple versions using the new Digital Negative (DNG) file format.

When you make a multiple selection of raw image thumbnails in Bridge and open them, you now get to see a single Camera Raw interface with a strip of thumbnails to the left (see Figure 1.3). This new interface makes it easier to manage batches of images. When multiple raw images are viewed via the Camera Raw dialog, Camera Raw builds a temporary cache of large previews for all the selected images, and these will allow you to use Camera Raw as a browser type interface in which you can review images in close-up detail, navigate from one image to the next at a synchronized zoom level and make important edit decisions, such as apply ratings to the selected images, the same way as you would in Bridge. You can manage the image processing by synchronizing the Camera Raw settings across selected images based on the first selected image and once you are finished editing in Camera Raw, have those files process in the background by choosing Done to update the image settings or click Save... to save to a specific destination.

Camera Raw opening

The Camera Raw plug-in will allow you to open your raw images in Bridge or directly in Photoshop. For example, the **EXR** ctrl **R** shortcut will display the Camera Raw plug-in (shown below) via the Bridge program. This method frees up Photoshop to carry out other tasks. If you simply double-click an image or selection of images, the plug-in will be hosted by Photoshop. But you can set the preferences in Bridge so that double-clicking will open the Camera Raw plug-in via Bridge instead.

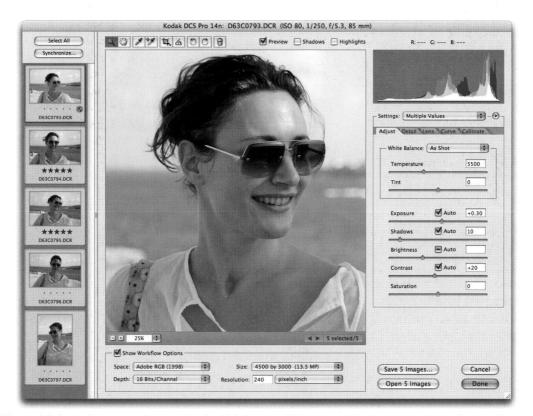

Figure 1.3 Camera Raw supports the processing of multiple images and their rating and also allows synchronization of a series of edits.

Vanishing Point

The Vanishing Point feature lets you retouch images in true perspective. Inside the modal dialog you can create a plane grid based on key perspective points in the picture. Once this is done you can clone, heal, paint and place image contents so that they match the perspective of the image.

Grid Size: 200 ***** Show Edges Cancel * Ms 1 Cance ----

Everything in perspective

As well as using the clone stamp tool in normal or healing mode, you can copy and paste image content and have it placed in perspective by dragging and dropping selections within the image itself. Vanishing Point also allows you to describe additional planes within the image and copy different planes of perspective. You can actually drag objects around corners from one plane to another!

Figure 1.4 In the example shown here I used the create plane tool to position four points on the image to describe the perspective of the deck in this picture. I was then able to drag the sidebar handles outwards to incorporate more of the deck area. Once I had described the plane of perspective, I then selected the clone stamp tool and used this to sample the deck texture in the middle of the picture and clone this to the corners of the photograph, matching the perspective in the rest of the picture.

What's new in Adobe Photoshop CS2

None

Custom

NE +

Chapter 1

Image warping

The image Warp command allows you to distort an image layer directly in Photoshop using handle controls. It differs from the Liquify filter in that the Warp command is actually a new type of Transform command that can be used to warp image pixels, pen paths and selections. If you ever complained about the lack of a decent Shear filter in Photoshop, well this is it! When editing a pixel image or image layer, a Warp or Transform command will permanently edit those pixels, transforming them into a new shape. The new Smart Objects feature, which we will be looking at next, now provides you with a non-destructive way of using the Transform and Warp command.

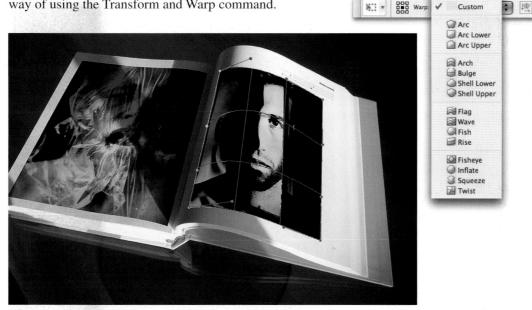

Figure 1.5 The new CS2 Warp command is an extension of the Transform command in Photoshop. To warp images, choose Edit ⇒ Transform ⇒ Warp. The Options bar will change to reveal the Warp options, that include a pop-up list of Warp effects. These are similar to the existing Type text Warp effects. You can vary these warp distortions by adjusting the sliders in the Options bar or mouse-dragging within the bounding box area segments. The most useful of these Warp effects is the Custom option that allows you to apply a freeform warp. In the example shown here, I was able to use a Custom warp to add curvature and perspective to a new photograph placed on the page of a book and match the curvature of the page.

La	yers			2	0
No	rmal	\$)	Opacity:	100%	•
Loc	x 🖸 🤉	10	Filt:	100%	
	5 C		Curves	1	
	5	Right page	L		
	8	left page			
9	E.A	Backgroun	đ	۵	

Placing raw files as Smart Objects

You can even place a Camera Raw file as a Smart Object or multiple Smart Object layers within a Photoshop CS2 document and keep the raw adjustments editable. This technique can be useful if you wish to combine different interpretations of a master raw file, keeping them on separate layers with layer masks.

Smart Objects

This feature is not quite the answer to filter layers, but it is getting close. Smart Objects provide a mechanism in Photoshop for non-destructive pixel adjustment layers. Smart Objects in Photoshop CS2 follow the same logic as those in GoLive. When you promote a layer or group of layers to become a Smart Object, the original pixels are preserved as a separate set of layers within the document. You can apply unlimited transforms or warps to Smart Objects (as shown below) without ever degrading the original pixels. This means that you can scale a Smart Object layer to make it smaller and then bigger again without degrading the image layer any more than is necessary. And you can also duplicate a Smart Object as many times as you like so that whenever you update one layer, you update them all.

Figure 1.6 When you promote a layer or group of layers to become a Smart Object, the layer data contents are stored separately within the image file as a document within a document. The advantage of this is that you can transform or warp a Smart Object any way you like. Each time you transfer a Smart Object layer, the original pixels are referenced, which means there is no cumulative pixel loss. So, for example, in the example shown here, you scale a Smart Object down in size and then decide to enlarge it again or transform it in some other way. The Smart Object contents can also be edited independently. The Smart Object contents for the flower layer are shown on the left.

32-bit support and Merge to HDR

Photoshop CS2 is enabled for High Dynamic Range (HDR) imaging. This is all fairly new still but it is anticipated that in the not too distant future, more digital cameras will boast HDR capability and be able to capture a high dynamic range scene within a single image and store it as an HDR type file. HDR has many applications within special effects work and 3D modeling. For photographers though it offers you a means to capture all the luminance information in a bright daylight scene and decide later which exposure or tonal compression works best.

We now have the Merge to HDR feature that will enable you to combine multiple digital exposures to create a 32bit per channel HDR image. Photoshop CS2 provides an HDR conversion dialog for when you wish to convert these HDR files to a normal 8-bit or 16-bit per channel image in Photoshop. You have at your disposal four different conversion methods, of which the Exposure and Gamma and the Local Adaptation are probably the most easy to work with.

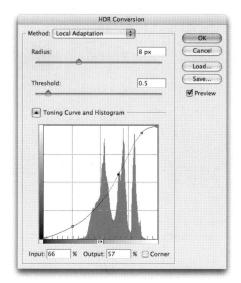

Figure 1.8 The HDR conversion dialog is displayed whenever you change the bit depth from 32-bit per channel to either 8-bit or 16-bit per channel mode. The HDR Conversion dialog provides four different conversion methods for rendering the high dynamic range image data as a normal low dynamic range image.

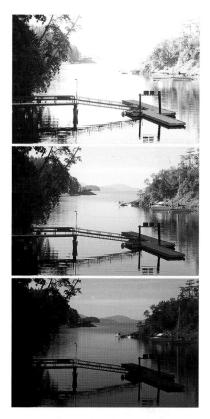

Figure 1.7 A typical daylight scene such as the one shown here will require different exposures depending on whether you wish to expose to capture the shadow detail in the foreground, the highlight detail in the sky and the hills in the distance or somewhere between these two extremes. Merge to HDR will let you combine multiple bracketed exposures, register the images and blend them into a single High Dynamic Range image in 32-bit mode which can then be rendered as a normal 8-bit or 16-bit image. This two-step process provides a mechanism for greatly extending the dynamic exposure range of your digital camera.

Chromatic aberration and vignetting

Photoshop CS2 will now let you correct the chromatic aberration color fringeing and vignetting in any image file, not just the raw image files that are processed using Camera Raw.

Lens Correction

If you spend good money buying the best lenses for your camera system then you shouldn't encounter too many problems with the optics. But most of the digital cameras on the market these days, and especially the small compact cameras, have fairly basic lenses and these are prone to problems such as barrel lens distortion at the widest angle setting and pincushioning when you zoom in close. The Lens Correction filter provides a comprehensive set of lens distortion correction tools that can be used to great effect to correct the curvature in a photograph caused by using a less than perfect lens.

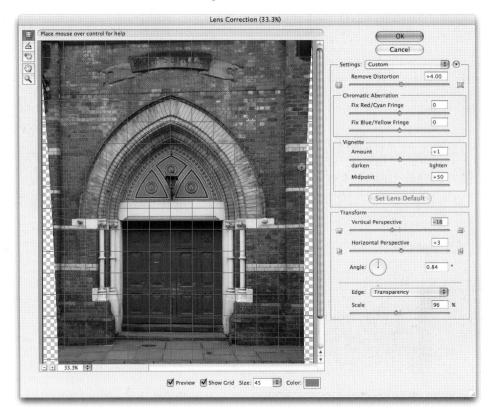

Figure 1.9 The poor lens performance you get with some cameras can be vastly improved with the new Lens Correction filter. As is shown in the above example, you can correct for both the curvature and planar distortion. Also included are the Vignetting and Chromatic Aberration controls that were previously found only in the Camera Raw dialog.

Noise reduction

The new Reduce Noise filter uses a smart method of noise reduction that can get rid of unwanted noise without destroying edge detail in a picture. The Reduce Noise filter is also able to treat images with heavy JPEG artifacts and smooth out the square block patterns that you sometimes see. It can even be used to much improve the appearance of GIF images in Indexed Color mode (but you do have to convert them to RGB mode first).

More 16-bit capability

Photoshop CS2 has extended the support for some of its filters such as the Liquify filter, so that they are now able to work in 16-bit per channel mode.

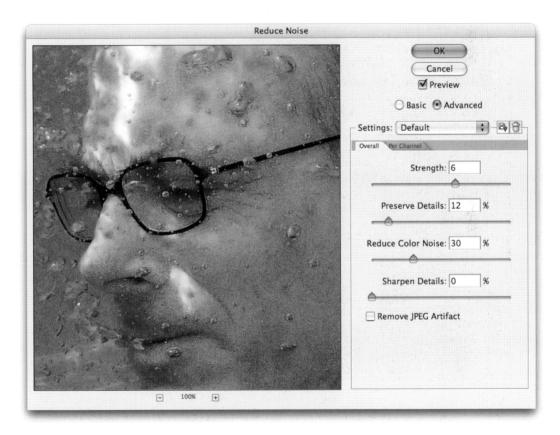

Figure 1.10 Grainy pictures like this can be cleaned up with the help of the Reduce Noise filter. In the Advanced mode you can filter out the noise on a per channel basis.

Smart Sharpen	
	OK Cancel Preview Basic Advanced Settings: Default Sharpen badow Hegelight Amount: 200 % Radius: 3 pixels Remove: Lens Blur Angle: 0 ° ↔ More Accurate

Figure 1.11 The Smart Sharpen filter dialog provides improved sharpening controls with an easy-to-use interface.

Smart Sharpen

The Smart Sharpen filter has a nice, simplified interface and provides a less destructive form of image sharpening, enabling better edge detection and producing fewer haloes. In Advanced mode the Smart Sharpen filter offers additional controls that allow you to selectively sharpen the shadows and highlights and you can also save and load Smart Sharpen settings. The other interesting feature is the added ability to counteract certain types of image blurring. It offers improved optical lens blur correction and a limited ability to correct for motion blurring as well.

Blur filters

Three new blur filters have been added to Photoshop CS2. The first is Box Blur, which applies a square type blur to an image instead of a circular type blur. The Surface Blur is like a blur filter that blurs an image based on the tonal levels. The Radius controls the blur radius amount while the Threshold control governs the range of tones to which the blur is applied. The result is in some ways like a diffusion type filter and can be useful for removing image grain and noise from a photograph. The other new blur filter is the Shape Blur. This filter is like an extension of the Box Blur and allows you to select a blur shape from the preset list shown in the dialog. You can add or replace more shape presets via the fly-out menu, the same way as you can with other shape presets.

Halftone interference patterns

The Box Blur filter can provide a useful alternative to the use of the Median and Gaussian Blur filters for the removal of interference patterns from scanned halftone images.

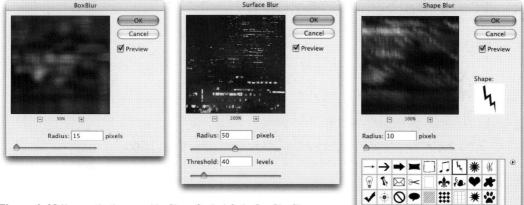

Figure 1.12 Here are the three new blur filters. On the left, the Box Blur filter. In the middle, the Surface Blur filter. And on the right, the Shape Blur filter. These three filters have all been applied to the same image of a night-time scene in order to provide the best comparison.

Red eye removal

The color replacement brush in Photoshop CS was never particularly successful at the task of removing red eye from images. The red eye tool is new to Photoshop CS2 and uses an improved algorithm for removing red eye from flash portrait photographs. It is fairly simple to work with. All you have to do is select the right options for the Pupil size and darken amount from the Tool Options bar and then click inside the red eye pupil.

Figure 1.13 There are limits as to how good you can make someone look using Photoshop, but with the new red eye removal tool all you have to do is click inside the eye to remove the red eye effect completely.

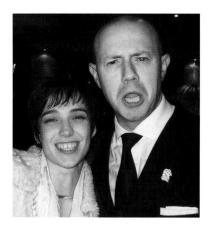

C R TM

Figure 1.14 The spot healing brush tool options. In general, the spot healing brush is just as effective as the normal healing brush, providing there is enough usable source data surrounding the blemish you wish to repair.

Image window tiling

The Window \Rightarrow Arrange menu now allows you to manually choose whether to tile images vertically or horizontally.

Scroll wheel and pen stylus behavior

If the mouse or pen stylus you use features a scroll wheel then you can use the scroll wheel to quickly zoom in and out of an image, centered around the position of the cursor. If you are using a pressure sensitive pen such as a Wacom, the brush attributes can be linked to pen barrel rotation movements.

'n	? Futura	Sample
'n	Cadget	Sample
(Adobe Garamond Pro	Sample
Ą	🕻 Geeza Pro	
Ą	🕻 Geneva	Sample
H	🕻 Georgia	Sample
6	Gill Sans (T1)	Stample
C	Gill Sans (TT)	Sample
'n	Gill Sans	Sample
~	Helvetica	Sample
1	Helvetica Neue	Sample
'n	P Herculanum	SAMPLE
Ą	l'Hoefler Text	~~ 201000
Ą	Humana Serif ITC TT	Sample
F	P Humana Serif Md ITC TT	Sample
100	Impact	Sample
18	Contributer.	SPREASE BEAUS

Figure 1.15 Photoshop CS2 features a WYSIWYG font menu display listing which will appear whenever you select a new typeface from the Type tool Options bar.

Spot healing brush

The spot healing brush works in a similar way to the normal healing brush except you don't have to use all first to define a source sample point. All you have to do is simply click on or paint over the marks you wish to remove. The spot healing brush works so well in Photoshop CS2, it can often be used in place of the normal healing brush.

Interface and performance

Photoshop CS2 performance has been enhanced through auto optimized tiling to provide improved image cache management and an overhaul of the big data management. If you use Windows, you will notice that image documents are no longer restricted to the application window. This will make it possible for Windows users to take full advantage of a dual display setup when using Photoshop.

Menu font size

The latest LCD displays are getting bigger and as the pixel resolution size of the displays increase, the palette sizes are becoming relatively smaller. I am fortunate enough to own a large 30 inch LCD display which is great for viewing images big on the screen, but the downside is that the font size in all the dialogs can be tiny to read from a normal viewing distance. The General preferences will let you increase the small font sizes to make smaller text items easier to read.

Menu customization

The Keyboard Shortcuts option in the Edit menu has been updated to provide more options for customizing the Photoshop CS2 interface. As the number of features in Photoshop has grown over the years, all the menu choices can be simply overwhelming. This is especially true if you are new to the Photoshop program. The new Customize feature is like a 'make simpler' command. You can edit the shortcuts as before, but also choose to hide those menu options you never use and apply color coding to make more prominent the menu items you use most often. Photoshop CS2 ships with menu customization presets such as a What's New in Photoshop CS2 preset. The philosophy behind the use of this feature is: 'everything you do want with nothing you don't want'!

Last Filter	SEF	
Lastriter	001	
Extract	жх	
Filter Gallery		
Liquify	ЖХ	
Pattern Maker Tû	ЖХ	
Vanishing Point	¥V	
Artistic		
Blur		Average
Brush Strokes	•	Blur
Distort		Blur More
Noise	•	Box Blur
Pixelate	•	Gaussian Blur
Render	•	Lens Blur
Sharpen		Motion Blur
Sketch	•	Radial Blur
Stylize	•	Shape Blur
Texture	•	Smart Blur
Video	•	Surface Blur
Other	► I	
Digimarc		

Memory access limits increased

The advent of modern operating systems running on 64-bit processor computers has brought expectations of Photoshop being able to run using more RAM memory. To date, the most RAM you could allocate to Photoshop was 2GB. And if you are running Windows 2000 or a regular version of Windows XP, you can still only allocate up to 2GB. But if you are using a G5, a 64-bit AMD or 64-bit Intel processor, that figure has now been increased. For a Mac running OS X 10.3 or higher, you can now allocate up to 4GB (less whatever the operating system frameworks take up, so effectively up to 3.5 GB). If you are running Windows XP 64-bit edition you can allocate 4GB (minus a very small amount for the operating system).

Figure 1.16 The Info palette is customizable so that you can have all these status items such as the document profile space, scratch disk size and so on, displayed at once in this palette. Macintosh users will now get to see tool hints shown here as well. These change according to the keys you have held down to indicate extra available options. These tool tips are particularly useful for Photoshop newcomers.

Name: Workspace-standard	Save
Capture	Cancel
Palette Locations	
Keyboard Shortcuts	
Menus	

Figure 1.18 The new Save Workspace options allow you to save complete work space settings that include not just the palette layouts but the custom menu settings as well.

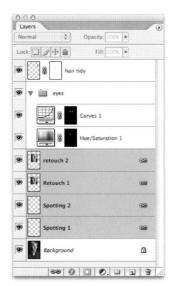

Figure 1.19 The new Layers palette design.

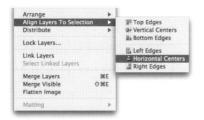

Figure 1.20 The Align Layers to Selection Layer menu option lets you make a selection and instruct Photoshop to align the linked layers to the border sides or center of that selection.

Client: Rainbow Room. Model: Jasmin @ Nevs.

Changes to the Layers palette

The Layer linking column has been removed from the Layers palette and linking is now done via a link button at the bottom. Now some people will doubtlessly be up in arms over these changes. Yes, it does take some getting used to, but ultimately, the layer selection and linking has really been made more simple.

Contiguous layers can be selected by *Shift* clicking on the layer names. Discontiguous layer selections are made by **H** *ctrl* clicking on layer names to add to or subtract from a layer selection (but you can still load the nontransparent contents of a layer as a selection by **H** *ctrl* clicking on the layer image icon). Layer groups can now be selected (and then linked) by **H** *ctrl* dragging over the image with the move tool (or just marquee-drag if the Auto Select option is checked).

Layer masks can be moved by dragging them from one layer to another and you can also copy layer masks by all dragging them within the Layers palette.

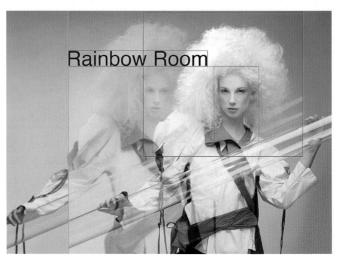

Figure 1.21 The View menu options include Show Layer Edges which means that the currently selected layer or layers will be indicated with a rectangular color edge border. The Smart Guides option is useful as a visual aid for aligning layer elements. The Smart Guides (shown here in pink) will flash on and off to indicate when a layer element is aligned to other layers in the image.

Automation

Along with the interface refinements and better optimization, several improvements have been made to the automation features in Photoshop, which are designed to make Photoshop run faster automatically and provide more opportunity for users to write their own customized batch processing routines.

Scripting additions

Scripts are similar to Photoshop actions but they operate at the operating system level instead of at the application level only. Scripts are not new. They have been available for use in previous versions of Photoshop, but there is more emphasis now on making them easier to implement and this will encourage anyone who has the know-how to design their own scripts for others to use in Photoshop.

A good example of the power of scripting is the Image Processor script (see Figure 1.22). This will forever be known to me as Russell Brown's, sorry, Dr. Brown's Image Processor. But sadly, there is no place for such frivolous naming in the sober world of Adobe Systems!

The Script Events Manager lets you combine multiple scripts in a sequence, combine these with Actions in Photoshop and attach these to specific Photoshop events. For example, you could set up a script event where Photoshop automatically generated a low resolution JPEG version every time you saved an image out as a Photoshop format document. The potential is there to create preset image processing routines for the batch handling of files, taking source image files and processing them out to designated folders. This will go beyond what you can do with Actions alone. And with the Image Processor, you can create scripts to perform multiple tasks at once.

		Image P	rocessor		
0 Selec	0 (54	s to process sen images lect Folder) No is n first image to appli		been selected	Run Cance
O Selec	t location to O Save in	save processed images and same Location		mages	CLoad.
File 1	Save a Quality		€ Resize W: 650 H: 650	рк	
	Save a	s PSD imize Compatibility	Resize	px	
	Save a	s TIFF Compression	C Resize	px px	
R Ri Copy	rences in Action: right Info: clude ICC Pr	© Marrtin Evening		td metadata 🛟	

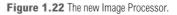

🖞 Enable Evi	ents to F	lun Scripts/Actions:		Oone
itart Applica	ition Di	splay Camera Maker.jsx		Remove
Photoshop	e Event:	Start Application		Add
Script:		r Camera Maker.jsx your events by adding and removing.		
	Select d descrip	ifferent JavaScript files to get detailed		
	Set 1	Add std metadata	-	

Metaframer script

For a good example of what scripting can do in Photoshop, look out for the Metaframer script, which will be available to download from Russell Brown's website: www.russellbrown.com. The Metaframer script will enable you to automate taking specific metadata from your image files (such as copyright credit information) and adding this information to the border of an image.

Adobe Help Center

The new Adobe Help Center enables registered Adobe customers to conduct improved searches and access support for all their Adobe products from Adobe and third parties. The new database is also able to provide related links to word searches. This makes the Help Center more useful for beginners who may be unfamiliar with some of the terminology used in Photoshop.

Web Photo Gallery

Several new templates have been added to the Web Photo Gallery, some of which are Flash-based. Web Photo Galleries can be created directly from selected images in Bridge, but unfortunately there is still no mechanism for producing sRGB converted JPEGs from the master images, or utilizing the cached JPEG preview data. But the Web Photo Gallery still remains a cool and important Photoshop feature.

Figure 1.24 The Web Photo Gallery features several new template designs including several that use Macromedia Flash. The web gallery shown here was created using the Flash 2 gallery template.

Animation in Photoshop

This is not a new feature but rather something that used to be in ImageReady only. It is yet another indication that Photoshop and ImageReady will become merged at some stage in the future. This is also further reason for having Photoshop menu optimization. With menu optimization different users can be satisfied more easily by setting up Photoshop to display only the tools they most need.

Figure 1.25 The Animation palette.

Print with Preview dialog

The print options have long been a source of confusion due to the contradicting settings options and different print flow behaviors that exist. The problem has essentially been linked to the constraints of the various operating systems and the print interfaces supplied by the print manufacturers. But Adobe have done their best to help ease the pain by making a few small changes to the front-end Print with Preview dialog box so that users will find it easier to select the correct options at this stage in the print process.

PDF saving

The Photoshop PDF format save dialog has been significantly updated in order to provide a consistent approach to PDF creation across all the programs in the Adobe Creative Suite, where all Suite applications will now share the same dialog. The Preserve Photoshop Editing Capabilities checkbox will enable you to preserve all the image components such as layers and adjustment layers, just the same as if you had saved an image as a Photoshop or TIFF format file.

	Adobe PDF Export
Adobe PDF Preset:	
Standard:	None Compatibility: Acrobat 5 (PDF 1.4)
Standard: Generat Compression Marks and Bleeds Output Security Summary	Ceneral Description: Options Options Preserve Photoshop Editing Capabilities Embed Page Thumbnails Optimize for Fast Web Preview View PDF After Saving
Save Preset)	Fonts Subset fonts when percent of characters used is less than: 1%

Figure 1.26 The new PDF save dialog.

Print simulation

Professional photographers like having the ability to simulate the conditions of the print press on their desktop inkjet printers. This was possible to do before, but it required careful configuration of the Print with Preview color management settings. the new Print with Preview dialog contains a menu option in which you can select the apprropriate print space to simulate and then all you have to do is click on the Simulate Paper White and Simulate Black ink buttons.

FireWire out

This is a video editing feature. It enables you to send a still image to preview on a video device via a FireWire connection and see a preview of how an image in Photoshop will then appear on a given video device. To use this feature you need to have a video device such as the input on a TV monitor connected to the computer via a FireWire cable and then in Photoshop select File \Rightarrow Export \Rightarrow FireWire...

Overall impressions

Photoshop CS2 is in many respects a most notable upgrade. There are a lot of features in this version to satisfy photographers, especially if you shoot digitally. The separation of the Bridge browser program has freed up Photoshop to allow Photoshop to run more efficiently and the added controls in Bridge should be greatly appreciated since it now makes the picture selection editing faster and easier.

The Warp Transform and Lens Correction filter make a welcome addition and the introduction of Smart Objects has opened up new ways to work with the Warp feature and the existing Transform commands as well as hinting at more extensive developments in the future for this feature. The 32-bit editing capability may be a little ahead of its time, but we now have the capability to create HDR images from a standard digital camera and convert these using Merge to HDR to produce fine detail in the shadows and highlights like never before.

The ability to customize the interface and the extra automation features such as improved scripting ability are also important if you are looking to streamline the Photoshop interface and speed up the processing of repetitive tasks beyond the limits of what you can do using Actions alone.

This upgrade to the Photoshop program is one of the most significant updates I have seen in all the years I have been writing about Photoshop. It gets a definite thumbs up for providing a well-thought out response to the needs of busy photographers.

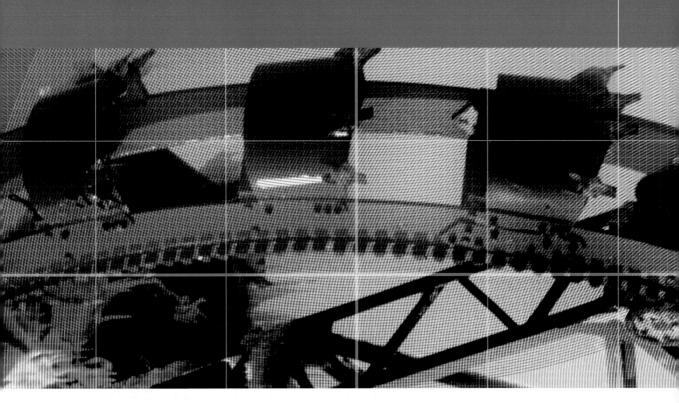

Chapter 2

The Work Space

efore moving on to the practical Photoshop techniques, let's first look at the Photoshop interface. The following pages give an account of the basic Photoshop working area and introduce you to all the different tools and palettes and a brief description of their function. You can use this chapter as a reference, as you work through the remainder of the book. If you want to dive straight in, then you can quite easily skip forward to Chapter 4 on Basic Image Adjustments.

If you are an experienced Photoshop user then the biggest change to the Photoshop interface is the removal of the File Browser to become a separate application in its own right. The new Bridge program will require some getting used to, but it does bring many benefits.

Martin Evening Adobe Photoshop CS2 for Photographers

Figure 2.1 This is the Photoshop CS interface showing the default layout for all the palettes. The Options bar is normally positioned at the top of the screen just below the menu bar, but you can also position it at the bottom or even on a second monitor.

Photoshop installation

Installing Photoshop is as easy as installing any other application on your computer. There are no special things to point out about the install process. Just select the default options to install Adobe Photoshop and Bridge. After completing your user information and serial number details, you will be faced with a Product Activation option. This has to be selected in order to activate Photoshop. And the reason it is there is to limit unauthorized distribution of the program. The standard license entitles you to use Photoshop on up to two computers, but not both at once.

Adobe Bridge

Say farewell to the File Browser and hello to Bridge, the new file browser application which is designed to provide integrated navigation across all the Creative Suite applications. On the face of it the Bridge experience is not too different from the old File Browser. Bridge is accessed in exactly the same way. You launch it by clicking on the Bridge icon in the Tool options bar (you can also set the Photoshop preferences so that Bridge launches automatically as you launch Photoshop). Bridge will initially open a new window pointing to the last visited folder of files. The main Bridge interface is shown in Figure 2.2, as it will appear on the desktop and again in more detail in Figure 2.3, with the main controls itemized.

The Bridge window interface allows you to inspect images in a folder quickly, make decisions about which

Figure 2.2 And here is the new Adobe Bridge interface. Bridge is an independent program which can be launched separately or by clicking on the Bridge icon in the Photoshop CS2 Options bar. If you wish, you can configure the Photoshop General Preferences so that Bridge is always launched automatically as you launch Photoshop.

pictures you like best, rearrange those pictures, hide the ones you don't like and so on. At a more advanced level, you can share properties between files and perform batch operations like applying a copyright tag to all selected pictures, rotating a selection of images, or applying specific Camera Raw settings. At the simplest level though you use Bridge to quickly review the images in a folder and then open in Photoshop the ones you wish to work on.

Switching back and forth between Photoshop and Bridge is really easy. And one of the key benefits of separating Bridge in this way is that it has freed Photoshop from the constraints of trying to perform two jobs at once. Because Bridge now has the specific tasks of generating thumbnails and previews etc. within a separate application, Photoshop is no longer fighting with the processor.

Macintosh and PC keys

Throughout this book I will be referring to the keyboard modifier keys used on the Macintosh and PC computers. Where the keys used are the same, such as the *Shift* key, these will be printed in black. Where the keys used are different on each system, I use the Macintosh key first in magenta and the PC equivalent after in blue. So, if the shortcut used is Command (Mac) and Control (PC) this appears abbreviated in the text as: **#** *otro*. Other keys will be explained as you progress through this and subsequent chapters.

Adobe Photoshop CS2 for Photographers

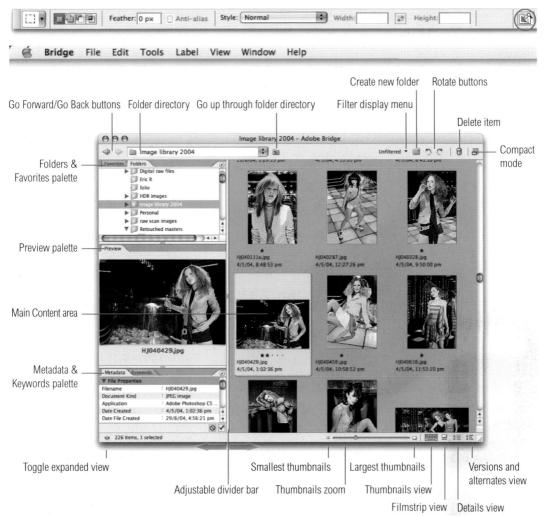

The Bridge interface

Bridge is your gateway to accessing images within Photoshop. It allows you to preview, select, manage, search and open up images, all within the Bridge environment. Bridge can be accessed by choosing the File \Rightarrow Browse... or by clicking on the Open Bridge button which is always present in the Photoshop Tool Options bar (see the circled button in Figure 2.3). The first time you launch Bridge, it makes sense to resize the Bridge window to fill the screen and if you have a dual monitor setup you can always arrange to have the Bridge window (or windows) displayed on the secondary screen. Image folders can be selected via the Folders or Favorites palettes and the folder contents then viewed in the thumbnail area. An enlarged view of individually selected images can be seen in the Preview palette. Images can be opened by double-clicking on the thumbnail or image preview. The Bridge window can remain open after you open an image, but as was pointed out, this will not compromise Photoshop's performance.

There are a great many features to explore in the revamped browser and ways you can use it as an essential Photoshop CS2 tool, which is why I have devoted most of Chapter 16 at the back of this book to the discussion of image management and how to get the most out of Bridge.

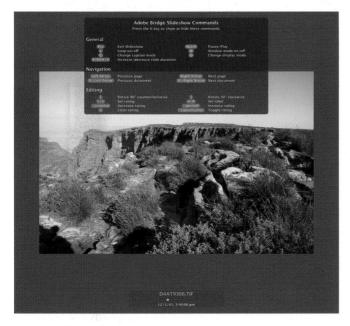

Figure 2.4 Reviewing images in Bridge does not have to be complicated. Use the Bridge application View ⇒ Slideshow mode to display all selected images in a slideshow form. You can make all your essential review and edit decisions with this easy-to-use interface. Press the question mark key to call up the Slideshow shortcuts as shown here.

Custom work spaces in Bridge

The Bridge work space can be customized and there are already a number of work space presets ready to load which are available from the Window ⇒ Workspace menu. The palettes can be grouped together in different ways and the palette dividers dragged so that if you wish, the preview palette can fill the Bridge window more fully.

Multiple folder windows

In Bridge you can now have multiple folder view windows open at once. This is very useful if you want to manage files better by being able to drag them from one folder to another more easily. It also saves having to navigate back and forth between different folders. To make multiple Bridge windows more manageable, you can click on the Compact mode button in the top right corner to toggle shrinking/expanding the Bridge windows.

Return to Photoshop

Most of the time you will probably click on the Bridge button in Photoshop to launch Bridge and return to Photoshop every time after you have opened a file. But you can also toggle between the two programs when you are not opening images by remembering the following Bridge shortcut: **Shift O ctr Shift O** which will launch Bridge as well as return you to the last used application.

Saving from raw files

Raw files can come in many flavors, but the one thing they share in common is that they cannot be modified. So if you apply any changes within the Camera Raw dialog these settings are stored in a separate file or location and remembered the next time you open that image. If you save an image opened up from a raw file original, Photoshop will by default suggest you save it using the Photoshop native file format. You are always forced to save it as something else and never to overwrite the original raw image. Most raw formats have unique extensions anyway like .crw or .nef. But Canon did once decide to use a .tif extension for some of their raw file formats (simply so that the thumbnail would show up in their browser program). The danger here was that if you overrode the Photoshop default behavior and tried saving an opened Canon raw image as a TIFF and you also ignored the warning you were about to overwrite the original image, you did run the risk of losing the original raw file!

Corrupt files

There are various reasons why a file may have become corrupted and refuses to open. Images sent as attachments are the biggest culprits. Quite often, there is a break during transmission somewhere and the file is missing important data.

Opening and saving images

The Bridge interface offers the easiest method of opening an image up in Photoshop. All you have to do is select the thumbnail of the image you want to open and double-click either the thumbnail or the large preview image. Or you can choose File \Rightarrow Open from the main Bridge menu. Any of these actions will open the image in Photoshop. If it is a raw camera image you are opening then you will see the Camera Raw dialog shown in Figure 2.5 (if you are opening multiple raw images then you will see a filmstrip of thumbnails on the left of this dialog). Camera Raw usage is discussed in depth in Chapter 11, but for now, you can often just click Open without concerning yourself too much just yet with what all these controls do. One of the great things about Photoshop CS2 is that the default Camera Raw settings will automatically adjust to give you the best exposure, shadows, brightness and contrast for each image. So clicking Open should give you a good image to start working in Photoshop and the beauty of opening from a raw image is that you don't overwrite the original master raw file (but do see the warning in the sidebar on saving raw files).

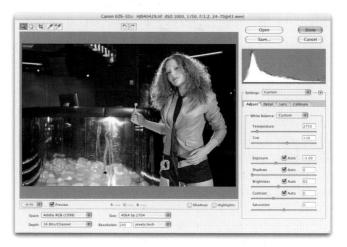

Figure 2.5 When you select a single raw image from Bridge, and double-click to open, you will be faced with the Camera Raw dialog shown here. If you are not familiar yet with how Camera Raw works it is often fine to click OK to the default auto settings until you understand more about how they should be configured.

When files won't open

You don't have to use Bridge to open an image of course. You can open up a file you find anywhere on your computer. If an image file is in a format Photoshop recognizes, if you double-click, it will open in Photoshop. And if the program is not running at the time, this action will also launch Photoshop as well.

If you use Bridge as the main interface for opening your files in Photoshop then there should be few times where an image file will fail to open. But if you try to open a file outside of Bridge, there are a few things to watch out for. Every document file on your computer will contain a header section which among other things tells the computer which application should be used to open it with. For example, Microsoft Word documents all have a familiar blue letter icon and Excel spreadsheets, a green cross. Photoshop will recognize nearly all image type documents regardless of the application they may have originated from. But sometimes you will see an image file with an icon for another specific program, like Macintosh Preview, or Internet Explorer. If you double-click these files, they will open in these respective programs. To get around this, do what I suggested at the beginning, and use Bridge to open everything. Or, you can use the File \Rightarrow Open command from within Photoshop. Or, you can drag a selected file or files to the Photoshop program icon or a shortcut or alias of the program icon. In each case you are overriding the computer operating system reading the file header and forcing the file to open in Photoshop.

Yet there are times when even this will fail as well and this points to one of two things. Either you have a corrupt file, in which case the damage is most likely permanent. Or, the file extension has been wrongly changed. It says .psd, but is it really a PSD? It is possible that someone has accidentally renamed a file with an incorrect extension. If you double-click or drag to the Photoshop icon, the file will fail to open. But it will now only open if you use the File \Rightarrow Open command. Or try using the *ettal* right mouse key to access the contextual menu and choose Open with...

Figure 2.6 When files won't open up directly in Photoshop the way you expect them to, then it may be because the header is telling the computer to open them up in a different program instead. To force open an image in Photoshop, drag the file icon on top of the Photoshop application icon or an alias or shortcut thereof, such as an icon placed in the dock or on the desktop.

▼ Name	& Extension:			
D4AT0	272.JPG			
🗍 Hide	extension			
🔻 Open	with:	2		
Pr	eview (default	t)		:
	s application ents like this.	to open a	dl	
Cha	nge All			
▶ Previe	:w:			
🔻 Owne	rship & Permi	ssions:		
You	can Read &	Write	:	

Figure 2.7 The header information in some files may contain information that tells the operating system to open the image in a program other than Photoshop. On a Macintosh go to the File menu and choose File \Rightarrow Get Info and under the Open with item, change the default application to Photoshop. On a PC you can do the same via the File Registry.

History saves

Alas, it is not possible to save a history of everything you did to an image, but there are some things you can do that are quite useful. If you go to the Photoshop preferences you can save the history log information of everything that was done to the image. This can record a log of everything that was done during a Photoshop session and saved to a central log file or saved to the file metadata.

The other thing you can do is go to the Actions palette and click to record an action of everything that is done to the image. The major downfall here is that Actions cannot record everything. For example, you cannot record brush strokes with an action.

Version Cue

Version Cue was first introduced as a component of the original Adobe Creative Suite and is included when you buy a complete Creative Suite set of applications. Version Cue is made more prominent in this new version of Photoshop. If you find this dialog intimidating and wish to revert to the more simpler Save As dialog shown in Figure 2.8, go to the Photoshop menu and choose Preferences ⇒ File Handling and deselect the checkbox next to Enable Version Cue Workgroup Management.

Save often

Do you remember the bit at the end of the movie *Stand by Me* where the author shuts down the computer at the end of writing his book? Every computer literate person in the theater wanted to shout 'No, don't. Save first!' It goes without saying that you must always remember to save often while working in Photoshop. Thankfully you don't come across many crashes when working with the latest UNIX-based operating systems for Macintosh and PC. But that doesn't mean you should relax too much. Saving a file is fairly easy, but there are some pitfalls to be aware of.

Choosing File \Rightarrow Save will always create a safe backup of your image, but as with everything else you do on a computer, make sure you are not overwriting the original with an inferior modified version. There is always the danger that you might make a drastic reduction in the image size, accidentally hit Save and lose the original in the process. But before you close the file you can always go back a step or two in the History palette and resave the image in the state it was in before it was modified.

When you save an image in Photoshop, you are either resaving the file (which will overwrite the original) or forced to save a new version using the Photoshop file format. The determining factor will be the type of file format the image was in when you opened it and how it has been modified in Photoshop. All the different file formats are discussed in greater depth towards the end of this book in Chapter 16, but the main thing to be aware of is that some file formats will restrict you from saving things like layers, pen paths or extra channels. If, for example, you open a JPEG format file in Photoshop and modify it by adding a pen path (to use as a clipping path), you can choose File \Rightarrow Save and overwrite the original without any problem. But if you open the same file and add a layer or an extra alpha channel, you can't save it as a JPEG any more. This is because a JPEG file can contain pen paths, but a JPEG cannot contain layers or additional channels, so it has be saved using a file format that can contain these extra items.

I won't go into lengthy detail about what can and can't be saved using each format. But basically, if you modify a file and those modifications can be saved using the file format the original was in, that's what Photoshop does. If the modifications made mean it can't be saved using the original file format then it will always default to using the PSD format, but could still be saved using TIFF or PDF. PSD is a good format with which to save any master image, since PSD files can contain anything you add in Photoshop and it offers good, lossless file compression, which can save you valuable disk space.

Save As... and Save a Copy

But what if you want to save the image in the original format without saving all the layers etc. Or, if you want to save an image as a duplicate? When you choose File \Rightarrow Save, you can force Photoshop to save in the original file format still, by selecting the file format you want to save in from the format menu list. When you do this the incompatible features will be automatically removed and the image flattened if necessary. The Save dialog will indicate with a warning triangle the items that will not be saved when you do this.

	Save As: _F2F0449.jp	9		
	Where: Pictures		•	
	Format: JPEG		•	
Save:	As a Copy	Annotations		
1	Layers			
Color:	Use Proof Setup: V	Vorking CMYK e: Adobe RGB (1998)		
File mu	st be saved as a copy with this sele	ction.		

The 'save everything' file formats

There are four main file formats that can be used to save everything you might add to an image such as image layers, type layers, channels and also support 16-bits per channel. These are: TIFF, Photoshop PDF, the large document format, PSB and lastly the native Photoshop file format, PSD. I always favor using the PSD format when saving master RGB images.

Quick saving

As with all other programs, the keyboard shortcut for saving a file is: **H**S *cttl*S. If for some reason you should wish to force Photoshop to save without showing the Save dialog, then use: **H**SCS *ctrl alt*S.

Figure 2.8 The basic Photoshop Save As dialog will be similar in appearance to other operating system application save dialogs. This particular dialog can be expanded by clicking on the downward pointing disclosure triangle to reveal an expanded folder view. If the file format you select to save in won't support all the components in the image such as layers, then a warning triangle will alert you that when you save this document, the layers will not be included.

Title bar proxy icons (Macintosh)

Macintosh users may see a proxy image icon in the title bar. This is dimmed when the document is in an unsaved state and is reliant on there being a preview icon; many JPEGs will not have an icon until they are saved as something else.

To relocate the existing source file and move it to a new location, *ctrl* drag on the proxy icon and drag to a new destination (if you move it to a new disk volume, it will make a copy).

To view the file's folder hierarchy and jump to a specific folder location, 🌐 click on the proxy icon.

The image document window

The document window displays extra information about the image in the two boxes located in the bottom left corner of the image window (Mac) or at the bottom of the screen (PC). The left-most displays the zoom scaling percentage, showing the current zoom factor. You can type in a new percentage of any value you like from 0.2% to 1600% up to two decimal places and set this as the new viewing resolution. In the middle is the Work Group Server button, which is used to check in or check out a document that is being shared over a WebDAV server. Next to this is the Preview box. Mousing down on the Preview box will display an outline box of how the image will be scaled and positioned relative to the current Page Setup paper size (also reflecting the settings in Print with Preview). The preview reflects the image dimensions at the current pixel resolution. The resolution can be checked by holding down **C** all while you mouse down. This will display both the dimensions and image resolution. **(H)** *ctrl*+mouse down shows the image tiling information. The Preview box also always displays updated information about the file.

(III) click to display the title bar proxy icons (Mac only)

Preview box options

display the tiling.

Mouse down to display a scaled preview

print with the current page setup.

Figure 2.9 The window layout of a Photoshop document as it appears on the Macintosh. If you mouse down on the arrow icon next to the status information box, you can select the type of information you wish to see displayed there.

Status display options

The status display information can be changed by mousing down on the arrow next to the status information box. Here are descriptions of what these status options tell you.

Document Sizes

The first figure represents the file size of a flattened version of the image. The second, the size if saved including all layers.

Document Profile

The current profile assigned to an open document.

Document Dimensions

This displays the physical image dimensions, as would currently be shown in the Image Size dialog box.

Scratch Sizes

The first figure displays the amount of RAM memory used. The second shows the total RAM memory available to Photoshop after taking into account the system and application overhead.

Efficiency

This summarizes how efficiently Photoshop is working. Basically it provides a simplified report on the amount of scratch disk usage.

Timing

This will time Photoshop operations. It records the time taken to filter an image or the accumulated timing of a series of brush strokes. Every time you change tools or execute a new operation, the timer resets itself.

Current Tool

This displays the name of the tool you currently have selected. This is a useful aide-mémoire for users who like to work with most of the palettes hidden.

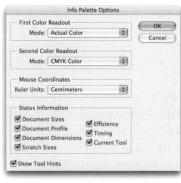

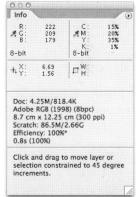

Figure 2.10 The document window can only display one item at a time. But if you open the Info Palette Options (via the Info Palette fly-out menu), you can check to have all the items here displayed in the Info Palette. And in addition to this, you have Show Tool Hints. These appear at the bottom of the Info Palette and will change according to any modifier keys you have held down at the time, to indicate extra available options.

Multiple window views

Multiple window views can prove useful if you wish to compare different soft proof views of the same image to get an impression on screen of how the colors in your image might appear in print. See Chapter 13 on Color Management for more about soft proofing in Photoshop.

Portrait/Landscape tiling

The Window \Rightarrow Arrange \Rightarrow Tile options in Photoshop CS2 now include tile for horizontal and tile for vertical mode images. This is designed to allow maximum useful use of the display area.

Managing document windows

You can create a second window view of the image you are working on by choosing Window \Rightarrow Arrange \Rightarrow New Window for (document name). The image is duplicated in a second window. For example, you can have one window with the image at a Fit to Screen view and the other zoomed in close-up on a detailed area. Any changes you make can then be viewed simultaneously in both windows. You can arrange the way all the document windows are displayed on the screen. Choose Window \Rightarrow Arrange \Rightarrow Cascade to have all cascading down from the upper left corner of the screen. Choose Window \Rightarrow Arrange \Rightarrow Tile to have all the currently opened image windows tiled edge to edge. Note that in Photoshop CS or CS2, when two or more document windows are open, you can synchronize the scrolling and magnification to affect all document windows by depressing the Shift key as you scroll or zoom in and out on any window view.

Figure 2.11 To open a second window view of a Photoshop document, choose Window \Rightarrow Arrange \Rightarrow New Window for (document name). Changes applied to the close-up view are automatically updated in the full frame view.

Photo: Eric Richmond.

Rulers, Guides & Grid

The Grid provides you with a means for aligning image elements to the horizontal and vertical axis (choose View \Rightarrow Show \Rightarrow Grid). To alter the grid spacing, go to the General Preferences and select Guides & Grid.

Guides can be flexibly positioned anywhere in the image area and be used for the precise positioning and alignment of image elements. Guides can be added at any time, providing the Rulers are displayed. If not, choose View \Rightarrow Rulers ($\Re R$ ctr/R). To add a new guide, mouse down and drag out a new guide from the ruler bar. Release the mouse to drop the guideline in place. If you are not happy with the positioning, select the move tool and drag the guide into the exact required position. But once positioned, it is often a good idea to lock the guides (View \Rightarrow Lock Guides) to avoid accidentally moving them again.

'Snap to' behavior

The Snap option in the View menu allows you to toggle the snap to behavior for the Guides, Grid, Slices, Document bounds and Layer bounds. The shortcut for toggling Snap to behavior is **H** *j ctrl j*. When the Snap to is active and you reposition an image, type or shape layer, or use a crop or marguee selection tool, these will snap to one or more of the above. It is also the case that when Snap is active, and new guides are added with the Shift key held down, the guide will snap to the nearest tick mark on the ruler. Objects on layers will snap to position when placed within close proximity of a guide edge. The reverse is also true: when dragging a guide, it will snap to the edge of an object on a layer at the point where the opacity is greater than 50%. Furthermore you can Lock Guides and Clear Guides. If the ruler units need changing, just *ctrl* right mouse-click on one of the rulers and select a new unit of measurement. If the rulers are visible but the guides are hidden, dragging out a new guide will make the others reappear. You can also position a guide using View \Rightarrow New Guide... Enter the exact measurement coordinate for the horizontal or vertical axis in the dialog box.

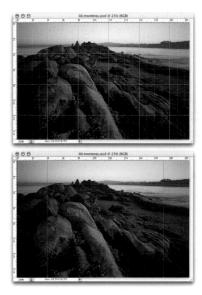

Is it on or off?

If a tick mark appears next to an item in the View \Rightarrow Show menu, it means it is switched on. If you then select the item in the menu and release the mouse, you can switch it off.

Smart Guides

When Smart Guides are switched on, these can help you align layers as you drag them with the move tool (see previous chapter).

Figure 2.13 The Photoshop palettes can be collapsed by clicking on the plus button (Mac) or minimize/maximize button (PC). The Mac button is shown circled above. Clicking this button once will collapse the palette to shrink to the most compact size, according to the number of items present (middle). Clicking again or double-clicking the palette tab will collapse the palette to display the palette tab only (bottom).

The Photoshop palettes

The Photoshop palettes can be positioned anywhere you like on the screen by mousing down on the palette title bar and dragging to a new location. You can change the height of a palette by dragging the size box at the bottom. To return a palette to its default size, click the plus button (Mac) or click the minimize/maximize box (PC). One click will resize, a second click collapses the palette. Double-clicking will always collapse the palette to a title bar. If an uncollapsed palette is positioned on the bottom of the screen display, the palette collapses downwards when you double-click on the palette tab and open upwards when you double-click.

Palettes can be grouped together. To do this mouse down on the palette tab and drag it across to another palette. When palettes are grouped this way they are like folders in a filing cabinet. Click on a tab to bring a palette to the front of the group. To separate a palette from a group, mouse down on the palette tab and drag it outside of the palette group.

Figure 2.14 The individual palettes can be nested in groups. To do this, mouse down on the palette tab and with the mouse held down, drag the tab across to another palette or group of palettes and release the mouse once inside the other palettes. To remove a palette from a group, you simply mouse down on the palette tab and drag outside the palette group.

Palette docking

The Photoshop palettes can be arranged in individual groups (as in the default work space layout setting) or they can be docked together as shown in Figure 2.15. If you have a limited sized screen this is a convenient way of arranging the palettes and also makes it easier to alter the height of individual palettes within the docked group when any one palette needs more or less space.

To set up palette docking, first separate all your palettes and position one palette (like Styles) immediately below another (like Tool Presets) and drag the tab of the Styles palette up to meet the bottom edge of the Tool Presets palette. As the palettes dock, you will see the bottom edge of the upper palette change to a double bar. Release, and the two palettes are joined. Drag the Actions and History palette across to group with the Styles palette. Now repeat the operation by separating the Layers, Channels and Paths palettes and join them to the bottom of the Styles palette group using the method I just described. When the cursor is positioned over the palette divider, you will see the icon change to a double arrow, indicating that you can adjust the relative height between two sets of palettes (where allowable). If you drag on the lower height adjustment/ grow tab in any palette, you can adjust the overall height of the docked palette grouping.

Figure 2.15 The Photoshop palettes shown with vertical docking.

Figure 2.16 To dock palettes together as shown in Figure 2.15 you need to mouse down on a palette tab and drag the tab across to align precisely with the bottom of another palette, at which point you will see a double bar appear.

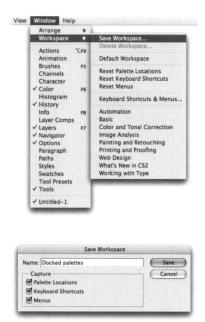

Figure 2.17 The Save Workspace menu in Photoshop can be used to save custom palette work space setups. These can be recalled by revisiting the menu and highlighting the work space name. To remove a work space, choose Delete Workspace... from the menu.

Work space settings

If you are searching for a particular palette and can't find it, the palette may just be hidden. Go to the Window menu and select the palette name from the menu. The **Tab** key (also indicated as **)** shortcut will toggle hiding and showing all the palettes. **Tab** Shift will toggle hiding/ showing all the currently visible palettes except the Tools palette and options bar. This is useful to remember if all your palettes seem to have disappeared. Try pressing **Tab** and you should be able to view them once again.

If at any time you wish to restore the palette positions, go to the Window \Rightarrow Workspace menu and select Reset Palette Locations. You can also save the current palette arrangement as a custom workspace by going to the Window menu and choosing Workspace \Rightarrow Save Workspace... A dialog box will pop up that will ask you to name the workspace and save it. The next time you visit the Window \Rightarrow Workspace menu you will see the saved work space appear in the menu listing. This is a real handy feature that can enable you to switch quickly between different custom palette arrangements.

If you want to be extra clever, you can go to the Edit \Rightarrow Keyboard Shortcuts menu and choose Shortcuts for Application menus: Windows. Scroll down and you will see a list of all the currently saved Workspace presets. You can now assign keyboard shortcuts that will allow you to jump quickly from one work space setting to another.

If you have a second monitor display, you can arrange for all the palettes to be displayed nestled on the second screen, leaving the main monitor clear to display the whole image.

With Photoshop CS2 you can save more than just the palette positions though. You can create custom keyboard shortcuts and customize the layout and coloring of the menu items. You will note that the Save Workspace dialog allows you to include these items in the saved workspace setting and you will note that there are also a number of preset Workspace options that are available for you to try out in the Workspace submenu.

Navigator

The Navigator is usually grouped with the Info, Character and Paragraph palettes. The Navigator offers an easy and direct method of scrolling and zooming in and out of the image window. The palette window contains a small preview of the whole image and enables you to scroll very fast with a minimum of mouse movement by dragging the colored rectangle. This colored rectangle indicates the current view as seen in relation to the whole image (other rectangle colors can be selected via the palette fly-out menu options). To operate the zoom, hold down the **R** *ctrl* key and drag the mouse to define an area to zoom to. Alternatively, with the slider control at the bottom, you can quickly zoom in and out or click on the 'little mountain' or 'big mountain' icons to adjust the magnification in increments. You can also type in a specific zoom percentage in the bottom left corner up to two decimal places to set the new zoom percentage. It is also possible to resize the palette as shown in the illustration here, by dragging the bottom of the palette window out. This means that you can make the Navigator palette as big as you like. Although not very practical on a single display, if you are using a dual display setup, it can make more sense to work with a bigger Navigator palette.

Figure 2.18 The Navigator palette plus the Navigator Palette Options which will allow you to choose a different color for the zoom outline in the palette.

	100	Comores
Mode: Actual Color	199	Cance
- Second Color Readout		
Mode: CMYK Color	•	
Mouse Coordinates		
Ruler Units: Centimeters	•	
Status Information Document Sizes Document Profile Document Dimensions	Efficiency Timing	

Figure 2.19 The Info palette and Info Palette Options dialog. Mouse down on the disclosure triangle in the top right of the Info palette and choose Palette Options... to reveal the Options dialog shown here. If you mouse down on the pop-up menus, you can alter the readout display or the ruler units used. I usually have the First Readout display indicate the Actual Color space values and the Second Color Readout display CMYK values. But there are other choices you can pick, such as the image transparency opacity.

Info

This palette reports information relating to the position of the cursor in the image window, namely: pixel color values and coordinate positions. When you drag with a tool, the coordinates update and in the case of crop, marquee, line and zoom tools, report back the size of a dragging movement. The submenu flyout leads to Palette Options... Here you can change the preferences for the ruler units and color readouts. The default color display shows pixel values for the currently selected color mode plus the CMYK equivalents. When working in RGB, illegal colors which fall outside the current CMYK work space gamut are expressed with an exclamation mark against the CMYK value. This default view suits the way most professional Photoshop users like to work, because as you edit a master image in RGB mode, you can simultaneously view the RGB and CMYK readouts of the pixel values anywhere in the image. It is worth pointing out here that the pixel readouts are linked to the sample area size setting of the evedropper tool (see evedropper tool on page 90).

Since the introduction of extended support for 16-bit editing in Photoshop CS, you can view the Info palette numbers expressed as 16-bit values. As a matter of interest, Photoshop's 16-bit per channel mode is actually using only 15 bits per channel. This means that the 16-bit number values go from 0 to 32,768 instead of from 0 to 65,546, which is what many people have assumed.

As was mentioned a few pages back in this chapter, the Info palette can be customized to display document status information. And the advantage of this is that you can choose to display multiple items at once in the palette. Below this is the Show Tool Hints box. When this is checked, Photoshop will constantly update the Info palette with information about the current tool you have selected. If, for example, you have a marquee tool selected and hold down the **(S)** *alt* key, the Tool Hint will change to inform you that dragging with the tool will draw a marquee centered around the point where you first drag.

Histogram palette

The Histogram palette complements the histogram display found in the Levels and Camera Raw dialogs, except this is a persistent display which can be used to help you observe visually the levels in an image when you use other image adjustment tools and are applying these to the whole image or a selected area. The Histogram palette can be expanded to provide a larger palette size and expanded again to simultaneously show all the color channels. The main histogram view can be set to display the merged channel RGB/CMYK composite view you normally see in the Levels histogram, individual color channel views, a colored histogram view (as shown in Figure 2.20) or a Luminosity view. There used to be an Image menu item called Histogram which displayed a luminosity histogram view of the merged channels. This is considered a more accurate representation of the merged channel image data and useful for making shadow and highlight assessments (more on this in Chapter 4). Although the Histogram palette will provide a continual update on the image levels. it is unable to provide a consistently accurate and true representation. The histogram display will reflect levels changes based on the pixels stored in what is known as the image cache. If the image you are editing is zoomed out to fit the screen, the histogram display information will be based on the current image cache - the stored image view used to display the image at that magnification only. The Histogram palette does not attempt to read in the pixels for the whole image each time you perform an operation, it uses the image cache only. Because of this, the histogram may display an unrepresentative, broken histogram with gaps in it. You know when the cache is being used, the Cache Level will indicate a number higher than '1' and a warning triangle appears in the top right corner of the histogram display area. To update the histogram display based on the full image size data: double-click anywhere inside the Histogram palette, click on this warning triangle or click the refresh histogram button just above the warning triangle.

Expanded channels

Figure 2.20 The Histogram palette is shown here in an expanded view with the composite histogram displayed using color coded channels.

Tool Options bar

When you first install Photoshop, the Options bar will appear at the top of the screen, snapped to the main menu. This is a convenient location for the tool options, and you will soon appreciate the ease with which you can make changes to any options with minimal mouse navigation movement. The Options bar can be unhooked, by dragging the gripper bar (on the left edge) away from the top of the screen. The Options bar contains a 'palette well' docking area to the right, which is visible whether the Options bar is docked at the top or bottom of the screen, so long as your monitor pixel display is set to at least 1024 × 768 pixels (although ideally you will want a larger pixel display to see this properly). Palettes can be docked here by dragging a palette tab into this palette well. Mouse over the palette tabs docked in this way and the name highlights in black and will open when you click on the tab. As was mentioned earlier on page 36, you can use the Shift Tab shortcut to toggle hiding the palette stack only, keeping just the Tools palette and Options bar visible.

The individual Options bar settings for each tool are shown throughout the rest of this chapter. To reset a tool or all tools, *ctri* right mouse-down on the tool icon on the left and choose Reset Tool or Reset All Tools. The 'tick' and 'cross' icons on the right, before the palette well, are there to make it simpler for users to know how to exit a tool that is in a modal state. You can change the palette tab order by *ctri* right mouse-clicking on a palette tab in the well. A contextual menu will pop up and you can opt to move the palette tab left or right or to the beginning or end of the palette well (see Figure 2.22).

Tool Presets

The Tool Presets palette can be used to store custom tool presets. All of the Photoshop tools have a range of tool options and the Tool Presets palette allows you to configure a specific tool setting and then save it. This allows you to access a number of tool options very quickly and saves you the bother of having to reconfigure the Options bar settings each time you use a particular tool. For example, you might find it useful to save crop tool settings for different image dimensions and pixel resolutions. The example in Figure 2.23 shows a display of presets for all available tools. If you click on the Current Tool Only button at the bottom of the palette, you can restrict the preset options to the current tool.

The Tool Presets palette is also useful for storing preconfigured brush preset settings. In fact one of the first things you should do is go to the Tool Presets palette submenu and choose Load Presets... Choose: Presets \Rightarrow Tools \Rightarrow Brushes.tpl. Another thing that may not be immediately apparent is the fact that you can also use the Tool Presets to save type tool settings. This again is very useful, as you can save the font type, font size, type attributes and font color settings all within the single tool preset. This feature is very useful if you are working on a web page or book design project.

Cna	racter		
Helve	etica		Regular
Ŧ	12 pt	F 🛋	(Auto)
AĮ́v	Metrics	AV AV	0
IT	100%]]	100%
<u>A</u> ª†	0 pt	Color	
T	T	Tr T'	T ₁ T Ŧ
Eng	lish: USA	a.	Sharp :

Figure 2.24 The Character palette.

Para	agraph		0
-			
+	0 pt	≣ + 0 pt	
*≣	0 pt		
* E	0 pt	,≣ 0 pt	

Figure 2.25 The Paragraph palette.

T	Futura	Sample
Ŧ	Gadget	Sample
0	Adobe Garamond Pro	Sample
T	Geeza Pro	
Ť	Geneva	Sample
Ą	Georgia	Sample
0	Gill Sans (T1)	Sample
a	Gill Sans (TT)	Sample
ħ	Gill Sans	Sample
/	Helvetica	Sample
Ţ	Helvetica Neue	Sample
Ħ	Herculanum	SAMPLE
T	Hoefler Text	~ 20 00 d
	T Humana Serif ITC TT Sampl	
Ţ		
	Humana Serif Md ITC TT	Sample

Figure 2.26 The new WYSIWYG font menu.

Character

The type tool settings can all be controlled using the three palettes shown on this page. When the type tool is selected you will see the Type Options bar shown in Figure 2.27. From left to right, the Type Options allow you to choose a saved type tool preset. You can click on the second button along to toggle switching the type orientation from horizontal to vertical. The font name is displayed next and if you mouse down on the arrow next to this, you can choose from any available font that's loaded on your computer. Plus, you will notice the nice new WYSIWYG font menu list in Photoshop CS2. If you know the font you are looking for, click in the font name field, type the first few letters unique to the font name, and it should appear straight away. Next you have the font style and font size settings, followed by the anti-aliasing options. These allow you to set the smoothness of the font edges from no anti-aliasing (None), to Smooth. The paragraph controls allow you to set the text justification to align left, center or right. Next a button for accessing the type warp control and lastly a palette icon which when clicked will open both the Character and Paragraph palettes shown here.

These palettes provide additional controls over the type character and paragraph settings. The Character palette provides a level of character control that is comparable to InDesign's text handling. You have access to leading, tracking and baseline shift. Multilingual spell checking is available and the small type buttons at the bottom enable you to quickly modify the text capitalization.

Paragraph

Photoshop will let you place multiple lines of text, and the Paragraph palette lets you control the paragraph text alignment and justification as in the Type Options. The indentation controls enable you to indent the whole paragraph left and right, or just indent the first line of text.

T • II Helvetica • Regular •	T 72 pt	aa Sharp		0 🗸 🗟
	COMPANY OF THE OWNER WATER OF		and the second	

Figure 2.27 The type tool options.

Brush tools in Photoshop

The standard brush presets in Photoshop range from a single pixel to a 2500 pixel-wide brush, which are available with varying degrees of softness. This introduction to the brushes in Photoshop applies to all of the painting tools in Photoshop.

The Brush Preset picker is the second item from the left in the Tool Options bar and this is where you begin, by selecting a brush shape. You can select from many different shapes and then simply adjust either the brush size or the hardness. To select a new brush, mouse down on the Brush Preset picker, next to the word Brush in the Options bar. Select the desired brush shape and brush size and doubleclick on the chosen preset to close the Brush Preset picker. There is an easier way to change the brush presets. If you *ctrl* right mouse-click in the image you are working on, this will open the same Brush Preset list on screen, directly next to the cursor. Click on the brush preset you wish to select and once you start painting, the Brush Preset menu will then close. There is a subtle variation to this technique of opening the Brush Preset on screen, where if you *ctrl* right mouse-drag the mouse instead of clicking, the menu will open and stay open as long as you have the mouse held down. When you release the mouse, the Brush Preset menu will close.

If you *ctrl Shift*-click right mouse *Shift*-click in the image with a brush tool another menu will appear. The Edit Brush... option will take you to the Brush Preset menu again. Underneath this will be a list of different brush blending modes to choose from.

Once you have created a new brush setting you can save this as a new Brush Preset. Click on the New Brush Preset button in the Brush Preset menu (see Figure 2.30). The New Brush dialog will appear. Give the brush shape a name and click OK to append it to the current list. You may notice that Photoshop does not have a separate airbrush tool. Instead, all the brush tools feature an airbrush mode button in the Tool Options bar.

Figure 2.28 There is no need to visit the Brush or Tool presets each time you want to change the size of a brush. Use the right square bracket key 1 to make a brush bigger and the left square bracket key 1 to make it smaller.

Figure 2.29 Combine the square bracket keys with the Shift key on your keyboard and you can use the *Shift* 1 to make a brush edge harder and *Shift* 1 to make a brush edge softer.

Brushes palette

So far we have looked at the Brush Preset options which determine the brush shape and size. The Brush Tool Presets (the first icon on the left in the Options bar) are a combination of two things: the Brush Preset size and shape, and the brush attributes, which are defined in the separate Brushes palette. The brush attributes include things like how the opacity of the brush is controlled. If you are using a pressure sensitive pen stylus, there are options in the Brushes palette that will enable you to link the pen pressure of the stylus to how much paint opacity will be applied. You can switch this behavior on or off and determine if things like how the paint opacity and flow will be controlled by the pen pressure or the angle of tilt of the pen. And new to Photoshop CS2, the barrel rotation of the pen as well. The following paragraph explains more about some of these settings.

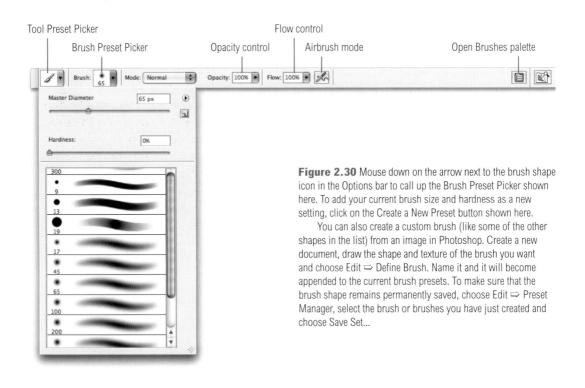

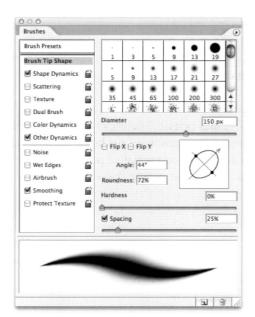

Scattering Minimum Diameter 0% Texture Tilt Scale 160% Dual Brush Angle Jitter 0% Other Dynamics Angle Jitter 0% Other Dynamics Angle Jitter 0% Noise Angle Jitter 0% Noise Angle Jitter 0% Control: Stylus Wheel Airbrush Angle Control: Off	Brush Presets	Size Jitter	0%
Stape Dynamics Scattering Texture Texture Dual Brush Color Dynamics Noise Control: Stylus Wheel Noise	Brush Tip Shape		
Scattering Image: Control: Stylus Wheel Texture Image: Control: Stylus Wheel Other Dynamics Image: Control: Stylus Wheel Noise Image: Control: Stylus Wheel Wet Edges Roundness Jitter Airbrush Image: Control: Off	Shape Dynamics		
Dual Brush Color Dynamics Angle Jitter Other Dynamics Control: Stylus Wheel Other	Scattering	Minimum Diameter	0%
Dual Brush Color Dynamics Color Dynamics Angle Jitter OK Other Dynamics Other Dynam	Texture	Tilt Scale	160%
Other Dynamics Other Dynamics Other Dynamics Noise Wet Edges Airbrush Smoothing Control: Off	Dual Brush 🖬		
Noise No	Color Dynamics	Angle Jitter	0%
Wet Edges Airbrush Smoothing Control: Off	Other Dynamics 📓	ê	1
Airbrush a Control: Off	Noise 🖬	A Control: Stylus Wheel	
Smoothing	Wet Edges 🖬	Roundness Jitter	0%
-	Airbrush 🖬	A	L
Protect Texture	Smoothing	Control: Off	•
ender state and the state of th	Protect Texture	Minimum Roundness	
🖂 Flip X Jitter 🛛 🖂 Flip Y Jitter		🖯 Flip X Jitter 🛛 🖯 Flip	p Y Jitter

Figure 2.31 Here are two views of the Brushes palette. If you highlight a brush dynamic option in the Brushes palette this will display the dynamics settings on the right. Click one of the named items in this list if you want to activate the settings and modify them. As you can see here, Photoshop allows you to lock specific brush panel settings, such as the Shape Dynamics shown here. This means that the Shape Dynamics settings will now always remain fixed whenever you select other, different brush presets.

Pressure sensitive control

The Wacom Intuos range includes some pens that have a thumbwheel control and in Photoshop you can exploit all of these responsive built-in Wacom features to the full via the brush dynamics settings. You will notice that as you alter the brush dynamics settings, the brush stroke preview below will change to reflect what the expected outcome would be if you had drawn a squiggly line that faded from zero to full pen pressure (likewise with the tilt and thumbwheel). This visual feedback is extremely useful as it allows you to experiment with the brush dynamics settings in the Brushes palette and learn how these will affect the brush dynamics behavior.

Martin Evening Adobe Photoshop CS2 for Photographers

Figure 2.32 In this example, I selected the Aurora brush preset and experimented with the pen tilt settings for things such as the size and angle in the Shape Dynamics settings. I then set turquoise as the foreground color and purple for the background. I used a pen pressure setting to vary the paint color from foreground to background. I created the doodle in this image by twisting the pen angles as I applied the brush strokes.

Brushes palette options

The 'jitter' settings introduce randomness into the brush dynamics behavior. Increasing the opacity jitter means that the opacity will still respond according to how much pen pressure is applied, but there will be a built-in random fluctuation to the opacity that will vary even more as the jitter value is increased. The flow setting governs the speed at which the paint is applied. To understand how the brush flow dynamics work, try selecting a brush and quickly paint a series of brush strokes at a low and then a high flow rate. When the flow rate is low, less paint will be applied, but more if you increase the flow setting or apply more pressure (or you paint slower). Other tools like the dodge and burn toning tools use the terms Exposure and Strength. Essentially these have the same meaning as the opacity controls.

The Shape Dynamics can be adjusted as well to introduce jitter into the size angle and roundness of the brush. The scattering controls can enable you to produce broad, sweeping brush strokes with a random scatter. The Color Dynamics let you introduce random color variation to the paint color. The foreground/background color control can be useful as this will let you vary the paint color between the foreground and background color, according to how much pressure is applied. The Dual Brush and Texture Dynamics introduce texture and more interactive complexity to the brush texture. It is worth experimenting with the Scale control in the Dual Brush options. The Texture Dynamics utilize a choice of blending modes for different effects and of course you can add a custom texture of your own design, direct from the Pattern presets. When you have finished tweaking with the Brushes palette dynamics and other settings, go to the Tool Presets palette and click on the New Preset button at the bottom, to add your new settings as a preset.

Styles

Styles are layer effect presets which can be applied to image layers, type layers or vector layers. New custom layer effect combinations can be saved as Styles, where they are represented in the palette by an icon, which will visually indicate the outcome of applying the style to a square button shape. Styles can incorporate Pattern and Gradient fill layer effects.

Swatches

You can choose a new foreground color by clicking on a swatch in the Swatches palette. To add a new custom color to this list, click in the empty area at the bottom (and name the new color being added). $\[\] alt - click$ to erase an existing swatch. New sets of color swatches can be appended or replaced via the palette submenu and color swatches can be shared across all applications in the Creative Suite. You can edit the position of swatches (and edit other presets) by going to the Preset Manager in the Edit menu. When the Preset Manager is open, you can easily rearrange the order the color swatches appear in.

Color

Use this palette to set the foreground and background colors by dragging the color sliders, clicking inside the color slider or in the color field below. Several color modes for the sliders are available from the submenu including HTML and hexadecimal web colors. Out-of-gamut CMYK colors are flagged by a warning symbol in the palette box. Black and white swatches appear at the far right of the color field.

Figure 2.33 The Styles palette.

Figure 2.34 Here are two views of the Swatches palette. The top one shows the default view and below that an alternative view chosen from one of several options in the palette fly-out menu.

Figure 2.35 The Color palette.

Figure 2.36 You can use the Photoshop Preset Manager to load custom settings or replace them with one of the pre-supplied defaults. Presets include: Brushes, Swatches, Gradients, Styles, Patterns, Contours and Custom Shapes.

Figure 2.37 Apart from being able to load and replace presets, you are able to choose how the presets are displayed. In the case of Gradients, it is immensely useful to be able to see a thumbnail preview alongside the name of the gradient.

Preset Manager

The Preset Manager manages all your presets from within the one dialog. It keeps track of: brushes, swatches, gradients, styles, patterns, layer effect contours and custom shapes. Figure 2.36 shows how you can use the Preset Manager to edit a current set of Custom Shapes. You can append or replace an existing set (if the current set is saved, then you can easily reload it). The Preset Manager will directly locate the relevant preset files from the Presets folder. The Preset Manager can be customized, which is particularly helpful if you wish to display the thumbnails of the gradients (see Figure 2.37). If you double-click any Photoshop setting that is outside the Photoshop folder, it will automatically load the program and append the relevant preset group.

Actions

Actions are recordable Photoshop scripts. The palette shown opposite in Figure 2.38 has the Default Actions set loaded. As you can see from the descriptions, these will perform automated tasks such as adding a vignette or creating a wood frame edge effect. If you go to the palette fly-out menu and select Load Actions... you will be taken to the Photoshop CS2/Presets/Photoshop Actions folder. Here you will find many more sets of actions to add to your Actions palette. Another way to load an action you have downloaded or had sent to you, is to simply doubleclick it. This step will automatically install the action in the Actions folder and if Photoshop is not running at the time, launch Photoshop as well. To run an action, you will mostly need to have a document already open in Photoshop and then you simply press the Play button to commence replay. You can record your own custom actions as well. Chapter 17 explains these in more detail and lists many other useful Photoshop shortcuts.

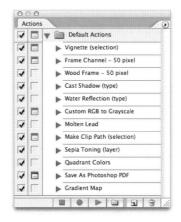

History

Photoshop can temporarily store multiple undo states and snapshots during a Photoshop session. These history states are displayed in the History palette. The number of states recorded are set in the General Preferences and this can be anywhere between 1 and 1000, although the more histories you record the more memory Photoshop will require to save all these history states. You can click on an earlier history state to revert to that particular stage of the edit, or you can select a particular history state and paint from history, using the history brush. For more information, see the later section on History, starting on page 71.

Grouping and linking

Layer sets are now known as Groups. Multiple layers can be selected by *Shift*clicking on the layer names to select contiguous layers, or **#** *ctrl*-clicking on the layer names to select discontiguous layers. Layers can be linked together by clicking on the new Link button at the bottom of the Layers palette. Selected layers can then also be grouped together by choosing **# G** *ctrl* **G** from the Layer menu.

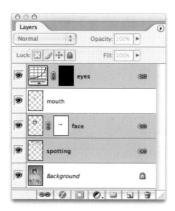

Layers

Photoshop layers allow you to create an image in multiple segments. Each layer will contain an image element, such as a duplicate of the background image, a copied selection from another layer, or another Photoshop document that has been copied across. Or, it can be a text layer or a vector shape layer. Adjustment layers are image adjustment instructions, but in a layer form. Layers can be placed together in groups (formerly known as sets) which makes the layer organization easier to manage. You can apply masking to the contents of a layer with either a pixel layer mask or a vector mask. Layers can blend with those underneath using 23 different blending modes. Layer effects/styles allow you to add effects such as drop shadows, gradient/pattern fills or glows to any layer. Custom styles can be loaded from and saved to the Styles palette. You will find some of the sub-menu options for layers are duplicated in the Layer main menu. Note that the Layers palette has been modified in Photoshop CS2, so that layer linking is now controlled via a link button at the bottom of the palette. And the layer selection method is different now as well. See Chapter 7 for more information about layers and montage techniques.

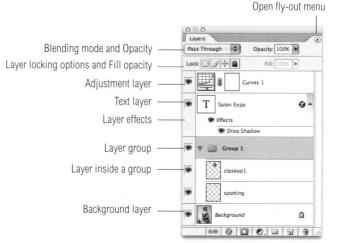

Layer Comps

Layers are commonly used as a means to edit an image and preserve the edited sections on discrete layers. Graphic designers and web designers can sometimes use layers to construct very complex images, so that by showing and hiding the various layers, contained within it, several different layout variations can be produced from the one document. In these circumstances, showing and hiding layers can be a tricky and error-prone exercise. The Layer Comps palette enables you to save specific layer visibility and layer positions as a layer comp that can be quickly accessed using this palette.

To save a layer configuration, click on the New Layer Comp button in the Layer Comps palette. This will pop the New Layer Comp dialog shown in Figure 2.42. The default dialog will save the layer opacities only. But you can also check the Position and Appearance boxes, to save the layer positions and layer effects as well. If you alter any of the selected attributes while a layer comp is selected, you can update a layer comp configuration by clicking on the Update Layer Comp button.

As a photographer, I often use Layer Comps to test out different color adjustments with more than one image adjustment layer, or other variations of layer combinations, to quickly compare different outcomes. For example, it is so much easier to save the different combinations of adjustment layers as layer comps, rather than go through the process of switching the visibility of individual layers on and off. One can simply click on the box next to the layer comp to select a new layer comp view, or use the previous/next arrow buttons.

Layer Comps and Scripts

You can run Scripts in Photoshop based on layer comps. Layer Comps to Files... will generate individual files. Layer Comps to PDF... will generate a multipage PDF document. And Layer Comps to WPG... will let you generate a Web Photo Gallery. The scripts are basic and not particularly well optimized, but are nevertheless useful.

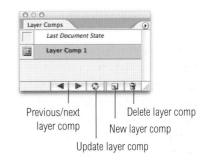

Name: Layer Comp 1	(OK
Apply To Layers: Visibility	Cancel
Position	
Appearance (Layer Style)	
Comment: Basic template	

Figure 2.42 The Layer Comps palette and New Layer Comp dialog.

Destination:	
/Desktop/Output folder	Browse) Run
Style:	Cancel
Horizontal Gray	
Selected Layer Comps	s Only
should be saved. Once	ation where flat image files e Photoshop has saved ich Web Photo Gallery in

Figure 2.43 Here is an example of a Layer Comps script. Go to the File menu and choose Scripts ⇒ Layer Comps to WPG. The dialog requires you to specify a destination folder for the Web Photo Gallery and a WPG style. The default setting says 'Simple', but you can manually type in the name of any WPG template style available in the normal WPG dialog (see Chapter 15 on output for the Web)

Channels

A Photoshop grayscale mode image is comprised of a single channel of image information, with 256 levels in 8-bit per channel mode and 32,000 levels in 16-bit per channel mode. RGB images are comprised of three channels: Channel 1-Red, Channel 2-Green and Channel 3-Blue (RGB); CMYK images, four channels: Channel 1-Cyan, Channel 2-Magenta, Channel 3-Yellow and Channel 4-blacK. The Photoshop Channels palette displays the color channels in this order, with a composite channel (Channel \sim) always at the top. Use \Re *ctrl*+the channel number (or tilde key in the case of the composite channel) as a keyboard shortcut for viewing channels individually. When saving a selection (use Select \Rightarrow Save Selection), this will add a new alpha channel or you can overwrite an existing one. New channels can also be added by clicking the Add Channel button at the bottom of the Channels palette (up to 56 channels including the color channels are allowed). For specialist types of printing, alpha channels can be used to store print color information like varnish overlays or fifth/sixth color printing of special inks. Photoshop has a spot channel feature enabling spot color channels to have a color specified and be previewed on screen in color (see Chapter 9). You can use the Channels palette submenu or the buttons at the bottom of the Channels palette to delete, duplicate or create a new channel.

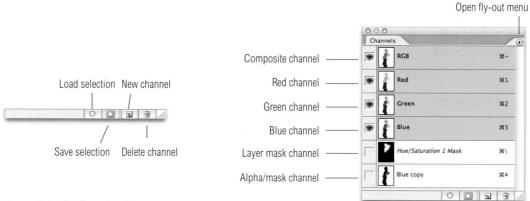

Figure 2.44 The Channels palette.

Paths

Where alpha channel masks use essentially pixels, paths use mathematical descriptions to define lines, outlines, or shapes. The advantage of a path is that it is resolutionindependent and infinitely editable. Paths can be imported from a vector drawing program such as Adobe Illustrator, or they can be created within Photoshop using the pen path or shape tools. A freshly drawn path is always displayed as a work path in the palette window. Work paths should ideally be promoted to become a normal path (double-click the work path or drag it down to the New Path button) if you don't wish the current work path to be overwritten. A path can be used in several ways: to convert to a selection; apply as a layer clipping path or save as a clipping path in an Encapsulated PostScript (EPS) or TIFF file.

I use the pen tool all the time to create paths in Photoshop. I mainly use paths whenever I need to define an intricate outline that I will later convert to an active selection or a mask. A lot of people are inclined to use the lasso tool to draw selection outlines. As you read through this book, you will notice that I strongly urge you to ditch the lasso tool in favour of the pen tool. This is because the pen tool is more efficient to use – you can easily edit a pen path and make corrections at any time. To fill a path with the foreground color, click on the Fill Path button. To stroke a path, drag it to the Stroke Path button. The stroke will use whichever tool and brush setting is currently associated with that tool. To convert a path into a selection, drag to the Make Selection button. To convert an active selection to a path, click on the Make Work Path button.

Figure 2.45 The Stroke Path button will use whichever tool has been selected in the Stroke Path options and also whichever brush setting is currently associated with that tool. To open the Stroke Path options, mouse down on the fly-out menu button and select the Stroke Path... item.

Tools palette

The Tools palette contains 58 separate tools and their icons give a clue as to each tool's function. The individual tool options are located in the Options bar and double-clicking any tool will automatically display the Options bar if this happens to be hidden for some reason. Figure 2.47 shows the Tools palette layout. Within the basic Tools palette are extra tools (designated by the small triangle at the bottom of the icon). These become visible when you mouse down on the tool's palette icon. You will notice that each tool or set of tools has a keyboard shortcut associated with it (this is displayed whenever you mouse down to reveal the nested tools or hover with the cursor to reveal the tool

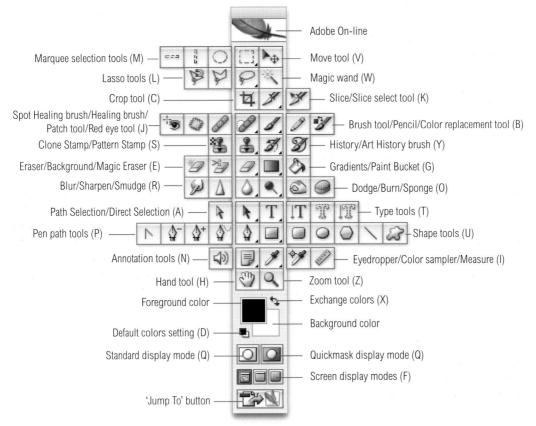

Figure 2.47 The Tools palette with keyboard shortcuts shown in brackets.

tip info). For example, pressing \bigcirc on the keyboard will activate the crop tool. Where more than one tool shares the same keyboard shortcut, you can cycle through these other tools by holding down the *Shift* key as you press the letter key. If you prefer to restore the old behavior whereby repeated pressing of the key would cycle the tool selection, go to the Photoshop menu, select Preferences \Rightarrow General and deselect the Use Shift Key for Tool Switch option. Personally, I prefer to use the shift modifier. You can also \bigotimes *all*-click the tool icon in the Tools palette to cycle through the grouped tools.

There are specific situations when Photoshop will not allow you to use a particular tool. Clicking once in the image document window will call up a dialog explaining the exact reason why you cannot access or use a particular tool. If you click at the very top of the Tools palette, this will open the Adobe On-line... dialog (also available in the File menu). Any late-breaking information plus access to on-line help and professional tips are all easily accessible within Photoshop.

Easter eggs

If you drag down from the system or Apple menu to select About Photoshop... The splash screen reopens and after about 5 seconds the text starts to scroll telling you lots of stuff about the Adobe team who wrote the program etc. Hold down and after and the text will scroll faster. And last, but not least, a special mention to the most important Photoshop user of all... Now hold down and choose About Photoshop... and you will see the Space Monkey beta test version of the splash screen. When the credits have finished scrolling, carefully aft.-click in the white space above the credits, but below the image to see what are known as Adobe Transient Witticisms appearing one at a time above the credits. If you want to see another Easter egg, go to the Layers palette, hold down

Figure 2.48 The Space Monkey splash screen.

Figure 2.49 Can you find Merlin?

ATWs

Being a member of the team that makes Photoshop has many rewards. But one of the perks is having the opportunity to add little office in-jokes in a secret spot on the Photoshop splash screen. It's a sign of what spending long hours building a new version of Photoshop will do to you! The instructions for how to access these are in the main text.

Feather: 0 px 🗌 Anti-alias	Style: Normal 🗘 Width: 🚅 Height:	R.

Magic wand tolerance setting

You can adjust the magic wand tolerance setting so that it will select fewer or more pixels, based on how similar they are in color to the pixel you click on. The tolerance setting governs the sensitivity of the magic wand selection. When you click on an area in the image, Photoshop selects all the adjacent pixels whose numeric color values are within the specified tolerance either side of the pixel value. If the pixels clicked on have a mean value of 120 and the tolerance setting is set at the default of 32, Photoshop will select pixels with a color value between 88 and 152.

Making the magic wand look good

The magic wand tool has been around since the very early days of Photoshop. A lot of the early tutorials were illustrated using only screen size images. It was therefore quite easy to create the impression of the magic wand being truly a 'magic' tool. When you work these days with what are considered normal size images, the usefulness of the magic wand tool is certainly diminished.

Selection tools [] 🔿 🚥 🕴 🖄

The usual editing conventions apply in Photoshop: pixels can be cut, copied and pasted just as you would do with text in a word processing document. Mistakes can be undone with the Edit \Rightarrow Undo command or by selecting a previous history state in the History palette. The selection tools are used to define a specific area of the image that you wish to modify separately, float as a layer or copy and paste. The use of the selection tools in Photoshop is therefore like highlighting text in a word processor program in preparation to do something else.

The marquee options include rectangular, elliptical or single row/single column selection tools. The lasso tool is used to draw freehand selection outlines and has two other modes – the polygon lasso tool, which can draw both straight line and freehand selections and the magnetic lasso tool. The magic wand tool selects pixels on the basis of their luminosity values within the individual channels. If you have a picture of a landscape with a blue sky and click in the sky area with the magic wand tool, the sky should get selected. That's what most people expect the magic wand tool to do; in reality it does not perform that reliable a job. I find it works all right on low resolution images but not with much else. However, you can use the smoothing options in the Select menu to tidy up a magic wand selection. If you are going to create complex selections this way then really you are often better off choosing the Select \Rightarrow Color Range option, which also creates selections based on color values. This selection command provides all the power of the magic wand tool, but has much more control. I rarely ever use the magic wand when defining critical outlines, but do find it quite useful when I want to make a rough selection area based on color. In short, don't dismiss the wand completely but don't place too much faith either in its capabilities for professional mask making. There are better ways of going about doing this, as shall be explained later in the book.

Modifier keys

Macintosh and Windows keyboards have slightly different key arrangements, hence the double sets of instructions throughout the book reminding you that the **H** key on the Macintosh is equivalent to the *ctrl* key on a Windows keyboard (because Windows PC computers don't have a Command key) and the Macintosh **S** key is equivalent to the *all* key in Windows. In fact, on most Macintosh keyboards the Option key is labeled as Alt. Macintoshes do have a *ctrl* key too. On the Mac its function is to access contextual menus (more of which later). Windows users will find their equivalent is to click with the right mouse button. Finally, the *Shift* key operates the same on both Mac and PC.

These keys are 'modifier' keys, because they modify tool behavior. Modifier keys do other things too – hold down the selection the marquee tool in the Tools palette. Notice that the tool display cycles through the options available. For the most part, modifier keys are used in conjunction with the selection tools and as you get more proficient you should be able to reach to the appropriate key instinctively without your eyes having to leave the display.

The *Shift* and *C alt* keys also affect the shape and drawing behavior of the marquee tools: holding down *Shift* when drawing a marquee selection constrains the selection to a square or circle; holding down *C alt* when drawing a marquee selection centers the selection around the point where you clicked on the image.

Holding down *Shift* Shift all when drawing a marquee selection constrains the selection to a square or circle and centers the selection around the point where you first clicked.

After the first stage of drawing a selection, whether by marquee, lasso, magic wand or a selection has been loaded from a saved alpha channel with subsequent selection tool adjustments, the modifying keys now behave differently.

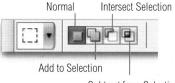

Subtract from Selection

Figure 2.50 The Options bar has four modes of operation for each of the selection tools: Normal; Add to Selection; Subtract from Selection; and Intersect Selection. You can also achieve these same operating modes by using the modifier keys.

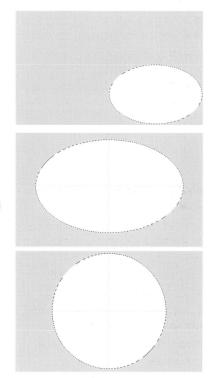

Figure 2.51 These composite screenshots show Quick Mask views of selections created by dragging out from the center with *Shift* held down (top), with *all* held down (middle) and *Shift Shift all* (bottom).

Martin Evening Adobe Photoshop CS2 for Photographers

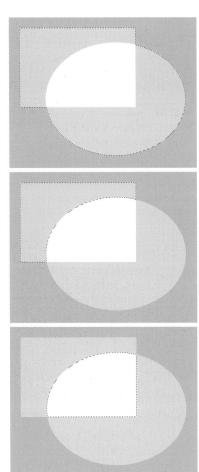

Figure 2.52 These composite screenshots show Quick Mask views of selections modified after the first stage. The top view shows an elliptical selection combined with a rectangular selection with *Shift* held down, adding to a selection combined with a rectangular selection with *Shift* held down, which will subtract from the original selection. The bottom view shows an elliptical selection combined with a rectangular selection held down, which will subtract from the original selection combined with a rectangular selection. The bottom view shows an elliptical selection combined with a rectangular selection with *Shift Shift Shift Shift selection* selection with *Shift selection* selection with *Shift selection sele*

Holding down the *Shift* key as you drag with the marquee or lasso tool adds to the selection. Holding down the *Shift* key and clicking with the magic wand tool also adds to the existing selection.

Holding down the **(S)** *(all)* key as you drag with the marquee or lasso tool subtracts from the selection. Holding down the **(S)** *(all)* key and clicking with the magic wand tool also subtracts from the existing selection.

A combination of holding down the *Shift* Shift all keys together whilst dragging with a selection tool (or clicking with the magic wand) creates an intersection of the two selections.

To find out more about practical techniques requiring you to modify selection contents, refer to Chapter 7 on montage techniques.

Figure 2.53 The modifier keys on a Macintosh keyboard and their Windows PC equivalents.

59

2

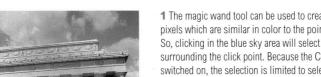

Tolerance: 32 🖉 Anti-alias 🖉 Contiguous 📄 Sample All Layers

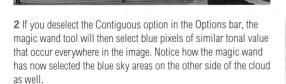

* • • • • •

3 Once most of the desired blue pixels have been selected, the Select \Rightarrow Grow command can be used to expand the wand selection. The Grow command is based on the tolerance value set in the Options bar for the magic wand tool. **1** The magic wand tool can be used to create a selection of pixels which are similar in color to the point where you clicked. So, clicking in the blue sky area will select all the blue pixels surrounding the click point. Because the Contiguous option is switched on, the selection is limited to selecting neighboring pixels only. In other words, it only selects pixels that are connected to each other.

Martin Evening Adobe Photoshop CS2 for Photographers

Lasso: freehand/polygon/magnetic $\wp \not \bowtie \not \gg$

The lasso tool behavior is more or less identical to that of the marquee selection tools – the same modifier key rules apply. To use the standard lasso tool, just drag around the area to be selected holding down the mouse as you draw. When you release the mouse, the last point drawn joins up with the starting point to form a complete selection.

In polygon mode, you can click to start the selection, release the mouse and position the cursor to draw a straight line, click to draw another line and so on. To revert temporarily to freehand operation, hold down the selection and the tool reverts to polygon mode. To complete the polygon lasso tool selection position the cursor directly above the starting point (a small circle icon appears next to the cursor) and click.

The magnetic lasso has a sensing area, which is set in the Options bar. When you brush along the edges in a picture, the magnetic lasso is able to sense where that edge is and create a selection that follows the edge. You continue to brush along the edges until the outline is complete and then close the selection.

This innovation is bound to appeal to beginners and anyone who has problems learning to draw a lasso selection with the lasso tool. I reckon on this being quite a powerful Photoshop feature and should not be dismissed lightly as an 'idiot's lasso tool'. Used in conjunction with a graphics tablet, you can broaden or narrow the area of focus by varying the stylus pressure. Without such a tablet, you have basic mouse plus keyboard control, using the square bracket keys **1** and **1** to determine the size of the tool focus area. The only way to truly evaluate the performance of the magnetic lasso tool is to take it for a spin and learn how to use it in combination with the relevant keyboard keys. In operation, the magnetic lasso draws a pseudo path, laying down fastening points along the way – the distance apart of the points can be set in the Options bar as a frequency value, whilst the edge contrast specifies the minimum contrast an edge has to have before the tool is attracted. As you brush along an edge, an outline follows the edge of greatest contrast within the brush width area and sticks to it like a magnet.

To reverse a magnetic outline, drag back over the outline that has been drawn so far. Where you meet a fastening point, you can either proceed from that position or hit the delete key to reverse your tracks even further to the fastening point before that and so on... You can manually add fastening points by clicking with the mouse.

When defining an outline, a combination of mousing down with the set all key changes the tool back to the regular lasso to manually draw round an edge. Holding down set all with the mouse up changes the tool to the polygon lasso (or freeform pen tool if using the magnetic pen). Other selection modifier key behavior comes into play before you start to drag with the tool – hold down the *Shift* key then drag to add to an existing selection. You don't have to keep the mouse pressed down as is necessary with the lasso. When using the magnetic lasso, you can just click, drag and only click again when you wish to lay down a fastening point.

To complete a selection, click on the start point. Double-click or hit *Enter* to close with a line determined by the magnetic tool. Photoshop will intelligently follow the line you are currently on and close the loop wherever there is good edge contrast for the tool to follow. (C) *all* +double-click closes the path with a straight line segment.

Spacebar tip

After drawing the selection, do not release the mouse button yet – hold down the Spacebar. This lets you reposition the placement of the selection. Release the Spacebar and you can continue to modify the shape as before.

Martin Evening Adobe Photoshop CS2 for Photographers

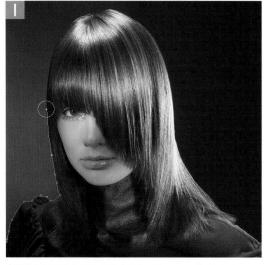

1 Where there is a high contrast edge, the magnetic lasso has little problem following the suggested path as I drag around the edge of the head. Fastening points are automatically added along the way. The center cross-hair hotspot will help guide you when locating the edge.

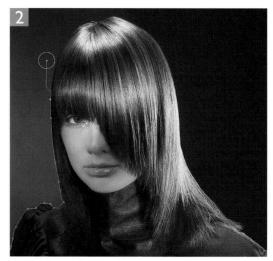

2 The magnetic lasso does not add another point until it senses a continuation of the edge. The magnetic lasso lays down a path like a magnet sticking to an edge. To scroll the screen as you work, hold down the Spacebar – this temporarily accesses the hand tool without disturbing the operational flow of the selection tool.

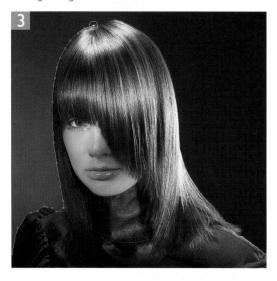

3 When using a graphic tablet input device, the size of the magic lasso selection area can be enlarged by lessening the pressure. This makes drawing an outline much quicker. For precise edge definition, add more pressure to narrow down the tool's field of view.

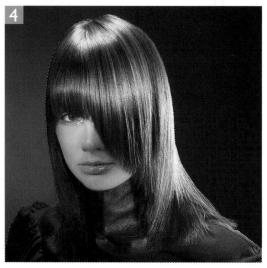

4 To undo points, reverse the path of the tool and hit the *Delete* key to erase previous points (there are no limits to this type of undo). To complete the selection, double-click or hit *Enter*. The end points will join up and if there is a gap, attempt to complete the image outline.

1 Photoshop's magnetic lasso tool operates by analyzing the composite image to determine where the edges of an object lie. The difficulty here is that although the edges may appear clear to us, Photoshop is not always able to determine them so easily.

2 One answer is to add a temporary, contrast increasing adjustment layer to the image. In this example, I added a new curves adjustment layer and made the curve an 'S' shape. The outline then appeared much clearer and the magnetic lasso had no trouble seeing the edges. Once the magnetic selection was complete, I could discard the adjustment layer.

Photograph: Peter Hince.

 ▲
 ✓ Auto Select Layer
 ✓ Show Transform Box
 ✓ Auto Select Groups
 ■
 ■
 ■
 ■
 ●
 ●
 ●
 ●
 ●
 ●
 ●
 ●
 ●
 ●
 ●
 ●
 ●
 ●
 ●
 ●
 ●
 ●
 ●
 ●
 ●
 ●
 ●
 ●
 ●
 ●
 ●
 ●
 ●
 ●
 ●
 ●
 ●
 ●
 ●
 ●
 ●
 ●
 ●
 ●
 ●
 ●
 ●
 ●
 ●
 ●
 ●
 ●
 ●
 ●
 ●
 ●
 ●
 ●
 ●
 ●
 ●
 ●
 ●
 ●
 ●
 ●
 ●
 ●
 ●
 ●
 ●
 ●
 ●
 ●
 ●
 ●
 ●
 ●
 ●
 ●
 ●
 ●
 ●
 ●
 ●
 ●
 ●
 ●
 ●
 ●
 ●
 ●
 ●
 ●
 ●
 ●
 ●
 ●
 ●
 ●
 ●
 ●
 ●
 ●
 ●
 ●
 ●
 ●
 ●
 ●
 ●
 ●</

You can use the move tool to:

- Drag and drop layers and selections from one image window to another.
- Move selections or whole images from Photoshop to another application.
- Move selection contents or layer contents within a layer.
- Copy and move a selection (hold down at alt).
- Apply a transform to a layer.
- · Align and/or distribute layers.
- Make a selection of layers

Align/Distribute layers

When several layers are linked together, you can click on the align and distribute buttons in the Options bar as an alternative to navigating via the Layer \Rightarrow Align Linked and Distribute Linked menus (see Chapter 9 for more about the align and distribute commands).

Layer selection shortcuts

When the move tool is selected you can use the **H A** *ctrl* **A** shortcut to select all layers and use **H D** *ctrl* **D** shortcut to deselect all layers. Note that the move tool selection will not select locked layers. So if you use the Auto Select layer mode to marquee drag across the image to make a layer selection, the background layer will not be included in the selection.

Move tool 🌬

The move tool can be more accurately described as a move/transform/alignment tool. The transform mode is apparent whenever the Show Bounding Box is checked (initially a dotted bounding box appears around the object). When you mouse down on the bounding box handles, the Options bar display will change to reveal the numeric transform controls. This transform feature is only active when the move tool itself is selected and not when you use the **Strong Control**.

The move tool can also be activated at any time when another tool is selected by holding down (#) *ctrl*. The exceptions to this are when the slice or slice select tools are selected ((#) *ctrl* toggles between these two tools), or when the hand, pen tool or path selection tools are active.

The call key will modify the move tool behavior. Holding down call plus call (the move tool shortcut) as you drag a selection will make a copy of the selection contents.

Layer selection using the move tool

When the move tool is selected, dragging with the move tool will move the layer or selection contents (the cursor does not have to be centered on the object or selection, it can be anywhere in the image window). When the Auto Select Layer option is switched on, the move tool will auto-select the uppermost layer containing the most opaque image data below the cursor. This is a useful trick to use with certain layered images. And the move tool in Photoshop CS2 now makes multiple layer selection possible as well. When the move tool is in the Auto Select Layer mode you can marquee drag with the move tool to select multiple layers the same way as you can make a marquee selection using the mouse cursor to select multiple folders or documents in the Finder. If you have the move tool selected in the Tools palette and the Auto Select Layer option is unchecked, holding down **H** *ctrl* temporarily inverts the state of the move tool to Auto Select Layer mode. So select the move tool first and hold down the **H** *ctrl* key to marquee drag in the image window to select multiple layers. Where you have many layers that overlap, you can use the move tool plus *ctrl* right mouse-click to access the contextual layer menu. This is a more precise method of selecting any layer with greater than 50% opacity from within the document window.

Figure 2.54 When the move tool is selected and the Auto Select Layer box is checked, you can marquee drag with the move tool to select specific multiple layers. When the Auto Select Layer option is deselected, you can hold down **E**

Keyboard shortcuts

You can temporarily access the move tool by holding down the **(H) (except**) when the pen or hand tool is selected). The keyboard arrow keys can be used to nudge a layer or selection in 1 pixel (10 pixels with the **Shift** key also held down) increments. A series of nudges count as a single Photoshop step in history and undone with a single undo or step back in history.

Hold down the Spacebar to temporarily access the hand tool. Hold down ctrl+Spacebar to zoom in. To zoom out, hold down the sea alt +Spacebar keys. If the hand tool is already selected, then holding down either the (#) ctrl or alt key will have the same effect. Double-clicking the zoom tool will set the view to actual pixel size (100%) as does the keyboard combination of $\mathfrak{R} \sim 0$ *ctrl alt 0*. Double-clicking the hand tool will set the view to the fullest screen size within the constraints of the visible palettes. The alternative keyboard shortcut is **HO** ctrl O. Pressing the Tab key (also shown as 🔊) will toggle hiding and displaying the Tools palette and all palettes (except when a Palette Settings box is selected). The Shift Tab keys will keep the Tools palette in view and toggle hiding/displaying the palettes only.

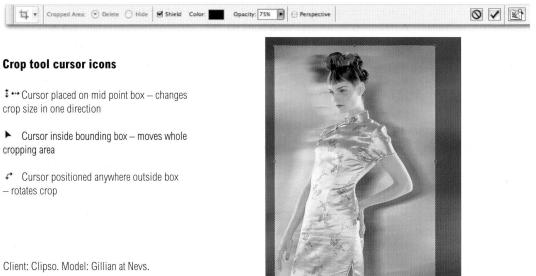

Figure 2.55 The crop tool bounding box. The cursor positioned on the corner box changes the crop dimensions both horizontally and diagonally. The center point can be repositioned to set the central axis of rotation. Holding down the Shift key and moving a corner point preserves the aspect ratio.

Switching unit dimensions

You will notice the switch arrows icon in the Crop Options bar (and also in other tool options). If you click on this it allows you to toggle between landscape and portrait mode cropping.

Crop tool 🙀

The crop tool uses color shading to mask the outer crop area. This provides a useful visual clue when making a crop. Figure 2.55 shows the Options bar in 'crop active' mode, where the default shade color is black at 75% opacity. This color can easily be changed by clicking on the color swatch in the Options bar and choosing a new color from the picker. The standard color and opacity will enable you to preview the crop with most images quite adequately. Only if the images you are working on have very dark background will you benefit from changing the color to something like a bright red or another lighter color. You can also hide/show the crop outline using the View menu \Rightarrow Hide Extras command. The delete button in the Options bar will delete layered image data outside of the crop boundary. The Hide button will crop the image, but only hide the layer data that is outside the crop boundary

(also referred to as big data). The hidden layer data will be preserved, but only on non-background layers. When one or more layer's contents extend beyond the canvas boundary, the Image \Rightarrow Reveal All command can be used to enlarge the canvas size to show the hidden 'big data'.

You can use the *Enter* key to OK the crop and the *esc* key to cancel and exit from a crop. On Macintosh and PC keyboards, these keys should be diagonally positioned, with *esc* at the top left and *Enter* at bottom right. Drag the crop tool across the image to marquee the area to be cropped. Refine the position of the crop by directly dragging any of the eight crop handles. If View \Rightarrow Snap To \Rightarrow Document Bounds is checked, the crop tool will snap to the edge of the document. To avoid this, go to the View menu and uncheck the Document Bounds or general Snap To behavior. If the Perspective box is checked in the crop tool Options bar, this will take you into the perspective cropping mode.

To constrain the proportions of the crop, hold down the *Shift* key as you drag. You can reposition the crop without altering the crop size by dragging within the crop area. To rotate the angle of the crop, move the cursor anywhere just slightly outside the crop window. The crop bounding box has a movable center point. When you click and drag the center point elsewhere, the central axis of rotation is repositioned accordingly, even to a point outside the crop rectangle.

Trimming an image

The Image \Rightarrow Trim... command can be used to crop an image based on pixel color values. Figure 2.56 shows an example of how trimming can crop an image based on transparency. For more about cropping and big data, see Chapter 4.

Crop presets

I find that it is very useful to save the crop sizes that you use regularly as Tool Presets. If the Tool Preset contains a resolution setting, then the crop will resize the image to fit the resolution (the number of pixels per inch) and the dimensions. For more on resolution, see Chapter 12.

If the resolution field is left blank, the crop will be made to fit the image dimensions and the number of pixels per inch will adjust accordingly. Note that you only need to save one preset for landscape and portrait crops. Just click on the double arrow between the width and height fields to switch them.

Figure 2.56 In this example the Image Trim... command is used to crop the image based on transparency. Photoshop crops all four edges, removing transparent contents only.

Figure 2.57 Images can be sliced up in Photoshop using the slice tool. You can optimize individual slices inside the Photoshop Save for Web Dialog (ImageReady slices will also be recognized in Photoshop). Choose Layer ⇒ New Layer Based Slice to create slices based on Photoshop layers. This will update the slices when layer effects such as a drop shadow effect are added or adjusted.

Slicing tools 🖋 🏏

Slices are a web designer's tool that is used to divide an image into rectangular sections. These are then used in Photoshop or ImageReady, for example, to specify how each individual slice will be optimized, what file format a slice area will be saved in and what compression shall be utilized. You use the slice tool to manually define a user-slice. As you create user-slices, Photoshop automatically generates auto-slices to divide up the other areas (as can be seen in Figure 2.57). You can use the slice select tool (toggle with the **H eff eff** key) to go back and edit the size of each slice afterwards. If you are looking for the Show Slice Numbers checkbox, this is now contained in the Guides, Grid and Slices preferences. In Photoshop you can auto-create slices from the Photoshop guides, by clicking on the Slices From Guides button in the Options bar.

The painting tools

The painting tools are all grouped below the selection and move tools. There are some common options available for these tools – they all make use of blending modes and have variable opacity settings. If you have a graphic tablet as your input device (which I highly recommend) the stylus pressure sensitivity options will become active in Photoshop. These can offer fine control over some of the following tool behaviors (see the earlier section on the Brushes palette). Here now is a rundown of the main Photoshop paint tools.

Brush: 9 Mode: Normal 7 Type: Proximity Match Create Texture Sample All Layers	
Brush: 30 Mode: Normal Source: Sampled O Pattern: Aligned Sample All Layers	×1
Patch: Source Destination Transparent Use Patterr	1
Pupil Size: 50% Darken Amount S0%	1

Spot healing brush/Healing brush/Patch tool/Red eye tool

The healing brush enables you to clone areas from an image and blend the pixels from the sampled area seamlessly with the target area. The basic principle is that the texture from the sample area is blended with the color and luminosity surrounding wherever you paint. The patch tool performs a similar type of function except you define the area to clone from, or clone to, via a selection. The spot healing brush is the new default tool in Photoshop CS2. The spot healing brush requires no source point. You simply click on the blemishes you want to get rid of and the spot healing brush works out the rest for you. It is actually extremely effective and can easily be used as the default healing tool when retouching images in Photoshop CS2. To see examples of the healing brush and the patch tool in action, check out some of the repairing and retouching tutorials shown in Chapter 6. The new red eye tool is now the most suitable, easy-to-use tool for removing red eye from photographs taken with a direct flash source.

Brush: 13 Mode: Color 1 Limits: Contiguous Tolerance: 30% Anti-alias

Color replacement tool 💕

The color replacement brush is now grouped with the brush tool in the Tools palette. You typically use this tool in Color mode. Just sample a color you wish to color with and paint over the area of the image you wish to colorize. You can control how the paint is applied by adjusting the settings in the Options bar.

Brush: 65 Mode: Normal	Opacity: 100% Flow: 100% F		
------------------------	----------------------------	--	--

Brush 🖌

The brush tool can be used with a range of brush sizes from a single hard edged pixel up to the largest soft edged brush (2500 pixels). The airbrush mode makes the brush tool mimic the effect of an airbrush, producing a spray of paint. As you click with the mouse or press down with the stylus, just as in real life, if you stop moving the cursor, the airbrush paint will continue to spread out until the opacity level you set is reached. The Flow control determines how 'fast' the brush tool applies paint to the image. Brush tool presets are accessible via the brush icon on the left and brush shapes and shape controls accessible via the icon next to it. You can also open the Brushes palette by clicking on the palette icon at the far right.

Pencil 🧷

The pencil produces hard edged, anti-aliased, pencil-like drawing lines. The pencil tool is simply a fast response sketching tool, that does have some uses, such as creating and editing icons. It was maybe more useful in the early days of Photoshop when computers ran more slowly and the painting speed was restricted. These days, the brush tool should meet all of your painting requirements.

Clone stamp/Pattern stamp 🛔 🏭

This is an essential tool for retouching work such as spotting (which is discussed later in Chapter 6) and general image repairing. The clone stamp tool is used to sample pixels from one part of the image to paint in another. I usually recommend that you keep the Aligned

box checked. Hold down **S** all and click over the point where you want to sample from. Release the key and click in the area you want to clone to. This action defines a relationship between sample and painting positions. Once this is set, any subsequent clicking or dragging with the mouse will apply the clone stamp, always using the same coordinates relationship until a new source and destination are defined. The sample point can also be from a separate image or a separate layer within the same image. This can be useful for combining elements or textures from other pictures. The clone stamp normally samples from a single layer only. The Use All Layers option permits the clone sample to be taken from merged layer pixel information. The pattern stamp tool allows you to select a pattern in the Options bar and paint using the chosen pattern as your image source. The Impressionist mode option adds some jitter to the pattern source and can be used to produce a more diffuse pattern texture.

History brush 🏼

3.

Photoshop's History feature enables you to store multiple image states as you progress through a Photoshop session and work on an individual image. History states can also be temporarily saved as Snapshots as you work. The History cleverly makes use of the image tiling to limit any unnecessary drain on memory usage. One can look at the History as a multiple undo feature in which you can reverse through up to 1000 image states, but in actual fact History is a far more sophisticated and powerful tool than just that. Painting from History saves you from tedious workarounds like having to duplicate a portion of the image to another layer, retouching this layer and merging back down to the underlying layer again.

The History palette displays the sequence of Photoshop states as you progress through a Photoshop session (as shown in Figures 2.59 and 2.60). To revert to a previous state, move the slider back or click directly to select that

Figure 2.58 The History Options are accessed via the History palette fly-out menu. These will allow you to decide the Snapshot settings. I usually prefer to check the Allow Non-Linear History option, because this enables me to use the History feature to its full potential (see page 74).

Figure 2.59 A previous history state can be selected by clicking on the history state name in the History palette. When the History palette is set to its default configuration, you will notice that the history states which appear after the one selected will be dimmed. When you make further edits to the image, the dimmed history states after the selected history state will then be deleted. You can change this behavior by selecting Allow Non-linear History in the History palette options.

Figure 2.60 A previous history state can be selected as the source for the history brush by going to the History palette and clicking in the empty space to the history state you want to paint from using the history brush.

state. Click in the box to the left of the chosen state and paint with the history brush to paint from that state. The number of recorded histories can be set in the Photoshop preferences. When the maximum number of history states has been reached, the earliest history state at the top of the list is discarded. If you reduce the number of history states allowed, any subsequent action will also cause the earlier history states to be discarded.

History brush and Snapshot

To create a snapshot, click on the Snapshot button at the bottom of the palette. Snapshots are stored above the divider - this records the image in its current state and prevents this version of the image from being overwritten for as long as the document is open and being edited. The default operating mode stores a snapshot of the opening image state. You can choose not to store an opening image this way if you prefer or take more snapshots at any time to add to the list. This feature is useful if you have an image state that you wish to temporarily store and not lose as you make further image changes. There is no real constraint on the number of snapshots stored. In the History palette options you can check to automatically generate a new snapshot each time you save (which will also be timestamped). Alternatively, you can click the duplicate image button to create a duplicate image state and then save this as a separate file.

To use the history brush, go to the History palette and click on the space just to the left of the history state you wish to paint from – you will see a history brush icon appear against it. You can paint information in from a previous history state (or from one of the snapshots) to the active state. The history brush lets you selectively restore the previously held image information as desired. That is a simple way of looking at the history brush, but it has the potential to be very versatile. The alternative spotting technique in Chapter 6 shows how the History feature can be used to avoid the need for duplicating layers. The History feature does not really take on the role of a repeat Edit \Rightarrow Undo command and nor should it. There are a number of Photoshop procedures which will remain undoable only with the Edit \Rightarrow Undo command, like intermediate changes when setting the shadows and highlights in the levels dialog. Furthermore there are things which can be undone with Edit \Rightarrow Undo that have nothing to do with the history. If you delete an action or delete a history, these are also only recoverable using Edit \Rightarrow Undo. So although the History feature is described as a multiple undo, it is important not to confuse Photoshop History with the role of the undo command. The undo command is toggled and this is because the majority of Photoshop users like to switch quickly back and forth to see a before and after version of the image. The current combination of undo commands and history has been carefully planned to provide the most flexible and logical approach. History is not just as an 'oh I messed up. Let's go back a few stages' feature, the way some other programs work, it is a tool designed to ease the workflow and allow you more creative options in Photoshop.

History and memory usage

Conventional wisdom suggested that any multiple undo feature would require vast amounts of scratch disk space to be tied up storing all the previous image states. Proper testing of History indicates that this is not really the case. It is true that a combination of global Photoshop actions may cause the scratch disk usage to rise, but localized changes will not. You can observe this for yourself – set the image status display to show Scratch Disk usage and monitor the readout over a number of Photoshop steps. The right-hand value is the total amount of scratch disk size currently available – this will remain constant, so watch the left-hand figure only.

Every Photoshop image is made up of tiled sections. When a large image is in the process of redrawing you may see these tiles rendering across the screen. Photoshop's History memorizes the changes that take place in each tile only. If a brush stroke takes place across two image tiles,

Figure 2.61 To record a new snapshot, click on the New Snapshot button at the bottom of the History palette. This will record a snapshot of the history at this stage. If you all -click the button, there are three options: Full Document, which stores all layers intact; Merged Layers, which stores a composite; and Current Layer, which stores just the currently active layer. The adjacent New Document button will duplicate the active image in its current history state.

Figure 2.62 This picture shows the underlying tiled structure of a Photoshop image. In this example we have a width of four tiles and a height of three tiles. This is the clue to how history works as economically as possible. The History stores the minimum amount of data necessary at each step in Photoshop's memory. So if only one or two tile areas are altered by a Photoshop action, only the data change for those tiles is recorded.

Open file	793 MB
Levels adjustment	884 MB
16 bit to 8 bit	938 MB
Healing brush	968 MB
Healing brush	980 MB
Healing brush	992 MB
Marquee selection	974 MB
Feather selection	990 MB
Inverse selection	1006 MB
Add adjustment layer	1050 MB
Flatten image	1100 MB
Unsharp mask filter	1160 MB

Figure 2.63 The accompanying table shows how the scratch disk usage will fluctuate during a typical Photoshop session. The opened image was 63 MB in size and 1300 MB of memory was allocated to Photoshop. The scratch disk overhead is always quite big at the beginning of each Photoshop session, but notice how there is little proportional increase in scratch disk size with each added history state.

only the changes taking place in those tiles are updated. When a global change takes place such as a filter effect, the whole of the image area is updated and the scratch disk usage will rise accordingly. A savvy Photoshop user will want to customize the History feature to record a reasonable number of histories, while at the same time being aware of the need to change this setting if the history usage is likely to place too heavy a burden on the scratch disk. The Figure 2.63 example demonstrates that successive histories need not consume an escalating amount of memory. After the first adjustment layer, successive adjustment layers have little impact on the scratch disk usage (only the screen preview is being changed). Clone stamp tool cloning and brush work affect changes in small tiled sections. Only the flatten image and unsharp mask filter which are applied at the end add a noticeable amount to the scratch disk usage. The Purge History command in the Edit ⇒ Purge menu provides a useful method of keeping the amount of scratch disk memory used under control. If the picture you are working with is exceptionally large, then having more than one undo can be both wasteful and unnecessary, so you should perhaps consider restricting the number of recordable history states. On the other hand, if multiple history undos are well within your physical system limits, then make the most of it. Clearly it is a matter of judging each case on its merits. After all, History is not just there as a mistake correcting tool, it has great potential for mixing composites from previous image states.

Non-linear history

Non-linear history enables you to branch off in different directions and recombine effects without the need for duplicating separate layers. Non-linear history is not an easy concept to grasp. The best way to think about nonlinear history is to imagine each history state having more than one 'linear' progression, allowing the user to branch off in different directions instead of as a single chain of events in Photoshop. You can take an image down several

Chapter 2 The work space

different routes, whilst working on the same file in a single Photoshop session. Snapshots of history branches can be taken and painted in with other history branches without the need to save duplicate files. Non-linear history requires a little more thinking on your part in order to monitor and recall image states, but ultimately makes for more efficient use of the available scratch disk space. To see some practical examples of how to use this and other history features in a typical Photoshop retouching session, refer to Chapter 6.

Figure 2.64 Photographer Jeff Schewe has had a long standing connection with the Adobe Photoshop program and its development. The origins of the History feature can perhaps be traced back to a seminar where he used the Globe Hands image shown here to demonstrate his use of the Snapshot feature in Photoshop 2.5. Jeff was able to save multiple snapshots of different image states in Photoshop and then selectively paint back from them. This was all way before Layers and History were introduced in Photoshop. Chief Photoshop Engineer Mark Hamburg was suitably impressed by Jeff's technique and the ability to paint from snapshots became an important part of the History feature. Everyone had been crying out for a multiple undo in Photoshop, but when History was first introduced in Photoshop 5.0 it came as quite a surprise to discover just how much the History feature would allow you to do.

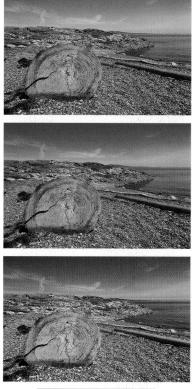

Figure 2.65 The Non-linear history option allows you to branch off in different directions and simultaneously maintain a record of each history path up to the maximum number of history states that can be allowed. Shown here are three history states: a Levels adjusted version, another with a sky gradient and lastly a toned monochrome version (I colored the history states in the History palette to make the illustration clearer).

Brush: 1 Mode: Normal Opacity: 100% Style: Tight Short Area: 50 px Tolerance: 0%						
	🕅 🔹 Brush: * *	Mode: Normal	pacity: 100% Style: Tight Short	Area: 50 px	Tolerance: 0%	
	21				-1	

Art history brush 🏼 🚿

The art history brush is not the most essential Photoshop tool that was ever invented. The art history brush samples from a history state, but the brush strokes have some unusual and abstract characteristics that smudge the pixels with sampling from the selected history state. The brush characteristics are defined in the Art History Options bar. The Tolerance determines how much paint to apply based on how close in color the paint strokes are from the history to the destination color. And the larger the Area setting, the larger the area covered by and more numerous the paint strokes.

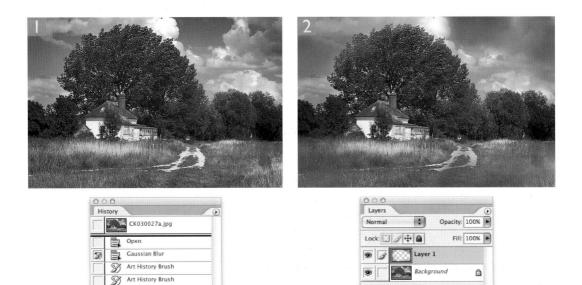

1 The art history brush is located next to the history brush in the Tools palette. And you can use it to paint from history with impressionistic type brush strokes. To explore the potential of the art history brush, I applied a Blur ⇔ Gaussian Blur filter. I then selected the open history state, and clicked on the space next to the Gaussian Blur history state to set this as the history source.

Art History Brush

2 The most significant factor will be the art history brush Style. In this example I mostly used the Tight Long and Loose Medium Styles. The brush shape will have an impact too. The bristle brush shapes can be effective. But in the picture you see here, I simply used a soft edged brush to paint in a soft, diffusion effect around the edges of the photograph.

00.033

Eraser/Background	eraser/Magic era	iser

Brush: • Node: Brush • Opacity: 100% • Flow: 100% • Erase to History

8.

The eraser removes pixels from an image, replacing them with the current background color. There are three brush modes: brush, pencil and block. If you check the Erase to History box, the eraser behaves like the history brush. Holding down and all as you paint also erases to the currently selected history. The brush flow option is only available when erasing in brush mode. The eraser tools are destructive, so if you are using the background eraser to make a cutout, it is always a good idea to first duplicate the layer you are going to erase in case you need to recover the original pixels again.

The magic eraser works like the paint bucket tool in reverse, erasing neighboring or 'similar' pixels, based on the pixel color value where you click. It's a very basic tool and one you should probably avoid mostly.

The background eraser, however, is a much cleverer tool. It erases the pixels based on the pixel colors sampled by the tool. The erase limits can be set to Contiguous or Discontiguous (see sidebar explanation). The Find Edges mode also limits the erasure to contiguous pixels but is better at preserving the edge sharpness. The Tolerance setting is like the magic wand tolerance, it determines the range of pixel values that will be erased. The Protect Foreground option allows you to sample a color from inside the area you are making the cutout. When this box is checked, the background eraser will protect this color from being erased. The Sampling options allow you to sample 'Once' to erase pixels based on the pixel color value of where you first clicked. Or 'Continuous' to continually update the sample color as you drag. And finally 'Background Swatch', which will enable you to erase based on the background swatch color set in the Tools palette.

The Wacom eraser

Note that some graphic tablet devices like the Wacom series operate in eraser mode when you flip the stylus upside down. This is recognized in Photoshop without having to select the eraser tool.

Contiguous selection modes

The magic eraser, magic wand and paint bucket tools all have contiguous selection modes. A contiguous selection is one based on just those neighboring, connecting pixels which fall within the specified tolerance that surround the point where you clicked and which have a similar color value. A discontiguous selection will use the same tolerance setting, but is not restricted to selecting the neighboring pixels only. A non-contiguous selection will select all pixels in an image or selection within an image, which fall within the specified tolerance.

1 In this first example, I clicked with the magic eraser in the sky area about half way up to the left of the spire. The magic eraser options were set to Contiguous. This meant that only neighboring pixels which fell within the specified tolerance (32) would be selected and deleted by the magic eraser.

2 When the Contiguous option is deselected, all pixels with a color value within the specified tolerance will be deleted. In this example, I clicked with the magic eraser in the same position as example 1. Nearly all of the blue pixels are erased at a stroke, like all the sky pixels on the right of the spire, but also some of the blue pixels contained in the shadow of the roof. This does not matter too much because I can always use the history brush later to restore any detail which becomes lost this way.

Brush: 40 Limits: Find Edges	Tolerance: 51% Protect Foreground Color	Sampling: Once	2
------------------------------	---	----------------	---

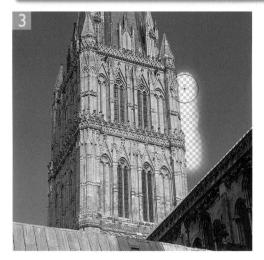

3 The background eraser tool provides more precise control. Here the tool is set to erase sampling 'Once' and in Find Edges mode. This means that when I click and drag, all pixels within a specified tolerance (or pressure applied by the stylus) of the pixel value where I first clicked will be erased by the tool. The background eraser will also erase the background sample color from the edge pixels – this will help remove the color contamination as you erase. The Find Edges mode preserves the edge sharpness better.

The work space

Extract ОК 20 Click ed or OK to extract and exit immediately Cancel A Preview Brush Size: 20 1 Highlight: Green -0 Fill: Blue -Smart Highlighting Textured Image Smooth: 100 -Channel: Alpha 1 -Force Foreground Chre Origin Display: None -Show Highlight Show Fill

1 The Extract command is an integral part of Photoshop and works well in combination with the background eraser which can be used to remove any portions of the image that the Extract command fails to erase. You first define the edge of an object, roughly painting along the edge with the highlighter tool (Smart Highlighting makes this task even easier). Any mistakes can be undone using 🔢 🜌 [2017] Where the object to be extracted has a solid, well-defined interior, you then fill the inside areas using the fill tool.

OK

Smart Highlighting Textured Image Smooth: 100 Channel: Alpha 1

Force Foreground

Show Highlight Show Fill

Show: Extracted Display: None

-

-

2 When you click on the Preview button, Photoshop makes an Extract calculation and previews the resulting mask in the dialog window. You can then edit the mask edges with the highlighter, eraser and fill tools or adjust the smoothness to remove any pixel artifacts. You can also tidy up the extraction in the preview using the clean-up tools. The Extract command is covered in more detail in Chapter 7 on montage techniques.

40 Cancel a Preview A ol Ontio 0 -Brush Size: 20 The. Highlight: Green 1 00 Fill: Blue -

The Extract command

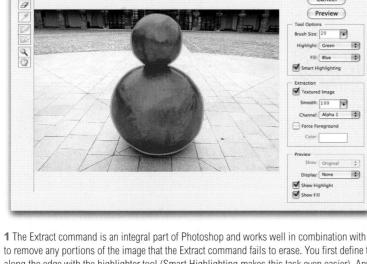

Extract

Closes the dialog without making any changes. Hold down Option to Reset instead

	Mode: Normal Opacity: 100% 💌 🗌 Reverse 🗹 Dither 🗹 Transparency	
--	--	--

Figure 2.66 New gradients can be selected by mousing down on the gradient ramp in the Options bar and can also be edited (see page opposite). A gradient can then be applied using one of the five gradient tool modes: Linear, Radial, Angle, Reflected or Diamond. The combination of a gradient setting and gradient mode can then be saved as a gradient tool preset by mousing down on the triangle button next to the tool icon shown here. Click on the New Tool Preset button to add a new custom preset to the list. Gradients 🔲 🖬 🖿 🛄

The gradient tool can be used to draw linear, radial, angular reflected or diamond gradients. Go to the Options bar and click on the gradient ramp (top left) to select a gradient option such as Foreground to Background color, or click on the small arrow to the right to open the gradient list. When you drag with the gradient tool inside an image window, a gradient fill is created between those two points. Hold down the *Shift* key to constrain the gradient angle to a horizontal/vertical or 45 degree angle. Check the Reverse box to reverse the gradient fill colors before you drag. The Dither checkbox should be kept on – this will add a subtle noise, ensuring there is less risk of any banding appearing in the gradient fill. When the Transparency box is checked, if there are transparency masks in a gradient, these are recognized.

You will notice that a number of gradient presets are readily available when you first open the gradient list from the Options bar. You can also easily edit and create your own gradient pattern and save these as gradient tool presets which are a combination of a gradient setting and gradient type (see the accompanying tutorial showing how to create and customize a gradient).

Gradients can also be applied as a fill layer in Photoshop. Go to the Layers palette, click on the Adjustment Layer button and select Gradient... This action will add a gradient that fills the whole layer and has an empty layer mask. This feature is like any other type of adjustment layer in that it allows you to edit the gradient fill. You can double-click the Gradient layer and alter the angle, the gradient setting or gradient type etc. at any time.

Delete

%

Color:

1 Go to the gradient Options bar and click on the side arrow next to the gradient ramp. This will display the list of gradient presets (shown here in Large List view mode.)

To create a new custom gradient, click on the gradient ramp. This will open the accompanying Edit dialog box.

2 Click on the lower left-most stop to select it and then doubleclick it or click once on the color box – this will open the Color Picker. Choose a new color for the start of the gradient. In this example, I picked a bright blue.

3 If I click above the bar, I can add a new transparency stop. Notice how the lower part of the dialog changes. I can alter the opacity of the gradient at this 'stop' point to, say, 50%. And I can position this transparency stop anywhere along the gradient scale and adjust the diamond-shaped midpoints accordingly.

4 I can then add another transparency stop, but this time restore the opacity to 100% and prevent the transparency fading to the right of this point. I added a new color stop below and introduced a new color by clicking in the Color box and choosing a purple color this time. When the gradient editing is complete all I have to do is rename the gradient and click on the New button. The new gradient will be saved and added as a new Gradient Preset. Poothness: 100 • % A Stops + % Location: Delete Opacity: Location: 0 Color: Delete • % oothness: 100 Ê Stops Location: 26 Opacity: 50 • % Delete % b Delete Color: Location: 4 pothness: 100 • % ٦ A Stops Opacity: + % Location: 96 Delete Location: 64 Color: • % Delete

Location: 0

Martin Evening Adobe Photoshop CS2 for Photographers

Noise gradients

Noise gradients are based on a random distribution of colors between a specified color range. The Noise Gradient Editor is a separate component of the Solid Gradient Editor, and any settings made in the Solid Gradient Editor will have no bearing on the appearance of the noise gradient. The Roughness amount will determine the smoothness of a noise gradient and the Color model settings will allow you to edit the range of colors used. One of the best ways to experiment with this feature is to click on the Randomize button and adjust the settings from there. Noise gradients can be saved the same way as solid gradients.

Figure 2.67 An example of a Noise Gradient applied as a radial gradient fill.

1 When you change the Gradient Type to Noise, the smooth gradient ramp will be replaced by a random noise ramp. Clicking on the Randomize button will present you with many interesting random gradient options to choose from.

2 Of the three Color Models, the HSB is the most useful. You can narrow the range of colors used in the random equation by adjusting the hue sliders. As you can see here, the Roughness can be increased to make the gradient more spiky. The Restrict Colors option will prevent the colors from oversaturating and produce a more usable gradient for general print work.

3 By reducing the Roughness amount and adjusting the hue and brightness sliders you can produce some very subtle gradients. If you check the Add Transparency box, you can introduce random transparency into the equation as well. The gradient shown here was used to create the radial gradient shown in Figure 2.67.

Paint bucket	3	
--------------	---	--

Foreground \$

8.

This tool amounts to nothing more than 'make a magic wand selection based on the sampled color and Tolerance setting in the Options bar and fill the selection with the current foreground color or predefined pattern'. In this mode of operation, there is none of the flexibility associated with making a magic wand or Color Range selection and modifying it before filling. You can use the paint bucket to quickly fill the inside areas of a mask or quickmask outline. The Contiguous option is also available for the paint bucket (see the magic wand description) and the All Layers option neatly allows you to fill using a pixel color sample based on all layers. The paint bucket can also be used for filling with a pattern as well as with a solid color. Choose the Pattern mode from the Options bar and select the pattern type.

* Mode: Normal

Changing the color of the canvas

Opacity: 100% 🕨 Tolerance: 32 🛛 🗹 Anti-alias 🖉 Contiguous 🗌 All Layers

If you are fond of working in Full Screen mode with a totally black border, but miss not having access to the menu bar, in the two Full Screen modes you can toggle the display of the menu bar with the Shift F keyboard command. When you are in the middle full-screen viewing mode you can replace the gray colored canvas by selecting a new color in the Color Picker and Shift-clicking with the paint bucket tool in the canvas area. Be warned that this action cannot be undone using **H**Z ctr/ Z! If you do need to restore the original gray canvas color, go to the color picker and enter 192 in the red, green and blue fields to make a new gray foreground color and Shift-click in the canvas area.

screen display mode by selecting a new foreground color and Shift clicking in the Canvas area with the paint bucket tool. To restore the canvas to its original color,

repeat this step using a 192 red, 192 green and 192 blue RGB color value.

Client: Rainbow Room. Model: Nicky Felbert @ MOT.

Focus: blur/sharpen/smudge 🥥 🛆 🞾

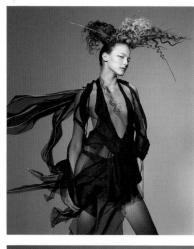

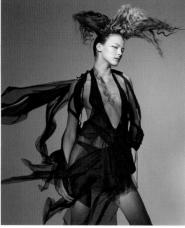

These tools enable you to apply localized blurring or sharpening effects. The blur tool is the most useful of all. It can be used to soften portions of an image or smooth the edges of an alpha channel mask. The sharpen tool is something I rarely ever use, because in my opinion there are better ways to apply localized sharpening (which are discussed later in Chapter 4). The smudge tool is an interesting painting tool which can be used to smear pixels the same way as one might mix paints together. The smudge tool selects the color of the pixels where you first click and smears the pixels in whichever direction you drag the brush. In Figure 2.69 I have presented a before and after example of the smudge tool being applied as a stroke along a path.

For best results I recommend you use a pressure sensitive graphics tablet. The Finger Painting option uses the current foreground color for the start of the smudge. The smudge tool basically smears the pixels rather than distort them the way the Liquify filter does.

The Use All Layers option is useful if you want to paint with the blur/sharpen/smudge tools on a new layer, sampling pixels from all the visible layers below. For example, create a new empty layer at the top of the layer stack, and have the Use All Layers option checked. You can then blur/sharpen/smudge in the empty new layer without harming the layers underneath.

Figure 2.69 One way to use the smudge tool effectively is to stroke a path. The upper picture shows a screen shot of an image in which I had drawn a series of open pen paths, using the pen tool. I then selected a large brush size for the smudge tool and went to the Paths palette fly-out menu and selected Stroke Path... The Stroke Path dialog lets you select the tool to stroke with. I selected the smudge tool from the list and clicked OK. The smudge tool applied a smudge stroke to each of the paths, producing the finished result shown here.

Client: JFK. Model: Courtney @ Premier.

The work space

🕻 Exposure: 50% 🕨 🏑

Range: Midtones

Toning: dodge/burn/sponge 🔍 🕥 🍚

Brush:

Dodging and burning should be familiar photographic concepts (for those who can remember darkrooms, that is). And these tools offer the user a limited amount of dodge and burn control. You can choose to apply the toning effect selectively to either the Highlights, Midtones or Shadows. Therefore if you want to darken or burn the shadow portion of an image without affecting the adjacent highlights, choosing the burn tool in Shadows mode will enable you to do this. The dodge tool is also excellent for removing wrinkles and facial lines without altering the underlying texture when used at a very low percentages. The third option is the sponge tool, which has two modes: Saturate increases the color saturation, Desaturate decreases the color saturation.

Limitations of dodge and burn

The dodge and burn tools only work well when applied at low opacities to small areas of a picture. Whenever I want to dodge or burn a large area of a picture, I always use an image adjustment layer in conjunction with a filled layer mask. Examples of how to go about this can be found on pages 155–156 in Chapter 4.

Tool switch shortcut

When the blur or sharpen tool is selected, you can temporarily switch between one tool and the other, by holding down the att modifier key. This keyboard tool switch will also work with the toning tools when the dodge or burn tool is selected. Holding down the safet att modifier key will enable you to swap between the two.

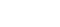

Chapter 2

Get out of Filled Layer mode

The first time you select the pen tool in Photoshop and start using it, the pen tool will default to drawing a filled shape layer. If you simply want to draw a pen path, make sure the Paths button is selected in the Options bar. Once this option has been selected it will remain sticky until you choose to change it.

Magnetic pen tool

The freehand pen tool has a magnetic mode. When this is checked, the pen tool behaves just like the magnetic lasso, except that the path points can be saved as a path instead of being converted directly to a selection.

Pen and path drawing 🕨 🎙 🎝 🏠 🗠 🕨

Photoshop provides a suite of vector path drawing tools that work in the same way as the pen path tools found in drawing programs like Adobe Illustrator and other programs that enable you to draw vector paths. If you are approaching Photoshop without any experience in using the above, then the Photoshop path tools will require some getting used to.

There are many ways that you can create a selection in Photoshop. You can use the marquee tool, the magic wand tool, or you can make a Color Range selection, the list goes on... When faced with a situation where you need to define an outline in an image you need to weigh up which method of selection is the most appropriate to use. Any of the above methods might work, but where the outline is a little more complicated, you might be tempted to use the freehand or magnetic lasso, discussed earlier in this chapter. But in all honesty, in the time it takes to define an outline with one of the lasso tools, you can often do a much better job by drawing a pen path instead. Now I am not going to pretend that it is easy to master the art of drawing pen paths, because it is not. But this is a skill worth learning. In the long run you will find it is much easier using the pen tool to draw a pen path to define the outline of an object (especially when you have something photographed against a busy background). You can then convert the pen path into a selection to be used the same way as you would with any other selection.

For detailed instructions on drawing paths and working with the pen tool, refer to Chapter 7 on montage techniques.

Type tool TIT T T

The type tool allows direct on-image text editing. There are two ways you can use the type tool: either click in the image window and begin typing – this will add a single line of text – or you can click and drag to define a type box to which you can add lines of wraparound text (where the text wraps within the text box). Click on the Palettes button (on the far right in the Options bar) to bring the Character and Paragraph palettes to the front of the palette set. These provide fairly comprehensive typographical control.

Because the type is added as a separate layer, in type form, it remains fully editable. To edit a type layer, highlight the type using the type tool, or double-click the Type Layer icon in the Layers palette. You can change the fonts, apply different colors to all the text or single characters, or enter new text.

When you mouse down on the Font Family menu you will notice the font names now have a nice new WYSIWYG (what you see is what you get) menu listing.

Adding layer effects

Layer effects/styles can be applied to both type layers and image layers. Layer effects automate the process of adding grouped layers to provide effects such as drop shadows. Layer effects now offer a phenomenal variety of text effects and you can also distort the text in a type layer by using the warp controls that are available from the Type Options bar Warp Text menu.

For more about type

This is a book about Photoshop and photography. A rich variety of text effects can be achieved in Photoshop and designers who work in print and multimedia often mainly use the program for this purpose. Since there are plenty of other Photoshop books dedicated to the needs of graphic designers, I am going to concentrate here on the needs of image makers. But you will find more information on using the type tools in Chapter 9.

Hiding the type highlighting

It is easier to make decisions about the type appearance if you can see the text without any highlighting. Choose View \Rightarrow Hide Extras (**SE H** *ctrl* **H**) to hide the inverted highlighting.

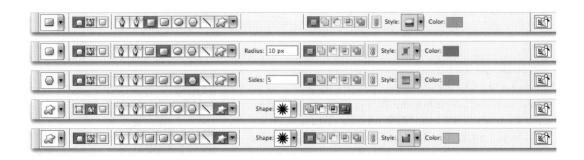

GCDD

Figure 2.70 The shape tool options include the following modifying modes. From left to right: add to shape area, subtract from shape area, intersect shape areas, exclude overlapping shape areas.

Figure 2.71 The Polygon shape options include options to add smooth corners and to create an inverted 'star' polygon shape with optional smooth indents.

Figure 2.72 The line tool options let you define the proportions of arrowheads which can be added at the start and/or end of a line shape.

Shape tools 🔲 🔍 🔾 📿

The Photoshop shape tools are a crossover feature from ImageReady and can be applied in the form of a filled layer with a vector mask, a solid fill, or a path outline. Using the shape tools you can draw rectangular, rounded rectangular, elliptical, polygon and custom shapes and also import custom shapes from EPS graphics, such as a regularly used company logo, and store these as Shape presets using the Preset Manager. Single pixel or wider lines can be drawn with the line shape tool. To constrain the drawing angle by 45 degree increments, hold down *Shift* (this applies to all the painting tools as well). Arrowheads can be added to the line at the start or finish (or both ends) of the line. Click the Shape... button in line tool options to customize the appearance of the arrowhead proportions.

Figure 2.73 The custom shape presets offer a huge number of designs which can be loaded from the Shapes presets folder and to which you can add your own custom shape designs.

The work space

Chapter 2

Annotation tools 📑 📣

You can add text or sound notes to a file in Photoshop. Documents that are annotated in this way can be saved in the Photoshop, PDF or TIFF formats. To annotate an open document, select the text note tool and click inside the image window. A note icon is placed together with an open text window. Enter text inside the window, which for example could be a short description of the retouching that needs to be carried out on a portion of the picture. After entering the text you can close the note window. The text note will remain as a small icon floating above the actual image. Although viewable in Photoshop, these notes will not be visible when you actually come to print the image. If you save a copy of an image as a PDF and send this to a client, they will be able to open it in Adobe Acrobat, add notes in the full version of the Adobe Acrobat program and export a notes file for you to import back into the original Photoshop image. To delete a note or delete all notes, *cttl* right mouse-click on a note icon. The contextual menu will offer you the choice of deleting that note or all notes in the current document. If you want to append a sound note to a file, check in your System Control Panels that the computer's built-in microphone is selected as the incoming sound source. When you click in the window with the sound note tool a small sound recording dialog appears. Press the record button and record your spoken instructions. When finished, press Stop. The sound message will be stored in the document when saved in the above file formats.

Notes not showing?

If you are fairly sure that your image has notes added but you can't see them, it is worth checking the View \Rightarrow Show submenu and checking to see if there is a tick mark next to Annotations. If this item is unchecked, the notes icons won't be displayed.

	(1004000
ample Size:	3 by 3 Average	- 1999
	ample Size:	ample Size: 3 by 3 Average

Sample anywhere

You can sample colors from anywhere with the eyedropper tool. Click in an image document window first and then move the tool outside of the image document and sample colors from anywhere on the display.

Quick access to the color sampler

You can access the color sampler tool when the normal eyedropper tool is selected by *Shift*-clicking with the eyedropper. Or, while any painting tool is selected by *Shift alt Shift*clicking with the paint tool to add a color sampler point.

Sample size

The eyedropper sample area can be set to Point, 3×3 Average, 5×5 Average. The Point option will sample a single pixel color value only and this may not be truly representative of the color you are trying to sample. You might quite easily be clicking on a 'noisy' pixel or some other pixel artifact. A 3×3 Average, 5×5 Average sample area will usually provide a better indication of the color value of the pixels in the area you are clicking.

Eyedropper/color sampler 🥒 💖

The eyedropper can sample pixel color values from any open image window and make that the foreground color. If you hold down 🔀 *alt*, the sample becomes the background color (but when working with any of the following tools: brush, pencil, type, line, gradient or bucket, holding down the 💽 *alt* key while clicking on a particular color will make it the foreground color). The color sampler tool provides persistent pixel value readouts in the Info palette from up to four points in the image. The sample point readouts will remain visible all the time in the Info palette. The sample points themselves are only visible whenever the color sampler tool is selected. The great value of the color sampler tool is having the ability to monitor pixel color values at fixed points in an image. To see what I mean, take a look at the tutorial in Chapter 5, which demonstrates how the combination of placing color samplers and precise curves point positioning means that you now have even more fine color control with valuable numeric feedback in Photoshop. Sample points can be deleted by dragging them outside the image window or alt -clicking on them.

1

Measure

The measure tool lets you measure distances and angles in an image. To draw a measuring line, make sure the Info palette and/or tool options bar is visible and click and drag with the measure tool in the image window. The measure tool also has a protractor mode. After drawing a measuring line, \bigcirc *alt*-click on one of the end points and drag out a second measuring line. As you drag this out, the angle measurements are updated in the Info palette. The measure tool line will only remain visible when the tool is selected, or you can hide it with the View \Rightarrow Hide Extras command. The measure tool line can be updated at any time by clicking and dragging any of the end points. As with other tools the measure tool can be made to snap to the grid or guides.

Navigation tools – hand and zoom 🤍 🔍 To navigate around an image, select the hand tool and drag to scroll. To zoom in on an image, either click with the zoom tool to magnify, or drag with the zoom tool, marqueeing the area you wish to magnify. This combines a zoom and scrolling function. In normal mode, a plus icon appears inside the magnifying glass icon. To zoom out, hold down 🔀 all and click (the plus sign is replaced with a minus sign). Holding down the Spacebar at any time will access the hand tool. Holding down the Spacebar+ # *ctrl* key calls up the zoom tool (except when you are editing text). Holding down the Spacebar+ C all calls up the zoom out tool. An image can be viewed anywhere between 0.5% and 1600% magnification. Another zoom shortcut is $\Re + ctrl +$ (Command-click the = key) to zoom in and $\mathbb{H} = ctrl = (next to the = key) to$ zoom out. The hand and zoom tools also have another

navigational function. Double-click the hand tool to make the image fit to screen. Double-click the zoom tool to magnify the image to 100%. There are buttons on the Options bar which perform similar zoom commands: Fit On Screen; Actual Pixels; Print Size. Navigation can also be controlled from the Navigator palette, the View menu and the lower left box of the image window. Checking the Resize Windows to Fit box will cause the Photoshop document windows to always resize to accommodate resizing, but within the constraints of the free screen area space. The Ignore Palettes checkbox will tell Photoshop to ignore this constraint and resize the windows behind the palettes. If your mouse or pen stylus features a scroll wheel then you can use this in Photoshop CS2 to control the zoom (but go the Photoshop General Preferences first and check that you have the Zoom with Scroll Wheel box checked). If you hold down the *Shift* key as you operate the scroll wheel you can constrain the zoom to the usual fixed percentages.

Scroll All/Zoom All Windows

When two or more documents are open, if you check the Scroll All Windows box in the hand tool Options bar, Photoshop will synchronize the scrolling for all open windows. If Scroll All Windows is selected, when you click in a document window all other document windows will snap to match the same zoom location. Another way to set Photoshop up to do this is to choose Window ⇒ Arrange ⇒ Match Location. And if you hold down the *Shift* key and click in an area of an image or drag with the hand tool, the other image windows will match the location and scroll accordingly.

If you check the Zoom All Windows box for the zoom tool, Photoshop will synchronize the zooming across all windows. You can also set Photoshop up to do this by choosing Window ⇒ Arrange ⇒ Match Zoom. If you hold down the *Shift* key and click in an area of an image with the zoom tool, the other image windows will all zoom in by a corresponding amount. And if you use *Shift all Shift* the windows will simultaneously zoom out.

Martin Evening Adobe Photoshop CS2 for Photographers

Foreground/Background colors

The default settings are for black as the foreground color and white as the background color. To reset the default colors, either click on the black/white foreground/ background mini icon or simply click D. Next to the main icon is a switch symbol. Clicking on this exchanges the colors, so the foreground becomes the background. The keyboard shortcut for this is X. Double-click the Foreground color swatch to open the Color Picker dialog and choose a new color.

Selection mode/Quick Mask

The left icon is the standard for Selection mode display. The right icon converts a selection to display as a semitransparent colored 'Quick Mask'. Double-click either icon to change the default overlay mask color. Hit 📿 to toggle between these two modes.

Figure 2.75 The Photoshop Color Picker is shown here with a 'graved out' color field because the Gamut Warning is currently checked in the View menu. The alert icon beside the newly selected foreground color tells you it is out of gamut. If you check on the cube icon below, this will make the selected color jump to the nearest HTML web safe color. If you check the Only Web Colors box the Color Picker will display the restricted web safe color palette.

Screen display

The standard screen display mode will display images in their document windows. More than one document can be seen at a time and it is easy to select individual images by clicking on their windows. The middle, Full Screen display option presents the frontmost image against a medium gray canvas color with none of the distracting system window border or desktop backdrop visible. All remaining open documents are hidden from view (but can still be accessed via the Window menu). The Absolute Full Screen mode displays the image against a black background and hides the menu bar. The Tools palette and other palettes can be hidden too by pressing the Tab key (also marked as \rightarrow) on the keyboard). To show all the palettes, press Tab again. To toggle between these three viewing modes, press the F key. You can also use Tab ctrl Tab right mouse-click to cycle through each open image window, however the associated screen display is set.

Jump to button

ImageReady CS2 is a stand-alone application that is installed with Photoshop CS2. Clicking on the 'Jump to' icon will switch you from Photoshop to ImageReady and vice versa, without having to exit from the current program. The file will always continue to remain open in the previous program and you can select different programs to jump to from the File \Rightarrow Jump to menu. Upon installation, applicable application aliases are installed in the Photoshop CS2 \Rightarrow Helpers \Rightarrow Jump to Graphics Editor folder, i.e. Adobe Illustrator from Photoshop or HTML editing programs like Adobe GoLive from ImageReady. If the other program is not currently open, the Jump to button will launch it.

Of course, with Photoshop CS2 you are effectively also jumping to a separate program every time you click on the Bridge button. And if you need to you can use the Bridge interface to jump to other loaded applications in the Creative Suite, providing the document file can be recognized in other programs.

Hovering tool tips

In order to help familiarize yourself with the Photoshop tools and palette functions, help dialog boxes will pop up after a few seconds whenever you leave a cursor hovering over any one of the Photoshop buttons or tool icons (see Show Tool Tips in the General Preferences). A brief description is included in the box and tools have their keyboard shortcuts written in brackets.

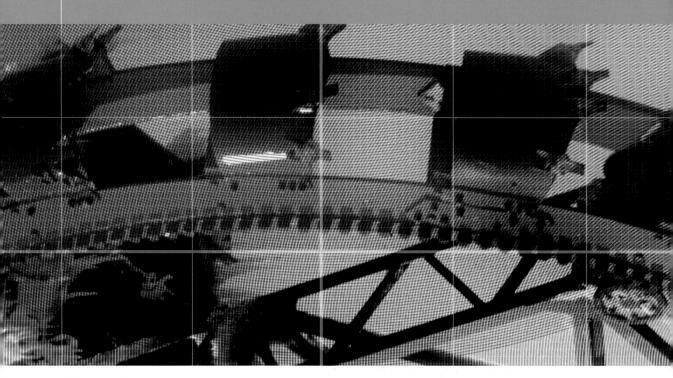

Chapter 3

Configuring Photoshop

n order to get the best performance out of Photoshop, you need to ensure that your computer system has been optimized for image editing work. When I first began writing the 'Photoshop for Photographers' series of books, it was always necessary to guide readers on how to buy the most suitable computer for Photoshop work and what hardware specifications to look for. These days I would suggest that almost any computer you can buy is capable of running Photoshop and can be upgraded later to run the program faster. As always, I try to avoid making distinctions between the superiority of the Macintosh or PC systems. If you are an experienced computer user, you know what works best for you and I see no reason to evangelize my preference for using a Mac. Throughout my computer career, it's what I have grown up with and it feels like home. The same arguments apply if you're a Windows PC user. And apart from anything else, once you have bought a bunch of programs, you are kind of locked into using that particular system. If you switch, it means facing the prospect of buying most of your favorite software packages all over again.

Buying a system

Today's entry level computer will contain everything you need. For example, take the Apple G4 700 MHz eMac. At the time of writing, this entry level Apple eMac features a 1.25 Hz G4 processor, a 17" CRT display, has 256 MB of on-board RAM which can be upgraded to a maximum of 1 GB. It's got a 40 GB hard drive, CD/DVD drive and the video performance is provided by an ATI Radeon 9200 32 MB DDR video memory. Photoshop CS2 requires a minimum of 192 MB of RAM so you would probably want to add more RAM at the time of purchase, but otherwise it's got quite enough to get you started. If you purchased the basic 1.6 GHz iMac G5 Macintosh, then this too has excellent specifications for Photoshop work and its processor can be upgraded. On the PC side there are many more choices and I would say that without being able to pinpoint any particular model, nearly all the basic PC bundles will be able to satisfy your basic Photoshop requirements. I shall be dealing with the specifics shortly but I would assume that at the very least your entry level computer should have the following: a Pentium class 4 processor, 40 GB hard drive and ideally a minimum of 256 MB with room for further RAM expansion. If you are able to get all of this and more, then you have yourself the beginnings of a powerful image editing system. If you have acquired an old computer system you will almost certainly encounter compatibility problems since Photoshop CS2 will need to run on a Macintosh G3, G4 or G5 with OS X 10.2.8 (or later) or OS X 10.3 through 10.3.4. On the Windows platform: a PC Pentium III or 4 running Windows 2000 with Service Pack 3, or Windows XP.

Start out small

If you are new to Photoshop, my main buying advice is don't splash out on a top of the range system just yet. If you later decide image editing is not for you, then at least you can make use of your computer for general purpose office use, or shooting down rogue asteroids. In a year or two you can either upgrade your current system or purchase a machine that will probably be at least twice as fast as the most powerful computers around today. And besides, even a basic system can include a pretty good-sized monitor and plenty of opportunities for expansion.

64-bit processing support

64-bit processing is now the new standard for the latest computer hardware. Photoshop CS was able to partly take advantage of this on the Macintosh G5 system. Photoshop CS2 offers more extensive support. If you are running Mac OS X 10.3 or higher, you can now allocate up to 4 GB (less whatever the operating system frameworks take up, so effectively up to 3.5 GB). If you are running Windows 2000 or the regular version of Windows XP, you can still only allocate up to 2 GB. If you are running Windows XP 64 bit edition you can allocate 4 GB (minus a very small amount for the operating system).

Chip acceleration

Upgrading the processor chip is the most dramatic way you can boost a computer's performance. But not all computers will allow you to do this. If you have either a daughter card slot or some other processor upgrade slot then you will be able to upgrade your old computer and give it a new lease of life. The upgrade card may also include an increase of backside cache memory to further enhance performance. The cache memory stores frequently used system commands and thereby takes the strain away from the processor chip allowing faster performance on application tasks.

Operating environment

Your computer work area matters. Even if space is limited there is still a lot you can do to make your work space an efficient area to work in. Choose a comfortable operator's chair, ideally one with arm rests and adjust the seating position so that your wrists are comfortably resting on the table top. The monitor should be level with your line of view or slightly lower. Figure 3.1 shows a general view of the office area from where I run the business and do all my Photoshop work and as you can see, it allows two operators to work simultaneously. The desk unit was custom built to provide a large continuous worktop area with good cable management in order to minimize the number of stray leads hanging all over the place. The walls are painted neutral gray. I was able to get the paint from a local hardware store, and when measured with a

Figure 3.1 This is the office area where I carry out all my Photoshop work. It has been custom built so that the desk area remains as clear as possible. The walls are painted neutral gray to absorb light and reduce the risk of color casts affecting what you see on the monitor screens. The lighting comes from daylight balanced tubes which backlights the monitor screens. I usually have the light level turned down quite low, in order to maximize the monitor viewing contrast. It really did used to look this tidy once!

spectrophotometer it is almost a perfect gray. The under the shelf lighting uses cool fluorescent strips that bounce off behind the displays to avoid any light hitting the screens directly. The window is north facing, so I never have any problems with direct sunlight entering the room and what daylight does enter the office can be controlled with the venetian blind. If I could just find a way to block annoying incoming phone calls while I am in the middle of a complex retouching session, it would be the perfect setup!

Once you start building an imaging workstation, you will soon end up with lots of electrical devices. While these in themselves may not consume a huge amount of power, do take precautions against too many power leads trailing off from a single power point. Cathode ray tube monitors are vulnerable to damage from the magnets in an unshielded speaker or the electrical motor in an inkjet printer. Just try not to position any item other than the computer too close to a CRT monitor screen. Interference from other electrical items can cause problems too. To prevent damage or loss of data from a sudden power cut, place an uninterruptible power supply unit between your computer and the mains source. These devices will also smooth out any voltage spikes or surges in the electricity supply.

Choosing a display

The display is one of the most important components in your entire kit. It is what you will spend all your time looking at as you work in Photoshop. You really do not want to economize by buying a cheap screen that is unsuited for graphics use. There are two types of display that you can buy. Cathode ray tube (CRT) monitors and liquid crystal displays (LCDs). A cathode ray tube fires electrons from its red, green and blue guns to produce a color image as the electrons strike the colored phosphor screen. CRTs have been around a long time and they remain popular with high-end graphics users. This is because most CRT displays make it possible to manually adjust the calibration of the display (see page 103) so

Chip speed

Microchip processing speed is expressed in megahertz, but performance speed also depends on the chip type. A 2 GHz Pentium III is not as fast as a 2 GHz Pentium class 4 chip. Speed comparisons in terms of the number of megahertz are only valid between chips of the same series. Many of the latest computers are also enabled with twin processing. The Macintosh Motorola G4/G5 processor includes AltiVec. This helps in providing several instructions per clock cycle to enabled programs such as Photoshop, and it is claimed can boost performance speeds of certain operations by at least a third. Windows machines use a similar speed enhancer which is known as MMX. Another crucial factor is the bus speed. This refers to the speed of data transfer from RAM memory to the CPU (the central processing unit, i.e. the chip). CPU performance can be restricted by slow system bus speeds so faster is better, especially for Photoshop work where large chunks of data are always being processed.

Using a second display

If you are able to run two displays from your computer, then you might want to invest in a second, smaller screen and have this located beside the main display and use it to show the Photoshop palette windows and keep the main screen area clear of palette clutter. To run a second display you may need to buy an additional PCI card that can provide a second video port.

Floating windows

In the past, PC users were restricted by the limits of the Photoshop application window. This is now resolved in two ways. Firstly, because Bridge is now a separate application, it is no longer constrained to working in Photoshop, as we were with the File Browser. And secondly, Photoshop CS2 has a floating windows feature in the PC version which lets you move document windows outside the bounds of the application window.

Sony Artisan

If you are looking for a great value professional CRT display, the Sony Artisan is one of the best value high-end displays you can buy. The Artisan system was designed by Dr Karl Lang with professional prepress users very much in mind.

that you can achieve a nice, neutral-looking output and there is less further adjustment required with the monitor profile. So ideally, the monitor profile will simply fine tune the image to appear correctly on the calibrated CRT. But because CRT displays are analog devices, they are prone to fluctuate in performance and output. This is why you must always regularly calibrate a CRT monitor. The hardware controls of a CRT will typically allow you to adjust the contrast, brightness and color balance of the display output. The more expensive CRT monitors such as the Barco Calibrator have built-in self-calibrating tools. These continually monitor and regulate the output from the moment you switch the device on. A 22" CRT display is a big and bulky piece of equipment, whereas the light, slimline design of a flat panel LCD screen will occupy less desk space than an equivalent sized CRT display and these have become the most popular type of display you can buy now. LCDs range in size from the screens used on a laptop computer to big 30" desktop displays. An LCD contains a translucent film of fixed-size liquid crystal elements that individually filter the color of a backlit, florescent light source. Therefore, the only hardware adjustment you can usually make is to adjust the brightness of the backlit screen. You can calibrate the brightness of the LCD hardware but that is about all you can do. The contrast is fixed, but it is usually as high as, if not higher even than, a typical CRT monitor, which is not a bad thing when doing Photoshop work for print output. Because LCDs are digital devices they tend to produce a more consistent color output. They still need to be calibrated and profiled. but the display's performance (unlike a CRT monitor) will remain fairly consistent over a longer period of time. On the other hand, there will be some variance in the image appearance depending on the angle from which you view the screen. The brightness and color output of an LCD will only appear to be correct when the screen is viewed front on. And this very much depends on the design of the LCD display. The worst examples of this can be seen on ultrathin laptop display screens. But the evenness of the output

from a 23" Apple Cinema display and other desktop LCD screens is certainly a lot more consistent.

It is interesting to speculate what displays will look like in the future. Sunnybrook Technologies (www. sunnybrooktech.com) are developing a LCD display which uses a matrix of LED lights instead of a fluorescent light source to pass light through the LCD film. These displays have an incredible dynamic range and are capable of displaying a 16-bit per channel image with an illumination range that makes an ordinary 8-bit display look flat and dull by comparison. We may one day have display technologies that are able to get closer to simulating the dynamic range of natural light. This will be great for viewing computer games and video, but for Photoshop print work we mostly want to have the display we are looking at match our expectations of what can be reproduced on a print.

Display calibration and profiling

We now need to focus on what is the most important aspect of any Photoshop system: getting the monitor to correctly display your images in Photoshop at the right brightness and neutralized to avoid introducing color casts. This basic setup advice should be self-evident, because we all want our images in Photoshop to be consistent from session to session and match in appearance when they are viewed on another user's system. There are several ways that you can go about this. At a bare minimum you will want to calibrate the monitor display so that the contrast is turned up to maximum, the brightness is consistent with what everyone else would be using and that a neutral gray really does display gray. As I mentioned earlier, CRT displays will fluctuate in performance all the time. So before you calibrate a CRT monitor, it should be left switched on for at least half an hour to give it a chance to warm up properly and stabilize. A decent CRT monitor will have hardware controls that allow you to adjust the brightness and the color output from the individual color guns so that you can easily correct for color shifts and reset the gray balance of the output. However, the life-span of a CRT is about

Video cards

The graphics card in your computer is what drives the display. It processes all the pixel information and converts it to draw a color image on the screen. An accelerated graphics card will enable your screen to do several things. It will allow you to run your screen display at higher screen resolutions, it will allow you to view everything in millions of colors, it will also hold more image screen view data in memory and it will use the monitor profile information to finely adjust the color appearance. When more of the off-screen image data remains in memory the image scrolling is enhanced and this provides generally faster screen refreshes. In the old days, computers were sold with a limited amount of video memory. If you were lucky you could just about manage to run a small screen in millions of colors. If you buy a computer today the chances are that it will already be equipped with a good, high performance graphics card, easily capable of doing all of the above. These cards will contain 32 MB (or more) of dedicated memory. There is probably not much advantage to be gained in fitting anything other than this (unless you have a very large LCD screen) because the top of the range graphics cards are mostly optimized to provide faster 3D games performance rather than providing a better 2D display.

Prolonging the life of a CRT display

A CRT display will typically be good for three years use before the tube starts to fade and calibration becomes difficult. Using a screen saver will help prolong the life of a CRT. A CRT monitor display will usually have hardware controls that allow you to configure the alignment of the image. It is suggested that you carefully configure the alignment so that you don't have the display image filling the entire area of the CRT screen. Use the hardware controls to reduce the width and height slightly so that you have, say, a quarter inch unused border around the display viewing area. three years and as these devices get older they will lose their brightness and contrast to the point where they can no longer be successfully calibrated or be reliable enough for Photoshop image editing.

The initial calibration process should get your display close to an idealized state. From there, you can build a monitor profile which at a minimum describes the black point, white point and chosen gamma. The black point describes the darkest black that can be displayed so that the next lightest tone of dark gray is just visible. The white point information tells the video card how to display a pure white on the screen that matches the specified color temperature (I suggest you always use D65/6500 K and not D50). And lastly the gamma. This tells the video card how much to adjust the midtone levels compensation. Note that the gamma you choose when creating a monitor profile does not impact on how light or dark an image will be displayed in Photoshop. The monitor profile gamma only affects how the midtone levels are distributed. Whether you use a Mac or PC computer, in most instances you should choose a gamma of 2.2 when building a monitor profile. If you use a measuring instrument (see Figure 3.3) to accurately calibrate and profile the display, you can build a monitor profile that contains a lot more detailed information about how the screen is able to display a broad range of colors.

The calibration resets your hardware to a standardized output. Next you build a monitor profile that describes how well the display actually performs after it has been calibrated. A good CRT monitor will let you manually adjust the color output of the individual guns (smart monitors like the Sony Artisan and Barco Calibrator do this automatically). If the screen is more or less neutral after calibration there is less further adjustment required to get a perfectly profiled display. The monitor profile sends instructions to the video card to fine-tune the display. If these adjustments are relatively minor, you are making full use of the video card to describe a full range of colors on the screen. If you rely on video card adjustments to

calibrate the display as well, then the video card is having to make bigger adjustments and the color output may suffer as a result. For example, when you use the Adobe Gamma or the Apple Display Calibrator Assistant method described on the following pages, as you adjust the color gamma sliders you are color compensating via the video card to neutralize the color on the display. It is much better to do this using the hardware controls, if your monitor has them. Not all CRT monitors do and LCD displays certainly don't. The only adjustment you can make on an LCD monitor is to adjust the brightness. This is not to say that all LCD screens are unsuitable devices for graphics work. The better LCD screens feature relatively good viewing angle consistency, are not too far off from a neutral color and D65 white balance and they will not fluctuate much in performance. If you are not going to invest in a calibration/ measuring device, your best option with an LCD is to load a canned profile for your monitor and keep your fingers crossed. It will sort of work and is better than doing nothing.

Calibrating hardware

Let's now look at the practical steps for calibrating and profiling the display. First, get rid of any distracting background colors or patterns on the computer desktop. And consider choosing a neutral color theme for your operating system. The Mac OS X system has a graphite appearance setting especially there for Photoshop users! If you are using a PC, try going to Control Panels \Rightarrow Appearance \Rightarrow Themes, choose Display and click the Appearance tab. Click on the active and inactive window samples and choose a gray color for both. If you are using Windows XP, try choosing the silver color scheme. This is all very subjective of course, but personally I think these adjustments improve the system appearances.

The only reliable way to calibrate and profile your display is by using a hardware calibration system. The LaCie Electron BlueEye, Mitsubishi SpectraView and Barco Calibrator are examples of monitors that come

Figure 3.2 This is a screen shot showing the hardware monitor controls for the LaCie Electron Blue III CRT display. The hardware controls enable me to adjust the output of the individual guns that control the red, green and blue color of the display. I adjust these settings as part of the display calibration process to make the screen neutral before building the monitor profile.

1 An uncalibrated and unprofiled monitor cannot be relied on to provide an accurate indication of how colors should look.

2 The calibration process simply aims to optimize the display for gray balance, contrast and brightness.

3 The profiling process records at a minimum the black point, white point, and gamma. With the right software, the profiling process will also measure how a broad range of colors are displayed. Recording this extra color information is the only way you can truly produce an accurate profile.

4 To create a profile of this kind you need a colorimeter device like the ColorVisions Monitor Spyder with PhotoCal or OptiCal software. A spectrophotometer such as the Gretag Macbeth Eye-One with Eye-One Match or Profile Maker Professional software will produce the most accurate results. bundled with their own calibrating systems. Alternatively you can buy a stand-alone calibration instrument to do the job. The ColorVision Monitor Spyder and Spyder2Pro Studio are affordable, and are sold either with PhotoCal or the more advanced OptiCal software. The Monitor Spyders are colorimeter devices and can be used to measure the output from a CRT or LCD monitor display. Monaco Systems make the X-Rite, which is also a good system and comes with the easy-to-use OPTIX software.

CRT measuring devices generally use rubber suckers to attach to the screen. To measure an LCD display, a weighted strap is used to counterbalance the instrument so it just rests against the LCD screen. Whatever you do, don't try attaching anything with rubber suckers to an LCD screen, as you will completely ruin the display! My personal preference is the Gretag Macbeth Eye-One system, which is available in several different packages. The Eye-One Spectro measuring device is an emissive spectrophotometer that can measure all types of displays and build printer profiles as well when used in conjunction with the Eye-One Match 3.0 or Basicc software. The new Eye-One Display 2 device is an economically priced device and is designed for measuring both CRT and LCD displays.

10000000000	a deservations	and the second second second	
			000
Monitor Camera	Scanner	Printer	Multicolo
	the reference and profile.	I sample files to c	alculate
Reference	Pr	ofile Size	
LCD Monitor Reference 2.	• •	arge	\$
		onitor Type	
		.CD	\$
	and the second se	hite Point	:
Sample			
None			
None 2		lculate Profile	
None		Iculate Profile	

Figure 3.3 The Gretag Macbeth Eye-One is a popular spectrophotometer that can be used to accurately measure the output from the monitor display to both calibrate the output and using the accompanying Eye-One software, measure color patches, and build an ICC profile for your display.

Figure 3.4 A screenshot of the ProfileMaker Pro software which can be used with calibration hardware such as the Eye-One to profile monitor displays, scanners, cameras and printers.

Gamma and white point setup

When you utilize a calibration device the calibrating software will want to ask you two important questions. Firstly, which gamma you will be using? Now quite often you are told that PC users should use a 2.2 gamma and Macintosh users should use a 1.8 gamma. But a 2.2 gamma is the ideal gamma setting to use regardless of whether you are on a Mac or a PC. You can build a correct monitor profile using a 1.8 gamma option, but 2.2 is closer to the native gamma of most displays. I once asked an engineer why they still included it as an option in their software and he replied that it's only there to comfort Mac users who have traditionally been taught to use 1.8. So now you know.

The other puzzling question concerns the white point. You will sometimes be urged to choose a 5000 K whitepoint for print work. My advice is to always use 6500 K instead. Most displays run naturally at a white point of 6500 K. Some people regard 5000 K as being the correct value to use for CMYK proofing work. But in reality, the whites on your display will appear too yellow at this setting. 6500 K may be cooler than the assumed 5000 K standard, but 6500 K will give much better contrast on your display and your eyes always adjust naturally to the colors on the display, the same way as your eyes adjust normally to fluctuations in everyday lighting conditions. The apparent disparity of using one white point for the lightbox and another for the display is not something you should worry about.

Do you want good color or just OK color?

Let me summarize in a few paragraphs why you should pay special attention to how your images are displayed in Photoshop and why good color management is essential.

As I said earlier, the choice of monitor display is really important. You are going to spend a lot of hours looking at the screen. The choice of an LCD or CRT display can be a matter of individual choice. I have a personal preference for using LCDs, but CRT monitors like the Barco and Sony Artisan are also popular with a lot of photographers. Once you have chosen a good display you need to consider how you are going to calibrate and fine-tune the display. This is crucial and if it is done right it will mean you can trust the colors you see on the screen. And what you see on the display will end up looking the same in print. Not so long ago, the cost of a large display, plus a decent video card, would have cost a fortune and monitor display calibrators were specialist items. These days, a basic monitor calibration and profiling device can cost about the same as an external hard drive, so I would urge anyone setting up a computer system for Photoshop, put a monitor display calibrator high on their spending list. A standard colorimeter like the Eye-One Display 2 from Gretag Macbeth is easy to set up and use and all the necessary software will be supplied to enable you to calibrate and build a profile for your monitor.

All the monitor display calibrator products I have tested will automatically place a profile for your monitor in the correct folder in your system and you are then ready to start working straight away in Photoshop with a properly calibrated display. Once you are in Photoshop you need to make sure you are using the right color settings for your workflow: see page 109 for instructions on how to check if you are using the right settings for a photography setup. Once that is done, the Color Settings will remain set until you change them. After that, all you need to worry about is making sure that the calibration and profiling for your display is kept up to date. If you are using a CRT type display, this should probably be done about once a week. If you are using an LCD type display, the profiling is just as important, but regular calibration will not be quite so critical. Checking once a month will probably be enough.

Color management does not have to be intimidatingly complex and nor does it have to be expensive. So the question is do you want good color or simply OK color? Or, to put it another way, how can you afford not to?

Calibration without a budget

So far I have outlined some solid reasons why you shouldn't be scared off by color management and how easy and inexpensive it is to calibrate your display. But I know that a lot of Photoshop users out there will still feel that they cannot afford this, so I do also need to cover the 'eyeball' methods of display calibration. These are not particularly accurate, but it is a better than doing nothing at all. When you are finished, a basic profile of your monitor will be automatically created and placed in the appropriate system folder. I have provided a step-by-step guide for Mac and PC here. If you are using a Macintosh you will need to launch the Apple Display Calibrator Assistant. Open the System Preferences, choose Displays, click on the Color tab and click the Calibrate... button. If you are using a PC, the Adobe Gamma control panel should be located in the Program files/Common files/ Adobe/Calibration folder which may also be accessed on a PC by going to My Computer and opening the Control Panel folder. Adobe Gamma will now work with most PC computers, providing the video card will allow Adobe Gamma to interact with the monitor device. When you launch Adobe Gamma, select the Assistant radio button and click Next. If you already have a monitor profile, such as a canned profile supplied by the manufacturer, click the Load... button, locate this profile and use that as your starting point. Any existing monitor profiles should be found in the ICM Color Profiles folder. If not, any will do as a starting point here. When this is complete you will be ready to configure the color management settings.

Color managing the print output

This leaves the question of how to profile the print output. Well, aetting custom profiles built for your printer is a good idea, and this topic is covered in some detail in Chapter 14. However, calibrating and building a profile for your display is by far the most important step in the whole color management process. Get this right and the canned profiles that came with your printer should work just fine. You should already be seeing a much closer match between what you see on the display and what you see coming out of your printer. But without doubt, a custom print profile will help you get even better results.

Visual display calibration for Mac OS X and PC

The Display Calibration Assistant opening screen introduces the calibration utility and steps to create a monitor profile. On the Mac, check the Expert Mode button at the bottom of the screen. If you already have a monitor profile, such as a canned profile supplied by the manufacturer, click the Load... button in Adobe Gamma, locate this profile and use that as your starting point. Any existing monitor profiles should be found in the Profiles folder.

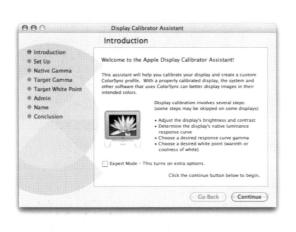

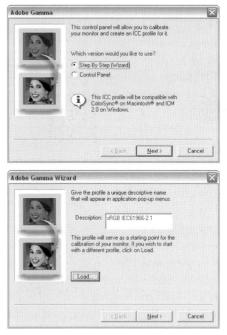

Contrast and brightness

On a PC, you will then be asked to set the contrast to maximum and adjust the monitor brightness control so that the gray box inside the larger box just becomes visible and the two darker halves of the square appear to be a solid black. This step optimizes the monitor to display at its full dynamic range and establishes the optimum brightness for the shadow tones. On a Mac, follow the five step process to determine the display's native luminance response curves.

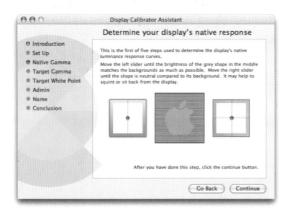

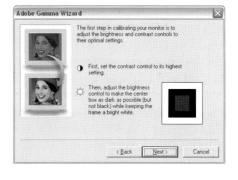

Neutralizing the color

On a Mac, continue adjusting the sliders, as advised through the five steps. When making these judgements it helps to have the screen behind filled with a neutral gray. This will help you judge whether the color is indeed neutral. On a PC, in Adobe Gamma, keep the setting indicated by the profile you loaded at stage one. If starting from scratch, check with the monitor vendor which to select here.

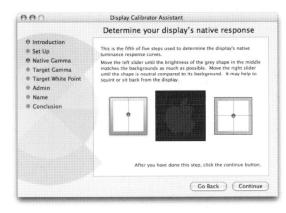

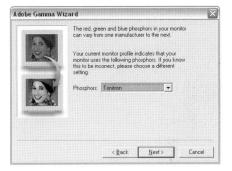

Target Gamma

On a PC, the next dialog will feature a single striped gray box with a square inside it. Deselect the View Single Gamma Only box and do a similar type of visual judgement to that described for the Mac, and adjust the sliders below the three colored boxes to make the display color as neutral as possible. Whether you are using a PC or a Macintosh, you are advised to select a 2.2 gamma in the Apple Calibrator Assistant and Adobe Gamma dialogs, as this is the best monitor gamma setting for most Mac and Windows graphics cards.

000	Display Calibrator Assistant
	Select a target gamma
O Introduction Set Up O Native Gamma O Target Camma O Target White Point Admin O Name O Conclusion	Select your desired gamma setting for this display. This will adjust the overall contrast of the display. Watch the difference of the different of the different of the setting of the different of the set the difference of the di
	After you have done this step, click the continue button.

53	The gamma setting of your monitor defines how bright your midtones are. Establish the current gamma by adjusting the sider until the center box fades into the patterned frame.
	T View Single Gamma Only
	Now choose the desired gamma.
	Gamma: Windows Default 2.20
	< Back Next > Cancel

White point

I would advise choosing a white point of 6500 K. You might be guided to choose a white point of 5000 K, because this is the color temperature of a calibrated, proofing lightbox, but the screen will look rather dull and have a slightly yellow cast, so stick to using a 6500 K white point. The next Adobe Gamma screen will ask if you want to carry out a visual measurement to set the white point differently (see lower dialog). Unless you have a particular need to alter the white point, leave this set to Hardware White Point.

900	Display Calibrator Assistant
	Select a target white point
Introduction Set Up Native Gamma Target White Point Admin Name Name Conclusion	Select the white point setting you want for your display. This will adjust the overall tint color if the display. In most cases is best to us to or odd. $\begin{array}{c} 050 065 9300 \\ \hline 0500 6000 7000 8000 9000 \\ \hline 0 \mbox{ Use native white point } \end{array}$
	Co Back Continue

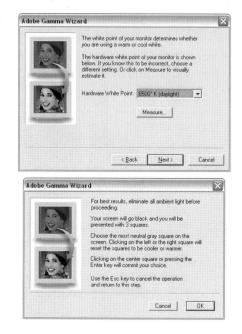

Conclusion

Name the new monitor profile and click on the Create button. A good tip here is to include a date in the profile name to remind you when you last calibrated and profiled the display. You will by now have created an ICC profile that describes the basic characteristics of the monitor and which Photoshop will automatically recognize.

000	Display Calibrator Assistant
	Give the profile a name
⊖ Introduction © Set Up © Native Gamma	Give your profile a name.
 Target Camma Target White Point Admin Name Conclusion 	
	After you have done this step, click the continue button.
	Go Back Continue

You have now completed the Adobe Garma Vicaud To view your screen prior to these changes, compare the results of the following options. Before C After To save your settings, click on Finish.
< Back Finish Cancel

Chapter 3

Color management settings

One of the very first things you should do after installing Photoshop is to configure the color management settings. The default Photoshop color settings are configured using a general setting for the region you live in, which will be: North America, Europe or Japan. If you are using Photoshop for design work or photography, you will want to follow the prompt that Photoshop is giving you here. Go to the Photoshop menu (Mac OS X) or the Edit menu (PC) and select Color Settings. This will open the dialog shown in Figure 3.5. Go to the Settings menu and select one of the prepress settings. These individual preset settings only differ in the default RGB to CMYK conversions that they use. Which you should choose will depend on the geographical area you are working in. So if you live and work in the US, choose US Prepress Defaults and you will be fine with that setting. Please note that adjusting the RGB working space from sRGB to Adobe RGB is a good thing to do if you intend editing RGB photographs in Photoshop. But it is not enough just to change the RGB work space setting on its own. The prepress settings will also adjust the policy settings in order to minimize any

ettings: No	rth America General Purpose 2	Cance
Advanced Mode	The second and a second and a second a	Load.
		LOad
 Working Spaces RGE 	8: sRGB IEC61966-2.1 +	Save
CMYR		
Gray		
Spo	t: Dot Gain 20%)
Color Manageme	ent Policies	
RGE	8: Preserve Embedded Profiles	
CMYR	C Preserve Embedded Profiles	
Gray	/: Preserve Embedded Profiles	
Profile Mismatches	s: Ask When Opening Ask When Pasting	
Missing Profiles	5: Ask When Opening	
Description		-
	eral Purpose 2: General-purpose color settings for screen America. Profile warnings are disabled.	
no print in North	renerica, rione narnings are disabled.	

Figure 3.5 The Photoshop Color Settings. All the Photoshop color settings can be managed from within this single dialog.

Figure 3.6 Wacom pad and pen.

Graphics tablets

I highly recommend getting a digitizing graphics tablet. It can be used alongside the mouse as an input device, is pressure responsive and is easier to draw with. Bigger is not necessarily better. Some people like using the A4-sized tablets. others find it easier to work with an A5 or A6 tablet from the Wacom Intuos range, which also feature a cordless mouse and switchable pens. You don't have to move the pen around so much with smaller pads and are therefore easier to use for painting and drawing. Once you have experienced working with a pen, using the mouse will seem like trying to draw while wearing boxing gloves. Wacom recently introduced the Cintig, which is a combination of LCD monitor and digitizing pen pad. This radical new design will potentially introduce a whole new concept to the way we interact with the on-screen image. I don't know if it is going to be generally seen as the ideal way of working with photographs, but early reports suggest that it makes painting and drawing a more fluid experience.

errors or frustrations when working with image files that are in different color spaces. You are on much safer ground if you choose one of the default prepress settings here, which seek to recognize and preserve embedded profiles.

By now your display should be neutralized and the brightness set to an optimum luminosity. Photoshop is aware of the monitor profile you just created and your color settings are configured to correctly read the colors of any incoming, profiled files and you are all set to get to work with confidence. You don't need to worry too much more about the ins and outs of Photoshop color management just yet, but as your Photoshop knowledge increases you will definitely want to read in more detail about the color management system in Chapter 13 and also Chapter 14 on how to make perfect prints.

Extras

An internal 24× or faster CD-ROM drive is standard issue these days. Other things to buy could include a second hard drive to use as a scratch disk plus a removable media storage device such as the Iomega Zip drive or a CD writer, although a lot of computers are sold with a CD drive that functions as a CD writer and DVD writer too. You need these to back up your main hard disk and store all your image documents. It is tempting to accumulate lots of image files on the computer hard drive, but you have to ask yourself what would happen if your computer got stolen or that hard drive failed. Removable disks are ideal for transferring documents off-site. Print bureaux should be able to satisfactorily read Mac and PC format files whether supplied on ZIP, CD or DVD. USB and FireWire (IEEE 1394) are the latest connection standards for peripheral devices. You can have up to 127 USB devices linked to a single computer and you can plug and unplug USB devices while the machine is switched on. USB 2.0 is the latest standard and has many advantages for those in a PC working environment. USB 1.0 is slow, but it's fine for connecting control devices such as the mouse, Wacom tablet and printer. FireWire has the potential to provide

fast data transfer rates of 100 MB+ per second (faster still with FireWire 800). So use FireWire wherever possible to connect devices that rely on fast data transfer such as hard drives, CD writers, digital cameras and scanners.

Backing up image data

The choice of backup media is a vexed issue. In the lifetime of the Photoshop program we have seen many different systems come and go. Floppies, Syquests, Magneto Opticals... the list goes on. And although you can still obtain devices capable of reading these media formats, the question is, for how long? And what will you do in the future if a specific hardware device fails to work? The introduction of recordable CD media has been very successful. Audio CD drives have been around since the early eighties and will undoubtedly continue to be supported for some time to come. CD drives and the media they use have evolved to provide much faster read/write speeds and they have also evolved to be compatible with DVD format disks. DVD media may be able to offer increased storage space in the future, but undoubtedly we will eventually see a faster and bigger media storage system being developed. So how long will CD and DVD media remain popular and be supported by future computer hardware? More to the point, how long will the media disks themselves last? It is estimated that aluminium and gold CD disks could last up to 30 years, or longer, if stored carefully in the right conditions such as at the right temperature and away from direct sunlight. DVD disks which use vegetable dyes may have an even shorter life-span. The solution I use is to archive important data to CD and DVD media, but also to high capacity hard drives. The cost of hard disk storage space is so cheap that this is now an easily affordable solution. It means I can access important files more easily while I am working on the computer and I am using the one method of disk storage which has so far remained relatively unchanged over the years and therefore has more chance of continuing to be supported in the future.

Where to buy your equipment

Mail order companies are hard to beat on price, and the customer service is generally satisfactory, but you do occasionally come across bad shopping experiences, particularly when a piece of kit goes wrong. Try to find out if anyone else has had bad service with a particular dealer before parting with your money. Under UK consumer law, any claim on your warranty will require you to pursue the matter via the company who sold the equipment. Legally your consumer rights are protected. For extra protection, use your credit card for mail order purchases. In practice, these suppliers are working in a very competitive market and only make small margins on all equipment sold. Consequently, you can expect little in the way of technical support and the procedures for handling complaints can be very slow. If you do have a problem, and wish to ensure your complaint is dealt with swiftly, be patient, and polite, but above all be methodical in pursuing your grievance. Note down dates and times of any calls you make. Computer trade shows are a good place to find special offers, but again check who you are dealing with. Remember prices are always dropping - the system you buy today could be selling for half that price next year. Your capital investment is not going to hold its value. Businesses that rely on their equipment to be working every day of the week may wisely choose to buy from a specialist dealer who will provide professional advice and equipment tailored to their exact needs and, most important of all, instant backup in case things go disastrously wrong.

Resetting the preferences

Holding down **H S***hift ctrl alt Shift* during start-up will allow you to delete the current Photoshop preferences.

Mac OS X key fix

The Mac OS X system broke some of the once hallowed rules about not implementing keyboard shortcuts that might conflict with shortcuts in an application designed to run on the Mac system. Mac OS X keyboard shortcuts are now disabled completely since this would only further conflict with the custom keyboard shortcuts in Photoshop. One exception is the **(H) (C)** feather selection command. This still has to be deselected manually via the Mac OS X System Preferences ⇒ Keyboard & Mouse ⇒ Keyboard Shortcuts.

Customizing the UI Font Size

LCD computer displays are getting bigger all the time and are only really designed to operate at their best when using the finest resolution setting. This can be great for viewing photographs, but the downside is that the application menu items are getting smaller and smaller. The UI (user interface) Font Size option allows you to customize the size of the smaller font menu items in Photoshop so that you don't have to strain your eyes too hard to read them. For example, when using a large LCD screen, the Medium font size option in Photoshop CS2 makes it easier to read the smaller font menu items from a distance.

Photoshop preferences

The Photoshop preferences are located in the Edit menu in Windows and the Photoshop menu in OS X. The preferences let you customize the various Photoshop functions and update the preference file which is stored along with other program settings in the system level Preferences folder (Mac) or Registry folder (PC): (C:\ Documents and Settings\Current User\Application Data\ Adobe\Photoshop\9.0\Adobe Photoshop CS2 Settings). A new preference file is generated each time you exit Photoshop and deleting or removing this file will always force Photoshop to reset all its preferences.

General preferences

When you open the Preferences you will first be shown the general preferences. I suggest you leave the Color Picker set to Adobe (unless you have a strong attachment to the system Color Picker). And leave the image interpolation set to Bicubic. If you need to override this setting then you can do so in the Image \Rightarrow Image Size dialog. The default number of History States is 20, so you may wish to reduce this if you feel it is more or less than you need. Unchecking the Export Clipboard box saves time when exiting Photoshop to launch another program. If you really need the ability to paste clipboard contents to another program, then leave it on, otherwise switch it off. When the Show Tool Tips option is checked you will see tool tips displayed a few seconds after you roll over most items in the Photoshop interface. Tool tips are an excellent learning tool, but can become irritating after a while. Check the Keyboard Zoom Resizes Windows if you want the image window to shrink to fit whenever you use a keyboard zoom shortcut like $\mathfrak{H} - \mathfrak{ctrl} - \mathfrak{or} \mathfrak{H} + \mathfrak{ctrl} + \mathfrak{l}$. If you are going to be jumping between Photoshop and ImageReady, then you may want to check the Auto-Update Open Documents option. Otherwise, Photoshop will remind you anyway when you jump between applications. Photoshop CS2 allows you to create custom menu settings and use colors to highlight favorite items. This feature aspect can

be disabled by unchecking the Show Menu Colors item. The Resize Image During Paste/Place is useful if you want pasted or placed items to be automatically scaled to match the size of the image you are pasting/placing them in. Only check the Beep When Done box if you want Photoshop to signal a sound alert when tasks are complete. The Dynamic Color Sliders option ensures that the colors change in the Color palette as you drag the sliders, so keep this selected. If you would like Photoshop to always remember the last used palette layout, check the Save Palette Locations box (the Reset Palette Locations to Default option is located under the Window menu, as are the saved Workspace settings). The Use Shift Key for Tool Switch answers the needs of users who wish to disable the Shift key modifier for switching tools in the Tools palette with repeated keyboard strokes. The Automatically Launch Bridge option will ensure Bridge is always launched in the background and ready for immediate use. And lastly, the Zoom Scroll Wheel option which among other things will enable you to zoom in and out via the scroll wheel if you have one on your mouse. Holding down Shift will constrain the zoom to the usual percentage increments.

Logging the edit history

The History Log is something that is very useful if you wish to keep track of everything that has been done to an image. The History Log options will let you save the history log directly in the image file metadata, to a saved text file stored in a pre-configured folder location, or both. The edit log items can be recorded in three modes. Sessions will record which files are opened and closed and when. The Concise mode will record an abbreviated list of which tools or commands were applied, again with times. Both these modes can provide basic feedback that could be useful in a studio environment to monitor time spent on a particular project and calculate billing. The Detailed mode records everything, such as the coordinates used to make a crop. This mode is useful, for example, in forensic work.

		Preferences	A CONTRACTOR	
General	•			ОК
Color Picker: Ad	lobe			Cancel
Image Interpolation: Bio	ubic			
UI Font Size: Me		ges will take effect the next you start Photoshop.		Prev Next
History States: 6				
- Options				
Export Clip	oboard	Beep When Done		
Show Tool	Tips	Dynamic Color Sliders		
🗹 Zoom Resi	zes Windows	Save Palette Locations		
Auto-Upda	ate Open Documents	Use Shift Key for Tool Switch		
Show Men	u Colors	Automatically Launch Bridge		
🗹 Resize Ima	ge During Paste/Place	Zoom with Scroll Wheel		
History Log				
Save Log Items To: 🖲	Metadata			
0.	Text File Choose			
0	Both			
Edit Log Items: D	etailed 🛟			
	Reset All Warni	ing Dialogs		

Figure 3.7 The General Preferences dialog.

Backwards compatibility issues

Once I update to a new version of Photoshop, I never need to go back to using a previous version and I am not in the habit of allowing anyone else access to my layered, version-specific Photoshop files. I have no need to maximize backwards compatibility, so I prefer to switch this option off and keep the file size down and the save times shorter. But by doing so, I am losing out when I use Bridge, because Bridge likes to utilize the flattened composite layer as it builds the thumbnails and previews. Without the composite layers it may take longer to cache the PSD files, but once the cache is written, it is stored in the individual volume's File Browser cache folder and will be instantly available the next time I visit that folder, unless I have edited the image in between.

File Handling

You will normally want to include image previews when you save a file. It is very useful to have image thumbnail previews in the Open dialog boxes although the Bridge program is capable of generating large thumbnails regardless of whether a preview is present or not. If you are working on a Mac, you can choose to save a Windows and Macintosh thumbnail with your file, to allow for crossplatform access. Appending a file with a file extension is handy for keeping tabs on which format a document was saved in and is also very necessary when saving JPEG and GIF web graphics that need to be recognized in an HTML page. If you are exporting for the web, you may want to check the Use Lower Case box for appending files. But instances of servers tripping up on upper case naming are very rare these days.

Photoshop PSD files created in Photoshop CS2 are never going to be 100% compatible when they are read by someone using an earlier version of Photoshop. This has always been the case with every upgrade of the program. Setting the Maximize PSD File Compatibility to 'Always' will allow you to always include a flattened version of the image in a saved Photoshop file and the safe option is to keep this checked. For example, if you add a Photo Filter image adjustment layer in Photoshop CS or CS2, it will not be interpreted correctly when read by Photoshop 7.0 or earlier unless it is made backwards compatible. In these circumstances, if Photoshop is unable to interpret an image, it will present an alert dialog. This will warn that certain elements cannot be read and offer the option to discard these and continue or to read the composite image data. Discarding the unreadable data will allow another user to open your image, but when opened, it will be missing the elements you added and look unexpectedly different. If they click the Read Composite Data button, and a composite was saved, the image they open will open using a flattened composite layer which does look the same as the image you saved. If no composite was created, they will just see a white picture and a multi-language message

saying that no composite data was available. So there are good reasons for maintaining backwards compatibility, but checking this option will lead to slower saves and bigger Photoshop files.

A TIFF format file saved in Photoshop 6.0 or later is able to contain all types of Photoshop layer information and a flattened composite is always saved in a TIFF. If you place a layered TIFF image in a page layout, only the flattened composite will be read by the program when the page is finally converted to print. Some people argue that there are specific instances where a layered TIFF might trip up a print production workflow, so it might be safer to never save layers in a TIFF if you don't know for certain where your files will be printed.

Adobe InDesign allows you to place Photoshop format (PSD) files in a page layout, but if you do so, the Maximize Backwards Compatibility option must be checked in the General Preferences, which as I just explained will generate a flattened composite when you save as a PSD. If you use layered TIFF, PSD (or Photoshop

Economical web saves

There are times though when you don't need previews. Web graphic files should be uploaded as small as possible without a thumbnail or platform specific header information (Save for Web defaults to removing previews). I usually upload files to my server in a raw binary format, which strips out the previews and other file resource information anyway.

Resetting dialogs

The Reset All Warning Dialogs will reset things like the profile mismatch warning messages. These dialogs contain a Don't Warn Me Again checkbox — if you had pressed any of these at any time, and wished to restore them, click here. The Reset All Tools in the Options bar will reset the tool behavior.

- File Saving Options		
Image Previews:	Always Save	Cance
	Icon 🖂 Full Size	Prev
	Macintosh Thumbnail	Next
	Windows Thumbnail	-
Append File Extension:	Always	
	☑ Use Lower Case	
 ✓ Ignore EXIF profile tag ✓ Ask Before Saving Layered TIF ✓ Enable Large Document Forma Maximize PSD File Compatibility: 	at (.psb)	
Version Cue		
Enable Version Cue Workgrou	p File Management	
Recent file list contains:	10 files	

Figure 3.8 The File Handling Preferences.

Version Cue

The Enable Version Cue Workgroup File Management relates to the use of Adobe Version Cue. This option caters for those working in a networked environment and where they are sharing working on image files with other Photoshop users. When a user 'checks out' a file, only he or she can edit it. The other users who are sharing your files will only be able to make edit changes after the file has been checked back in. This precautionary file management system means that other users cannot overwrite your work while it is being edited.

Recent File list

The Recent File list refers to the number of image document locations remembered in the Photoshop File \Rightarrow Open Recent submenu. I usually like to set this number to remember the last 10 opened images. But you may wish to set this higher. PDF) format files in your page layout workflow, you can modify the layers in Photoshop and the page design image will immediately be updated. This way you don't run the risk of losing synchronization between the master image that is used for Photoshop edits and a flattened version of the same image that is used solely for placing in the layout.

If you want to 'round trip' your images this way, TIFF is the more universally recognized file format. The downside is that you may end up with bloated files and these can significantly increase the file transmission times. For example, I typically begin my Photoshop editing with a single layer, 8-bit per channel, RGB image. As a PSD document it can occupy about 75 MB on my hard disk. After adding a few layers it may easily double to 150 MB in size. If I were to save as a PSD with maximize compatibility switched on, the size will increase to 215 MB and if I save as a layered TIFF it may increase to 275 MB. These figures will vary depending on factors such as how many layers are present. If you are archiving layered Photoshop images, the most efficient option is to save using the native PSD format and have Maximize PSD File Compatibility set to 'Never'. When the Ask Before Saving Layered TIFF Files option is checked, Photoshop will present you an option to either flatten or preserve the layers whenever you save a layered image as a TIFF. If this is unchecked, then the layer information will always be saved with a composite and there will be no warning dialog.

Enabling the Large File Format (.psb) option will allow you to save images whose dimensions exceed the limits of the standard file formats such as TIFF and PSD. The PSB format can be used to save images with pixel dimensions of up to $300,000 \times 300,000$ pixels. But you have to remember that currently only Photoshop CS and CS2 will be able to read an image saved using this PSB file format.

Display & Cursors

The Display Color Channels in Color option is a somewhat redundant feature as this does not really help you visualize the channels any better. If anything it is a distraction and is best left unchecked. The Use Pixel Doubling option will temporarily convert the image preview to display a quarter as many pixels when you are making an image adjustment with, say, Levels or Curves or moving a pixel selection or layer on screen. Pixel Doubling will improve screen refresh times, but again not necessary with today's fast computers.

The Painting cursor is able to display a painting tool icon, a precise crosshair or the default setting, which is an outline of the brush shape at its actual size in relation to the image magnification. In Photoshop CS2 you can choose to display a Full Size brush tip, representing the entire outer edge reach of a soft edged brush, although it is debatable whether this improves the appearance of the painting cursors or not. The Show Crosshair in Brush Tip option will allow you to additionally display a crosshair inside the brush size cursor. For all other cursors, the tool icon is the default setting. But I suggest changing this to Precise.

Brush Cursor options

The *Caps Lock* key will toggle the cursor display. When the standard paint cursor is selected, *Caps Lock* will toggle between standard and precise. When the precise or brush size paint cursor option is selected, *Caps Lock* will toggle between precise and brush size. When standard cursor mode is selected for all other cursors, *Caps Lock* will toggle between the standard and precise cursor.

Figure 3.10 This is an example of the brush cursor using the Full Size Brush Tip mode with Show Crosshair in Brush Tip.

Display & Cursors		OK
Display		Cance
Color Channels in Color		Cance
Use Pixel Doubling		Prev
- Painting Cursors	Other Cursors	Next
 Standard Precise Normal Brush Tip Full Size Brush Tip Show Crosshair in Brush Tip 	Standard Precise	

Figure 3.9 The Display & Cursors Preferences.

Removing the checkerboard

I had an email recently from a reader who wanted to know how to get rid of the transparency checkerboard pattern. If you go to the preferences shown here you can select different grid sizes and colors, but you can also select None. When None is selected the transparent areas will be displayed as solid white.

Transparency & Gamut

The Transparency settings determine how the transparent areas in an image are represented on the screen. If a layer contains transparency and is viewed on its own with the background layer visibility switched off, the transparent areas are normally shown using a checkerboard pattern. The display preferences let you decide how the checkerboard grid size and colors are displayed. The Gamut Warning will alert you in advance to any colors that will be out of gamut after a conversion is made from RGB or Lab Color mode to whichever color space is currently loaded in the View ⇒ Proof Setup menu. So, if you are working on an image in RGB or Lab Color mode and you choose View ⇒ Gamut Warning, Photoshop will highlight these out-of-gamut colors with a color overlay. The default overlay color is a neutral gray at 100% opacity. I suggest reducing the opacity to make the gamut warning appear as a transparent overlay. The Gamut warning can also be invoked independently of the image in Photoshop's Color Picker dialog (see Figure 2.75 on page 92).

	Preferences	
Transparency & Gamut		OK Cancel
Grid Colors:		Next
Use video alpha (requires hardware su Gamut Warning	pport)	
Color:	Opacity: 100 * %	

Figure 3.11 The Transparency display settings are editable. You have a choice of Transparency display settings: None, Small, Medium or Large grid pattern, and a choice of different grid colors.

Chapter 3

Units & Rulers

Use this preference to set the Ruler measurement (inches or centimeters etc.) and type units used. The measurement units can also be changed via the Info palette submenu or by *ctrl* right mouse-clicking a ruler to open the contextual menu. Double-click the ruler bar as a shortcut for opening this preference window. The New Document Preset Resolution options allow you to decide what pixel resolution should be the default for screen display or print output work when you select a Preset size from the File \Rightarrow New Document dialog. The Print Resolution setting is the more useful as this always has an important bearing on the size that an image will print. The Screen Resolution has typically always been 72 ppi. But there is no real significance to whatever resolution is set here for an image that is destined to appear in a web page design. Web browser programs are only concerned with the physical number of pixels an image has. The resolution setting actually has no relevance.

Units & Rulers Units Rulers: Cm Quits Rulers: Cm Quits Cance Prev Type: points Prev Vidth: 180 points Quiter: 12 points	Preferences	
Rulers: cm Cance Type: points Prev Column Size Width: 180 points Prev Width: 180 points Prev Next Cutter: 12 points Prev Next New Document Preset Resolutions Print Resolution: 300 pixels/inch Prev Point/Pica Size PostScript (72 points/inch) Prev Prev Prev	Units & Rulers	OK
Column Size Next Width: 180 points Points Gutter: 12 points Points Points New Document Preset Resolutions Print Resolution: 300 pixels/inch Points Screen Resolution: 72 pixels/inch Points/Pica Size PostScript (72 points/inch)	Rulers: cm	Cance
Gutter: 12 points Points New Document Preset Resolutions Print Resolution: 300 pixels/inch Pixels/inch Screen Resolution: 72 pixels/inch Pixels/inch Pixels/inch Pixels/inch Point/Pica Size PostScript (72 points/inch) Pixels/inch Pixels/inch Pixels/inch	Column Size	Next
Print Resolution: 300 pixels/inch 🔅 Screen Resolution: 72 pixels/inch 🗘 Point/Pica Size PostScript (72 points/inch)		
Point/Pica Size PostScript (72 points/inch)		
PostScript (72 points/inch)		
	PostScript (72 points/inch)	

Figure 3.12 Ruler units can be set in pixels, inches, cm, mm, points, picas or as a percentage. The percentage setting is ideal for recording actions that you wish to apply proportionally at any image size.

Guides, Grid & Slices

These preferences let you choose the Guides, Smart Guides and Grid Colors. Both Grid and Guides can be displayed as solid or dashed lines, with the Grid having the added option of using dotted lines. The number of Grid subdivisions can be adjusted to suit whatever project you are working on. The Slice options include Line Color style and whether the Slice numbers are displayed or not.

Guides, Grid & Slices	ОК
Guides	Cancel
Color: Cyan	Prev
Style: Lines	Next
Smart Guides	
Color: Magenta	
Grid	
Color: Custom	
Style: Lines	
Gridline every: 2 cm	
Subdivisions: 4	
Slices	
Line Color:	
Show Slice Numbers	

Figure 3.13 The Guides, Grid & Slices Preferences.

Accessing the JPEG 2000 plug-in

The JPEG 2000 file format plug-in is not installed as part of the regular Photoshop CS2 install, but it will be installed in the Bridge Plug-ins folder. So if you click the Additional Plug-ins Folder checkbox and click on the Choose button and navigate to the Bridge Plug-ins folder, you will be able to save images in Photoshop CS2 using JPEG 2000 after you relaunch Photoshop.

Plug-ins & Scratch Disks

The Plug-ins folder will automatically be recognized by Photoshop so long as it resides in the same application folder. But you can also choose an additional plug-ins folder that may be located in another application folder (such as Adobe Photoshop Elements) so these can in effect be shared with Photoshop. Click on the Browse... button to locate the additional folder. If you install any third-party plug-ins that predate Photoshop CS2, they may possibly incorporate a hidden installation process that looks for a valid Photoshop serial number in the older style, consisting of letters and numbers. If you experience this type of problem, just remember that you can enter your old Photoshop serial number in the Legacy Serial Number box.

In the section below that you can specify the primary and spill-over scratch disks, where up to four scratch disks can be specified. The scratch disk choice will only take effect after you restart Photoshop and the primary scratch disk should ideally be one that is separate to the disk running the operating system and Photoshop. Partitioning the main disk volume and designating an empty partition as the scratch disk serves no useful purpose, as the disk drive head will simply be switching back and forth between different sectors of the same disk as it tries to do the job of running the computer system and providing scratch disk space. If you hold down **H C** *ctrl alt* at the beginning of the Photoshop start-up cycle, you can choose the location of the Additional Plug-ins Folder. Keep holding down the same key combination and Photoshop will then prompt you to assign the scratch disks.

Ensuring preferences are saved

Once you have configured your preferences and got everything set up just the way you want, it is a good idea to Quit and restart Photoshop, as this will then force Photoshop to save these preferences to a preference file.

Addi	tional Plug-Ins Folder—		COK
<none></none>			Choose Can
			Pre
egacy Photosi	hop Serial Number:	and the strength	Nex
Scratch	Disks	I	
First:	RAID	•	
Second:	None		
Third:	None	•	
Fourth:	None		
		cratch disks will remain in use Intil you quit Photoshop.	

Figure 3.14 The Plug-ins & Scratch Disks Preferences. Up to four scratch disks are supported by Photoshop. And you can specify if any Additional Plug-ins Folders are to be used (which may be shared with another application).

How much RAM does Photoshop need?

Photoshop utilizes free hard disk space as an extension of RAM memory. It uses all the available free hard disk as 'virtual memory'. In Photoshop terms, this is known as a 'scratch disk'. If you are making extensive use of scratch disk space in place of real RAM, you will see a real slowdown in performance. So this is why you are recommended to install as much RAM memory as you can. Photoshop CS2 now allows you to allocate more than 2 GB of RAM memory up to a maximum of 4 GB. The maximum amount will vary depending on the computer system you are using. 1 GB of RAM will be fine for most purposes. But if you can afford to install more RAM than this, then do so.

Move don't copy

To copy selections and layers between documents, use drag and drop actions with the move tool. This will save on memory usage and preserve any clipboard image at the same time.

Virtual memory tricks

The Apple Macintosh and Windows operating systems are able to make efficient use of memory using their own virtual memory management systems. The Windows VM file should be set to at least 1.5 times your physical memory size. There are some software utilities that claim to double your RAM, but these will conflict with Photoshop's virtual memory and should not be used.

RAM memory and scratch disks

The amount of RAM memory you have installed is a key factor that will determine how fast you can edit your images in Photoshop. Adobe recommend you allocate a minimum of 192 MB application memory to Photoshop CS2, which means that if you allow 128 MB of RAM for the operating system, you need at least 320 MB of RAM in total. Most PCs and Macs use DIMMs (Dual In-line Memory Modules). The specific RAM memory chips may vary for each type of computer, so check carefully with the vendor that you are buying the right type for your machine. RAM memory used to cost a small fortune, but these days the price of RAM is almost inconsequential. If you have four RAM slots on your machine, you should easily be able to install 4×512 MB RAM or 4×1 GB RAM memory chips, which will give you 2 or 4 GB of installed RAM. The speed boost gained from having the extra RAM installed in your machine will be significant.

When you first install Adobe Photoshop CS2, 50% of all available system RAM is automatically allocated for Photoshop use. You can improve upon this memory allowance by increasing the partition. For example, if you are running Mac OS X and have a gigabyte or more of RAM memory, you can increase the memory allocation in the Memory and Image Cache preferences to between 60 and 80%. But on a Windows system, do not go higher than 90%, and remember that this percentage does not take into account the percentage used by the operating system. In either case, you have to quit and relaunch Photoshop for these changes to take effect. See the sidebar: 'How much RAM does Photoshop need?' for more information about configuring the memory preferences.

The free hard disk space must be at least equivalent to the amount of RAM allocated for Photoshop. To use an extreme example, if you have 1200 MB of free RAM allocated to Photoshop but only 600 MB of free disk space on the drive allocated as the primary scratch disk, Photoshop will use only 600 MB of the real RAM. For optimal image editing, at least 2 GB of free hard disk space is recommended and ideally you want a scratch disk with 20-40 GB of free space. Under these conditions, Photoshop will use all the available free RAM for realtime calculations (mirroring the actual RAM on the scratch disk) and when Photoshop runs out of real memory, it uses the extra space on the scratch disk as a source of virtual memory. Photoshop is designed always to make the most efficient use of real RAM memory and essentially the program tries to keep as much RAM as possible free for memory intensive calculations. Low level data like the 'last saved' version of the image is stored in the scratch disk memory giving priority to the current version and last undo versions being held in RAM. Photoshop continually looks for ways to economize the use of RAM memory, writing to the hard disk in the background, whenever there are periods of inactivity. Scratch disk data is also compressed when it is not in use (unless the optional plug-in extension that prevents this has been loaded at start-up).

With all this scratch disk activity going on, the hard disk performance of your scratch disk plays an important role in enhancing Photoshop speed. Most modern Macs and PCs have IDE, ATA or SATA drives as standard. A fast internal hard disk is adequate for getting started. But for better performance results, you should really install a second hard drive, and have this dedicated as the primary scratch disk (assign it as the primary scratch disk in the Photoshop preferences). Most likely your computer will have the choice of a USB or FireWire connector for linking external devices. USB is about as fast as an old SCSI 1 connection. USB 2 is faster, although at the time of writing I will have to wait to see how much faster it runs on a Macintosh computer running OS X 10.3 or later.

FireWire (IEEE 1394) has many advantages over the older SCSI interface. First of all FireWire is a lot faster and secondly, it will often allow you to hot swap a drive between one computer and another. This is particularly useful when you wish to shuttle very large files around quickly. With the advent of FireWire 800 we are now seeing an appreciable improvement in data transfer speeds.

Configuring the RAM memory settings

If you want to run other programs simultaneously with Photoshop, then you should lower the percentage of RAM that is allocated to Photoshop. Although the memory assigned to Photoshop is freed up whenever Photoshop is not running, if the memory is set too high, Photoshop may end up competing with the operating system for memory and this will slow performance. Try allocating the maximum suggested amount of memory first. Relaunch Photoshop and closely observe the Efficiency readout in the Status bar or Info palette. If the Efficiency soon drops below 100%, then try allocating a lower percentage of RAM, relaunch and compare the Efficiency performance once more. Repeat this process until you feel you have worked out the optimum amount of memory to assign.

Info	· /				
*	R : G : B :	255 255 255	*	С: М: Ү: К:	0% 0% 0%
+.	X : Y :	34.22 17.64	t t	₩ : Η :	
		W/O bytes)		
sele	ction	angular se outline. U	se Shift	t, Opt, a	

Figure 3.15 You can monitor the Efficiency of Photoshop by adjusting the Info palette options to have the Efficiency readout displayed as shown here.

RAID array hard drives

A wide array RAID disk can be connected via a FireWire 400/800 connection or via an internal SCSI connection. Speed specifications vary according to the drives but whichever type of drive you allocate as a scratch disk, you should ensure that it is a separate, discrete hard drive and is not shared with the disk which is running either Photoshop or the operating system. There is provision in Photoshop for as many as four scratch disks. Each individual scratch file created by Photoshop can be a maximum of 2 GB and Photoshop can keep writing scratch files to a scratch disk volume until it becomes full. When the primary scratch disk runs out of room to accommodate all the scratch files during a Photoshop session, it will then start writing scratch files to the secondary scratch disk and so on. This makes for more efficient and faster disk usage.

FireWire drives are still IDE drives with a bridge to the FireWire standard, and since the Oxford Chipset came out, they have been able to enhance the throughput closer to the theoretical limit. Internal SCSI connections are often using SCSI 2, which provides a quicker data transfer standard. Note that it is the data transfer and not data access time that is the measure of disk speed to look out for.

Clearing the Photoshop memory

Photoshop wants all the memory it can get, so allocate most of the RAM available to Photoshop and ideally run the application on its own. Whenever you perform a Photoshop task that uses up a lot of program memory, you can check the system performance in the document status box scr: 109M/204.1M in the lower left window display or in the Status bar of a PC. The right-hand figure shows the amount of memory available and the left, the amount used so far. Photoshop stores data such as recent history states and clipboard data in its memory on the scratch disk. Copying a large selection to the clipboard also occupies a lot of memory. Should you experience a temporary slowdown in performance you might want to purge Photoshop of any excess temporarily held data in the memory. To do this, choose Edit \Rightarrow Purge \Rightarrow Undo, Clipboard, Histories or All.

Figure 3.16 A RAID system drive setup contains two or more drives linked together that can provide either faster disk access or more secure data backup.

Memory & Image Cache

The image cache settings affect the speed of screen redraws. Whenever you are working with a large image, Photoshop uses a pyramid type structure of lower resolution, cached versions of the full resolution picture. Each cached image is a quarter scale version of the previous cache level and is temporarily stored in memory to provide speedier screen previews. Basically, if you are viewing a large image on screen in 'fit to screen' display mode, Photoshop will use a cache level that is closest to the fit to screen resolution to provide a screen refresh view of any edit changes you make at this viewing scale. The cached screen previews can provide you with faster screen redraws and larger images will therefore benefit from using a higher cache level. A higher setting will provide a faster screen redraw, but at the expense of sacrificing the quality of the preview. This is because a lower resolution cache preview is not as accurate as viewing the image at Actual Pixels.

The cache pyramid structure

You may sometimes notice how the layered Photoshop image on screen is not completely accurate at anything other than the 100% magnification – this is the image cache at work, it is speeding up the display preview at the expense of accuracy. If you have to work on an image at a less than 100% magnification, then do make sure the magnification is a wholly divisible number of 100%. In other words, it is better to work at 50%, 25% or 12.5% magnification, rather than at 66% or 33%. Note also that the number of cache levels chosen here will affect the structure of a 'Save Image Pyramid' TIFF file.

Preferences	
Memory & Image Cache	ОК
Cache Settings Cache Levels: 6	Cancel
Memory Usage Available RAM: 3930MB Maximum Used by Photoshop: 80 💌 % = 3144MB	Prev Next
Changes will take effect the next time you start Photoshop.	

Figure 3.17 The Memory & Image Cache Preferences. If you are editing large images, increase the image cache setting to 5 or more. This will speed up the screen redraws.

Tr Fut	ura	Sample
Tr Gad	lget	Sample
O Add	be Garamond Pro	Sample
T Gee	za Pro	
T Ger	ieva	Sample
T Geo	orgia	Sample
O Gill	Sans (T1)	Sample
a Gill	Sans (TT)	Sample
T Gill	Sans	Sample
T Hel	vetica	Sample
T Hel	vetica Neue	Sample
Tr Her	culanum	SAMPLE
T Ho	efler Text	~ 2000s
T Hu	nana Serif ITC TT	Sample
T Hu	nana Serif Md ITC TT	Sample
Tr Imp	act	Sample
O Add	be Jenson Pro	Sample
T Jok	erman LET	Sample
Q Let	ter Gothic Std	Sample
O Lith	ios Pro	SAMPLE
The sure	ida Grande	Sample
ar Luc		

Figure 3.18 Photoshop CS2 now presents the font lists using a WYSIWYG menu listing.

Type preferences

We could all do with smart quotes I guess, but the smart quotes referred to here are a preference for whether the text tool uses vertical quotation marks or rounded ones that are inverted at the beginning and end of a sentence. The Show Asian Text Options is there for Asian users, to enable the Chinese, Japanese and Korean text options in the Character palette. The Show Font Names in English option is of more significance for non-English language users. If they are using a regionalized version of Photoshop they will see an option for displaying font names in their native language.

The Photoshop CS2 type tool Options bar now provides a WYSIWYG menu listing of all the available fonts when you mouse down on the Font Family menu (see Figure 3.18). The Font Preview Size that you select here will determine the font sizes used when displaying this list and should not be confused with the UI Font Size Preference in the General Preferences section.

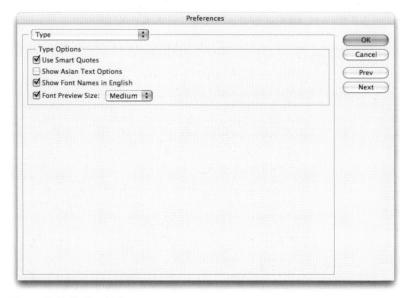

Figure 3.19 The Type Preferences.

Bridge preferences

The Photoshop File Browser has been replaced by the standalone Bridge application which because it is a separate application, has its own set of preferences. The Bridge preferences are located in the Edit menu in Windows and the Bridge menu in Mac OS X.

The first section contains the General controls where you can select the shade color for the gray Thumbnail background. The Show Tooltips option is like the one in Photoshop preferences. It is useful if you want to learn what each section in Bridge does. And it does also allow you to read long file names in the Bridge content area more easily. But overall, it tends to become rather irritating after a while. You can choose to have additional lines of metadata appear next to the thumbnails in Bridge (see Figure 3.21). The Favorites Items contains checkbox items for selecting the items you want to appear in the Favorites palette. The Reveal Scripts in Finder... button will open the Startup Scripts folder from which you can open one of these scripts inside the ExtendScript Toolkit program. Lastly, Reset All Warning Dialogs will reset all alert dialogs.

Figure 3.21 Up to three additional lines of metadata can be selected in the Bridge General preferences to appear beneath the thumbnails in Bridge.

	Prefer	ences	
Ceneral Metadata Labels File Type Associations Advanced	Ceneral Thumbnails Background: Black Show Tooltips Additional Lines of Thum Show: Date Created Show: Exposure Show: Document Kin		✓ Date Created Date Modified File Size Dimensions Label Author Keywords Copyright Color Profile Color Mode Bit Depth
	,	Computer Collections Desktop Pictures cripts in Finder Warning Dialogs Cancel	Document Kind Document Creator Opening Applicatio Exposure

Figure 3.20 The General Bridge preferences. You can select up to three additional lines of metadata from the submenu shown here.

All digital cameras, regardless of whether you shoot using raw or JPEG mode, will generate and embed metadata information in your image capture files at the time of shooting. Some cameras are designed so that they generate what are known as 'sidecar' files alongside the raw files. These sidecar files will contain all the metadata information. The metadata preferences in Bridge let you decide which metadata items will be displayed in the Bridge Metadata palette. You can uncheck individual items so as to reduce the amount of information displayed in the Metadata palette. If you keep the Hide Empty Fields box checked, then a metadata item will only appear listed if it contains actual data.

It can take a long time for Bridge to generate preview images from large image files. If you have the Maximize PSD Backwards Compatibility preference turned on (see page 118) the layered PSD files will generate a composite image layer when saved. This will certainly reduce the time it takes to build each preview in Bridge. If you limit the file size for rendering previews using 'Do not process

General	Metadata
Metadata Labels File Type Associations Advanced	▼ File Properties ♥ Filename ♥ Preserved Filename ♥ Document Kind ♥ Document Kind ♥ Date File Created ♥ Date File Created ♥ Date File Created ♥ Date File Created ♥ Date File Size ♥ Dimensions ♥ Resolution ♥ Bit Depth ♥ Color Mode ♥ Color Profile Label Rating ♥ Job Name ♥ Notes Supports XMP Has XMP ♥ IPTC (IM, legacy) Document Title Headline Kewords
Powered By	✓ Hide Empty Fields

Figure 3.22 The Bridge Metadata preferences.

file larger than: x MB' this will also help speed up the time it takes to build a cache of previews from very large files.

The Bridge program maintains a list of most recently visited folders to enable fast and easy access. The default number is 10, but you can make this any number you want. The Double-click edits Camera Raw settings in Bridge option allows you to override the default behavior and forces Bridge to be the program that always hosts the Camera Raw plug-in.

The Cache referred to here in the preferences is used to store all the thumbnail information, the previews and all the additional metadata information such as the thumbnail rotations and image rating. The cache can be stored centrally in a single folder location. But this will mean that the cache information is only stored in a single location on your computer. If you move the folder to another location, burn it to a DVD, or rename it even, the cache information will no longer be accessible. The Use Distributed Cache Files When Possible option will automatically place a cache file in the image folder itself.

Cache updates

The image cache produced in Bridge is an important and useful source of information. If you point Bridge at a folder of images and there is no cache available for Bridge to access, then Bridge will have to generate an entirely new set of thumbnails and previews. All your previously created thumbnail rotations and Camera Raw settings will be lost.

The cache will also become lost if you relocate an image folder to another computer, or burn a CD or DVD and send it to someone else. If the Use Distributed Cache Files When Possible option is selected, Bridge will always try to place an exported cache in the image folder. This is a precautionary preference to help guard against the user forgetting to create a folder cache themselves.

Metadata	
Labels File Type Associations Advanced	Miscellaneous Do not process files larger than: 200 MB Number of Recently Visited Folders to Display in the Look In Popup: 10 Double-click edits Camera Raw settings in Bridge Language: English Changes to the language settings will take effect the next time the application is launched. Cache When Saving the Cache: Use a Centralized Cache File Use Distributed Cache File Centralized Cache Location: /Users/martinevening/Library/App/Adobe/Bridge/Cache/Thumbnails/ Choose

Figure 3.23 The Advanced Bridge preferences.

SCSI compatibility in Mac OS X

Many professional Photoshop users like myself still rely on certain digital devices like drum scanners or high-end printers that are SCSI based. If you are using a PC, then there should be no problem to connect with a SCSI device using any of the compatible OS systems with Photoshop CS. On a Mac you have to be more crafty to keep these devices compatible with OS X. For example, I use a Pictrograph printer that only has a SCSI connection. I can get this printer to be recognized in Photoshop by downloading the latest Pictrography driver for OS X 10.3 from the www.fujifilm.com website. But I also had to make sure that the device was connected to the computer by an Adaptec 2930 SCSI adapter PCI card.

Photoshop and Mac OS X

Photoshop CS2 will only run on a Macintosh computer using the Mac OS X 10.2.8 operating system or later. The Macintosh OS 9 system is not supported. Because OS X is based on the UNIX operating system, the Adobe engineers had to rewrite a lot of the existing program code. The OS X system loads much faster than before and is very stable. Mac OS X features memory protection, which will prevent any application-level memory leaks from affecting another open application, resulting in fewer system-level crashes. While OS X may be a more stable operating system, Photoshop's speed performance is compromised somewhat by the demands made by the OS X system itself which will at times devour a sizeable chunk of the processor's resources. For example, the anti-aliasing engine that produces the rounded corners on the windows and the transparency support will place extra demands on the processor chip. The OS X throbbing buttons alone can consume up to 10% of the processor's resources. But if you are running the more recent twin processor G5, these high overhead demands on the processor are much less noticeable. Remember also that OS X will require at least 128 MB of RAM memory to run the operating system. And the symmetric multiprocessing under OS X means that Photoshop will receive less of a speed boost on the new multiprocessor Macintoshes than might be expected. In my opinion OS X is a very smart looking operating system that in some ways is ahead of its time. Although OS X is maturing nicely, there are a number of old OS 9 features which could have been added in Mac OS X, but are sadly missing.

The standard Aqua blue interface is rather too colorful for my taste, but you can easily switch to using the Graphite look instead via the system preferences. Photoshop users typically rely on the use of third-party plug-ins such as filters and import/export plug-ins to add functionality to the program. If any of your plug-ins are not OS X compliant, they will not function within OS X and you will have to check the availability of any OS X updates.

Photoshop and Windows XP

While Apple were bringing out OS X, Microsoft were busy developing the Windows XP operating system. Like OS X, Windows XP radically abandoned the previous Windows interface design. The standard Windows XP interface design is known as Luna. The dark blue color featured in Luna is rather distracting for Photoshop work and so I would advise you to choose the 'Silver' theme instead. Both OS X and XP feature advanced operating systems, and are more reliable and not prone to regular crashing like their predecessors. Or if a program does crash, at least it does not disrupt the system and freeze the whole computer. The Windows XP does have a neat way of displaying image folder information, which in a way complements the Photoshop CS2 Bridge program. The XP file navigation system can enable you to browse the images contained in a folder as a slideshow, which is very cool.

Operating System maintenance

A computer that is in daily use will require some general housekeeping. Mac OS X and Windows XP are both UNIX-based programs and as such they are both somewhat easier to maintain than their previous operating systems. For example, the Mac OS X system is designed to be left switched on 24 hours a day and put to sleep mode when not in use. The operating system will automatically schedule routine maintenance work to take place in the early hours of the morning when you are (or should be) asleep. This automatic background housekeeping should keep everything running smoothly. But if you are not in the habit of leaving your computer switched on all the time, then consider using a Mac utility like MacJanitor which can perform the same type of cleaning-up job of clearing system logs etc.

A UNIX based system is also less prone to disk fragmentation problems. Providing that is you don't overload the hard drives by using up all the available disk space. It is recommended that you never use more than 90% of your storage disk capacity. Once you exceed this

Windows XP system reverts

Adapting to a new system can be a slow learning process. Fortunately, Windows XP features the ability to revert to a previous system configuration. This is particularly useful if you were to install a driver that proved troublesome. You simply revert to earlier system setup. Windows XP is a much refined version of the Windows NT operating system, so it has a good solid legacy.

Mac maintenance programs

There are three programs that have similar functionality and subtly different contents: MacJanitor, Onyx and Macaroni. Onyx is very slick and all seem fairly straightforward. Macaroni is shareware, the other two are freeware, but with requests for donations to ensure the programs are updated. MacJanitor is a very useful Mac OS X maintenance utility that was developed by Brian Hill. You can download a copy from his website at: http://personalpages.tds.net/~brian_hill/ macjanitor.html. Or alternatively, try making a Google search.

Disk maintenance

Norton Utilities is a suite of programs that adds functionality. Image files continually read and write data to the hard disk, which can lead to disk fragmentation. Norton's Speed disk (which has to be run from a separate start-up disk) will defragment files on the main hard disk or any other drive. Windows users should also look out for a program like Windows Disk Defragmenter. This is essential on the drives you allocate as the scratch disks in Photoshop. If you're experiencing bugs or operating glitches and want to diagnose the problem, run Norton's Disk Doctor. This will hunt out disk problems and fix them on the spot. Norton have begun to lose their way with support for the Mac OS X system, but they are still going strong with support for PC computers. For your Mac disk housekeeping and disk insurance, TechTool Pro, Disk Warrior and Data Rescue are programs that are worthwhile keeping handy for those times when disasters occur. When for one reason or another, a disk's catalog does a disappearing act, Disk Warrior is one program that rarely fails to restore it, along with your piece of mind!

percentage, the operating system will have a harder time preventing disk fragmentation from occurring. If you exceed this amount of disk usage, you may then suffer file fragmentation problems. Housekeeping on Mac OS X can also be effected by opening the computer in Single User Mode – holding **H S** at start-up – the computer starts in verbose mode filling the screen with white text information against a black background. When this is complete you type in '/sbin/fsck -f' and hit R. Do this until the message 'This volume seems OK' appears, then type in 'reboot'. Another measure is to always Repair Disk Permissions immediately prior to any system or application updates and immediately after. Especially if you see signs of any untoward system behavior.

Figure 3.24 If you go to the Help menu in Photoshop CS2 and choose System Info, you will see the dialog shown Here. This dialog will contain a report of all the system information, which can be relevant when tracing the cause of a problem to do with Photoshop's behavior or performance. In these instances, you may be asked to copy the report information and send it to a technical support expert.

Chapter 4

Basic Image Adjustments

t is reasonable to assume that a great many Photoshop users mostly want to learn how to open an image and improve its appearance without too much artifice and make a print that matches what they saw on the display. It is therefore important that you follow the instructions laid out in the last chapter on how to calibrate the display and configure the color settings. Do this and you will now be ready to start editing your photographs with confidence. The aim of this chapter though is to introduce you to Photoshop's image correction tools and all you need to know about making basic image corrections. And since this is what you are going to be doing to every picture you edit in Photoshop, it is worth spending some time understanding the underlying principles of what the image correction tools do and how they should be used.

Interpreting an image

A digital image is nothing more than a lot of numbers and it is how those numbers are interpreted in Photoshop that creates the image you see on the display. We can use our eyes to make subjective judgements about how the picture looks, but we can also use the number information to provide useful and usable feedback. The Info palette is your friend. If you understand the numbers, it can help you see the fine detail that your eyes are not sharp enough to discern. And we now have the Histogram palette, which is a godsend to geeks who just love all that statistical analysis stuff, but it is also an excellent teaching tool. The Histogram palette will make everything that follows much easier to understand.

Digital camera histograms

Some digital cameras provide a histogram display that enables you to check the quality of what you have just shot. This too can be used as an indication of the levels captured in a scene. However, the histogram you see displayed is often based on a JPEG capture only. If you are shooting in JPEG mode, that's what you are going to get. But if you prefer to shoot using raw mode, the histogram will not provide an accurate guide to the true potential of the image you have captured. See Chapter 11 for more about digital capture and shooting in raw mode.

The histogram

The histogram is a bar chart that graphically represents the shades of tone (described as Levels) that make up a digital photograph. A basic 8-bit per channel grayscale image has a single channel and uses 256 shades of gray to describe all the shades of tone from black to white. Black has a levels value of 0 (zero) and white has a levels value of 255. And all the numbers in between represent the shades of gray going from black to white. The histogram is like a graph with 256 increments, each representing how often a particular levels number (a specific gray color) occurs in the image. If a picture contains mostly a lot of grays with number values of between 30 and 130 levels, you will expect to see a peak around the 30–130 levels point of the histogram graph. Figure 4.1 shows a typical histogram and how the appearance of the graph relates to the tonal structure of a photographic image.

Now let's look at what that information can tell us about a digital image. The histogram show us the distribution of tones in an image. A high-key photograph will have lots of peaks towards the right of the graph and a low-key photograph will have lots of peaks to the left. And most importantly, it shows the positioning of the shadow and highlight points. When you apply a tonal correction using Levels or Curves, the histogram provides a visual clue that helps you judge where the highlights and shadows should be. And the histogram also tells you something about the condition of the image you are editing. If the bars are bunched up at either end of the histogram, this suggests that the highlights or shadows are most likely clipped and that when the original photograph was scanned or captured it was effectively under - or overexposed. Unfortunately, if the levels are clipped at either end of the scale you can't restore the detail that has been lost. And if there are gaps in the histogram, this will most likely indicate a poor quality scan or that the image had previously been heavily manipulated.

The histogram can therefore be used to check the quality of an image at the beginning of an edit session. If it looks particularly dreadful then maybe you should try

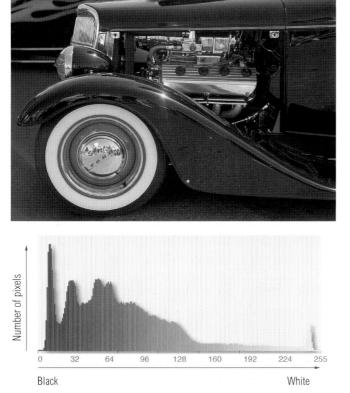

rescanning the picture. But must one be so absolutely pixelcorrect about always obtaining a smooth histogram? Any image editing you do will inevitably degrade the image. Because after a picture has been manipulated the histogram will always look less smooth than it was at the beginning. If you are preparing a photograph to go to a print press, you would be lucky to detect more than 50 levels of tonal separation from any single ink plate. So the loss of a few levels at the completed edit stage does not necessarily imply that you have too little digital tonal information from which to reproduce a full-tonal range image in print. But appreciate that if you begin with a bad-looking histogram, the image is only going to be in a worse state after it has been retouched, so start with the best image scan or capture. And in particular watch out for any signs of clipping. Figure 4.1 Here is an image histogram that represents the distribution of tones from the shadows to the highlights. Because this photograph mostly contains dark shades of gray you will notice that the levels are predominantly located to the left end of the histogram. The height of each bar in the histogram indicates the frequency of pixels occurring at each level point.

The Histogram palette

There has always been a histogram in the Levels dialog and there is now also a Histogram palette, which gives you even more feedback when working in Photoshop. With the Histogram palette, you can continuously observe the impact your image editing has on the image levels. You can also check the histogram while making curves or any other type of image adjustment. The Histogram palette only provides an approximate representation of the image levels. To ensure that the Histogram palette is giving an accurate representation of the image levels, it is advisable to force Photoshop to update the histogram view, by clicking on the Refresh button at the top of the palette.

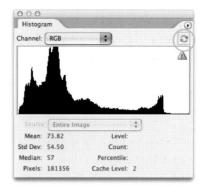

Adobe Photoshop CS2 for Photographers

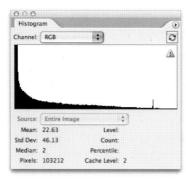

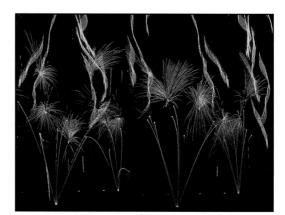

Figure 4.3 If the levels are bunched up towards the left, this is a sign of shadow clipping. But in this example we probably want the shadows to be clipped in order to produce a rich black sky.

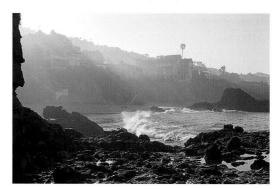

Figure 4.4 If the levels are bunched up towards the right, the highlights may be clipped. But in this image I wanted the brightest areas of the sky to burn out to white.

Figure 4.5 A histogram with a comblike appearance indicates that either the image has already been heavily manipulated or an insufficient number of levels were captured in the original scan.

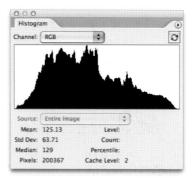

Figure 4.6 This histogram shows that the image contains a full range of tones, without any shadow or highlight clipping and no gaps between the levels.

Levels adjustments

When you open an image in Photoshop your main objective will probably be to make an inkjet print, convert the image to CMYK or add it to a website. And the first thing you will want to do is adjust the tonal range so that the photograph has a nice, full range. If it is destined for the web, your only concern will be how light or dark you want to make it, so that it appears OK on a typical PC display. If it is going to print then you may be aware of the fact that the shadow point should be adjusted to compensate for the printing process. But you shouldn't let any of this concern you too much, because the shadow point is always adjusted automatically in Photoshop when you choose a print profile in the print driver (as described in Chapter 14) or when you convert the image from RGB to CMYK. If you are optimizing an RGB image for output, all you need to worry about is making sure that the blacks go to black and the whites go to white. We are now going to look at a few different ways to make a tonal correction in Photoshop. We will begin with some black and white images. I deliberately chose to start with some monochrome photographs, because it makes the interpretation of the histogram simpler.

Gamma slider

Output highlights slider

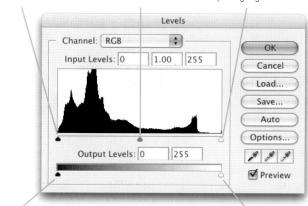

Output shadows slider

Output highlights slider

When Levels have to be set manually

You should be aware that some repro companies operate what is known as a closed-loop system where they edit files in CMYK and do not use a profiled workflow. This is something that will affect highend repro users of Photoshop and if this is the case, then you will need to target the shadows manually according to the conditions of the printing press. The same is also true if you are editing a grayscale file in Photoshop that is going to press. These prepress examples are covered later on in the chapter.

Exposure Image adjustment

The Exposure adjustment is new in Photoshop CS2. It is mainly included as an image adjustment for specialist users only, who are doing compositing work with HDR images (see page 166). You can use it to adjust normal images, but that is not its real purpose.

Figure 4.7 The Photoshop Levels dialog. The Input sliders are just below the histogram display and you use these to adjust the input shadows, highlights and gamma (the relative image brightness between the shadows and highlights). Below these are the Output sliders and you can use these to set the output shadows and highlights. It is best not to touch these unless you are retouching a prepress file in grayscale or CMYK, or you deliberately wish to reduce the output contrast for some reason.

Martin Evening Adobe Photoshop CS2 for Photographers

1 The monochromatic photograph shown here was in fact in RGB mode (because this allowed me to demonstrate the full range of Levels adjustment options). And the Histogram palette displays a histogram of the composite RGB channel. The contrast could be improved by expanding the levels so that the histogram displays a fuller range of tones going from black to white. To improve the tonal range, I chose Image ⇒ Adjustments ⇒ Levels.

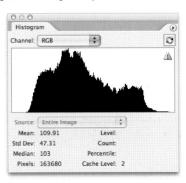

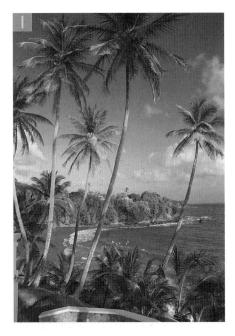

2 As I dragged the highlight and shadow Input sliders in the Levels dialog, I could decide where the new shadow and highlight endpoints should be. One way of doing this is to simply look at the histogram in the Levels dialog and drag the Input sliders inwards until they meet either end of the histogram. But you can get a better idea of where to set the endpoints by switching to threshold display mode. I held down the a dw will key as I dragged the shadow slider inwards and the image in the document window then appeared posterized. This threshold view enables you to discern more easily where the darkest shadows are in the picture. Drag in too much and you will clip all the shadow detail. The view shown opposite is too extreme, so I would want to back off from here, otherwise the shadows would become too clipped.

3 I now wanted to adjust the highlights. The same technique can be applied here as well. I held down the same technique display started off completely black and the lightest highlights appeared first as I dragged inwards. As before, the view shown here was too extreme so I would want to back off a bit and search for the lightest highlight point without the risk of clipping too much of the highlight detail.

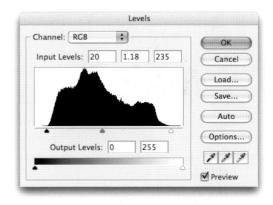

4 All that remained now was to compensate the lightness of the picture, which was achieved by dragging the gamma slider (which is the middle Input slider). Dragging to the right made the image relatively darker, and dragging to the left made it relatively lighter. The final image shown here has a full contrast range and the correct brightness.

Automatic Levels compensation

Figure 4.8 provides an example of what an image histogram looks like after it has been optimized in Photoshop. This is accompanied by two more histogram views that show how the histogram would look after the image has been converted to make an inkjet print or converted to CMYK color. Notice how the histogram shape changes and in particular how the shadow point is adjusted inwards after the image has been converted. This is because Photoshop will automatically calculate the shadow point compensation for you (advanced users who use the Convert to Profile command in the Image \Rightarrow Mode menu should remember to always check the Black Point Compensation checkbox).

Levels after a conversion

So far you have seen how the Levels histogram can be used to help you visualize the tonal range of an image from the shadows to the highlights. By using the Levels dialog in conjunction with the histogram you can optimize the contrast precisely so that the darkest pixel in the image goes to black and the lightest pixel goes to white. And in the majority of instances it really should be as simple as that. But there are instances when you will want to hold back on the highlights slightly and these are discussed over the following few pages. The only other times when you need to give special consideration to setting the shadows to anything other than level 0, and the highlights to level 255, are when you are required to edit a CMYK or grayscale file which is destined to go to a printing press.

Sometimes you come across advice that the shadows in an RGB image should be set to something like 20, 20, 20 (the Red, Green, Blue RGB values) and the highlights should be set to 245, 245, 245. And the reason given for this is because anything darker than a 20, 20, 20 shadow value will reproduce in print as a solid black. Well, if you follow these instructions you will certainly get to see the shadow detail, but your prints may have much lighter shadows than is really necessary. In the early days of Photoshop it was necessary to make this kind of compensation when you were setting the levels. But for some time now, Photoshop has had a built-in mechanism which automatically compensates the shadow point for you whenever you convert an RGB image to CMYK or produce a desktop print output (see Chapter 14: Output for Print). Not only that, but Photoshop is able to compensate the shadow point by the exact amount for each different type of output. So when you are setting the shadows, just keep it simple: use 0, 0, 0 and let Photoshop automatically calculate the best optimized shadow point for you during the conversion to the output color space.

And what about the highlight points? Will Photoshop automatically convert these for you as well? The answer here is no, the highlights have to be set manually and it

0

F

0

0

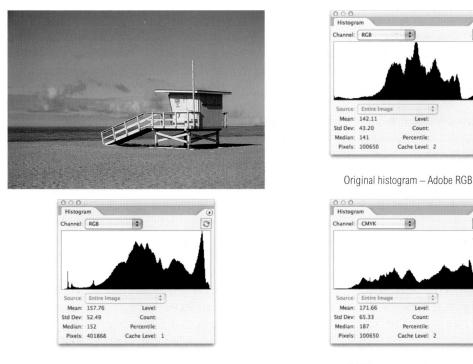

Figure 4.8 The histogram appearance usually changes after a mode or profile conversion. For example, when you use the Print with Preview dialog to convert an RGB file to a print output space the shadow tones are automatically made a little lighter so as to render the best shadow detail on the paper. The same thing happens when you make a CMYK conversion, but the black point will probably shift in even more. If you see a box called Black Point Compensation, leave it checked. Photoshop automatically compensates the black point to suit your CMYK conversion. Do not attempt to deliberately make the shadows lighter beforehand when you are editing an image in RGB.

really is dependent on the image as to what is the best highlight point setting to use. The problem here is that if you make the highlights go all the way to 255, 255, 255, the levels may be so high that the image highlight tones within the 240–255 range will all print as pure white. With certain types of image this will cause problems and you will want to make sure your brightest tones are no lighter than, say, 245. And other times you will have photographs where you don't need to preserve all the highlight detail. We will be looking at two examples of setting the highlights shortly, but first, let's look at one of the exceptional cases where you may be required to fine-tune the endpoints manually.

Resetting the image adjustments

If you want to reset the settings in any of the Image Adjustment dialog boxes, hold down the all all key – the Cancel button changes to Reset. The Auto button will set the clipping points automatically (the Auto settings are covered in Chapter 5).

Fine-tuning the endpoints

You can also use the black point and white point tools in the Levels or Curves adjustment dialogs to assign specific pixel values independently to the shadows and the highlights. Normally you can rely on the image mode conversion to adjust the shadow points. But there are certain situations where it is desirable to fine-tune the endpoints manually yourself. Targeting and assigning the endpoints in this way is important if you are working on grayscale images that are destined for print in a book, magazine or a newspaper. And it may also be necessary if the image is already in CMYK mode but without an embedded profile, where you know what the press output should be. Instead of relying on profiles to do the conversion, you can assign a shadow point that is higher than 0% and assign a highlight point that is slightly darker than 100%. You usually do this when you wish to ensure that the highlight detail will be adequately preserved. It can also be useful as a means of color correcting an image and removing a color cast from the shadows or highlights in an image. In between the black point and white point tools is the gray point tool which can be used to assign a target gray color to the midtones (this and other methods of color correction will be dealt with more thoroughly in the next chapter).

Let's now run through the basic steps for assigning a highlight and shadow point via the black point and white point tools. But before you do anything else, select the eyedropper tool in the Tools palette and go to the eyedropper Options bar and set the Sample Size to 3×3 Average. You can use the black point and white point tools with their default settings to simply assign a highlight point of 100% and a shadow point of 0%, but in the example shown on the page opposite I demonstrate how to assign specific target values to the black point and white point tools, so that you can map specific parts of the image to new pixel values. This method allows you to decide exactly where the highlight and shadow points should be.

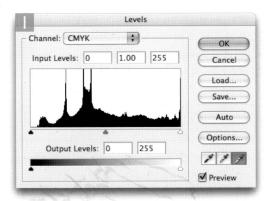

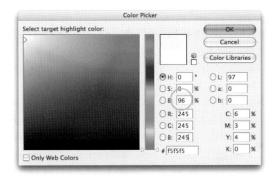

1 I double-clicked the highlight eyedropper icon in the Levels dialog box and set the highlight target value to match that of the press. A brightness setting of 96% as shown here is OK for most printing situations.

2 I studied the image and looked for the shadow and highlight points. The previously described Threshold mode technique is a good way of finding out where these are. I zoomed in on the image and clicked on the area I wanted to assign as the highlight target point. This should be a subject highlight, not a specular highlight such as a reflection or glare.

3 Next I set the shadow point. I double-clicked the shadow eyedropper icon and set a brightness setting of 4% (or higher, depending on the press) in the text box as the target brightness. After that, with the shadow eyedropper still selected, I zoomed in on the image to identify and clicked on the darkest shadow point. The gamma slider could be adjusted the same way as in the last example to adjust the relative image brightness.

Setting the highlights

As you aim to expand the tonal range, you want to make the lightest point go to white so the whites do not look too dull. But at the same time you don't want the highlights to look burnt out either. Setting the highlight point is very often a subjective decision and where you set the white point is really dependent on the nature of the image. In most cases you can use the basic Levels adjustment threshold mode technique to locate the highlight point and set the endpoint accordingly and not worry about losing any highlight detail. But if the picture you are editing contains a lot of delicate highlight information then you will want to be careful to set the highlight point to somewhere slightly less than pure white on the levels scale. This is because a pixel value that is close to maximum white, when converted to a printing process, may blow out to white as well. But what if the image contains bright specular highlights, such as highlight reflections off metal? Specular highlights do not contain any detail, so you therefore want these to print to paper white. If you don't, then the image will print a lot duller than is necessary.

Figure 4.9 The highlights in this image contain no detail. There is no point in limiting the image contrast by setting the highlight to anything less than the maximum white possible. One can safely afford to clip the highlights in this image without losing important image detail.

Specular Highlights

When you are using a Levels adjustment to set the highlights you have to examine the image and ask yourself if the highlight detail matters or not. Some pictures will contain subtle highlight detail while others may look like the photograph below in Figure 4.9, where the highlights consist of what is referred to as 'specular' light reflecting off a shiny metal surface. In a case like this the last thing you need to concern yourself with is preserving the detail. You can safely drag the Input highlight slider inwards to clip the highlights and thereby force these specular highlights to print as pure white. Because there is no actual detail in these highlights, there is nothing worth preserving anyway. By forcing the specular highlights to the maximum white you are safely enhancing the image contrast.

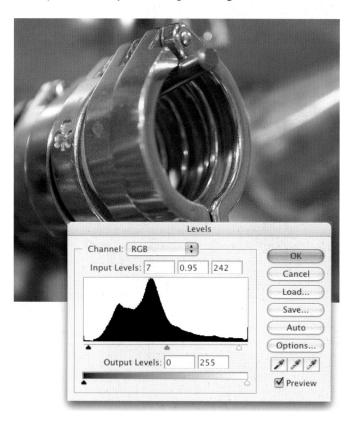

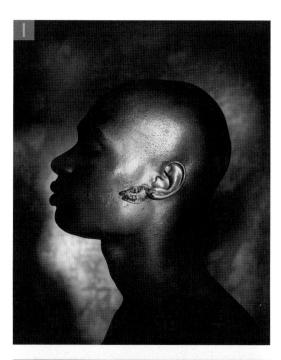

1 If you are too cautious about setting the endpoints for the shadows and highlights and do not make full use of the tonal range, this can lead to a dull print output. There are times when you will want to make use of rich blacks and bright paper whites to reproduce a full contrast image. The subject shown here contains specular highlights. In other words, it contains highlights that have no detail. If I were to assign these 'specular' highlights a white point of 243, and the shadow point 12, the printed result will look needlessly dull and flat.

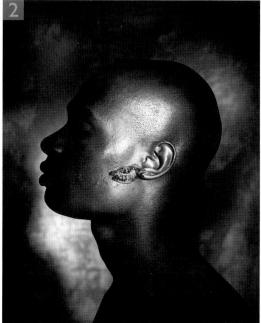

2 The brightest portions of the image are the shiny skin reflections and I can safely let these areas burn out to white, because they do not contain any significant image detail. I assigned the brightest area in the highlights (where there is detail) as the white point and let the specular highlights print to paper white. The adjusted version shown here benefits from a wider tonal scale making full use of the press and at the same time retains important highlight detail where it matters.

Levels	
Channel: RGB	ОК
Input Levels: 12 1.00 225	Cancel
	Load
	Save
	Auto
Output Levels: 0 255	Options
	1 1 1
•	Preview

Adobe Photoshop CS2 for Photographers

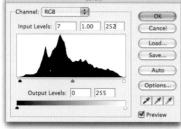

Figure 4.10 The highlights in this picture contain a lot of important detail. So you really want avoid clipping the highlights too much. It is important to ease off slightly more than usual when setting the highlights. This will avoid you running the risk of losing important highlight information in the final print.

Preserving the highlight detail

So the lesson we have learnt so far is that one has to be very careful when judging where to set the highlight point. If you don't drag the Levels highlight slider in far enough, you will get dull highlights. But if you drag the highlight slider in too far then you risk losing important highlight detail. The photograph in Figure 4.10 is a good example of an image requiring careful attention to preserve all the highlight detail. In most cases you will want to use the threshold analysis method described on pages 108–109 to detect the highlight point and use your informed judgement to decide whether to drag the Input highlight slider in further, leave it where it is (where the highlights just start to clip) or drag it out ever so slightly.

Cutouts against a white background

Subjects photographed or cut out against a white background are another special case deserving careful treatment. Ideally you want the white background to print as pure white on the paper, but not at the expense of losing image detail in important highlight areas elsewhere in the photograph. When preparing such a cutout, the levels should first be adjusted with consideration for the subject only. The background should be adjusted separately without compromising the tonal range of the subject. The accompanying example suggests one strategy to achieve this. I made a feathered selection of the background, filled with white and then used the history brush to paint the edge detail back in. Graphic designers may sometimes use a clipping path to create the cutout. A clipping path is a designated pen path saved in an EPS or TIFF file format that is used to mask an image when placed in a page layout program. If I was preparing a clipping path of the model in the following step-by-step, I would do everything the same, but make the clipping path a few pixels beyond the model's outline, so that the tonal transition to pure white is preserved.

Basic image adjustments

1 The above image required special attention to ensure the background went to pure white. Yet I did not want to blow out the highlights on the white shirt or on the model's blonde hair.

3 There should be a gentle tonal transition between the white cutout and the edges of the subject. If not, the edge detail will become lost in print. I deselected the selection and set the history source against the original history state (see the circled history state icon in the History palette) and carefully painted around the subject edges, especially around the fine strands of hair, to restore detail.

2 A Levels adjustment was applied to make the highlights go as light as possible on the shirt, but without losing any detail. But the background still needed to go whiter. I made a 'contiguous' magic wand selection of the background area, feathered the selection by 2–4 pixels and filled this with white.

tory		۲	
A	jordan_burr01.tif		
	Open		
	Load Selection		
	Feather		
:==	Fill		
司	Deselect		

4 If we check the final histogram you can see a slight gap between where the highlight tones of the subject tail off and the white background cuts in.

Client: Jordan Burr. Model: Vivi @ M&P.

Move the Input sliders inwards to increase the contrast.

Move the Output sliders inwards to match the way Brightness/Contrast reduces image contrast.

Drag the Gamma slider left to lighten and drag it to the right to darken the image.

Figure 4.11 Anything that can be done using Brightness/Contrast can be done better using Levels. To increase contrast, drag the Input sliders inwards. To decrease the contrast using the 'Brightness/Contrast' method, drag the Output sliders inwards. To make the image brighter, drag the Gamma slider to the left. To make it darker, drag the Gamma slider to the right.

Brightness and contrast

So far we have discussed how to maximize the tonal range and lighten or darken an image. Since Photoshop has an image adjustment tool called Brightness/Contrast, you might assume this does the same thing as Levels. But I think it should more accurately be described as the 'how to ruin your brightness and contrast' image adjustment. And here is why: in Levels you set the shadow and highlight input points individually and the gamma slider is used to adjust the 'relative' brightness and make the image relatively lighter or darker. Brightness/Contrast is a very crude image adjustment tool. The Brightness slider simply shifts all the pixels either left or right to make everything lighter or darker. And the Contrast slider brings the Input sliders evenly inwards to increase contrast or the Output sliders evenly inwards to decrease the contrast.

My recommendation is that you avoid using Brightness/ Contrast completely and use the Levels adjustment method (described here and on the previous pages) to set the highlight and shadow points. Use Levels to maximize the contrast in the image. And if the image brightness needs to be adjusted use the gamma slider (see Figure 4.11) to make the relative brightness of the image brighter or darker. This is an essential first step image adjustment which can be followed by a Curves adjustment to make refined adjustments to the tonal contrast.

And if you are still not convinced check out the histograms in Figure 4.12 to see just how much important image detail you could be destroying when using Brightness/Contrast on a photographic image!

Mask adjustments with Brightness/Contrast

The one time when you may find it useful to use the Brightness/Contrast image adjustment is when you want to edit the contents of an image layer mask. The crudeness of the brightness and contrast adjustments can actually be beneficial when you want to force the mask highlight areas to go to white.

Figure 4.12 The Histogram palette makes it easy to demonstrate why the Brightness/Contrast image adjustment is such a poor tool to use for photographic tonal correction and why you should avoid using it and always work with Levels and Curves instead. Yet so many Photoshop users are drawn to using it because of its name and the simple interface. The histogram at the top shows the normal histogram for the image shown here. If you use the Brightness slider to increase the brightness, all you are doing is shifting all the tones lighter and the highlight detail will immediately become clipped. If you try to increase the contrast, then the tones are stretched in both directions so that both the shadows and highlights become clipped.

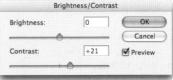

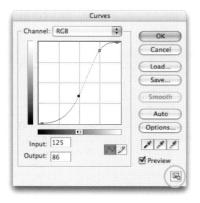

Figure 4.13 The Curves dialog is an alternative way of representing the input and output levels, in which the levels' relationship is plotted as a graph. In this example, the two ends of the curve have been dragged in as you would in Levels, in order to set the optimum shadow and highlight points. You can control both the lightness and the contrast of the image by adjusting the shape of the curve. To enlarge the curves dialog, click on the bottom right box.

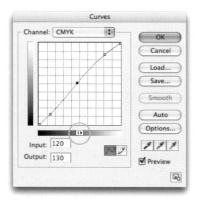

Figure 4.14 If you click on the horizontal output ramp (circled), the input/output ranges will become reversed with the shadow point in the top right corner and the highlight point in the bottom left, and the units will be displayed using percentage values. If you and click anywhere inside the grid area the grid units will switch from 25% to 10% increments.

Curves adjustments

Any image adjustment you do in Levels can also be done using Curves. At first, the Curves interface may appear less easy to use, but it is much more powerful than Levels because you can not only set the shadows and highlights, but control the overall contrast as well. You can accurately control the contrast of the master composite image as well as the individual color channels.

Figure 4.13 shows the basic Curves dialog. You can toggle enlarging the dialog view by clicking the zoom button in the bottom right corner. With Curves, you can target specific points on the tone curve and remap the pixel values to make them lighter and darker or increase the contrast in that tonal area only. In Figure 4.13 the highlight and shadow input points have both been moved inwards and extra points added to the curve to increase the steepness of the curve and thereby increase the contrast.

The default RGB units are measured in brightness levels from 0 to 255. The linear curve line represents the tonal range from 0 in the bottom left corner to 255 levels top right. The vertical axis represents the output values and the horizontal axis, the input values. So, if you move the shadow or highlight points only, this is equivalent to adjusting the input and output sliders in Levels. CMYK curves are by default displayed differently (click on the horizontal output ramp to toggle between displaying with levels or ink percentage readouts). This alternate mode (see Figure 4.14) is designed for repro users who primarily prefer to see the output values expressed as ink percentages. You can toggle the Curves dialog grid display mode by so attorned in the graph area; the finer grid allows for more accurate tweaking.

There are various examples showing how to use curves featured throughout this book. For example, in Chapter 8 we will be looking at how different coloring effects can be achieved through the use of individual channel curve adjustments.

Using Curves to improve contrast

In the previous section on using the Levels adjustment we looked at using Levels to optimize the image to set the shadows and highlights correctly. A Levels adjustment should maximize the tonal range from blacks to whites quite nicely. And a Levels adjustment such as this may be all that is required to achieve the perfect contrast in a picture. But there are times when you want to improve the contrast in an image further, and you can do this using Curves and without compromising the shadow and highlights you set previously.

When using the Curves adjustment as a contrast adjustment control all you have to understand is that a steep curve will produce increased contrast and a flatter curve will produce a softer contrast result. Turn to page 152 and take a look at the examples shown in Figures 4.18–4.20. These three examples demonstrate how you can use a Curves adjustment to increase the contrast in an image without clipping the shadows and highlights or decrease the contrast without having to lose the optimized shadows and highlights that were set previously. You basically add points to the curve and aim to draw an 'S' shaped curve to increase or decrease the steepness of the curve. When you first start using Curves try to get used to working with no more than two or three points at a time. As you develop your Photoshop skills you can try adding more points. But as you do so, take care to maintain a nice smooth curve shape. Adding more points, especially if they are set too close together, can induce a sharp kink in the curve which will produce an ugly-looking tonal correction.

Save As: Untitled.acv	
Where: Desktop	

	Fade	
Opacity:	100 %	ОК
	Cancel	
Mode: Lum	inosity 🛟	Preview

Figure 4.15 When you make a Curves adjustment for contast in Photoshop you are adjusting not only the tonal balance, but the color saturation as well. After you click OK, try choosing Fade Curves... from the Edit menu. This will pop a dialog like the one shown here. Mouse down on the Mode menu and select Luminosity. When you select Luminosity the Curves adjustment will only affect the luminance and the saturation will be unchanged. Note that you don't use a Luminosity fade after using Curves to make a color adjustment!

Figure 4.16 The Levels and Curves adjustments shown in this chapter all take place in the composite channel. When you choose Levels or Curves, the default setting enables you to simultaneously correct all the color channels that make up the composite color image. If you mouse down on the Channel menu, you can select an individual color channel to edit. This is how you can use Curves to make color adjustments.

Figure 4.17 You can save any image adjustment as a reusable setting by clicking on the Save... button in the adjustment dialog. This will pop a dialog like the one shown here. If you name the setting and save it, this same setting can be reused on another image by clicking on the Load... button and selecting the setting you just saved (or any other pre-saved setting). The Photoshop image adjustment settings each have their own extensions — you can only load a Curves extension if there is a setting available with a .acv extension.

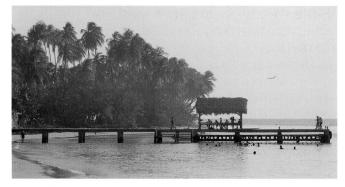

Figure 4.18 This is a normal landscape view with no Curves adjustment.

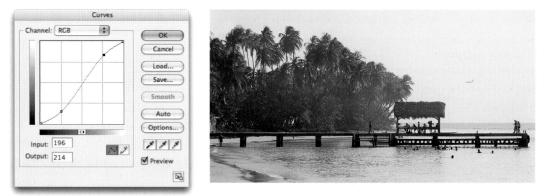

Figure 4.19 You can increase the contrast in this image by adding two or more curve points and creating an 'S'-shaped curve as shown in the accompanying Curves dialog.

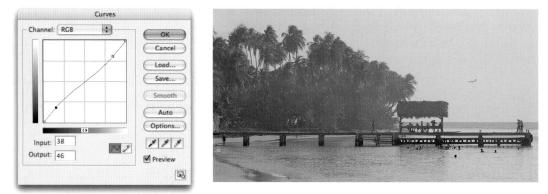

Figure 4.20 You can also decrease the contrast in the same image by adding two or more curve points and creating an 'S'-shaped curve in the opposite direction as shown in the accompanying Curves dialog.

Manipulating portions of a curve

Following on from this basic introduction to curves contrast corrections, let's now look at how one might approach improving the contrast in a less standard type of image like the one shown in Figure 4.22. In this image example I wanted to increase the contrast overall, but I mostly wanted to increase the contrast in the shadow to midtone range. But at the same time I did not want to lose any of the highlight detail.

If you look at the shape of the curve in the example shown here, you will notice that I placed a curve point at the top end of the curve to anchor the highlights and I then added three more points to the curve to create a steep curve 'S' shape which would add contrast in the desired tonal area. When you compare the before and after, note how the tonal detail in the highlight area has been preserved and the increased contrast elsewhere has produced a more contrasty looking photograph and brought out more detail where it matters most.

Accurate point placement

If you wish to place a point on the curve that corresponds with an exact tonal value in the picture you are editing then all you have to do is move the cursor outside of the Curves dialog and mouse down inside the document window. As you do so, you will notice a hollow circle appear, hovering on the curve. If you (#) cm?-click on the image a point will be added to the curve.

Figure 4.21 When the cursor is dragged over the image, a hollow circle will indicate where the tone value is on the curve.

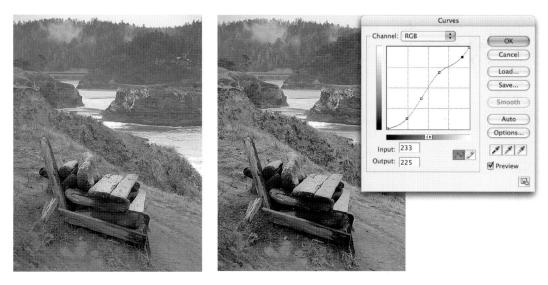

Figure 4.22 Careful manipulation of the curve points will enable you to create irregular-shaped curves that enhance the contrast at different portions of the tonal scale.

Shadows Amount	30	%	ОК
	[30		Cancel
Highlights			Load
Amount:	0	%	Save
0			Preview

Figure 4.23 The Shadow/Highlight adjustment dialog shown here in basic mode. Checking the Show More Options box will reveal the advanced mode dialog shown below in Figure 4.24.

Shadow	/Highlight		
- Shadows Amount:	50]%	OK Cance
Tonal Width:	30]%	Load
Radius:	30	px	Preview
Highlights	0	7%	
Amount:	50	3%	
Radius:	30	DX	
Adjustments	100	15.4	
Color Correction:	+20]	
Midtone Contrast:	0		
Black Clip: 0.01 % White	Clip: 0.01	%	
Save As Defaults Show More Options			

Figure 4.24 The Show More Options mode Shadow/Highlight dialog contains a comprehensive range of controls. I would advise you to always leave this box checked.

Correcting shadow and highlight detail

The Shadow/Highlight image adjustment enables you to reveal more detail in either the shadow or highlight areas of a picture. Shadow/Highlight is a great image adjustment tool to use whenever you have useful tonal information but it is just too compressed to be seen properly. It can be used to perform wonders on most images, not just those that desperately require corrections to recover detail in the shadows and highlights.

The Shadow/Highlight image adjustment tool makes adaptive adjustments to an image, and it works much in the same way as our eyes do when they automatically compensate and adjust to the amount of light illuminating a subject. The Shadow/Highlight adjustment works by looking at the neighboring pixels in an image and making a compensating adjustment based on the average pixel values within a given radius. In Advanced mode, the Shadow/ Highlight dialog has various controls which allow you to make the following fine-tuning adjustments.

Amount

This is an easy one to get to get to grips with. The default Amount setting is 50%. Increase or decrease this to achieve the desired amount of highlight or shadow correction. I find this default setting annoying, so try setting the slider to a lower amount or zero and click on the Save As Defaults button to set a new default setting.

Tonal Width

The Tonal Width determines the tonal range of pixel values that will be affected by the Amount set. A low Tonal Width setting will narrow the adjustment to the darkest or lightest pixels only. As the Tonal Width is increased the adjustment will spread to affect more of the midtone pixels as well.

Basic image adjustments

Radius

The Radius setting basically governs the pixel width of the area that is analyzed when making an adaptive correction. Let's concentrate on what would happen when making a shadow correction. If the Shadow Radius is set to zero, the result will be a very flat-looking image. You can increase the Amount to lighten the shadows and restrict the Tonal Width, but if the Radius is low or is set to zero, Photoshop will have very little 'neighbor pixel' information to work with when trying to calculate the average luminance of the neighboring pixels. So if the sample radius is too small, the midtones will also become lightened. If the Radius setting is set too high, this will have the effect of averaging all of the pixels in the image and likewise the lightening effect will be distributed such that all the pixels will get the lightening treatment, not just the dark pixels. The optimum setting to use is dependent on the image content and the area size of the dark or light pixels. The optimum pixel Radius width should be about half that amount or less. In practice you don't have to measure the pixel width of the light and dark in every image to work this out. Just be aware that after you have established the Amount and Tonal Width settings, you should adjust the Radius setting making it larger or smaller according to how large the dark or light areas are. There will be a 'sweet spot' where the Shadow/Highlight correction is just right.

Figure 4.25 The Tonal Width slider determines the range of levels the Shadow/ Highlight adjustment is applied to. So, for example, if the Shadow adjustment Tonal Range is set to 50, then the pixels which fall within the darkest range from level 0 to level 50 will be adjusted.

Radius halos

As you make an adjustment to the Radius setting you will sometimes notice a soft halo appear around sharp areas of contrast between dark and light areas. This is a natural consequence of the Radius function and is most noticeable when you are making dynamic changes to the image. Aim for a radius setting where the halo is least noticeable or apply a Fade... adjustment after applying the Shadow/Highlight adjustment. If I am really concerned about reducing halos, I sometimes use the history brush to selectively paint in a Shadow/Highlight adjustment. 1 In this photograph of young Lillian, her face is quite dark because she is backlit by the sun and ideally I would want to use the Shadow/Highlight adjustment to bring out more detail on her face and maybe darken the sky slightly.

2 I went to the Image menu and chose Adjustments ⇒ Shadow/Highlight. I set the Amount to 36% and raised the tonal width to 60%. The Radius adjustment is now crucial because this determines the distribution width of the Shadow/Highlight adjustment. As you can see in the picture here, if I set the Radius to zero, the result will look incredibly flat.

³ The other alternative is to take the Radius setting up really high. But this too can diminish the Shadow/Highlight adjustment effect. The simple way to approach setting the Radius is to realize that the optimum setting is area size related and it will fall somewhere midway between these two extremes. In the end, I went for a high radius setting of 124 pixels for the shadows and 165 pixels for the highlights. This was because I was correcting large shadow and large highlight areas and these settings appeared to produce the optimum correction for this particular photograph.

Shadows			ОК
Amount:	36	%	Cance
			Cance
Tonal Width:	60	%	Load
			Save
Radius:	0	px	Preview
<u>ه</u>)			
Highlights			1
Amount:	0	%	
۵			
Tonal Width:	42	%	
ô			
Radius:	165	px	
(<u> </u>		
Adjustments			1
Color Correction:	+20	7	
Midtone Contrast:	-5		
			
Black Clip: 0.01 % Whit	te Clip: 0.01	%	
Save As Defaults			

Basic image adjustments

Shad	dow/Highlight		Sheet and the state
Shadows			Ок
mount:	36	%	Cance
onal Width:	60	%	Load.
			Save
adius:	(124)	px	Preview
_			
Highlights			
mount:	65	%	
	۵		
onal Width:	42	%	
¢	0		
adius:	165	рх	
	0		
Adjustments		.]	
Color Correction:	+20		
		1	
lidtone Contrast:	-5		
Black Clip: 0.01 % Wh	ite Clip: 0.01	1%	
black clip. [0.01] % Wil	ite Cilp. [0.01	1 20	
Save As Defaults			

Color Correction

As you correct the highlights and the shadows, the color saturation may unexpectedly change. This can be a consequence of using the Shadow/Highlight to make extreme adjustments. The Color Correction slider will let you compensate for any undesired color shifts.

Midtone Contrast

Even though you may have paid careful attention to getting all the above settings optimized just right so that you target only the shadows or highlights (or both), the midtone areas may still get affected and you may lose some contrast. The Midtone Contrast slider control lets you restore or add more contrast to the midtone areas.

CMYK Shadow/Highlight adjustments

You may notice that the Shadow/Highlight adjustment performance is improved and you can now use Shadow/Highlight in CMYK color as well.

Martin Evening

Adobe Photoshop CS2 for Photographers

In this example I took a 16-bit image and chose Image ⇒ Adjustments ⇒ Shadow/ Highlight. I clicked on the Show More Options button to display the expanded dialog shown below.

Shadow/H	lighlight		Active And And And
Amount:	50	3%	Cance
Tonal Width:	30	%	Load.
Radius:	30	рх	Preview
Highlights Amount:	0	3%	
Tonal Width:	50	%	
Radius:	30	рх	
Adjustments			
Color Correction:	+20		
Midtone Contrast:	0		
Black Clip: 0.01 % White Cli	p: 0.01	%	
Save As Defaults Show More Options			

2 I set the Shadows Amount to 35% and increased the Tonal Width to 50%. This combination of settings enabled me to bring out more detail in the shadow areas of the picture, particularly in the brickwork of the bridges. I adjusted the Radius to find the ideal setting and decided to use 80 pixels.

- Shadows			ОК
Amount:	35]%	Cancel
Tonal Width:	50]%	Load
Radius:	80	px	Preview

Basic image adjustments

3 After lightening the shadows, I wanted to bring out more detail in the sky. So I set the Highlights Amount to 45% and the Tonal Width to 55%. The optimum radius was around 70 pixels. This combination of Shadow and Highlight adjustments enabled me to produce a much better looking photograph with a full range of tones. But the consequence of making such a major adjustment was to considerably soften the image contrast. A small boost to the Midtone Contrast added a little more punch to

the picture.

+20

+20

4 So far so good. The photograph was much improved, but under close inspection there were noticeable halos in the image which were an unfortunate consequence of a strong Shadow/ Highlight adjustment such as this. To remedy this I went to the Edit menu and chose Fade Shadow/Highlight... I reduced the effect to 70% and applied a gentle contrast increasing curve adjustment to fine-tune the tonal balance in the final image.

	Fad	le	
Opacity:	70	%	(ок
e			Cancel
Mode: Norm	al	+	Preview

Highlights

Tonal Width:

Amount

Radius:

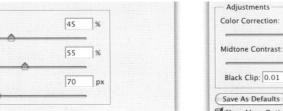

Screen redraw times

One potential drawback is that by having a lot of adjustment layers present this may slow down the screen preview. This slowness is not a RAM memory issue, but to do with the extra calculations that are required to redraw the pixels on the screen.

Repeated adjustments warning

It is important to stress here that the color data in an image can easily become lost through repeated image adjustments. Pixel color information will progressively become lost through successive adjustments as the pixel values are rounded off. This is one reason why it is better to use adjustment layers, because you can keep revising these adjustments without damaging the photograph until you decide to finally flatten the image.

Cumulative adjustments

When you add multiple adjustment layers to an image, it is wrong to assume that when flattened, the cumulative adjustments will somehow merge to become a single image adjustment. When you merge down a series of adjustment layers, Photoshop will apply them sequentially as if you had made a series of normal image adjustments. The chief advantages of adjustment layers are therefore: the ability to defer image adjustment processing and the ability to selectively edit the layers and make selective image adjustments.

Adjustment layers

Adjustment layers are identical to the Image \Rightarrow Adjustments commands. Adjustment layers offer the ability to apply multiple image adjustments and/or fills to an image and have these changes remain 'dynamic'. In other words, an adjustment layer is an image adjustment that can be revised at any time – adjustment layers enable the image adjustment processing to be deferred until the time when the image is flattened. Adjustment layers always have an active layer mask, which means that whenever an adjustment layer is active, you can paint or fill using black to selectively hide the adjustment effect, and paint or fill with white to reveal. Adjustment layers are sayable in the Photoshop native, TIFF and PDF formats, they add very little to the overall file size and best of all, provide limitless opportunities to edit and revise the image adjustments that are made to an image.

Multiple adjustment layers

You can have more than one adjustment layer saved in a document, with each producing a separate image adjustment. In this respect, they are very useful because combinations of adjustments can be previewed to see how they will affect a single layer or the whole image before you apply them. You can have several adjustment layers in a file and choose to readjust the settings as many times as you want. It is possible to keep changing your mind and make multiple changes to an adjustment layer without compromising the image quality. The ability to edit adjustment layers and mask them to selectively apply an adjustment provides the most obvious benefit over making a series of normal image adjustments.

Blending mode adjustments

You can lighten or darken an image by adding an adjustment layer above the Background layer (or at the top of the layer stack) and simply change the blend mode to Screen or Multiply. You don't need to make any image adjustments, just add an adjustment layer (any will do) and change the layer blending mode. You could achieve the same type of result by duplicating a background layer and changing the blend mode, but it is pointless to do so as you end up with an image that is twice the file size. Adding an adjustment layer will normally increase the file size by just a few kilobytes.

This technique of adding a neutral adjustment layer and changing the blending mode offers a useful shortcut route for lightening or darkening an image. As a sidenote, a Multiply or Screen blend mode is effectively nothing more than another type of Curves adjustment. Figures 4.27 and 4.28 show the curves calculated from a Multiply and Screen mode adjustment at 100%.

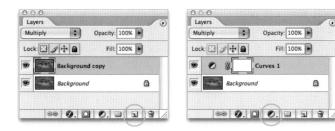

Figure 4.26 Here are two Layer palette views. In the one on the left I dragged the Background layer down to the New Layer palette button to make a duplicate layer and changed the Layer blending mode from Normal to Multiply. When the image was saved, the file size doubled to 64 MB. In the example on the right, I added a neutral adjustment layer. In this example I clicked on the Add Adjustment layer button and selected Curves. A Curves dialog appeared and I clicked OK without making an adjustments to the curve. I then changed the adjustment layer blend mode from Normal to Multiply. Both methods produced identical results, but in the second example the file size was increased by just 57 kilobytes.

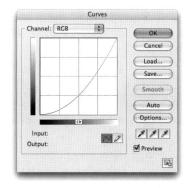

Figure 4.27 The Multiply blend mode calculated as a curve.

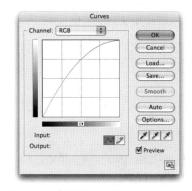

Figure 4.28 The Screen blend mode calculated as a curve.

۵

Adobe Photoshop CS2 for Photographers

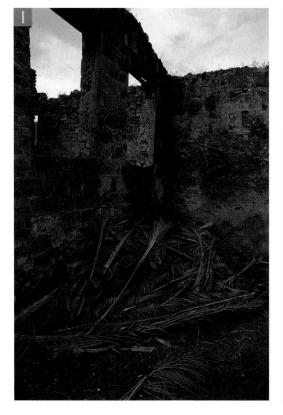

1 You can use the layer blending modes as an alternative method to lighten or darken an image. In this example I had a dark image that needed to be made brighter. I went to the Layers palette and added a new adjustment layer. It does not particularly matter which. In this example I happened to choose Curves.

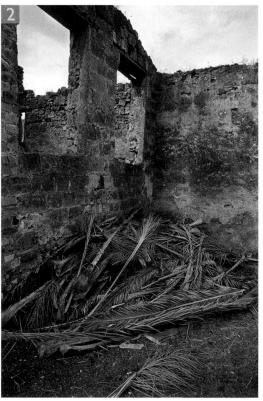

2 I changed the adjustment layer blending mode to Screen. The result of this would be the same as if I had made a copy of the Background layer and set it to Screen blend mode. Screening will make the image lighter and Multiply will make the image darker. I then added a gradient to the adjustment layer using the default foreground/background colors. This partially hid the adjustment layer and retained some of the original darker tones at the top of the picture.

Basic image adjustments

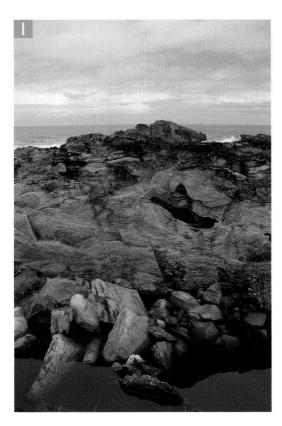

1 When you increase the contrast in an image using a Curves adjustment, you will also increase the color saturation.

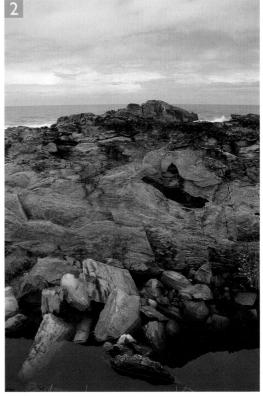

2 In this example I applied a Curves adjustment as an adjustment layer and changed the blending mode to Luminosity. This effectively increased the contrast in the original scene, but without increasing the color saturation.

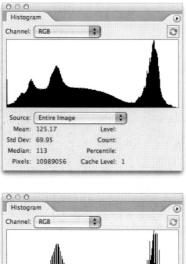

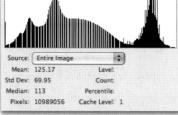

Figure 4.29 The histogram at the top is from an image in 8 bits per channel mode that started out in 16 bits per channel mode but where the levels were expanded using a Levels and a Curves adjustment. The histogram below is of the same image after the same adjustments had been applied as before, but the image was in 8 bits per channel mode throughout. As you can see, if you keep a picture in 16 bits per channel mode at the initial stages while you apply Levels and Curves adjustments, more of the levels data will be preserved.

16 bits per channel support

Most of the techniques described in this book have been carried out on files that originated from a 48-bit RGB color original file (an image made up of three 16-bit color channels). Most scanners and professional digital cameras are able to capture more than 8 bits per channel. And if an imported image contains more than 8 bits per channel data, it will be opened in Photoshop in 16 bits per channel mode. A 24-bit color image will have only 256 data points in each of its 8-bit per color channels, whereas a 16-bit per channel image in Photoshop can have up to 32,768 data points per color channel (because in truth, Photoshop's 16bit depth is 15 bit +1). This gives you a lot more levels of tone to play around with, especially when using Levels or Curves adjustments where you are stretching these levels to expand and fill a wider tonal range. As well as when you are modifying the contrast or altering the color balance.

Some have argued that 16-bit image editing is a futile exercise because no one can tell the difference by looking at an image that has been edited in 16 bit compared to one that has been edited in 8 bit. Well, perhaps, but I personally believe this to be a foolish argument. For a start, if you can capture a picture in 16 bit why not make use of all that extra tonal information, even if it is only to make your primary Levels and Curves edits? After that you switch to do everything else in 8-bit per channel mode. If you look at Figure 4.29, this shows two histogram displays which compare the result of making Levels and Curves edits to an image in both 8-bit per channel and 16-bit per channel modes. You may save a second or two by making these corrections in 8-bit mode, but is that saving worthwhile when you see how much data will become lost? The second point is you never know what the future has in store. A few pages back we looked at Shadow/Highlight adjustments. This feature exploits the fact that a deep-bit image can contain lots of hidden levels data which can be exploited to reveal more image detail than was possible before. It will work with 8-bit images too, but you get better results if you scan or capture in 16-bit per channel mode.

Photoshop offers extensive support for 16-bit mode editing. You can crop, rotate, make all the usual image adjustments and use all the Photoshop tools and work with layers in 16-bit mode, in grayscale, RGB, CMYK and Lab Color modes. But only a few filters are available including the new Lens Correction and now also the Liquify filter. Wherever possible, I always aim to begin my editing with a file that has been scanned or captured using high-bit data and brought into Photoshop in 16-bit per channel mode. I will crop the picture and apply a Levels and Curves adjustment to get the picture looking good on the screen and then and only then will I consider converting the image to 8 bits per channel mode. But since Photoshop also allows you to work using layered images in 16 bit, I will keep the image in this mode for as long as I can. You may not feel the need to use 16 bits per channel all the time for every job, but I would say that for critical jobs where you don't want to lose an ounce of detail, it is essential to make all your preliminary edits in this mode.

16-bit and color space selection

For a long time now Photoshop experts such as myself have advocated editing in RGB using a conservative gamut color space such as Adobe RGB (if you want to read more about RGB color spaces then you will need to read Chapter 13 on color management). Although 16-bit editing is not new to Photoshop, it is only since the advent of Photoshop CS that it has been possible to edit more extensively in 16 bit. And one of the advantages this brings is we are no longer limited to using a relatively small gamut RGB work space to edit in. It is perfectly safe to use a large gamut space such as ProPhoto RGB when you are editing in 16bits per channel mode because there are 128 times as many data points in each color channel compared to when you are editing in a standard RGB space such as ColorMatch or Adobe RGB. In practice, I still use Adobe RGB as my main color space, but I sometimes start editing my captures or scans in 16-bit ProPhoto RGB and convert to 8-bit Adobe RGB afterwards.

Where did the extra levels go?

If you have a keen knowledge of math, you will notice that Photoshop uses only 32,768 levels out of a possible 65,536 levels when describing a 16-bit mode image. This is because having a tonal range that goes from 0 to 32,767 is more than adequate to describe the data coming off any digital device. And also because from an engineering point of view, 15-bit math calculations give you a midpoint value. Most digital compacts and digital SLRs claim a bit depth of 12 bits per channel. High-end cameras are realistically capable of capturing up to 14 bits per channel. So the true figure of 15 bits per channel when editing in Photoshop's 16-bit per channel mode is still more than adequate for now.

Displaying deep bit color

It is hard to appreciate a significant difference between 8-bit per channel and 16-bit per channel editing when all you have to view your work on is an 8-bit per channel display. But screen display technology is rapidly improving and in the near future we will see the introduction of flat screen displays that use a combination of LEDs and LCDs, capable of displaying images at greater bit depths and at a higher dynamic range. Sunnybrook Technologies have shown an early prototype and the difference is remarkable. In the future, such displays will enable you to see the images you are editing in greater tonal detail and over a much wider dynamic range, should you wish to do so.

Other HDR applications

All those special effects used in movies such as 'Jurassic Park' used a 32-bit color space to render the computer generated characters and make them interact convincingly with the real world film footage. So 32-bit image editing is useful in creating realistic animated special effects. The way this is usually done is to record what is known as a lightprobe image of the scene in which the main filming takes place. A lightprobe is an omnidirectional HDR image which can consist of a sequence of six or seven overlapping exposures shot using a 180 degree fisheye lens pointed in opposite directions. A basic lightprobe can be a series of photographs of a mirrored sphere taken with a normal lens. The resulting lightprobe image contains all the information needed to render the shading and textures on a computer generated object with realistic-looking lighting.

32-bit rendering is applicable to the computer games industry. The military and aeronautics industries are also particularly interested in the potential to render more realistic looking virtual landscapes for simulation training. A wireframe landscape designed on a computer can be made to respond dynamically to different programmed lighting environments.

Paul Debevec is a leading expert in HDR imaging. His website www.debevec. org contains much interesting information on HDR and its various applications.

32 bits and High Dynamic Range

Photoshop CS2 now has a 32 bits per channel mode. After reading the last section this may sound like overkill because, as was pointed out, Photoshop's 16 bits per channel mode is all you really need to make the most of the data your scanner or camera can capture. But 32-bit imaging will nevertheless be useful in a number of ways.

We are used to editing images with a fixed exposure and preparing them for print. However, a 32-bit color space has the potential to contain deep-bit detailed, tonal information. A 32-bit file will be four times bigger than a standard 8-bit per channel image and the HDR format in 32 bit is able to use floating point math calculations (as opposed to regular whole numbers) to describe everything from the deepest shadows to the brightness of the sun. High Dynamic Range (HDR) imaging is not big yet, but it is predicted that digital cameras will soon start to feature HDR capture capabilities. Such cameras may not even need an exposure setting, because a single standard HDR exposure will be capable of capturing everything! And exposure decisions could then be made on the computer after the picture has been taken. That is the vision for the future of HDR stills photography. In the meantime, Photoshop CS2 is gearing up for HDR image editing by providing initial support for 32-bit per channel images.

Merge to HDR

HDR cameras are not common yet, but for now you can simulate HDR capture by using the Merge to HDR feature to combine two or more images captured at different exposures with a normal digital camera and blend the selected images together to produce a 32-bit high dynamic range image. You can then convert this 32-bit HDR file into a 16-bit per channel or 8-bit per channel low dynamic range version which you can then edit normally in Photoshop. The HDR conversion dialog provides several methods for converting the merged exposure file, the most useful of which are probably the Exposure and Gamma and the Local Adaptation method. To use Merge to HDR, you need to think about making some bracketed exposures. Ideally, the camera should be mounted on a tripod, but if your digital camera has fast burst capture with auto bracketing, you can often get away with hand holding the camera. However, the subject matter must be perfectly still, as you won't be able to merge photographs where the subject is moving. The exposure bracketing should be between 1 and 2 stops apart and the auto exposure set to aperture priority so that the aperture remains fixed and only the exposure times vary.

Really still, still life

The Merge to HDR dialog can automatically align the images for you. But it is essential that everything else remains static. For example, the aperture must remain fixed, because if you bracket your images using the lens aperture, the depth of focus will vary between each exposure. This will prevent you from achieving smooth, HDR merged images.

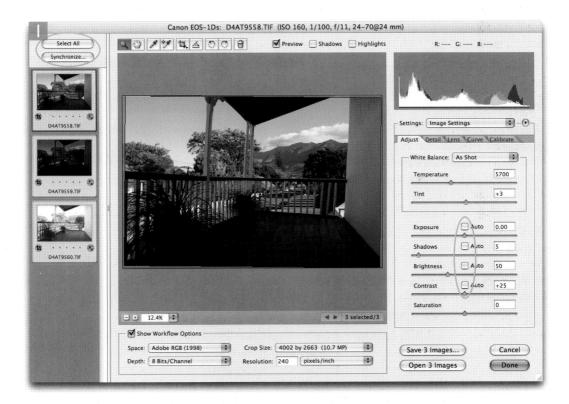

I l began by making a selection of three raw digital capture images shot using different time exposures set at one stop or more apart. The raw settings must be set with the Auto checkboxes switched off. In this example, I used the straighten tool to apply a rotation and synchronized and applied this to all three captures. 2 One can either go to the Bridge menu and choose Tools \Rightarrow Automate \Rightarrow Merge to HDR or do as I have shown here and go to the File menu in Photoshop and choose Automate \Rightarrow Merge to HDR. In the dialog to the right, I clicked on the Browse button and navigated to select the three images shown at step 1 that I wished to merge together. Ideally, you should plan to capture your HDR merge images with the camera firmly secured on a tripod and use a cable release. You will notice that there is an automatic alignment feature in the Merge to HDR dialog. This means that you can get away with shooting the HDR merge images with a hand-held camera using an auto bracket setting. Again, remember that the aperture must remain fixed and you only want to adjust the time exposure. Try setting the camera to the aperture priority exposure mode and the bracket function to three exposures at 1−2 stops apart.

Choo	urce Files use two or more files from le and create a High Dyna		OK Cancel
Use:	Files 🗘		
	D4AT9560.TIF D4AT9559.TIF D4AT9558.TIF	Browse Remove	

3 After you click OK, the Merge to HDR dialog will attempt to display the merged HDR image. This is impossible to do on a standard computer monitor, so the slider beneath the histogram will allow you to preview slices of the HDR image. At this stage you can deselect or select the source image thumbnails on the left to see how this will affect the merged HDR picture.

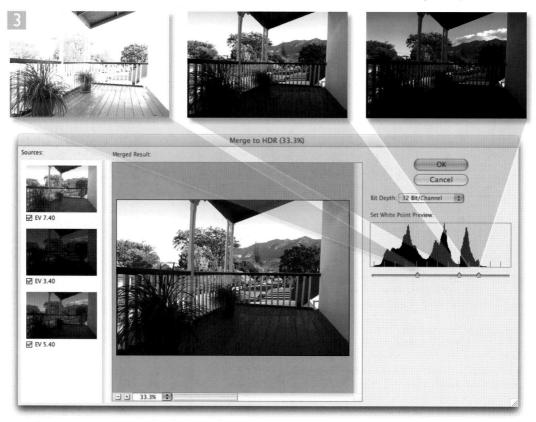

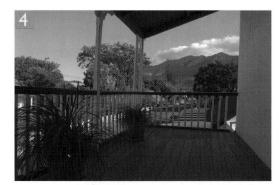

Exposure:	-2.70	Cancel
Gamma:	0.60	Load Save

4 After you have chosen the desired images to blend together to make the merged HDR, all you need to do is to set the bit depth (which should be 32 bits per channel) and click OK to render a 32-bit per channel HDR composite image. This can then be saved as a Portable Bit Map (.pbm) master image. If you wish to convert this HDR format image and compress the high dynamic range to create a normal Photoshop image, then go to the Image menu and choose Mode \Rightarrow 16 bits (or 8 bits) per channel. This will pop the HDR conversion dialog shown here, which provides four methods for converting the image data. Exposure and Gamma provides two slider controls. You can use the Gamma slider to (effectively) reduce or increase the contrast and the Exposure slider to compensate for the overall exposure brightness. These controls are rather basic, but they do allow you to create a usable conversion from the HDR image data, which of course can then be further modified using the image adjustment controls in Photoshop. The Highlight Compression simply compresses the highlights, preserving all the highlight detail. It can render good midtones and highlights at the expense of losing detail in the shadows. The Equalize Histogram option attempts to map the extreme highlight and shadow points to the normal contrast range of a low dynamic range Photoshop image, but this too can be a rather blunt instrument to work with.

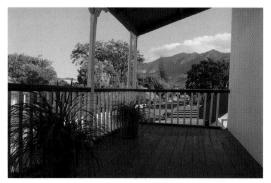

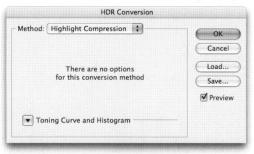

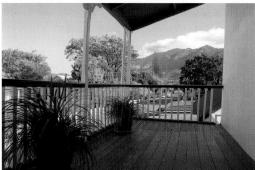

Method: Equalize Histogram	ОК
	Cancel
There are no options	Load
for this conversion method	Save
	🗹 Preview
Toning Curve and Histogram	

Martin Evening Adobe Photoshop CS2 for Photographers

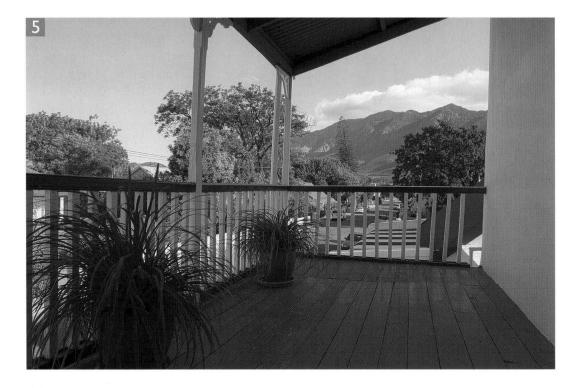

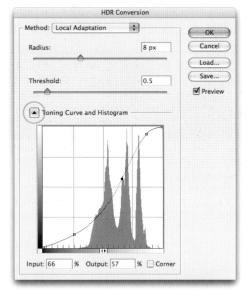

⁵ The final method is called Local Adaptation. And you will notice that the controls here bear some similarity to those found in the Shadow/Highlight image adjustment dialog. It is best to start with a low Threshold setting of 0.5 and then adjust the Radius slider to determine the ideal radius setting that will produce a reasonably good looking conversion. You can then switch to adjusting the Threshold slider again to fine-tune the adjustment, but take care to make sure that you don't create any ugly haloes around the high contrast edges.

If you now click on the disclosure triangle in the HDR Conversion dialog you will display the Toning Curve and Histogram. You can now treat this as a Curves adjustment tool with which you can create a tone enhancing contrast curve that will be applied during the HDR conversion. Click OK and Photoshop will apply whichever conversion method you have selected and create a finished image like the one shown here.

It has to be said that HDR merged images can sometimes look pretty freaky because the temptation is, as shown here, to try to squeeze a wide dynamic range scene into a low dynamic range print. Just because you can preserve a complete tonal range does not mean you must always represent it in print.

Cropping

The image you are editing will most likely require some kind of crop, either to remove unwanted edges or to focus more attention on the subject. Select the crop tool from the Tools palette and drag to define the area to be cropped. To zoom in on the image as you make the crop, you will find it useful to use the zoom tool shortcut: \mathfrak{R} *ctrl*+Spacebar and marquee drag over the area you want to magnify. To zoom out, use \mathfrak{R} *o ctrl o*, which is the shortcut for View \Rightarrow Fit To Window. Then you can zoom back in again to magnify another corner of the image to adjust the crop handles.

If the crop tool does not behave as expected try clicking on the Clear button in the Tool Options bar. This will reset the tool. In the normal default mode the crop tool will allow you to set any rectangular-shaped crop you like and merely trim away the unwanted pixels without changing the image size or resolution.

Front Image cropping

If you want a crop to match the dimensions and resolution of a document that is already open in Photoshop, click on that document to make it active. Then click on the Front Image button in the Crop Options bar. This will load the document dimensions and resolution into the Crop Options settings. Now select the image you wish to crop and as you drag with the crop tool, the aspect ratio of the front image will be applied. When you OK the crop, the image size will be adjusted to match the front image resolution.

Martin Evening Adobe Photoshop CS2 for Photographers

1 I selected the crop tool and dragged across the image to define the crop area. The cursor can then be placed above any of the eight handles in the bounding rectangle to readjust the crop.

2 Dragging the cursor inside the crop area will allow you to move the crop. You can also drag the crop bounding box center point to create a new central axis of rotation.

3 You can mouse down outside the crop area and drag to rotate the crop around the center point (which can even be positioned outside the crop area). You normally do this to realign an image that has been scanned slightly at an angle.

4 The shield color and shade opacity can be anything you like. In this example I increased the shading opacity to 100% to produce a completely opaque shield. You can even use **(R) (D) (D)** to hide the bounding box completely and still be able to drag the corners or sides of the crop to make adjustments.

Selection-based cropping

You can also make a crop based on any active selection by simply choosing Image \Rightarrow Crop. Where the selection has an irregular shape, the crop will be made to the outer limits of the selection and the selection will be retained. The practical advantages of this are that you can sometimes use an automatic selection method such as the magic wand tool to make a selection of an object surrounded by a solid color or maybe you might want to \Re *ctrl*-click a layer to make a selection based on a single layer and then execute a crop.

Fixed aspect ratio crops

One of the big advantages of using the rectangular marquee tool to make a selection crop is that you can set a fixed aspect ratio for the crop in the marquee tool options (see Figure 4.32).

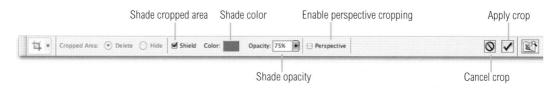

Figure 4.31 After you have dragged with the crop tool and before you commit to a crop, the Tool Options bar will change to the one shown here, which is what is known as a 'modal state'. The modal crop tool options allow you to change the color and opacity of the shield/shading of the outer crop areas. To apply a crop, click on the Apply button in the Options bar, double-click inside the crop area or hit the *Enter* or *Return* keys. Click on the Cancel Crop button or hit the *esc* key to cancel a crop.

Feather Feather	er: 0 px Anti-alias Sty	yle: Fixed Aspect Ratio	Width: 2	Height: 3	R.
				la contra con	n second s

Figure 4.32 If you select the rectangular marquee tool you can use the Constrain Aspect Ratio option to make a proportional crop without altering the image resolution or dimension units. Enter the desired proportions in the Width and Height boxes, drag the marquee selection tool across the image to define the area to be cropped and chose Image \Rightarrow Crop.

Figure 4.33 Sometimes it is quicker to make a crop from a selection instead of trying to precisely position the crop tool. In the example shown here, if we want to make a crop of the box containing the letter D, the quickest solution would be to (H) crop-click on the relevant layer in the Layers palette and then choose Image \Rightarrow Crop.

Layers			0
Screen	•	Opacity: 100%	•
Lock:	3/4/2	Fill: 100%	•
9 7	Set 1		11111111111
	Layer D	0	-
	Layer C	0	•
9	Layer B	0	•
	Layer A	0	•
•	Background	۵	

Disable edge snapping

Edge snapping can be very distracting when you are working with the crop tool. But this can easily be disabled in the View ⇒ Snap To submenu (or by using the Shift ; ctrl Shift ; shortcut).

Perspective cropping

With Photoshop's crop tool you can crop and correct any converging verticals or horizontal lines in a picture, with a single crop action. In the Figure 4.34 example, we might wish to remove the converging verticals or 'keystone' effect in the photograph of the buildings. If you check the Perspective box, you can accurately reposition the corner handles on the image to match the perspective of the buildings and then apply the crop to straighten the lines that should be vertical. This tweaking adjustment can be made even more precisely if you hold down the *Shift* key as you drag a corner handle. This will restrict the movement to one plane only. I find the perspective crop tool is useful when preparing photographs of flat copy artwork as it enables me to always get the copied artwork perfectly square.

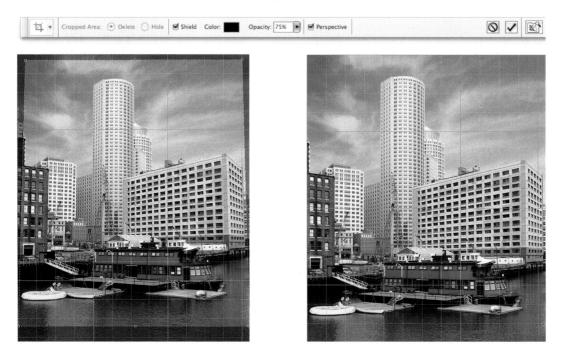

Figure 4.34 The crop tool is great for correcting the perspective in a photograph. Once a crop is in progress you are then able to check the Perspective box in the Options bar and move the corner handles independently. By using this method, you will find it much easier to zoom in and gauge the alignment of the crop edges against the converging verticals in the photograph. And it helps as well to switch on the Grid display. Go to the Window menu and choose Show \Rightarrow Grid.

Image rotation

If an image requires rotating you can use the Image \Rightarrow Rotate controls to orientate your picture the correct way up or flip it horizontally or vertically even. More likely you will want to make a precise image rotation, especially if the horizon line is not perfectly straight. You can correct a wonky image by making a rotated crop with the crop tool or by using the more precise method of an angle measurement made with the measure tool followed by an arbitrary rotation as described below.

Figure 4.35 The Image ⇒ Rotate menu including the Arbitrary option which is described below in Figure 4.36.

Figure 4.36 When an image is opened up in Photoshop, you may discover that a scanned original is not perfectly aligned. Although the crop tool will allow you to both crop and rotate at the same time, there is another, more accurate way of correcting the alignment. Select the measure tool from the Tools palette and drag along what should be a straight edge in the photo. After doing this, go to the Image menu and select Rotate Canvas \Rightarrow Arbitrary... You will find that the angle you have just measured is already entered in the Angle box. Choose to rotate either clockwise or counterclockwise and the picture will then be accurately rotated so that it appears to be perfectly level, although Photoshop usually auto-selects the correct direction to rotate in.

Canvas size

The Image \Rightarrow Canvas size lets you enlarge the image canvas area, extending it in any direction. This is useful if you want to extend the image dimensions in order to place new elements. If you check the Relative box you can enter the unit dimensions you want added to the current image size. The pixels that are added will be filled using the current background color but you can now also choose other fill options from the Canvas Size dialog (see Figure 4.37). It is also possible to add to the canvas area without using Canvas Size. You can use the crop tool as an 'add canvas tool' by dragging beyond the document boundaries.

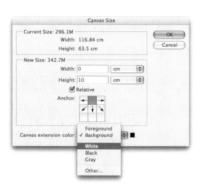

Figure 4.37 To add extra pixels beyond the current document bounds, use the Canvas Size from the Image menu. In the example shown here, the image is anchored so that pixels will be added equally left and right and to the bottom of the image only. The relative box is checked and this allows you to enter the number of units of measurement you wish to add 'relative' to the current image size.

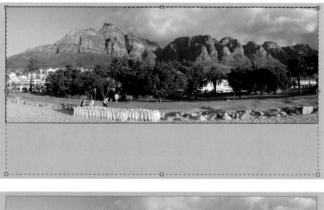

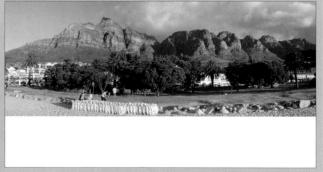

Figure 4.38 To use the crop tool as canvas size tool, first make a full frame crop, release the mouse and then drag any one of the bounding box handles outside of the image and into the canvas area. Double-click inside the bounding box area or hit *Enter* to add to the canvas size, filling with the background color.

Big data

The Photoshop, PDF and TIFF formats all support 'big data'. This means that if any of the layered image data extends beyond the confines of the canvas boundary, it will still be saved as part of the image when you save it, even though it is no longer visible in the image. If you have layers in your image that extend outside the bounds of the canvas, you can expand the canvas to reveal all of the big data by choosing Image \Rightarrow Reveal All. But remember, you will only be able to reveal the big data again providing you have saved the image using the PSD, PDF or TIFF format. When you crop a picture using the crop tool, you can delete or hide the layered big data by selecting either of these radio buttons in the modal crop options bar (see below).

Background layers and big data

If your image contains a background layer and you want to preserve the data on this layer after making a 'hide' crop, you must first double-click the background layer to promote it to a normal layer. If you don't take this step you will still be deleting everything on this layer when you crop.

Big data in Photoshop CS2

In this latest version of Photoshop, the virtual memory management of big data is much improved. There is now less of a performance hit when you promote a background layer to a normal layer.

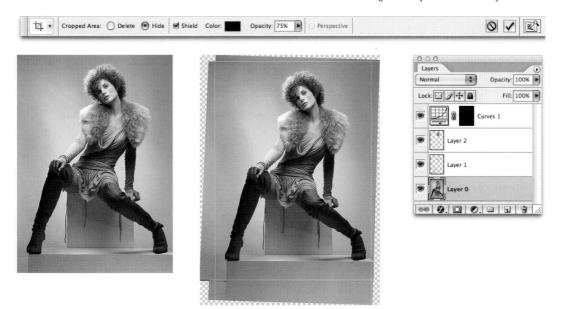

Figure 4.39 The cropped version of this picture contains several layers which when expanded using the Image \Rightarrow Reveal All command show all the hidden 'big data' extending outside of the cropped view. The Hide option in the crop tool options enables you to preserve the pixels that fall outside the selected crop area instead of deleting them. Note also how the Background layer has been converted to a normal Photoshop layer (Layer 0). This is essential if you wish to preserve all the information on this layer as big data.

Client: Rainbow Room. Model: Nicky Felbert @ MOT.

Adobe Photoshop CS2 for Photographers

Image sharpening

It is an unavoidable fact, but the image detail will always become progressively lost at critical stages of the digital image making process. And without making sharpening corrections, this will result in the printed image appearing softer than expected.

This is by no means a new phenomenon associated specifically with digital imaging. The problems begin as soon as you focus the subject in your viewfinder and press the shutter release. The first variable is the camera lens. Most photographers are aware that cheaper, inferior lenses will produce less sharp pictures, but the film emulsion can also influence the sharpness, as can the quality of the digital sensor and the number of photosites on the sensor chip. And if you are shooting film, then you will have to scan a chrome transparency, negative or photographic print made with a darkroom enlarger (which involves yet another optical step). Therefore, even if you use the finest quality lenses and digital equipment, it is inevitable that the capture/scanning process will lead to some image degradation and an apparent loss of sharpness before you even bring the photograph into Photoshop and start editing it.

The other age-old problem concerns the loss of sharpness at the output stage. Whenever you make a print output you are converting an image that is made up of pixels into an image that is printed using ink dots, or in the case of other printers, the image is created using laser diode exposures. In all cases though, translating pixels into an image that is printed with a mechanical process inevitably involves even more loss of sharpness.

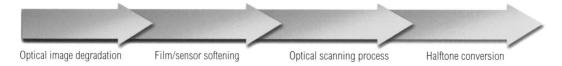

Figure 4.40 The above diagram maps out the path to blurry destruction for photons that enter a camera lens and are eventually interpreted as printer's ink on the page. At each of the above stages either a little or a lot of crisp detail will be forever lost.

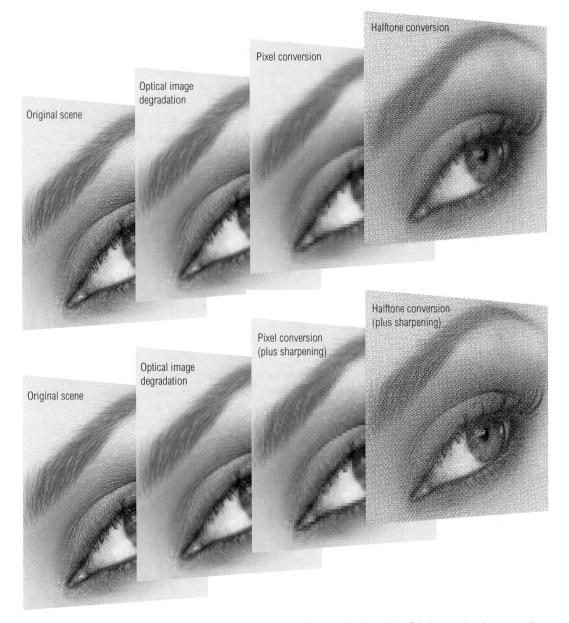

Figure 4.41 The quality of the pixels you edit in Photoshop can only be as good as the quality of the lens used on the camera, the number of pixels captured and the quality of the camera sensor or scanning device. Even the finest recorded images will benefit from some sharpening to adjust for a loss in sharpness. More sharpening losses will occur when outputting the image as a halftone print or inkjet. Further sharpening in Photoshop is therefore recommended before you make any type of output.

Origins of unsharp masking

Unsharp masking sounds like a contradiction in terms, because how can unsharpening make a picture sharper? The term in fact relates to the reprographic film process whereby a light, soft, unsharp negative version of the image was sandwiched next to the original positive during exposure. This technique was used to increase the edge sharpness on the resulting plate. The Photoshop Unsharp Mask (USM) filter reproduces the effect digitally and you have a lot of control over the amount of sharpening and the manner in which it is to be applied.

Sharpening solutions

These loss of sharpness problems have been around for a long time (see the sidebar on the origins of unsharp masking). And over the years various strategies have evolved to deal with the problem. For example, some film scanning devices are set up to automatically apply lots of sharpening to the scanned images so that they can go straight to a printing press. To some extent this is fine if all you are concerned with is preparing images to go to print in a publication. The downside of this one-step sharpening is that because the sharpening is so heavy-handed, the pictures will be more difficult to retouch in Photoshop. Plus the sharpening will usually be calculated for a specific print output size and this also creates more limitations as to what else you can do with the scanned pictures.

These days, a lot of digital cameras and scanners will try to apply some level of modest sharpening at the capture stage in order to create the impression that their equipment performs to an optimum standard. If you shoot digitally and capture anything other than a raw file, the chances are the camera's built-in software will apply a small amount of artificial sharpening in order to make their product look good. Of course, nobody wants unsharp pictures, but it is useful to realize that an unsharpened 'soft' capture file is not necessarily the sign of a bad camera or scanner. For example, Adobe Camera Raw uses a default sharpen setting of 25%. All raw digital files look softer than expected until they have been sharpened. The question is, how much sharpening does an image need?

Capture sharpening

One solution is to apply an initial corrective sharpening to each image before you start any retouching. The aim here is to compensate for the loss of sharpness I just described, which occurs naturally during the photographic process. There are various ways you can do this. If you are happy with the amount of sharpness that is automatically applied by your scanner or digital camera, then no more sharpening will be required at this stage. If you prefer, you may want to disable any sharpening in your camera or scanner software and apply a presharpening in Photoshop instead. One should recognise of course that not all methods of scanning and capture are the same and not all film emulsions or digital camera types and resolutions are the same either. And different amounts of sharpening may be required in order to attain a standard level of sharpness where each image appears sharp enough to look good on the computer display you are using. This is what we call capture sharpening.

Sharpening for output

What you see on the screen will not exactly match the printed result. The process of converting a digital image to a halftone plate and from there to ink on the page (or making an inkjet print) inevitably incurs a further loss of sharpness. For this reason it is always necessary to 'sharpen for print'. This means that if you are preparing a picture to appear in print, you should apply an extra amount of sharpening, beyond what makes the image look good on the computer display. The difference between this and the capture sharpening is that this should be done at the end of a Photoshop session and after the image has been resized to the final print size. It therefore makes sense to keep a master version which you can make copies from as requested and always apply the final unsharp masking on a resized copy of the master.

Turning off the auto sharpening

Wherever possible, use an unsharpened original as your master and apply any sharpening as necessary in Photoshop. Do check the settings in the camera capture or scanner software carefully because a lot of manufacturers like to sneak in some unsharp masking even when they tell you everything is set to zero. If you find this is happening, check to see if you can turn off the sharpening completely in the scanner software.

Judge the print, not the monitor

It is difficult to judge the correct amount to sharpen an image for a print output when you are using a monitor to preview the image. At a normal viewing distance, the human eye can resolve detail to around 1/100th of an inch. So if the image you are editing is going to be printed from an image with a resolution of 300 pixels per inch, the edges will need a 3 pixel radius if they are to register as sharp in print. When an image is viewed on a monitor at 100%, this kind of sharpening will look oversharp and quite ugly, because at a 100% screen view you are viewing the image much closer up than it will actually be viewed when printed. This is why it is better to prejudge the output sharpening at a lower zoom percentage such as 50% or 25% even.

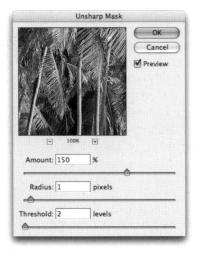

Figure 4.42 The Unsharp Mask filter dialog.

Unsharp Mask filter

The only sharpening filters you ever need are the Unsharp Mask (USM) or the new Smart Sharpen filter. Sharpen and Sharpen More are preset filters which sharpen edges but feature none of the flexibility associated with unsharp masking. While unsharp masking may make a picture look sharper, this apparent sharpening is achieved at the expense of introducing artifacts into the image that will permanently degrade the picture and possibly emphasize any noise present. Furthermore, if you oversharpen the image before carrying out color adjustments and any retouching, the sharpening artifacts can become even more noticeable afterwards. So the goal when using the unsharp mask filter is to aim to increase the apparent sharpness and at the same time minimize the amount of artifacting introduced by the sharpening process. Let's begin by looking at the three controls in the Unsharp Mask filter dialog and what they do.

Amount

The Amount setting controls the intensity of the sharpening applied. And this is a really simple one to understand. The higher the percentage (up to 500%) the greater the sharpening effect will be. The correct amount to apply will vary depending on the state of the image or the type of press output. Generally speaking, I would typically apply an amount between 50 and 100% for a capture sharpening (experience will help you make the right judgement on screen as to what the correct amount to use should be). And around 120 and 200% for an output sharpen. Here is a good tip: try setting the amount value really high to begin with. Try to find out which Radius and Threshold settings work best at this high Amount setting and then reduce the Amount percentage to an appropriate level.

Radius

The Amount setting controls the level or intensity of unsharp masking, but the Radius and Threshold settings affect the distribution of the sharpening effect. The Radius setting controls the width of the sharpening effect and the ideal setting will depend very much on the subject matter and also the size of your output. Use a Radius of between 0.5 and 1 for capture sharpening and use a Radius between 1.0 and 2.0 when sharpening for inkjet or halftone output. As the Radius setting is increased you will notice how the edges are emphasized more when a wider radius is used. Figure 4.42 demonstrates the impact increasing the Radius can have on the edge sharpness.

Threshold

The Threshold setting controls which pixels will be sharpened based on how much the pixels to be sharpened deviate in brightness from their neighbors. Higher Threshold settings apply the filter only to neighboring pixels which are markedly different in tonal brightness, i.e. edge outlines. At lower settings more or all pixels are sharpened including areas of smooth continuous tone. If the Threshold setting is 4, for example, and there is a difference of fewer than 4 levels of tone between any two neighboring pixels, they won't be sharpened. If there are more than 4 levels of tone difference between them they will be sharpened. Raising the Threshold setting will therefore enable you to sharpen edge contrast, but without sharpening scanner noise artifacts or film grain (the things you don't want to make sharper). For this reason, scans made from 35 mm film originals usually benefit from being sharpened with a higher Threshold setting than would need to be applied to a 120 film scan. The Threshold setting is most critical when preparing a scanned film image. As a general rule, use a Threshold of between 0 and 10.

Figure 4.43 These pictures demonstrate the effect of increasing the Unsharp Mask filter Radius size and have been treated as follows: no sharpening (top). Amount 200% Radius 1, Threshold 0 (middle). Amount 200% Radius 2, Threshold 0 (bottom).

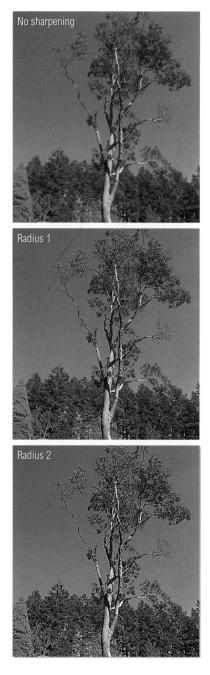

Martin Evening Adobe Photoshop CS2 for Photographers

Ur	nsharp Mask	
A A		OK Cancel Preview
100% Amount: 280		
Radius: 2	pixels	
Threshold: 1	levels	

Figure 4.44 This photograph taken of musicians underwater
was shot through a scratched glass porthole. As a result of these
environmental conditions, the picture was already quite soft
in appearance and therefore needed a lot of extra sharpening.
But the problem with doing that is that at a low threshold
setting, the high Amount and Radius also emphasized the film
grain. Increasing the Threshold to 10 solved the problem. The
photograph was made to appear sharper but without sharpening
too much of the film grain.

Photograph by Eric Richmond.

Un	isharp Mask	
4		OK Cancel Preview
100% Amount: 280	• _%	
Radius: 2	pixels	
Threshold: 10	levels	

185

Basic image adjustments

Edge sharpening

This is a technique which is designed to selectively sharpen the edges only. This is useful if you want to minimize the amount of unsharp masking that is applied to areas of flat tone. For example, if you wish to sharpen a portrait photograph, the main thing you want to see looking sharp are things like the eyes, lips and the hair, but you don't really want to apply too much unsharp masking to the areas of flatter detail such as the skin, because this will most likely only exaggerate any grain or noise in the image. The edge sharpening technique is useful if you want to achieve the very best capture sharpening results and is described in a step-by-step tutorial here. The settings used in edge sharpening will vary depending on the type of input file you are sharpening. But if you are always using the same type of input, you might find it useful to record these steps as an action.

↑ I first created an alpha channel mask based on the image luminance. One way to do this is to drag the RGB composite channel to the Make Selection button in the Channels palette and follow this by clicking on the Make New Channel button just to the right of it and choose Select ⇒ Deselect to get rid of the selection.

Ch	annel	s	10	0
Г		RGB		ж~
Г	φ	Red		H 1
Г	\$	Green		¥2
Г	ø	Blue		% 3
9	-	Alpha 1		₩4
_		18		3

000

2 I made sure the new alpha channel was active. I went to the Filter menu and chose Stylize \Rightarrow Find Edges. There is no dialog for this filter – it will simply produce a high contrast edge image like an ink pen drawing of the photograph. I then chose Image \Rightarrow Adjustments \Rightarrow Invert. I then applied a Gaussian Blur filter to the alpha channel. I chose Filter \Rightarrow Blur \Rightarrow Gaussian Blur and used something in the region of a 1–2 pixel radius which softened the edges of the mask.

3 With the alpha channel still active, I went to the Image menu and chose Adjustments \Rightarrow Auto Levels. This helped expand the contrast of the alpha channel automatically.

Ch	annels		
Г	-	RGB	¥6~
Г	1	Red	961
Γ	0	Green	362
Г	ψ	Blue	963
		Alpha 1	麗4
		10 0	J B

4 I then loaded the modified alpha channel as a selection (in this example, you could use the shortcut: **B a d c**tr(**a**) **d d**) and chose the Unsharp Mask filter. The Unsharp Mask filter will now be applied to the selected areas only. This technique basically allows you to apply sharpening to the image edges where the sharpening matters most, while leaving the softer areas of continuous tone, mostly unaffected.

Client: Reflections. Model: Elle S @ FM.

Selective sharpening

Anti-aliased text and other graphic artwork is fine left as it is and will not benefit from being sharpened. Photoshop vector objects are on separate layers anyway and will be processed separately by a PostScript RIP when rendered in print. If you do render any of the shape or type layers, try to keep them on their separate layers. Only sharpen the bitmapped image data.

The unsharp masking controls will enable you to globally correct most pictures and prepare them ready for print output. But you may find it preferable to selectively apply the sharpening in a way that will reduce the problems of unwanted artifacts becoming too noticeable. You don't always want to globally sharpen the image and so selective sharpening can sometimes be useful as an interim step, applied between the capture and output sharpening. There are several ways to sharpen an image selectively. The history brush can be used to locally apply the unsharp masking (refer to the history section in Chapter 2 for advice on how to use the History palette and history brush). Basically, you can create a sharpened image state in Photoshop, undo the sharpening in the History palette, but select the sharpened image state as the history source. You can then use the history brush to selectively paint in the sharpened state.

Another strategy is to add a new layer to the top of the layer stack and fill this with a merged snapshot of the current image. Apply your sharpening to this merged layer and then add a layer mask, filled with black (this hides the layer contents). Now if you activate the sharpened image layer mask and paint with white as the foreground color, you can paint in the sharpened version of the image.

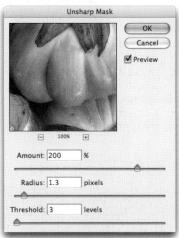

Figure 4.45 This illustrates one way of applying unsharp masking to a picture. I copied the background layer and applied an aggressive amount of unsharp masking to the layer. I then and -clicked on the Add Layer Mask button at the bottom of the Layers palette to add a layer mask that 'hides all'. With the layer mask active, one can paint in the sharpness using a brush and with white as the foreground color.

Figure 4.46 Unsharp masking can produce chromatic artifacts in some areas of the image. Luminance sharpening can help when you want to avoid overemphasizing the color noise artifacts in an image. Apply an Edit ⇒ Fade command and change the blending mode to Luminosity. This has the same effect as converting an image to Lab mode and sharpening the luminosity channel only, but less destructive (and faster).

Figure 4.47 The Pixel Genius PhotoKit Sharpener automated plug-in that is able to apply sharpening routines in stages for capture selective (painting in on a layer) and output sharpening. The sharpening routines are each customized to provide the optimum amount of sharpening for these different tasks.

Luminance sharpening

The artifacts caused by unsharp masking can sometimes be avoided by filtering the luminance information in the image only. Some people will suggest that you convert the image to Lab Color mode, select the luminance channel, apply the Unsharp Mask filter and convert back to RGB mode. But converting to Lab mode and back is an old outdated technique, bad for the image and completely unnecessary. Instead, apply the unsharp mask filter, and follow this immediately going to the Edit menu and choosing Fade Filter and change the blend mode to Luminance. This will accomplish the same type of result as sharpening in Lab mode but you will want to make the initial unsharp masking amount just slightly stronger than is required and use the fade opacity slider to adjust the sharpening effect to achieve the desired result.

Third-party sharpening plug-ins

As you can see, there is a lot more to sharpening than meets the eye. The unsharp mask filter in Photoshop is perfectly capable of giving good results and these can be further enhanced using some of the selective sharpening tips I have described here. But there are also some thirdparty plug-in solutions available that offer an alternative to the Unsharp Mask filter. For example, there is a product called PhotoKit Sharpener from Pixel Genius, a company I am personally involved with. But all credit goes to fellow Pixel Genius member and author Bruce Fraser, who devised this special set of Photoshop sharpening effects that are designed to apply just the right amount of image sharpening for all different types of film and digital file formats. Bruce's sharpening routines incorporate all the techniques discussed here in this chapter, and then some. They include import sharpening for a multitude of film types and digital captures, output sharpening for inkjet printers or repro and creative sharpening layers for selective image sharpening. A demo version of PhotoKit Sharpener is on the CD and can also be downloaded from the Pixel Genius website: www.pixelgenius.com.

Smart Sharpen filter

The new Smart Sharpen filter provides you with an alternative method of sharpening that does a good job of sharpening an image with better edge detection and can improve the appearance of blurry images without introducing any unwanted halos. The interface has been kept as simple as possible.

When you start using it you will want to mainly concentrate on using the Amount and Radius slider controls to adjust the effect. There are three blur removal modes: Gaussian Blur removal is more or less the same method as that used in the Unsharp Mask filter. The Lens Blur method is the most useful though since it enables you to counteract optical lens blurring. And lastly, Motion Blur removal, which can be effective at removing small amounts of motion blur from an image, but the trick is to set the Angle to match the direction of the blur. The Gaussian and

Saving the Smart Sharpen settings

You can save Smart Sharpen settings as you work by clicking on the Save Settings icon circled below in Figure 4.48, and call these up via the Settings menu at a later time.

Smart Sharpen	
OK Cancel Preview Basic Advanced Settings: Default Parpen adow Highlood Amount: 150 More Accurate	OK Cancel Preview Basic @ Advanced Settings: Default Pade Amount: 40 % Tonal Width: 50 % Radius: 10 pixels

Figure 4.48 This photograph of a lion cub was shot at dusk using a 1250 ISO setting with a 200 mm image stabilizing lens at 1/100th second @ f2.8. I set the Smart Sharpen filter to Advanced mode and applied an Amount of 150% at a radius of 1.5 using the Lens Blur mode with the More Accurate box checked. Once I had chosen suitable settings for the main Smart Sharpen, I clicked on the Shadow and Highlight tabs and used the settings in these sections to decide how to limit the main sharpening effect. A high Fade Amount setting will fade the sharpening more and the Tonal Width determines the range of tones that are to be faded. And lastly, the Radius slider where you can enter a radius value to set the scale size for the corrections.

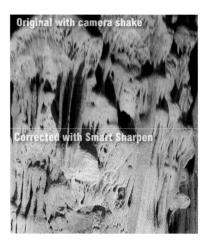

		ancel Preview
() Basic (Advanced
Settings: (Default	: 3
Sharpen Sh	adow High	hlight
Amount	150	%
	1. X	0
Radius	: 6.0	pixels
Remove	: Motion	n Blur 🛟
	Angle: -	82 •
More	Accurate	

Figure 4.49 The Motion Blur method of smart sharpening is reasonably good at improving the sharpness where there is just a slight amount of camera shake or subject movement. The trick is to get the angle in the dialog to match the angle of the motion blur in the picture. Lens Blur options are the most useful, but if you want to achieve optimum results, then do check the More Accurate option below. This will increase the time it takes the filter to process the image. But as they say, all good things come to those who wait, and if you want to get the very best results, then I suggest you leave this checked.

Advanced Smart Sharpen mode

In advanced mode you will get to see two additional tabbed sections marked Shadow and Highlight. The controls in these sections act like a dampener on the main smart sharpening effect. The Fade Amount slider will selectively reduce the amount of sharpening in either the shadow or highlight areas. This is the main control to play with as it will have the most initial impact in reducing the amount of artifacting that may occur in the shadow or highlight areas. Below that is the Tonal Width slider and this operates in the same way as the one in the Shadow/Highlight image adjustment: you use this to determine the tonal range width that the fade is applied to. These two main sliders allow you to subtly control the smart sharpening effect. The Radius also works in a similar way to the Radius slider in the Shadow/Highlight adjustment and is used to determine the lighting conditions of the image. The estimation of the lighting can be done by blurring the luminance channel of the image and the radius setting is one of the parameters of the blurring.

Basic image adjustments

Chapter 4

High Pass filter edge sharpening

The final sharpening technique shown here has the potential to produce quite aggressive sharpening and is therefore more suitable as a technique to be used when sharpening photographs that are destined for print output. Figure 4.48 outlines the basic steps that you need to follow to add a High Pass sharpening layer.

Figure 4.50 In this example, I made a duplicate copy of the Background layer and set the copy layer blend mode to Hard Light (this will temporarily make the image appear very contrasty). I then went to the Filter menu and chose Other ⇒ High Pass... The normal image contrast will now be restored and you can use the Image window to help judge the correct Radius amount to apply. You can modify the High Pass layer by changing the blend mode to Soft Light or try adding a layer mask so that you can apply the results selectively.

Chapter 5

Color Correction

he image adjustment controls discussed in the preceding chapter looked at basic image enhancements. Now we shall get to grips with the fine-tuning aspects of the Photoshop image adjustment controls, and more specifically, the methods for correcting and enhancing color. Color correction is just like tonal correction, but when corrections are applied to individual color channels, these will allow you to affect the color balance in an image. But before all that it helps to understand the relationship colors have to each other. You may find the color wheel shown in Figure 5.1 a useful guide to refer to when applying a color correction. For example, if you want to make a picture less blue, by looking at the diagram you know you will need to add more yellow because yellow is the complementary color of blue.

Variations

The Variations adjustment features an easy-to-use dialog box. It is not an image adjustment tool I use that often, but the Variations interface is perhaps a good starting point for looking at the way color correction works in practice and how this relates to the color wheel diagram shown in Figure 5.1. You can choose to add color in either the shadows, midtones or highlights, making the image more green, more red etc. by clicking on the image color previews in the dialog. You can then select from the darker, lighter and more/less saturated options. You can alter the adjustments incrementally so they can be fine or coarse. If the Show Clipping is checked, you will see a gamut warning alert (usually shown as a gray overlay color) displayed in the previews. This will indicate when you have reached the point beyond which some of the image's color will become clipped. Variations is not bad as a starting tool for beginners, because it combines a range of basic image adjustment tools in a single interface and you can use it to help familiarize yourself with the basic principles of color correction.

Figure 5.1 The Variations dialog displays color balance variations based on the color wheel model. Here you see the additive primaries, red, green, and blue, and the subtractive primaries, cyan, magenta, and yellow, placed in their complementary positions on the color wheel. Red is the opposite of cyan; green is the opposite of magenta, and blue, the opposite of yellow. Use these basic rules to gain an understanding of how to correct color.

Figure 5.2 The Variations interface will enable you to modify the color of the shadows, highlights or midtones separately. For example, clicking on the More Red thumbnail image will cause the red variant to shift to the center and readjust the surrounding thumbnail previews accordingly. Clicking on the More Cyan thumbnail will restore the central preview to its original color balance. In this respect, Variations is just like the Color Balance adjustment, but you also have built in the saturation adjustments and a lighter or darker option. And you can save or load a previous Variations adjustment setting. Variations may be a crude color correcting tool, but it is nonetheless a useful means by which to learn color theory.

Color corrections in RGB

You will note that the instructions for all the color corrections described in this chapter are done using the RGB color mode. This is because RGB is a more versatile color mode for photographers to work in. There are further reasons why I recommend this particular workflow, which I will discuss in more detail in Chapter 13.

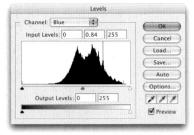

Color balancing with Levels

You can correct color casts by adjusting the input and output sliders in the individual color channels in the Levels dialog. Where you see the pop-up menu next to the channel at the top, mouse down and choose an individual color channel to edit. So let's say you have a picture which looks too blue and you want to add more yellow. Go to the Channel menu and select the Blue channel. Increasing the Blue channel gamma (moving the middle input slider to the left) will make the image more blue. And conversely, decreasing the gamma in the Blue channel will make the image more yellow. Another way to neutralize midtones in the Levels or Curves dialog box is to select the gray eyedropper and click on an area in the image that should be a neutral gray. The levels will automatically adjust the gamma setting in each color channel to remove the cast. Levels may be adequate enough to carry out basic image corrections, but does not provide you with much control beyond reassigning the highlights, shadows and midpoint color values. The best tool to use for color correction is Curves. This is because you can change the color balance and contrast with a degree of precision that is not available with all the other image adjustments.

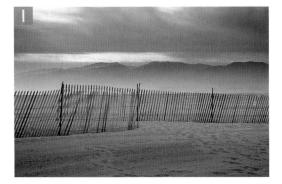

With a photograph like this it is not necessarily a bad thing to have a color cast, but let's say we wanted to apply a basic color correction to the photograph to make it more yellow.

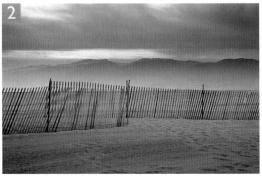

2 I went to the Image menu and chose Adjustments \Rightarrow Levels. I selected the Blue channel from the Channel menu and moved the Input gamma slider to the right. This decreased the gamma in the blue channel and made the midtones in the photograph more yellow.

Color Balance

The Color Balance is a sort of blind curves adjustment tool. A lot of Photoshop users are instinctively drawn to the Color Balance image adjustment because it looks intuitive enough to make color adjustments with, but in truth it is no better than the Variations adjustment and not really the most useful tool for correcting color. Even if you have the Preserve Luminosity box checked, a Color Balance adjustment still has the potential to mess up the tonal detail in the shadows and highlights. If you are able to follow the later tutorials which show how to use Curves adjustments to correct color accurately, then you might as well disregard Color Balance. Although I do find the Color Balance is handy if you want to tone black and white photographs.

Color blend mode

If you want to apply a Color Balance adjustment so that it really does preserve the luminosity and affects the color only, there are two ways you can do this. Choose Edit \Rightarrow Fade Color Balance and change the blending mode to Color. The other method is to apply the Color Balance as an Adjustment layer and set the layer blending mode to Color.

1 The Color Balance adjustment allows you to adjust the color separately in the shadows, midtones and highlights. The color correction principles here are identical to those in the Variations dialog.

2 If you use Color Balance for making fine-tuned adjustments, keep the Preserve Luminosity box checked. If you are making extreme color adjustments and it is not checked you may get posterized-looking results. But even when it is checked, you will notice that you have limited control over the image tonal balance when making a Color Balance adjustment.

	Color Balance		
– Color Bala Color Cyan Magenta Yellow	Levels: +35 +3 -16	Red Blue Green	OK Cancel Preview
- Tone Bala O Shadows Preserve	Midtones O Highli	ghts	

Figure 5.3 The Auto image adjustments discussed here and shown on the page opposite can also be accessed when you click on the Options... button in the Levels or Curves dialogs. If Snap Neutral Midtones is selected, Auto Color will also neutralize these. You can customize the Clipping values to set how much the highlights and shadow tones are clipped by the image adjustment.

PhotoKit Color gray balancing

In the previous year I was the project manager for a new Pixel Genius plug-in called PhotoKit Color. PhotoKit Color contains a set of gray balancing effects which provide effective automatic color balancing with most images. The RSA Neutralize is especially good at the automatic removal of heavy color casts. www.pixelgenius.com/color/

Auto adjustments

The Image \Rightarrow Adjustments menu contains three auto image adjustment tools: Auto Levels, Auto Contrast and Auto Color. These are designed to provide automated tone and color correction.

The Auto Levels adjustment works by expanding the levels in each of the individual color channels, to fully optimize them. This per-channel levels contrast expansion will always result in an image that has fuller tonal contrast. But it may also change the color balance of the image as well. Auto Levels can produce improved results, but sometimes not. So if you want to improve the tonal contrast without affecting the color balance of the photograph then try using the Auto Contrast adjustment instead. This will carry out a similar type of auto image adjustment as Auto Levels, except it will optimize the contrast by applying an identical levels adjustment to all the color channels.

Lastly, there is the Auto Color adjustment. This provides a combination of Auto Contrast to enhance the tonal contrast, combined with an auto color correction which maps the darkest colors to black and the lightest colors to white.

If you open the Levels or Curves dialogs you will see an Options... button at the bottom. Click on this and you will see the Auto Color Correction Options shown in Figure 5.3. The algorithms listed here match the auto adjustments. Enhance Per Channel Contrast is the same as Auto Levels. Enhance Monochromatic Contrast is the same as Auto Contrast and Find Dark & Light Colors is the same as Auto Color. But notice there is also a Snap Neutral Midtones option. When this is checked, a gamma adjustment is applied in each color channel which aims to correct the neutral midtones as well as the light and dark colors. A clipping value can be set for the highlights and shadows and this will determine by what percentage the endpoints get automatically clipped.

Auto Levels (Enhance Per Channel Contrast)

Auto Contrast (Enhance Monochromatic Contrast)

Figure 5.4 These photographs show the three auto adjustment methods (with the equivalent descriptions, as they are also described in the Levels and Curves dialogs).

Auto Levels optimizes the shadow and highlight points in all three color channels. This will generally improve the contrast and color balance of the image. Auto Contrast will apply an adjustment across all three channels that will increase the contrast, but without altering the color balance. The Auto Color option will map the darkest and lightest colors to a neutral color. (If the swatch colors shown in Figure 5.3 have been altered, you may see a different result.) And lastly, an Auto Contrast adjustment followed by a PhotoKit Color RSA Gray Balance Fine effect has been applied.

Auto Color (Find Dark & Light Colors + Snap Neutral Midtones)

Auto Contrast + PhotoKit Color RSA Gray Balance Fine

Before

Finding a neutral RGB value

If you are editing an image in RGB mode and using one of the standard RGB color spaces such as Adobe RGB, sRGB, ColorMatch RGB or ProPhoto RGB you can use the eyedropper or color sampler tool to match the RGB values so that if red = green = blue, the resulting color will always be a neutral gray (see Figure 5.5).

Info			
R:	179	C :	40%
X.G:	179	.∦M:	25%
B:	179	Y :	25%
		K:	5%
8-bit		8-bit	
. X:	9.39	→ W:	
+, X:	10.71	LT H:	
		nove layer or degree increr	

Figure 5.5 The Info palette can be used to read color information which helps determine whether the colors are neutral or not regardless of any monitor inaccuracies. Equal values of R, G, and B will produce a neutral gray tone.

Precise color correction with Levels

Of all the color correction methods described so far, Auto Color provides the best automatic one-step tone and color correction method (although because of my personal involvement in PhotoKit Color, I have a personal bias to using my own product for auto gray balancing!). But if you prefer to do all your color corrections manually, then I would recommend you forget Variations and Color Balance and explore using Levels and Curves color channel adjustments. In the previous chapter I introduced you to using the Levels image adjustment to determine the highlight and shadow points followed by a gamma adjustment to lighten or darken the image. To keep things simple I used a monochrome image. Let's now take this technique of adjusting the shadows, highlights and midpoint of the composite image and apply this knowledge when editing the individual color channels.

The example here shows how you can use the threshold mode analysis technique discussed in Chapter 4 to discover where the shadow and highlight endpoints are in each of the three color channels and use this feedback information to set the endpoints accordingly. This is a really good way to locate the shadows and highlights and set the endpoints at the same time. Then use the Levels gamma adjustment technique discussed on page 194 to correct for any cast in the midtones.

 $\fill This photograph has a red cast in the shadows, a yellow cast in the highlights. The first step is to go to the Image <math>\Rightarrow$ Adjustments menu and choose Levels...

2 I went to the Channel menu and selected the Red channel and adjusted the Shadow and Highlight input sliders until the red shadow and highlight points were set just to the point where they started to clip. If you hold down the end and key as you do this you will see the threshold display mode shown here which will help you locate the shadow and highlight points more easily. I then repeated these steps with the Green and Blue channels until I had adjusted the shadow and highlight points individually in all three color channels.

³ This technique of adjusting the color channels one by one will help you remove color casts from the shadows and highlights with a lot of precision. The trick is to use the threshold mode display as a reference tool to indicate where the levels start to clip in each channel and consider backing off slightly, so that you leave some headroom in the composite/master channel to make general refinements to the Levels adjustment, ensuring that the highlights do not blow out (as discussed in Chapter 4). And finally, I adjusted the Gamma slider in the Blue channel to add a little more yellow.

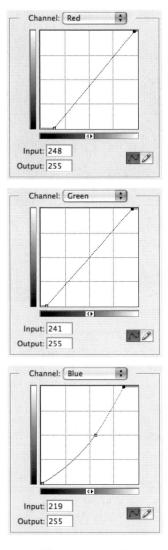

Figure 5.6 If you wanted to apply the image adjustment made to the photograph on the preceding pages using Curves instead of Levels, this is how the individual channel curves would have to be applied.

Precise color correction with Curves

The Levels adjustment technique is quite effective in correcting the color at the shadows, highlights and midtones. And in fact, the Auto Color image adjustment is doing exactly the same thing, but doing so automatically. And since Auto Color adjustments can be done in both Levels and Curves, we can just as easily apply the image adjustment made in the last example as a curve (see Figure 5.6).

So, if Levels enables you to make a precise color corrections, then Curves must surely enable you to make even more precise color corrections. As a general rule, once you have corrected for a cast in the highlights and then the shadows, everything else mostly falls into place. And a further tweak to the midtones is maybe all you need. But there are still plenty of situations where you might wish to exploit the full potential of a Curves adjustment in order to gain the maximum amount of control over the way you modify the colors in an image to improve the color appearance. Let's look at how to make a Curves adjustment based on a sample analysis of the colors in an image.

To add a new color value as a control point on the curve, **H** *ctrl*-click inside the document window and you will see a control point appear on the corresponding portion of the curve. If you hold down H Shift ctrl Shift and click in the document window, Control points will be automatically added to all three color channels at once. So when adding control points to color correct the white shirt image example that follows on page 202, I 😤 Shift *ctrl Shift*-clicked on top of each of the color sampler points to add these as control points in all three color channels in the Curves dialog. When you are editing the points in the Curves dialog, use Shift -click to select multiple points. As you adjust one control point the others will move in unison. To deselect all the points, use **HD** ctrl **D**. When a single point is selected you can select the next point using *Tab ctrl Tab* right mouse and you can select the previous point by using Tab Shift ctrl Tab Shift right mouse.

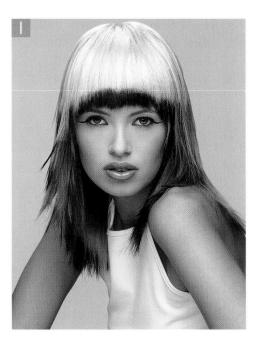

¹ The above photograph has a cold blue cast. This is particularly noticeable in the backdrop, which should be a neutral gray. I went to the Image ⇒ Adjustments menu and chose Curves... this opened the Curves dialog and I was able to get rid of the cast in stages by adjusting the shape of the curve in the individual color channels.

2 This shows you the curves corrected version. The main Curves dialog allows you to make tonal corrections to the composite color channel (in this case, the RGB composite channel). I first selected the red color channel from the Channel menu and added a couple of control points to the curve to adjust the color balance for the midtones and highlights. I then went to the Blue channel and added two points to the curve, this time to correct the color for the shadows and highlights in the Blue channel. I applied these corrections based on appearance and what would make the image look right. The next example illustrates how you can carry out a more accurate, measured correction.

Client: Anita Cox Salon.

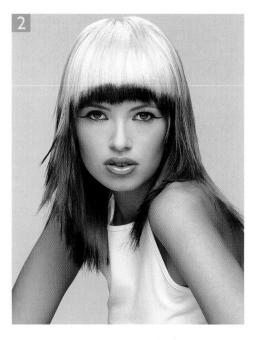

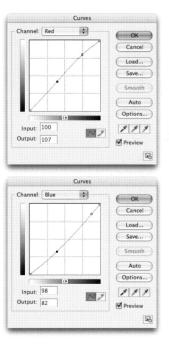

Martin Evening Adobe Photoshop CS2 for Photographers

1 Whenever you have something white photographed against a white or gray background, any color cast will be extremely noticeable. To begin with I selected the color sampler tool and clicked on the image at three different places on the model's white jacket. With each click I positioned a new persistent color sampler readout and the readout values are displayed in the Info palette. The intention here was to measure the color at different points of lightness so that these measurements could be used to calculate a precise curves adjustment.

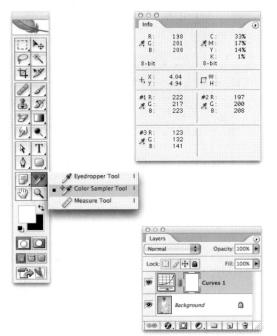

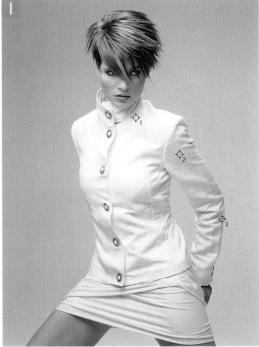

2 The color sample points can be repositioned as necessary by dragging on them with the color sampler (you can access the tool while in an image adjustment dialog, by holding down the Shift key). Now that the color sampler readouts were in place, it was time to add a Curves adjustment layer above the Background layer. With the Curves dialog open, I zoomed in to get a close-up view of the jacket where the points had been placed and Shift orth Shift orth Shift orth Shift orth Shift orth Shift orth Shift add a corresponding curve control point on the individual channel curves. When I inspected the Red, Green and Blue channels in the Curves dialog I could see three points had been added to each channel.

Client: Alta Moda. Model: Nicky Felbert @ MOT.

³ Here is an example of a Curves adjustment made to the three channels using the information provided in the Info palette. The first RGB readout figure indicates the original Input value. At each point I would look at the numbers and decide which of these represented the median value. I would then adjust the points in the other two channels so that the other two output values matched the median value. One can manually drag the point or use the keyboard arrows (Snift) arrow key moves the control points in multiples of 10) to balance the output value to match those of the other two channels.

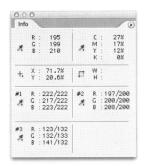

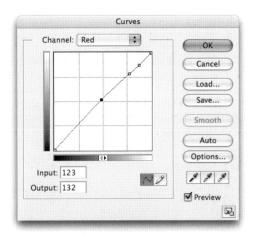

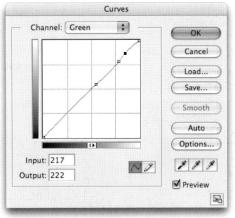

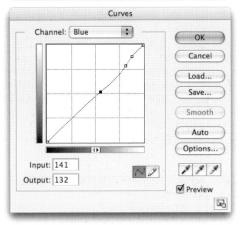

Arbitrary Map mode

If you click on the Arbitrary Map mode button in the Curves dialog, you can sketch in the grid area with the pencil cursor to create a freehand curve map shape. The initial results are likely to be quite repulsive, but if you click on the smooth button a few times you will see the curve becomes less jagged and the tonal transitions will then become more gentle. Another example of an Arbitrary Map mode curves adjustment can be found in Chapter 8 on darkroom effects.

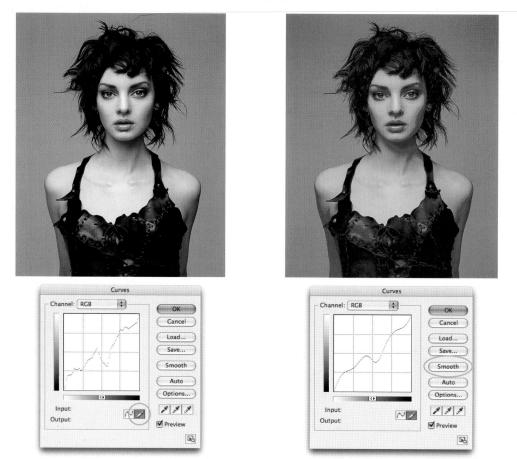

Figure 5.7 If you click on the Arbitrary Map button in the Curves dialog, you can draw a freehand curve shape like the one shown here. Click on the Smooth button to produce a gentler effect.

Client: Anita Cox Salon. Model: Sorcha, Bookings.

Photo Filter

One of the advantages of shooting digitally is that most digital cameras will record a white balance reading at the time of capture and this information can be used to automatically process an image either in-camera or using Camera Raw in Photoshop to produce an improved color balance. But if you are shooting with color film, then the only way to compensate for fluctuations in the color temperature of the lighting is to use the right film (daylight or tungsten balanced) and, if possible, use the appropriate color compensating filters.

The Photo Filter can be found in the Image \Rightarrow Adjustments menu and the adjustment layer menu in the Layers palette. The Photo Filter adjustment offers a preset range of filter colors, but if you click on the color button, you can select any color you like after clicking on the color swatch and modify the Density to adjust the strength of the filter.

Color Temperature

Color Temperature is a term that links the appearance of a black body object to its appearance at specific temperatures, measured in degrees Kelvin. Think of a piece of metal being heated in a furnace. At first it will glow red but as it gets hotter, it emits a yellow and then a white glow. Indoor tungsten lighting has a low color temperature and is warmer than sunlight which emits a cooler, bluer light.

Use	(m	ОК
• Filter:	Warming Filter (81)	Cancel
O Color:		Preview
Density:	35 %	

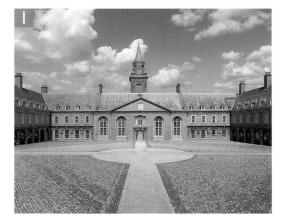

This photograph was shot using 35 mm transparency daylight film, balanced for a color temperature of 5500 K. The color temperature was clearly higher when the photograph was taken, hence the blue cast.

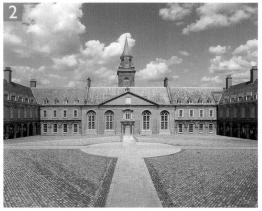

2 To improve the photograph, I chose Image \Rightarrow Adjustments \Rightarrow Photo Filter. By mousing down in the Filter pop-up menu, I could select a preset filter color to apply to the image. In this case, I chose a Warming Filter (81) at a density setting of 35%.

Matching color and lighting across images

The Match Color image adjustment can be used to sample and match the colors from one image to another or match the color of a specific object from another shot in the same series. For example, one can use Match Color to ensure that an important product is always reproduced the same in different shots throughout a publication. Or you can use it to sample and match colors within the same image. Let me illustrate the last example by taking a photograph used for a ballet poster and match the colors from the dress of the ballerina with the pyjamas of the two dancers.

The Match Color adjustment works by taking the image data from the sample image or sample selection area and converts this to a separate, high-precision perceptual color

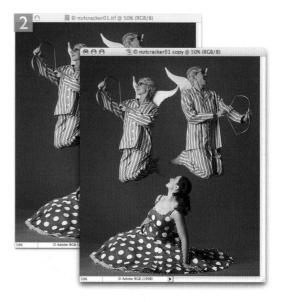

The first step is to create a duplicate of the master image. This is because one needs to have an image to sample colors from and an image to apply the correction to. In the original image window I have made a marquee selection of the pyjama colors that I want to sample from in the original image window. 2 In the Duplicate window I made a selection of the ballerina's blue dress. We now have an active selection in both window views. I selected the copy image window, the one with the ballerina selection and chose Image \Rightarrow Adjustments \Rightarrow Match Color.

space made up of Luminance and two color components. Match Color aims to transfer the image statistics taken from the source image or selection area and then apply them to the active, target image or selection area so that eventually the colors in the target will match the colors sampled from the source.

Match Color can also work quite effectively if you have two images taken of the same subject and you simply want to match the lighting color between the two images. It is less good at matching dissimilar photographs, because the reference source needs to have something in common with the target.

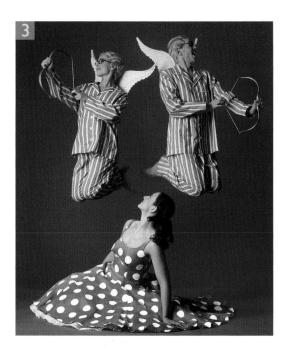

Destination Image Target: nutcracker01 copy	(RCB/8)	ОК
	when Applying Adjustm	ent Cancel
- Image Options	inten rippiying risjustin	Previe
Luminance	100	- Binen
Color Intensity	100	
Fade	0	
Neutralize		
Image Statistics		
Use Selection in	Source to Calculate Colo	ors
Use Selection in	Target to Calculate Adju	stment
Source: nutcracker01.tif		
Layer: Background		
Load Statistics		
Save Statistics		A State of the second

3 There are two sections in the Match Color dialog. The upper section allows you to control the color conversion settings. The lower section is where we can select the source for the Color Match conversion. I moused down and selected the original image window as the source. Notice that we have the two options above checked here. One says: Use Selection in Source to Calculate Adjustment. And also: Use Selection in Target to Calculate Adjustment. If both these boxes are checked you will then see a preview of the calculated adjustment in the target document window. When I did this the color of the dress matched the color of the pyjamas.

Photograph: Eric Richmond.

Martin Evening Adobe Photoshop CS2 for Photographers

	Match Color	
Destination Image Target: tobago-uw001.tif (F		Cancel
Ignore Selection w Image Options	when Applying Adjust	trnent Preview
Luminance	100	e Previes
Color Intensity	100	
Fade	0	
Neutralize		
Image Statistics		
Source: None Layer: Background	:	
(Load Statistics)	1000 343	

Figure 5.8 The Match Color image adjustment is also a useful image correction tool in its own right. In this extreme example, I used the Match Color adjustment with the Neutralize button checked, to help reduce the color cast in this underwater photograph.

Coloring effects with Match Color

One can also use the Match Color adjustment in a creative way to sample colors from various source images and save the Match Color statistics as Match Color settings (that will have a .sta extension). You can load saved Match Color statistic settings or use any currently open images as a source and apply these to a completely different image to produce sometimes interesting but often weird and unnatural looking results.

The Image Options let you modify the Color Match result after you have decided on the Source and Target image settings. The Luminance and Color Intensity sliders will prove useful in allowing you to fade the amount of adjustment or compensate the color intensity to get an ideal color match between two images.

As you will have seen in the previous step-by-step example, it often helps to make a selection of the areas of interest in both the source and target images. When you use selections in this way, you will need to use the Selection in Source to Calculate Colors and Use Selection in Target to Calculate Adjustment options in the Match Color dialog.

Finally, the Match Color image adjustment also functions as an Auto Color correction tool for extreme images wherever there is a heavy color cast. As you can see in Figure 5.8, Match Color can sometimes be effective at removing a deep blue/cyan cast from underwater photographs, although this can be at the expense of producing an image with less overall saturation.

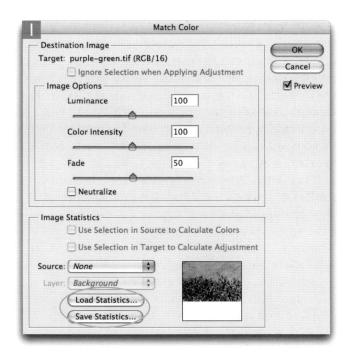

1 Match Color can be used as a tool for applying creative color effects. I opened an image in Photoshop, chose Image \Rightarrow Adjustments \Rightarrow Match Color and clicked on the Save Statistics button to save out a Match Color statistics setting.

2 I then opened the image on page 196 and opened the Match Color dialog again and clicked on the Load Statistics... button. I selected the previously saved Match Color setting, set the Fade to 50% and clicked OK.

Creating a Color Match library

If you like the idea of using this technique then you should perhaps consider creating your own library of Match Color statistics settings. Open up a bunch of images and save out different Match Color settings which you can then call upon at any time to apply to an image or a selection within an image.

Martin Evening Adobe Photoshop CS2 for Photographers

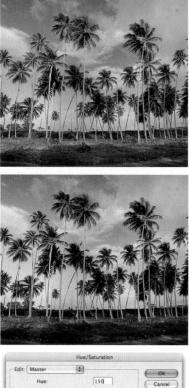

Hue:	150	Cancel
Saturation:	0	Load
Lightness:	0	
	11	Colorize

Figure 5.9 This is an extreme example of how a Hue/Saturation adjustment can be used to radically alter the appearance of a photograph. As you move the Hue slider left or right the colors in the image will be mapped to new values. You get an indication of this transformation by looking at the two color ramps at the bottom of the dialog. The top one represents the original 'input' color spectrum and the lower ramp represents how those colors will be translated as output colors.

Hue/Saturation

The Hue/Saturation dialog controls are based around the HSB (Hue, Saturation, Brightness) color model, which is basically an intuitive form of the Lab Color model. When you select the Hue/Saturation image adjustment you can alter these components of the image globally, Or, you can selectively apply an adjustment to a narrow range of colors. The two color spectrum ramps at the bottom of the Hue/Saturation dialog box provide a visual clue as to how the colors are being mapped from one color to another. The hue values are based on a 360 degree spectrum. Red is positioned mid-slider at 0 degrees. All other colors are assigned numeric values in relation to this, so cyan (the complementary color of red) can be found at either minus180 or +180 degrees. Adjusting the Hue slider only will alter the way color in the image will be mapped to a new color value. Figure 5.9 shows extreme examples of how the colors in a normal color image will be mapped by a Hue adjustment only. As the Hue slider is moved you will notice the color mapping outcome is represented by the position of the color spectrum on the lower color ramp. Saturation adjustments are easy enough to understand. A plus value will boost saturation, a negative value will reduce the saturation. Outside the Master edit mode, you can choose from one of six preset color ranges with which to narrow the focus of the Hue/Saturation adjustment. Once in any of these specific color ranges, a new color value can be sampled from the image window, around which to center a Hue/Saturation adjustment. *Shift*-click in the image area to add to the color selection and **C** alt -click to subtract colors (see page 211).

When the Colorize option is switched on, the hue component of the image is replaced with red (hue value 0 degrees), lightness remains the same at 0% and saturation is 25%. Some people recommend this as a method of obtaining a colored monochrome image, but there are better ways of achieving this, which are outlined later in Chapter 8 on darkroom effects.

1 The Edit menu in the Hue/Saturation dialog box defaults to the Master setting, and any adjustments will affect all the colors in an image. If you mouse down on the Edit menu you can narrow the Hue/Saturation adjustment to specific colors. If I select Greens, I can enhance or subdue the saturation of the green color component of the image. And I can shift the green colors so that they become more yellow and less cyan.

2 As you can see, if I move the Hue slider to the left, I can make the green leaves turn more yellow and rapidly change the seasonal appearance of the photograph. You can also be very specific as to which colors are selected. In this example I clicked on the standard eyedropper in the Hue/Saturation dialog and clicked on a leaf in the picture to set this as the target green color to change (the two vertical markers creating the gap in the middle of the sliders represent the chosen color range to modify and the spaces defined by the outer triangular markers represent the fuzziness drop-off either side of the color selection). I then added to the color selection by selecting the Add to Sample eyedropper (circled) and clicked to add more color sample points to the Hue/Saturation adjustment color range.

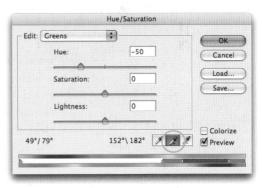

Color replacement brush

The color replacement brush is suitable for use as a color aware painting tool for making localized color changes. The steps shown here were done using the Color mode. This modifies the pixels, replacing the color and saturation with that of the foreground color. The Hue and Saturation modes are also useful if you want to modify these color components individually.

Tolerance: 30% 🕨 🗹 Anti-alias

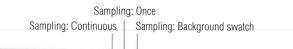

Limits: Contiguous

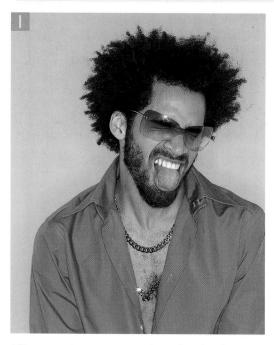

Mode: Color

1 There are various ways one can change the color of an object. The color replacement brush offers a simple easy-touse solution. I began by selecting it from the Tools palette (note that it is now grouped with the paint brush and pencil tool in Photoshop CS2).

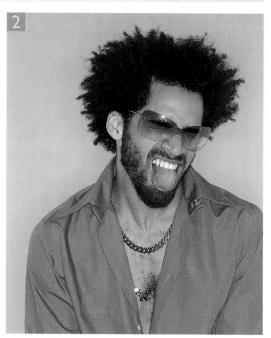

MA P

2 I wanted to change the color of the purple shirt. I doubleclicked the Foreground color in the Tools palette. This opened the Color Picker dialog and I selected a dark yellow as the new foreground color. The color replacement brush was set to work in Color mode with the sampling set to Once, which meant that the brush would start replacing the color based on the color of the pixels I clicked on first.

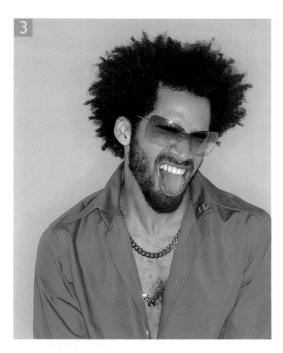

3 The color replacement brush limits in the Tool Options bar were set to Contiguous. This meant that I was able to use the brush to click and paint over the left-hand side of the shirt in one action. Because the shirt was undone, there were no contiguous pixels to allow me to carry on painting the other side of the shirt. So I clicked again and painted with the brush to complete the color replacement.

As was explained on the previous page, you can also use the Hue/Saturation image adjustment to make selective color corrections. In this example, I added a new Hue/Saturation image adjustment layer, selected Reds from the Edit pop-up menu and adjusted the red component of the underlying image such that the skin tones were made more yellow and less saturated.

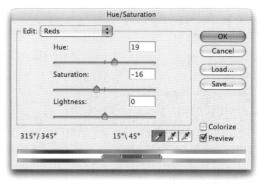

Client: Anita Cox salon.

In Sample Once mode, the color replacement will be based on where you first click and only the pixels within the specified tolerance will be modified. As with the magic wand, the tolerance setting determines the tonal range of pixels that will be modified. In Continuous mode, the sample source is updated as you drag through the image. In some instances this mode can produce smoother results, but as you drag, take care that the cursor cross-hair doesn't stray outside the area you are modifying.

Limits can be set for the color replacement too. In this example the Contiguous mode limits the tool's application to the pixels that are within the tolerance range and are also adjacent to each other. In Discontiguous mode you can paint beyond isolated groups of pixels. If you refer back to the forest images on page 211, you would need to use the color replacement brush in Discontiguous mode in order to bring about a similar color transformation of all the leaves.

Martin Evening Adobe Photoshop CS2 for Photographers

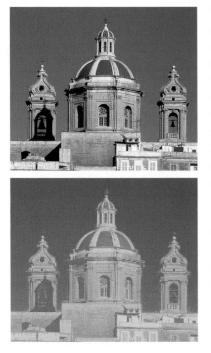

Figure 5.10 To use Color Range, click in the document window or dialog preview to sample a color on which to base your selection. The Fuzziness control is like the Tolerance control in the magic wand options. Click on the plus or minus eyedroppers to add or remove colors from the selection. The dialog preview can either display the original image or preview the selection as a mask. The Selection Preview can allow you to view the selection represented as a Quick Mask.

Photograph: Rod Wynne-Powell.

Color Range

The Color Range is not an image adjustment tool, but a color-based selection tool. Where the magic wand creates selections solely based on luminosity, the Color Range option creates selections that are based on color values which are similar to the sample pixel color. And the beauty of Color Range is that you can dynamically adjust the tolerance amount within the dialog. The only drawback is that a Color Range selection tool can only be used to make discontiguous selections. But it is possible to make a selection first of the area you wish to focus on and then choose Color Range to make a color range selection within the selection area.

To make a Color Range selection, first choose Select \Rightarrow Color Range. To add a color to a Color Range selection, select the Add to Sample eyedropper and click in the image window to add. To subtract from a selection, click on the Subtract from Sample eyedropper and click in the image to select the colors you want to remove from the selection. And then adjust the Fuzziness setting to adjust the tolerance of the selection to increase or decrease the number of pixels that will be selected. The selection preview in the document window can be None (the default) or Quick Mask (as shown in Figure 5.10) or Grayscale or Matte color. The Grayscale is a really useful preview mode if you want to get a nice large view in the document window of what the Color Range/mask will look like.

Among other things, you can use the Color Range command to make a selection based on out-of-gamut colors. This means you can use Color Range to make a selection of all those 'illegal' RGB colors outside the CMYK gamut and apply corrections to these pixels only. This task is made easier if you feather the selection slightly and hide the selection edges (View \Rightarrow Hide Extras). Then choose View \Rightarrow Gamut Warning. Adjustments can be made using the Selective Color or Hue/Saturation commands. Local areas may also be corrected with the sponge tool set to Desaturate.

Chapter 5 Color correction

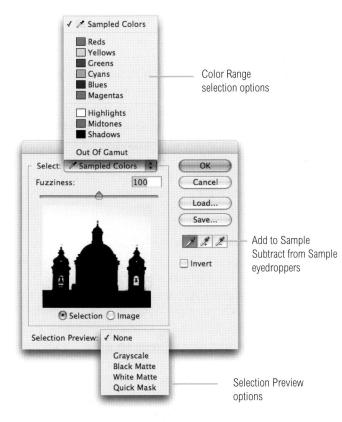

Figure 5.11 The Color Range dialog with expanded menus showing the full range of options that are available. The Grayscale preview mode is especially useful if you find the small Color Range dialog preview too small.

Replace Color

The Replace Color command is really like a combination of the Select ⇒ Color Range and Hue/Saturation command. With Replace Color, you can select a color or range of colors, adjust the fuzziness of your selection and apply the Hue/Saturation adjustments to those selected pixels only. Alas, the selection made this way is not savable. The Replace Color command has its uses. For example, if you want to correct out-of-gamut colors, before converting to CMYK, then you could use the Replace Color adjustment to adjust the out-of-gamut preview image.

Info			0
R:	220	C :	14%
A. G :	203		25%
B:	187	Y :	27%
		K:	1%
8-bit		8-bit	
. X:	3.34		
Ti Y :	3.28	H H	

Figure 5.12 When you are retouching a portrait, you can use the Info palette CMYK readout numbers to help judge if the skin tones are the right color. Set the palette options to display RGB and CMYK readouts. Using the eyedropper, Caucasian skin tones should have roughly a third or a quarter as much cyan as magenta and slightly more yellow than magenta. Black skin tones should be denser, have the same proportion of cyan to magenta, but usually a higher amount of yellow than magenta and also some black.

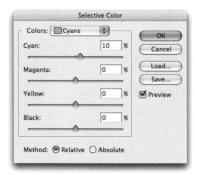

Figure 5.13 The Selective Color dialog.

Figure 5.14 Out-of-gamut color correction can be achieved using the Hue/Saturation adjustment to selectively (and smoothly) adjust the out-of-gamut colors. The Gamut warning shown here will also help indicate which colors remain out of gamut. Gamut warning tells you what is out of gamut, but not by 'how much'. It is therefore of limited use. Soft proofing, which is covered in Chapter 13, is a better solution.

Selective Color

The Selective Color command is more suited for adjusting CMYK images. It allows you to selectively fine-tune the color balance in the additive and subtractive primaries, blacks, neutrals and whites. Unlike the Hue/Saturation image adjustment, the Selective Color adjustment has fixed settings for selecting the reds, greens, blues, cyans etc. Selective Color may sometimes be useful for tweaking CMYK images, but you are otherwise better off using the Hue/Saturation image adjustment when editing RGB images. A Relative percentage change will proportionally add or subtract. So if you have a cyan value that is currently 40% adding a Relative 10% will equal 44%. Adding an Absolute 10% percentage change will make the new value 50%.

Adjusting out-of-gamut colors

If the colors in an image appear oversaturated and likely to clip when converted to CMYK, try creating a new window view of the image and choose View \Rightarrow Gamut Warning. Then use the Hue/Saturation adjustment. As you bring the colors back into gamut, the gamut warning will disappear, indicating the image colors are now in gamut.

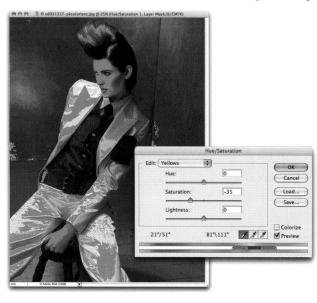

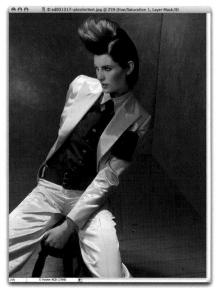

The essential adjustment tools

Hopefully this chapter and the previous one will have helped teach you the basics about making image adjustments and color corrections. As you can see, there are a lot of tools to choose from in the Image \Rightarrow Adjustments menu. But a lot of these adjustment tools are essentially doing the same thing. In many cases all you are using is a different type of interface to manipulate the image pixels. And you will also have learnt which ones are in fact the most essential. If I had to pick the top four tools I could not live without and use all the time, it would be (in descending order): Levels, Curves, Hue/Saturation and Shadow/Highlight. The only one I have not discussed yet is the Channel Mixer. I use this mainly for converting color images to black and white and I'll be covering this and other darkroom type effects in Chapter 8.

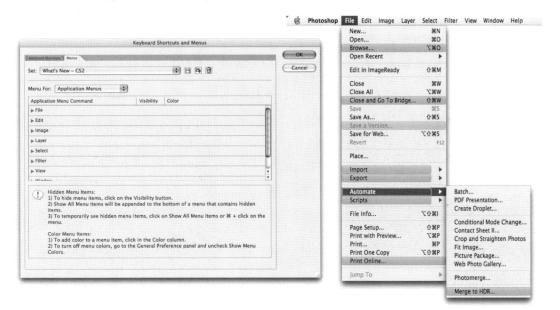

Figure 5.15 In Photoshop CS2 you can customize the way the Photoshop menus are displayed. You can use the Edit menu to open the Keyboard Shortcuts and Menus dialog shown here and create your own custom menu layouts in which important tools are color coded and less important items can be hidden. In this example I went to the Window \Rightarrow Workspace menu and selected the What's new in Photoshop CS2 Workspace setting.

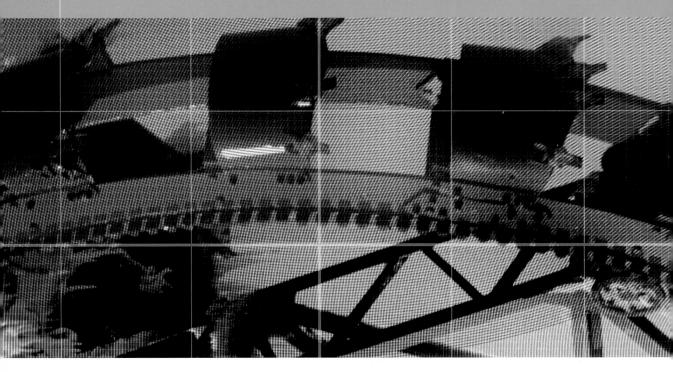

Chapter 6

Repairing an image

ost photographers are interested in the potential of using Photoshop as a tool for retouching pictures. So we shall start with simple techniques like cloning and then go on to explore some other advanced methods that can be used to clean up and repair damaged photographs. The clone stamp is a popular retouching tool even if it is a little difficult to master. But the healing brush and patch tool can make Photoshop retouching so much easier to accomplish. The healing brush in particular can always be guaranteed to impress!

Basic cloning methods

The clone stamp tool and healing brush are the most useful tools to apply at the beginning of a retouch session. Both tools work in a similar way. Hold down and click to select a source point to clone from. Release the select a source point to clone from. Release the select a click or drag with the mouse. If you want to clone to and click or drag with the mouse. If you have the tool set to aligned mode, this establishes a fixed relationship between the source point and the destination. If the tool is set to non-aligned mode then the source point will remain fixed, returning to that spot after each application of the clone stamp brush.

I find it more convenient to use the clone stamp tool in aligned mode and the healing brush in non-aligned mode. When I use the clone stamp I like to preserve the relationship between source and destination, apply a few clones, then sample a new source point and continue cloning. When I use the healing brush tool I prefer to use the non-aligned mode because this allows me to select a source point that contains the optimum texture and reference the same source point as I apply the healing brush.

As with all the other painting tools, you can change brush size, shape and opacity to suit your needs. While you may find it useful working with different combinations of these settings with the painting tools, the same does not apply to the clone stamp tool. Typically you want to stick to using the fine to medium-sized brushes (just as you would always choose a fine paintbrush for spotting bromide prints). When cloning over an area where there is a gentle change in tonal gradation, it will be almost impossible to disguise your retouching work, unless the point you sample from and the destination point matches exactly in hue and lightness. In these situations you will be better off using the healing brush, which is described later in this chapter.

Use All Layers

The 'Use All Layers' option is useful if you want to make sure that your retouching is always stored on a separate layer. Firstly, create a new empty layer above the Background layer, select the clone stamp tool and check the Use All Layers button in the Options bar. Make sure the empty new layer is kept active and as you carry out all your spotting. This technique will allow you to spot an image without altering the underlying image layer in any way. It could even be a useful way of proving to a client how much retouching work you had to do!

Figure 6.1 If you are carrying out any type of retouching work which relies on the use of the paint tools, a pressure sensitive tablet and pen such as the Wacom shown here, are an absolute must.

Martin Evening Adobe Photoshop CS2 for Photographers

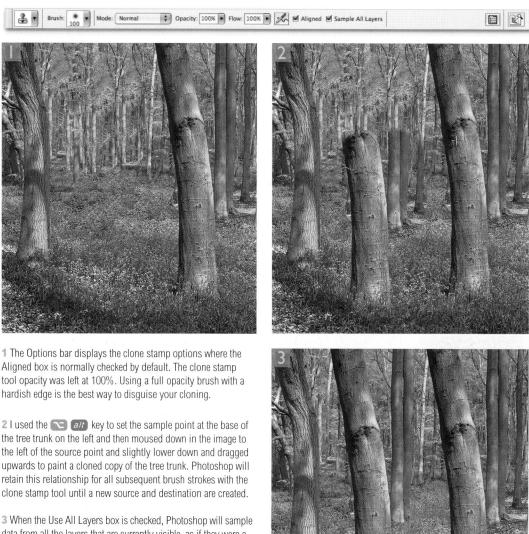

data from all the layers that are currently visible, as if they were a single flattened layer. So by adding a new layer at the beginning I was able to keep all the clone retouching on this one separate layer.

Repairing an image

Chapter 6

Figure 6.2 You can sample the sky from one image window and copy it to another separate image using the clone stamp. Just S all-click with the clone stamp in the source (sky) image, then select the other image window and click to

100%. Cloning at less than full opacity usually leads to telltale evidence of cloning. Where the film grain in the photograph is visible, this can lead to a faint overlapping grain structure, making the retouched area look slightly blurred or misregistered. When smoothing out skin tone shadows or blemishes, I will occasionally switch to an opacity of 50% or less. Retouching light soft detailed areas means I can get away with this. Otherwise stick to 100%. And for similar reasons, you don't want the clone stamp to have too soft an edge; ideally make the clone stamp brush shape have a slightly harder edge.

establish a cloning relationship between the source and destination images.

Figure 6.3 When you have the clone stamp tool selected and the Aligned box in the Tool options is unchecked, the source point will remain static and each application of the clone stamp will make a copy of the image data from the same original source point.

Alternative history brush spotting technique

This method of spotting a photograph has evolved from a technique that was first described by Russell Brown, Senior Creative Director of the Adobe Photoshop team. It revolves around using the Remove Dust & Scratches filter, which is found in the Filter \Rightarrow Noise submenu. If this filter is applied globally to the whole image, you will end up with a very soft-looking result. You are actually only meant to apply this filter selectively to the damaged portions of a picture in Photoshop. The technique shown here has the advantage of applying the filtered information via the history brush in a way that only the offending pixels which are considered too dark or too light will be painted out. This modified approach to working with the Dust & Scratches filter avoids destroying the tonal values in the rest of the picture.

As you can see, this technique works well when you have a picture that is very badly damaged and where using the clone stamp would be a very tedious process. What is really clever is the way that the history brush is used in Lighten or Darken mode so that Photoshop can be made to target replacing specific pixels. However, you may encounter a problem if the photographic original contains noticeable film grain. To counteract this it may help to apply a small amount of noise after you have applied the Dust & Scratches filter. Add enough noise to match the grain of the original (usually around 2-3%). This will enable you to better disguise the history brush retouching.

1 This photograph serves as a good example with which to demonstrate the history brush spotting technique, as there are a lot of hair and scratch marks that are clearly visible in this picture.

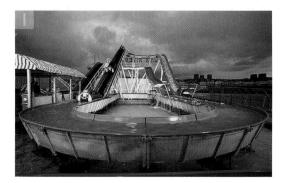

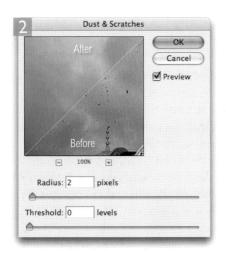

3 I then went to the History palette and clicked on the previous unfiltered image history state, but set the history brush source to paint from the filtered version. I selected the history brush and changed the history brush blending mode in the tool Options bar to Lighten. As I painted over the dark spots, the history brush would lighten only those pixels that were lighter than the sampled history state. All other pixels remained unchanged.

4 I continued using the history brush in this way. To remove light spots, changing the tool blending mode to Darken to remove the darker blemish marks.

Healing brush settings

The default mode for the healing brush has the Aligned box unchecked. This makes sense, because when you are using the healing brush to retouch the texture from a specific area and copy it across to other areas, you ideally want the sample point to always be made from the same source point.

Heal using 'All Layers'

When the Use All Layers box is checked in the healing brush tool options you can apply the healing brush to a separate layer. But be warned, if you work with large images in 16-bit mode, this may cause a potential slowdown in Photoshop's performance. You will need a fast computer in order to take full advantage of this flexibility.

Healing brush

The healing brush is used in the same way as the clone stamp tool, although it is important to stress that the healing brush is more than just a magic clone stamp and has its own unique characteristics. Although similar to the clone stamp, you will need to take these differences into account and adapt the way you work with it. You establish a pixel sample point by alt-clicking an area of an image to sample from. Release the although key and move the cursor over to the point where you want to clone to and click or drag with the mouse to carry out your healing brush retouching.

The healing brush performs its magic by sampling the texture from the source point and blending the sampled texture with the color and luminosity of the pixels that surround the destination point. For the healing brush to work it needs to always be aware of the pixels that surround the area where you paint. The healing brush senses the pixels within up to a 10% feathered radius outside the diameter of the brush. By reading the pixels outside of the brush perimeter, the healing brush is able (in most cases) to calculate a smooth transition of color and luminosity with the pixels outside the painting area. There is no need to use a soft edged brush, since you will get more controlled results when using a hard edged brush.

Once you understand the fundamental nature of how the healing brush works, you will also come to understand why it is that the healing brush will sometimes fail to work as expected. If the healing brush is applied too close to an edge where there is a sudden shift in tonal lightness then the healing brush will attempt to create a blend with what is immediately outside the healing brush area. When you retouch with the healing brush you need to be mindful of this phenomenon, but there are things you can do to address this. For example, you can create a selection that defines and constrains the area you are healing. A selection can be made using the lasso or you could draw a pen path first and then convert this to a selection.

Chapter 6 Repairing an image

Mode: Normal

Source: Sampled O Pattern:

1.

Brush:

1 The healing brush retouching can be carried out on the Background layer, on a copied Background layer or an empty new layer. In this example, I selected the healing brush from the Tools palette and edited the brush style to create a hard edged brush. The brush blending mode should be Normal, the Source radio button checked and ideally the Aligned box left unchecked.

2 To use the healing brush, S and -click to define the source point. This should be a clean area of skin texture. You are now ready to retouch with the healing brush. In this example, I clicked on the areas of skin tone with the healing brush where I wished to remove a blemish. If you are using a pressure sensitive tablet as an input device, then the default brush dynamics will be size sensitive. I applied light pressure to paint with a small brush, and applied heavier pressure to get a full-sized brush.

3 I continued using the healing brush to complete the skin tone retouching. In this example I sampled one pixel source point for the chest and neck areas and another to retouch the face.

Client: Thomas McMillan. Model: Sophie Boeson @ Models One.

Better healing edges

Since the healing brush is blending around the outside edge, you can improve the healing effect by increasing the outer circumference. The following technique came via Russell Brown, who informs me that he was shown how to do this by an attendee at one of his seminars.

If you change the healing brush to an elliptical shape, you will tend to produce a more broken-up edge to your healing work and this will sometimes produce an improved healing blend. There are two explanations I have for why this works. Firstly, a narrow elliptical brush will inevitably produce a longer perimeter to the painting edge. This means that more pixels are likely to be sampled when calculating the blend. The second thing you will notice is that when the healing brush is more elliptical, there is a randomness to the angle of the brush. Try changing the shape of the brush the way I describe. As you start using an elliptical-shaped brush, you will see what I mean.

Figure 6.4 To adjust the shape and hardness of the healing brush, select the healing brush tool and mouse down on the brush options in the tool Options bar. Set the hardness to 100% and drag the elliptical handles to make the brush shape more elliptical. Notice also that if you are using a Wacom tablet or other pressure sensitive input device, the brush size is linked by default to the pen pressure.

Chapter 6 Repairing an image

that is adjacent to a sudden shift in lightness or color. 3 In this picture you can see that even if you use the healing

brush with a small hard edged brush, the brush may pick up the darker tones of the model's dress and you will get to see the ugly looking shading shown here.

4 The answer to the problem is to make a preselection of the area you wish to heal (with maybe some minimal feathering) and thereby restrict the extent to which the healing brush tool

analyzes the surrounding pixels.

Client: Anita Cox. Model: Steph at IMG.

2 A potential problem arises when you wish to retouch a blemish

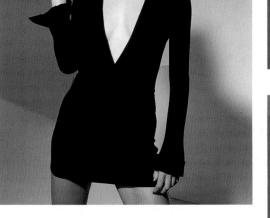

Default healing tool

The spot healing brush has been made the default healing tool, so the first time you select it and try to use the solution of the keys to establish a source point to sample from, you will be shown a warning dialog explaining there is no need to create a sample source with this tool. It will offer you the option to switch to using the normal healing brush instead.

Figure 6.5 In Proximity Match mode, the spot healing brush works by searching automatically to find the best pixels to sample from to carry out a repair. It is a good idea when using this tool to retouch larger areas, for the brush direction to be coming from the side that contains the most suitable texture to make the sample. This will give the spot healing brush a better clue as to where to sample from.

Spot healing brush

The spot healing brush is a new addition to Photoshop CS2 and is a healing tool that was originally in Photoshop Elements 3.0. The spot healing brush may not be quite as versatile as the healing brush, but in many ways is a lot easier to use. All you have to do is select the spot healing brush and click on the marks or blemishes you wish to remove and the spot healing brush will automatically sample the replacement pixel data from around the area you are trying to heal.

The spot healing tool has two basic modes of operation. The Proximity Match mode is analyzing the data, around the area where you are painting, to identify the best area to sample the pixel information from. It then uses the pixel data that has been sampled this way to replace the defective pixels beneath where you are painting. You can use the spot healing brush to click away and zap small blemishes, but when you are repairing larger areas in a picture you will usually obtain better results if the brush size used is smaller than the defective area. And because the brush is intelligently looking around for the good pixel data to sample from it is best to apply brush strokes that drag inwards from the side where the best source data exists.

The Create Texture mode works in a slightly different fashion. The spot healing tool will read in the data surrounding the area you are attempting to repair. As you do this it will generate a texture pattern from the sampled data. So the main difference is that Proximity Match is repairing and blending with actual pixels, while Create Texture is repairing and blending using a texture pattern that has been generated on-the-fly.

Figure 6.6 The spot healing brush Options bar.

Patch tool

The patch tool uses the same complex algebra as the healing brush to carry out its blend calculations, but the patch tool uses selection-defined areas instead of a brush. When the patch tool is selected, it initially operates in a lasso selection mode that can be used to define the area to patch from or patch to. For example, you can hold down the **S** alt key to temporarily convert the tool to become a polygonal lasso tool with which to draw straight line selection edges. You don't actually need the patch tool to define the selection, any selection tool or selection method can be used to prepare a patch selection. Once you have made a selection, select the patch tool to proceed to the next stage. As with the healing brushes, the patch tool has to work with either the Background layer or a copied pixel layer. One of the nice touches is the way that the Selection area in Source and Destination mode will preview the image as you drag to define the patch selection.

Source and Destination modes

In Destination mode you can drag the selection area with the patch tool to a new destination point and Photoshop will perform a healing blend calculation to merge the sampled patch area with the underlying pixels in the new area of the image. In Source mode you can drag the selection area with the patch tool to a new destination point to select the pixels that will replace those in the original source selection area. The Use Pattern button in the Options bar for the patch tool will let you fill a selected area with a preset pattern using a healing type blend.

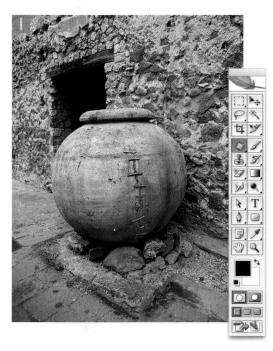

1 The patch tool works in a way that is similar to the healing brush. Using the picture opposite, I can show you how the patch tool can be used in Source mode to cover up the metal staples that are holding the large pot together. When you select the patch tool you can use it just like the lasso tool to loosely define a selection area. For example, you can use the selection area for example, you can use the selection drawing mode. Or you can use any other preferred selection method (it really doesn't matter at this stage) as you prepare the image for patching.

Adobe Photoshop CS2 for Photographers

2 Having finished defining the selection for the area I wanted to patch, I made sure that the patch tool was selected in the Tools palette and dragged inside the selection to relocate it on an area of texture on the pot that I wished to sample from.

4 If the patch/healing process is successful, you should see an almost completely smooth join. The pixels that you select to be sampled from in the patch process will adjust their luminosity and color to blend with the pixels in the original defined area, to match the lighting and shade etc. However, you won't always get a 100% perfectly convincing result. In the example used here, I made a couple of attempts at patching the staples before finding a patch selection that worked well. Furthermore, you have to beware of any repeating patterns giving away the fact that the image has been cloned. I finished retouching this photograph by applying a few healing brush strokes to remove those telltale signs.

.

R.

3 As I released the mouse, Photoshop began to calculate a healing blend, analyzing the pixels from the source area I had just defined and used these to merge seamlessly with the pixels in the original selection area.

1 The patch tool uses the same blending calculations as the healing brush to perform its blend calculations. In this image I wanted to demonstrate how you can use the patch tool in Destination mode to make a duplicate of this fishing boat. 2 I used the patch tool to define a rough selection outline of the boat. In use, the patch tool is just like the lasso tool, you can use the **(a)** modifier key to draw straight line points. If you prefer you can use any other selection tool such as the magic wand or convert a pen path into a selection.

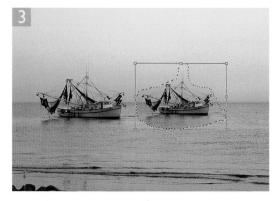

3 I made sure that Destination was selected in the Options bar. When the selection was complete, I used **B C T ctr alt T**, which copied the pixel selection and added the free transform bounding box to the selected pixels. I then dragged the transform to a new location. In this example I dragged the transform across to the right, aligned the center point to the horizon and held down the **Shift Shift alt** keys, to scale the transform down in size to make the second boat smaller and appear to be further away in the distance.

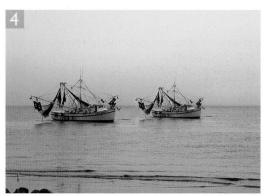

4 I then hit *Enter* to OK the transformation. After that I moused down with the patch tool inside the selection area and moved the selection very slightly. If you follow these steps precisely and release the copied selection, the patch tool will calculate how to merge the dropped selection with the underlying pixels. This will produce a smooth-looking blend with the surrounding sky and sea area. The patch tool works well with a subject such as this, because the sea and sky provide a fairly even backdrop for the pixels to blend smoothly.

Photograph: Thomas Fahey.

Healing brush modes

The healing brush has a choice of blending modes. The Replace mode is identical to the clone stamp tool, except it allows you to merge film grain more reliably and smoothly around the edges of your brush strokes.

The healing brush is already utilizing a special form of image blending to perform its work. The other healing brush blending modes can produce different results, but in my opinion they won't actually improve upon the ability of the healing brush in Normal mode.

Healing brush strategies

You can also use a pattern preset as the source for the healing brush or patch tool by choosing a preloaded preset or creating one of your own. The Filter \Rightarrow Pattern Maker is ideal for this purpose as you can sample from just a small area of useful texture in an image and use the Pattern Maker to create a randomly generated pattern source that can be used to apply a smoothly blended texture over a larger area of the picture using the healing brush. The following example illustrates how you can use the healing brush and patch tool to solve a rather more complex retouching problem. Although the healing brush and patch tool are natural candidates to use here, I needed to plan carefully how they would be used, as I also needed to rely on the clone stamp tool to do some of the preparation work, in particular where the edges of the selection to be healed extend to the edge of the document bounds.

1 Let us consider how we would go about covering up all the exposed bricks in the picture opposite, so as to match the remaining plaster work. Some of these areas are too large to use the patch tool in one operation. Notice how I prepared three paths, to define some of the areas to be repaired, that closely followed the outline of the cactus leaves. These will be used in the following steps. To begin with though, I converted Path 2 into a selection by dragging the Path 2 palette icon down to the Make Selection button in the Paths palette.

3 I could have tried selecting the healing brush and attempted to sample some of the plaster texture to fill in the remaining gap. In this and the other sections I wanted to repair, the area to be covered up was so large that I decided to create a new pattern based on a small selection of the image. I made the Background layer active and chose Pattern Maker from the Filter menu. I then marquee selected a small area as shown here. 2 I then used this selection to copy the pixels to make a new layer. Choose: Layer \Rightarrow New \Rightarrow Layer via Copy (**H**) (()). I clicked on the Lock Transparency box in the Layers palette and selected the clone stamp, and was then able to clone some of the pixels in the image to provide a wall textured border edge on the left and the right. I did this in order to provide the healing brush or patch tool some edge pixels to work with. If you don't do this, Photoshop will try to create a patch blend that merges with the cactus leaf colors.

	rs			۲
Norm	al 🗘	Opacity:	100%	
Lock:	0/1+0	Fill:	100%	•
	Layer 1			
	Backgroun	d	۵	

		Pattern Maker	
Too	apture large sample features, increase this value	(values over 5 increase time to Generate).	ОК
2	The second se		Cancel
3	The second		Generate
		A CONTRACT OF A	Tile Generation
			Use Image Size
	-		Width: 600 px
	senter as from		Height: 600 Px
			Offset: None
	TIP	7. /	Amount: 50 🖋 🕷
		· · · · · · · · · · · · · · · · · · ·	Smoothness: 1
		1 april and	Sample Detail: 5 px
	11157	I I I TOTAL	Preview Show: Original
			Tile Boundaries
		J. K.	Tile History
	-ALE		
Imag	e W:2815 H:4000 Tile Grid W:5 H:7	Sample W:384 H:300 Preview: none	

Adobe Photoshop CS2 for Photographers

4 I made the tile area fairly large (600 pixels square in this example) and I set the Smoothness setting to 3. If I clicked on the Generate button at the top of the dialog, the Pattern Maker would generate a randomized pattern that is a wraparound texture. The result of which is previewed in the dialog. I didn't need to click OK as this would apply the texture as a fill to the current image. Instead I clicked on the Save Preset Pattern button at the bottom of the dialog. Once I had named the new pattern, it would become appended to the other Pattern presets and it was then safe for me to click the Cancel button to return to the main image.

5 I then activated Layer 1 again, selected the patch tool and drew a rough selection of the plaster wall area I had just prepared as shown in this close-up image.

Chapter 6

Repairing an image

Use Pattern

6 I selected this new custom pattern in the patch tool Options bar, then clicked the Use Pattern button. As you can see, Photoshop was able to calculate a perfectly smooth blend, and this was achieved using a texture pattern that had been synthesized in Photoshop.

Patch: O Source O Destination I Transparent

 $7\ {\rm I}$ repeated these steps on the other parts of the photograph so that eventually I ended up with the finished result shown here.

1 To add contrast to the eyes, select the lasso tool and draw a selection around the outline of the eyes (hold down *shift* to add to a selection). To feather the selection choose Select ⇒ Feather and enter a radius of 2 pixels.

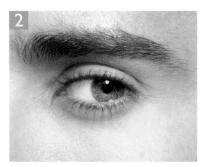

2 Apply either a Curves adjustment or add a Curves Adjustment layer and draw a lightening curve to add lightness to the eyes but keep the tone in the dark areas of the pupils the same.

Accentuating the eyes

The eyes are always the center of attention in a portrait. If the eyes are sharp then the rest of the photograph will appear to be in focus, even if you have a shallow depth of field and the eyes are the only thing that are sharp!

So what do you do if the eyes don't look sharp? I sometimes like to use the PhotoKit Sharpener plug-in (a demo is available on the CD) to apply a gentle capture sharpen to the image at the beginning of a retouching session. And if that is not enough, I will then also add a creative sharpener (with the same plug-in). This is returned in the form of a masked layer. If you don't wish to use the Sharpener plug-in, the other alternative is to copy the background layer to make a new layer, apply a heavier than normal sharpen and add a layer mask to hide the layer contents. Then paint with a white brush on the layer mask to selectively reveal the extra-sharpened layer. In some cases you can resort to using even more extreme measures to enhance the sharpness. You can actually draw the sharpening edges yourself. This is described in the step-by-step tutorial on the page opposite.

Adding lightness and contrast to the eyes

If you lighten the eyes too much they will look unnatural. Worse still, if you overdo the lightening and make them too white, the whites of the eyes will appear without any detail on the page and print as paper white. I use a fairly simple method for lightening the eyes which is based on making a feathered selection of the whole area in each eye and applying a Curves adjustment to the selected areas. Now you could just select the white of the eyes and lighten these areas on their own. That works too, but I find that by applying a Curves adjustment to all of the eye I can anchor some points in the curve to make the iris going darker or lighter. Or, I can add more contrast in the shadows to make the pupils darker. This is just as effective as selecting the whites only but you have simultaneous control over the lightness of the iris and pupils.

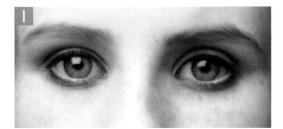

1 You can sharpen the eyes manually by adding a neutral Overlay blend layer. In this example, I held down the call key as I clicked the New Layer button in the Layers palette. This applied a new layer via the New Layer dialog box. I chose Overlay as the blend mode and then checked the box that says Fill with Overlay-neutral color (50% gray).

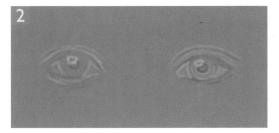

Alternatively, you could use the dodge and burn tools to add contrast to the features. Select the burn tool and set the Range to Midtones. Use the burn tool as before to darken the dark line edges and hold down the select and key to make the burn tool temporarily become a dodge tool and use this to lighten the lighter edges.

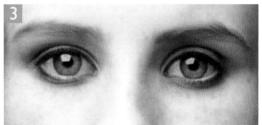

3 You won't normally see the neutral gray layer as shown in the previous illustration (to take the screen shot I turned off the visibility of the Background layer). But what you should see as you paint on this layer is a gradual increase in apparent sharpness to the eyes and other parts of a picture you wish to enhance using this technique.

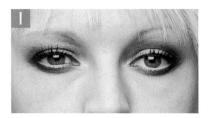

I In this close-up view you can see that the model's right eye has some burst blood vessels. Fortunately the model is looking straight to camera and we can easily make a repair by copying across pixel data from the good eye.

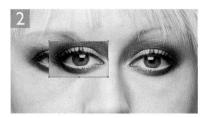

2 I made a selection of the other eye, and used the **(H)** c(n) shortcut to copy as a new layer and then used Edit \Rightarrow Transform \Rightarrow Flip Horizontal to match it to the other eye.

3 I all clicked the Add Layer Mask button to add a filled layer mask to 'hide all' on the layer. I selected the paintbrush and with white as the foreground color gradually painted back in the good eye layer to repair the bloodshot area.

Repair work using a copied selection

Another way to repair an image is to copy a selection of pixels sampled from another part of the picture or a separate image even. Back in the mists of time before there were layers in Photoshop, you could duplicate a selection to make it a temporary layer by \bigcirc *alt* dragging inside a selection with the move tool. Well, you can still do this in Photoshop, but you will usually find it more practical to copy the selection contents as a new layer. To do this, make a selection and then use Layer \Rightarrow New \Rightarrow Layer via Copy, or use the keyboard shortcut $\underbrace{\text{H}}$ \int *ctrl* \int . This will copy the selection contents as a new layer.

Once you have duplicated the selection contents as a new layer you can use the copied layer to cover up another portion of the image by dragging it across with the move tool and transforming the layer as necessary.

In the step by step example shown here, I wanted to cover up the burst blood vessels in the model's right eye. I made a simple rectangular selection over the good eye, copied the contents to a new layer and transformed the new layer by flipping it horizontally. The add layer mask step is important. When you add a layer mask and fill or paint with black, you are not deleting but merely hiding the layer contents. In this example the layer mask allowed me to initially hide all of the copied layer and then selectively paint back in with white, the bits that I wanted to reveal. In the example shown here, I could paint in over the eye to replace the damaged areas only. One of the things you have to be careful of when retouching the eyes in this way, is to make sure that you preserve the catch lights in the eyes. If you were to flip the catch lights as well, your subject could end up looking cross-eyed!

Removing stray hairs

As a fashion and beauty photographer I do all I can to make sure the hair is looking good at the shoot stage. But there will always be some stray hairs remaining. I like to use the healing brush as much as possible. But as I pointed out earlier, the healing brush is not an ideal tool when painting up against areas where there is a sudden change in tone. In most instances, I find it preferable to retouch the hair with the clone stamp tool. I use a Wacom pen stylus and a custom setting where the brush size is a round brush with a size of around 10 pixels with opacity and brush size linked to the amount of pressure applied. I have found this to be a useful brush setting for cloning hair strands and painting new strands of hair. The brush size can then be modified and made larger or smaller using the square bracket keys on the keyboard. Using the clone stamp tool in this way I can clone out cross-hairs, remove intricate strands of hair and paint new strands that match the texture and color of the existing hair.

If you are retouching fine strands of hair, pay careful attention to where the strands of hair originate, the direction they are flowing in and where they meet up with or cross over other strands of hair. A clumsy retoucher may simply lop off loose strands without regard to whether this leaves the hair looking natural or not. At times, it is like sorting through a mass of electric cable, making sure that you don't cut the hair off at the root and leave the rest of the hair just floating there! When I am asked to tidy up fluffy loose hairs, I approach the task in gradual stages, gradually thinning out the hair rather than cutting it all off. This is because it would look unnatural to see a soft, textured hairstyle suddenly change into a perfectly smooth outline. To keep the hair looking real I try to leave some stray hairs in the picture. Sometimes I will begin by erasing the loose hairs around the hair outline and actually paint in some loose stray hairs afterwards (using the clone stamp tool configuration in Figure 6.7). Doing so enables me to obtain a more natural look to the hair.

Tool Presets				•
🛃 Clone Stamp Tool Soft Ro	und 45	pixels	1	
hair retouch				
				-
Current Tool Only		ाज	0	

Figure 6.7 When using the clone stamp tool to retouch hair strands, I use a special preset setting. The brush size is around 10 pixels. And the Shape Dynamics and Other Dynamics (Opacity) are linked to the pen pressure of the Wacom pen.

Adobe Photoshop CS2 for Photographers

Roots coloring

Here is a two-step process that can help correct dark roots in a picture. Firstly, make a copy of the Background layer. This allows you to fade out or selectively mask the work that is done on this layer. Select the paintbrush and choose the Color blend mode. Hold down the state alt keys to sample a color from the lighter hair area. Now paint over the darker hair roots using the paintbrush in Color mode. This painting step applies the correct color to the roots. To make the hair look lighter, change the paintbrush blend mode to Soft Light. Sample a light hair color again and paint over the roots once more with the paintbrush tool. This should do a good job of coloring the hair without destroying the contrast in the hair texture. To restore contrast, add an empty new layer mask. Reset the paintbrush blend mode back to Normal and apply fine black paint strokes to the layer mask to hide parts of the new layer.

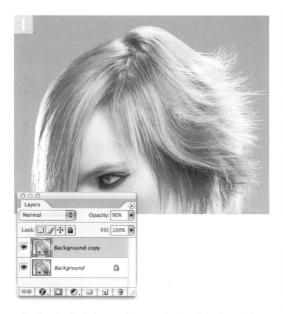

¹ To disguise the hair roots that were showing, I duplicated the Background layer, selected the brush tool and changed the brush blending mode to Color.

2 I held down the set and gently painted over the dark hair areas where the roots were showing most. This colorizes the hair. I then changed the brush blend mode to Soft Light and painted some more, gently adding more lightness to the hair. It sometimes helps to add a layer mask to the Background Copy layer and paint thin brush strokes to restore some of the hair shadows and achieve a smoother blend with the rest of the hair.

Vanishing Point

The Vanishing Point filter provides a modal dialog in which you can define the perspective planes in an image and then use the tools available inside the Vanishing Point dialog to carry out basic retouching work that will match the perspective of the picture. You can make a selection within the Vanishing Point preview area and clone the selection contents within one or more predefined plane areas. You can paste the contents of a selection and align it in perspective with the target image. And you can also apply the clone stamp in healing or non-healing modes, or paint with the paintbrush in perspective.

Rotate in perspective

If you have a copied selection active in Vanishing Point, you can, if you wish, move the cursor outside of the selection area to rotate the contents.

CD demo

A complete run-through of the steps used in Vanishing Point to create the image shown here is included on the CD, as is a layered version of the final image.

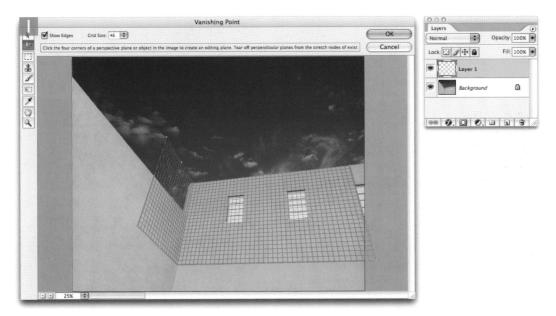

1 Before commencing any Vanishing Point work, it is a good idea to create an empty layer first and make it active before choosing Vanishing Point from the Filter menu. The next task is to define the planes of perspective using the create plane tool (C). I clicked to set four points to define the first plane of perspective, using visual clues in the picture as a guide (hold down X to temporarily double the preview magnification). Once the first four points have been set, a blue grid will appear within the plane. A blue grid means you have described a good perspective plane. A red or yellow grid will indicate that this does not meet the criteria of a good grid plane. I could then resize the grid by dragging on the side or corner handles. The grid size can be adjusted via the control settings at the top, and the individual grid corners can be realigned by using the edit plane tool (V). I then created a second plane to define the perspective of the left-hand wall, by a grid dragging the side handle on the left side of the first plane.

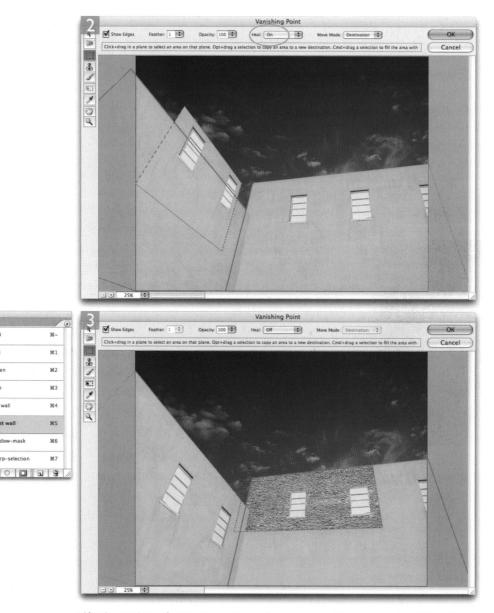

2 After the two planes of perspective had been defined, I dragged with the marquee tool (M) to define the two windows on the right-hand wall and held down the 2 ctrl att key as I dragged from inside the marquee selection, to copy the selection and place it on the left-hand wall. As I did this the windows snapped to the predefined perspective plane of the second wall. Notice that before I commenced copying the selection contents, the Heal option was switched to On (circled).

000

RGB

ed

Green

Blue

eft wall

ight wal

sharp-selection

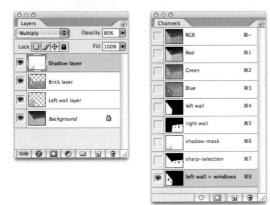

Original photograph: Jeff Schewe.

3 Because the Heal option was switched on, the area surrounding the window frames blended smoothly with the other wall. But the perspective of the windows themselves was wrong. So before I clicked outside the marquee selection to flatten the contents, I selected the transform tool (T) and this changed the control options view at the top of the Vanishing Point dialog so that I could check the Flip option (to flip the selection contents from left to right). I then clicked OK to apply the filter.

I opened a photograph taken of a brick wall and made a Select \Rightarrow All of the contents (\Re A ctr/A). I then loaded a pre-made selection of the right-hand wall that masked the two windows and chose Vanishing Point from the Filter menu again. I used \Re V ctr/V to paste the selection contents. The selection containing the brick wall image could then be dragged across to the perspective plane area, and as I did so the selection contents snapped to the perspective of the wall, leaving the windows visible.

4 The selection contents had not been flattened yet, so I could all drag the selection to copy it and drag across to fill more of the wall area. I could keep on all dragging to make more copies of the brick wall to fill the whole wall in the picture. I then clicked OK to apply Vanishing Point again.

5 Next, I loaded a selection of the left wall (again masking the windows) and did the same thing as in Step 4, except this time I selected the stamp tool (S) and used it with Heal set to Off, to clone the bricks in perspective to fill in the gaps.

6 You can see that I carried out all the Vanishing Point work on separate layers. I faded the Brick layer to 72% opacity and I added a Shadow layer in Multiply mode at 80% to add shading.

The dodge and burn tools

Although there are tools in Photoshop called dodge and burn, they are not really suitable for the types of dodging and burning that photographers wish to achieve when working with Photoshop. This is not to say that the dodge and burn tools serve no use. They are just not ideal for this type of photographic retouching. I therefore recommend you use the adjustment layer method described here.

Dodging and burning

Photographers who have been trained using the traditional darkroom techniques will naturally think in terms of dodging and burning when they want to make a selective tonal correction. The best way to dodge and burn a photograph in Photoshop is by the use of adjustment layers. In the technique shown here, you can create an adjustment layer that will lighten or darken the image as a whole and then add a layer mask filled with black to hide the layer adjustment and paint or fill the adjustment layer mask with white to apply the image adjustment selectively.

Working with adjustment layers is by far the best way to shade or lighten an image. This is because you have the freedom to re-edit the adjustment layer to make the adjustment lighter or darker. And you can edit the mask associated with the adjustment to redefine the areas you want to adjust. In the following example I show you how to use Levels to create a darkening vignette, but you could also use a Curves adjustment layer. Either technique will work just as well.

1 Here is a faded photographic print which I copied from my father's archives when he lived and worked in what was then known as the Belgian Congo. You will notice that the photograph is slightly faded towards the edges and in need of a little repair work.

2 The first steps are simple enough. The original photograph was scanned and brought into Photoshop in 16 bits per channel mode. This enabled me to make some tonal corrections to enhance the contrast minimizing the loss of levels information. I also used the clone stamp and spot healing brush to remove the various dust and scratch marks.

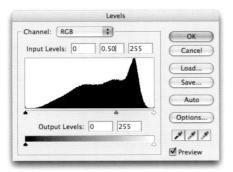

3 I carried out all the retouching on an empty new layer and cloned some elements of the foreground to fill in the bottom left corner where there was some missing detail. I then wanted to apply a darkening vignette to burn in the corners. I made a rectangular selection and feathered the selection using Select ⇒ Feather, entering a feather radius of 150 pixels. I then inverted the selection (the selection is shown here as both a selection and Quick Mask).

Layers		/	۲
Normal 🛟	Opacity:	100%	·
Lock:	Fill:	100%	P
• • •	Levels 1		
🖲 🔣 Layer 1			
Backgrou	nd	۵	

4 With the feathered selection active, I clicked on the Add Adjustment Layer button in the Layers palette and selected Levels and made a darkening image adjustment. And finally, I added a Curves adjustment layer to create a warm sepia toning effect.

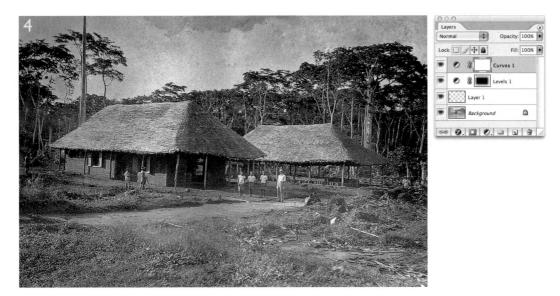

Reduce Noise filter

The technique shown here is fairly simple to work with, but there is now also a Reduce Noise filter which is new to Photoshop CS2 that is particularly effective at removing noise from an image (see pages 248–249).

Image noise and moiré

The following technique was shown to me by Thomas Holm of Pixl in Denmark. Camera noise and moiré problems can often arise when you shoot digitally. Typical examples of this can be seen in the accompanying stepby-step examples. Digital noise can occur whenever you shoot at high ISO settings and especially in dark areas of the picture. If you are shooting in raw mode, one way to overcome this is to use the Color Noise filter in the Camera Raw dialog (see page 446). Failing that, camera noise can be removed by duplicating the Background layer, changing

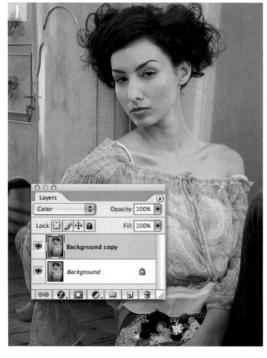

1 This photograph was shot digitally using a high ISO setting on the camera in low light conditions. The quality of the image capture was inevitably compromised by the presence of noise in the image. As in the previous example, I duplicated the background layer and changed the blend mode to Color.

Client: Impressions. Model: Jana at Isis.

2 I then went to the Filter menu and chose Blur \Rightarrow Gaussian Blur and applied a 5 pixel radius blur to the Background copy layer. This was enough blur to remove the color noise. Because the layer is blending in Color mode, the luminosity in the underlying Background layer is preserved. The left half of this image shows a comparison of the image with the noise removed.

1 In this digitally captured photograph, there is a moiré pattern visible on the fabric of the dress.

2 To remove the moiré pattern, I again copied the Background layer, changed the blend mode to Color and applied the Gaussian Blur filter to this layer. In this instance, more blur was required to eradicate the moiré.

the blend mode to Color and applying the Gaussian Blur filter to the copied layer. When you use a color blending mode, it is only color information that is blurred, the luminosity (the detail information) will remain unaffected.

A moiré pattern can also be dealt with in a similar way. Follow the same steps that were used to remove the camera noise, but you may have to apply rather more Gaussian Blur to remove the distracting pattern effectively.

Moiré is becoming less of an issue now that the pixel resolutions are getting larger. But if you do see a moiré problem arise at the shooting stage, try changing the camera distance from the subject. This can often cure the problem in advance. I would also advise applying a layer mask to the blurred layer and selectively painting in the blurred layer.

Gaussian Blur	
	OK Cancel
Radius: 12 pixels	

Luminosity blending

An alternative strategy is to duplicate the Background layer, change the copied layer blending mode to Luminosity and blur the original, underlying layer. This method will produce the same result as converting an RGB image to Lab Color mode, and individually blurring the 'a' and 'b' channels and converting back to RGB. Except the layer blending mode is a lot quicker to use. I find that the methods described on these pages do a better job of retaining the color saturation.

Reduce Noise	
	OK Cancel I Preview Basic O Advanced Settings: Defaults :
 set 	Strength: 7 Preserve Details: 50 % Reduce Color Noise: 85 % Sharpen Details: 15 % Remove JPEC Artifact

Figure 6.8 Here is the Reduce Noise filter being used to help remove the noise from a digital capture of 'Special Agent' Russell Brown, which was shot at 1250 ISO. The Reduce Noise filter helped get rid of most of the noise artifacts.

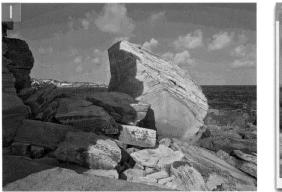

1 The Reduce Noise filter has a Remove JPEG Artifact option that can be useful if you wish to improve the appearance of an image that has suffered from overheavy JPEG compression. But it can also help rescue a GIF image where a lot of the color levels information has been lost in the conversion to Indexed Color mode.

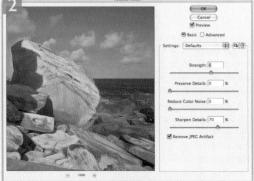

2 A GIF image will have to be converted to RGB mode first. You can then apply the Reduce Noise filter. In this example I checked the Remove JPEG Artifact box. To remove the color banding, the Preserve Details had to be set to 0%. To make the image sharp again I increased the Sharpen Details to 70%.

Reduce Noise filter

The Reduce Noise filter uses a method of smart noise reduction that can remove noise from an image without destroying the edge detail in the image. It is quite a memory intensive filter, so be prepared to wait a little while as it performs its calculations.

In Basic mode you can simply adjust the strength of the noise reduction and then use the separate controls below to modify the noise filtering. These should be adjusted in the order they are displayed. When the Preserve Details is left at 100%, the luminance information is preserved completely. Reduce the Preserve Details amount to introduce more image noise smoothing. Below that is the Reduce Color Noise slider. Increasing this amount will allow you to separately control the color noise suppression. So, if the Preserve Details is set to 100% and the Reduce Color Noise is at 0%, you will see little improvement in the image. As you adjust these sliders you will have separate control over the luminance noise and color noise. When you look at the combination of the noise reduction strength, the detail preservation and color noise reduction, the image is likely to have suffered some loss in sharpness. The Sharpen Details slider allows you to dial back in some more sharpness. But I would urge caution here as adding too much sharpening can simply introduce more artifacts.

JPEG noise removal

You can also use the Reduce Noise filter to smooth out JPEG artifacts. If you have a heavily compressed JPEG image, the Reduce Noise filter can certainly help improve the image smoothness. But I reckon you can use the Reduce Noise filter in this mode to improve the appearance of GIF images as well. Of course you will need to convert the GIF image from Indexed Color to RGB mode first. But once you have done this you can use the Reduce Noise filter adjustments to help get rid of the banding by taking the Preserve Details slider down to zero % and raising the Sharpen Details to a much higher amount than you would be advised to use normally.

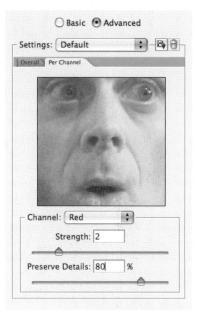

Figure 6.9 In Basic mode you can only adjust the Reduce Noise settings so that they affect the overall strength and preservation of image detail. If the Advanced mode button is checked you can apply the noise reduction adjustments on a per channel basis.

Figure 6.10 Favorite Reduce Noise settings can be saved by clicking on the Save Changes to Current Settings button. And Reduce Noise settings can be deleted by clicking on the trash icon next to it.

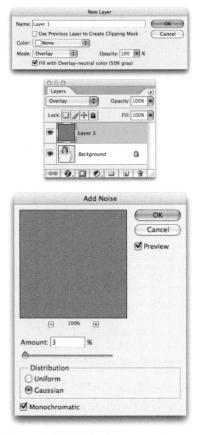

Figure 6.11 To add noise on a separate layer, (S) all-click the Add New Layer button in the Layers palette. This will pop a New Layer dialog. Select Overlay as the blending mode and you will notice that you can now check the Fill with Overlay-neutral color (50% gray) box below. In this blending mode the layer will have no visible impact on the underlying layers. But if you filter the layer and add noise, you can create a film grain layer. Try adding a layer mask to this layer to selectively add or remove the noise.

Adding Noise

As well as removing noise you sometimes need to actually add more noise instead. When you use Photoshop to retouch a photograph you may at times find yourself painting with what might be called 'pure pixels'. If you are cloning pieces from one part of the picture to another then you are probably not going to run into too many problems. But if you use the paint brush tool and apply gradients or blurs to parts of a photograph there can be a mismatch where the smoothness of the pixels painted using Photoshop do not match the inherent texture of the rest of the image. You should therefore consider selectively adding noise whenever you add a gradient or paint with Photoshop. Note that 'add noise' options are already included in a lot of Photoshop features such as the Brush options, Gradient Fill layers and the Lens Blur filter.

Add Noise
OK Cancel ♥ Preview Amount: 5 %
Distribution Uniform Gaussian Monochromatic

Figure 6.12 Gradient banding is a common problem in Photoshop. Banding can occur whenever you apply a heavy blur filtration. It can also sometimes appear on gradient fills. The Gradient options include a dither mode and this will help somewhat. However, the best way to hide banding is to apply a small amount of noise, using the Noise \Rightarrow Add Noise filter. The Gaussian option will produce a more irregular distribution of noise. The example here shows a noticeably banded gradient with and without the noise being added. The noise filter is well worth remembering any time you wish to hide banding or make Photoshop painting work appear to merge better with the grain of the scanned original.

Other tools for retouching

Some Photoshop tools are more suitable for retouching work than others. The blur tool is very useful for localized blurring as you can use it to soften edges that appear unnaturally sharp. Exercise caution when using the sharpen tool, as it has a tendency to produce unpleasant artifacts. If you wish to apply localized sharpening, follow the instructions that were described at the end of Chapter 5.

The smudge tool is a paint smearing tool. It is important to recognize the difference between this and the blur tool. The blur tool is best suited for merging pixels, but the smudge tool is more of a painting tool. It can be used either for blending in a foreground color or 'finger painting'. In other words, for smearing pixels across an image. Smudge strokes created with the smudge tool do tend to look odd on a photographic image unless you are trying to recreate the effect of Instant Polaroid smearing. A better smudge tool is the super putty plug-in which is part of the Pen Tools suite freely distributed by Wacom.

Some retouchers like to use the smudge tool to refine mask channels, working in Quick Mask mode, and the smudge tool set to Finger Painting to drag out mask pixels to follow the outline of hair strands. I tend to stick with the brush tool and use this in conjunction with a pressure sensitive graphic tablet device. Under the Other Dynamics options you can use a low stylus pressure to produce faint brush strokes. And under the Size Dynamics you can set the Size control to be linked to the stylus pressure.

Blurring along a path

You can use Photoshop paths to apply a stroke using any of the Photoshop tools. If you are working with selections then a selection can be converted to a path (use the current selection or load a selection – go to the Paths palette options and choose Make Work Path). For example, if you want to soften the outline of an image element and have a matching selection saved, convert this to a path, select the blur tool and choose Stroke (Sub) Path from the Paths palette.

Figure 6.13 To stroke a path in Photoshop, create a closed or open path and go to the Paths fly-out menu and select the Stroke Path... option. Select the tool you wish to stroke with in the Stroke Path dialog. Now click OK and the path will be stroked with the selected tool using the currently selected brush setting for the chosen tool.

Disguise your retouching

The basic rule of retouching should be to disguise your work so that whatever corrections are made to a photograph, it is not immediately apparent that the picture has been retouched. If you are working for a fashion client they are usually looking for image perfection. Although I may sometimes employ a lot of Photoshop wizadry in order to satisfy the client, I feel it is important to fade out the retouching and let some of the original blemishes show through. My preference is to retouch the skin enough to clean up blemishes and smooth the tonal shading, and do this without hiding the underlying skin texture. I achieve this by reducing the opacity of the layer that contains all the retouching work.

Beauty retouching

I have included in this chapter a mixture of Photoshop retouching techniques that would be useful for photographers and have selected a few specific Photoshop retouching tasks that demand a special approach, like how to retouch areas where there is not enough information to clone from. In the following example, I show how to retouch using the paint brush and where it is important to carefully disguise your retouching.

There are many different types of skin and the skin texture varies a lot on different parts of the body. If you examine the face, neck, arms etc. in close-up detail you will notice that each area has a different skin texture. For example, the skin under the eyes will have a coarse goose bump texture. The forehead will generally be very smooth (apart from any lines). The cheeks will also be smooth, but slightly pitted with pores. And if you are retouching a female portrait you may notice fine downy hair. As you move down towards the neck area the texture of the skin changes to become more coarse again. It is important to pay close attention and carefully choose your source point for the skin whenever you are cloning or healing a portrait.

Brush blending modes

The painting and editing tools can be applied using a variety of blending modes which are identical to those you come across in layers and channel operations. You could try experimenting with all the different tool blending mode combinations but I wouldn't advise you do so, as it is unlikely you will ever want to use them all. I reckon that the following modes are probably the most useful: Screen, Multiply, Lighten, Darken and Color when combined with the paint brush, blur and gradient tools.

Painting in Color mode has many uses. Artists who use Photoshop to colorize scanned line art drawings will regularly use the Color and other blending modes as they work. Painting using the Color blending mode is also ideal for hand coloring a black and white photograph.

1 The first thing to retouch here are the eyes, which I nearly always want to lighten to some extent. I used the lasso tool to draw around the outline of the eyes. This selection does not have to be perfect - a reasonably steady hand is all you need! After that I went to the Select menu and chose Feather... and entered a feather radius of 1 or 2 pixels. After making the selection and feathering it, I moused down on the Adjustment Layer button at the bottom of the Layers palette and selected Curves. This will automatically add a Curves adjustment layer with a layer mask based on the selection just made. I normally draw a curve that will lighten the whites of the eyes and also increase the contrast between the whites and the iris. I also added a Hue/Saturation adjustment layer to gently reduce the saturation of the red veins in the eyes. I then S all -clicked between this and the Curves adjustment layer in the Layers palette to create a clipping group with the eye lightening adjustment layer.

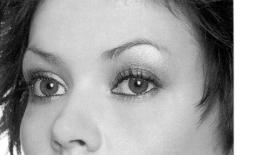

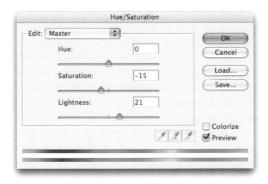

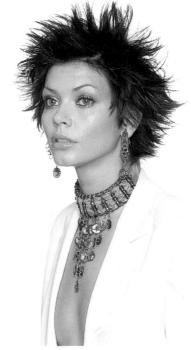

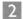

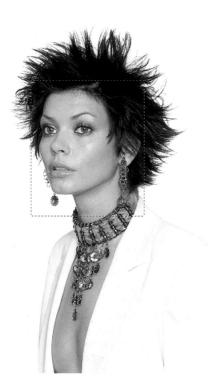

3 I do much of my beauty retouching using the brush tool on this copied layer. I prefer to use a pressure sensitive stylus and pad such as the Wacom Intuos, because this allows me a much finer degree of control than I can get with a normal mouse. Whenever you select a painting type tool you can select from a number of options from the Brushes palette that will enable you to determine what aspects of the brush behavior will be governed by the way you use the pressure sensitive stylus. Photoshop will not just be aware of the amount of pressure you apply with the stylus. If you are using the Wacom Intuos, Photoshop is now able to respond to input information such as the barrel rotation of the stylus, the angle of tilt or the movement of the thumbwheel (if you have one). In the example shown here I have checked the Other Dynamics checkbox and selected Pen Pressure from the Control menu. You can lock these brush attribute settings so that they stay fixed whenever you change brush presets.

2 When you create a clipping group in the Layers palette, the clipped layer will be displayed indented with a downward pointing arrow, as shown in the Layers palette screen shot below. I next wanted to concentrate on retouching the face. This was done by marqueeing the head and making a new layer via copy ((E)) (C)). This enabled me to modify the pixels on a separate layer, without permanently altering the background layer. Mistakes are easily made and this way I can always revert to the before version and compare the retouched layer with the original version of the image.

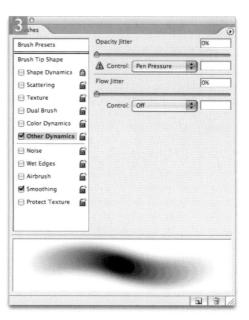

Repairing an image

5 I continued painting like this in Lighten mode to smooth other areas of the face. Where there were some shiny highlights, I switched to using the brush tool in Darken mode. I sampled a new color that was a touch darker than the highlights and painted over these areas to remove the shine. When using Darken mode, only the pixels that are lighter than the sampled color will be replaced. I like to retouch at 'full volume' so to speak. Some fashion photographers quite like the super-retouched effect. Others will argue that too much retouching will make the model's skin look more like a plastic doll rather than that of a real woman. It is up to you, but I usually prefer to fade the opacity of the retouched layer. Try reducing the layer opacity down to somewhere between 55 and 85%. Doing so will restore more of the original skin texture. The final result will be retouched but look more convincing.

Lay	1 P. A. CONTRACTOR		Opacity:	81%
Lock		+		<u>()</u>
	t	8	Hue/Satu	ration 1
		C	irves 1	1 0
	Laye	er 1		
	Back	ground		۵

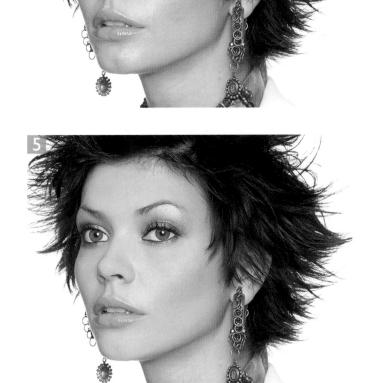

Chapter 6

Martin Evening

Adobe Photoshop CS2 for Photographers

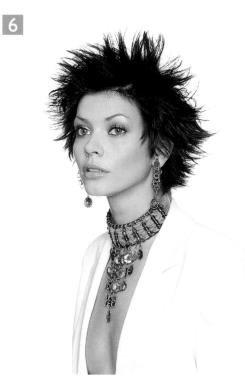

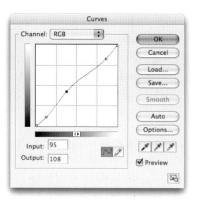

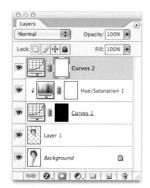

6 Finally, I introduced a Curves adjustment to increase the contrast in the red and green color channels and decreased the contrast in the blue color channel, to add a subtle cross-processing type of effect to the photograph.

Client: Andrew Price Salon. Model: Lisa Moulson at MOT models.

Removing wrinkles

Facial wrinkles can be removed by using the dodge tool set to Midtones and applied with a smallish soft edged brush at low opacity (1–2%). After gently brushing with the dodge tool, you will notice how the lines start to disappear.

Portrait retouching

Beauty retouching is about enhancing the makeup and the smoothness of the lighting on the face in a fashion/beauty photograph. Portrait retouching requires a fairly similar approach to getting rid of the blemishes and enhancing the skin texture of the subject. But I find that portrait retouching perhaps requires more restraint as you don't really want to always reduce the lines and wrinkles on older subjects, although the subject may argue otherwise.

Repairing an image

Chapter 6

1

Red eye correction

Red eye in portraits is caused when the flash source is used too close to the lens axis and the eye pupils are wide open. One way to avoid this happening is to set your camera flash to red eye mode (if available). The camera will usually pop a single or short series of flashes just before firing the main camera flash exposure. Failing that, the new red eye tool can be used to correct the picture in Photoshop afterwards.

The Pupil Size setting should be adjusted depending on the pixel dimensions of the image you are working on. And the darken amount can be adjusted according to the lightness of the red eye in the shot. Although you will find that the default settings tend to work just fine in the majority of cases.

Pupil Size: 50% 🕨 Darken Amount: 50% 💌

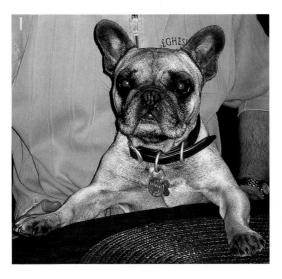

1 The red eye tool is very easy to use and effective at removing red eye from portraits shot with a direct flash.

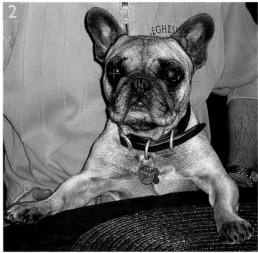

2 The default tool settings should be OK to start with. To use the tool just click on the red area of the eye. Photoshop will automatically calculate how to remove the red cast and darken the pupils.

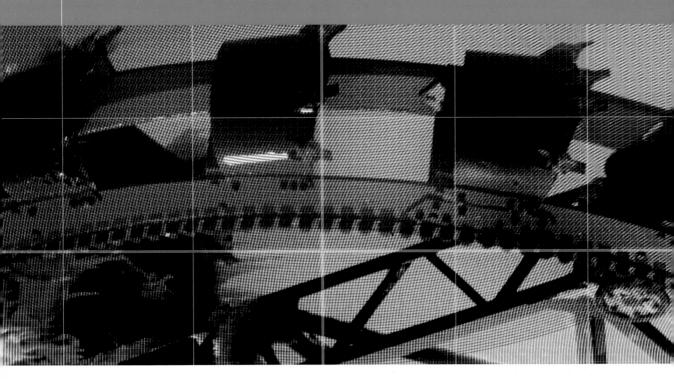

Chapter 7

Montage Techniques

or a lot of people the real fun starts when you can use Photoshop to swap parts of one photograph with another and make composite photographs using different image elements. This chapter explains the different tools that can be used in montage work. I will suggest some strategies for shooting pictures with a view to making a composite image which will also serve as a neat introduction to the use of layers in Photoshop. Later we will be looking at some of the other tools and methods that can be used to isolate picture elements from photographic images. But to begin with, let us focus on some of the basic principles of how to make a selection and the interrelationship between selections, alpha channels, masks, Quick Mask mode and paths.

Chapter 7 Montage techniques

Selections and channels

When you read somewhere about masks, mask channels, image layer mask channels, alpha channels, quick masks and saved selections, they are basically all the same thing: either an active, semipermanent or permanently saved selection.

Selections

There are many ways you can create a selection in Photoshop. You can use any of the main selection tools, the Select \Rightarrow Color Range command, or convert a channel or Path to a selection. When you use a selection tool to define an area within an image, you will notice that the selection is defined by a border of marching ants. Selections are only temporary though. If you make a selection and accidentally click outside the selected area with the selection tool, it will disappear. Although you can restore the selection with Edit \Rightarrow Undo (\Re \mathbb{Z} ctt \mathbb{Z}).

During a typical Photoshop session, I will draw basic selections to define the areas of the image where I want to carry out image adjustments and afterwards deselect them. If you end up spending any length of time preparing a selection then you will usually want to save the selection as an alpha channel (also referred to as a mask channel). To do this, choose Save Selection from the Select menu.

- Destinatio	n ————	ОК
Document:	DTA401298.psd	Cancel
Channel:	New	÷
Name:	Alpha 1	
- Operation		
New Char	nnel	
O Add to Cl	nannel	
O Subtract	from Channel	
	with Channel	

Figure 7.2 To save a selection as a new alpha channel you can choose Select \Rightarrow Save Selection and select the New Channel button option.

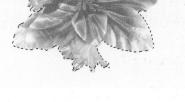

Figure 7.1 A selection is represented in Photoshop using marching ants.

Figure 7.3 When you save a selection it is added as a new alpha channel in the Channels palette. An alpha channel can be viewed by clicking on the channel name. If you click on the empty space next to the composite RGB channel (circled) to switch it on, you can preview an alpha channel as if it were a Quick Mask.

Recalling the last used selection

The last used selection will often be memorized in Photoshop. Choose Select ⇒ Reselect to bring back the last used selection.

Figure 7.4 The Quick Mask mode option is in the Tools palette just below the foreground/ background swatch colors. You can switch between Selection mode and Quick Mask mode by clicking on either of these two buttons. You can change the Quick Mask color settings by double-clicking on either of these buttons. The Save Selection dialog box will ask if you want to save as a new selection. Doing so creates a brand new alpha channel. If you check the Channels palette, you will notice the selection appears there labeled as an alpha channel (#4 in RGB mode, #5 if in CMYK mode). To reactivate this saved selection, choose 'Load Selection' from the Select menu and select the appropriate channel number from the submenu, or **H** *ctrl*-click the alpha channel in the Channels palette.

You can also create a new alpha channel by clicking on the Make New Channel button at the bottom of the Channels palette and fill the empty new channel with a gradient or paint in the alpha channel with a painting tool using the default black or white colors. This new channel can then be converted into a selection.

In marching ants mode, a selection is active and available for use. All image modifications made will be effective within the selected area only. Selections are temporary and can be deselected by clicking outside the selection area with a selection tool or by choosing Select \Rightarrow Deselect ($\Re D$ ctrl D).

Quick Mask mode

You can also preview and edit a selection in Quick Mask mode where the selection will be represented as a transparent colored mask overlay. To switch to Quick Mask mode from a selection, click the Quick Mask icon in the Tools palette (see Figure 7.5) or use the keyboard shortcut (Q) to toggle between the Selection and Quick Mask mode. Quick Mask modifications can be carried out using any of the fill, paint or even selection tools. If the mask color is too similar to the subject image, double-click the Quick Mask icon, click on the Color box in the opened dialog and choose a different color from the Color Picker. In Quick Mask mode (or when working directly on the alpha channel) you can use any combination of Photoshop paint tools, Image adjustments to modify the alpha channel content. To revert from a quick mask to a selection, click the Selection icon in the Tools palette or press *Q* again.

Modifying selections

You can modify the content of a selection using the modifier key methods discussed earlier in Chapter 2 (see pages 57–58). Just to recap, you hold down the *Shift* key to add to a selection, hold down the *shift* key to subtract from a selection and hold down the *shift all shift* keys to intersect a selection as you drag with a selection tool. The magic wand is a selection tool too, but you just click (not drag) with the magic wand, holding down the appropriate key(s) to add or subtract from a selection. While the lasso or marquee is still selected, placing the cursor inside the selection and dragging moves the selection boundary position, but not the selection contents.

Alpha channels

Note that an alpha channel is effectively the same thing as a mask. A selection can be stored as a saved selection by converting it to become a new alpha channel. To do this choose Select \Rightarrow Save Selection. An alpha channel can also be converted back into a selection by choosing Select \Rightarrow Load Selection. Alpha channels are stored as extra channels in the Channels palette in sequence below the main color channels. Just like a normal color channel, an alpha channel can contain up to 256 shades of gray in 8 bits per channel mode or up to 32,000 shades of gray in 16 bits per channel mode.

When an alpha channel is selected and made active, it can be viewed on its own as a grayscale mask and can be manipulated almost any way you want inside Photoshop. An alpha channel can also effectively be viewed in a 'Quick Mask' type mode. To view and edit an alpha channel in this way, make the alpha channel active and then click on the eyeball icon next to the composite channel, which is the one at the top (see Figure 7.3). You will then be able to edit the alpha channel mask with the image visible below.

Figure 7.5 The right half of the image shows a feathered selection and the left half the Quick Mask mode equivalent display.

Reloading selection shortcuts

To reload a selection from the saved mask channel, go to Select ⇒ Load Selection. (¥) ctrr-clicking a channel is the other shortcut for loading a selection and by extension, combining (¥) ⊂ channel # ctrr att channel # (where # equals the channel number) does the same thing. Alternatively you can also drag the channel icon down to the Make Selection button in the Channels palette.

Martin Evening Adobe Photoshop CS2 for Photographers

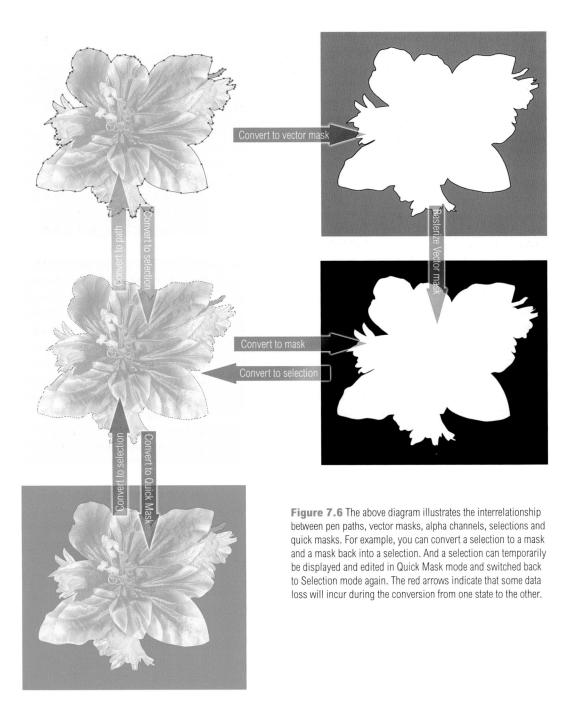

Selections, alpha channels and masks

As was pointed out at the beginning of this chapter, there is always an intertwined relationship between selections, quick masks and alpha channel masks. This interrelationship also extends to the use of vector paths and vector masks. The accompanying diagram in Figure 7.6 illustrates these relationships more clearly.

Starting at the top left corner, we have a path outline that has been created with the pen tool in Photoshop. A pen path can be used to make a vector mask (a layer masked by a pen path mask) and a vector mask can be rasterized to become a layer mask (a layer masked by an alpha channel). Meanwhile, a pen path can be converted to a selection and a selection can be converted back into a work path. If we start with a selection, you can view and edit a selection as a quick mask and a selection can also be converted into an alpha channel and back again.

When preparing a mask in Photoshop, most people will start by making a selection to define the area they want to work on and save the selection as an alpha channel mask. This means that you can convert the saved alpha channel back into a selection again at any time in the future. The other popular route is to use the pen tool to define the outline first, convert the pen path to a selection and then convert the selection to an alpha channel.

The business of using vector masks and layer masks is covered in more detail later on. But basically, a vector mask is a pen path applied to a layer which defines what is shown and hidden on that layer. A layer mask is an alpha channel applied to a layer which defines what is shown and hidden.

Converting vector to pixels

In Figure 7.6 I mention that some of the conversion processes will incur a loss of data. This is because when you convert vector data to become a pixel-based selection, what you end up with is not truly reversible. Drawing a pen path and converting the path to a selection is a very convenient way of making an accurate selection. But if you attempt to convert the selection back into a pen path again, you will not end up with an identical path to the one that you started with. Basically, converting vectors to pixels is a one-way process.

Converting a vector path into a pixelbased selection is a good thing to do, but you should be aware that converting a pixel-based selection into a vector path will potentially incur some loss of data. More specifically, a selection or mask can contain shades of gray, whereas a pen path merely describes an outline where everything is either selected or not.

Smoothing a selection

If you make a selection using the magic wand or Color Range method, the chances are that the selection is not as smooth as you might think. You will mostly notice this when you view such a selection in Quick Mask mode. The Smooth option in the Select \Rightarrow Modify submenu addresses this by enabling you to smooth out the pixels selected or not selected to the level of tolerance you set in the dialog box.

1 The objective here was to make a simple soft edged selection based on tonal values and change the color of the background slightly. I used the magic wand tool to make a selection of the backdrop. A tolerance setting of 25 was used. I enlarged the selection locally by choosing Select ⇒ Grow. Note that the amount of growth is governed by the tolerance values linked to the magic wand tool options.

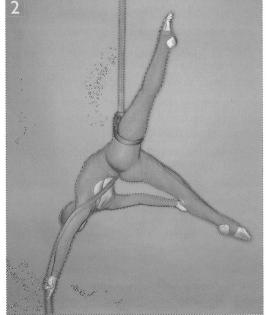

2 The magic wand tool may not select all the desired backdrop pixels. I chose Select \Rightarrow Modify \Rightarrow Smooth, and entered a Radius value of between 1 and 16. The selection is now a lot smoother. Smooth works like this: if the Radius chosen was 5, Photoshop will examine all pixels with an 11 × 11 pixel block around each pixel. If more than half are selected, any stray pixels will be selected as well. If less than half are selected, any stray pixels will be deselected.

3 With the selection satisfactorily complete, I hid the selection edges (View \Rightarrow Hide Extras) and opened the Hue/Saturation dialog box. Adjust the Hue and Saturation sliders to color the selected area.

Master Hue:	-30	OK Cance
Saturation:	-10	Load
Lightness:	0	Save
		Coloriz

Photograph by Eric Richmond.

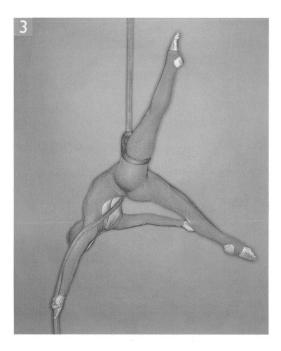

Expanding and shrinking selections

To expand or shrink a selection, choose Select \Rightarrow Modify \Rightarrow Expand/Contract. Selections can be modified up to a maximum of 100 pixels. Other options include Border and Smooth. To see how these work, make a selection and choose one of the Modify options from the Select menu. Enter various pixel amounts and inspect the results by switching from Selection to Quick Mask mode. The border modifications are rather crude, but they can sometimes be improved by applying feathering or saving the selection as a channel and applying the Gaussian Blur filter. To see the Border selection command in use, check out the matte removal tutorial on pages 304–305.

But be beware, there is an inherent flaw in Photoshop that creates angled corners when you use Select \Rightarrow Modify \Rightarrow Expand Selection. The most accurate way to expand an active selection is to choose Select \Rightarrow Transform Selection, and use the bounding box handles to scale a selection more accurately.

Grow and Similar

The Grow and Similar options enlarge the selection using the same criteria as with the magic wand tool, regardless of whether the original selection was created with the wand or not. To determine the range of color levels to expand the selection by, enter a tolerance value in the Options palette. A higher tolerance value means that a wider range of color levels will be included in the enlarged selection.

The Select \Rightarrow Grow option expands the selection, adding contiguous pixels, i.e. those immediately surrounding the original selection of the same color values within the specified tolerance. The Select \Rightarrow Similar option selects more pixels from anywhere in the image of the same color values within the specified tolerance.

Figure 7.7 The above illustration shows a graphic where the left half is rendered without anti-aliasing and the right half uses antialiasing to produce smoother edges.

Figure 7.8 If you want to soften the edges of a selection, then use Select \Rightarrow Feather and enter the desired feather radius.

Feather shortcut conflict?

The Select \Rightarrow Feather keyboard shortcut is **H S D ctr? a**/**t D**. If you are using Mac OS X then it is possible that this keyboard shortcut will instead toggle showing/hiding the Dock. To get around this, go to the System Preferences and choose Keyboard & Mouse \Rightarrow Keyboard Shortcuts and deselect the Automatically Show/Hide the Dock shortcut.

Anti-aliasing and feathering

All selections and converted selections are by default antialiased. A bitmapped image consists of a grid of square pixels. Without anti-aliasing, a diagonal line would be represented by a jagged sawtooth of pixels. Photoshop gets round this problem by anti-aliasing the edges, which means filling the gaps with in-between tonal values. All non-vertical/horizontal sharp edges are rendered smoother by the anti-aliasing process. So wherever you encounter anti-aliasing options, these are normally switched on by default. And there are only a few occasions when you may wish to turn this off.

Sometimes you may have an 8-bit image which resembles a 1-bit data file (say an alpha channel after you have applied the Threshold command) which needs to be anti-aliased. The best way to do this is to apply a Gaussian Blur filter to the mask, using a radius of 1 pixel. If it is just a small portion of a channel mask that requires smoothing, you can use the blur tool to lightly soften the edge.

To soften a selection edge, go to the Select menu, choose Feather and enter a pixel radius. A low pixel radius of between 1.0 or 2.0 is enough to dampen the sharpness of a selection outline, but there are times when it is useful to select a much higher radius amount. For example, in the previous chapter on pages 244–245, I used the rectangular marquee tool to define a rectangular selection. I then feathered this selection by 150 pixels, inverted the selection and applied a Levels adjustment through the feathered selection to create a vignette that darkened the outer edges of the photograph.

Smoother selection edges

ALL ADD

When you are doing any type of photographic retouching it is important to always keep your selections soft. If the edges of a picture element are defined too sharply, it will be more obvious to the viewer that a photograph has been retouched or montaged. The secret of good compositing is to avoid creating hard edges and keep the edges of your picture elements soft so they merge together more smoothly.

Photoshop paths

The selection tools are nice and easy to use and many people will quite happily use a combination of, say, the magic wand and Quick Mask to generate a selection of an outline. But if you are editing anything other than low resolution images there will be times when the standard selection tools just won't be able to provide the precision you are after. In these circumstances you really will need a more accurate way to define an outline. This is where the pen tools and Photoshop paths come in.

If you are planning to work with large files, you will mostly find it quicker to draw a path and convert this to a selection rather than relying on the selection and paint tools alone. The magic wand may do a fine job on tutorialsized files, but is not a method that translates well to working on bigger images. The magnetic tools fall half way between. They are cleverly designed to automate the selection process, but there is usually no alternative available but to manually define the outline with a path.

Selections to paths

An active selection can also be converted to a path by clicking on the Make work path from selection button at the bottom of the Paths palette. Alternatively, choose the Make work path option from the Paths palette fly-out menu.

Figure 7.9 The Shape layers mode is the default setting in the pen tool options. I usually recommend that you click on the Paths mode button to set this as your new default.

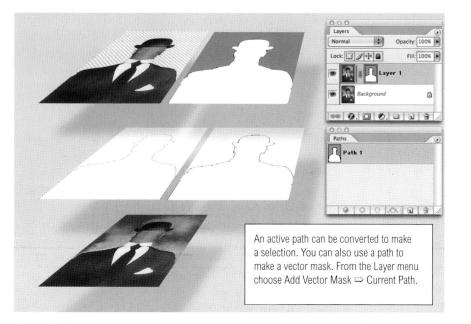

Figure 7.10 A current path can be converted to a selection or loaded as a vector mask to hide the contents of a layer.

Figure 7.11 The path tutorial file which can be found on the CD-ROM.

Editing path segments

You can edit a straight line or curved segment by selecting the direct selection tool, clicking on the segment and dragging. With a straight segment the anchor points either end will move in unison. With a curved segment, the anchor points remain fixed and you can manipulate the shape of the curve as you drag with the direct selection tool.

Figure 7.12 Simply click with the pen tool to create straight line segments.

Creating a path

A work path can be created in Photoshop using the pen tool and there are two main ways of making a path. In Paths mode a 'work path' is created and the subsequent work path (whether it is closed or not) can then be converted to a foreground fill, stroke or a selection by dragging the path down to the appropriate button at the bottom of the Paths palette. In Shape layers mode you can create a filled object defined by the path that is filled with the current foreground color. An active, 'current' path can also be converted into a vector mask which will mask the contents of a layer using the path.

Drawing paths with the pen tool

Unless you have had previous experience working with a vector-based drawing program like Freehand or Adobe Illustrator, the concept of drawing with the pen tool will probably be an unfamiliar one. It is difficult to get the hang of at first, but I promise you it is well worth mastering the art of drawing with the pen tool. It is a bit like learning to ride a bike, but once you have acquired the basic skills, it will all start to fall into place. Paths are useful in several ways: either applying a stroke with one of the paint tools, for saving as a clipping path, or defining a complex shape, which can be converted to a selection or applied as a vector mask to mask a layer.

Guidelines for drawing pen paths

We shall start with the task of following the simple contours illustrated in Figure 7.11 (you will find a copy of this image in a layered Photoshop format on the CD). This Photoshop file contains saved path outlines of each of the shapes. The background layer contains the basic image and above it there is another layer of the same image but with the pen path outlines and all the points and handles showing. Make this layer visible and fade the opacity if necessary so that you can follow the handle positions when trying to match drawing the path yourself. Start at kindergarten level with the letter 'd'. If you mastered drawing with the polygon lasso tool, you will have no problem doing this. Click on the corner points one after another until you reach the point where you started to draw the path. As you approach this point with the cursor you will notice a small circle appears next to the cursor which indicates you are now able to click (or drag) to close the path. Actually this is better than drawing with the polygon lasso, because you can now zoom in if required and precisely reposition each and every point. Hold down the **H** *ett* key to temporarily switch the pen tool to the pointer tool and drag any point to realign it precisely. After closing the path, hit **H** *Enter ctrl Enter* to convert the path to a selection and click *Enter* on its own to deselect the path.

Now try to follow the letter 'h'. This will allow you to concentrate on the art of drawing curved segments. Observe that the beginning of any curved segment starts by dragging the handle outward in the direction of the intended curve. To understand the reasoning behind this, imagine you are trying to define a circle by following the imagined edges of a square box containing the circle. To continue a curved segment, click and hold the mouse down while you drag to complete the shape of the end of the last curve segment and predict the initial curve angle of the next segment. This assumes the next curve will be a smooth continuation of the last. Whenever there is a sharp change in direction you need to make a corner point. Convert the curved segment by holding down the 🔀 all key and clicking on it. Click to place another point. This will create another straight segment as before in the 'd' example. Hold down the **H** *ctrl* key to temporarily access the direct selection tool which can be used to reposition points. When you click a point or segment with this tool, the handles are displayed. Adjust these to refine the curve shape.

The 'v' shape will help you further practice making curved segments and corner points. A corner point should be placed whenever you intend the next segment to break with the angle of the previous segment. In the niches of the 'v' symbol, hold down the all all key and drag to define the predictor handle for the next curve shape.

Figure 7.13 To draw a curved segment, instead of clicking, mouse down and drag as you add each point. The direction and length of the handles define the shape of the curve between each path point.

Figure 7.14 When you create a curved segment the next handle will continue to predict a curve, continuing from the last curved segment. To make a break, you need to modify the curve point, converting it into a corner point. To do this, hold down the additional add

So, to edit a pen path, you use the **H** *ctrl* key to temporarily convert the pen tool to the direct selection tool, which you use to click on or marquee anchor points and reposition them. And you use the **C** *alt* key to convert a curve anchor point to a corner anchor point and vice versa. If you want to convert a corner point to a curve, **C** *alt*+mouse down and drag. To change the direction of one handle only, **C** *alt* drag on a handle. To add a new anchor point to an active path, simply click on a segment with the pen tool. To remove an anchor point, just click on it again.

Rubber Band mode

As you read on in this chapter you will notice there are a number of occasions where I find it necessary to use the pen tool to define an outline and then convert the pen path to a selection. In the end, the pen tool really is the easiest way to define many outlines and create a selection from the path. One way to make the learning process somewhat easier is to switch on the Rubber Band option which is hidden away in the pen tool Pen Options.

Auto Add/Delete	
Pen Options	

Figure 7.15 The easiest way to get accustomed with the ways of the pen tool is to go to the Pen Options in the Options bar, mouse down on the Pen Options options and check the Rubber Band box. The pen tool will now work in Rubber Band mode, which means that you will see the segments you are drawing take shape as you move the mouse cursor, and not just when you mouse down again to define the next path point.

Layers

Layers play an essential role in all aspects of Photoshop work. Whether you are designing a web page layout or editing a photograph, working with layers lets you keep various elements in a design separate from each other. Layers allow you the opportunity to construct an image in stages and maintain the flexibility to make any editing changes you want at a later stage.

To rename a layer in Photoshop, simply double-click the layer name. To duplicate a layer, drag the layer icon to the New Layer button. To discard a layer, drag the layer icon to the delete button in the Layers palette. There is also a Delete Hidden Layers command in both the Layers palette submenu and the Layer \Rightarrow Delete submenu.

The Photoshop Layers feature has evolved in several stages over the years and Photoshop CS2 now introduces new methods for selecting multiple layers and linking them together. But first let's look at the different types of layers that you can have in a Photoshop document.

Image layers

The most basic type of layer is an image layer which is used to contain pixel information only. Using either the Layer menu or the Layers palette fly-out, layers can be duplicated from one file to another, either individually, in multiples or as Groups. The same applies when dragging and dropping a layer or layers from one file to another. And this can be assisted by the use of the *Shift* key to ensure they are centered with the destination file. New empty image layers are also created by clicking on the New Layer button in the Layers palette. They can also be created by copying the contents of a selection from another image layer within the same document. Choose Layer \Rightarrow New \Rightarrow Layer via Copy, or use the keyboard shortcut \mathbb{H} *ctrl* **J**. This will copy the selection contents, duplicating them to become a new layer in register with the image below. Alternatively you can cut and copy the contents from a layer by choosing Layer \Rightarrow New \Rightarrow Layer via Cut or the keyboard shortcut (# Shift J) ctrl Shift J.

Deleting multiple layers

Photoshop CS2 will now let you delete multiple layers more easily. Use *Shift* click or (#) *ettl* to select the layers or layer groups you want to remove and then press the Delete Layer button at the bottom of the Layers palette.

Layer number limits

You can add as many new layers as you like to a document up to a maximum limit of 8000 layers.

Layer visibility

You can selectively choose which layers are to be viewed by selecting and deselecting the eye icons. And in Photoshop CS2 the layer visibility (switching the layer visibility on or off) is recorded in the history and is therefore also an undoable step.

Figure 7.16 The pen tool and shape tools include a shape layer mode button for creating shape layer objects defined by a vector path created with the above mentioned tools.

Figure 7.17 Text layers are created whenever you add type to an image. Text layers allow you to re-edit the typed content at any time.

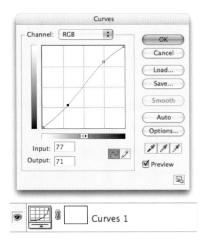

Figure 7.18 Adjustment layers don't contain pixels or vector objects. They are image adjustments that can be strategically placed within an image to apply image adjustments to individual or multiple layers. But like other layers, you can mask the contents and adjust the blending mode and layer opacity.

Shape layers

Shape layers is a catch-all term to describe a non-pixel layer where the layer is filled with a solid color and the outline is defined with a vector mask and/or a layer mask. A shape layer is created whenever you add an object to an image using one of the shape tools, or draw a path in the shape layer mode, or when you add a solid fill layer from the adjustment layer menu. Figures 7.19 and 7.20 include examples of shape layers in use. One is masked with a layer mask and the other is masked with both a vector mask and layer mask.

Text layers

Text layers, like shape layers, are also vector based. Type faces are essentially made up of vector data which means they are resolution dependent. When you select the type tool in Photoshop and click or drag with the tool and begin to enter text, a new text layer will be added in the Layers palette. A text layer is symbolized with a capital 'T'. When you hit *Return* to confirm a text entry, the layer name will display the initial text on that layer, making it easier for you to locate.

Adjustment layers

Adjustment layers contain image adjustments that will be applied to all layers that appear below the adjustment layer in the Layers palette. If you create a clipping mask between an adjustment layer and the layer immediately below, the image adjustment will be applied just to that layer. You can toggle an adjustment layer on or off by clicking the layer eyeball icon. And one of the chief advantages of working with adjustment layers is that you can re-edit the adjustment settings at any time.

Layers palette controls

The blending mode options determine how the selected layer will blend with the layers below, while the Opacity controls the transparency of the layer contents. The Fill opacity slider controls the opacity of the layer contents independent of any layer style (such as a drop shadow) which has been applied to the layer. And next to this are the various layer locking options. A lot of the essential layer operation commands are conveniently located in the Layer palette fly-out options. And at the bottom of the palette are the layer content controls for layer linking, adding layer styles, layer masks, adjustment layers, new groups, new layers as well as a delete layer button.

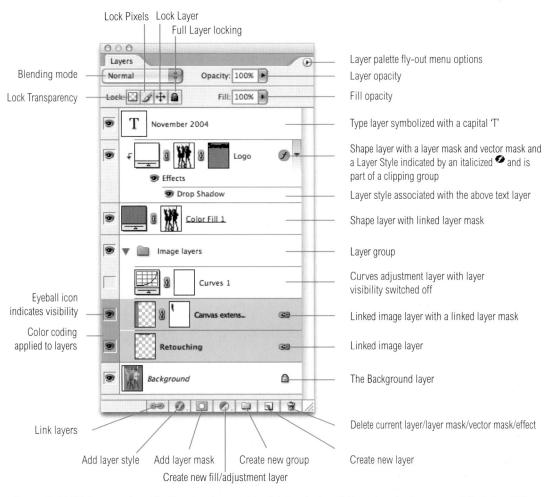

Figure 7.19 This is an overview of the Photoshop Layers palette. Note how the layer linking column has been removed. Photoshop CS2 allows you to make selections of layers and work with them without the need for linking. Or, you can permanently link them via the Link button.

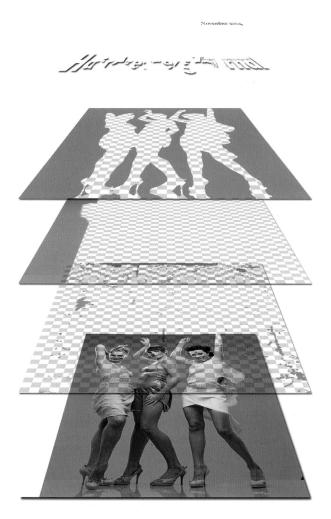

Figure 7.20 Here is an expanded diagram of how the layers in the magazine cover presented in Figure 7.19 are arranged inside Photoshop, one on top of the other. The checkerboard pattern represents transparency and the layers are represented here in the order they appear in the Layers palette.

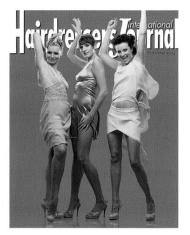

Client: Goldwell Professional Haircare.

Masking layers

You can hide the contents of a layer either wholly or partially by adding a layer mask, a vector mask or both. Layer masks are defined using a pixel-based mask, while vector masks are defined using path outlines. Masks can be applied to any type of layer: image layers, adjustment layers, type layers and shape layers. Click once on the Add Layer Mask button to add a layer mask, and click a second time to add a vector mask. In the case of shape layers a vector mask is created first and clicking the button will then add a layer mask. The most important thing to remember about masking in Photoshop is that whenever you apply a mask you are only hiding the contents and not deleting anything. By using a mask to hide rather than erase unwanted image areas, you can go back and change the mask at a later date. Or if you make a mistake when editing the layer mask, it is easy to correct mistakes - you are not limited to a single level of undo.

Adding a layer mask

Click once on the Add Layer Mask button to add a layer mask to an image layer, type layer or shape layer (when you add an adjustment layer or fill adjustment layer a layer mask will be added automatically). The layer mask icon will appear next to the layer icon and a dashed stroke surrounding the icon will tell you which is active.

To show or hide the layer contents, first make sure the layer mask is active. Select the paintbrush tool and paint with black to hide the layer contents and paint with white to reveal.

To add a layer mask based on a selection, highlight the layer, make the selection active and click on the Add Layer Mask button at the bottom of the Layers palette, or choose Layer \Rightarrow Layer Mask \Rightarrow Reveal Selection. To add a layer mask to a layer with the area within the selection hidden, **alt**-click the Layer Mask button in the Layers palette or choose Layer \Rightarrow Layer Mask \Rightarrow Hide Selection.

Figure 7.21 The Layers palette view shown here contains two layers. The selected layer is the one highlighted in blue. The dashed border line around the layer mask icon indicates that the layer mask is active and any editing operations will be carried out on the layer mask only. There is no link icon between the image layer and the layer mask. This means that the image layer or layer mask can be moved independent of the other.

Figure 7.22 In this next palette screen shot, the border surrounding the vector mask indicates that the vector mask is active and that any editing operations will be carried out on the vector mask only and not the image layer or layer mask. The image layer, layer mask and vector mask are all linked together.

Adding an empty image layer mask

If you create an empty layer mask (one that is filled with white) on a layer, you can hide pixels in a layer using the fill and paint tools. To add a layer mask to a layer with all the layer remaining visible, click the Layer Mask button in the Layers palette. Alternatively, choose Layer ⇒ Add Layer Mask ⇒ Reveal All. To add a layer mask to a layer that hides all the pixels, **S a**tt-click the Add Layer Mask button in the Layers palette. Alternatively, choose Layer ⇒ Add Layer Mask ⇒ Hide All. This will add a layer mask filled with black.

Viewing in Mask or Rubylith mode

The small Layer Mask icon shows you roughly how the mask looks. But if you all-click the Layer Mask icon you can have the image window view switch to display the mask. And if you Shift alt Shift-click the layer mask, the layer mask will be displayed as a Quick Mask type transparent overlay. Both these actions can be toggled.

Removing a layer mask

To remove a layer mask, go to the Layer menu \Rightarrow Layer Mask submenu. There are now several options here: if you simply want to delete the layer mask, then select Delete. If you wish to remove the layer mask and apply it at the same time, then choose Apply. Or select the mask in the Layers palette and click on the Layers palette delete button or drag the layer mask to the delete button. A dialog box will appear asking do you want to Apply mask to layer before removing? Then click Discard to delete the mask, Cancel to cancel the operation, or Apply to apply the layer mask. To temporarily disable a layer mask, choose Layer \Rightarrow Layer Mask \Rightarrow Disable. To reverse this, choose Layer \Rightarrow Layer Mask \Rightarrow Enable. Another shortcut is to *Shift*-click the Layer Mask icon to disable it and *Shift*-click to enable it again (when a layer mask is disabled the icon is overlaid with a red cross). Or alternatively, *ctrl* right mouse-click the mask icon to open the full list of contextual menu options to apply, discard or disable the layer mask.

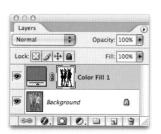

Copying a layer mask

You can use the **S** *all* key to drag/ copy a layer mask across to another layer. Figure 7.23 Here is an example of how the image view will look if you Shift all Shift-click the layer mask (left) to display the layer mask in Quick Mask mode. And on the right, how it will look if you all click the layer mask to view the mask in the image window. The layer mask can still be edited while it is viewed in these modes.

277

Vector masks

A vector mask is just like an image layer mask, except the mask is described using a vector path instead. A vector mask can be edited using the pen path tools or the shape geometry tools. Because a vector mask is vector based, it is resolution-independent and can be transformed or scaled to any size without a loss in image quality. To add a vector mask from an existing path, go to the Paths palette, select a path to make it active, and choose Layer \Rightarrow Add Vector Mask \Rightarrow Current Path.

Hiding/showing layer/vector masks

You can temporarily hide/show a layer mask by *Shift*-clicking on the Layer Mask icon. Also, clicking a vector mask's icon in the Layers palette hides the path itself. Once hidden, hover over it with the cursor and it will temporarily become visible. Click it again to restore the visibility.

1 A vector mask can be created from a currently active path such as the one displayed here. But the path mode will influence what is hidden and what is revealed when the path is converted into a vector mask.

2 The path icon appearance will indicate the path mode. The gray fill in the path icon represents the hidden areas. So a path like the one shown here will have been created in 'add to path area' mode. When this mode is used to generate a vector mask, the outside areas will become hidden.

3 If a path has been created in the 'subtract from path area' mode, the inside areas will become hidden when the path is used to create a vector mask. However, you can alter the path mode. Go back to step 1. Select the path selection tool (the one immediately above the pen tool). Click on the path to make all the path points active and then select the pen tool and click on the 'add to path area' mode button in the Options bar to turn a path into an additive path. Or click on the 'subtract from path area' mode button to turn it into a subtractive path.

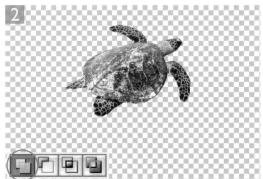

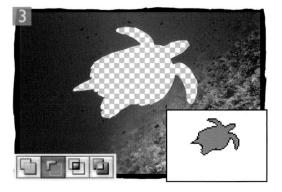

Photograph: Peter Hince.

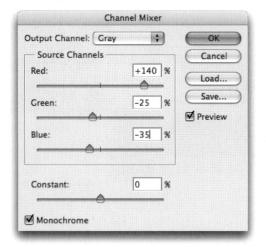

1 I used the pen tool to define the outline of this park sculpture. Note that the pen tool has to be in path mode (circled in the Options bar). And because I wanted to create a path that selected everything outside the enclosed path, I checked the Subtract from Path Area button (circled in red) before I began drawing the path.

E P

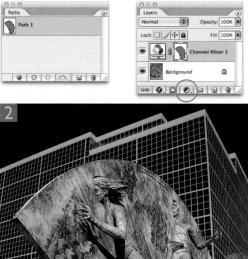

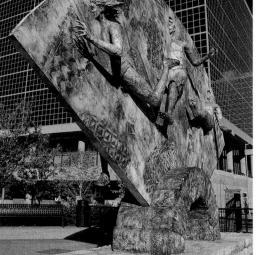

2 With the work path active, I clicked on the New Adjustment Layer button in the Layers palette and selected Channel Mixer. This added an adjustment layer with a linked vector mask. I used Channel Mixer to make a black and white conversion of the areas selected by the vector mask. You can use Layer \Rightarrow Change Layer Content to switch between different types of adjustment/fill layers. To edit a vector mask, use the direct path selection tool to manipulate the path outline.

Working with multiple layers

Layers have become an essential Photoshop feature and enable you to do complex montage work. But as the layer features have evolved there has been an increasing need to manage the layers more efficiently. A number of crucial changes have taken place with layers in Photoshop CS2. New functionality has been added but there have also been some important alterations made to the layer management, selection and linking processes. For some Photoshop users, the removal of the linking column is a heresy. While I appreciate that this represents a big change to the Layers palette interface, I do not believe that this has done anything to harm or slow down the way we use layers in Photoshop.

Layer group management

Multi-layered images can become extremely unwieldy to navigate when you have lots of layers all placed one above the other. Layers can be organized more efficiently by placing them in layer groups (previously known as sets). Layer groups use a folder icon and the general idea is that you can place related layers together inside a layer group folder. The layer group folder can then be collapsed or expanded. So if you have lots of layers in an image document, layer groups will make it easier to arrange your layers and make layer navigation much easier.

Layers groups can be made visible or invisible by clicking on the layer group eye icon. It is also possible to adjust the opacity and blending mode of a layer group as if it were a single layer, while the subset of layers within the layer group itself can all have individually set opacities and use different blending modes. You can add a layer mask or vector mask to a layer group and use this to mask the layer group visibility as you would with an individual layer.

To reposition a layer in the Layers palette, click on the layer and drag it up or down the layer stack. To move a layer into a layer group, drag it on top of the layer group icon or drag it into an expanded layer group. To remove a layer from a layer group, just drag the layer above or below its group in the stack.

Figure 7.24 Layers can be color coded. Choose Layer Properties from the Layers palette fly-out menu, or and all double-click the layer (one layer at a time) and pick a color to identify each of the layers with.

Nested layer groups

You can have a layer group (or groups) nested within a layer group up to three nested layer groups deep.

1 Layers can be moved into a layer group by mousing down on a layer and dragging the layer into the desired layer group.

2 The same method is used when you want to move a layer group within another layer group. Mouse down and drag to the position where you want it to be placed.

3 You can also move multiple layers at once. Make a Shift select, or 🔐 ctrl layer selection and drag the selected layers into a layer group (note that the Brush work layer group is now collapsed and nested within the Retouching layer group).

drag the layer out of the layer group until you see a bold line appear on the divider above or below the layer group.

4 To remove a layer from a layer group, just 5 Here is a view of the Layers palette with the Hair layer now outside the retouching layer group.

Clicking on the Create a New Layer Group button in the Layers palette will add a new layer group above the current target layer. **H** *cttl*-clicking on the Create a New Layer Group button will add a layer group below the target layer. **C** *alt*-clicking opens the New Group from Layers dialog. You can also lock all layers inside a layer group via the Layers palette submenu.

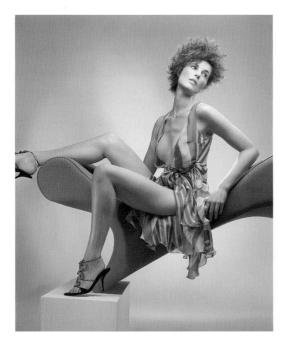

Figure 7.25 When a Photoshop document ends up with this many layers, the layer stack can become extremely unwieldy. It is possible to organize layers within layer groups. All the basic cleanup work layers are grouped together in a single layer group. I was able to group them by Smith-clicking on the bottom five layers to make a multiple layer selection. I then chose New Group from Layers... from the Layers palette fly-out menu. I entered a name for the new group and selected a violet color to color code the layers within this group. The visibility of all layers in a group can be switched on or off and the opacity of the layer set group can be adjusted as if all the layers were a merged layer.

Client: Rainbow Room. Model: Nicky Felbert @ MOT.

Group layer shortcut

Selected layers can be grouped together by choosing Layer \Rightarrow Group Layers or using the **#** G ctt/G shortcut.

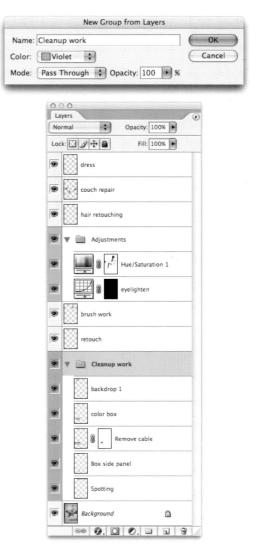

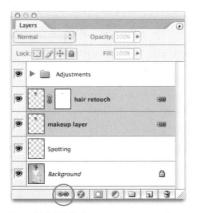

Figure 7.26 To link two or more selected layers, click on the link button at the bottom of the Layers palette.

Opacity: 100%

Fill:

Layer 11

naint laver

Anto Select Laye

Lock: 2 3 + 0

🄊 🕨 🛄 Front image

Step 5
 Step 4
 Step 3
 Step 2
 Step 1
 Step 1
 Step 1
 Step 1
 On box

Layer selection and linking

When working with more than one layer you can choose to link layers together by creating links in the Layers palette. Multiple layers can be linked by first making a layer selection and then linking them together. Start by Shift-clicking on the layer names to select contiguous layers, or **#** *ctrl*-clicking to select discontiguous layers. At this point you can move, transform or group the layers as a group. But if you need to make this layer selection linking more permanent, then the layers can then be linked together by clicking on the Link Layers button at the bottom of the Layers palette. When two or more layers are linked by layer selection or formal linking, any moves or transform operations will be applied to the linked layers as if they were one. But they still remain as separate layers, retaining their individual opacity and blending modes. To unlink a layer, select the layer and click on the link button to switch it off.

1

Figure 7.27 Whenever the move tool is selected and Auto Select Layer is checked in the move tool options you can auto select a layer by just clicking in the image. If Auto Select Layer is not checked, you can toggle this behavior by holding down the **EX COU** as you click. When Auto Select Layer is checked you can also marquee drag with the move tool from outside the document bounds to achieve a layer selection of all the layers within the marqueed area. But the move tool marquee must start from outside the document bounds, i.e. you must start from the canvas area inwards. If the Auto Select Groups option is checked then only layer groups will be selected by this action. If unchecked, all layers that fall within the marqueed area will be selected.

Client: Hitachi/Ogilvy & Mather Direct. Model: Lidia @ M&P.

You can select all layers and make them

Selecting all layers

▶_⊕ . (

DOO Layers Pass Through

active when any tool is selected, by using the **H C** *A ctrl alt* **A** shortcut.

Background

Layer mask linking

Layer masks and vector masks are by default linked to the layer content. If you move a masked layer, the mask moves with it, as long as no selection is active, then any movement or transformation of the layer content will be carried out independently of the associated mask. It is therefore sometimes desirable to disable the link between layer mask/vector mask and the layer it is masking. When you do this, any further movements or changes can now be applied to the layer or the layer/vector mask separately. You can tell if the layer or the layer/vector mask are selected, because a thin black dashed border will surround the layer or layer mask icon.

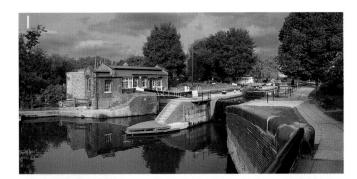

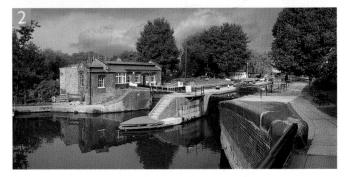

Figure 7.29 This photograph contains a masked sky layer which is adding some dark clouds to the picture. The layer and layer mask would normally be linked. But if I click on the link icon between the layer and the layer mask, I can disable the mask and when the layer is made active I can move the sky layer independently of the mask.

Figure 7.28 When the move tool is selected, you can use the contextual menu to select individual layers. Mouse down on the image using *ctrr* right mouse click to access the contextual menu shown here and click to select a named layer. The contextual options will list all of the layer groups in the document plus just those layers within the layer group immediately below the mouse cursor. The Similar Layers option is interesting because it will allow you to select layer is selected, the Similar Layers option will select all other type layers in the document.

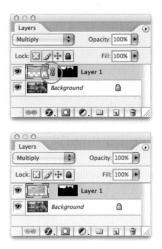

1 This shows the Layers palette with a new image layer (Layer 1) above the Background layer. Lock Transparent Pixels will prevent you from painting in the layer's transparent areas accidentally.

Layers			۲
Multiply :	Opacity	: 100%	•
Lock: 🖸 🍠 🕂 🔒	Fill	100%	
•	Layer 1	۵	
Backgroun	nd	۵	
60 0 0 0		1.3	

2 Lock Image Pixels will preserve transparency and prevent you from accidentally painting on any part of the image layer, yet allow movement of the layer.

3 Lock Layer Position will prevent the layer from being moved, while you can continue to edit the layer pixels.

4 The Lock All box will lock absolutely. The layer position will be locked, the contents cannot be edited. The opacity or blend modes cannot be altered, but the layer can be moved up or down the layer stack.

Layer locking

Photoshop layers can be locked in a number of ways. The layer locking options are to be found at the top of the Layers palette just below the blending mode options.

Lock Transparent Pixels

When Lock Transparent Pixels is switched on, any painting or editing you do will be applied to the opaque portions of the layer only. Where the layer is transparent or semitransparent, the layer transparency will always be preserved.

Lock Image Pixels

The Lock Image Pixels option locks the pixels to prevent further editing. If you attempt to paint or edit a layer that has been locked in this way, you will see a prohibit warning sign.

Lock Layer Position

The Lock Layer Position option will lock the layer position only. This means that while you can edit the layer contents, you are not able to accidentally knock the layer position with the move tool or apply a Transform command.

Lock All

You can select combinations of Lock Transparent Pixels, Lock Image Pixels, and Lock Layer Position, but you can also check the Lock All option which will let you lock everything absolutely on a layer.

The above options mainly refer to image layers. With non-pixel layers you can only choose to lock the layer position or lock all.

Layer blending modes

Figure 7.30 The following pages illustrate all the different blending modes in Photoshop. In these examples, the photograph of the model was added as a new layer above the gray textured Background layer and the layer settings recorded in the accompanying palette screen shot.

Normal

This is the default mode. Changing opacity simply fades the intensity of overlaying pixels by averaging the color pixels of the blend layer with the values of the composite pixels below (Opacity set to 80%).

Dissolve

Combines the blend layer with the base using a randomized pattern of pixels. No change occurs when using Dissolve at 100% opacity. As the opacity is reduced, the diffusion becomes more apparent (Opacity set to 80%).

Darken

Looks at the base and blending colors and color is only applied if the blend color is darker than the base color.

Multiply

Multiplies the base by the blend pixel values, always producing a darker color, except where the blend color is white. The effect is similar to viewing two transparency slides sandwiched together on a lightbox.

Martin Evening Adobe Photoshop CS2 for Photographers

Color Burn

Darkens the image using the blend color. The darker the color, the more pronounced the effect. Blending with white has no effect.

Linear Burn

The Linear Burn mode produces an even more pronounced darkening effect than Multiply or Color Burn. Note that the Linear Burn blending mode will clip the darker pixel values. Blending with white has no effect.

Lighten

Looks at the base and blending colors and color is only applied if the blend color is lighter than the base color.

Screen

Multiplies the inverse of the blend and base pixel values together, always making a lighter color, except where the blend color is black. The effect is similar to printing with two negatives sandwiched together in the enlarger.

Color Dodge

Brightens the image using the blend color. The brighter the color, the more pronounced the effect. Blending with black has no effect (Opacity set to 80%).

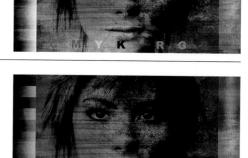

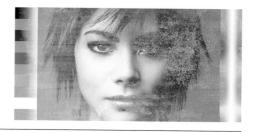

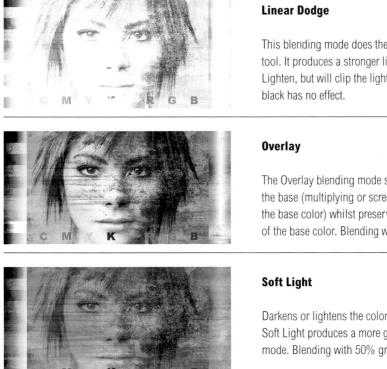

This blending mode does the opposite of the Linear Burn tool. It produces a stronger lightening effect than Screen or Lighten, but will clip the lighter pixel values. Blending with black has no effect.

The Overlay blending mode superimposes the blend image on the base (multiplying or screening the colors depending on the base color) whilst preserving the highlights and shadows of the base color. Blending with 50% gray has no effect.

Darkens or lightens the colors depending on the base color. Soft Light produces a more gentle effect than the Overlay mode. Blending with 50% gray has no effect.

Hard Light

Multiplies or screens the colors depending on the base color. Hard Light produces a more pronounced effect than the Overlay mode. Blending with 50% gray has no effect.

Vivid Light

Applies a Color Dodge or Color Burn blending mode, depending on the base color. Vivid Light produces a stronger effect than Hard Light mode. Blending with 50% gray has no effect.

Linear Light

Applies a Linear Dodge or Linear Burn blending mode, depending on the base color. Linear Light produces a slightly stronger effect than the Vivid Light mode. Blending with 50% gray has no effect.

Pin Light

Applies a Lighten blend mode to the lighter colors and a Darken blend mode to the darker colors. Pin Light produces a stronger effect than Soft Light mode. Blending with 50% gray has no effect.

Hard Mix

Produces a posterized image consisting of up to eight colors: red, green, blue, cyan, magenta, yellow, black and white. The blend color is a product of the base color and the luminosity of the blend layer.

Difference

Subtracts either the base color from the blending color or the blending color from the base, depending on whichever has the highest brightness value. In visual terms, a 100% white blend value will invert (i.e. turn negative) the base layer completely, a black value will have no effect and values in between will partially invert the base layer. Duplicating a background layer and applying Difference at 100% will produce a black image. Dramatic changes can be gained by experimenting with different opacities. An analytical application of Difference is to do a pin register sandwich of two near identical images to detect any image changes – such as a comparison of two images in different RGB color spaces, for example.

Exclusion

A slightly muted variant of the Difference blending mode. Blending with pure white will invert the base image.

Hue

Preserves the luminance and saturation of the base image, replacing with the hue of the blending pixels.

Saturation

Preserves the luminance and hue of the base image, replacing with the saturation of the blending pixels.

Preserves the luminance values of the base image, replacing the hue and saturation values of the blending pixels. Color mode is particularly suited for hand coloring photographs.

Luminosity

Preserves the hue and saturation of the base image while applying the luminance of the blending pixels.

Client: Taylor Phillipps. Model: Tina at FM.

Difference blend registration

The Difference blend mode has lots of potential for creating funky looking images, which is shorthand for saying: if you think you are being original by using Difference mode when creating digital art, then think again.

But on a more serious note, the Difference blend mode is actually very useful as a tool for registering images or making visual analysis comparisons. If you have two supposedly identical layers and you set the upper one to Difference mode, the two should cancel each other out and all you will see is solid black. So let's say you want to test the effects of applying JPEG compression to an image. If you place one version as a layer on top of the other, the differences caused by the JPEG artifacting will be the only thing you can see in the image. Place an Invert adjustment layer above and you should see the differences even more clearly.

Advanced Blending options

Layer groups allow you to group a number of layers together such that the layers contained within a layer group behave like a single layer. In Pass Through blending mode the layer blending passes through the set and the interaction is no different than if the individual layers were in a normal layer stack. However, when you select any of the other blending mode options, the layer group blending result will be equivalent to what would happen if you chose to merge all the layers in the current set to make them become a single layer and then set the blending mode.

Among the Advance Blending modes, the Knockout blending options enable you to force a layer to punch through some or all of the layers beneath it. A Shallow knockout will punch through to the bottom of the layer set, while a Deep knockout will punch through to just above the Background layer.

Layer styles are normally applied independent of the layer blending mode. When you check the Blend Interior Effects as Group box, such effects will take on the blending characteristics of the selected layer.

To put all this into practice, try opening the image shown on page 291 from the CD and follow the steps outlined here. In particular, observe how the Blend Interior Effects as Group option works on Layer C which is using the Difference blending mode. When you check the Blend Interior Effects as Group option, the result will be the same as if you had first 'fixed' the interior layer style using the normal blend mode and then changed the blend mode to Difference. Other aspects of the Layer Style blending options dialog box are covered in Chapter 9. 1 The four letter layers shown here are grouped together in a layer group. Layer A is using the Multiply blending mode; B is using Overlay; C is using Difference; and D is using the Screen blending mode. The default blending mode of this layer group is 'Pass Through'. This means that the layers in the layer group blend with the layers below the same as they would if they were in a normal layer stack.

2 If you select Layer D and double-click the layer to open the Layer Style dialog, you can alter the Advanced Blending options. The Knockout options allow you to 'punch through' the layers. A 'Shallow' knockout will punch through the three layers below it to just above the layer or layer group immediately below. A 'Deep' knockout will make the Layer D punch through all layers below it, straight down to the Background layer. Layer D now appears as it would if resting directly above the Background layer.

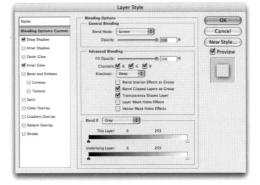

3 The default layer group blend mode is Pass Through. If you change the layer group blending mode to anything else, the layers within the group will blend with each other as before, but will not interact with the layers underneath as they did in Pass Through mode. When the blend mode is Normal, the group layers appear as they would if you switched off the visibility of the Background layer.

9

.

neck extension

Background

88 Ø. D Ø. D J B

0

Smart Objects

One of the main problems you face when editing pixelbased layers is that every time you scale an image or the content of an image layer, you degrade the image slightly. And if you make cumulative adjustments, then the image quality will degrade quite rapidly. Creating a Smart Object from a layer or group of layers will enable you to carry out any editing on those layers within a separate document and they will from there on be 'referenced' by the parent document. The advantage of this is that once you have separated these layers from the parent document you can scale the Smart Object layer up and down in size, rotate it, distort it with the free transform or warp tool as many times as you like without degrading the original pixel data. Therefore, a Smart Object layer does in effect become a 'proxy' layer.

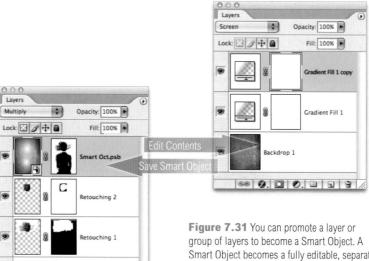

group of layers to become a Smart Object. A Smart Object becomes a fully editable, separate document within a Photoshop document. The principal advantage is that you can repeatedly scale, transform or warp a Smart Object in the parent document without affecting the integrity of the pixels in the original Smart Object document.

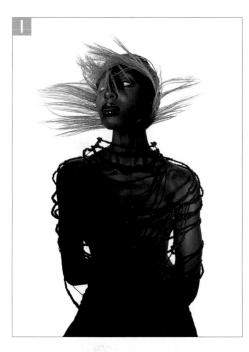

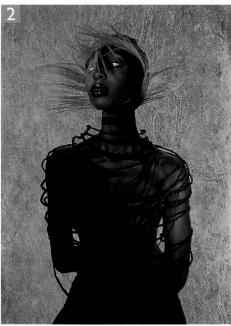

1 Let's examine in more detail how you would use a Smart Object in Photoshop. Here is a multi-layered image to which I have added a new backdrop layer that is currently hidden. I promoted this new layer to become a Smart Object by mousing down on the Layer palette fly-out menu and selected Group into New Smart Object. Notice how the layer icon appearance changes when you do this.

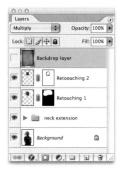

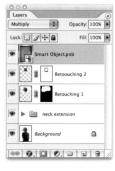

Layers	Dock to
Multiply Opacity: 1	New Lay
Smart Object.ps	
Retoouching 2	New Gro New Gro
Retouching 1	Lock All
💌 🕨 🚞 neck extension	Group in
Background	Edit Cor
ee Ø. 🖸 Ø. 🖬 🖬	Layer Pr
	Create 0
	Link Lay Select L
	Merge D Merge V Flatten
	Animati

o Palette Well **企業N** yer... ate Layer... Layer Hidden Layers oup... oup from Layers... II Layers in Group... nto New Smart Object ntents roperties... g Options... Clipping Mask **%%**G yers inked Layers Down ₩E Visible Ω₩E Image Animation Options Palette Options...

2 The Smart Object layer is much larger than the image it is placed in, but that did not matter too much at this stage. But I did want to mask the backdrop layer so that the model could be seen through this layer. I loaded a mask selection and converted it into a layer mask (this technique used is discussed more fully later in this chapter). To edit the Smart Object layer, I went to the Layers palette fly-out menu and selected Edit Contents.

Martin Evening Adobe Photoshop CS2 for Photographers

3 After choosing Edit Contents, the Smart Object layer opened in its own separate document window. This allowed me to edit the Smart Object layer as if it were a separate document. As I mentioned at the beginning, the backdrop layer was a lot larger than the main image and so I needed to choose Image ⇒ Reveal All to expand the document window to reveal the entire Smart Object layer. I then added a couple of radial gradient fill layers to add some spot lighting to the backdrop layer.

Client: JFK. Model: Tope @ Nevs.

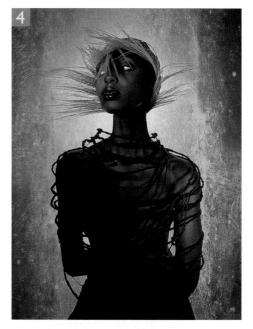

4 To update the original document you need to either close the Smart Object layer document and click Save when prompted to do so, or simply choose File ⇒ Save and keep the document open, ready for further editing. It may take a few seconds or longer, but the edit changes made to the Smart Object document will then appear in the Parent document Smart Object layer. At this point, the Smart Object is ready to be put to use. Remember that the Smart Object layer contains a high resolution backdrop image. I can now transform the Smart Object layer any way I like, making it bigger or smaller. The original Backdrop layer pixels will be referenced each time I scale, transform or apply a warp to the Smart Object layer.

Placing a Camera Raw file as a Smart Object

One of the most intriguing aspects of Smart Objects is that you can place a Camera Raw file as a Smart Object in Photoshop via Bridge. You have to have a document opened in Photoshop first to place the raw image into. Once the raw file is placed, the raw file will exist as a Smart Object layer and the Camera Raw settings can be edited at any time.

Create a new document preset

To place a raw file in Photoshop, you have to have a Photoshop document to place it into. I suggest you create a new document preset that matches the pixel dimensions of your default camera capture size.

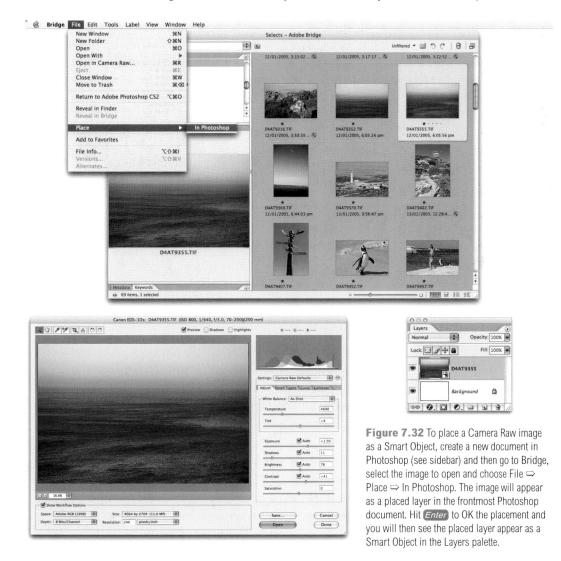

Warp transforms

Photoshop CS2 also features a new warp transform. This tool is great for carrying out curved distortions on a layer in Photoshop and this is covered in more detail in Chapter 10.

Dynamic transparency adjustments

This may not seem such a big deal if you are new to Photoshop, but Photoshop CS2 will now allow you to adjust the transparency of a layer during midtransform. The advantage of this is that a lot of folks like to use the Transform command to align layered images and having the ability to modify the opacity of the layer at the same time is very useful.

Transform commands

The Image menu provides a choice of options in the Rotate Canvas submenu to rotate or flip an image. You use these commands to reorient a document where, for example, the photograph was perhaps scanned upside down.

The Edit ⇒ Transform commands allow you to apply the same type of transformations to individual or linked groups of layers. Select a layer or make a selection of the pixels you wish to transform and choose either Edit \Rightarrow Transform or Edit \Rightarrow Free Transform (or check Show Bounding Box in the move tool Options bar). The main Transform commands include: Scale, Rotate, Skew, Distort and Perspective. These transformations can be applied singly or combined in a sequence before clicking *Enter* or double-clicking within the Transform envelope to OK the transformation, which will be applied using the default interpolation method selected in the Photoshop Preferences to calculate the new transform shape. You can apply any number of tweaking adjustments before applying the actual transform. A low resolution preview quickly shows you the changed image shape and at any time you can use the Undo command ($\mathbb{H}[Z]$ *ctrl*[Z]) to revert to the last defined transform preview setting.

The Free Transform option is probably the most versatile of all and the one you will wish to use most of the time. Choose Edit \Rightarrow Free Transform or use the **H T ett T** keyboard shortcut and modify the transformation using the keyboard controls indicated on the following pages. The Free Transform command is also available via the contextual menu. **ett** right mouse-click on a layer and select Free Transform.

2 Place the cursor outside the bounding border and drag in any direction to rotate the image. Holding down the Shift key as you

drag constrains the rotation in 15 degree increments.

4 If you want to constrain the distortion symmetrically around the center point of the bounding box, hold down the SS all key as you drag a handle.

1 You can rotate, skew or distort an image in one go using the

3 Hold down the 🔀 ctrl key as you click any of the handles of the bounding border to perform a free distortion.

4

2

Martin Evening Adobe Photoshop CS2 for Photographers

5 To skew an image, hold down the **Shift** ctrl Shift keys and drag one of the side handles.

Photograph by Davis Cairns. Client: Red or Dead.

6 To carry out a perspective distortion, hold down the Shift ctrl all Shift keys in unison and drag on one of the corner handles.

6

When you are happy with any of the new transform shapes described here, press *Enter* or double-click within the Transform envelope to apply the transform. Press *esc* if you wish to cancel.

Numeric Transforms

N" +

200

: 280.0 px

When you select any of the Transform commands from the Edit menu or check Show Bounding Box in the move tool options, the Options bar will display the Numeric Transform commands shown below. The Numeric Transform options enable you to accurately define any transformation as well as choose where to position the centering reference point position. For example, the Numeric Transform is commonly used to change the percentage scale of a selection or layer. You enter the scale percentages in the Width and Height boxes. If the Constrain Proportions link icon is switched off you can set the width and height independently. And you can also change the central axis for the transformation by repositioning the black dot (circled).

Repeat Transform

After applying a transform to the image data, you can instruct Photoshop to repeat that transform again. The shortcut is **(H)** Shift **(T)** Ctri Shift **(T)**. The image transform will take place again on whatever layer is selected and regardless of other steps occurring in between. Therefore you can apply the transform to the same layer again or transform another existing layer.

Transforming selections and paths

Δ Y: 767.8 px

W: 100.0%

H: 100.0% ▲ 0.0 * H: 0.0 * V: 0.0 *

You can also apply transforms to Photoshop selections and vector paths. Make a selection and choose Select \Rightarrow Transform Selection (if you choose Edit \Rightarrow Transform, you will transform the selection contents of course). Transform Selection is operated just like the Edit \Rightarrow Free Transform command. You can use the exact same modifier key combinations to scale, rotate and distort the selection outline. Or you can use *ctrl* right mouse-click to call up the contextual menu of transform options. With Transform Selection, you can modify a selection shape effortlessly.

Whenever you have an active pen path the Edit menu will switch to Transform Path mode. You can use the Transform Path command to manipulate a completed path or a group of selected path points (the path does not have to be closed). But remember, you will not be able to execute a transform on an image layer until you select a tool other than the pen tool or direct select tool. **Figure 7.33** The Photoshop Tool Options bar shown here in transform mode.

D D

1

Martin Evening Adobe Photoshop CS2 for Photographers

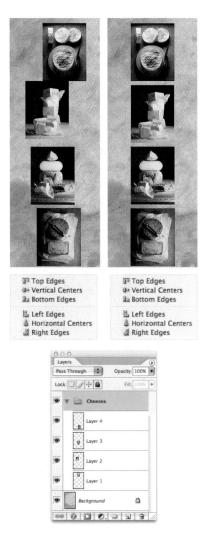

Figure 7.34 These linked, layered images were arranged using the layer alignment feature. I chose Layer \Rightarrow Distribute Linked \Rightarrow Vertical Centers to evenly balance out the spacing and followed this with the Layer \Rightarrow Align Linked \Rightarrow Horizontal Centers. These alignments brought all the individual images horizontally centered around their common axis as shown in the above example.

Transforms and alignment

Any transform you carry out can be repeated using the Edit \Rightarrow Transform \Rightarrow Again command (**H** *Shift* **T**). The transform coordinate change is memorized in Photoshop, so even if other image edits are carried out in between, the Transform \Rightarrow Again command will remember the last used transform.

When more than one layer is present, the layer order can be changed via the Layer \Rightarrow Arrange menu, to bring a layer forward or back in the layer stack. The full Layer menu and Layers palette shortcuts are listed in a separate appendix which is available on the CD only as a PDF document. In addition, two or more linked layers can be aligned in various ways via the Layer \Rightarrow Align Linked menu. The latter is a desirable feature for design-based work when you want to precisely align image or text layer objects in a design, although as can be seen the combination of repeat transforms and align layers provides interesting possibilities for making image patterns.

The alignment commands allow you to both distribute and align linked layers according to a number of different rules in the submenu list. To use this feature, first make sure the layers you want to align are all selected in the Layers palette, linked together, or in a layer group. The distribute command evenly distributes the linked layers based on either the top, vertical central, bottom, left, horizontal central or right axis. So if you have several linked layer elements and you want them to be evenly spread apart horizontally and you want the distance between the midpoints of each layer element to be equidistant, then choose Layer \Rightarrow Distribute Linked \Rightarrow Horizontal Center. If you next want the layer elements to align, then go to the Layer \Rightarrow Align Linked menu. If the layers to be moved are linked, select the one to which you want the other layers to align. The other layer elements will always reposition themselves around the active layer.

Photograph: Laurie Evans.

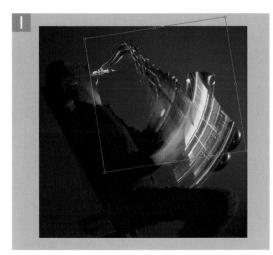

000		000		
Channels	•	Layers	/	۲
The Real	iit-	Screen 🗘 Opa	city: 38%	•
9 Red	HI	- [3]	Fill: 100%	Ð
Creen	H2	Layer 1 copy Layer 1		
The Blue	W 3	Layer 1 Background	۵	and the
sax mask	264	68 9. 0 0. u	<u> </u>	
00	33/			1/0

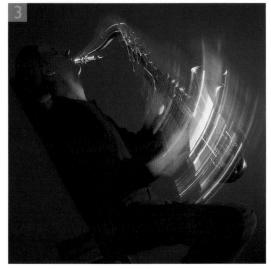

Photograph: Eric Richmond.

1 I wanted to add more motion blur to the saxophone in this photograph. I began by making a mask of the saxophone instrument (which you can see in the Channels palette). I loaded this mask as a selection and used **(H)** or the control of the mask as a new copy layer from the background. I then selected Free Transform from the Edit menu, positioned the central axis point on the mouthpiece and dragged outside the bounding box to rotate the layer.

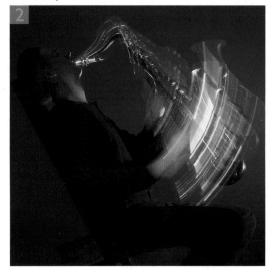

2 I dragged the rotated layer to the New Layer button in the Layers palette to make a duplicate layer and chose Edit ⇒ Transform ⇒ Again command (ℜ Shift T etr)Shift T). This applied a repeat transformation. I then changed the blend mode of the two layers to Screen mode at 38%.

3 To complete the effect, I chose Filter \Rightarrow Blur \Rightarrow Radial Blur and applied a Spin blur to the first layer. Note that the blur center was offset roughly to where the mouthpiece was. I then applied the filter again (**3 F**) coup **F**) to the second layer.

Matchlight software

Professional studio photographers may be interested in looking at the Matchlight system where you can place a special disk in a location scene and the software will be able to interpret the camera angle and lighting you need to use in the studio to match the outdoor location. For more information go to: www.gomatchlight.com.

Masking programs and plug-ins

There are some third party plug-ins which you might consider using as an alternative to the Photoshop methods described here. The most popular plug-ins are: Ultimatte Advantedge www.ultimatte.com and Extensis Mask Pro 3.0 www.extensis.com.

Creating a montage

We have so far covered the basics of using selections, channels, pen paths and layers. Now we shall look at how these tools are put to use with some practical examples that demonstrate how I went about creating some composite images using layers in Photoshop.

The image selection is important because you want to make sure that the pictures you are about to place can be made to match successfully. Care must be taken at the selection stage to check that the lighting conditions are similar and that the perspective will match. In the example shown on the page opposite this task is quite easy because I am combining two pictures that were shot outdoors with the sun coming from roughly the same direction. It also helps that the two pictures were both shot using a moderate wide-angle lens. If you want to be really precise then you may need to measure and match the camera height and angle. The colors may not match, but then that is a fairly easy thing to correct in Photoshop. If you want to achieve a realistic looking join between two images, then the edges need to be made soft so that the two pictures blend together as smoothly as possible.

The next thing to do is to plan how to make the mask. Ask yourself how precise the mask needs to be. Could you, for example, get away with a simple magic wand selection like in the example shown here? As you will see, I often like to inspect the individual color channels, copy the one with the most contrast and adapt the channel content to make a good mask. This will cut out the need to draw a complex path. But alas, there are many times when drawing a pen path is the only way you can ever hope to accurately define the outline of an object. You could of course persevere with magic wand selections and edit the selection with the paintbrush in Quick Mask mode. Occasionally I observe people preparing masks in Photoshop this way and I do find it really painful to watch because in the long run you will find drawing a pen path is nearly always the quicker option.

1

2 I then looked for an image with an interesting sky, opened it, selected the move tool and dragged the beach image across to the museum image, to add it as a new layer. This new layer needed to be scaled up slightly, so I chose Edit ⇒ Free Transform and dragged the corner handles so as to make the sky fit the width of the picture.

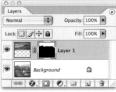

1 I wanted to add a new sky to the picture shown here. Because the photograph was cropped quite tightly, I added extra white canvas to the top of the frame and began by making a selection of the sky area. A simple way of doing this is to select the magic wand tool, set the tolerance to around 12 and click in the sky area. You can see here an example of the selection saved as a new alpha channel mask. My preferred method was to draw a pen path of the building and save as a new path in the Paths palette.

3 Once I had scaled the sky to match the dimensions of the master image, it was time to cut out the sky, which I did by loading the mask I had created earlier. I activated the pen path and hit **H** *Enter ctrl Enter* to convert the path to a selection (alternatively, I could have **H** *ctrl*-clicked the alpha channel I had pre-saved to reload the magic wand selection). I then clicked on the Add New Layer Mask button at the bottom of the Layers palette to convert the selection to a layer mask, hiding all but the sky of Layer 1.

Layer Matte commands

There are also some matting controls available in the Layer menu. One could use the Layer \Rightarrow Matting \Rightarrow Remove Black Matte command to remove all the stray black pixels. Likewise, the Remove White Matte command will remove the white pixels from a cutout which was once against a white background. Where you have colored fringing, the Layer \Rightarrow Matting \Rightarrow Defringe command will replace edge pixels with color from neighboring pixels from just inside the edge. But the effectiveness of these is somewhat limited.

Removing a matte color

If you use an anti-aliased selection to move an image element across to another image as a layer, the edge pixels may still contain some of the original background color. If the original picture has a black background, then some of the black matte pixels will appear as a black outline edge. The technique shown here is one based on a technique I once saw demonstrated by Greg Vander Houwen. The basic principle is that you can remove stray, spillover pixels from the edges of a layer by making a border selection of that layer and then copying some pixels from the layer below and sandwiching them on the layer above. The edge pixels are removed by selecting a layer blending mode which targets the edge pixels. To remove a black matte use Lighten, to remove white pixels try Darken.

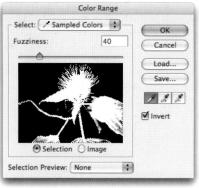

1 I began by making a Color Range selection of the black area surrounding the flower. The Invert box was checked in the Color Range dialog, so this created an inverted selection that defined the flower's outline. The selection needed a little tidying up though, and I was able to do this in Quick Mask mode. I then selected the move tool and prepared to drag the selected pixels across to the other image shown here.

2 Here is a close-up view of the flower placed as a new layer in the purple backdrop image. You will notice that a lot of black pixels have been carried over from the black background that surrounded the flower in the original image. One could try using the Layer \Rightarrow Matting \Rightarrow Remove Black Matte command to get rid of these black pixels, but it is not always as effective as one would like it to be.

3 I (H) circlecked Layer 1 to load the flower as a selection again and then chose Select \Rightarrow Modify \Rightarrow Border... and entered a width of 8 pixels (the width will vary depending on the size of your image and transition width of the image borders). I then feathered the selection by 2 pixels.

4 With the border selection active I selected the Background layer and chose Layer ⇒ New ⇒ Layer via copy and then moved this Layer 2 to the top of the layer stack, above the flower. Now for the clever bit. Because I wanted to remove the black pixels, I changed the blend mode to Lighten. If I had wanted to remove white pixels, then I would select Darken mode. And finally I reduced the layer opacity slightly to 85%.

Lavers			•
Normal	Opacity:	85%	Γ
Lock: 🖸 🍠 🖨	Fill:	100%	
S Layer 2			
🗩 💽 Layer 1			
Backgrou	nd	۵	
68 0.1			3/

Martin Evening Adobe Photoshop CS2 for Photographers

Figure 7.35 One should always be on the lookout for any easy ways to create a mask. If, for example, you are shooting a still life subject in the studio against a white backdrop you could try shooting an extra digital capture with the foreground lights switched off and this will give you an image that can quickly be converted into a mask.

Photo: Jeff Schewe.

Cheating a mask

Do you really need to spend ages creating a mask in Photoshop? If you are a still life studio photographer, the answer may be staring you in the face. Figure 7.35 gives you one example of a situation where a table top studio setup can allow you to cheat at creating a mask by simply turning off the foreground lights and making an additional exposure with a digital camera and using the silhouette image as the basis for a mask.

Masking an object with a vector path

This next example shows you how I prepared a silhouette mask based entirely on an outline made with the pen tool and how I created a vector mask in Photoshop.

A pen path is the most sensible solution to use here because the object to be cut out had a smooth 'geometric' outline and the background behind the aircraft was very busy and contained a lot of intersecting lines. With an image like this it would be almost impossible to separate the aircraft from the wall and girders behind using any other method than a pen path outline.

The Spirit of St Louis, flown by Charles Lindbergh, made the world's first solo transatlantic flight from the USA to Paris in 1927 and I photographed this historic aircraft inside the Washington DC National Air and Space Museum, Smithsonian Institution. The daylight coming in from the skylight above enabled me to produce a convincing composite when I blended the aircraft against an outdoor shot of a sky.

1 Here are the two images: the sky background and the museum interior shot of the Spirit of St Louis. I selected the move tool from the Tools palette and dragged the St Louis image across to the sky image window, where it became a new layer (if the *Shift* key is held down, the new layer will be centered).

2 I needed to isolate the aircraft from its surroundings. Because the subject had such a detailed background, there was no automatic way of doing this in Photoshop, so in this instance, the only solution was to draw a path. I magnified the image to view on screen at 200% and drew a path with the pen tool around the edges of the aircraft.

When the pen tool is selected, you can access all the other family of pen path modifying tools using just the **H** *ctd* and **ctd** keys. Holding down the **H** *ctd* key temporarily changes the pen tool to the direct selection tool. Holding down the **ctd** key temporarily changes it to the convert point tool. Clicking on a path adds a new point and clicking on an existing point deletes it. To make a hole in the work path, inside the outer edge, I clicked on the Subtract from Path Area mode button in the pen tool Options bar (circled).

Spirit of St Louis: Pioneers of Flight Gallery. Reproduced courtesy of: National Air and Space Museum, Smithsonian Institution.

Martin Evening Adobe Photoshop CS2 for Photographers

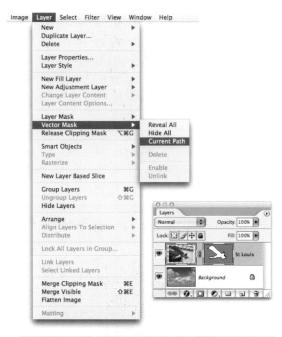

3 When the path was complete, I made sure that the aircraft layer and path were both active. I went to the Layer menu and chose: Vector Mask ⇒ Current Path. This added a vector mask to the aircraft layer based on the active work path. The vector mask appeared linked alongside the aircraft layer.

4 At this stage it was possible to reposition the aircraft if I wished, because the vector mask was linked to the layer image contents. Under close inspection, the aircraft appeared to have been reasonably well isolated by the path. However, where this is not the case, you can edit the vector mask outline using the usual pen path editing tools. If I group selected several of the path points around the wheel and moved them, you can see how the background is still visible and will show through the mask.

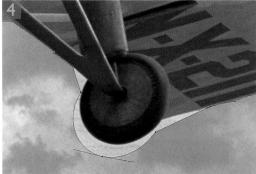

5 Once I was happy with the way the vector mask was hugging the outline, I chose Layer ⇒ Rasterize ⇒ Vector Mask. This converted the vector mask into an image layer mask.

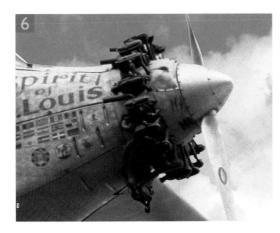

6 I activated the image layer mask. I then went to the Filter menu and selected Other ⇒ Minimum and chose a 1 pixel radius. This step effectively 'choked' the mask, making it shrink to fit around the edge of the masked object. Sometimes it helps to fade the last filter slightly using the Edit ⇒ Fade... command. Next, I applied a 1 pixel radius Gaussian Blur (you may wish to consider following this with an Edit ⇒ Fade... command, but it is not always absolutely necessary). I then applied a Levels adjustment to the mask. I chose Image ⇒ Adjustments ⇒ Levels, but kept the shadow point set where it was and adjusted the Gamma and Highlight sliders only. In effect what I did over these past few steps was to shrink the mask slightly, soften the edge and used the Levels adjustment to fine-tune the choke on the mask.

	Leve	13	
Channel: St Louis N	lask		ОК
Input Levels: 0	0.9	150	Cancel
			Load
			Save
			Auto
	0		Options
Output Levels:	0 3	255	8 1
		6	Preview

Martin Evening Adobe Photoshop CS2 for Photographers

 The mask was mostly OK and only a couple of areas needed further improvement. I went to the History palette and reverted to the history state which was the one before I began adjusting the mask (it usually helps to have Allow Nonlinear History switched on in the History palette options). I then clicked on the history brush icon to the left of the fully modified mask history state and selected the history brush from the Tools palette. The image had now reverted to the unmodified layer mask state, but wherever I painted with the history brush, I could paint in the modified mask and vary the opacity of the history painting as I did so.

St Lovis.psd Caussian Blur Cau	His	story				۲	
Modified mask history state	R	2	St Louis.psd				
History Brush History Brush History Brush History Brush History Brush			Gaussian Blur		 	11	
History Brush History Brush History Brush History Brush	R		Levels			++	 Modified mask history state
History Brush History Brush History Brush		Þ	History Brush			11	
History Brush			History Brush			11	
History Brush			History Brush				
			History Brush				
History Brush		Local Division			 		
		自	History Brus	1			

By this stage, the Spirit of St Louis appeared successfully cut out from its original museum surroundings. Because an image layer mask had been used to isolate the aircraft, no pixels had actually been erased and the mask could be edited at any time.

9 I selected the aircraft layer again and selected the aircraft layer again and selected the aircraft layer button in the Layers palette. I chose Curves and in the New Layer dialog box, checked Use Previous Layer to Create Clipping Mask. This ensured that the following color adjustment would affect this layer only. The Curves adjustment made the aircraft slightly more blue and helped it blend more realistically with the color balance of the sky.

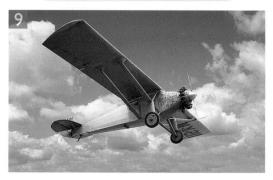

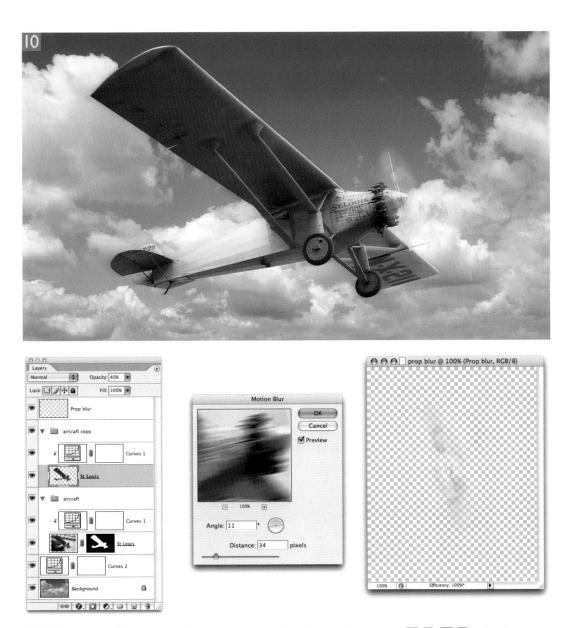

10 I **Shift** selected the St Louis layer and the Curves layer and selected Layer \Rightarrow Group Layers (\Re \bigcirc \bigcirc). I then dragged the new layer group down to the Add New Layer button to duplicate the layer group. With the copied aircraft layer selected, I applied a motion blur to the layer. I then reduced the opacity to 80%. I had also prepared a spinning propeller image. I dragged this in as a separate layer and transformed it to match the scale of the aircraft. This final tweaking helped create the illusion of the Spirit of St Louis flying through the air. But, did they have high speed color film to record Charles Lindbergh's transatlantic flight in 1927?

Keeping the edges soft

I have said it before, but I'll repeat is one more time: retouched photographs will not look right if they feature 'pixel-sharp' edges. Softer masks usually make for a more natural-looking finish. A mask derived from a path conversion will be too crisp, even if it is anti-aliased. So, either feather your selections and if you have a layer mask, try applying a little Gaussian Blur. You might find it helpful to use the blur tool to locally soften mask edges. Or you could apply a global Gaussian Blur filtration to the mask.

Masking hair

Hair is one of the hardest things to mask successfully and if you are a people photographer who uses Photoshop to create montages, you will readily appreciate the difficulty involved here. There is always a lot of discussion on the various Internet forums on this subject, so I know it is something that interests a lot of users. The problem most people have is how to get rid of the trace pixels around the edges of the hair, which are a sure giveaway that the picture has been comped together on the computer. What follows is a hair masking method which you can do in Photoshop without the need for any extra plug-ins and which I find works well in most cases.

The first thing I would like to point out here is that for this technique to work, your model or subject must be photographed against a white or light colored backdrop. If you don't do this then you are just making the task a lot harder for yourself, so it is important that you plan ahead. All serious composite work is carried out against a plain backdrop. For example, the Ultimatte Advantedge software requires you shoot your subject against a blue or green backdrop. But in this example, I am going to show you how you can use a white backdrop.

The trick here is to make use of the existing color channel contents and to copy the information which is already there in the image and modify it to produce a new mask channel. So instead of attempting to trace every single strand of hair on a mask with a fine-tipped brush tool, you can save yourself a lot of time by making use of the information already contained in the color channels and use this to define the finely detailed edges. However, you will still find that the pen tool is useful for completing the outline around the smooth, broad outline of the neck, shoulders and arms of the model's body.

1 The following steps describe how I would go about photographing a model with a view to adding a new backdrop later. I normally plan my shoots to always photograph against a white background as this is the best way to mask the fine hair detail. In this example the background does have a little detail, but we can still make an effective mask using this shot as it is.

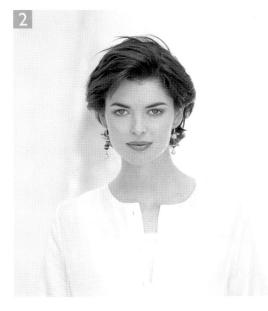

2 I began by looking at the individual color channels and duplicated the one that contained the most contrast, in this case I decided that the green channel had the most contrast between the hair and the background. I duplicated the channel by dragging it to the New Channel button in the Channels palette.

Adobe Photoshop CS2 for Photographers

Source:	rin01.psd	+		COK
Layer: (Background		:	Cancel
Channel: (Green copy	•	Invert	Preview
Blending: (Opacity: 1		9		
	Transparency			
Mask				

³ The next few steps all took place on the Green copy channel (when you copy this technique, do make sure that the Green copy channel is selected). I wanted to increase the contrast in the alpha channel and make the hair darker. I went to the Image menu and chose Apply Image... As you can see in the above dialog, the Target channel was the Green copy channel, the Source channel was also Green copy and the blending mode had been set to Overlay. So I was using the Apply Image to apply an Overlay blend mode on the alpha channel with itself. With Apply Image you can choose all sorts of channel blending combinations. Most of the time I use Apply Image in the Multiply Blending mode and will experiment blending one color channel with another. The objective at this stage is to increase the contrast in the hair, making use of the pixel information already present in the photograph.

4 Step 3 made quite a difference to the appearance of the mask channel and I now wanted to increase the contrast. To do this I used the paintbrush tool set to Overlay mode and switched between using black and white as the foreground colors. When using the Overlay blend mode, as you paint with black, paint is only applied to dark pixels. As you paint with white, paint is only applied to the lighter pixels. Overlay is therefore a useful paint mode because you can paint quite freely using a large pixel brush to gradually build up the density around the dark hair strands without risk of painting over the light areas. I continued painting, taking care not to build up too much density on the outer hair strands. I should mention here as well that I prefer to paint using a pressure sensitive Wacom pen and tablet, with the pen pressure sensitivity for the Opacity switched on in the Brushes palette Other Dynamics options.

Overlay

+

Opacity: 100% + Flow: 100% +

Chapter 7 Montage techniques

00000000

7 With the mask complete, it was time to add a new backdrop. I opened up a photograph of a textured wall in Photoshop, selected layer on top of the Background layer. I kept the Layer 1 active and the backdrop layer.

earrings. I then converted the pen path to a selection by dragging

the move tool and dragged the backdrop image across to the model image window. This added the backdrop as a new layer. I went to the Layers palette and changed the blending mode to Multiply. The Multiply blend mode effectively 'projects' the new chose Edit ⇒ Free Transform and dragged the handles to scale

Path 1 down to the Make Selection button in the Paths palette. I filled the selection with black and used the paintbrush tool in Normal mode to paint over the rest of her face.

Paths Path 1

6

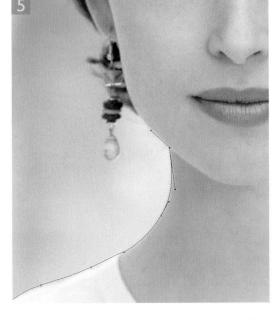

5 Now let's look at masking the rest of our subject. The model's clothing is almost the same color as the backdrop. Therefore, the best way to isolate the rest of her body is to draw a pen path around the sleeves of the shirt and along either side of the neck.

8 I dragged the Green copy channel to the Load Selection button in the Layers palette and then clicked on the Add Layer Mask button (circled) in the Layers palette to convert the active selection to a layer mask.

9 The layer mask worked reasonably well, but still benefited from some fine-tuning. I first went to the History palette and made sure that Allow Non-Linear History was selected. The layer mask was selected and I applied: Filter ⇒ Other ⇒ Maximum, followed by Filter ⇒ Blur ⇒ Gaussian Blur, followed by a Levels adjustment using the settings shown on this page. The Maximum+Blur+Levels adjustment shrunk the mask around the hair.

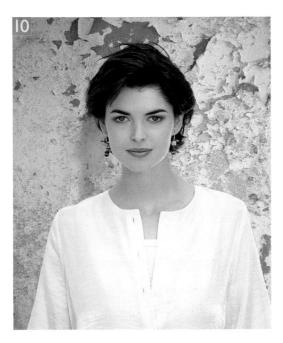

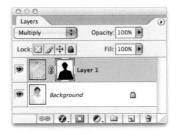

Client: Schwarzkopf Ltd. Model: Erin Connelly.

10 The reason for setting the History palette to allow nonlinear history may now become clear. In the last step, I modified the mask using a Levels adjustment to improve the hair masking. But doing so made the edges around the shoulder and neck too crisp.

I went to the History palette and clicked on the Gaussian Blur history state (note that the Levels history state does not go dim). I then applied an alternative Levels adjustment, one that modified the layer mask so that this time the edges around the body were kept soft. I went to the History palette and clicked on the icon to the left of the previous Levels adjustment. This set the history source to use the previous Levels history state. I then selected the history brush from the Tools palette and painted around the edges of the hair to restore the optimized hair mask state.

So to recap this final step: in step 9 I had created a modified layer mask in which the layer mask choked the hair outline perfectly. In step 10, I marked that history state as one I would wish to paint from again. I went back to the Gaussian Blur history state and applied an alternative Levels adjustment that would choke the rest of the model's outline better. I then selected the history brush and painted over the outline of the hair to paint back the mask around the hair.

This is a complex technique, so I have obtained permission to include the two master images on the CD to help you follow the steps outlined here.

This History state represents the best choke around the hair This History state represents the best choke around the rest of the body

Martin Evening Adobe Photoshop CS2 for Photographers

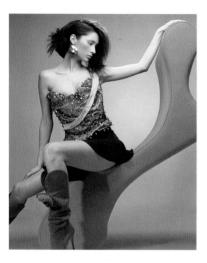

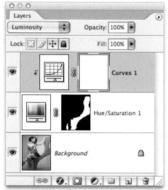

Figure 7.36 In this example, I made a mask of the red chair and loaded the selection as a mask as I made a Hue/Saturation adjustment to change the color to match the backdrop. I then added a Curves adjustment layer which I wanted to share the same mask as the Hue/Saturation layer. Instead of reloading the selection and adding an identical mask, I created a clipping mask between the two adjustment layers.

Client: Rainbow Room. Model: Jasmin Hemsley @ MOT.

Clipping masks

Clipping masks enable you to mask the contents of a layer based on a mask applied to another layer. So if you have two or more layers that need to be masked identically, the most logical way to do this is to apply a mask to the first layer and then create a clipping mask with the layer or layers above. When a clipping mask is applied, the upper layer or layers will appear indented in the Layers palette. You can alter the blending mode and adjust the relative opacity of the individual layers in a clipping mask, but the blending mode and opacity of the lower (masked) layer will affect the blend and opacity of all the layers in a clipping mask.

The main advantage of using clipping masks is that whenever you have a number of layers that are required to share the same mask, you only need to apply a mask to one layer and when you make a clipping mask the other layers will all share that mask. So for example, if you need to edit the mask, the edit changes will be applied simultaneously to all the clipped layers.

To create a clipping mask, make a *Shift* selection of the layers you want to group together and choose Layer \Rightarrow Clipping Mask \Rightarrow Create or, \checkmark *alt*-click the border line between the layers. This action will toggle creating and releasing the layers from a clipping mask. You can also use the keyboard shortcut $\Re \checkmark G$ *ctrl alt* G to make a selected layer form a clipping mask with the layer below.

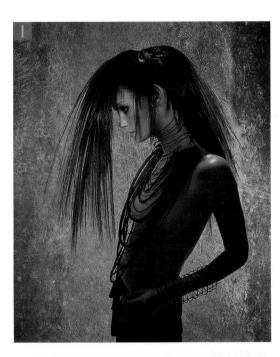

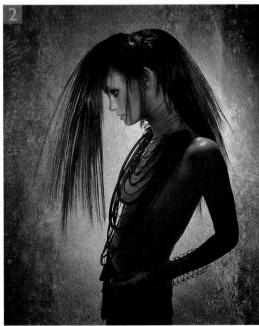

1 If you check out the Layers palette below, you will notice that this is another example where a photograph was shot against white in the studio and a backdrop layer was added on a separate layer above. The montage was created using the same steps described in the preceding tutorial.

2 I wanted to add a gradient glow to make it look as if I had shone a light on the backdrop. I set white as the foreground color, selected the Backdrop layer and a fill moused down on the Add Adjustment Layer button at the bottom of the Layers palette, and selected Gradient from the pop-up menu. In the New Layer dialog, I checked: Use Previous Layer to Create Clipping Mask. I clicked OK and the Gradient Fill dialog appeared. I selected the foreground to transparency gradient, using a Radial gradient style. If you check the Layers palette again, you will notice that the Gradient layer appears indented, which signifies that it has formed a clipping mask with the layer below. I can remove the grouping by a fill-clicking on the line between the two layers.

Client: JFK Hair. Model: Indriarty at Isis.

Figure 7.37 The Extract command options:

Tool Options Enter a value for the highlight or eraser brush size and choose a color for the Highlight and Fill displays. Smart Highlighting helps auto-detect the edges as you define a highlight edge.

Extraction The smoothness can be set anywhere between 0 and 100. If the preview shows an incomplete pixel selection, increasing the smoothness value will help rein in the remaining pixels. Force Foreground is useful where the object interior edge is particularly hard to define and the interior pixels are of a similar color value. Select the eyedropper tool to sample the interior color and check Force Foreground. Textured Image will take into account differences in texture as well as color.

Preview The view choices can be switched between the original image and the current extracted versions. The Show option allows you to choose the type of matte background to preview the extraction against. This can be the standard, transparent, Photoshop background pattern, gray, white, black or any other custom color.

Extract command

The Extract command is able to intelligently isolate an object from its background. While automatic masking can sometimes make light of tedious manual masking, it can rarely ever be 100% successful. However, the enhancements added since version 6.0 certainly do make the Extract command a very workable tool and it includes the means to separate an object based on texture content as well as color. Before using the command, you may find it helpful first to duplicate the layer you are about to extract.

Choose Filter \Rightarrow Extract or the shortcut: \bigcirc \Re X alt ctrl X. The active layer will be displayed in the Extract dialog window. You then define the outline of the object using the edge highlighter tool. This task is made easier using the Smart Highlighting option, which is like a magnetic lasso tool for the Extract command. Smart Highlighting will work well on clearly defined edges and can be temporarily disabled by holding down the R ctrl key as you drag. You need to highlight the complete edge of the object first (excluding where the object may meet the edge boundaries) and then fill the interior with the extract fill tool (clicking again with the fill tool will undo the fill). The Extract command eraser tool can be used to erase highlight edges and when using the edge highlighter tool you can toggle between highlighting and erasing by holding down the s all key. When the edges and interior fill are completed, click on the Preview button to see a preview of the extraction, or click OK to make an immediate extraction. The edge touchup tool can be used inside the preview window to add definition to weak edges, adding opacity where it sees transparency inside the edge and removing opacity outside of this edge. The cleanup tool will merely erase transparency from the extraction or restore erased transparency when you **C** alt drag.

As you define the highlight edge, wherever possible, you want to select a small size brush and aim to draw a narrow edge. Where there is an overlap between the object you want to extract and the background, you will want to draw a wider edge.

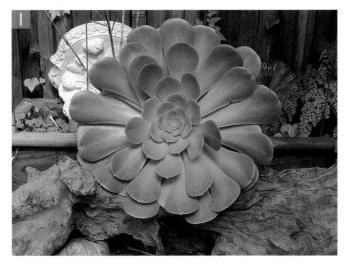

1 Here is an example of an ordinary photograph where I wanted to make a cutout of the large plant and remove it from the distracting elements in the background. I began by dragging the Background layer to the Make New Layer button in the Layers palette. (This duplicated the Background layer.)

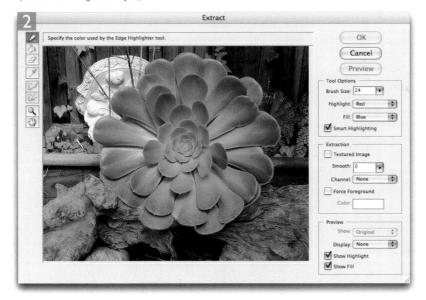

2 I then chose Filter \Rightarrow Extract. I selected the edge highlighter tool and started to draw around the edges of the leaves. You want the highlight edge to overlap the foreground and background areas. But the highlight edge must form a complete enclosure (you can ignore where the object meets the image boundaries). Notice that I had checked the Smart Highlighting box. This can make the edge drawing a little easier. The Smart Highlighting mode works in a similar way to the magic lasso and magic pen tool, it forces the edge highlighter tool to 'hug' the sharp edges as you draw. If you use a pressure sensitive pen, as you apply more pressure, you will produce a thicker edge.

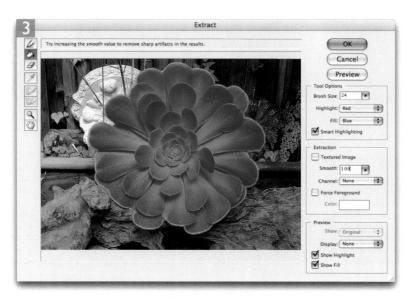

3 When I had finished drawing the outline around all of the leaves, I checked the result carefully and used the eraser tool to delete any parts where the edge was untidy and I then selected the fill tool to click inside and fill the interior. You can use the edge cleanup tool to follow the edges, adding opacity where the tool sees transparency inside the edge and removing opacity outside the edge.

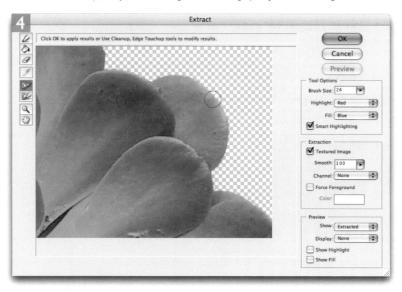

4 To test the potential success of the extraction, I clicked on the Preview button. This applied the extraction to the image in the preview window only. I first checked the Textured Image button though and set the Smooth setting to 100. While in preview mode, you can edit the edges using tools within the Extract dialog. Here, I selected the cleanup tool and used it to erase unwanted pixels and held down the Option to restore pixels so far erased by the extraction.

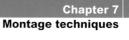

5 I clicked OK to permanently apply the extraction to the Background copy layer. If for some reason I needed to go back to the original version, it was still available in the layer below. But more usefully, one can use the History palette to restore any detail that shouldn't have been erased during the extraction. Go to the History palette, set the History state to the one before the Extraction as the history source and use the history brush to paint those pixels back in. If you want to erase more pixels, I recommend selecting the background eraser tool, described on pages 77–78. Set the background eraser tool to Find Edges mode, click on a sample area to define the pixel colors you want to erase and paint around the outside edge.

Figure 7.38 In this example, I drew a pen path around the edge of the cello case. I then went to the Paths palette fly-out menu and chose Clipping Path... It is often best to leave Flatness set as blank because this allows the RIP to use the optimum value. Flatness defines the length of straight lines that define the curves of vector images within a pixel image.

The image was saved as a TIFF and placed on this page. You can see the page guides show through the transparent areas of the cutout.

Client: Dan Tyrrell. Photograph: Eric Richmond.

Exporting clipping paths

Clipping paths are vector paths that can be used to mask the outline of an image when it is exported to be used in a DTP layout program such as Adobe InDesign or QuarkXPress. If an image you are working on contains a closed path, you can make that path become a clipping path within Photoshop. When the image is saved as an EPS or TIFF format file, the clipping path will define the transparency in an image. So when an image like the one in Figure 7.38 is imported into a DTP layout, it will appear as a cutout. If you are using QuarkXPress, any path present in an imported image can be promoted to a clipping path. With InDesign you can select a presaved path to use as a clipping path and it also has the capability to edit the paths as well.

Imagine a catalog brochure shoot with lots of products shot against white ready for cutting out. Still-life photographers normally mask off the areas surrounding the object with black card to prevent unnecessary light flare from softening the image contrast. Whoever is preparing the digital files for export to DTP will produce an outline mask and convert this to a path in Photoshop or simply draw a path from scratch. This is saved with the EPS or TIFF file and used by the DTP designer to mask the object.

Chapter 8

Darkroom Effects

he ability to duplicate traditional darkroom techniques in Photoshop will be of particular interest to photographers. This chapter shows you how to use Photoshop as your digital darkroom and how to replicate in Photoshop some traditional photographic effects such as solarization, split tone printing, cross processing and diffusion printing. We will also look at the different ways that you can convert a color image to monochrome.

The distinction between shooting black and white or color is not always fully appreciated, because how you light and color compose a shot can often be determined by whether it is intended for color or monochrome. However, in the digital age, everything is captured in RGB color and if you want a black and white image, your best bet is to do the monochrome conversion in Photoshop and not 'in camera'.

Color filters for monochrome work

Color filters can be used in monochrome photography to filter the colors in a scene and thereby alter the color contrast. A strong red filter will filter out the blue/cyan colors and make white clouds stand out with more contrast against a dark sky. A yellow or orange filter will produce a softer effect. A green filter can be used to make foliage appear lighter relative to everything else in the scene and so on... These principles can also be applied to the formulas used in the channel mixer to simulate the same type of filtration. A 50% Red channel and 50% Green channel mix in Monochrome mode will simulate the effect of using a vellow filter.

Lab Color conversions

Another way to convert a color image to monochrome is to do a Lab Color mode conversion and copy the luminosity channel. There is nothing necessarily wrong with this method, but it is not much better than making a conversion to grayscale and back to RGB mode. The Channel Mixer and Hue/Saturation techniques described here are, by comparison, far more versatile.

Black and white from color

When you change a color image from RGB to Grayscale mode in Photoshop, the tonal values of the three RGB channels are averaged out, usually producing a smooth continuous tone grayscale. The formula for this conversion roughly consists of blending 60% of the green channel with 30% of the red and 10% of the blue. The rigidity of this color to mono conversion formula limits the scope for obtaining the best grayscale conversion from a scanned color original. This is what a panchromatic black and white film does, or should be doing rather, because there are slight variations in the evenness of emulsion sensitivity to the visual and non-visual color spectrum. And it is these variations in spectral sensitivity that give black and white films their own unique character. But the point I would like to make here is that just like a grayscale conversion in Photoshop, a black and white film interprets color using a standard formula. You may also be familiar with the concept of attaching strong colored filters over the lens to bring out improved tonal contrast in a monochrome image. The same principles can apply to converting from color to black and white in Photoshop, and of course this allows you the freedom to make this decision after the photograph has been shot. Using the Channel Mixer, you can create a custom RGB to grayscale conversion. This gives you the latitude in Photoshop of being able to make creative decisions at the editing stage that will allow you to simulate the effect of shooting using black and white film with a color filter placed over the lens at the time of shooting.

I have included an alternative technique on page 328 for producing a monochrome image from a color original, which simultaneously uses the Hue/Saturation image adjustment to modify the hue color of the underlying image and at the same time a second Hue/Saturation layer neutralizes the color to create a neutral, monochrome image.

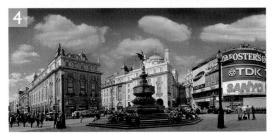

Color Balance Color Balance OK -17 Color Levels: 2 0 Cancel Red Cvar Preview Green Magenta Blue Yellow Tone Balance ○ Shadows ○ Midtones Highlights Preserve Luminosity

1 If you shoot using black and white film, the emulsion is more or less evenly sensitive to all colors of the visual spectrum. If you add a strong colored filter over the camera lens at the time of shooting, that color sensitivity is altered as certain wavelengths of color are blocked out by the filter. The following steps mimic the effect of a red lens filter being used to strengthen the cloud contrast in the sky.

2 To start with I went to the Image menu and chose Adjustments \Rightarrow Desaturate. This produced a flat-looking result based on a standard grayscale conversion formula where the monochrome RGB image is calculated using a mix of 30% red, 60% green and 10% blue.

utput Channel: Gray	•		ОК
Source Channels			Cancel
Red:	+80	*	(Load
Green:	+20	%	Save
		-	Preview
Blue:	0]%	
Constant:	0	3%	

3 I chose Edit \Rightarrow Undo to revert to the original color version of the image and added a Channel Mixer adjustment layer using the settings shown in the dialog above. Note that when the Monochrome box is checked the Channel Mixer will produce a monochrome result based on a color channel mix of your choosing. For the very best results, try to get the percentages in each slider box to add up to 100%. This is not a hard and fast rule – variations other than 100% will just be lighter or darker. So just use whichever settings produce the best-looking result. The predominant use of the red channel created a stronger tonal contrast with the clouds in the sky.

4 Lastly, I added a Color Balance adjustment layer to create a split tone coloring effect. I changed the blending mode of this layer to Color. Doing this preserved the full luminosity information of the layers below.

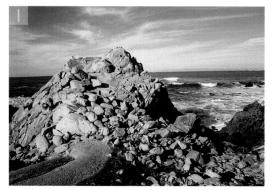

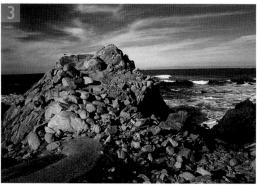

1 Russell Brown, the Senior Creative Director of the Adobe Photoshop team, was one of the first people to demonstrate the following alternative technique for creating a color to monochrome conversion in Photoshop.

2 I opened an RGB image, and went to the Layers palette and added a Hue/Saturation adjustment layer. I took the saturation all the way down to zero so that the photograph was desaturated and became a monochrome version of the color original. The result was more or less what you would expect to get if I had simply converted the image to Grayscale.

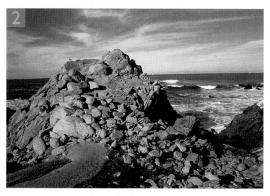

3 I activated the Background layer and added a second Hue/Saturation adjustment layer. This will be between the Background layer and the earlier Hue/Saturation layer. I made no adjustments and clicked OK and set the layer blending mode to Color. When you reopen the dialog you can now adjust the Hue slider and achieve a similar result to adjusting the channel mix in the Channel Mixer as shown in the previous tutorial. When you try this out for yourself, you can also adjust the Saturation and Lightness to further tweak the monochrome conversion.

Full color toning

The simplest way of toning an image is to use the Color Balance adjustment. I am normally inclined to disregard the Color Balance tool. But in situations such as this, the simple Color Balance controls are quite adequate for the job of coloring a monochrome image that is in RGB mode. The Color Balance controls are intuitive: if you want to colorize the shadows, click on the Shadows radio button and adjust the color settings. Then go to the Highlights and make them a different color and so on. I always apply these coloring effects by using an adjustment layer set to the Color blend mode. Other adjustment layers can be used as well. I often like to use two Curves adjustment layers and take advantage of the Layer Style blending options to create split tone coloring.

Color blend mode

You will notice that I regularly use the Color blend mode when applying adjustment layers that are intended to color an image. The advantage of using the Color blend mode is that you are able to alter the color component of an image without affecting the luminosity. This is important if you wish to preserve as much of the tonal levels information as is possible.

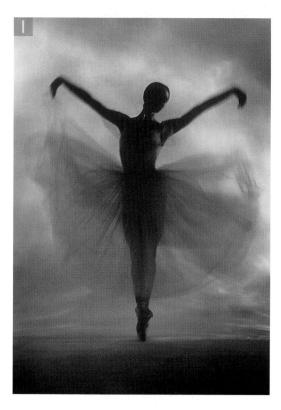

1 I started with a grayscale image and converted it to RGB color mode. Alternatively, you could take an RGB image and convert it to monochrome using one of the methods I just described. I then added a Color Balance adjustment layer to colorize the RGB/ monochrome image. To do this, I chose New Adjustment Layer... from the Layers palette fly-out menu and selected Color Balance. I clicked on the Shadows button and moved the sliders to change the shadow tone color balance.

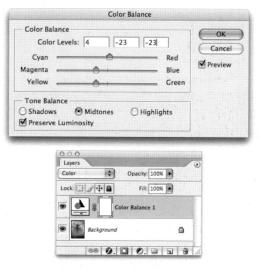

Photograph: Eric Richmond.

2 I did the same thing with the Midtones and Highlights. I then returned to the Shadows and readjusted the settings as necessary. When you use an adjustment layer you can return and alter these Color Balance settings at any time. To further modify the Color Balance toning, try varying the adjustment layer opacity in the Layers palette.

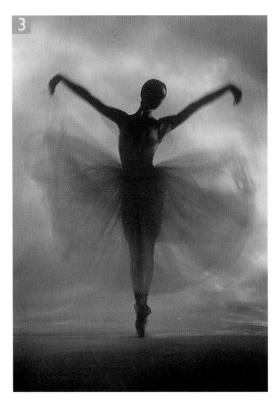

3 Providing the original monochrome image is in RGB or CMYK color mode, the Channel Mixer is another tool that can be used to color an image and imitate color toning effects. For more instructions on Channel Mixer use, see the simulating sunset light technique described on page 344.

Output Channel:	Blue	le ne le com	\$	(ОК
— Source Chann Red:	els	-10	%	Cancel
Green:	<u>م</u>	+10	%	Save
Blue:		+90	*	Entenen
Constant:		0	*	

4 You can also vary the technique to achieve split tone coloring effects. In this last version, I added two Curves adjustment layers. The lower Curves layer colors the image blue, while the top one colors it red. If you double-click the upper Curves layer, this will pop the Laver Style dialog shown below. If you S all -click on the divider triangle in the blend layer options, you can separate these dividers and split them in two. As you adjust them, you can control the amount of split between the two color adjustments.

Styles	Blending Options General Blending	ОК
Blending Options: Custom	Blend Mode. Color	Cancel
Orop Shadow	Opacity:	New Style
🖯 Inner Shadow	Advanced Blending	Preview
Outer Glow	Fill Opacity:	Preview
E Inner Glaw	Channels: R R G G B	
🖯 Bevel and Emboss	Knockout None	
Contour	Blend Interior Effects as Group	
🖯 Texture	Blend Clipped Layers as Group	
🖯 Satin	Layer Mask Hides Effects	
E Color Overlay	Vector Mask Hides Effects	
Gradient Overlay	Stend If Gray	
Pattern Overlay	This Layer: 61/181 255	
e Stroke	beertyin Layer: 0 55	

Solarization

+

Curves 1

0.00.00

Colo Lock: 🖸 🌶 🖨 Opacity: 100%

Fill: 100%

The original photographic technique is associated with the artist Man Ray and is achieved by briefly fogging the print paper towards the end of its development. The digital method described here uses the Curves adjustment and allows some degree of control, because you can experiment with different curve point shapes to create different solarization effects and you could also consider using a layer mask as well, to selectively mask the adjustment.

Double-click in this area of the layer to open the Layer Style dialog.

1 I began with an image in RGB mode. I went to the Layers palette and added a new Channel Mixer adjustment layer.

output Channel: Gray	•	(ОК
Source Channels	+54	Cancel
Green:	+52	Save
Blue:	0	*
Constant:	0	×

2 I checked the Monochrome checkbox at the bottom of the Channel Mixer dialog and then adjusted the individual channels to vary the mix of channels used to produce the monochrome conversion. As before, the percentage total should always roughly add up to 100%.

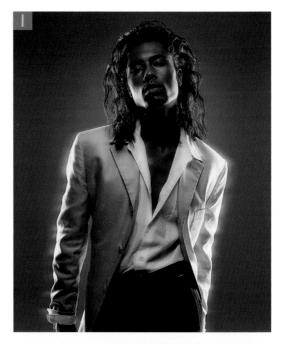

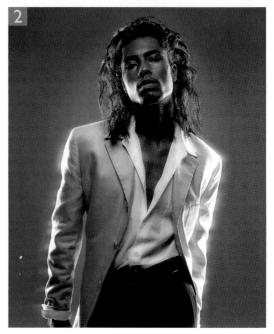

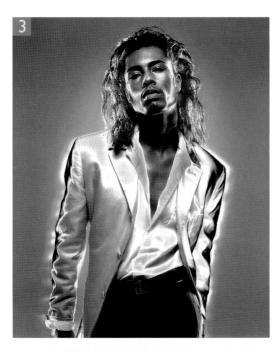

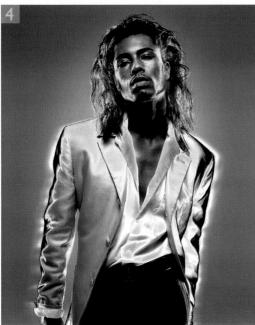

3 Next, I added a Curves adjustment layer above the Channel Mixer layer and selected the arbitrary map tool (circled) and drew an inverted V. The easiest way to do this is to first click in the bottom left corner and then hold down the Shift key as you click to add the top middle point and lastly, the bottom right point on the curve. This will produce the solarizing effect shown here.

4 I then added a second Curves adjustment layer and started experimenting with some different split tone color toning effects using the technique described on page 331. Note that I set the blending mode of this layer to Color so that any adjustments made using this layer only affect the color and preserved the tonal luminosity of the underlying layers. The other interesting thing you can do here is to double-click the Channel Mixer layer again and readjust the channel settings one more time. As you do this you will notice how it is possible to make subtle changes to the solarization effect.

000	
Layers	
Color	Opacity: 80%
Lock: 🖸 🖉 🕂 🕼	Fill: 100%
•	Curves 2
•	Curves 1
•	Channel Mixer 1
Backgro	und 🗅
se Ø.	00.000

Client: Anita Cox. Model: Sze Kei.

Deficiencies of grayscale printing

A black and white image can be reproduced a number of ways in print. If you are working from a basic 8bit grayscale image, this will have a maximum of 256 brightness levels. A practical consequence of using basic 8-bit grayscale files for print is that as many as a third of the tonal shades will get lost during the reproduction process and this is why images reproduced from a grayscale file can look extremely flat when printed, especially when compared alongside a CMYK printed image. Adding two or more printing plates will dramatically increase the range of tones that can be reproduced from a monochrome image. The fine quality black and white printing you see in certain magazines and books is often achieved using a duotone or conventional CMYK printing process.

Duotone mode

A duotone is a grayscale image printed using two printing plates (a tritone uses three and a quadtone four). To create a duotone image your image must first be in grayscale before you convert it to Duotone mode (Image \Rightarrow Mode \Rightarrow Duotone). The Ink Color boxes display a Photoshop preview of the ink color with the name of the color (i.e. process color name) appearing in the box to the right. Normally the inks are ordered with the darkest at the top and the lightest inks at the bottom of the list. The graph icon to the left is the duotone curve box. The duotone curve box is opened by double-clicking the graph icon and when it is open you can specify the proportions of ink used to print at the different brightness levels of the grayscale image. You can change the shape of the curve to represent the proportion of ink used to print in the highlights/ midtones/shadows.

The only file formats (other than Photoshop) to support duotones are EPS and DCS. So save using these when preparing an image for placing in either an InDesign or QuarkXPress document. Duotones are really a special printing mode which is used in commercial printing only. You can use the Duotone mode to produce split tone color effects of monochrome images, but you will need to convert them to RGB or CMYK mode if you wish to make any other type of print. Remember as well that if any custom ink colors are used to make the duotone, these need to be specified to the printer and this will add to the cost of making the separations if CMYK inks are already being used in the publication. Alternatively you can take a duotone image and convert it to CMYK mode in Photoshop. This may well produce a compromise in the color output as you will be limited to using the CMYK gamut of colors.

There are a number of duotone Presets (plus tritones and quadtones) to be found in the Photoshop Goodies folder. Experiment with these by clicking the Load... button in the Duotone dialog box and locating the different preset settings.

2 When the Preview is checked in Duotone Options, any changes you make to the duotone settings will immediately be reflected in the appearance of the on-screen image. In the example shown here, a custom color tritone was selected and the component ink colors are displayed with the darkest color at the top. If I doubleclick the cyan color graph icon, this will open the Duotone Curve dialog. The duotone curve is similar to the image adjustment curves, except a little more restrictive in setting the points. The color ramp in the duotone dialog reflects the tonal transformation across an evenly stepped grayscale ramp and you can specify the ink percentage variance at set points along the horizontal axis. 1 The grayscale display in Photoshop is foremost based on the assumption that you want to see a representation on screen of how the grayscale file will print. Go to the Color Settings and select the anticipated dot gain for the print output. This will be the Photoshop grayscale work space that all new documents will be created in or be converted to. If you are working on a grayscale image intended for screen-based publishing then go to Window ⇒ Proof setup and select the Windows RGB preview.

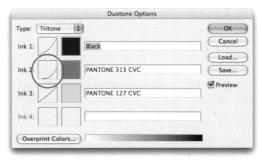

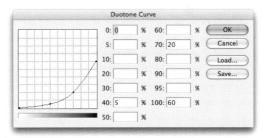

Infrared film simulation

There is a special infrared sensitive film emulsion you can buy that is predominantly sensitive to infrared radiation. And its other main characteristic is that the emulsion is quite grainy. Vegetation in particular reflects a lot of infrared light which is beyond the scope of human vision. Hence, green foliage will appear very bright and almost iridescent when captured on infrared film.

I first invented the following technique some six years ago when I was asked to come up with different ways to convert a color image to black and white. Since then I have had the opportunity to refine the steps used and make some improvements. And now that you can do layered editing in 16-bit per channel mode, one can achieve much smoother results by following the steps shown here.

1 This photograph of a Japanese garden is in RGB mode and is a good one for demonstrating the infrared technique, which is basically an extension of the color to monochrome technique using the Channel Mixer. As you can see, there are a lot of green leaves in the picture and the aim of this technique was to lighten the leaves and apply a slight glow to them. The following steps required some extreme image adjustments, and so I felt it was important to keep the image in 16-bit per channel mode throughout. I began by copying the Background layer and then added a Levels adjustment layer. I clicked on the Options button in Levels and checked the Enhance Per Channel Contrast button (shown below).

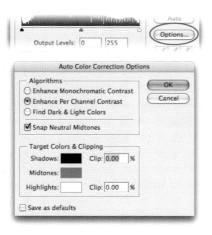

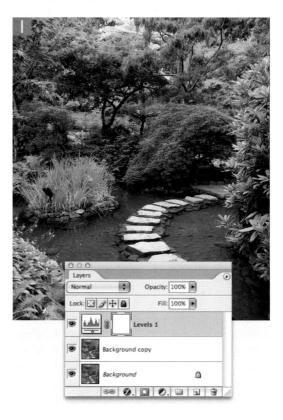

Normal Opacity: 100% •	Channels	
Lock:	RG8	ж-
Channel Mixer 1	Red	H 1
Levels 1	Green	M2
Background copy	Blue Blue	963
Background		

2 The next step was to add a Channel Mixer adjustment layer set to Monochrome mode. Now if we want the green channel to appear the lightest (because it contains most of the green foliage information) then we have got to somehow boost the green channel mix. The maximum setting allowed is 200% which produces a burnt-out result. Bearing in mind the 'keep everything adding up close to 100%' rule, I reduced the other two channel percentages to give them minus values. There was a lot of cyan coloring in the green, so I reduced the red channel by 80% and the blue channel was therefore set to minus 20%.

		Fad	e	
Opacity	:	25	%	(ок)
	·			(Cancel)
Mode:	Screen	in the second	-	Preview

3 I now wanted to add some glow to the foliage. It is important that the underlying image has remained in RGB (because it is the adjustment layer which is making the monochrome conversion). I first made the Background copy layer active and then went to the Channels palette and highlighted the green channel and applied a Gaussian Blur filtration to that channel only. The amount used here was 5 pixels, but you might want to apply more on bigger images or to achieve a more diffuse effect. I followed that with an Edit \Rightarrow Fade Filter command, reducing the blur to a 25% opacity and changed the blend mode to Screen.

4 After step 3, the picture looked rather light and there may have been some burnt-out detail in the highlight areas. So this is where the Levels adjustment comes in use again. When you try using this technique, make sure that you can view the Histogram palette as you revist the Levels dialog, because you will now want to refer to the histogram displayed in the Histogram palette and not the one in the Levels dialog. In this example, I set the Highlight Output slider to 220, in order to retain more detail in the highlights.

To further simulate the infrared emulsion, one could also try adding some Gaussian noise to the Background copy layer, or you could add a grain layer using the technique shown on page 250.

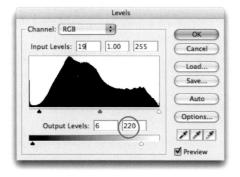

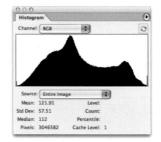

Cross-processing

The Cross-processing technique has long been popular among fashion and portrait photographers who are fond of distorting colors and bleaching out the skin tone detail. You can replicate cross-processing effects quite easily in Photoshop and do so without the risk of 'overdoing' the effect and losing important image detail. There are two basic cross-processing methods: E-6 transparency film processed in C-41 chemicals and C-41 negative film processed in E-6 chemicals. The technique shown on the next two pages aims to replicate the cross curve effect you typically get when using a C-41 film processed in E-6.

In the example shown on pages 340–341, you will notice how I manage to make the shadows go blue, while the highlights take on a yellow/red cast. The technique outlined here is another of those which I have adapted over the years and this most recent update is I think more flexible. As with all the other coloring effects described in this chapter, the main coloring adjustments are applied as adjustment layers using the Color blend mode. This helps you to preserve the original luminosity, but if you want to simulate the high contrast cross-processed look, then use the Normal blend mode instead and in addition to that consider deliberately increasing the contrast in the RGB composite channel as well (which will also boost the color saturation). The other thing you can do to adapt this technique is to explore alternative color channel adjustments and try using different color fills and layer opacities.

Lab Color effects

This is not a cross-processing effect per se, but this technique sure can mess with the colors in your images in some pretty interesting ways. I would suggest that this effect is best applied to medium or high resolution images and that the source image should be fairly free of artifacts. I found that you can also create some interesting variations if you invert the colors while the images are at the Lab mode stage.

Preserving the image luminosity

Some of the techniques described in this chapter involve applying a series of extreme image adjustments or multiple adjustment layers. Therefore, there is always the potential risk that if you are not careful, you will lose important highlight and shadow detail. A solution to this is to make a copy of the original background layer and place it at the top of the layer stack, set the layer blending mode to Luminosity and fade the opacity. This will allow you to restore varying percentages of the original image luminance detail.

Figure 8.1 You can restore the original image luminance information by copying the Background layer, dragging it to the top of the layer stack and setting the layer blend mode to Luminosity and then adjust the layer opacity to restore some or all of the original luminosity.

1 Here are the steps used to create a cross-processing effect that simulates C-41 film processed in E-6 chemicals. You can adapt this technique by using different channel curve adjustments and using different fill colors. To start with I added a Curves adjustment layer which was set to the Color blend mode. I then adjusted the curves in the individual color channels as shown in the screen shots below.

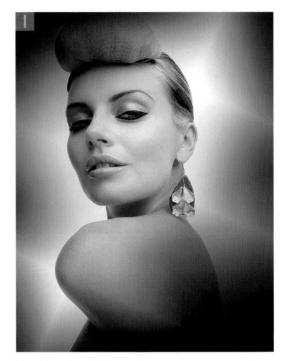

Model: Lucy Edwards @ Bookings.

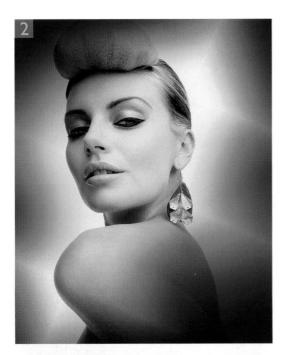

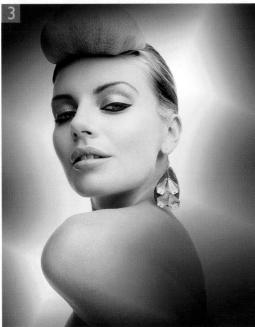

2 The curves channel adjustments applied in step 1 added a blue/cyan cast to the shadow areas and added a red/yellow cast to the highlights. Because the Curves adjustment layer was set to the Color blend mode, the luminosity was unaffected.

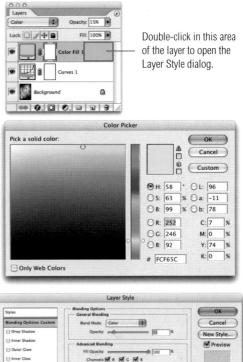

 Open Shadow
 Open Shadow

 Obser Shadow
 Open Shadow

 In the Shadow
 Advanced Banding

 Obser Gree
 To backrist

 In the Shadow
 Open Shadow

 In the Shadow
 Advanced Banding

 In the Shadow
 Open Shadow

 In the Shadow
 Open Shadow

 In the Shadow
 In the Shadow

3 I then added a Color Fill layer which was also set to Color mode at an opacity of 15% and selected a strong yellow fill color. I then double-clicked the Fill layer and adjusted the Underlying layer blend options. I (a) alt -clicked on the Underlying Layer shadow point triangle slider and dragged to separate the dividers and split them in two. I dragged the right-hand shadow slider across to the right. This created a transitional blend between the underlying layer and the fill yellow layer above. 1 Here is another type of Photoshop cross-processing effect for RGB images. It involves the use of the Lab Color mode to enhance the colors and the enhanced lab mode image is then brought back into RGB mode again as a new layer. To start with I opened an RGB image and created a duplicate copy by choosing Image
⇒ Duplicate...

Ch	annels			5
	-	Lab	36~	
	and the second	Lightness	#1	
		a	第2	
	-	ь	963	
		Lo Lol	9	Ļ

2 I converted the duplicate image to Lab Color mode by choosing Image ⇒ Mode ⇒ Lab Color. The Lab Color image contains a Lightness channel with **a** and **b** color channels. I went to the Channels palette and selected the a channel first and expanded the channel contrast by choosing Image \Rightarrow Adjustments \Rightarrow Equalize. This produced the extreme color shift shown in the image here. I then clicked on the Lab composite channel in the Channels palette (it is essential you remember to do this so that all three channels are selected again) and copied the enhanced image across to the original image as a new layer. You can do this by either choosing Select \Rightarrow All and copying and pasting the image contents. Or, you can select the move tool and drag the Lab image across to the original RGB version. Make sure that you hold down the Shift key as you do so. A Shift drag will ensure that the layer is centered when you let go of the mouse. There is no need to worry about the color space mismatch. Photoshop will automatically convert the file back to RGB mode again as you make a copy and paste.

3 I set the new layer blend mode to color and the layer opacity to 30%. This Lab coloring technique is inclined to generate harsh pixel artifacts, so I chose Filter \Rightarrow Blur \Rightarrow Gaussian Blur and applied a 2.5 pixel radius to soften the image layer slightly. Because the new layer is using the Color blend mode, this blurring will not affect the sharpness of the image luminosity.

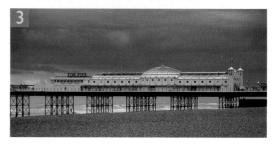

343

Chapter 8 Darkroom effects

F

8-

\$1

¥2

#3

3

4 I returned to the Lab copy image and went back a couple of steps in the History palette and selected the **b** channel this time and then repeated the steps described in step 2. I applied an equalize image adjustment and then copied the newly enhanced composite lab image across to the original RGB version, this time bringing it in as Layer 2. And, as before, I set the blend mode to Color, the opacity to 30% and applied a Gaussian Blur to the new image layer

000

.

Channels

S Lab

Lightness

5 Here is the finished result. As you can see, when using the Lab Color process described here, you can end up with two brightly colored, semi-transparent layers. The fun starts when you adjust the relative opacity of each and experiment with different amounts of opacity in these two layers.

Opacity: 30%

Fill: 100%

۵

Laver 2

Background

0.00.00

0 0 0 Layers

Lock:

Cold

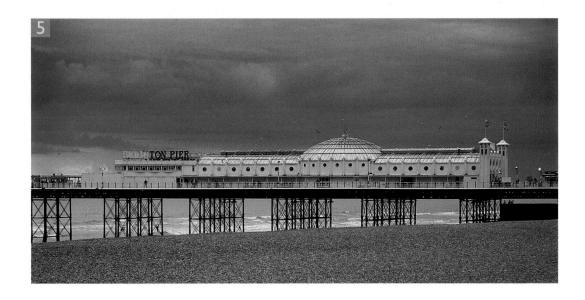

Channel Mixer color adjustments

The Channel Mixer will let you achieve the sort of coloring effects that could once only be done with the Apply Image command. The Channel Mixer is an interesting image adjustment tool because it alters the image by swapping color channel information, sometimes producing quite unique and subtle color adjustments which cannot necessarily be achieved with any of the other color adjustment tools. Controlling the Channel Mixer is no easy task. This first example shows you how to add a deeper sunset appearance to a photograph and add richer, more golden colors to the scene.

1 This image is correctly color balanced, but it lacks the drama of a golden warm sunlit image. One answer would be to adjust the overall color balance by applying a curves correction. The Channel Mixer, however, offers a radically different approach, it allows you to mix the color channel contents.

2 Examine the Channel Mixer settings shown below. The main color enhancement occurs in the red channel. I boosted the red channel to 125%, mixed in a little of the green channel and subtracted 34% with the blue channel. Very slight adjustments were made to the green and blue channels, but you will notice how when the red, green and blue channel percentages were added up, they were always close to 100%.

Channel Mixer	Channel Mixer	Channel Mixer
Output Channels Source Channels Red: +125 % Green: +13 % Blue: -34 %	Output Channel: Green	Output Channel: Blue Cancel Source Channels Red: -6 % Creen: -6 % Blue: +100 %
Constant: +2 % Monochrome	Constant: 0 %	Constant: -2 %

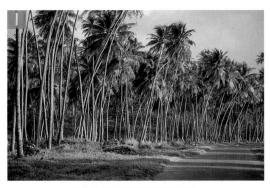

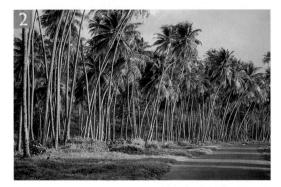

Outpu So Red: Gree Blue Con 1 If you are feeling adventurous then you can achieve some really quite wild coloring effects with the Channel Mixer. But I suggest you should tame the effect by sandwiching the Channel Mixer adjustment layer between the Background layer and a copied Background layer set to Luminosity mode (see page 339).

2 In this first example, I set the Channel Mixer blending mode to Darken and adjusted the individual color channel Channel Mixer settings as shown below. Because the Background copy layer is set to Luminosity, you can make quite extreme adjustments without losing luminosity detail. You also have to be very patient when making adjustments via the Channel Mixer, because leaving aside the Constant slider, there are nine sliders here you can adjust! The settings used here enabled me to produce a rich color distortion effect.

3 The Darken mode produced an interesting result, but you may want to also experiment with all the other blend modes. This variation was achieved by changing the blend mode to Exclusion and taking the adjustment layer opacity down to 50%.

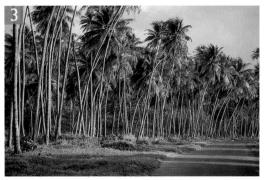

Channel Mixer	Channel Mixer	Channel Mixer
t Channel: Red Cancel orce Channels Cancel Load Save Save Preview tant: 0 % tant: 0 %	Output Channel: Green () Source Channels Cancel Red: 45 % Green: +65 % Blue: +120 % Constant: 0 % Monochrome	Output Channel: Blue Source Channels Red: -65 X Green: +95 X Blue: +90 X Constant: 0 X Monochrome

PhotoKit Color plug-in

Some of the effects shown in this chapter such as the split-toning, cross-processing and color overlays are all available in the form of an automated plug-in called PhotoKit Color. One reason for the plug is that I did design all the coloring effects myself. You can download a 7 day demo from the Pixel Genius website: www.pixelgenius.com.

Color overlays

My favorite method for colorizing an image is to add a solid color fill layer from the adjustment layer menu in the Layers palette and set the layer blending mode to Overlay, Color or Soft Light mode. The Overlay blend mode will produce the most intense looking results, and when selecting a color from the Color Picker, it is best to choose a fully saturated color from the top right corner and reduce the opacity of the fill layer afterwards to around 10–30%. The Color blend mode can work fine with any color, but by selecting a more saturated color you have more options at your disposal. The Soft Light blend mode provides a more gentle blend and is the one used in the accompanying steps to simulate using a color gradient to make the sky in the photograph appear more blue.

1 In this example I wanted to add a blue gradient to the top of the picture to enhance the sky and add a dash of blue. This is effectively a Photoshop technique for adding a blue gradient filter. I began by adding a new fill color layer using a bright blue color and set the Color Fill layer blend mode to Soft Light.

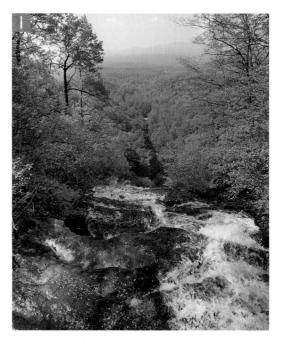

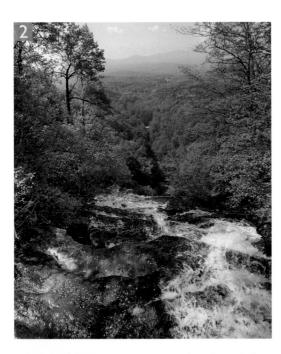

2 With the Color Fill layer active, I selected the gradient tool and with the foreground/background colors set to their defaults, dragged downwards around the middle of the picture to add a gradient to the Color Fill layer mask. I then double-clicked the Color Fill layer to open the Layer Style dialog and adjusted the layer blending option for 'This Layer' as shown below. To separate the triangle sliders, I are are clicked on the shadow point triangle slider and dragged to separate the dividers and split them in two.

Styles	Blending Options Ceneral Blending	(ок
Blending Options: Custom	Blend Mode: Soft Light	Cancel
Drop Shadow	Opacity:	New Style
E Inner Shadow	Advanced Bending	Preview
Outer Clow	Fill Opacity:	Entenen
E Inner Glow	Channels: 🗹 R 🗹 G 🗹 B	
Bevel and Emboss	Kneckout: None	
Contour	Blend Interior Effects as Group	
E Texture	Blend Clipped Layers as Group	
E Satin	Transparency Shapes Layer Layer Mask Hides Effects	
E Color Overlay	Vector Mask Hides Effects	
Gradient Overlay	Blend # Gray	
E Pattern Overlay		
🖯 Stroke	This Layer: 0 444 255 Underlying Layer: 0 255	

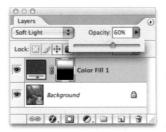

3 The above Layer Style adjustments produced a smoother blend of the blue color fill with the sky and trees, but I felt that the color was too strong. To address this, I went to the Layers palette and reduced the Color Fill layer opacity to 60%.

Hand coloring a photograph

Let's stick with the subject of color overlays for a moment and look at some other ways one might want to color a photograph. The Color overlay blend mode is probably the simplest one to use when hand coloring an image. Just create an empty new layer, set the blend mode to Color and add paint with the paintbrush. But what follows shows a more advanced technique that I use when adding a specific color.

1 This first step revolves around the use of the Gretag MacBeth Eye-One spectrophotometer to measure a precise color. I then used the measured reading to create a color swatch that can be used in Photoshop. But the steps after this will still work if you resort to guessing the color or are given a specific color swatch reference to work with. I used the Eye Share software to record color from some hair swatch colors and made a note of the Lab Color values.

2 I then opened the Color Picker in Photoshop and entered these (rounded up) Lab Color values in the Lab coordinates. I clicked OK and then clicked in an empty space in the Swatches palette to save and name the new swatch, ready for use at the next step.

3 It is at this point that I should acknowledge the photographer, Jim Divitale, who devised the following multi-layered coloring technique. The foreground color should have the desired swatch color loaded. I then added a new Color Fill layer in the Layers palette using this color. Now at this point you might find it helpful to create a new action and hit the record button to record the following steps as a Photoshop action. Start by copying the Color Fill layer two times.

5 I *Shift*-clicked the three layers to select them and chose New Group from Layers... from the Layers palette fly-out menu. I then all-clicked on the Add a Layer Mask button in the Layers palette to add a layer mask filled with black, which will hide the layer group contents.

4 Now set the uppermost Color Fill copy layer to Color mode @ 50% opacity. Click on the middle layer and set the blend to Overlay mode @ 25% and lastly go to the original layer, set that to Multiply blend mode @ 10%.

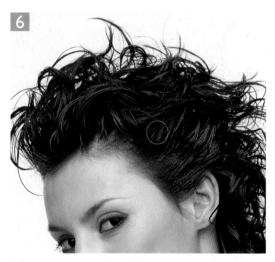

6 If you have been recording all this as an action, you can press the Stop button now. When you have completed these steps you can paint with white on the layer group's layer mask to simultaneously reveal all three layers in the group. The blend and opacity modes for the three layers are just a suggestion. Feel free to readjust the opacity settings as desired.

Client: Indola. Model: Lisa Maria @ Take 2.

Gradient Map coloring

The Gradient Map adjustment will map the colors in an image based on a gradient. Some examples of this are shown below, where the most effective way to do this is by using a reduced layer opacity and changing the layer blend mode.

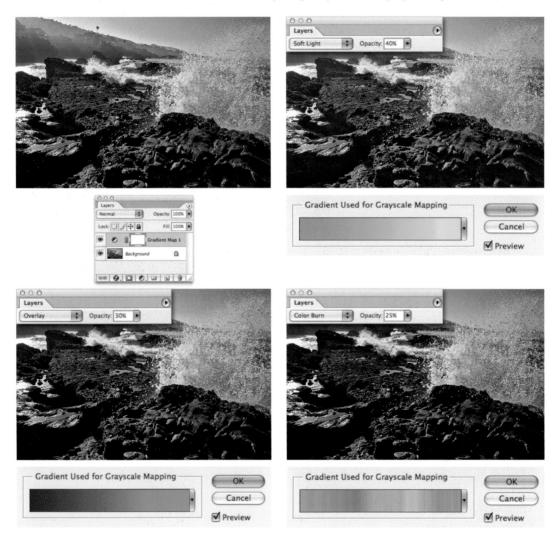

Figure 8.2 The above examples show how various types of gradient layers can be applied to a color image by adding a Gradient Map adjustment layer and how the original photograph can be colored in many different ways. Even the use of Noise gradients can produce some interesting results, although it pays to fine-tune the smoothness and shape of the gradient using the gradient edit options.

Adding a border to an image

Here is a simple two step technique for taking a scan made from a Polaroid border and adding it to another image.

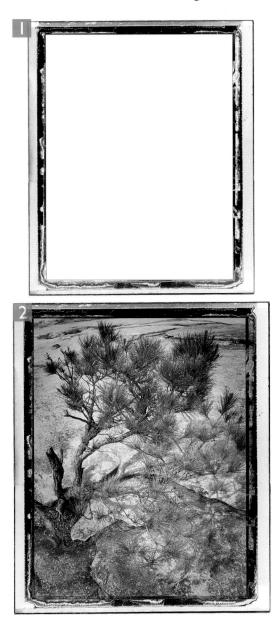

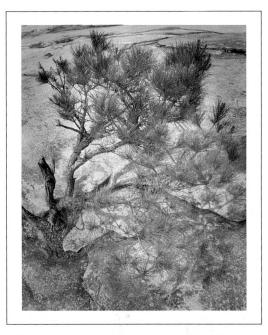

1 We have here a scan made from a print of a Polaroid processed border. I selected the move tool and dragged this image across to the second image (which had a white border) and added it as a new layer.

2 I then changed the blending mode of the Polaroid layer to Multiply. This made the border layer merge with the underlying layer. Once I had done this, I selected the Edit ⇒ Free Transform to scale the layer to neatly overlay the image below. Lastly I added a Curves adjustment layer to colorize the image to create a gold color tone effect.

Softening the focus

A quick way to soften the focus in a photograph is to duplicate the Background layer and use Filter \Rightarrow Blur \Rightarrow Gaussian Blur to blur the image. If you set the layer blend mode to Darken, this will simulate a diffuse printing effect. To achieve a lens soft focus effect, set the blend mode to Lighten. You can reduce the layer opacity as necessary to restore more of the original image sharpness. If you add a layer mask to the layer you can fill or add paint to the mask and apply the soft focus effect selectively.

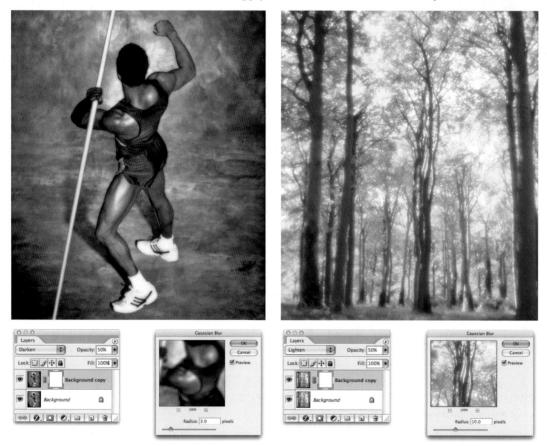

Figure 8.3 In the javelin thrower example, I applied a Gaussian Blur filter to a Background copy layer and set the layer blend mode to Darken at 50%. This method simulates diffusion darkroom printing. With the forest scene I applied a greater amount of blur and set the layer to Lighten blend mode, also at 50%. This produced a soft focus lens effect.

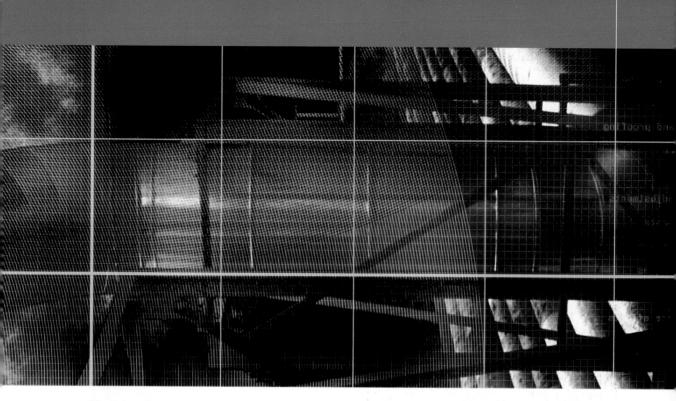

Chapter 9

Layer Effects

his chapter shows you some of the special things you can now do in Layers and how these features will be of use to image makers as well as designers working in graphics or web design. Layer effects enable you to make multiple (and reversible) Photoshop layering actions. This is a wonderful tool with which to automate the application of various Photoshop effects like embossing or adding a drop shadow. Layer effects can be used in various ways: applying effects to an image element on a layer; text effects with a type layer; and creating special image lighting effects such as glows and shadows around a subject.

Editing layer effects

Double-clicking the layer or anywhere in the layer effect list will reopen the Layer Style dialog.

Layer what?

Unfortunately, Photoshop uses mixed terminology to describe layer effects and layer styles and naturally this can lead to confusion. A layer style can be both an individual layer effect and a combination of layer effects. The Photoshop User Guide and help menu refer to the individual effects as layer effects, even though the Layer menu, Layers palette and layer effect dialog refer to them as layer styles.

Layer Styles

Layer Styles enable you to apply various layer effects linked to any of the following types of layer: a type layer; an image layer; or a filled layer masked by a vector mask or layer mask. A Layer Style is made up of individual layer effects which are accessed via the Layer menu or by clicking on the Add a Layer Style button at the bottom of the Layers palette. Layer effects can be applied individually or as a combination of effects to create a layer style and these can be saved by clicking in the empty space area of the Styles palette. As with the adjustment layers, layer styles will always remain fully editable. When you add a new layer effect, the Layer Style dialog will open to let you adjust the settings and create the desired layer effect. After adding a layer effect, an italicized @ symbol will appear in the layer caption area and next to that a disclosure triangle. When you click on this disclosure triangle, an indented Effects layer will appear below containing an itemized list of the individual layer effects used to create the master layer style and allow you to control the visibility of the individual effects.

000

Layers Opacity: 100% *
Normal Opacity: 100% *
Lock: 2 2 4 a Fill: 200% *
S Effects
S Drop Shadow
S Inner Shadow
B Background
B C. 2 . 2 2 2 2 2

Figure 9.1 A layer effect can be applied to an image, shape or type layer by mousing down on the Add a Layer Style button in the Layers palette. When you add a new layer effect an italicized icon will appear next to the layer name in the Layers palette.

Figure 9.2 If you click on the disclosure triangle next to the *i*con, an indented list of the effects making up the layer style will show below. These appear in the same descending order that the layer effects appear in the Layer Styles dialog. Each effect can be made visible or invisible by toggling the eye icon next to it in the Layers palette. Or you can hide all of the effects at once by clicking on the eye icon next to 'Effects'.

Drop Shadow

There are quite a range of options associated with each layer effect. We start with the Drop Shadow which uses the Multiply blending mode to create an offset shadow behind the layer object. The default color is set to black using Multiply blend mode at 75%. But you can change this so the shadow effect uses some other blend mode and alters the opacity to produce a stronger or lighter shadow. Below this is the angle setting, where you can either enter a numeric value or use the rotary control to manually set the shadow angle. The Use Global Angle comes into play when you want to link the angle set here with those used in other layer effect settings such as the Inner Shadow or Bevel and Emboss layer effects (and that of any other Layer Styles layers). Deselect this option if you want to set the angles independently. Below this are the main shadow effect controls. The Distance slider will determine the number of pixels the drop shadow will be offset by. The Size slider sets the pixel size increase of the shadow and the Spread slider should be used to control the softness of that shadow. At 100%, the shadow will have a harsh edge. At 0% it will be at its softest. The Contour shape will determine how the shadow fades out (the linear contour is best for most shadow creation).

Adjusting the settings directly

While the Drop Shadow Layer Style dialog is open you can set the drop shadow angle and position by simply dragging with the cursor in the document window area.

Adding Noise

The Drop Shadow and Inner Shadow layer effects have a Noise slider control. It is often a good idea to add a little noise, such as around 2-3%, when creating a shadow so as to reduce the risk of banding appearing in the image.

Inner Shadow

The Inner Shadow controls are more or less identical to the Drop Shadow effect. The only difference being that this applies a shadow within the layered type or object area. The result may appear to be either that of a recessed shadow or will give a convex 3D appearance to the layer object. It all depends on the angle you choose and the size and distance of the shadow.

Contraction of the second s		
lending Options: Default	Blend Mode: Multiply	Cancel
Drop Shadow	Opacity: 40 %	New Style
Inner Shadow	Angle: 123 * Vuse Global Light	Preview
Outer Glow	Angle: 123 1 G use Global Light	Freview
Inner Glow	Distance:	
Bevel and Emboss	Choke: 30 %	
E Contour	Size: 75 px	
E Texture	Quality	7
Satin	Contour: Anti-aliased	
Color Overlay		
Gradient Overlay	Noise: @%	
Pattern Overlay		
Stroke		

Figure 9.5 The Inner Shadow Layer Style dialog.

Figure 9.6 Here is an example of a still life product shot that was taken in a hurry against a simple white card background. As you can see, there is some spill light causing flare around the edges of the subject. I made an outline selection of the lens and copied it to its own layer and then applied the Inner Shadow settings shown in Figure 9.5, which used a distance of zero. This layer style was able to counteract the lightness around the edges.

Outer Glow and Inner Glow

These both have similar controls. The Outer Glow is also much like the Drop Shadow, but is defaulted to the Screen blending mode, and the effect spreads evenly out from the center. The glow layer effects can apply either a solid or a gradient-based glow. And the Inner Glow contains options for edge and center glows. Used in conjunction with the Inner Shadow, you can achieve a smooth 3D 'contoured' appearance with the centered Inner Glow setting.

Any color you want

The layer effect colors can easily be edited. Yellow is chosen as a default for the glow color settings because I guess yellow could be used to simulate the glow from a light bulb. But you don't have to use just yellow. You can select any color you like.

Figure 9.7 The Outer Glow Layer Style dialog.

Martin Evening Adobe Photoshop CS2 for Photographers

Figure 9.9 This example shows an image where I applied a Bevel and Emboss layer style to a shape layer using the settings shown in Figure 9.7, which also included a small amount of drop shadow.

Bevel and Emboss

The Bevel and Emboss effect adds a highlight and a shadow edge 180 degrees apart from each other. When you adjust the height or angle settings of the light, the two move in sync, and this can be used to create an illusion of depth. Bevel and Emboss is often used to create contoured type and 3D web page buttons. But this layer effect can sometimes be used in photography, as shown in the molten ice image on page 363.

The Structure settings are used to establish the type of bevel and emboss you want to create, such as an outer bevel, an inner bevel, or pillow emboss plus whether you want the bevel to use a smooth or hard chisel technique. The Shading options can then be used to enhance the bevel and emboss structure where you can adjust the lighting direction, the shadow and highlight properties. The Gloss Contour options, which are covered later on page 366, can add some interesting metallic-looking effects to the surface of a beveled object. If you check the indented Contour option you can apply a separate contour to define the bevel edge and if you check the Texture option below that, you can add an embossed pattern texture to the surface.

tyles	- Texture Elements
nding Options: Default	Construction M
Orop Shadow	Pattern Snap to Origin
Inner Shadow	
Outer Glow	Scale: 200 %
Inner Glow	Depth
Eevel and Emboss	invert 🕑 Link with Layer
Contour	
Texture	
Satin	
Galar Overlay	
Gradient Overlay	
Pattern Overlay	
- Stroke	

Figure 9.10 The Contour and Texture options can be used to adjust the bevel contour shape or add an embossed texture to the surface of the beveled object.

Styles	Bevel and Emboss OK
8lending Options: Custom	Style: Emboss Cancel
Orop Shadow	Technique: Smooth () New Style
🗐 Inner Shadow	Depth: 270 %
Outer Glow	Direction: Up 🖲 Down
Inner Glow	Size: 20 px
Bevel and Emboss	Soften: 3 px
Contour	Shading
[] Texture	Angle:+
Satin Color Overlay	Altitude:
Gradient Overlay	Gloss Contour: 🖉 📄 Anti-aliased
Pattern Overlay Stroke	Highlight Mode: Screen
	Opacity: 6100 % Shadow Mode: Color Dodge
15	Opacity: 53 %

Figure 9.11 The Bevel and Emboss Layer Style dialog.

Satin

This can be used to add a satin type finish to the surface of the layer or type. You will want to adjust the distance and size to suit the pixel area of the layer you are applying the effect to.

	Layer Style	
Styles	Satin Structure	ОК
Blending Options: Default	Blend Mode: Multiply	Cancel
Drop Shadow	Opacity: 75 %	New Style
Inner Shadow	Angle: 19 *	Preview
Outer Glow	inder (1)	Freview
Inner Glow	Distance: 50 px	annes a
Bevel and Emboss	Size: 65 px	
E Contour	Contour:	
E Texture	Invert	
Satin		
Color Overlay		
Gradient Overlay		The Courses
Pattern Overlay		
E Stroke		

Figure 9.12 Here is an example of a layer style which combines the Bevel and Emboss and Satin layer effects, using the settings shown in Figure 9.9.

Figure 9.13 The Satin Layer Style dialog.

Gradient Overlay

The separate opacity and blend modes can be applied to create subtle combinations of gradient coloring. The Align with Layer option will center align the gradient to the middle of the layer, although you can drag with the cursor in the image window to move the gradient, while the Scale option will enlarge or shrink the spread of the gradient.

Styles	Gradient Overlay	ОК
Blending Options: Default	Blend Mode: Normal	Cancel
Drop Shadow	Opacity: 100 %	New Style.
📄 Inner Shadow	Gradient:	
Outer Glow	Style: Linear 😯 🗹 Align with Layer	
E Inner Glow	Angle: 90 *	
Bevel and Emboss		
E Contour	Scale: 50 %	
E Texture		
🖂 Satin		
Color Overlay		
Gradient Overlay		
Pattern Overlay		
E Stroke	and the second second	
		A STATISTICS

Figure 9.14 The Gradient Overlay Layer Style dialog.

Figure 9.15 Here is an image created using a Photoshop Pattern preset called Stones which can be found in the Rock collection of loadable Pattern presets.

Figure 9.16 The Pattern Overlay Layer Style dialog.

Pattern Overlay

To add a Pattern Overlay, select a saved pattern from the presets. The Opacity and Scale sliders will modify the appearance of the overlay pattern. The Link with Layer option will lock the pattern relative to the layer object.

Styles	Pattern Overlay Pattern	ОК
Blending Options: Default	Blend Mode: Normal	Cancel
Drop Shadow	Opacity: 100	% New Style
Inner Shadow	KERTE	Preview
Outer Glow	Pattern: Snap to	o Origin
Inner Glow	KACH .	18.30
Bevel and Emboss		× Ko
🖯 Contour	Link with Layer	
E Texture		
Satin		
Color Overlay		
Gradient Overlay		and a second second
Pattern Overlay		
E Stroke		

Color Overlay

This Layer effect will add a color fill overlay to the layer contents. All you need to do here is select a color, vary the opacity and change the blending mode.

Styles	Color Overlay	ОК
Blending Options: Default	Blend Mode: Normal	Cancel
E Drop Shadow	Opacity:	New Style
😑 Inner Shadow		Preview
Outer Glow		Preview
Inner Glow		
Bevel and Emboss		
E Contour		
🖯 Texture		
🖂 Satin		
Color Overlay		
Gradient Overlay		
Pattern Overlay		
🖯 Stroke		All and the second

Figure 9.17 The Color Overlay Layer Style dialog.

Stroke

The Stroke effect applies a stroke to the outline of the layer or text with either a color, a gradient or a pattern. The options in this dialog are similar to those in the Edit \Rightarrow Stroke command, except as with all layer effects, the stroke is scalable and will adapt to follow any edits or modifications made to the associated layer.

Styles	Stroke Structure	ОК
Blending Options: Default	Size: 10 px	Cancel
Drop Shadow	Position: Outside	New Style.
Inner Shadow	Blend Mode: Normal	Preview
Outer Glow	Opacity: 100 %	Freview
Inner Glow	Fill Type: Color	
Bevel and Emboss		
Contour	Color:	A CONTRACTOR OF A CONTRACTOR OFTA CONTRACTOR O
E Texture		
E Satin		
Color Overlay		
Gradient Overlay		
Pattern Overlay		
Stroke		

New Style	
Mame: Style 1	ОК
Include Layer Effects	Cancel
Include Layer Blending Options	

Figure 9.19 There are many preset styles that you can load in Photoshop. The Styles palette shown here is using the Large Thumbnail view setting.

	Sun Faded Photo (Image)	1
	Blanket (Texture)	1
z	Nebula (Texture)	1
x	Sunspots (Texture)	
	Tie-Dyed Silk (Texture)	-
1	Chiseled Sky (Text)	
-	Chromed Satin (Text)	
	Overspray (Text)	

Figure 9.20 When you have found an effect
setting or a combination of settings which you
would like to keep, you can save these as a style
by clicking on the New Style button in the Layer
Style dialog, by clicking on the New Style button
in the Styles palette or clicking in an empty
space in the Styles palette. When you do this
you will be shown the New Style dialog (see
left) where you can give the Style a name and it
will be appended in the Styles palette.

% (ОК)
Cancel

Figure 9.21 When making a change to the image size, the layer styles will not adjust proportionally. If it is important that you retain the exact scaling, choose Layer ⇒ Layer Style ⇒ Scale Effects and enter a scale percentage which most closely matches the percentage change in image size.

Figure 9.22 Many Layer Styles (but not all) can be deconstructed into a series of layers. Choose Layer \Rightarrow Layer Style \Rightarrow Create Layers. Here is an example of how the layer effect applied on the page opposite would look if broken down in this way.

Applying layer styles to image layers

You can sometimes choose to apply layer effects and styles to image layers and use the layer at zero fill opacity to paint in certain textured effects. The example on the opposite page shows how I went about using a waterdrop layer style to add a molten ice texture to a photograph.

Layer effects work in the same way as adjustment layers do: they create a live preview of the final effect and only when you flatten down the layer are the pixels modified and the effect becomes fixed. Layer effects are not scalable in the same way as image data is. If you resize an image the layer effect settings will not alter to fit the new image size, they will remain constant. If you go to the Layer menu and choose Layer Style \Rightarrow Scale Effects, you will have the ability to scale the effects up or down in size.

If you need to work with real layers, you can rasterize a layer style by using the Create Layers option. Go to the Layer menu and choose Layer Style \Rightarrow Create Layers. This will deconstruct a layer style into its separate components placing the newly created layers in a clipping mask above the target layer.

Layer effects and styles can be shared with other layers or files. Select a layer that already has a style applied to it. Go to the Layer Styles submenu and choose Copy Layer Style, then select a different layer and choose Paste Layer Style from the same submenu. Alternatively you can alt drag on the conto copy the entire layer style from one layer to another. And if you don't wish to copy the complete layer style, you can alt drag to copy just a single effect between layers.

1 Using Layer Effects, you can create and save layer styles that can be used in Photoshop to paint a texture. This illustration shows a violin trapped in a block of ice. I added an empty new layer and applied a layer style I had created called waterdroplet. You will find the waterdroplet layer style on the CD. To load this style on your system, simply double-click the layer style and Photoshop will do the rest for you.

2 For the water droplet style to work effectively, I had to take the layer Fill opacity down to 0%. As I painted on the empty new layer with the brush tool, I was effectively able to paint using the layer style effect and create the translucent melted ice effect you see here. The Style is one that I created myself but it was based on the steps outlined by Greg Vander Houwen. If you still have Photoshop CS, you can access a PDF that includes Greg's great Rain Drop tutorial via the Photoshop CS Welcome screen.

Client: The South Bank. Photograph: Eric Richmond.

Adding glows and shadows

The steps shown here demonstrate how Photoshop's layer effects can be put to use to create glows and shadows in a photograph. One of the chief advantages of using layer effects in this way is that you can adjust the glow/shadow settings and revise the effect at any time. The object you wish to add the effect to must of course be on its own layer and the effectiveness of this technique is very dependent on having a well-defined cutout for the layered image. If there are some stray color pixels, you may wish to remove the matte colors first by choosing Layer \Rightarrow Matting \Rightarrow Remove Black/White Matte.

1 This layered composite image features a cutout image of a model, placed as a layer above a neutral gray-filled Background layer.

2 In this next step, I wanted to create an outer glow effect around the model. I first made a duplicate of Layer 1 by dragging it down to the Make New Layer button in the Layers palette. The Fill opacity for this duplicate layer was set to 0%. I then moused down on the Add Layer Style button and selected the Outer Glow layer effect. The settings used are shown here. I set the Opacity to 85%, changed the glow color from yellow to white and added 3% Noise. The glow effect was mostly determined by how I adjusted the Elements settings. The Spread setting should ideally be kept quite low, while you can use the Size slider to adjust the width of the glow effect.

3 The shadow effect was achieved using the same layer structure as the outer glow technique. In this next step I double-clicked the Effects Layer to open the Layer Style dialog again. I changed the color from white to black and the blending mode from Screen to Multiply and set the Opacity to 40%. All the other settings remained the same as before, and the outer glow suddenly becomes an outer shadow. You may want to fine-tune the layer contents in order to achieve a better blend between the shadow effect and the subject. In this example, I **(B) (ctr)** clicked on the Layer 1 Copy layer to load the opaque layer contents as a selection and then clicked on the Add Layer Mask button to convert the selection to a Layer Mask. These simple steps produced a smoother blend between the layer contents and the shadow effect. If required, you could also manipulate or paint on the layer mask to tidy up any gaps between the subject and the shadow effect.

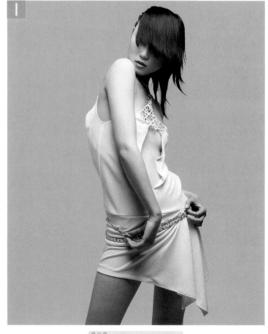

Norma	1	Opacity: 100%
Lock:	3040	Fil: 100%
	Layer 1	
	Background	۵

Client: Russell Eaton. Model: Gina Li @ Premier.

Chapter 9 Layer effects

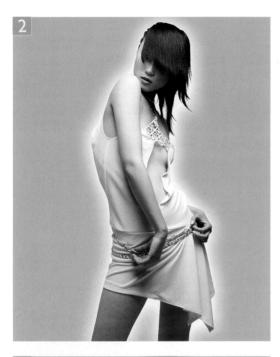

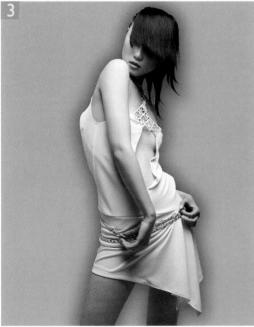

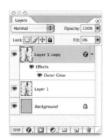

Styles	Outer Clow	6 ОК
Blending Options: Custom	Structure Blend Mode: Screen	Cancel
Drop Shadow Innet Shadow	Opacity: as as x Noise: 3 x	New Style
Cuter Claw	0 0	@ Freview
Inner Glow Bevel and Emboas Contour Texture Satin Color Overlay	Elements Technique Softer Spread: 5 Sizer: 130 Quality	
Gradient Overlay	Conteuer: 🖉 🖨 Anti-aliased	
Pattern Overlay	Range: 60 %	
Stroke	jøtter: @ 0%	

Styles	Outer Clow OK
Blending Options: Custom	Blend Mode: Multiply Cancel
Drop Shadow	Opacity: 40 % New Style
Inner Shadow	Noise: @ 3 N
Outer Claw	
M Duter Claw I tonar Claw I tonar Claw Contour	Barnets 3 % Sare 5 5 Sore 5 5

Martin Evening Adobe Photoshop CS2 for Photographers

Figure 9.23 Here is a Layer style applied to a filled shape layer. The silky texture can be attributed to the use of an inverted cone contour being combined with the Satin layer effect.

Layer effect contours

The layer effect contours in Photoshop will affect the shape of the shadows and glows for the Drop Shadow, Inner Shadow, Outer Glow and Inner Glow layer effects. The examples on this and the next page show the results of applying different contours and how this will affect the outcomes of these various layer effects. The Bevel and Emboss and the Satin layer effects are handled slightly differently. In these cases, the contour will affect the surface texture appearance of the layer effect. The Bevel and Emboss dialog refers to this type of contour as being a Gloss Contour and you can generate some interesting metallic textures by selecting different contour shapes. The Bevel and Emboss edge itself can be modified with a separate contour (see the Bevel and Emboss Layer Style dialog at the beginning of this chapter).

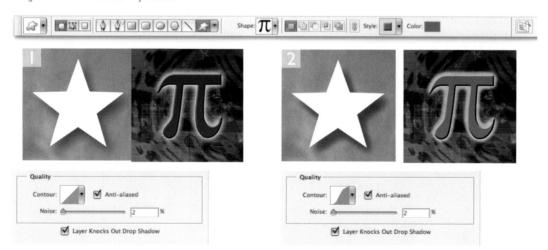

1 The linear contour is the default. In all these examples a Drop Shadow effect was added to the Star shape. Bevel and Emboss and Outer Glow effects were applied to the Π shape layer.

2 The Gaussian curve contour accentuates the contrast of the layer effect edges by making the shadows and glows fall off more steeply.

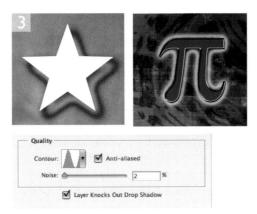

3 The single ring contour can produce a subtle bevel type shadow when applied with a slight displacement. The Outer Glow was made with Range set to 100%.

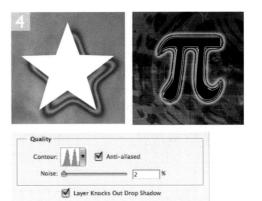

4 The double ring shape produces a more graphic type of layer effect. As can be seen here, the shadows look like contoured neon lights and the Bevel and Emboss resembles a chrome type effect. The Outer Glow Range was set to 70%.

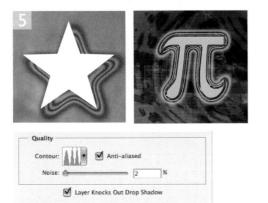

 ${\bf 5}$ A triple ring contour shape can produce a similar effect to the double ring shape. The Outer Glow Range was again set to 70%.

6 Clicking on the contour shape icon will open the Contour Editor dialog (shown opposite). Use this to load and save custom contour shapes. You can create your own customized contour and save as a new contour to add to your current set. And you can preview the effect the new custom contour has on the current Layer Effect. Check the Corner box if you want to make a point into an angled corner.

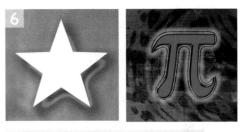

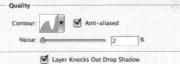

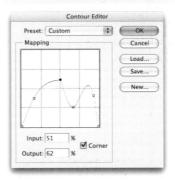

Spot color limitations

A four-color process mix can be used when printing larger non-serif type using large point sizes, but not for fine type and line diagrams, as the slightest misregistration can make the edges appear fuzzy.

Spot color channels

Spot colors can be added to images as part of the graphic design when you need to add a specific process color in addition to the standard CMYK printing inks. Photoshop is able to simulate the effect of how a spot color will reproduce in print and how a special color overlay will interplay with the underlying image. Spot colors include a wide range of industry standard colors. The colors available can include those found in the CMYK gamut, but also a whole lot more that are not, including metallic 'specials' (manufacturers' printed book color guides are an accurate reference for how the color will print). Spot colors are mostly used where it is important that the printed color conforms to a known standard and for the printing of small point size type and graphics in color.

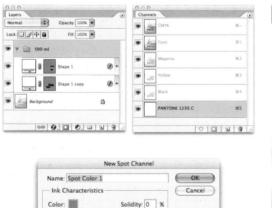

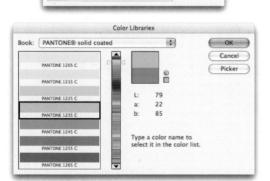

Color:

1 A spot color channel is used to add a fifth color to a CMYK file. The master image contained some shape layers based on artwork supplied by the designer, to which I added a drop shadow effect. To add the spot color channel, I went to the Channels palette flyout menu and chose New Spot Channel... This popped the New Spot Channel dialog. I clicked on the swatch color to open the Color Picker and then clicked on a button marked Color Libraries. A guick way to select a known Pantone reference color is to rapidly type in the Pantone reference number.

Chapter 9 Layer effects

2 I wanted to use the new spot color to add color to the fabric, but not to the iron. I drew a path to define the area outside the iron, made an inverse selection and feathered the selection. I activated the new spot channel and used Image ⇒ Apply Image to blend the selected Cyan channel contents into the spot color channel using a Normal blend.

Photograph: Laurie Evans. Designer: Richard Lealan. Client: Waitrose Limited.

	Apply I	mage	
– Source: waitrose0 Layer: <u>Merged</u> Channel: Cyan	2.psd	÷	OK Cancel
Target: waitrose0	2.psd (PANTO	N)	Preview
Opacity: 100 %			
0 annels		O O O Channels	
annels CMYK	() 8~		×
annels		Channels	3 36- 361
annels CMVK	н	Channels CMYK	
annels CMVK Cyan Naccore	H- H1	Channels CMYK	26.1
annels CMYX Cyan Magenta	8~ H1 162	Channels CMYK CMYK Cyan Cyan Magenta	96.3
CAPYX Cyan Cyan Magenta Yellow	8~ #1 %2 %3	Channels CMYK Cyan Cyan Cyan Cyan Cyan Cyan Cyan Cyan	961 962 964

3 Meanwhile, with the selection still active in the Cyan channel, I hit add delete to fill the selected area with white. I then did the same thing in the Magenta channel as well. There now remained a CMYK full color image of the iron, but the fabric and lettering outside of the iron was now using the yellow, black and spot color channels only. To preview all of the color channels combined, I clicked on the composite channel and the spot color channel eyeball icons. The client wanted the drop shadow lettering to predominantly use the spot color ink. I therefore had to make an inverted selection of the iron in the Black channel and apply a Levels adjustment to substantially lighten the lettering in the Black channel. And here is a screen shot of the image which shows the final result after I had basically taken the image information from the darkest channel (the cyan channel) and copied this over to the new spot color channel.

Ch	annel	1	
	Kin	СМҮК	36~
	V	Cyan	96.1
	X	Magenta	36.2
9	La	Yellow	263
	-42	Black	56.4
	-	PANTONE 1235 C	#5

Vector output

The vector layer information contained in the Figure 9.28 page design can be read by a PostScript device and output the same way as vectors and type in a page layout program are normally handled. If you save a Photoshop document as a PDF, you can use the pixel compression options to reduce the file size, while the vector layer content will be preserved and will print perfectly at any resolution.

Adding type

Photoshop type is stored in vector form in Photoshop, and as such is fully editable and scalable. A type layer can be rasterized or converted to a work path or shape layer. You can still place type as a selection and place EPS artwork as before. Or you can copy and paste path outlines of logos and save these as custom shapes (see Figure 9.24). OpenType fonts and their associated features are all supported by Photoshop. The text paragraph formatting, justification and hyphenation options found in the Paragraph palette work similar to the text engine found in Adobe InDesign.

Paragraph text is created by clicking and dragging to create a paragraph box. Single line text is entered by clicking directly in the document window and can be edited at a per-character level, i.e. you can change individual character colors and font size etc. The fractional widths option in the Character palette options is normally left on as this will automatically calculate how to render the anti-aliased text using fractional widths of pixels. However, when setting small point sized type in Photoshop

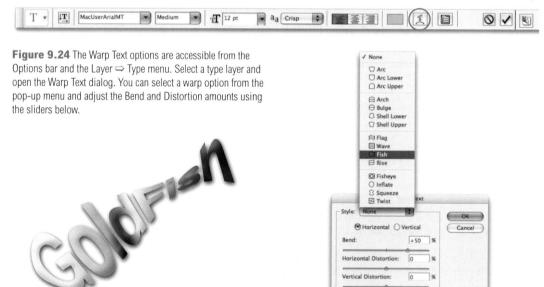

to be displayed on the screen, it is better to turn this option off. Photoshop will then round up the gap between individual characters to the nearest pixel distance and small text rendered this way will be easier to read. The anti-aliasing settings provide four levels: Sharp, Crisp, Strong and Smooth. With no anti-aliasing (None), font edges are likely to appear jagged, while the Strong setting is suited to most graphics work. The Crisp setting is the least smooth and will probably prove useful when creating small point sized bitmapped text that is designed to appear on a web page. Photoshop notably features multilingual spell checking, which can be accessed from both the Edit menu and the Character palette. Photoshop can share its linguistic library with Adobe applications and spelling additions can be shared between programs in the Creative Suite. The Tool presets palette is extremely useful if you wish to save your custom type and type attribute settings as a custom preset. So, for example, you could create a font preset which includes all the font attributes, including the font color.

		Save Ado	00.101		
Adobe PDF Preset:	High Quality	Print (Modified)	and the second		1
Standard:	None	•	Compatibility:	Acrobat 4 (PDF 1.3)	\$
General	General				
Compression Output Security Summary	Description:	printing on deskt	op printers and	be PDF documents for qualit proofers. Created PDF Acrobat and Adobe Reader 5.	
	Embed F	Photoshop Editing Page Thumbnails e for Fast Web Prev F After Saving			
(Save Preset)				Cancel Save	PDF

Figure 9.26 Photoshop CS2 offers improved and more extensive PDF save options, enabling you to adjust the compression more precisely and add security passwords to help protect the file. And a PDF save will always embed the font information.

10	Georgia	تتبلينية	
0	Gill Sans (T1)	Somple	1
a	Gill Sans (TT)	Sample	- E
T	Gill Sans	Sample	
Ŧ	Helvetica	Sample	
T	Helvetica Neue	Sample	
T	Herculanum	SAMPLE	
T	Hoefler Text	Sample	
77-	Humana Sarif ITC TT	Sample	

Figure 9.25 The new WYSIWYG font menu now makes it easier for you to see how the font you are about to choose will actually look. The word 'Sample' appears alongside each font name, indicating the font appearance.

Text on a path

Type can be added to a pen path or vector shape so that any type entered will follow along the path outline. Simply move the type cursor close to the edge of the path to begin adding the type. You can then edit the shape of the path to change the shape of the type. Similarly, type can also be constrained by a shape outline by placing the cursor within an active path shape.

Figure 9.27 Type can be added inside a shape or be made to follow a pen path.

Martin Evening

Adobe Photoshop CS2 for Photographers

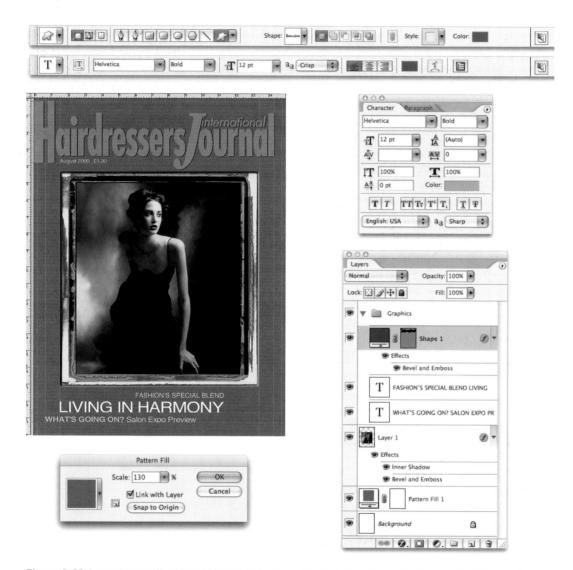

Figure 9.28 A magazine cover like this could be designed entirely within Photoshop. The masthead was a path that I copied from Illustrator and pasted into Photoshop. I then chose Edit \Rightarrow Define Custom Shape, to add it to the Shape presets (when I have a saved shape preset I can select it at any time and add it as a new shape layer). I added a Pattern Fill layer above the background, using a custom pattern, which was scaled up slightly. I then applied a couple of layer effects to the main image, to make the photograph appear as if it were recessed in a card mount frame. I added the text on separate layers, and was able to set different point sizes and change the color of the type line by line, as desired.

Chapter 10

Photoshop Filters

ne of the key factors attributed to Photoshop's success has been the program's support for plug-in filters. A huge industry of third party companies has grown in response to the needs of users wanting extra features within Photoshop. John Knoll, who together with his brother Thomas Knoll originally wrote the Photoshop program, was responsible for creating many of the plug-ins that shipped with the earlier versions of Photoshop (they are still there in Photoshop). This open door development policy enabled many independent software companies to add creative tools and functionality to Photoshop. In turn this ongoing development can largely be attributed to the success of Photoshop as a professional image manipulation program.

RGB only filters

You will notice that most of the effects filters work in RGB mode only. This is because they can have such a dramatic effect on the pixel values, and they would easily send colors way out of the CMYK gamut. So to unleash the full creative power of Photoshop plug-ins, this is a good argument for having to work in RGB mode and convert to CMYK later.

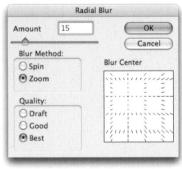

Figure 10.1 When using the Radial Blur filter in zoom mode, you can drag the center point to match the center of interest of the image you are about to filter.

Filter essentials

Most of the Photoshop filters provide a preview dialog and variable settings. Some of the more sophisticated plug-ins (such as Liquify) are like applications operating within Photoshop. These have a modal dialog interface, which means that whenever the filter dialog is open, Photoshop is pushed into the background and this can usefully free up keyboard shortcuts. With so many effects filters to choose from in Photoshop, there is plenty enough to experiment with. The danger is that you can all too easily get lost endlessly searching through all the different filter settings. There is not enough room here to describe every Photoshop filter, but we shall look at a few of the ways filters can enhance an image, highlighting the more useful creative filters plus a few personal favorites.

Blur filters

There are many ways you can blur a photograph in Photoshop. And each of these filters is able to blur an image differently. You don't really want to bother with the basic Blur and Blur More filters, but what follows is a brief description of the blur filters you will find useful.

Gaussian Blur

The Gaussian Blur is a good general purpose blur filter which can be used for many purposes from blurring areas of an image to softening the edges of a mask.

Radial Blur

Radial Blur does a very good job of creating blurred spinning motion effects. For example, the Spin blur mode can be used to add movement to a car wheel, where you wish to convey faster motion. While the Zoom blur mode can do a neat simulation of a zooming camera lens. This may appear to be a very sluggish plug-in, but it is after all carrying out a major distortion of the image. For this reason you are offered a choice of render settings. For top quality results, select the Best mode. If you just want to see a quick preview of the whole image area, select Draft.

Chapter 10 Photoshop filters

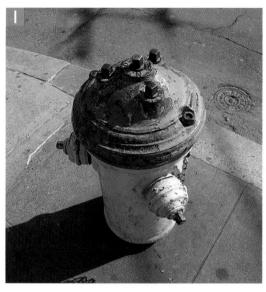

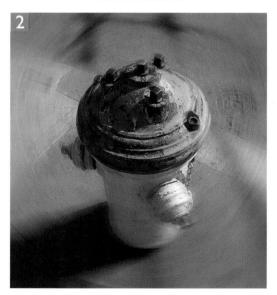

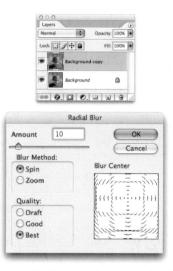

1 I made a copy of the Background layer and applied a Radial Spin blur to the copy layer using Best mode. I repositioned the center of the blur to roughly align with the top of the hydrant.

2 I wanted to remove some of the Spin blur from the center of the image, so I added a layer mask to the copy layer and added a black to white radial gradient to the mask where black was the foreground color and I dragged outwards from the center.

3 Here is a variation with the copy layer set to Screen mode.

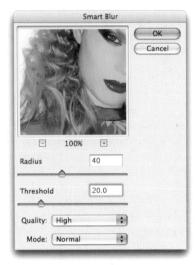

Figure 10.2 The Smart Blur filter.

Figure 10.3 The Average Blur can be used to merge the pixels within a selection to create a solid color which can then be used to take a sample color measurement of the average color within that selection area.

Smart Blur

This filter blurs the image while at the same time identifying the sharp edges and preserving them. When the settings are pushed to the extremes, the effect becomes very graphic and can look rather ugly. In some ways its function mimics the Median Noise filter and is another useful tool for cleaning up noisy color channels or artificially softening skin tones to create an airbrushed look. When retouching with this tool you could apply the Smart Blur to a copied layer and then lower the opacity.

Average Blur

The Average Blur simply averages the colors in an image or a selection. At first glance it doesn't do a lot, but it is a useful filter to be aware of. Let's say, you want to analyze the color of some fabric to create a color swatch for a catalog. The Average filter will merge all the pixels in a selection to create a solid color and you can then use this to sample with the eyedropper tool and create a new Swatch color.

Motion Blur

The Motion Blur filter can be used to create an effective impression of blurred movement. Both the blurring angle and length of blur (defined in pixels) can be adjusted and the blurring spreads evenly in both directions along the axis of the angle set. Let's suppose you want to offset the blur so that it appears to be trailing behind an object. Well, there is an example of this on page 311 where the blur was applied to a duplicate layer and the blurred layer shifted with the move tool to one side of the subject. In the accompanying example, I used the Motion Blur filter to add more general blurred movement to a photograph of a ballerina.

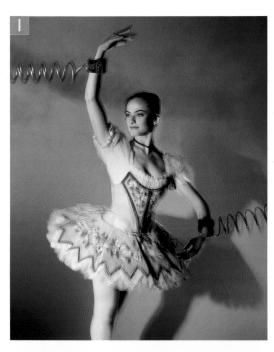

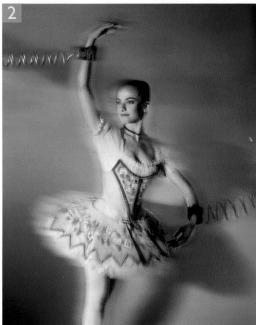

1 This photograph already has a little Motion Blur where the subject was moving slightly during the camera exposure. In this example I wanted to add the appearance of some extra motion using Photoshop's Motion Blur filter. I began by making a copy of the Background layer.

Motion Blur	
	OK Cancel
- 100K V	
Angle: -8 *	
Distance: 90	pixels

2 I then chose Filter \Rightarrow Blur \Rightarrow Motion Blur and applied a 90 pixel blur to the copied ballerina layer at an angle of minus 8 degrees. This of course blurred the entire layer, so I clicked on the Add Layer Mask button in the Layers palette to add a layer mask to the layer. I then selected the paintbrush tool, set Black as the foreground color and painted over the layer to reveal more of the unblurred layer below. The trick here is to paint with a large soft edged brush so as to maintain a soft transition between the two layers around the outline of the subject.

Photograph: Eric Richmond.

Fade command

Filter effects can be further refined by fading them after you have applied a filter. The Fade command is referred to at various places in the book (you can also fade image adjustments and brush strokes etc.). Choose Edit ⇒ Fade Filter and experiment with different blending modes. The Fade command is almost like an adjustment layer feature, but without the versatility and ability to undo later. It makes use of the fact that the previous undo version of the image is stored in the undo buffer and allows you to calculate many different blends but without the time-consuming expense of having to duplicate the layer first. Having said all that, history offers an alternative approach whereby you can do just that. If you filter an image, or make several filtrations, you can return to the original state and then paint in the future (filtered) state using the history brush or make a fill using the filtered history state (providing Non-linear History has been enabled).

Figure 10.4 The best way to learn how to use the blur filters discussed here and the Lens blur filter on the following page is to experiment with an image like the one shown here, which is available on the CD. In this night-time scene there are lots of small points of light you can use this image example to get a clear idea of how the Specular Highlights and Iris controls work and how they will affect the appearance of the blur in the photograph.

Surface Blur

This might be considered an edge preserving blur filter. The Radius adjustment is identical to that used in the Gaussian Blur filter. The higher the radius, the more blurred the image will become. But it is the Threshold slider that determines the weighting given to the neighboring pixels and whether they become blurred or not. Basically, as you increase the Threshold this will extend the range of pixels (relative to each other) that become blurred. So as you increase the Threshold, the flatter areas of tone are the first to become blurred and the high contrast edges will remain less blurred (until you increase the Threshold more).

Box Blur

The Box Blur uses a fairly simple algorithm to produce a square shape blur. It is a fairly fast filter and could be useful for creating special effects.

Sampled Blur

The Sampled Blur filter allows you to specify any shape you like as a kernel for creating the blur effect and adjust the blur radius accordingly. At the bottom of Figure 10.5 you will see that I selected a lightning bolt shape which enabled me to simulate a camera shake effect with this filter. The Sampled Blur is no match for the power of the Lens Blur filter, but is nonetheless a versatile and creative tool.

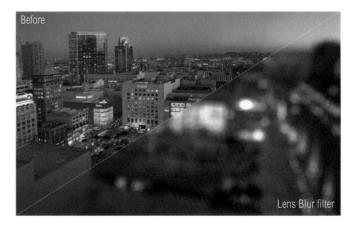

Chapter 10 Photoshop filters

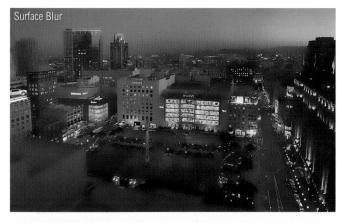

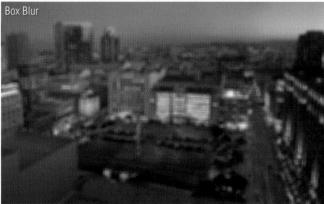

Figure 10.5 The new Photoshop CS2 blur filters.

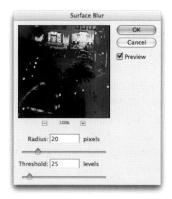

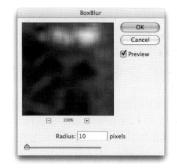

Martin Evening Adobe Photoshop CS2 for Photographers

Chan	nels	
	RGB	ж-
	Red	Ml
	Green	M2
	Blue	жз
	Alpha 1.	98.4
		1

Figure 10.6 In this example, I created a linear gradient mask channel called Alpha 1, where the gradient went from white to black. I then loaded the Alpha 1 channel in the Lens Blur filter dialog to use this as a depth map. With the Alpha 1 channel selected, I could adjust the Blur Focal Distance slider to determine the point where the image would remain sharp and the lens blur would not affect this portion of the image. But there is an even easier way to do this. You can just click anywhere in the image to decide which point you would like to keep sharp (in the above image example, I clicked on the angel at the top of the pillar to make her sharp). The out of focus effect will fade out gradually based on the gray values in the depth map channel source.

Lens Blur

If you want to make a photograph appear realistically out of focus, it is not a simple matter of making the detail softer. Consider for a moment the way a lens works. The camera lens will focus an object to form an image made up of circular points on the film/sensor surface. When the radius of these points is very small, the image is considered sharp. When the radii are large, the image will appear to be out of focus. It is particularly noticeable the way bright highlights blow out when this happens and how you can see the shape of the camera lens iris in the blurred highlight points. The Lens Blur filter has the potential to mimic the way a camera lens forms an optical image. The best way to understand how it works is to look at the shape of the bright lights in the night-time scene in Figure 10.4 which shows an image before and after I had applied the Lens Blur filter. You will also find this image on the CD.

Depth of field effects

You can also create a mask to define the areas where you wish to selectively apply the Lens Blur. This will allow you to create shallow depth of field effects. Using the Lens Blur dialog you can then load this mask under the Depth Map section in order to define the plane of focus.

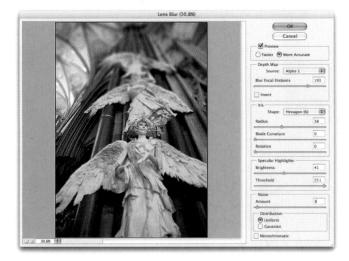

Chapter 10 Photoshop filters

1

Mode: Multiply

٠

.

1 The Depth Map controls in the Lens Blur dialog are designed to allow you to simulate a shallow depth of field focus effect. The image shown here is a good choice to demonstrate this with because the wall is photographed at an oblique angle and starts off with everything in sharp focus, which is one of the pluses (and minuses) of using a compact digital camera! I first drew a pen path to define the outline of the hydrant, I hit **# Enter ctrl Enter** to convert the path to a selection, and then clicked on the Save Selection as a Channel button in the Channels palette.

Opacity: 100% 🕨 🛛 Reverse 🗹 Dither 🗹 Transparency

2 I then needed to modify the mask to define a depth of field map. I selected the gradient tool in reflected gradient mode (circled) and set the tool blend mode to Multiply mode and dragged vertically from the center. To get the fade at the top, I kept the gradient tool in reflected mode and changed the blend to Normal mode. I made a rectangular marquee selection of the top half of the picture, selected the gradient tool again and dragged vertically from the middle again (as shown above).

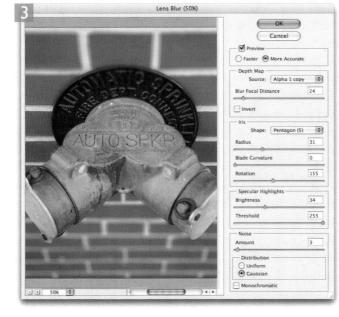

3 I then chose Filter \Rightarrow Blur \Rightarrow Lens Blur. I went to the Depth Map section and moused down on the channel source menu and selected the channel I had just created, which in this case was named: Alpha 1 copy. If you try this out for yourself, try adjusting the Blur Focal Distance slider to adjust the amount of blur that is applied to the areas that are selected and partially selected by the Depth Map Source channel.

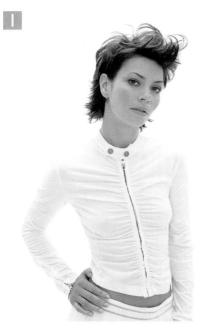

Layers		۲
Normal	Opacity: 100%	
Lock: 🖸 🍠 🖨	Fill: 100%	
Tayer 1		
Background	۵	
88 9 . 0 0.	alala	i.

2 I dragged the street image over to add as a new layer above the Background layer of the model. To make the background appear out of focus, I selected the New York street scene and chose Filter \Rightarrow Blur \Rightarrow Lens Blur. I first adjusted the Specular Highlights Threshold setting, bringing it down just enough until the highlights started to bloom. I then adjusted the Specular Highlights Brightness setting to create the desired amount of lens flare. The Iris Radius controls the width of the blur and the effect of this adjustment will be particularly noticeable in the specular highlights. Further adjustments can then be made to the iris shape, the blade curvature of the iris and the rotation. These minor tweaks allow precise control over the iris shape.

Applying Lens Blur to a composite image

1 I wanted to blend this photograph of the model with a New York street scene. The model has been lit so that the lighting matches the outdoor daylight. But if I merge the two images together as they are, the background detail would be too distracting.

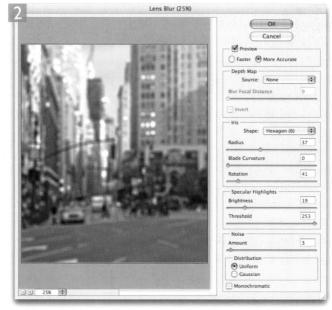

Chapter 10 Photoshop filters

3 I combined the two images together using the montage technique described in Chapter 7. As you can see in the Layers palette dialog, the street scene image is hidden by a mask I had prepared earlier and is blended with the Background layer using the Multiply blend mode. I also added a Curves adjustment layer which was grouped with the street image layer beneath it. The Curves adjustment was added in order to lighten the blurred layer and match the lightness of the model in the picture.

Client: Reflections. Model: Lisa Moulson @ MOT.

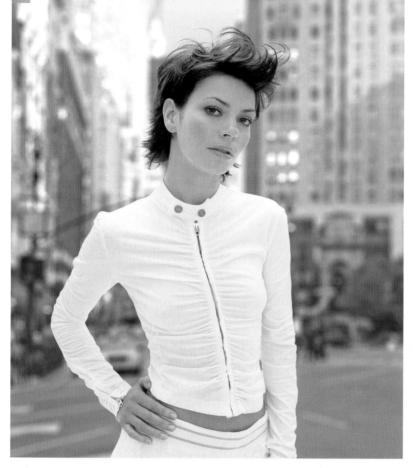

Pattern Maker

The Pattern Maker is a creative tool that you can use to generate random, abstract patterns that are based on a sampled image, either a whole image or a selected area. It is useful for creating interesting textures that can be saved as custom pattern presets, but more specifically, it can be used to generate texture patterns that can be used to convincingly fill parts of an image. The Pattern Maker is shown being put to use in Chapter 6, to create a stone wall texture pattern that can be used in conjunction with the healing brush to cover up an area with a texture matching the surroundings.

Pattern Maker tools: marquee selection; zoom; hand

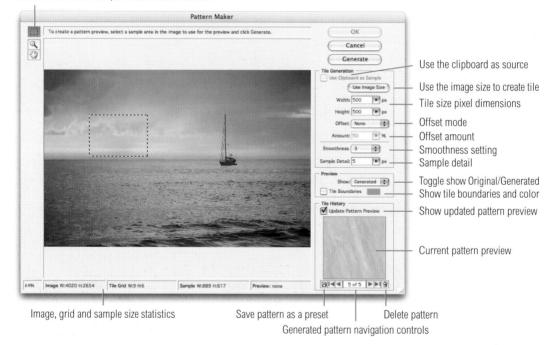

Figure 10.7 The Pattern Maker dialog controls. You can generate a pattern based on either the actual image size or a tile area of specified pixel size. If you wish, the generated tiles can be offset either horizontally or vertically by a set percentage amount. Increasing the smoothness will produce better results, but take longer to process. Increasing the sample detail will preserve more recognizable detail. A lesser amount will produce more abstract results. Check the Save Preset Pattern button at the bottom of the palette if you want to save a generated pattern to the Pattern Presets. For as long as the dialog is open, you can keep generating new presets, review their histories using the navigator buttons and delete or retain them as necessary.

Filter Gallery

To use the Filter Gallery, select an image, choose Filter Gallery from the Filter menu and click on various filter effect icons, revealed in the expanded filter folders. The filter icons provide a visual clue as to the outcome of the filter. As you click on it the filter effect can be previewed in the preview pane area. This in itself is a huge improvement as you can preview a much bigger area now. As you can see in Figure 10.8, you can combine more than one filter at a time and preview how they will look when applied in sequence. To add a new filter, click on the New Effect Layer button at the bottom. As you click on the effect layers you can edit the individual filter settings. To remove a filter effect layer, click on the Delete button.

Rapid filter access

There are around 100 filters in the Filter menu. That's a lot of plug-ins to choose from of which many are used to produce artistic effects. The Filter Gallery makes 47 of these filters accessible from the one dialog. The following filter categories are available: Artistic; Brush Strokes; Distort; Sketch; Stylize; Texture (but note that not all the filters in the above categories are included in the Filter Gallery).

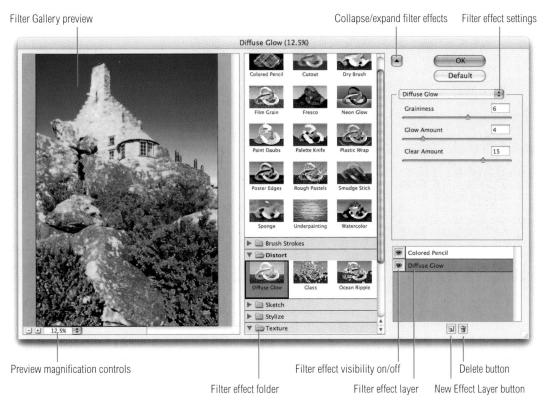

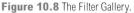

Displacement rules

The Displace filter must use an image saved using the native Photoshop file format to act as a displacement map when calculating the displacement. Black (0) will produce the maximum negative displacement shift and white (255) will produce the maximum positive shift, while gray (128) will produce no displacement. If a displacement map contains more than one channel, the first channel will determine the horizontal displacement and the second channel will control the vertical displacement.

Pixel distortions and corrections

In the following sections we will be looking at the various ways you can distort an image or make lens distortion corrections in Photoshop.

Displace filter

The Displace filter is not the most intuitive of filters but is still quite invaluable if you need to distort any type of layer so as to appear to match the shape or texture of the underlying layers. The effect works well with text effects and where the displacement map you use has been softened beforehand. You will find a large number of displacement maps contained on the Adobe Photoshop CD and these can be loaded to generate all types of surface texture patterns.

1 I wanted to add a tattoo to the arm of this model. This needed to be done in several stages. To start with I made a duplicate of the color image by choosing Image ⇒ Duplicate. I then converted the duplicate image to Grayscale mode, applied a 10 pixel Gaussian Blur to this grayscale version and saved this duplicate version of the image to the desktop, where it would be easy to locate again later on. It is important to note here that the image was in grayscale and saved in the native Photoshop (PSD) file format.

	Displace	1
Horizontal Scale	15	ОК)
Vertical Scale	15	Cancel
Displacement N	lap:	
Stretch To Fi	t	De la contra de la contra
() Tile		
Undefined Area	s:	
O Wrap Around	1	
Repeat Edge	Pixels	

2 I closed the blurred grayscale version, returned to the master image and added a shape layer of the desired tattoo and positioned this over the arm. I was now ready to displace the tattoo layer. I went to the Filter menu and chose Distort ⇒ Displace... Now because the layer I was about to filter was a vector layer, a dialog popped asking if I would like to rasterize the shape layer? I clicked OK. The Displace dialog allowed me to set the displacement amount for the horizontal and vertical axes. You don't always want to get too carried away with entering high amounts here. Start off with 10 and try redoing the displacement again using higher values if you feel this is necessary.

The Displacement Map settings won't make any difference in this instance because the pixel dimensions of the map I was about to use matched the image exactly. After I had clicked OK in the Displace dialog, I was asked to select a displacement map. This is where the saved grayscale image comes in. I located the grayscale map that had been saved earlier to the desktop and clicked Open to select it.

3 In the final image you can see how the shape has been displaced and appears to follow the contours of the arm. To achieve the blended result you see here I duplicated the newly displaced layer twice and adjusted the blend modes and layer opacities as shown here: the top layer used Color mode @ 80%; the middle layer Multiply mode @ 15% and the lower layer was set to Overlay mode @ 65%.

Chromatic aberration and Vignetting

Some lenses will suffer from other kinds of optical defects as well. For example, chromatic aberration can sometimes be noticed along high contrast edges. You can now remove these quite easily using the two chromatic slider controls in the Lens Correction dialog. You may sometimes notice a darkening vignette towards the edges of a picture when you are shooting with an ultra wide-angle lens. The Vignette controls allow you to compensate for this as well. Or if you prefer, you can use them to introduce a vignette even. These topics are also covered on pages 448–449.

Set Lens Default

If the image you are editing contains EXIF metadata describing the lens, focal length and f stop used, you can click on the Set Lens Default button to archive the settings used. These will be available in the future as a Lens Default option in the Settings menu.

Edge pixels

As you apply the Lens Correction, the curvature and shape of the image will change. The Scale slider will crop the picture as you apply a correction. If you prefer not to do this there is the problem of how to render the outer pixels. The default setting uses the Edge Extension mode to extend the edge pixels. This may be fine with skies or flat color backdrops, but otherwise quite ugly and distracting. Although having extended pixels will make it easier to apply the healing brush in these areas.

Lens Correction

Photographers are always striving for optical perfection but sadly not all lenses are capable of delivering the goods. The Lens Correction filter is a new addition to Photoshop CS2 and offers several ways you can correct images that suffer from different types of optical distortion.

The most obvious forms of distortion are the pin cushion and barrel lens effects which are all too common a problem when shooting with lower quality lenses. You can use the distort tool to drag toward or away from the center of the image to adjust the amount of distortion in either direction. Or you can use the Remove Distortion slider, which I find offers more precise control.

The rotate tool can be used to straighten photographs. Drag with the tool on the preview to define what should be a correct horizontal or vertical line and the image should rotate to align correctly. You can also adjust the rotation in the Transform section. Try clicking in the Angle field (circled) and use the up and down arrow keys to nudge the rotation in either direction by small increments.

The grid pattern will prove really useful for helping you to judge the alignment of the image. But better still, you can use the move grid tool to shift the placement of the grid. And the grid controls at the bottom of the Lens Correction dialog will enable you to adjust the grid color and dynamically adjust the grid spacing, plus toggle showing or hiding the grid.

The Transform controls let you adjust the vertical and horizontal perspective. These offer an immense amount of control to correct the perspective view of a photograph such as the vertical perspective keystone effect you get when pointing the camera up to photograph a building. Or, the horizontal perspective you get when photographing a subject from the side instead of dead center. You should only need to use these controls where you need your subject to appear perfectly square on to the camera, such as in architectural photography.

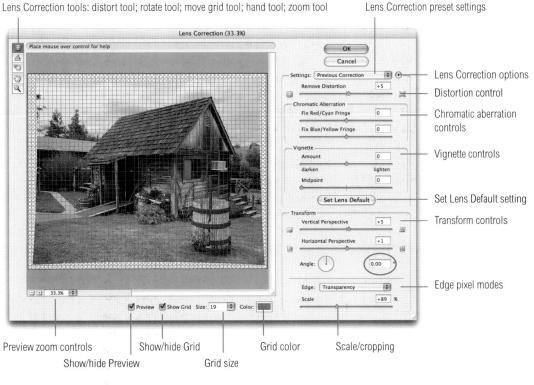

Lens Correction tools: distort tool; rotate tool; move grid tool; hand tool; zoom tool

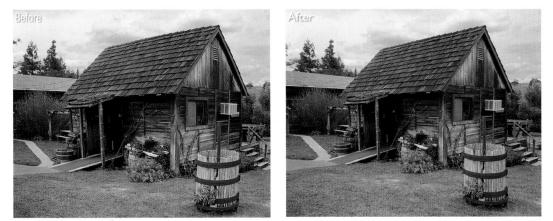

Figure 10.9 The Lens Correction filter was applied to the before image to correct for a barrel type lens distortion and I aligned the vertical lines of the building to the grid in the dialog shown above. The Lens settings (excepting the Transform settings) can be saved as presets via the Lens Correction options to the designated Settings folder. These presets can be associated with the lenses that you use most often and if saved to the correct folder will appear listed in the Lens Correction Settings menu.

Liquify

The Liquify filter is designed to let you carry out freeform pixel distortions. When you choose Filter \Rightarrow Liquify or use the **H** Shift **X** ctrl Shift **X** shortcut, you are presented with what is called a modal dialog, which basically means you are working in a self-contained dialog with its own set of tools and keyboard shortcuts etc. It is therefore basically like a program within the Photoshop program. To use Liquify efficiently, I suggest you make a marquee selection first of the area you wish to concentrate on manipulating before you select the filter. And once the dialog has opened, use the **H** O ctrl O shortcut to enlarge the dialog to fit the screen.

The Liquify tools are on the left-hand side of the dialog and you basically select one of these and use it to warp, shift, enlarge or shrink the pixels by applying one or more of the various tools to the image preview. When you are happy with your liquify work, click *Enter* to OK the pixel manipulation and the main image will then be updated.

The Liquify tools are all explained below in Figure 10.10 and shown in action on the page opposite in Figure 10.11. The easiest tool to get to grips with first is the warp tool and it is the one I probably use most of all, followed by the shift pixels tool.

PGRE # BX 0 00 0 K

Figure 10.10 The warp tool (W) provides a basic warp distortion with which you can stretch the pixels in any direction you wish. The reconstruct tool (E) is used to make selective undos and restore the image to its undistorted state. The wirl tool (R) will twist the pixels in a clockwise direction, and if you hold down the reference with the tool to twirl in a counterclockwise direction (a larger brush size works best with this tool). The pucker tool (P) shrinks pixels and produces an effect which is similar to the 'Pinch' filter. The pucker tool is sometimes useful for correcting overdistorted areas. The bloat tool (B) magnifies pixels and is similar to the 'Bloat' filter. The shift Pixels tool (S) shifts the pixels at 90 degrees to the left of the direction in which you are dragging. When you refer acting are not careful will easily rip an image apart). The reflection tool (M) is perhaps the most unwieldy of all, copying pixels from 90 degrees to the direction tool (A) produces random turbulent distortions. If you want, you can protect areas of the image using the reflect tool (F). Frozen portions of the image are indicated by a Quick mask type overlay. These areas will be protected from any further liquify distortion tool actions. The Freeze mask can be selectively or wholly erased using the reflection (T). Use the result of the core out (Z) to magnify or zoom out and the reflectively of (H) to scroll the preview image.

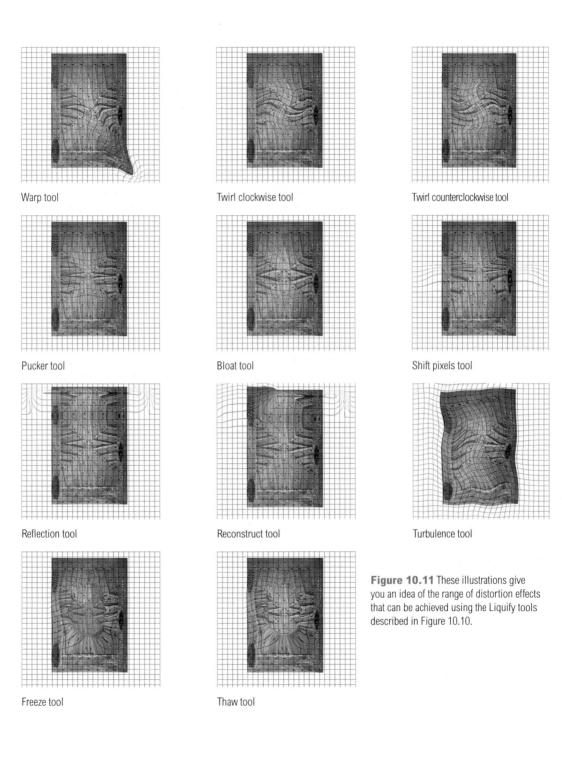

		-	1.	
Load Mesh	C	Save	Mesh.	
- Tool Options				
Brush Si	ze: 100		9	
Brush Dens	ity: 50		0	
Brush Pressu	ire: 10	R	0	
Brush Ra	ite: 80	:	Ð	
Turbulent Jitt	ter: 50	:	0	
Reconstruct Mo	de: Re	vert		\$
Stylus Pressure				
Reconstruct	de: Re	11111	ore All	
Reconstruct Mask Options None Mas		Rest	•	11111
Reconstruct Mask Options		Rest	•	11111
Reconstruct Mask Options None Mas View Options		Rest	•	11111
Reconstruct Mask Options None Mas View Options Show Image	sk All	Rest	•	11111
Reconstruct Mask Options None Mas View Options Show Image Mesh Size:	sk All	Rest	•	11111
Reconstruct Mask Options None Mas View Options Show Image Mesh Size: Mesh Color:	sk All	Rest	•	11111
Reconstruct Mask Options None Mas View Options Show Image Mesh Size: Mesh Color: Show Mask	sk All	Rest	•	11111
Reconstruct Mask Options None Mas View Options Show Image Mesh Size: Mesh Color: Show Mask Mask Color: Show Backdrop	sk All	Rest	•	11111
Reconstruct Mask Options None Mas View Options Show Mask Mask Color: Show Mask Mask Color: Show Backdrop Use:	sk All	Rest	•	11111

Figure 10.12 The Liquify dialog options. The Reconstruction Options discussed in Figure 10.13 are shown circled here.

One step at a time

The key to working successfully with the Liquify filter is to use gradual brush movements to build up a distortion. This is why I prefer to set the Brush Pressure to such a low setting and use a Wacom pad to control my painting.

Liquify tool controls

Once you have selected a tool then you will want to check out the associated tool options which are located to the right. All the tools (apart from the hand and zoom tool) are displayed as a circular cursor with a cross-hair in the middle. The tool options will be applied universally to all the tools and these options include: Brush Size, Brush Density, Brush Pressure and Brush Rate. If you mouse down on the double arrow icon next to the field entry box, this will pop a dynamic slider which you can use to adjust the tool option setting. You can also use the square bracket keys **()** to enlarge or reduce the tool cursor size. And the rate of increase/decrease can be accelerated by holding down the *Shift* key. I highly recommend that you use a pressure sensitive pen and pad such as the Wacom system and if you do so, make sure that the Stylus option is checked and adjust the brush pressure to around 10% (or less even). The Turbulent Jitter control is only active when the turbulence tool is selected. In this context the jitter refers to the amount of randomness that will be introduced in a turbulence distortion applied with this tool.

Reconstructions

Next we have the Reconstruction Options. The standard mode is Revert and if you apply a Liquify distortion and click on the Reconstruct button, the image will be restored to its undistorted state in stages each time you click on the button (while preserving any areas that have been frozen with the freeze tool). If you click on the Restore All button the entire image will be restored in one step (ignoring any frozen areas). The default Revert mode will produce scaled reversions that return you to the original image state in the preview window. There are some alternative options which are more relevant once you have created a frozen area. For example, the Rigid mode provides one-click reconstruction. Stiff, Smooth and Loose provide varying speeds of continual reconstruction, producing smoother transitions between the frozen and unfrozen areas as you revert the image. You can use *esc* or **H** *ctrl*

to halt the reconstruction at an intermediate stage. But avoid applying a second click, as this will exit the modal dialog and you will lose all your work! Another way to reconstruct the image is to click on the options triangle in the Reconstruction Options and select one of the options. This will pop a dialog control like the one shown in Figure 10.13, which will allow you to use a slider to determine what percentage of reconstruction you would like. The image reconstruction can also be achieved by using the reconstruct tool to selectively restore the image.

Mask options

The mask options can utilize an existing selection, the layer transparency or layer mask as the basis of a mask to freeze and constrain the effects of any liquify adjustments. The first option is Replace Selection and this will replace any existing freeze selection that has been made. The four other options allow you to modify an existing freeze selection by adding to, subtracting from, intersecting or creating an inverted selection. You can click on the buttons below to clear all freeze selections by clicking None, choose Mask All to freeze the entire area, or choose Invert All to invert the current frozen selection.

Figure 10.13 You can control the exact amount by which an image is reconstructed to its original state by going to the Reconstruction Options and selecting the desired reconstruction mode.

Multiple undos in Liquify

Don't forget that you also have multiple undos at your disposal while inside the Liquify dialog. Use **# Z** *ctrl* **Z** to undo or redo the last step; **# C** *ctrl alt* **Z** to go back in history and **#** *Shift* **Z** *ctrl Shift* **Z** to go forward in history.

Figure 10.14 Freeze masks can be used to protect areas of a picture before you commence doing any liquify work. In the example shown here a freeze mask was loaded from a layer mask. When you freeze an area in this way it is protected from subsequent distortions so you can concentrate on applying the Liquify tools to just the areas you wish to distort. The frozen mask areas can be unfrozen by using the thaw tool.

Predetermined distortions

In the main text I refer to the use of a 'target distortion guide'. Let's say you have a predetermined idea of what the final distortion should look like. You can create an empty layer, draw the distortion on this layer and use the Show Backdrop options discussed here to select that specific layer and have the ability to switch the guide layer visibility on or off.

View options

The freeze mask can be made visible or hidden using the Show Mask checkbox in the View options, where you can also set the color of the mask.

The mesh grid can be displayed at different sizes using different colors and this will give you an indication of the underlying warp structure and readily help pinpoint the areas where a distortion has been applied. You can use the checkboxes in this section to view the mesh on its own or have it displayed overlaying the liquify preview image.

The Show Backdrop option is normally left unchecked. If the Liquify image contents are contained on a layer, then it is possible to check the Show Backdrop option and preview the liquified layer against the Background layer, all layers or specific layers in the image. Here is how this option might be used. Let's say that you want to apply a liquify distortion to a portion of an image and you are starting out with just a flattened image. Make a selection of the area you wish to work on and make a copy layer via the selection contents using **H J** *ctrl* **J**. As you apply the Liquify filter you can check the Show Backdrop checkbox and set the Mode to Behind. At 100% opacity the Liquify layer will cover the Background layer completely, but as you reduce the opacity you will be able to preview the effect of your liquify distortion at different opacity percentages. This technique can prove useful if you wish to compare the effect of a distortion against the original image or a target distortion guide.

Saving the mesh

If you are working on an extremely large image then it may take a long time to carry out a liquify distortion. This is where the Save and Load mesh options can help. If you carry out your liquify distortions on a scaled-down version of the master image, you can save the mesh as a separate file. Open up the master file later, load the mesh you saved and apply. On page 396 I have provided an example of where a mesh should be saved and reused on a second image layer.

Chapter 10 Photoshop filters

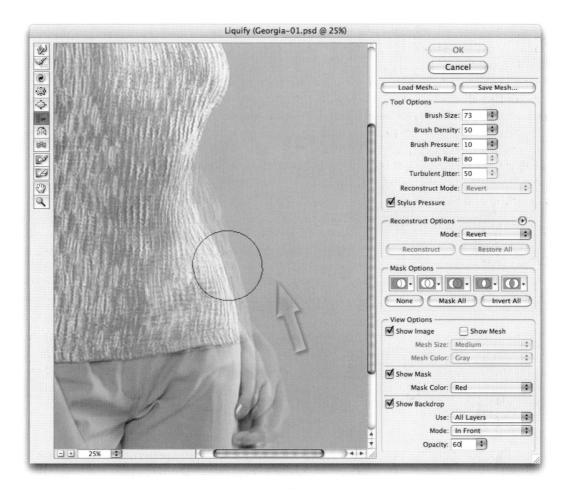

Figure 10.15 The shift pixels tool is great for slimming down waists. The pixels will be shifted to the left of the direction you drag with the tool. In this example the pixels were shifted inwards to the left as I dragged in an upward direction. If I drag downwards they would be shifted to the right. Because the Backdrop option is selected in the Preview options, you can see an overlaying preview of the undistorted version. If you have more than one layer selected, you can select a specific layer to preview your distortion against.

1 It is easy to imitate a Polaroid film emulsion transfer with the Liquify filter. The image shown here has a background layer, a tree stump image layer, and above this, an independent Polaroid emulsion border layer set to Multiply blend mode.

3 I then selected Layer 2 (which was the border image in Multiply mode) and opened Liquify again. This time I clicked on the Load Mesh button and loaded the recently saved mesh, applying an identical distortion, to produce the result shown here.

000

Layers Multiply Lock: Departy: 100% Lock: Layer 2 Layer 1 Exper 2 Exper 1 Exper 2 Exper 1 Exper 2 Exper 3 Exper 2 Exper 3 Exper 3 Exper 4 Exp

2 I activated the tree stump image layer and chose Liquify from the Filter menu. I mainly used the turbulence tool plus the clockwise and counterclockwise twirl tools to create the distortions that you see here. I then clicked on the Save Mesh button to save the distortion so that it could be reused.

Warp command

The Warp command is not actually a filter but it does provide a perfect solution to all those Photoshop users who have longed for a means to carry out direct, on-canvas image warping. The Warp command is therefore more like an extension of the Free Transform command and in fact the two are both quite nicely integrated. If you select the Free Transform option from the Edit menu you can click on the Transform/Warp mode button to toggle between the Free Transform and Warp modes. The beauty of this is that you can combine a free transform and warp distortion into a single pixel transformation. If you are familiar with the Smart Object feature, which is discussed in detail in Chapter 7, then you will realize that the Warp command can carry out non-destructive distortions to single layers or multiple layers at once.

When a Warp option is selected you can control the shape of the warp envelope using the bezier handles at each corner of the warp envelope box. The box itself contains a 3×3 mesh and you can mouse down and drag within any of the nine warp sectors and drag with the mouse to fine-tune the warp. What is really great about this command is the way that you can make the warp overlap on itself, as shown on the following page.

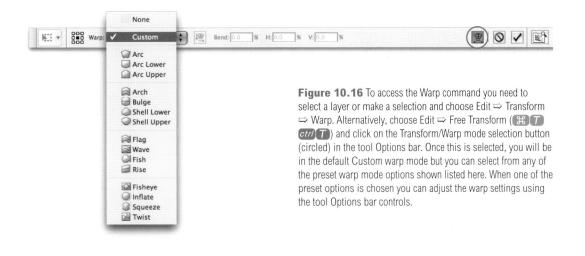

1 The easiest way for me to illustrate the power of the new Warp command is to create a made-up flag and use the custom warp controls to distort the flag shape to make it appear to be flapping in the wind. This flag is supposed to represent the nation of CMYK color. Am I suggesting here that some diehard CMYK advocates may be living in a world of their own? Of course not.

2 I went to the Edit menu and selected Edit \Rightarrow Transform \Rightarrow Warp. The default option is the custom mode. Alternatively, I could have chosen Edit \Rightarrow Free Transform and clicked on the Warp mode button in the tool options. In custom warp mode you have access to the bezier control handles at the four corners of the warp bounding box and these can be adjusted in the same way as you would manipulate a pen path to control the outer shape of the warp. One can then click inside any of the nine sectors and drag with the mouse to manipulate the image as if you were stretching the image on a rubber sheet.

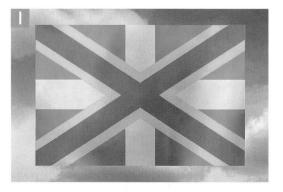

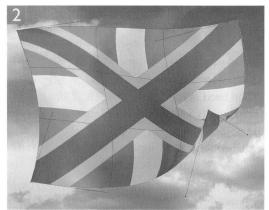

3 You will notice how I was able to twist the warp so that the flag was twisted in on itself to reveal the reverse side of the flag. To complete the picture I added a shading layer set to Overlay mode which had a layer mask based on a selection of the warped flag layer. And finally, I added a flag pole.

Lighting and rendering

Rendering processes are normally associated with 3D design programs, yet Photoshop has hidden powers itself when it comes to rendering 3D shapes and textures. Some of these filter effects will utilize texture maps, a number of which are preloaded in the Application Presets folder when you install Photoshop.

Fibers filter

The Fibers filter is a fairly new Photoshop plug-in that can be found in the Filter \Rightarrow Render menu. In some ways it is similar to the Render Clouds filters. It can generate abstract fiber patterns which could be useful if you wanted to artificially create a natural-looking fibrous texture.

Lighting Effects

When used properly, the Lighting Effects filter is an occasionally useful Photoshop tool for generating textures, 3D objects or lighting fills. The Lighting Effects filter has been around for a long time in Photoshop, and the tiny preview desperately needs to be updated to match the preview size area of the other modal dialogs. But apart from the lack of a decent preview, you can still put it to some good uses. The following tutorial shows you how the Lighting Effects filter can be used to render a theatrical-looking curtain from an ordinary pair of drapes and make it look as if they have been lit from below by a row of footlights. In this tutorial I am also able to show how you can use one of the image color channels to act as a texture map so that the lighting appears to enhance the texture of the curtain material.

Missing 3D Transform

The 3D Transform filter is no longer installed as standard in Photoshop. It hasn't been completely dumped, it is there on the Photoshop application CD-ROM and you can install it by simply copying it across to the Photoshop plug-ins folder.

1 In this example I wanted to use a photograph taken of some light colored drapes and use the Lighting Effects filter to apply some rendered lighting to help make them look more theatrical.

2 I duplicated the Background layer and applied a Hue/Saturation and Curves adjustment to darken the drapes and give them a darker red color. I then added a simple shadow layer above it to simulate the silhouette of stage footlights.

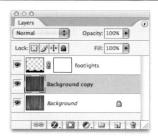

3 I selected the curtain layer and chose Filter \Rightarrow Render \Rightarrow Lighting Effects. I started off by applying a single spotlight to the middle of the image layer. The preview is really tiny compared to most other Photoshop filters, but you can just about see the outcome of the effect in the preview area. You can set the color of each individual light by clicking on the color swatch, which will open the Color Picker. The light I have selected here is a Spotlight effect and you can drag on the center spot or on any of the four handles to reposition the light source and adjust the width of the light spread. When I use this filter, I usually adjust the positioning and handles first and then adjust the Intensity and Focus settings to establish the desired lighting characteristics. After that I will go to the Exposure slider to fine-tune the brightness of the lighting and finally adjust the Ambience slider to increase or decrease the ambient lighting effect.

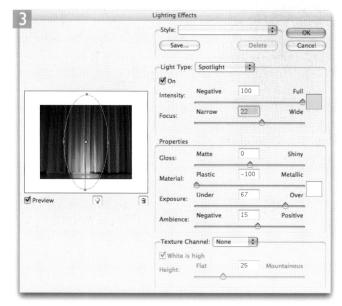

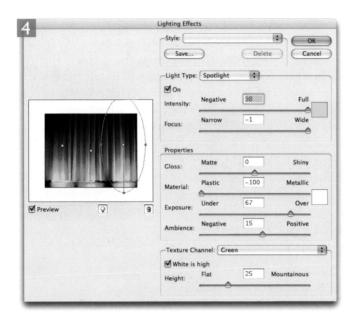

4 To add more lights, you can either drag from the light bulb icon up into the preview area or all drag on one of the existing lights to make a copy of the light. As you can see here, I copied the first light two times to create a triple uplighting effect. If you create a lighting effect like this and would possibly like to reuse it, then you can click on the Save... button to save this combination as a new lighting effect preset.

One of the unique (and rather clever) things you can do in the Lighting Effects dialog is to utilize a color channel or alpha channel as a texture map. In the dialog shown here you will notice that I selected the green channel as a Texture Channel. The White is high checkbox was checked and I set the texture height setting to 25%. A higher amount will produce a more pronounced texture.

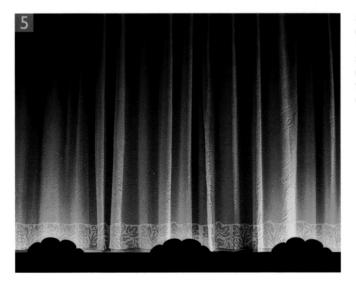

5 Here is the finished result in which the plain drapes have been dramatically lit using the Lighting Effects filter. To complete the scene, I selected the footlights layer and added an outer glow layer effect to add a little extra atmosphere to the rendered scene plus I added a patterned gilt decoration.

Figure 10.18 Examples of the Render \Rightarrow Clouds filter (top) and the Render \Rightarrow Difference Clouds filter (bottom).

Clouds and Difference Clouds

This filter generates a cloud pattern that fills the whole image (or selected area), based on the foreground and background colors. The cloud pattern alters each time the filter is applied, so repeated filtering (**H F ctt F**), for example, will produce a fresh cloudscape every time. If you hold down the **a a**tt key whilst applying the Cloud filter, the effect is magnified. The Difference Clouds filter has a cumulative effect on the image. Applying it once creates a cloud pattern based on the inverse color values. Repeating the filter produces clouds based on the original colors and so on... although after each filtration the clouds will become more pronounced and contrasty.

1 Here is a neat way you can use the Clouds filter to create a rough edged border. Create a new document, add an empty new layer and choose Select ⇒ All. Follow this with Select ⇒ Modify ⇒ Border and enter a pixel value that is large enough to create the border you want. Now feather the selection by a much smaller percentage. In this example I created a 36 pixel border selection and feathered it by 6 pixels. Reset the foreground/background colors. Now go to the Filter menu and choose Render ⇒ Clouds. Add another empty new layer and with the selection still active, fill the selection with black and set the blend mode to Multiply.

2 I then deselected the selection, merged these two layers and applied an extreme Levels adjustment to harden the edges of the border. I then dragged/copied this border to another image and set the blend mode to Multiply to create the result shown here.

Lens Flare

This is another one of the render filters and a little overused perhaps, but nevertheless quite realistic when it comes to adding the effect of light shining into the lens along with the ghosting type of patterns normally associated with camera lens flare. The Lens Flare filter is ideal for adding realism to computer rendered images.

Instead of applying the lens flare directly to the background layer, I prefer to add a new layer filled with neutral gray set to Overlay mode and apply the Lens Flare filter to this layer only. This allows me the option of repositioning the flare effect afterwards. Another approach is to apply the filter to a black fill layer and set the blending mode to Screen.

1 To add a new layer filled with a neutral blending gray, I S all -clicked on the New Layer button in the Layers palette, selected the Overlay blend mode and then checked the Fill with Overlay Neutral Color checkbox.

2 I then applied the Lens Flare filter. The position of the lens flare center point can be adjusted in the dialog preview. If you all -click in the preview box, this will call up the Precise Flare Center dialog, where you can set precise mouse coordinates for where to center the lens flare effect.

Chapter 11

Digital Capture

photographer I worked for once told me 'learn the tricks of the trade first, and art will find its course'. Photoshop is certainly a complex program to learn, but as you begin to understand it in depth, this acquired knowledge will give you the freedom to solve all sorts of technical challenges and the talent to express yourself photographically. This chapter is all about the process of capturing a digital image before it is brought into Photoshop and provides an updated account of the latest camera and scanning equipment. It is very relevant to everything else you do in Photoshop, because everything begins with the creation of an image and how you capture that image matters greatly, especially from a technical standpoint. Because the better the image is to begin with, the easier it will be to manipulate later.

Digital imaging has successfully been employed by the printing industry for over fifteen years now and if you are photographing anything that is destined to be printed, your images will at some stage be digitized. At what point in the production process that digitization takes place is up for grabs. Before, it was the sole responsibility of the scanner operator working for the printer or at a high-end bureau. The worldwide sales success of Photoshop tells us that the prepress scanning and image editing more commonly takes place at the desktop level. It is self-evident that the quality of your final output can only be as good as the quality of the original. Taking the digitization process out of the hands of the repro house and closer to the point of origination is quite a major task. Before, your responsibility ended with the supply of the film to the client. Issues such as image resolution and CMYK conversions were not your problem, whereas now they can be.

It is worth bearing in mind the end product we are discussing here: digital files that have been optimized for reproduction on the printed page. The media by which the images are processed are irrelevant to the person viewing the final product. Those beautiful transparencies are only ever appreciated by a small audience: you, the art director and the client. Pretty as they might be, transparencies are just a means to an end and it is odd if a client should still insist on digital files being 'proofed' as transparency outputs when a calibrated digital proof would give a better impression of how the job will look in print. I am not knocking film – a roll of film has the potential to record and store many gigabytes of data at high quality quickly, and for a very reasonable cost. For over two years now I have shot nearly everything digitally with the Canon EOS 1Ds, and more recently, the EOS 1Ds Mk II camera. Some clients have embraced digital completely, while others still prefer me to shoot film in tandem with digital. For me, the main priority is the speed of capture and one reason why I prefer using the Canon EOS 1Ds Mk II is because I can shoot up to around 25 frames without having to wait for the camera to catch up.

Digitizing from analog

Scans can be made from all types of photographic images: transparencies, black and white negatives, color negatives or prints. Each of these media is primarily optimized for the photographic process and not for digital scanning. For example, the density range of a negative is very narrow compared to that of a transparency. This is because a negative's density range is optimized to match the sensitometric curve of printing papers. On the other hand, a negative emulsion is able to capture a wider subject brightness range. That is to say, a negative emulsion can record more subject detail in both the shadows and the highlights compared to a chrome transparency. Therefore the task of creating a standardized digital result from all these different types of sources is dependent on the quality of the scanning hardware and software used and the ability to translate different photographic media to a standard digital form. If one were to design an ideal film with CMYK print reproduction in mind, it would be a chrome transparency emulsion that had a slightly reduced density range and an ability to record natural color without oversaturating the blues and greens. In other words, what might look good on a light box is not necessarily the best type of image to use for print reproduction.

Structure of a digital image

A digital image is a long string of binary code (like the digital code recorded and translated into an audio signal on your music CDs). It contains information which when read by the computer's software displays or outputs as a full tone image. A digital image original is capable of being replicated exactly, any number of times. The image itself is constructed of picture elements called 'pixels'. The brightness of each pixel is defined numerically, and each pixel is part of a mosaic of many thousands or millions of pixels which make up a digital image.

Figure 11.1 This diagram shows the inside of a flatbed scanner. An artificial light source illuminates the object to be scanned and the light reflected from the surface of the object bounces across a series of mirrors before arriving at the sensor.

Scanners

A scanner reads in the analog information from an original, which can be a print, negative, transparency or artwork, and converts this into a digital format and saves it as an image file, ready for image editing.

Drum scanners

Many professional bureaux prefer to use high-end drum scanners as these are considered to produce the best quality. The optical recording sensors and mechanics are superior, as is the software, and you should also be paying for a skilled operator who will be able to adjust the settings to get the finest digital results from your original. Smaller, desktop drum scanners are available as well and at a much more affordable price.

With a drum scanner, the image is placed around the surface of a transparent drum. To avoid Newton rings, the film original is oil mounted. A very thin layer of a specially formulated oil ensures good, even contact with the drum surface. Fastening the film originals in place is quite a delicate procedure, and demands skillful handling of the film materials. High-end drum scanners are often sited in an air-controlled room to minimize the amount of dust that might contaminate the process. The image on the drum is rotated at high speed and a light source aligned with a photomultiplier probe travels the length of the film. This records the image color densities in very fine detail. Drum scanners offer mechanical precision and advanced features such as the ability to make allowance for microscopic undulations in the shape of the drum and thereby guaranteeing perfectly even focusing. Drum scanners generally use a bright point light source, so that the photomultiplier is able to record shadow detail in the densest of transparencies (this is where inferior scanners are usually lacking). Drum scanners often have a separate photomultiplier (PMT) head to record tonal values in advance of the recording RGB heads and intelligently calculate the degree of sharpening required for any given area (of pixels).

Flatbed scanners

Flatbed scanners work a bit like a photocopying machine. There are professional ranges of flatbeds that are gaining popularity in bureaux due to the true repro quality output which can now be obtained and the ease of placing images flat on the platen, compared to the messiness of oil mounting on a drum. The better models record all the color densities in a single pass and have a transparency hood for chrome and negative scanning. Heidelberg have a good reputation - they manufacture a broad range of flatbeds and even the cheapest model in their Linoscan range has an integrated transparency hood. Other top of the range flatbeds include: the Agfa, Fuji Lanovia, Microtek and Umax. Another reason why high-end flatbeds have now become more popular is largely due to the quality of the professional scanning software now bundled such as Linotype and Binuscan.

Most flatbed scanners fall into the cheap and cheerful class of equipment and a lot of designers use budget priced scanners to create what are known as 'positional' scans for placing in the layout. Although not necessarily designed for repro work, a great many photographers are finding they can nevertheless attain quite acceptable scans within the limiting confines of a cheap flatbed.

CCD scanners

CCD (Charge Coupled Device) slide scanners are designed to scan film emulsions at high resolutions. Microtek, Polaroid, Nikon, Canon and Kodak make good scanners that are specifically designed for scanning from 35 mm and 120 formats. It is also worth investigating the Imacon Flextight range of CCD scanners. These CCD scanners offer high optical scanning resolution and a good dynamic range. To my mind the Flextight scanners such as the Flextight 343 (35 mm and 120 films only), Flextight 646 and Flextight 848 (which I use in my studio) are the best quality CCD scanners you can buy for small and medium format professional scanning and they offer excellent value compared to a desktop drum scanner.

Aim for the sweet spot

To get the best optical scanning quality from your flatbed scanner, you should position the original around the center of the platen, which is known as the 'sweet spot'.

CCD scanners and dust removal

CCD scanners tend not to emphasize dust and scratches as much as some other scanners. The reason for this is that the light source is much softer in a CCD scanner and it is a bit like comparing a condenser with a diffuser printing enlarger. The latter has a softer light source and therefore doesn't show up quite so many marks. To combat the problem of dusty originals, the Nikon LS 2000 was the first 35 mm CCD scanner to employ Digital ICE (Image Correction and Enhancement) image processing. This is a clever filtering treatment that involves the use of the infrared portion of the data to mask out surface imperfections. The ICE processing can automatically remove dust and scratches with very little softening to the image.

Figure 11.2 A diagram of a CCD sensor.

DPI or PPI?

This is a subject that I'll be discussing in more detail in the following chapter. You will quite often see the resolution of a scanner expressed using DPI which stands for dots per inch. Just about every Photoshop instructor you meet will agree that this is an incorrect way to describe the resolution of a pixel generating device such as a scanner. The correct way to describe the resolution of a scanner is to use PPI, which stands for pixels per inch.

Illusions of high resolution

Some manufacturers claim scanning resolutions of up to 9600 ppi, when in fact the maximum optical resolution is only 600 ppi. This is a bit like claiming you possess a video of your car breaking the sound barrier and you prove it by playing the tape back at fast speed.

What to look for in a scanner

A flatbed is certainly the cheapest option and if you get one with a transparency hood you will be able to scan prints, negatives and transparencies. If your main goal is to scan small format films, then you will probably be better off purchasing a basic 35 mm CCD scanner such as the Nikon Super Coolscan 5000 ED. If you want to scan 120 films as well and get professional repro quality, the Nikon 9000 ED scanner can scan larger film formats at near-repro quality. For the very best quality consider looking at any of the products in the aforementioned Imacon Flextight range.

The manufacturer's technical specifications can guide you to a certain extent when deciding which to buy. What follows is a guide to what those figures actually mean.

Resolution

The resolution should be specified as pixels per inch, this indicates how precisely the scanner can resolve an image. The Konica Minolta Dimage Scan Dual III is a 35 mm scanner with a resolution of 2802 ppi. The Nikon Super Coolscan 5000 ED is a slightly more expensive 35 mm film scanner and has a scanning resolution of 4000 ppi. This means you can scan a full-frame 35 mm image and get a 60 MB 24-bit file. Remember that it is the optical resolution that counts and not the interpolated figures. The low-end flatbed machines begin with resolutions of 1200×2400 ppi, rising to 3200×6400 ppi for the high-end models. Flatbed resolutions are expressed by the horizontal resolution: the number of linear scanner recording sensors, and vertical resolution: the mechanical accuracy of the scanner. My advice when using a flatbed is to set the scanning resolution no higher than the 'optical' resolution and interpolate up if necessary in Photoshop. There is also a good case to be made for scanning at the maximum optical resolution and reducing the file size in Photoshop, as this will help average out and reduce some of the scanner noise pixels that are typically generated by the cheaper flatbed scanners.

Dynamic range

A critical benchmark of scanner quality is the dynamic range, which is the range of tones that can be captured by the sensor from the maximum intensity to the minimum intensity. Not every manufacturer will want to tell you about the dynamic range of their scanner (especially if it is not very good). A good, repro quality scanner should be able to attain a dynamic range of 3.8, but note that the dynamic range specified by some manufacturers may be a little optimistic and the quoted values could actually be influenced by scanner shadow noise.

A wide dynamic range usually means that the scanner can record detail from the brightest highlights to the darkest shadow areas. When it comes to scanning transparencies the ludicrous density ranges of modern E-6 emulsions can provide a really tough scanning challenge (Ektachrome transparencies have a typical dynamic range of 2.85–3.6). Some photographers are deliberately overexposing a chrome transparency film like Velvia and underprocessing it. This produces weaker shadows in the chrome transparency, which is a good thing, because it means they are easier to scan.

Multipass scanning

Some CCD scanners feature multipass modes. Since a CCD will tend to generate random noise, especially in the shadow areas, scanning the original more than once can help average out the CCD noise and produce a cleaner result, although the scanning process will take much longer.

Figure 11.3 The Imacon FlexColor 3.6 interface. Like other camera and scanner software, FlexColor allows you to configure the scanner/capture settings. Most professionals prefer to keep the image processing options neutral, leaving all the tonal correction and sharpening to be done in Photoshop.

Understanding bit depth

To understand what the bit depth numbers mean, it is best to begin with a grayscale image where there are no color values, just luminosity. A 1-bit or bitmapped image contains black or white colored pixels only. A 2-bit image contains 4 levels (2²), 3-bit 8 levels (2³) and so on, up to 8-bit (2⁸) with 256 levels of gray. 8-bit grayscale images are made up of 256 shades of gray. An RGB color image is made up of three color channels. Each channel contains 8-bit grayscale information defining the amount of each color component of the full color image. When the three color channels are overlaid a single pixel in an RGB color image contains 3 × 8 bits of information. which makes it a 24-bit color image that can define up to 16.7 million possible colors.

A scanner may be described as being able to scan an RGB image in 30-bit or 36bit color. If you use a scanner to scan at a bit depth greater than 8 bits per channel it is possible to open a 'high-bit' image like this into Photoshop, where you will be able to edit it in 16-bit per channel mode (note that anything scanned at a bit depth greater than 8 bits per channel is automatically defined using 16-bit per channel mode, even though the image was actually scanned at a lower bit depth). Photoshop has extended support for 16 bits per channel editing. So you can crop, clone, adjust the color and apply certain filters all in 16-bit per channel mode.

Bit depth

The bit depth refers to the maximum number of levels per channel that a scanner can capture. This is not the same as the dynamic range, as it refers to the precision of the sensor. Let's say you are scanning a black and white negative and need to expand the tonal range to produce a more contrasty positive. The more levels the scanner is capable of capturing at the scanning stage, the more headroom you will have to manipulate the levels to produce a decent image without stretching the levels too far so that you drop useful image data. A 24-bit RGB color image is made up of three 8-bit image channels and each 8bit channel can contain up to 256 levels of tone. If you start with an image that contains a maximum of 256 levels per color channel and you use Levels or Curves to expand the contrast in each channel, then you will always end up with even fewer levels per channel than what you started with. You end up stretching the limited number of levels of tone in each channel. Most of the scanners you come across should be able to scan at 12 bits per channel or higher. A 12-bit per channel scanner will be able to record up to 4096 levels in each color channel. This means that whenever you apply a tonal correction to the scanned image, you will still end up losing levels data, but whatever you end up with will convert nicely to a 24-bit color space where each color channel should have a full range of levels.

Any image that has been captured at a greater bit depth than 8 bits per channel will be interpreted by Photoshop as a 16-bit per channel file (you can check the bit depth of an image quite easily by looking at the document window title bar). I always capture everything using the deep bit mode in the scanner software. And I perform all my initial image adjustments in 16-bit per channel mode. Editing in 16 bits per channel enables me to maintain the maximum integrity of my data. Once I am satisfied with the basic image corrections I have made I can happily convert the image to 8-bit per channel mode. But it makes a significant difference keeping the image in 16-bit per channel mode for those first few edits.

Bitmap image (1 bit)

Combined RGB image (24 bit)

Red channel (8 bit)

Green channel (8 bit)

Blue channel (8 bit)

Figure 11.4 The bit depth of an image is a mathematical description of the maximum levels of tone that are possible, expressed as a power of 2. A bitmap image contains 2 to the power of 1 (2 levels of tone), in other words, either black or white tone only. A normal Photoshop 8-bit grayscale image or individual color channel in a composite color image will contain 2 to the power of 8 (up to 256 levels of tonal information). When three RGB 8-bit color channels are combined together to form a composite color image, the result is a 24-bit color image that can contain up to 16.7 million shades of color.

1 A scanned black and white negative will contain a lot of subtle tonal information. It is important that the scanner you use is able to accurately record these small differences in tone. A histogram display of the inverted, but otherwise unadjusted negative confirms that you will need to expand the shadow and highlight points in order to produce a full tonal range image in print.

2 If we scan in the standard 24-bit RGB, 8 bits per channel mode and expand the shadow and highlight points, you will see how ragged the Levels histogram appears after inverting the image and adjusting the levels.

Photograph: Eric Richmond.

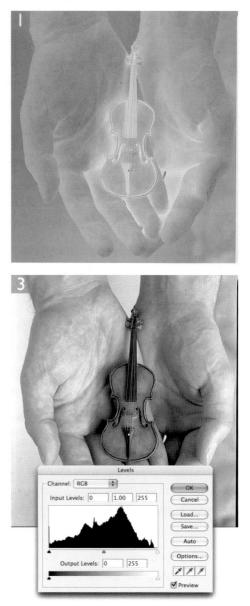

3 If instead we always scan in high-bit (anything greater than 8 bits per channel scanning mode) the image will always open in 16 bits per channel in Photoshop. The histogram after adjusting the Levels will look smooth as shown here, which means we have minimized the amount of tonal information that was lost.

Scanning software

The scanner will be supplied with a software driver that controls the scanner. The scanner driver may be in the form of a stand-alone application which will import the image and save as a TIFF file ready to open in Photoshop, or it may come in the form of a plug-in or TWAIN driver designed to be incorporated within Photoshop. The installer will automatically place the necessary bits in the Plug-ins folder. The scanner will then be accessed by choosing File \Rightarrow Import \Rightarrow name of scanner device.

A well-designed driver should provide a clear scan preview that will help you make adjustments prior to capturing a full resolution scan. The ideal situation is one where the scanning device faithfully captures the original image with minimal tweaking required in Photoshop to achieve an accurate representation in the master file. Modern scanner software should be using ICC-based color management to take care of interpreting the color from the scan stage to when it is opened in Photoshop. Even the 'canned' scanner ICC profiles that might be supplied with your scanner should get you into the right ball park. For really accurate color management you may want to investigate having customized profiles created for you.

Purchasing bureau scans

Low-end scanners are fine for basic image-grabbing work such as preparing scans for a website. But professional photographers should really investigate the purchase of a repro quality scanner and if you cannot afford to do that, get a bureau to do the scanning for you. The cost may seem prohibitive, but you should be getting the best that modern digital imaging technology can offer. It amazes me that people are prepared to spend good money on professional cameras and lenses, yet use the equivalent of a cheap enlarging lens to scan their finest pictures.

When buying bureau scans, you need to know what to ask for. Firstly, all scanners scan in RGB color, period. The person you deal with at the bureau may say 'our scanners scan in CMYK'. When what they really mean

Scanning speed

If it takes a long time for the scanner to make a preview plus carry out the final scan, this could really stall your workflow. The manufacturer's quoted scan times may be a bit on the optimistic side, so check the latest magazine reviews or the Web for comparative performance times. Do also take into account the time it takes to set up and remove the original and the additional time it might take to scan at higher resolutions or work in a multipass scanning mode. I have used a drum scanner in the past and am very aware of the length of time it takes to mount each transparency, peel these off the drum and then have to clean everything afterwards.

TWAIN origins

On a side note here, the name TWAIN was originally arrived upon as a reference to Rudyard Kipling's 'The Ballad of East and West' – '...and never the twain shall meet...'. But geeks love their acronyms and this led people to speculate what those initials really stood for. And so they came up with: Technology Without An Interesting Name.

Visual assessment

All scanners are RGB devices. CCD chips are striped with three or four colored sensors, usually with one red, two green and one blue sensor (the extra green is there to match the sensitivity of the CCD to that of the human eye). When evaluating the quality of a scan, check each individual channel but pay special attention to the blue channel because this is usually the weakest. Look for excess noise and streaking. The noise will not always be noticeable with every subject scanned, but if you had lots of underwater pictures or skyscapes to process, this would soon become apparent.

Photo CD profiles

Pro Photo CD scans use the 4050 profiles and standard Photo CD scans use the 'Universal' profiles. The color negative profile is common to all Photo CD scanners. Selecting the correct Input profile will improve the quality of the imported image, particularly in the shadow detail of reversal films. is, the scanner software automatically converts the RGB scan data to CMYK color. A bureau may normally supply scans to go direct to press, and these are converted onthe-fly to CMYK color and pre-sharpened. If you want to do any serious retouching before preparing the file to go to press you are always better off with an RGB scan that can be sharpened and converted to CMYK later. You can edit and composite in CMYK, so long as you don't mind not being able to access many of the plug-in filters. The pre-sharpening can be a real killer though. Make sure you ask the bureau to always turn off any sharpening. And insist on the scans being done in 16 bits per channel of course and supplied with an embedded profile. If they don't understand these basic needs, you should probably shop around to find a bureau that is more used to the requirements of photographers.

Kodak Photo CD and Picture CD

Kodak launched Photo CD in 1992 as a platformindependent storage medium of digitized images for use with desktop computers and for display on TV monitors via a CD player. Photo CD was initially targeted at the amateur market, but interest has dwindled with the advent of cheap, affordable digital cameras.

Labs/bureaux offering the Kodak Photo CD service can supply the processing of a roll of film, transparency or negative plus transfer of all the images to a Master CD disc as an inclusive package. Depending on where you go, it can work out at around a dollar per scan including the film processing, although in addition you will have to purchase the CD disc. A Master disc can store up to 100 standard resolution (18 MB) 35 mm scans, while the Pro disc can store 25 individual high resolution (72 MB max) scans from either 35 mm, 120 or 5×4 films.

Opening a Photo CD image

The easiest mistake Macintosh users can make is to go to the folder marked 'PHOTOS' and open the files directly in Photoshop. These PICT format images (for TV monitor display) are not suited for reprographic output as the highlight tones tend to be clipped. Insert the Photo CD disc into the CD-ROM drive. With Photoshop loaded, open the image required via the File \Rightarrow Open menu. Click to select desktop and open the PCD icon. Go to the 'Photo CD' folder. Open the folder marked 'IMAGES'. Check the indexed print on your CD for the image number and click 'Open'. The dialog box which now appears offers several choices. Go to Pixel Size and choose the resolution size for output, i.e. 2048×3072 which will yield a file size of 18.4 MB. Where it says Profile, choose the one which closely matches the film type of the original and the scanner model used. You have a choice of opening the Photo CD image in either YCC (Photoshop Lab) mode or as an RGB image. If you select RGB, the file will automatically convert and open to whatever is your current default RGB space. Note you can also choose to open a Photo CD image in 16 bits per channel color to produce a 48-bit RGB file.

Kodak Picture CD

Kodak Picture CD should not be confused with Kodak Photo CD, as Picture CD is simply a CD containing JPEG compressed files. All you have to do is check the appropriate box and a CD will be included when you go to collect your prints. Picture CD will supply a folder of JPEG scanned images on a disk.

	Kodak PCD Format		and the second
	Source Image	IMG0012.PCD	OK Cancel
Allian	Pixel Size:	2048x3072	•
	Profile:	KODAK Photo CD Uni	
	File Size:		
	Resolution:	(300 ppi	•
Image Info	Color Space:	RGB 16 Bits/Channel	•
Original Type: Color reversal (slide film) Product Type: FilmScanner 200	Orientation:	 Landscape Portrait 	

Figure 11.5 Here is the Photo CD interface. The Image Info on the left tells you which film emulsion type the photograph was shot on and the type of scanner used. This information will help you determine which is the best source profile setting to use. This latest, much simplified interface is a great improvement on those found in early versions of Photoshop. It is possible to set the pixel resolution you want the file to open at and you can open a Photo CD file as a 16-bit per channel RGB image. It is claimed that the luminance channel in a YCC file contains 12 bits of information, so bringing a file in at 48-bit RGB will make the most of all the information captured in the original Photo CD scan.

Early digital camera systems

Eight or ten years ago the professionallevel digital options were rather limited and hideously expensive. Some of the early digital cameras looked more like CCTV security cameras: a brick with a lens stuck on the front. The eggheads who designed these had perhaps spent too much time looking the wrong way down the lens as these cameras had no viewfinder and you were forced to preview directly off the screen (this was about as useful as replacing a car's steering wheel with a mouse). Manufacturers such as Leaf, Phase One and Dicomed were among the first companies to produce digital backs that could easily fit on the back of conventional professional camera systems.

Counting the megapixels

The most important component in any digital camera system is the pixel sensor and the first thing most people look for is a large megapixel size, which represents the number of pixels the chip can capture. For example, a 3000 \times 2000 pixel chip can capture 6 million pixels (more commonly referred to as 6 megapixels). Be aware that very often not all of these pixels are actually used to capture an image and the megapixel size that is quoted should more precisely describe the effective number of pixels that the camera uses. Although the megapixel size can help you determine how big the image will be, it doesn't really tell the whole story, because not all sensor chips are the same.

Digital cameras

Silver film has been with us for over 150 years. We know it works well because the manufacturers are continuing to refine the film emulsions we use today. But digital capture technology has improved so much over recent years that digital cameras are already superseding film. We have seen an incredible rise in interest for digital cameras among the consumer end of the market and we are all taking more pictures than ever before. Digital capture has become popular because you get to see the results immediately, you can email pictures to friends and more importantly, it's fun!

Professional photographers are similarly adopting digital capture because of the immediacy and also because the approved image is the final file. All that waiting for labs to collect the film, process it and you sending the edited results by courier to the client are a thing of the past. The client can leave the studio with the finished result burnt to a disk. The client not only saves time, they can save money on film, processing and scanning costs as well.

Comparing chips

Consumer-level digital cameras will have a lowish number of megapixels. But you should be able to make decent inkjet prints from the files, and that is all that most users really want. But the performance of some of the low-end consumer cameras is actually quite exceptional for the price you are paying. But you can't really compare the file output megapixel for megapixel with the more advanced SLR digital cameras. The spectral response in consumer cameras can be uneven, the chips may be noisy and the optics not that great. But nevertheless the results will be as good as if not better than the mini lab prints you were used to getting from a compact film camera. And once you have bought the camera there is no more film and processing to pay for and all you will need is a computer to download the images to and somewhere to store them.

The most common type of camera chip is CCD, which stands for Charge Coupled Device. These have been around a long time and are used in a lot of digital cameras. The downside of CCDs are that they draw quite a lot of electric power. As a result of this, a chip will get warm when it is in use and its charged nature can attract dust particles. They are also prone to suffering from shadow noise, especially in the blue channel. Most professional digital camera backs use CCDs, but they also employ various strategies to keep the chip cool at all times. One of the most effective methods is the Peltier chip which is attached directly to the sensor chip and uses electronic cooling to dissipate the heat by transference and thereby significantly reduces the amount of noise generated. This is one of the reasons why the professional digital backs are so much bulkier compared to the digital SLR cameras. More recently, CMOS (complementary metal oxide semiconductor) technology has begun to be used in still digital cameras. CMOS chips are cheaper to make, and more significantly, they draw about a quarter the amount of power of a CCD chip and therefore don't suffer from the same type of noise problems. The Kodak DCS Pro SLR and Canon EOS 1Ds series use CMOS chips, and both these cameras have full-frame sized sensors that correspond to the area of a conventional 35 mm film frame.

There are some other subtle variants of camera chip. Fuji produce what they call a Super CCD, which has a honeycomb structure of large CCD elements. The Fuji FinePix S3 Pro has a 6.17 megapixel chip and yet the (uninterpolated) pixel size is stated as being 12.34 megapixels. Some argue that this figure is a cheat, but the image results do actually compare well with the output from other high resolution SLR cameras. The Sigma SD10 features the unique Foveon X3 CMOS chip which, unlike any of the other CCD or CMOS chips, reads full color information from every pixel sensor (or Photodetector, as Foveon prefer to call it). The camera sensor is advertised as having 10.2 megapixels, which is true, although it would be more accurate to say that it has 3.43 million pixel sensors per layer.

Which digital camera is right for you?

As a service to readers, I have provided a PDF document on the CD and website that lists most of the professional and some of the better quality consumer digital cameras. The list is split up into four categories. The first lists a selection of cameras that are primarily targeted at the consumer market and have noninterchangeable lenses. Some of these are actually quite sophisticated and could be used professionally, as you can set the exposure manually or link them to an external flash unit. These models are really amateur cameras but with professional aspirations. What actually limits them is the awkward way they perform professional tasks and their limited battery life and card size. The next category features digital SLRs. These are all based on conventional 35 mm camera body designs and all accept interchangeable 35 mm lenses. They are mostly considered professional cameras, but at a more affordable price. The third section lists the medium format digital backs. These use approximately 24 × 35 mm or 35 × 35 mm sized chips, or larger and have the latest state of the art technology to reduce noise in the file and some use multiple captures to produce greatly increased file sizes. And lastly, I have listed the scanning back cameras, which although still around, are looking increasingly redundant in light of recent improvements in digital back technology.

Martin Evening Adobe Photoshop CS2 for Photographers

Figure 11.6 The sensor chip in most one shot CCD and CMOS cameras consists of a mosaic of red green and blue sensors. The RGB sensor elements use what is known as the Bayer pattern. This is a 2 × 2 matrix with one red, one blue and two green sensors. The green sensors match closest to the region of the visual spectrum that our eyes are most sensitive to.

Figure 11.7 The Foveon X3 chip features a revolutionary new design whereby the RGB CMOS photodetectors overlap each other. Light can pass straight through the upper blue-sensitive layer of photodetectors to record information on the green and red-sensitive layers below. The result is a one shot CMOS chip less prone to moiré and edge artifacting which is able to capture image detail with a smoothness to rival the multishot mode camera backs. Although this is still a 'consumer' level product, it may hold the key to professional one-shot digital camera design.

Digital image structure

Figure 11.6 illustrates how a typical single shot CCD or CMOS sensor will generate pixel color values by averaging out the color pixel readings from one red, one blue and two green pixel sensors in a 2×2 mosaic structure. When you take a picture with a single-shot camera, the camera software has to guess the color values for 75% of the red pixels, 75% of the blue pixels and 50% of the green pixels. This is why you sometimes get to see moiré patterns or ugly color fringing artifacts when you shoot finely detailed subjects. Software programs such as Quantum Mechanic from www.camerabits.com are useful at helping to eliminate these problems as is the Luminance Smoothing slider in the Adobe Camera Raw plug-in.

A 6 megapixel size RGB capture file has sufficient enough pixels to fill a magazine page. However, because of the way the sensor captures the one-shot image using a striped chip, there will be a limit as to how much you will be able to crop a picture and still enlarge it to fill the page. The Foveon X3 features triple layers of red, green and blue sensors where red, green and blue color information is simultaneously recorded in each single sensor position. Although the Foveon X3 contains a relatively small number of pixel locations, each location actually contains three pixels, one on top of the other. The clean image quality attained using the Foveon X3 sensor is comparable with that of the advanced multishot digital camera backs. But for all that, the low pixel size capture will limit its versatility.

The sensor size

As well as the number of the pixels, you will want to consider the physical size of the camera chip. Among the cameras in the 35 mm digital SLR category, these typically vary in size from 14×21 mm on the Sigma SD10 to a 24×36 mm full-frame sensor on the Canon EOS 1Ds Mk II and Kodak Pro SLR. The latter are all said to have a lens magnification factor of $\times 1$, meaning that the relative focal length of any system lens will be

Figure 11.8 Let's now analyze more closely the way a one shot camera captures and interprets color using the bayer pattern arrangement with most CCD and CMOS sensors. The sensor is simultaneously able to capture red, green and blue color. But there is only one red sensor element for every four pixel sensors. Likewise, there is only one blue sensor and there are two green sensors. The right hand picture gives some indication in close-up of how a CCD/CMOS chip captures the RGB data using this pattern of colored pixel sensors. The capture data must next be interpreted in order to produce a smoother looking result. Since only one in four pixel sensors is recording red or blue information, the values for the other three pixels (75%) has to be guessed. Although in the case of the green information, only 50% has to be guessed. Once the raw image has been processed, the underlying pattern is not seen. However, you should be aware that in the case of most one shot cameras, two thirds of the color information is guesswork. The weakness of one-shot cameras can sometimes be seen in a capture of a subject containing lots of sharp detail. Sometimes you get to see Christmas tree type artifacts, which is a result of the pixel guesswork having to fill in the gaps.

Figure 11.9 Multishot cameras capture sequential exposures of red, green and blue. Therefore, each resulting pixel is based on 100% color information, with no pixel guesswork. The raw data is able to produce a much smoother and cleaner image. Multishot mode is only suitable for still-life photography. Many of the professional digital camera backs are able to shoot in one-shot and multishot modes.

Megapixel limits

The first thing most people look for is a large megapixel size, which represents the number of pixels the chip can capture. For example, a 3000 × 2000 pixel chip can capture 6 million pixels (or 6 megapixels). Be aware that very often not all of these pixels are actually used to capture an image and the megapixel size that is quoted should more precisely describe the effective number of pixels that the camera uses. Although the megapixel size can help you determine how big the image will be, it doesn't really tell the whole story, because not all sensor chips are the same.

People have wondered if the megapixel sizes will keep getting bigger and bigger. In the last edition of my book, I stated that it was unlikely we would see a digital SLR exceed the 14 megapixel barrier (especially after all the initial teething problems that beset the release of the original Kodak 14n). Well, fortunately, Kodak were eventually able to resolve a lot of those issues and the later Kodak 14n cameras have been much better received. And with the release of the EOS 1Ds MkII, Canon have now upped the limit to 16 megapixels. But despite all this, you still have to take into account that as you squeeze more pixel sensors into a 35 mm frame area, they will have to get smaller. Smaller pixel sensors will be less efficient at collecting light and the result of this will be noisier images, unless something can be done to address this physical limitation. the same as when shooting with an equivalent 35 mm film camera. If the sensor is smaller than 24×36 mm in size, then the magnification factor will increase. Therefore, a 28 mm wide angle lens that is normally used on a 35 mm film camera will effectively behave more like a 35 mm wide angle when used on a digital SLR that has a lens magnification factor of ×1.3. Most of the cheaper, noninterchangeable lens cameras typically have a maximum wide angle that is equivalent to a 35 mm lens. But you can sometimes buy a specially designed wide angle lens adaptor to place over the camera lens to increase the wide angle view. It is interesting to note that the sensors used in the digital camera backs for medium format cameras, are not that much larger than a full-frame 35 mm camera. They are nearly all 25×37 mm or 37×37 mm in size. Only Hasselblad, Pentax and Contax manufacture nondistorting lenses with a 35 mm focal length. There are no shorter length lenses than this designed for the 6×4.5 cm medium format systems. So if wide angle photography is your thing, your choice of camera will be restricted to one of the full-frame digital SLRs. The notable exceptions are the Phase One P25 and the Sinar 54, which both use a $37 \times$ 49 mm sized sensor. So if you were to use a 35 mm focal length lens combined with one of these sensors, it would be roughly equivalent to shooting with a 28 mm lens on a 35 mm SLR camera system.

The quest for the ideal digital camera is somewhat hampered by the goal of trying to make digital sensors fit within conventional film camera system designs. The Sigma SD10 sticks the small Foveon X3 chip inside a camera system body that is really designed to accommodate 35 mm film. This is done for practical reasons, because at the moment it is more economical to adapt conventional 35 mm camera bodies to digital than to reinvent an SLR system to suit the constraints of digital capture technology. Olympus have been working on an answer to this, called the four thirds system, based on the 4/3 aspect ration Kodak CCD, which is smaller in size than the 35 mm frame area. Conventional film camera designs sometimes force the light to hit the surface of the CCD at acute angles and this can lead to light fall-off towards the edges of the sensor. This is due to some CCD designs having a layer of micro lenses on the chip surface. By designing a new type of digital SLR with an interchangeable lens system from the ground up. Olympus have been able to avoid such technical limitations and establish a new digital format which made its first appearance in the form of the Olympus E-1 camera. In the meantime. Nikon have released the DX Nikkor 12-24 mm f4/G zoom lens. This is a lens that has been custom designed for the Nikon D100, D70, D1X, D1H and D2 digital SLRs. The extreme wide angle optics are optimized to match the coverage of the smaller chips in these cameras, but would be unsuitable for use in a conventional 35 mm film camera.

Making every pixel count

One of the reasons why we have been conditioned to work with large digital files from a film scanner is due to the grain structure inherent in the film. When a film original is scanned, the scanner records the density of all the minute grain clusters that make up the photograph. The grain structure can cause the scanner to record sharp variations in pixel values from one pixel to the next. This is especially noticeable when you examine an area of pure color. Even on a low resolution scan, the pixel fluctuation caused by the grain can still be visible. And with a high resolution scan you will actually see the grain clusters. If you increase the size of such a file through image interpolation, the pixel fluctuations become even more magnified. With a capture image shot on a professional digital camera capture, there is no fluctuation so it is therefore possible to interpolate a file upwards in size without generating unpleasant image artifacts. Such high-end equipment is not cheap of course, but the purity of the pixel image obtained from a professional digital camera sets it apart from anything else you have seen before, including the best drum scans made from film.

Comparing film with digital

The optimum ratio of an image's pixel resolution to the printer's line screen is close to ×1.5. If you were to make an RGB scan, to fill an A4 magazine page using a 133 lpi screen, you would need a raw RGB image that measured A4 and with a pixel resolution of 200 ppi. This would then be converted to produce a CMYK file of 15.5 MB. If you allow a little extra for the bleed, you need at least a 12 MB RGB file to produce an A4 output. All the professional cameras mentioned in this chapter are able to capture at least 12 MB of RGB 8 bit per channel data. But these are by no means limited to producing A4 output. The file capture is so smooth that you can realistically interpolate the files up to reproduce at bigger sizes and without incurring any perceivable loss of image quality as you would if you were to interpolate up a scanned image.

Multishot exposures

The very first multi-capture backs used grayscale CCDs to capture three sequential exposures through a rotating wheel of red, green and blue filters. As the new generation of mosaic CCD arrays were being designed it was realized that moving the CCD in one pixel increments gave similarly good results. The CCD chip is moved between three or four exposures by a piezo crystal that can be made to expand or contract in exact increments whenever a small voltage is applied. The piezo crystals shift the single grayscale chip, repositioning it by fractional amounts. In multishot mode such cameras are only suitable for shooting still-life subjects. Some multishot backs are also able to capture a single shot image keeping the chip still and capturing a single exposure.

For example, the CCD chip in the 6 megapixel Leaf Valeo 6 camera captures a 6 MB sized rectangular image in each color channel. And the RGB composite image will therefore be 18 MB in size. This does not sound so impressive, but with high-end digital cameras you have to think differently about the meaning of megabyte sizes or more specifically pixel dimensions and the relationship this has with print output size. Images that have been captured with a digital camera are pure digital input, while a highend scanned image recorded from an intermediate film image is not. The optimum relationship between pixels per inch and lines per inch for images prepared for print output is a ratio of either 1.5 or 2 to 1. In either case the film image must be scanned at the correct predetermined pixel resolution to print satisfactorily. If a small scanned image is blown up, the scanning artifacts will be magnified. If a good quality digital capture image is relatively free of artifacts, it is possible to enlarge the digital data by 200% or more and match the quality of a similar sized drum scan.

It's hard to take on board at first, I know. It came as a shock to me too when I was first shown a digital picture: an A3 print blowup from a 4 MB grayscale file! Not only that, but digital images compress more efficiently compared to noisy film scans.

Chip performance

Apart from the physical size and the number of megapixels, it is important to give equal consideration to the bit depth and the dynamic range the sensor is able to record. Both these topics were covered earlier in the scanner section. It is even more important when capturing a scene digitally that the camera you use is able to record data using more than 8 bits per channel information. A higher bit depth will mean that more detailed tonal information is captured.

The dynamic range is sometimes expressed in f-stops and this refers to the sensor's ability to record image detail across a broad subject brightness range. So a camera with a large dynamic range will simultaneously be able to see and record detail in the darkest shadows and the brightest highlights. In light of the recent high dynamic range support now in Photoshop CS2, I have heard predictions that we will soon see cameras capable of capturing with wider dynamic ranges.

Leaf, Sinar, Phase One, Kodak and Imacon all make single and multishot backs. Some of these cameras are built round the outstanding Philips 2K × 3K chip capturing 6 MB of raw pixel information in each color channel to produce finished files of 18 MB RGB or 24 MB CMYK. Kodak launched the DCS ProBack in 2001, which featured their own Kodak designed 38 mm × 38 mm, 4000 × 4000 pixel Tin Indium Oxide CCD. Phase One have implemented the Kodak chip in their H20 back and Imacon have already used the Kodak chip in the Flexframe 4040. The Imacon Ixpress 384 can capture a single or multishot 96 MB image in 48-bit color or a 384 MB 48-bit RGB image in the 16 exposure micro step mode.

At this level the photographer can expect quite superb image quality, exceeding that of film. It is sharper, has no grain structure to interfere when images are resized, and offers more precise control of color over a greater dynamic range which will typically be 10-11 f-stops, between the shadows and highlights. To give you some idea of how impressive this is, transparency chrome film has a typical dynamic exposure range of around 4-5 f-stops and negative film about 7-8 f-stops. So if you take into account the benefits of shooting with a high-end digital system, such as the grain-free smoothness, the absence of noise and the incredible amount of tonal information that can be captured digitally compared to film, you can see why most pros prefer to shoot digital all the time now. In nearly all these cameras, special attention has been paid to reduce the electronic noise through special cooling mechanisms. In some cases the electronics are put to sleep, awakening milliseconds before the exposure is made and then going back to sleep again.

Looking after the chip

As you might expect, the chip sensor is extremely delicate and is also the single most expensive component in a digital camera. If it becomes damaged in any way there may be no alternative but to have it replaced. Pay special attention to using the manufacturers' correct cleaning methods and take every precaution when removing dust from the sensor surface. Insurance policies against accidental damage are also available for the more expensive digital cameras – a wise step to take considering how fragile the sensor is.

SpheroCamHDR camera

So far there is only one high dynamic range camera I am aware of that is able to capture a high dynamic range subject and that is the SpheroCamHDR camera. This is admittedly a specialist camera used for capturing 360° panoramas with a single scan pass. But it does have a remarkable dynamic range of up to 26 f-stops. For more information visit the Spheron VR website: www.spheron.de.

Choosing a memory card

It is worth doing a little research to find the right type of card for your camera. Memory cards have different read/write speed specifications. This will be specified on the card but does not necessarily provide a truly accurate indication of the actual performance. The read/write speeds are due to factors such as the speed of the device used to transfer the data to the computer and the speed the camera can write the data to the card. I highly recommend that you visit Rob Galbraith's website and check out his ongoing data sheet reports into compact flash card performance with the latest cameras: www.robgalbraith.com. You will notice that the speed test results of individual cards can be surprisingly varied from camera to camera.

Avoiding card failure

Flash memory cards are surprisingly robust. 'Digital Camera Shopper' magazine found that 'five memory card formats survived being boiled, trampled, washed and dunked in coffee or cola, and given to a six-year-old boy to destroy'! Even when the cards were nailed to a tree, 'data experts Ontrack Data Recovery were able to retrieve photos from the xD and Smartmedia cards'. But to reduce the risk of card failure or file error, don't use up the card's capacity beyond 90% each time you shoot with it. And always reformat the card in the camera before you start shooting a new batch of pictures.

Memory cards

Another essential consideration is the speed with which you can get your photographs from the camera to the computer. At the high end, you can expect most if not all camera backs and cameras to have FireWire connectivity, including nearly all the digital SLRs. Most digital cameras can store the captured images on an internal memory card such as Compact Flash, so you can transfer the data directly off the camera via a USB or FireWire card reader (ideally you need to use FireWire or a USB 2 device). The memory cards supplied with consumer cameras will usually offer limited storage capacity, so it is worth buying extra cards. I recommend that the card should be able to contain up to 100 captures. So if the average size of raw file is, say, 10 MB, then you should not use anything bigger than a 1 GB card. It is better to use multiple cards to capture extra shots as this reduces your reliance on a single card. Plus the very largest cards are proportionally more expensive to buy.

Selecting the right storage card for your particular camera is not a simple process. There are several types of cards. The most common are the flash memory type I and type II cards. These contain non-volatile memory that, unlike RAM memory, is able to store and hold digital data in the memory cells when not connected to a power source. Flash memory cards will wear out with use, but nevertheless they are still very robust, although the higher capacity cards are quite expensive. The IBM 1 GB Microdrives are miniature hard disks. At one time these were cheaper and more economical than flash memory, but are on the way out now. They are also more fragile and prone to damage, especially if dropped. There is Memory Stick, a memory storage medium for Sony devices. Secure Digital (SD), which can be used in Kodak, Konica, Kyocera and other cameras. Multimedia cards, which can often be interchanged with the Secure Digital cards. And lastly, SmartMedia, that can be used with Fuji and Olympus cameras, which is in the process of being superseded by the new xD card standard - also for Fuji and Olympus.

Camera response times

A major drawback with the lower-end cameras is the time it takes for the camera to respond after you press the shutter. You compose your shot, you press the shutter release, and by the time the shutter actually fires, your subject has disappeared out of the frame. This annoying delay is not something you will experience with the highend cameras, but even these can suffer from being able to capture only a limited number of shots within a given time. If you compare cameras carefully, you will notice that not many of the high-end digital backs can match the fast performance of the digital SLRs. News and sports photographers will probably prefer to use a camera such as the Canon 1D Mk II, purely because of the priority given to making this the fastest digital camera on the market, with the Nikon D2H coming a close second. However, the new Imacon Ixpress can shoot at an impressive rate of two frames every three seconds almost indefinitely to a highcapacity, portable, tethered drive.

Comparing sharpness

As CCD and CMOS sensors have got to the point where they are now capturing a much greater number of pixels, there is less need for anti-aliasing filters. There was always a trade-off to be taken into account. You could remove the anti-aliasing filter and get sharper captures, or leave it in and have fewer problems with moiré. Note that the Camera Raw plug-in is able to resolve some moiré as you import the file (see pages 444–445) and there is also a tutorial in Chapter 6 showing you how to remove moiré.

If you want to compare the output sharpness of different cameras, you should be aware that many cameras carry out some on-board image processing that artificially sharpens the captured image to make it look better. Some cameras can even interpolate the captured data to enlarge the central area and call this a 'digital zoom', or 'digital marketing con' as it's otherwise known. You can more easily crop the image and enlarge it in Photoshop and get better results.

Dust removal

Camera chips generate a static charge and this will attract dust like a magnet. The chips used in compact digital cameras are completely sealed, so they are not at risk. But if you use anything else, such as a digital SLR, the chip can be exposed to dust particles every time the mirror flips up. There is no getting around the fact that you have to keep a regular check on the camera chip and have to keep it clean. Do not use an aerosol spray, use a blower brush instead to remove dust. Don't try blowing with your mouth as the air you blow will contain moisture and leave more marks on the sensor. You can safely clean the sensor thoroughly using special sensor swabs and cleaning fluid. Eclipse make sensor swabs designed for all sizes of digital sensors, including the full-frame SLRs. A few careful swipes with a fresh swab should keep the sensor spotless.

Anti-aliasing filters

The Kodak anti-aliasing filter works by very slightly unsharpening the image, but a better method may be to use software such as Quantum Mechanic from Camera Bits Software. Other camera manufacturers overcome the infrared problem by fitting a hot mirror type filter to the face of the CCD itself, but within the engineering confines of the existing Canon and Nikon bodies; this option is not available to Kodak.

Hot mirror filters

The spectral sensitivity of many CCDs matches neither the human eye nor color film and extends awkwardly into the infrared wavelengths. This is partly inherent in their design and partly due to their original development for military uses. To overcome the extreme response to the red end of the spectrum a hot mirror filter is used to reduce the infrared wavelengths reaching the CCD. In most cameras this is part of the CCD design. But some cameras have a removable filter which will allow you to shoot with the camera in infrared grayscale mode.

Figure 11.10 The Studiotool-Stm STS-Model 1 system has been designed by photographer Patrik Raski in conjunction with ICS. It enables you to integrate a Sinar view camera with a digital SLR camera body such as the Canon camera EOS 1D series. This is an interesting and affordable solution for those who wish to capture large, multishot files from a view camera system. For more information go to: www.studiotoolsystem.com.

Scanning backs

These record a scene similar to the way a flatbed scanner reads an image placed on the glass platen. A row of light sensitive elements travel in precise steps across the image plane, recording a digital image. The digital backs are designed to work with large format 5×4 cameras, although the scanning area is slightly smaller than the 5×4 format area. Because of their design, daylight or a continuous light source must be used. HMI lighting is recommended in the studio because this produces the necessary daylight balanced output and lighting power. Some flash equipment manufacturers, like the Swiss firm Broncolor, have made HMI lighting units that are identical in design to the standard flash heads and accept all the usual Broncolor lighting adaptors and accessories. Many photographers are actually able to use standard quartz tungsten lighting, providing the camera software is able to overcome the problem of light flicker. But the lower light levels may require a higher ISO capture setting and this can lead to increased blue shadow noise. Sometimes bright highlights and metallic surfaces will leave bright green streaks as the CCD head moves across the scan area. This is known as blooming and looks just like the effect you often saw in the early days of color television. It might have appeared cool in a TV recording of a seventies glam rock band, but it is really tricky to have to retouch out in a stills photograph. Some scanning back systems contain anti-blooming circuitry in the equipment hardware.

The exposure time depends on the size of final image output. It can take anything from under a minute for a preview scan to almost 10 minutes to record a 100 MB+ image. The latest Betterlight scanning back can scan a high-resolution image in just a few minutes. But everything has to remain perfectly still during exposure. This limits the types of subject matter which can be photographed. You can use a scanning back on location, but sometimes you get unusual effects similar to the distortions achieved with high-speed focal plane shutters. When digital photography was in its infancy, scanning backs were considered to be technologically superior to most of the CCD camera backs. This was mainly because they were the only devices that enabled you to capture such big file sizes. These days, you can capture a 384 MB 16-bit RGB file using the Ixpress 384 or a top of the range Sinar or Phase One camera back. To my mind, CCD technology now offers the better technical quality and at large file sizes.

Figure 11.11 Photograph by Stephen Johnson. Copyright © 1994 by Stephen Johnson. All rights reserved worldwide: www.sjphoto.com. Notice the shape of the plumes of steam in this photograph are a result of this exposure being made via a scanning back system.

Stephen Johnson

One of the first photographers to adopt digital capture was Stephen Johnson, who shoots fine-art landscape photographs, using a Betterlight scanning back attached to a 5×4 plate camera which he takes on location. When Stephen Johnson began testing a prototype Betterlight scanning system in January 1994, he simultaneously shot a sheet of 5×4 film and made a digital capture of a view overlooking San Francisco using the Betterlight. He made a high resolution scan of the film and compared it with the digital capture. He was blown away by what he saw. The detail captured by the scanning back was incredibly sharp when compared side by side with the film scan. This was the moment when Stephen Johnson declared 'Film died for me on that day in 1994.' Since then, everything he has photographed has been captured digitally (you can visit his gallery website at: www.siphoto.com). It wasn't just the sharpness and resolution of the images that appealed. The Betterlight scanning back system is able to discern a much greater range of tonal information between light and shade than normal film ever can. The digital sensors are able to see deep into the darkest shadows and retain all the highlight detail. The color information can also be made to more accurately record the scene as it really appeared at that time of the day.

Digital workflows

A lot of people underestimate the potential pitfalls of switching to a digital workflow which can trip up the unwary or inexperienced digital photographer. All too often photographers and their clients have rushed to switch from an analog to a digital workflow without paying serious attention to important issues such as maintaining an image archive and the color management. Worse still, mistakes made by ill-prepared newcomers risk jeopardizing the confidence of everyone else working in the desktop publishing industry.

There are some obvious workflow differences when shooting digitally. In a traditional, analog workflow, clients received transparencies or contact sheets and once the final picture had been selected and approved, the photographer's responsibility ended there. But now there are a lot more things for you to consider. For example, how long does it currently take to review a contact sheet or roll of transparencies, compared to the time it takes to open and close an equal number of digital captures? On the other hand, what price the immediacy of having your photograph instantly displayed on the computer and ready to send off to print? And how are you going to preview and edit your digital pictures? If you are present while the photographs are being taken, then it will be easy to approve the results there and then and walk away with a finished CD or DVD. If you or the final client wish to approve the pictures remotely, then you need to work out a method of getting the pictures to them for approval. Chapter 16 looks at the issue of image management in more detail, which is followed by a chapter on how to automate Photoshop. For instance, the Web Photo Gallery in Photoshop is a very easy-to-use automated plug-in. A photographer can quickly build a web gallery of images, upload these to a server and share the results of a day's shoot with anyone who has Internet access. And if the client does not want to judge the photos on a screen or does not have a computer, you can always use the Contact Sheet II feature to produce printed contact sheets with identifying file names below each picture.

Raw versus JPEG

If you are shooting with a professional back, digital SLR, or an advanced compact digital camera you will almost certainly have the capability to shoot using the camera's Raw format mode. The advantages of shooting in Raw as opposed to JPEG mode are not always well understood. If you shoot in JPEG mode the files are compressed by varying amounts and this file compression will enable you to fit more captures on a single card. Many photographers assume that shooting in Raw mode simply provides you with uncompressed images without JPEG artifacts and the trade-off with this is that fewer captures can be stored. But there are some more important reasons why capturing in Raw mode is better than shooting with JPEG.

From light to digital

Let's begin by looking at the way the CCD or CMOS chip in your camera converts the light hitting the sensor into a digital image. In order to digitize the information, the signal must be processed through an analog-to-digital converter (ADC). The ADC measures the amount of light hitting the sensor at each photosite and converts the analog signal into a binary form. At this point, the raw data simply consists of image brightness information coming from the camera sensor. The raw data must then be converted somehow and the raw conversion method used can make a huge difference to the quality of the final image output. Most cameras will have an on-board microprocessor that is able to convert the raw data into a readable image file, which in most cases will be a JPEG type format. The quality of a digital image is primarily dependent on the lens optics used to take the photograph, the recording capabilities of the CCD or CMOS chip and the analog-todigital converter. But it is the raw conversion process that matters most. If you choose to process the raw data on your computer instead, you have much greater control than is the case if you had let your camera automatically guess which were the best raw conversion settings to use.

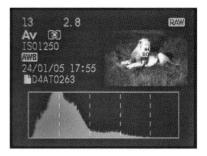

Figure 11.12 The camera's on-board processor is used to generate the low resolution JPEG preview image that appears in the LCD screen. The histogram is also based on the JPEG preview and is therefore a poor indicator of the true exposure potential of a raw capture image.

White balance and tonal correction

The most important camera capture setting is the white balance. If you shoot JPEG, the on-board processor will create a file with a fixed white balance based on the camera's preference settings, which might be to set to apply a predetermined white balance or use an auto setting. When you shoot using Raw mode it does not matter which settings the camera uses, you can decide on the most appropriate white balance setting to use later when you convert the image on your computer. For example, the Adobe Camera Raw plug-in enables you to apply an optimum white balance for any lighting situation.

Third party raw converters

The other software programs that can read the raw camera data include: Bibble: www.bibblelabs.com, FotoStation: www. fotostation.com, and iView MediaPro: www.iview-multimedia.com. I particularly liked iView because it offered an easyto-use digital lightbox interface. It can recognize many popular raw camera formats and is really fast at importing image files and generating large previews. The Capture One software from Phase One is also a popular choice among PC users and is also available for Mac OS X.

Raw is the digital negative

You can liken capturing in Raw mode to shooting with negative film. The great thing about negative film is that it doesn't matter if someone makes a bad print, because you can always make an improved print from the original negative. When you shoot raw, you are recording a master file that contains all the color information that was captured at the time of shooting. To carry the analogy further, shooting in JPEG mode is like taking your film to a high street photo lab, throwing away the negatives and scanning from the prints. If you shoot using JPEG, the camera is deciding automatically at the time of shooting how to set the white balance and the tonal corrections, often clipping the highlights and shadow detail in the process. These days, everything I shoot is captured in Raw mode (unless I am using a small compact camera for fun or I am not concerned about preserving fine image quality). The difference in what can be achieved from a Raw file compared to a JPEG is quite incredible and only goes to show that even on the more sophisticated digital compacts, it is well worth saving the raw data and making the conversion later, at your leisure, on the computer.

Raw conversion software

Cameras that are capable of shooting in Raw mode will usually come supplied with the software to process the raw data, make custom white balances, tonal corrections and save out as TIFF files that can be read by Photoshop or other image editing programs. The camera-supplied software programs are often disappointingly slow, but there are programs such as Capture One from Phase One that have proved popular with raw shooters. The raw conversion is very important and therefore the photographer must feel confident that the software they use is up to the task of making an optimum interpretation of the raw data. If you hang out on any of the photography Internet forums, it is quite obvious that this subject stirs the emotions of raw shooters just as much as the PC versus Mac debates have done in the past. My personal view is that when anyone invests a lot of their time and reputation in using a specific workflow they will inevitably become very defensive when someone tells them they are using the wrong raw processing software and this other software is the only one you should use. I don't believe there are necessarily any image quality differences between what can be processed in one program and another and it is mainly a matter of knowing how to use the adjustment controls to their full advantage in the software you prefer using. In the case of Adobe Camera Raw the criticisms I have read have usually been based on ignorance and prejudice rather than being considered opinion. This new version of Photoshop features a new update to the Camera Raw plug-in which makes the raw processing easier. Some of the apparent improvements in image quality are as a result of using new default settings such as a more contrasty default tone mapping and auto tone settings.

DNG file format

In the slipstream of every new technology there follows the inevitable chaos of lots of different new standards competing for supremacy. Nowhere is this more evident that in the world of digital imaging. In the last ten years or so, we have seen many hundreds of digital cameras come and go along with other computer technologies such as Syquest disks and SCSI cables. And I have probably encountered more than a 100 different raw format specifications. It would not be so bad if each camera manufacturer had adopted a raw format specification that could be applied to all the cameras they produced. Instead we have seen raw formats evolve and change with each new model that has been released. And those changes have not always been for the better.

The biggest problem is that with so many types of raw format being developed, how reliable will a raw format be for archiving your images? Six years ago Adam Woolfitt and myself conducted a test report on a range of professional and semi-professional digital cameras. Wherever possible, we shot using Raw mode. I still have

Whose data is it anyway?

If photographers think it is a good thing for the industry to move towards a standardized raw file format, then the DNG format deserves to succeed. It will also encourage other software manufacturers to support DNG and give the camera user even more choice. The only sticking point appears to be those camera manufacturers who have adopted a protective stance about the raw file processing. One gets the impression that there is a certain amount of irritation within some camera companies whenever outsiders have managed to 'crack the code' and successfully reverse engineered their proprietary raw file formats. One manufacturer once went so far as to devise a method of encryption that would defeat any attempts to make the file format more widely accessible. Photographer and Photoshop expert Jeff Schewe raised an important point here: 'After I have taken a photograph and captured an image as a raw file, whose data is it? It's my damn data, and not anyone else's!' Which neatly brings us back to the whole raison d'etre of the DNG file format, which is to make raw shooting more accessible for all. The opportunity is there for everyone to gain. Photographers have a new file format that will enable them to archive their raw captures with confidence for the future. If the camera manufacturers support the new DNG format they will make their customers happy too. But the real choice will be down to the consumer. They will decide which camera choice to make and support for DNG should be regarded as an important decision when making future purchases of camera equipment.

Support the petition!

If you agree that a common raw format standard would be beneficial to the photographic industry and would like to let the manufacturers know this, then you can register your feelings by going to www.rawformat.com and signing the DNG petition.

	ONG Converter		
dobe Digital Negat	tive Converter		17
t the images to convert			
(Select Folder) /Volu	imes/Big Disk 400 Go/Mast	ter Images/Personal/Amsterdam/	
Include images contain	ned within subfolders		
location to save converte	ed images		
Save in Same Location	•		
(Select Folder) /Volu	imes/Big Disk 400 Go/Mast	ter Images/Personal/Amsterdam/	
Preserve subfolders			
Document Name	(0) +	(\$) +	
Begin numbering: File extension: (udng	0 +	•	
rences			
Compressed (lossless) Preserve Raw Image Don't embed original	Change Preferen	ces)	
	the images to convert Select Folder	dobe Digital Negative Converter the images to convert (defect Fidder) Inservecting this woll colves (include images contained within subfidders) teacher for accounted images Save in Same Location (Reg) defect Fidder) Notementging tools 400 Conteal Neurone subfidders Neurone subfidders Neurone subfidders Neurone subfidders Neurone subfidders Neurone subfidders File extension: dog (Reg) File extension: dog (Reg) (dog (Reg) (dog (Reg)) (dog (Reg))	dobe Digital Negative Converter the inages to convert false Tidder //democrating 004.000 Conference reages/threanal/Americany include images contained within subfiddes. factor to Same Constained images Same to Same Contention //democrating 004.000 Conference reages/threanal/Americany //democrating 004.000 Conference reages/threanal/Americany //democrating //

Figure 11.13 Although there are no cameras yet which are using the DNG file format, Adobe have made the DNG converter program available for free, which can be downloaded from their website: www.adobe.co.uk/products/ dng/main.html. The DNG converter is able to convert raw files from any camera currently supported by the Camera Raw plug-in for Photoshop into DNG files. The advantage of doing this is that you can start making backups of your raw files in a raw file format that will preserve all the data in your raw captures and archive them now in a format that is more guaranteed to be supported in the future. the CD of master files. If I want to access those images today, in some cases I am going to have to track down a computer running Mac OS 8.6 in order to load the camera manufacturer software required to read the data! If that is a problem now, what will the situation be like in 60 years' time?

It is the proprietary nature of all these formats that is the central issue here. At the moment, all the camera manufacturers appear to want to devise their own brand of raw format and therefore if you want to access the data from a raw file, you are forced to use their brand of software to do so. Now while the camera manufacturers are excellent at designing fantastic hardware, the raw processing software they have produced has mostly been quite basic. Just because a company is good at building digital cameras, it does not follow that they are going to be good at designing graphics software to read the raw data.

The DNG solution

Fortunately there are third party companies who have devised ways of processing some of these raw formats. So you are not always limited to using the software that came with the camera. Adobe are the most obvious example here of a company who offer a superior alternative. At the time of writing, Camera Raw will recognise raw formats from over 60 different cameras. The new DNG (digital negative) file format specification has come about partly as a means of making Adobe's life easier for the future development of Camera Raw and making Adobe Photoshop compatible with as many cameras as possible. DNG is a well thought out file format that is designed to accommodate the many specification requirements of all today's cameras and is also flexible enough to adapt to future technologies. Because it is an open standard, the specification is freely available for anyone to develop and to incorporate into their software or camera system. It is therefore hoped that the camera manufacturers will adopt the DNG file format more widely and that the DNG format will be offered as the main raw file format, or at least offered as an

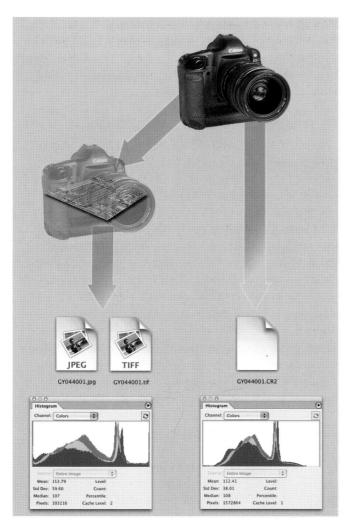

alternative choice on the camera. If this happens then this will bring several advantages. If DNG is adopted there will be less risk of your raw image files becoming obsolescent, as there will be ongoing support for the DNG standard despite whatever computer operating system or platform changes take place in the future. Whenever a new camera is released, the DNG format will allow the raw files to be immediately accessible, assuming the camera is enabled to provide DNG raw files. Figure 11.14 If you shoot using the JPEG or TIFF mode on your camera, the raw conversion is carried out on-the-fly using the camera's on-board computer. All the important tonal editing decisions such as the white balance, the highlight exposure, shadow point and contrast will be decided for you by the camera and permanently fixed in the resulting JPEG or TIFF image. When you shoot using JPEG or TIFF, the camera is immediately discarding up to 88% of the image information captured by the sensor. This is not as alarming as it sounds, because as you know from experience, you don't always get a bad photograph from a JPEG capture. But consider the alternative of what happens if you shoot using a raw mode capture. In the simplified raw workflow shown here, the raw file is saved to the memory card without being processed by the camera. This allows you to work with all 100% of the image data captured by the sensor and you can edit the image later on your computer. The histograms at the bottom illustrate the advantage this can bring. With a JPEG capture you may permanently clip the shadows and highlights. With raw, you will often be able to recover lots more tonal detail.

Camera Raw compatibility

The Camera Raw plug-in won't 'officially' interpret the raw files from every digital camera (check the camera spec PDF on the CD). But Adobe are committed to providing intermittent, free Camera Raw updates to include any new camera file interpreters as they become available. Now understand that while not all raw camera file formats are supported, this is in no way the fault of Adobe. Certain camera manufacturers continue to delude themselves that they know how to write image processing software and have stubbornly refused to play ball with the Photoshop engineers.

Double-click behavior

If you go to the Advanced Bridge settings and check Double-click edits Camera Raw Settings in Bridge, you can switch the behavior so that double-clicking will open raw files via Bridge and not via Photoshop.

Opening a raw image directly

In default mode, with 'Double-click edits Camera Raw Settings in Bridge' deselected in the Advanced Bridge preferences, *Shiff* double-clicking will allow you to open an image or multiple selection of images in Photoshop directly, bypassing the Camera Raw dialog.

Closing Bridge as you open

If you hold down the S all key as you double-click to open a raw image, this will close the Bridge window as you open the Camera Raw dialog.

Camera Raw in Photoshop CS2

The Camera Raw plug-in is an important tool. If you want to get the best quality images from your camera, then you should always shoot raw. And the major advantage of Photoshop is that so long as your camera is supported, you don't have to leave Photoshop to open your raw images.

A significant number of improvements have now been made to the new CS2 suite. The File Browser has been removed and replaced with a standalone program called Bridge that can be shared between all the CS2 suite programs and integrates smoothly with Photoshop CS2.

Camera Raw in use

The combination of the Bridge browser interface and the Camera Raw 3.0 plug-in provides a satisfactory solution for previewing and making edited selections of raw images so that you can use Bridge and Photoshop throughout for all your raw image processing. The mechanics of how Photoshop and Bridge work together have been made as simple as possible so that you can open single or multiple images or batch process images quickly and efficiently. Figure 11.15 summarizes how the linking between Bridge, Photoshop CS2 and the Camera Raw plug-in works.

Central to everything is the Bridge window interface in which you can make your image selection choice. The way most people are accustomed to opening images is to select the desired thumbnail icon (or icons) and either double-click, use the File \Rightarrow Open command or \Re *ctrl* O shortcut. With the default Bridge configuration, all of the above options will open the selected raw image or images via the Camera Raw plug-in dialog and the plug-in will be hosted by Photoshop (if the image is not a raw file, it will open in Photoshop directly). Alternatively, you can use File \Rightarrow Open in Camera Raw... or the $\Re R$ *ctrl* R shortcut to open the images via the Camera Raw dialog. In these instances, Bridge will host the Camera Raw plugin and allow you to perform batch processing operations in the background without compromising Photoshop's performance.

Chapter 11 Digital capture

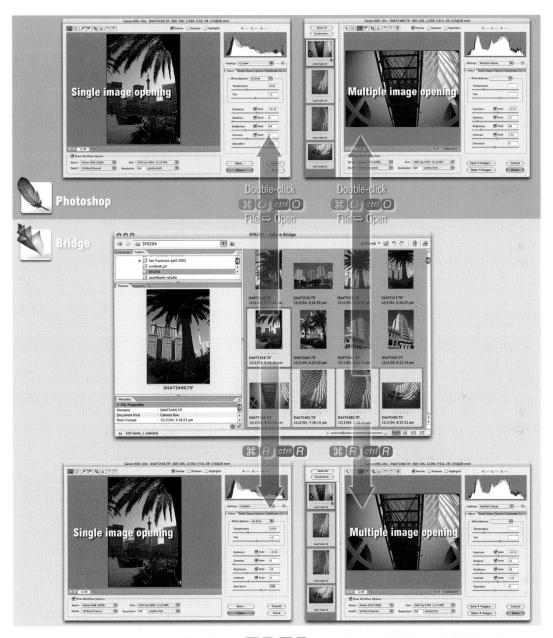

Figure 11.15 You can double-click, use File \Rightarrow Open or $\Re O$ to open single or multiple images from Bridge so that Photoshop hosts Camera Raw. If you use $\Re R$ O Photoshop, Bridge will host the single or multiple Camera Raw dialog. Photoshop is ideal for processing small numbers of images. Opening via Bridge is better suited for processing large batches of images in the background.

Camera Raw tools

🔍 Zoom tool (Z)

Use as you would with the normal zoom tool to zoom in or out the preview image.

🖤 Hand tool (H)

Use as you would with the normal hand tool to scroll an enlarged preview image.

🖋 White balance tool (l)

The white balance tool is used to set the White Balance in the Adjust controls.

Color sampler tool (S)

This allows you to place up to nine color sampler points in the preview window.

4. Crop tool (C)

The crop tool will apply a crop setting to the raw image which will only be applied to the Bridge thumbnail/preview or when the file is opened in Photoshop. It has a submenu of aspect ratio crop presets to which you can add custom crop ratios.

🔺 Straighten tool (A)

You can drag with the straighten tool along a line that is meant to be horizontal or vertical for Camera Raw to apply a 'best fit', straightened crop.

🔊 Rotate counterclockwise (L)

Rotates the image 90° counter clockwise.

C Rotate clockwise (R)

Rotates the image 90° clockwise.

Opening single raw images via Photoshop will be quicker than opening them via Bridge. Opening multiple images via Photoshop will take about the same time, but Photoshop will consequently be tied up managing the Camera Raw processing. The advantage of opening via Bridge is that Bridge can process large numbers of raw files, while freeing up Photoshop to do other work.

General controls for single file opening

When you open a single image, this will reveal the dialog shown in Figure 11.16. The status bar area will summarize the camera EXIF metadata, always displaying in order: the make of camera used, the file name, ISO setting, lens aperture, shutter speed and lens focal length. In the top left corner you have the Camera Raw tools. The main preview enables you to preview any adjustments that you make, and the zoom setting can be set in the pop-up menu just below the preview display. The Preview checkbox toggles previewing the individual changes made in the controls on the right on a panel by panel basis; to see the overall cumulative changes, change the settings from Custom to Camera Defaults and back. Next to this are the Shadows and Highlights buttons. When checked, these will help indicate the shadow and highlight clipping, although I still prefer to hold down the **C** alt key as I adjust the Exposure and Shadows sliders to preview the image in Threshold display mode. At the bottom we have the Show Workflow Options checkbox. When this is selected you can set the file import and output options. The destination color space should ideally match your RGB work space setting configured in the Photoshop color settings, such as Adobe RGB. I would suggest setting the bit depth to 16 bit. This will ensure that the image bit depth integrity is maintained to the maximum when it is converted and opened up in Photoshop. The file size setting will let you open the image using smaller or larger pixel dimensions than the default capture file size (these size options are indicated by + or - signs). The Resolution field lets you set the file resolution in pixels per inch or per centimeter. Note that the value selected here will have no impact on the pixel dimensions.

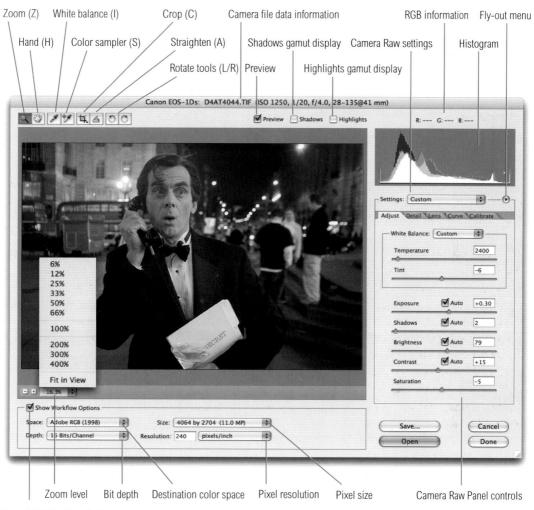

Show/hide Workflow Options

Figure 11.16 The Camera Raw dialog in Photoshop CS2, showing the main controls and shortcuts for the single file open mode. The Open button needs no explanation. The Done button is an 'Update' button. Click this button when you are done making Camera Raw edits and wish to save these settings without opening the image or images.

Adobe Photoshop CS2 for Photographers

Select all images

Adjust Detail Lens Curve Calibrate White Balance: Custom Temperature 2850 Tint -2 Exposure Auto +0.50 Shadows Auto 4 Brightness Auto 64 Contrast Auto 64 Contrast Auto 0	Synchronize Camera Raw settings	Warning triangle warns that the preview image has not refreshed completely yet
Synchronizz	The second s	
DAAT4044 TF DAAT4044 TF DAAT4045 TF DAAT4		Settings: Multiple Values
OAA74045.7F OAA74045.7F Show Workflow Options Space: Adobe RG8 (1998) Depth: 16 Bits/Channel Pepth: 16 Bits/Channel		Shadows Auto 4 Brightness Auto 64
Space: Adobe RGB (1998) \$ Size: 4064 by 2704 (11.0 MP) \$ Save 14 Images Cancel Depth: 16 Bits/Channel \$ Resolution: 300 pixels/inch \$ One 14 Images Cancel		
	Space: Adobe RG8 (1998)	salution 200 nivale/inch

....

......

File navigation controls Save all selected images

ve all selected images

Figure 11.17 Here is a view of the Camera Raw dialog, showing the main controls and shortcuts for the multiple file open mode. The Save option allows you to save a raw file as DNG, TIFF, PSD or JPEG files. The file save processing is then carried out in the background, allowing you to carry on working in Bridge or Photoshop (dependent on which program is hosting the plug-in at the time). And if you hold down the *(a)* (key as you click on the Save... button, you can bypass the Save dialog box, which is really handy if you want to add file saves to a queue as you progress with making more edit changes in this or the single view Camera Raw dialog (see Figure 11.16).

General controls for multiple file opening

The multiple image Camera Raw dialog will appear whenever you open multiple images from Bridge. In the default mode, double-click, File \Rightarrow Open or **HO** *ctt***O** will open the Camera Raw plug-in via Photoshop and File \Rightarrow Open in Camera Raw... or **HR** *ctt***O** will open the Camera Raw plug-in via Bridge.

The multiple image dialog contains a filmstrip of the selected images running down the left-hand side. You can select these images individually to make settings adjustments or make a *Shift* or **H** *cttl* selection and apply specific adjustments to that thumbnail selection. You can navigate through your selection by clicking on the thumbnails in the filmstrip or use the navigation buttons to progress through the images. The Synchronize... button will allow you to synchronize the Camera Raw settings adjustments across all the selected images and the subdialog will let you select which settings should be synchronized. The Select All button can be used to select all images in the filmstrip before you do this.

Destination: Save in New Location		iave
Select Folder /Users/martinevening/Desktop/	G	ancel
File Naming		
Example: D4AT4026.dng		
Document Name +	+	
+		
Begin Numbering:		
File Extension: .dng		
Format: Digital Negative		
Compressed (lossless) JPEG Preview:	Aedium Size	
Convert to Linear Image		
Embed Original Raw File		

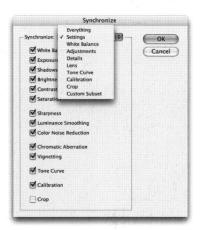

Figure 11.18 When the Synchronize options dialog box appears you can select a preset range of settings to synchronize or make your own custom selection of settings to synchronize between the currently selected images.

Figure 11.19 When you click on the Save x Images... button you have the option of choosing a folder destination to save the image to and a batch file naming dialog so you can customize the file naming as you do so. In the Format section you can choose the file format. For example, when choosing the new DNG format, you can select the desired file format options. A save operation from Camera Raw will always auto-resolve any naming conflicts so as to avoid overwriting any existing files in the same save destination. This is important if you wish to save multiple versions of the same image as separate files. Holding down the area for the save will bypass the save dialog shown here.

Deleting images

As you use Camera Raw to edit your shots, the *Delete* key can be used to mark images to be sent to the trash later. This will place a big red X in the thumbnail and can be undone by hitting *Delete* again.

Image browsing with Camera Raw

In multiple view mode, the Camera Raw dialog will enable you to make picture selection edits. You can match the magnification and location across all selected images to check and compare details, inspect them in a sequence and apply ratings to selected images. If you **#** *ctrl*-click on the Select All button, it will select the rated images only.

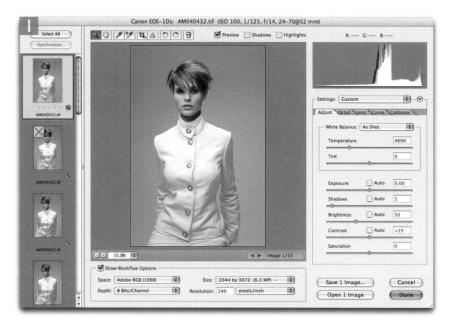

1 If you have a large folder of images to review with a sequence of images, the Camera Raw dialog can be configured to provide a synchronized, magnified view of all the selected pictures. The dialog is shown here in a compacted mode, but on a normal display you can expand the dialog to fill the screen.

2 I clicked on the first image in the sequence and then clicked on the Select All button. I then used the zoom tool to magnify the image. This action will synchronize the zoom view display for all selected images in the Camera Raw dialog. You can also use the hand tool to synchronize the scroll location for all the images.

3 Once this has been done you can deselect the thumbnail selection and scroll through all the images. This can be done by clicking on the file navigation controls or by using the () keyboard arrow keys to progress through the images. You can then mark your favorite pictures by using the usual Bridge shortcuts: **H** > *ctrl* > will progressively add more stars to a selected image. **H** < *ctrl* < will progressively decrease the number of stars.

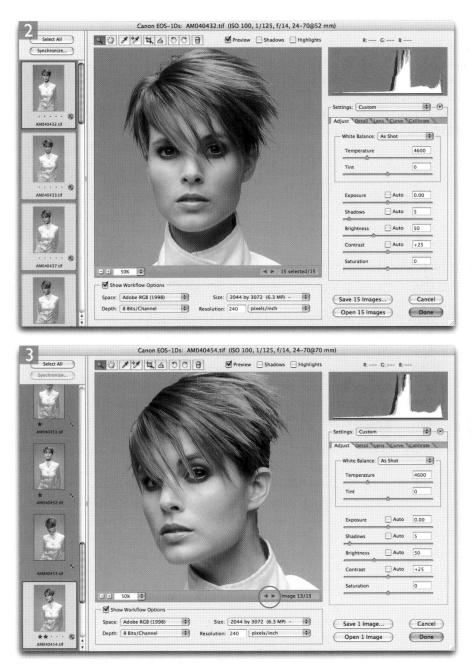

Client: Alta Moda. Model: Nicky Felbert @ MOT.

Color temperature

In the world of traditional color photography we basically had just two color temperature choices when choosing a film emulsion: daylight and tungsten. Daylight film for outdoor photography and studio flash was rated at 5500 degrees Kelvin and Tungsten at 3200 degrees Kelvin. These absolute values would rarely match the lighting conditions you were shooting with, but they would enable you to get roughly close to the appropriate color temperature of the light you were using in either a daylight/strobe lighting or indoor/tunasten light setting. One could then fine-tune the color temperature by using filters over the camera lens or color gel filters over the lights themselves.

Camera Raw white balance

The Camera Raw plug-in was designed by Thomas Knoll, one of the original creators of the Photoshop program. Thomas has cleverly used two profile measurements, one made under tungsten lighting conditions and another done using daylight balanced lighting and used these to calculate the white balance adjustment between these two white balances and then extrapolated the data to calculate the white balance going to extremes either side of these measured values.

Adjust panel controls

The Adjust controls are best approached and adjusted in the order you find them. The White Balance refers to the color temperature which essentially describes the warmth or the coolness of the lighting conditions. Tungsten lighting has a low, warm color temperature, while daylight has a higher, more blue color temperature. It does not matter how you set the white point settings at the time of shooting. That is the beauty of shooting in raw mode, you can decide later which is the best white balance setting to use. The white balance setting will normally default to using the 'As Shot' white balance setting embedded in the raw file metadata at the time the image was taken. This might be a fixed white balance setting that is used on your camera or it could be an auto white balance made at the time the picture was shot. If this is not correct, you can try mousing down on the White Balance pop-up menu and select a preset setting that correctly describes the white balance used. Alternatively, you can simply adjust the Temperature slider to make the image appear warmer or cooler and adjust the Tint slider to balance the white balance green/magenta tint bias. The easiest way to do this is to select the white balance tool and click on an area that is meant to be an off-white color (you will notice that as you move the tool across the image, the RGB values will be displayed above the histogram). If you refer back to Figures 11.16 and 11.17 there was a lot of mixed lighting in these shots, and because of this I found that clicking with the white balance tool on the various whites could produce quite different results. In the end I clicked on the white shirt where it was slightly in shadow. This produced the most useful white balance measurement.

The image tonal adjustment controls are next. These allow you to make further adjustments to the way the Camera Raw data will be interpreted when it is converted into an image that can then be opened in Photoshop. The raw data exists in a different type of gamma space compared to the images we are normally used to working with. Camera sensors have a linear response to light and the unprocessed raw files exist in what is referred to as a linear gamma space. Human vision interprets light in a non-linear fashion, so one of the main things a raw conversion has to do is to apply a large gamma correction to the original image data to make the correctly exposed, raw image look good to our eyes (Figure 11.22 provides a visual illustration of this aspect of the raw conversion process). So the preview image you see in the Camera Raw dialog presents a gamma corrected preview of the raw data. But the adjustments you apply in Camera Raw are in fact being applied to the raw, linear data.

The reason I mention this is to illustrate one aspect of the subtle but important differences between the tonal edits that can be made in Camera Raw and those you can make in Photoshop. The Exposure slider is a little like the input highlight slider in the Levels dialog. Dragging to the right will brighten the highlights and dragging to the left will darken them. And if you hold down the state alt key as you drag the Exposure slider, you get to see a threshold mode preview. This can make it easier to determine the optimum setting. But Camera Raw can sometimes use extra tricks such as ignoring digital gain values used to create higher ISO captures. Camera Raw can also cleverly utilize highlight detail in whichever channels contain the best recorded highlight detail and thereby boost the detail in the weakest highlight channel. There are limits as to how far you can push Camera Raw, but one may be able to recover as much as a stop of overexposure. The Shadows slider is a little less critical, but again I find it useful to hold down the **all** key to obtain a threshold mode preview display to help determine the point where the shadows just clip. The Brightness control is like the gamma slider in Levels, you can use it to adjust the relative lightness of the image to be processed. And below that are the Contrast and Saturation sliders. I mostly like to increase the contrast amount and sometimes boost the saturation as well. But there are also times when it is useful to reduce the contrast to help restore shadow and highlight information in a contrasty capture.

Auto Settings

The auto settings will mostly produce nicely optimized images that need little extra adjustment. And as soon as you make a custom adjustment, the check mark will disappear. To disable the auto settings and set the default to 'off', simply go to the fly-out menu (circled) and deselect the Use Auto Settings item in the menu or use the **EU** ctrlU shortcut.

ust Detail L	ens Curve	Calibrate
White Balance:	As Shot	•
Temperature	in an a	4600
Tint	<u>¢</u>	0
Exposure	Auto	-0.60
Shadows	Auto	1
Brightness	Auto	82
Contrast	Auto	0
Saturation		0

Figure 11.20 The Camera Raw Adjust panel controls. Camera Raw 3.0 features default auto settings for the Exposure, Shadows, Brightness and Contrast.

Shadow and highlight clip boxes

I am so used to using the register at the switch to threshold preview mode to help spot the point where the highlights and shadows get clipped. But if you check the Shadows and Highlights boxes in the Camera Raw dialog, color gamut clipping warnings will appear in the preview image.

Martin Evening Adobe Photoshop CS2 for Photographers

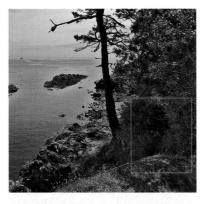

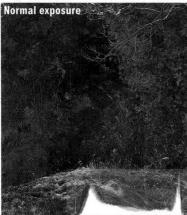

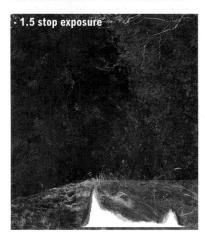

Digital exposure

Digital shooting requires a whole new approach to determining the optimum exposure setting compared to shooting with film. Most digital cameras such as the popular digital SLRs and even the raw enabled compacts are capable of capturing 12 bits of data, which is equivalent to 4096 recordable levels per color channel. As you halve the amount of light that falls on the chip sensor, you potentially halve the number of levels that are available to record an exposure. Let us suppose that the optimum exposure for a particular photograph is f16. This exposure will make full use of the chip sensor's dynamic range and consequently the potential is there to record up to 4096 levels of information. If one were then to halve the exposure to f22, you would only have the ability to record up to 2000 levels per channel. It would still be possible to lighten the image in Camera Raw or Photoshop to create an image with similar contrast and brightness. But, and it's a big but, that one stop exposure difference has immediately lost us half the number of levels that could potentially be caught at a one stop brighter exposure. The image is now effectively using only 11 bits of data per channel instead of 12. This is true of digital scanners as well. You may have already noticed how difficult it can be to rescue detail from the very darkest shadows, and how these can end up looking very posterized. Have you also noticed how much easier it is to rescue highlight detail compared to shadow detail when using the Shadow/Highlight adjustment? This is because the shadow areas may have as few as 32 levels or less to digitally record the light information in the darkest areas of the picture. This is why posterization is more noticeable in the shadows. It also explains why it is important to target your digital exposures as carefully as possible so that you make the brightest exposure possible, but without the risk of blowing out highlight detail.

Figure 11.21 This shows the difference that correctly exposing to the right can make in retaining shadow information. The darker the exposure, the fewer discreet levels the CCD chip can capture and this can result in poor, compromised shadow detail.

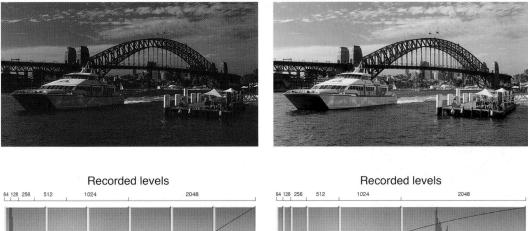

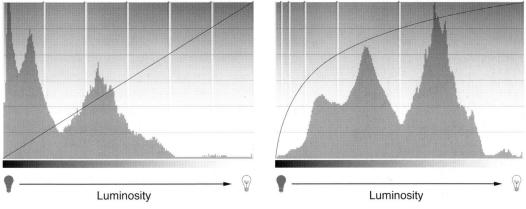

Figure 11.22 If you inspected the images your camera captured as raw files, they would look something like the image shown top left. Notice that the image is very dark, it is lacking in contrast and the levels (representing the tonal information) in the histogram appear to be mostly bunched up to the left. During the raw conversion process, a gamma curve correction is applied when converting the linear data so that the processed image matches the way we are used to viewing the relative brightness in a scene. The picture top right shows the same image after a basic raw conversion.

A consequence of this is that the more brightly exposed areas will preserve the most tonal information and the shadow areas will end up with fewer levels. A typical CCD sensor can capture up to 4096 levels of tonal information. Half these levels will be recorded in the brightest stop exposure range and the recorded levels are effectively halved with every stop decrease in exposure. The digital camera exposure is therefore quite critical. Ideally, you want the exposure to be as bright as possible so that you make full use of the levels histogram, but at the same time are careful to make sure the highlights don't get clipped. As a side note, the histograms that appear on your camera LCD are unreliable because these are usually based on the camera-processed JPEG and not representative of the true raw capture.

Panel previews

The initial Camera Raw dialog displays the Adjust panel control settings. In this mode the Preview checkbox will allow you to toggle previewing any global adjustments made in Camera Raw. Once you start selecting any of the other panels, the Preview will toggle showing only the changes that have taken place within that particular panel.

Figure 11.23 After opening or applying Done to an image from the Camera Raw dialog a settings icon will be displayed in the bottom right corner of the image thumbnail to indicate that the image has been adjusted in Camera Raw.

Detail panel controls

The Detail settings allow you to make improvements to the smoothness and sharpness of the raw conversion and compensate for any color noise. To make a proper judgement when using any of the detail slider controls, you should preview the image at 100%. The default settings will apply a 25% sharpening. This is a fairly gentle amount, but I prefer to leave the processed images unsharpened and carry out all the sharpening in Photoshop, starting with a capture sharpen, as described in Chapter 4 which will make the image slightly sharper before applying a larger amount of sharpening prior to output.

But it is nonetheless useful to see sharpening applied to the preview images in Camera Raw as this will help you make better judgements when making tonal and contrast edit adjustments. If you mouse down on the small triangle next to the Camera Raw settings you can open the Camera Raw preferences shown in Figure 11.25. I prefer to set the sharpening so that it is applied to the preview images only and then leave the Detail Sharpness setting at 25%.

Whenever you shoot using a high ISO setting on the camera, you will almost certainly encounter noise in your images. The Luminance Smoothing and Color Noise Reduction can be used in conjunction to improve the appearance of images that suffer from such noise artifacts. The luminance smoothing can be used to smooth out the physical clumpiness of the noise artifacts while the color noise reduction can soften the color and get rid of the colored speckles. The noise will vary a lot from camera to camera, so it is hard to give out any specific settings advice. You can safely set the color noise reduction to maximum. Figure 11.24 shows the settings used on a fairly grainy capture that was shot using the camera's maximum 1250 ISO setting. The luminance should probably not be set any higher than the 15% setting used here. I would recommend that you also consider using the Reduce Noise filter in Photoshop as a method for reducing heavy image noise artifacts.

Chapter 11 Digital capture

Canon	EOS-1Ds: D4AT4044.TIF (ISO 1250, 1/20, f/4.0, 28-135@41 mn	n)	
20/19/4.400	🗹 Preview 📄 Shadows 📄 Highlights	R: G: B:	-
		ettings: Custom Ndjust Detail Lens Curve Sharpness (Preview Only) Luminance Smoothing Color Noise Reduction	25 15 100
Image: 100% Image: 100% <t< th=""><th></th><th>Save Open</th><th>Cancel Done</th></t<>		Save Open	Cancel Done

Figure 11.24 The Camera Raw Detail panel controls. The preview is shown here divided in two. The top half shows the before image and the bottom half the preview with the luminance smoothing and color noise reduction applied. Mouse down on the Camera Raw settings options (circled) to select the Camera Raw Preferences dialog shown below in Figure 11.25.

Save image settings in	: Sidecar ".xmp" files		OK
Apply sharpening to	: Preview images only	•	Cancel
Camera Raw Cache			7
Maximum Size: 1.0	GB Purge Cache)	
Select Location	/Users/martinevening/Library	/Caches/Adobe Camera Raw/	

Figure 11.25 Here is the Camera Raw Preferences where you can set the Sharpening to apply to Preview images only. I would also suggest having the Camera Raw image settings saved as sidecar '.xmp' files (this is discussed on page 456). You may also want to increase the Camera Raw cache if you have enough free hard disk space available.

Figure 11.26 If you hold down the all all key as you make adjustments to the Red/Cyan Chromatic aberration controls you can hide the Blue/Yellow color fringing. Do the same with the Blue/Yellow Chromatic aberration controls to hide the Red/Cyan color fringing.

Lens panel controls

The Lens controls can help correct some of the optical problems that are associated with digital capture. If you inspect an image closely towards the edge of the frame area, you may notice some color fringing, which will be most apparent around areas of high contrast. This is mainly a problem you get with cheaper lens optics used on some digital cameras. The Chromatic Aberration controls should be used with the preview image set to 100% and can help remove any visible color fringing. The Red/Cyan Fringe adjustment works by adjusting the scale size of the red channel relative to the green channel and the Blue/Yellow Fringe slider will adjust the scale size of the blue channel relative to the green channel. The chromatic aberration controls are also available in the Lens Correction filter.

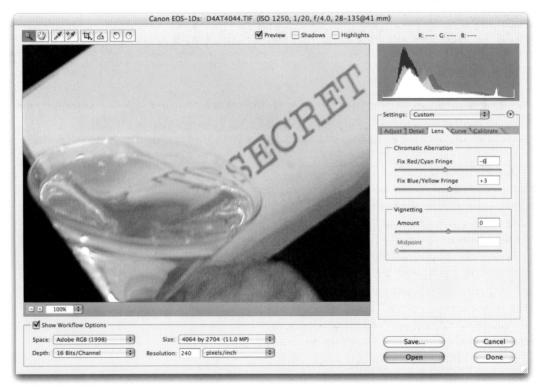

Figure 11.27 The Camera Raw Lens panel controls.

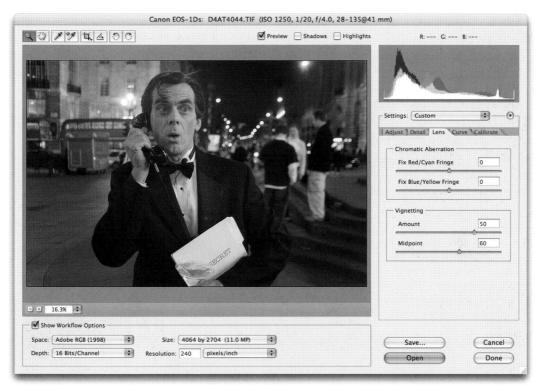

Figure 11.28 The Camera Raw Lens panel controls where the vignette controls have been used to lighten the corners of the picture to produce a more evenly balanced exposure towards the edges of the frame.

Vignette control

With some camera/lens combinations you may see some brightness fall-off to occur towards the edges of the picture frame. This will result in the corners being more darkly exposed compared to the center. This is a problem you are more likely to encounter with wide angle lenses, and you may notice the deficiency if the subject features a blue sky or a plain, evenly-lit background. The vignetting amount will apply a gentle lightening exposure from the center outwards. The Vignetting Midpoint slider will offset the fall-off exposure correction. As you increase the Midpoint value, the exposure compensation will be accentuated more towards the outer edges.

Raw processing comparisons

There are a lot of strong opinions out there as to which is the best raw processing program to use. But there are also some misleading reviews which are simply based on a comparison made using the default program settings. A good review should feature an in-depth look at all the image adjustment options before making any definitive conclusions.

Curve panel

The Curve panel control is a fine-tuning control that is applied to the image in combination with the initial adjustments made in the Adjust panel controls. The Tone Curve allows you to set your preferred tone curve behavior for Camera Raw processing. The default setting uses a Medium Contrast curve which applies a moderate increase in contrast and arguably matches the default contrast applied by most cameras when they carry out their onboard processing to produce a JPEG image. So this default setting combined with the auto settings will probably produce the 'snappiest' looking results. But it is just a default and it is quite simple to turn the curve off by setting it to Linear and this can become your new default.

Figure 11.29 Here is the Camera Raw Curve panel using the Medium Contrast curve. The top left portion of the image preview shows the tone curve being applied.

Calibrate panel controls

The Camera Raw plug-in is the product of much camera testing and raw file analysis carried out by Thomas Knoll. The list of cameras that the latest plug-in is compatible with can be found at the Adobe website and following this link: www.adobe.com/products/photoshop/cameraraw.html. The test cameras were used to build a two part profile of each camera sensor's spectral response under tungsten and daylight lighting conditions and from this, the Camera Raw processor is able to calculate a pretty good color interpretation under these lighting conditions, and beyond, across a wide range of color temperature lighting conditions. This method is not as accurate as having a proper profile built for our camera and to be honest, profiling a camera is something that can only really be done where the light source conditions are always the same, because you would need to re-profile the camera every time the lighting changed.

The Calibrate panel controls provide a mechanism for fine-tuning the color adjustments in Camera Raw so that you can customize the Camera Raw output and produce a custom calibration for each individual camera and the specific lighting conditions. This system of calibration requires a little extra effort, but if you are always shooting with the same camera in a studio using the same lighting setup, then it is worth doing. I also create a calibration setting if I am shooting on location under unusual lighting conditions such as when I shot a building interior which was lit entirely using fluorescent strip lights. The tutorial on the following pages describes how I was able to use a Gretag MacBeth color checker chart in conjunction with the Camera Raw white balance and calibrate controls to create a custom Camera Raw setting that could be applied to all the images I had shot in the interior that day and apply an effective color correction at the raw processing stage.

Real World Camera Raw

For a definitive explanation of Camera Raw and Bridge and a more detailed explanation of how to create a custom Camera Raw calibration for your camera, I highly recommend you buy 'Real World Camera Raw in Photoshop CS2' by Bruce Fraser, published by Peachpit Press.

Camera Profile: ACR 3.0	\$
Shadow Tint	+3
Red Hue	+4
Red Saturation	+17
Green Hue	-5
Green Saturation	-17
Blue Hue	+5
Blue Saturation	-13

Figure 11.30 The Camera Raw Calibrate panel controls are used to fine-tune the Camera Raw color interpretation. The Camera Profile setting at the top can offer a choice of camera profile settings. The reason for this is that some of the original Camera Raw profiles that came with the Camera Raw plug-in did not necessarily reflect the best average chip performance of the supported cameras. So some camera profiles have been updated and made available as ACR 3.0 profiles. These profiles will be better than the ACR 2.4 setting. but the older profile is still there so as to not cause conflict for those users who wish to continue using this profile with their pre-saved calibrations.

1 This interior was shot entirely with the available fluorescent strip lighting. The default camera settings produced an image with a heavy yellow/green color cast.

2 To calibrate the camera for this lighting setup I needed to place a Gretag MacBeth color checker chart in the scene and take a photograph of it under the same lighting conditions and compare the Camera Raw preview of the photographed chart with a synthetic color chart in Photoshop. Bruce Lindbloom has produced a synthetic ColorChecker Calculator image which can be downloaded from his website at: www.brucelindbloom.com. The synthetic image is in Lab mode so I first needed to convert the image to my Adobe RGB work space by choosing Image
⇒ Mode ⇒ RGB Color. I opened the synthetic ColorChecker image and the raw capture image so that both could be viewed side by side.

To set the white balance, I selected the white balance tool and clicked on the light gray patch (circled) adjacent to the white patch, because choosing the brightest white can easily produce a false result. I then made some initial tonal adjustments to get the chart in the Camera Raw preview to match the synthetic chart.

3 I began by adjusting the Exposure slider until the white patch was just clipped. I then selected the color sampler tool in Camera Raw and clicked to place a sample point on the Black patch and adjusted the Shadow slider until the RGB values were close enough to R 53 G 53 B 53. I then dragged this sample point to the light gray patch (next to the white patch) and placed three more sample points as shown here. I started by checking the two middle gray patches, which were referenced by the #2 and #3 color sample readouts. By checking the number values for the gray patches, shown in Figure 11.31, I was able to adjust the Brightness and Contrast sliders to obtain a close match between the captured chart and the Synthetic color checker chart. I clicked on the Clear Samples button and switched to the Calibrate panel controls.

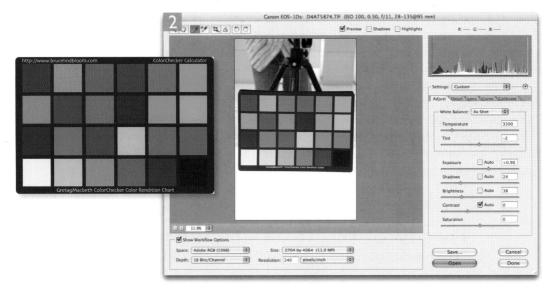

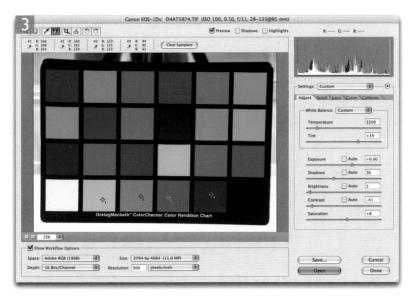

4 I placed a new color sampler on the Shadow patch and adjusted the Shadow tint until the RGB readouts were as even as possible. I cleared the samples again and set the four points as shown here. I now wanted to concentrate on getting a good match for the red, green and blue patches. One can just make a visual comparison between this and the synthetic chart patches, or refer again to the chart in Figure 11.31 and adjust the Calibrate panel Hue and Saturation sliders and aim for a closely matching relationship between the RGB values at each patch. It is recommended that you adjust the green hue and saturation first and then move on to the blue and lastly the red hue and saturation.

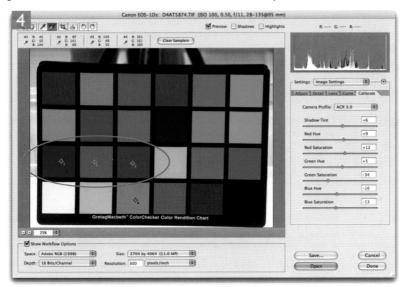

Adobe Photoshop CS2 for Photographers

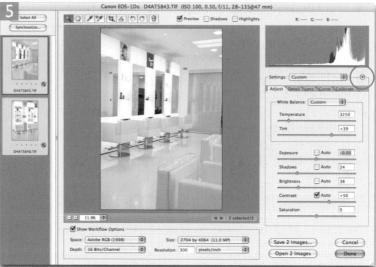

5 As you adjust the individual Hue and Saturation color sliders you will notice that each will have an impact on the other two color values. It is virtually impossible to obtain an exact match, but with careful fine-tuning you should be able to get fairly close. I then went to the Camera Raw options (circled) and chose Save Settings Subset... I selected Custom Subset and checked the White Balance and Calibrate boxes only and clicked Save... The next dialog will prompt you to name the setting and save it in the Application Support\Adobe\Camera Raw\Settings folder. This saved subset setting will ignore the initial Exposure, Shadows, Brightness and Contrast settings that were set at the beginning. It saves just the white balance and calibrate settings. Once saved, this setting will always be accessible from the Settings menu in Camera Raw and you can use it to apply to single or multiple images that were shot using the same lighting conditions to obtain a more perfect color rendition of the scene photographed with an individual camera. If you don't want to go to the bother of creating a custom setting, you can simply update the calibrated image by clicking Done and choose 'Previous Conversion' from the Settings menu to apply this calibration to other images in a series. Although you may perhaps need to reset the Adjust panel settings before doing this.

Figure 11.31 The numbers shown here refer to a Lab space Synthetic color chart that has been converted to the Adobe RGB color space.

Saving and applying Camera Raw settings

Each time the Camera Raw dialog opens you have a choice of Camera Raw settings that can be applied to the selected image or images. The default Image Settings will use the last saved setting. The Camera Default setting will use the white balance settings recorded when the image was captured, while the Previous Conversion setting will utilize the settings applied to the last image that was opened using Camera Raw. Or you can create a new custom Camera Raw configuration. As I explained in the example on the previous page, you can save a Camera Raw setting or subset setting with the intention of creating a new custom preset that can be easily accessed via the Settings menu. Go to the fly-out menu, choose Save Settings... or Save Settings Subset... and save a named setting that will in future be accessible whenever you use Camera Raw.

Once you have configured the Camera Raw settings you will be ready to click on the Open button and open the image in Photoshop. When you do this, the settings you have applied will be saved to the Camera Raw database. Or, you can have this information saved as a sidecar '.xmp' file to the same folder location as the original raw file. If you go to the fly-out menu in the Camera Raw dialog and choose Preferences... (see Figure 11.25), the default Save Image Settings preference should show: Sidecar '.xmp' files. Saving the applied settings to the Camera Raw database may be a tidier solution, but it means that only your computer will then be able to access this database. The saved settings are used to regenerate the thumbnails and preview images in Bridge. It is not necessary to open or save the image in order to save the Camera Raw settings. If you click the Done button an xmp settings file will be saved without opening the image from Camera Raw.

Now let's look at sharing the Camera Raw settings across multiple images. If you have a multiple selection of images in the Camera Raw dialog, you can make a selection of images from the filmstrip or click on the Select All button to select all images, then any adjustments you make to the selected image will be simultaneously updated

Figure 11.32 The Camera Raw image settings will always default to 'Image Settings' which will be the last saved Camera Raw setting for that image. The Camera Default will set the white balance setting to the one embedded at the time the picture was captured. The Previous Conversion will apply the Camera Raw setting that was applied to the previous image. If you make any custom changes in the Camera Raw dialog then the Settings will change to, say, Custom. For as long as the dialog remains open you can select any of these four settings plus any of the previously saved Camera Raw settings which will appear listed below the divider.

Figure 11.33 The Camera Raw buttons. The behavior of the Done button is exactly the same as the Update button in the previous version of Camera Raw.

Sidecar .xmp files

If you select the save sidecar files option, sidecar '.xmp' files will accumulate in the same folder as the raw camera files. The reason for having sidecar files is because the header in raw camera files cannot always be edited. Some camera manufacturers have been willing to share information about their file formats with Adobe. Others have not, and that is why keeping the metadata stored in a separate file has been necessary. Sidecar files normally remain hidden from view in Bridge (unless you select Show Unreadable Files in the Bridge View menu). If you move the folder location of a raw camera file using Bridge, the sidecar file will (by its nature) move with it. The advantage of saving sidecar files is that they are very small in size and any previously applied settings will always be accessible should you want to burn the files to a CD or DVD or share with another user.

The DNG format was designed to be an open format and the means for storing settings in metadata is well defined. Camera Raw can therefore store settings files in saved DNG files, thereby eliminating the need for sidecars.

Save As:	Lightingsetup-1.xmp	
<	Settings	
Network Macintosh HD Storage 120G8 RAID Zoe HD Big Disk 400 Go MAXTOR	🕷 Settings	elinchrom.xmp Einchrom2.xmp interior Rourescent.xmp Prolinca lights.xmp studio tungsten.xmp
Desktop martinevening Applications Documents Movies	-	

in the other images as well. Alternatively, if you make adjustments to a single image, then include other images in the filmstrip selection and click on the Synchronize... button, this will pop the Synchronize dialog which looks exactly like the Save Settings Subset dialog shown in Figure 11.34. Select the specific settings you wish to synchronize and click OK. The Camera Raw settings will now synchronize to the currently selected image. You can also copy and paste the Camera Raw settings via Bridge. Select an image and choose Edit \Rightarrow Apply Camera Raw Settings \Rightarrow Copy ($\Re \ C \ Ctr(alt \ C)$). Select the image or images you wish to paste the settings to and choose Edit \Rightarrow Apply Camera Raw Settings \Rightarrow Paste ($\Re \ C \ Ctr(alt \ C)$).

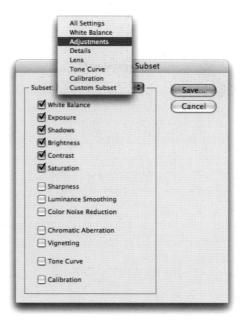

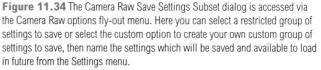

Camera Raw black and white conversions

The Camera Raw settings will also let you make monochrome conversions from a raw digital capture. All you have to do is set the Saturation slider to 0% and play around with the Tonal adjust and Calibrate panel controls to create different monochrome conversions which you can then save as custom presets for future use.

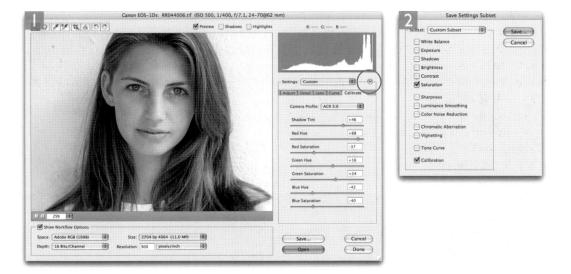

1 I first went to the Adjust panel and turned the saturation down to the lowest setting and adjusted the Exposure, Shadows, Brightness and Contrast settings. I then went to the Calibrate section and experimented with different hue and saturation settings. In this example I was looking for the best monochrome conversion for the skin tones.

2 After finding a combination of Adjust and Calibrate settings that I liked, I moused down on the arrow button next to the Settings menu (where it says Custom) and chose Save Settings Subset... from the menu. I first selected Calibrate from the Subset options, but then also checked the Saturation checkbox and clicked on the Save... button to save this as a custom monochrome conversion preset.

3 I saved the custom subset setting to the Camera Raw settings folder. When you do this, the next time you open the Camera Raw dialog this saved setting will appear in the main Camera Raw Settings list. One could also try experimenting with different white balance settings as well to create interesting conversions.

Removing a crop

To remove a crop, open the image in the Camera Raw dialog again, select the crop tool and choose Clear Crop from the menu. Alternatively, you can hit *Delete* or simply click outside of the crop in the gray canvas area.

Camera Raw cropping

You can crop an image in Camera Raw before it is opened in Photoshop. Camera Raw cropping is limited to cropping within the bounds of the image area and is non-permanent. The crop will be applied when the image is opened and also updated in the Bridge thumbnail and preview. The Camera Raw Straighten tool can initially be used to measure a vertical or horizontal angle and apply a minimum crop to the image, which you can then resize accordingly. If you save a file out of Camera Raw using the Photoshop format, there is also an option to preserve the cropped pixels.

Canon EOS-11	Ds: D4AT2399.TIF (ISO 100, 1/400, f/8.0, 24-70@55	5 mm)	
	Preview 🔄 Shadows 📄 Highlights	R: G:	B:
Vormal 1 to 1 2 to 3 3 to 4 4 to 5 5 to 7 Custom Clear Crop		Settings: Custom Adjust Detail Lens C White Balance: Custo Temperature Tint	
		Exposure	
	,,	Brightness	luto 53
	and the second sec	Contrast	uto +52
• <u>16.3%</u>		Saturation	+9
Show Workflow Options Space: Adobe RGB (1998) 3 Crop Size: 3905 Depth: 16 Bits/Channel 3 Resolution: 300	by 2144 (8.4 MP) : pixels/inch :	Save Open	Cancel Done

Figure 11.35 The Camera Raw crop tool suboptions include a range of preset crop proportions where you can add your own custom presets by clicking on the Custom... item in the menu shown here. The crop units can be adjusted to crop according to the aspect ratio (the default) or by pixels, inches or centimeters.

Multiple raw conversions of an image

The Merge to HDR command provides an interesting first step into the world of high dynamic range photography. The chief disadvantage is that you have to remember to take sequential captures at the time of shooting and there must be absolutely no movement in the subject you are photographing.

It has been suggested that we may see one-shot cameras come to market with extended dynamic ranges during the lifetime of this book. And we are already seeing the potential to record a wide range of tones with the cameras that are in use today. To get the most out of your raw files it can sometimes be useful to have the Camera Raw plug-in make two or more conversions and combine these together as layers in a single image and then blend them together to produce a composite image.

One way to create two interpretations from a Camera Raw file is to open an image via Camera Raw, make some initial adjustments and click Open. Return to Bridge to open the same file a second time, and it will open via Camera Raw again (rather than bouncing you to the file that was already open). You can then make separate adjustments to achieve a different tonal rendering and save the image again. The Camera Raw plug-in is able to distinguish the number of saves you have done and append an additional number at the end of the file after each save so as to avoid accidentally overwriting the original image or additionally saved files.

The other method you can use is to place the raw file as a Smart Object in Photoshop. To do this, you need to select a raw file in Bridge and go to the Bridge main menu and choose File \Rightarrow Place \Rightarrow Photoshop CS2. This is the simplest way to convert a raw image into a Smart Object. Once the image is placed in this way you can create an unlinked duplicate of the Smart Object layer by choosing Layer \Rightarrow Smart Objects \Rightarrow New Smart Object via Copy. Then go to the Layers palette and choose Edit Contents to make adjustments to the original and copied Smart Object layer or layers.

Curve panel contrast control

The Curve panel adjustment allows you to apply a preset or custom tone curve to the raw data before opening it in Photoshop. The tone curve control will enable you to apply improved tonal corrections at the raw processing stage in which you can soften or boost the contrast of the image as necessary. The curve control can also do a much better job than before of recovering detail in the shadow and highlight areas before you bring the processed raw image into Photoshop.

Camera Raw Smart Objects

A Smart Object is storing the before (the raw file data) and the after (the processed pixels) as a single unit inside Photoshop.

Martin Evening Adobe Photoshop CS2 for Photographers

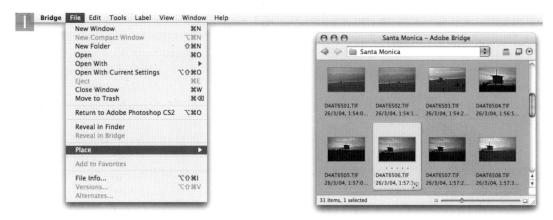

1 I selected an image in Bridge and chose File
⇒ Place from the Bridge menu. This opened the selected image in Photoshop and placed it as a Smart Object Layer above a Background layer.

2 As the layer was placed, the Camera Raw dialog opened allowing me to edit the Camera Raw settings before clicking Open to OK the settings for this first placed, Smart Object layer. I then moused down on this first Smart Object layer using *ctrl* right mouse (to access the contextual menu) and selected New Smart Object via Copy.

3 This duplicated the Smart Object layer and allowed me to select Edit Contents from the Layers palette menu and apply a lighter image adjustment to bring out more detail in the shadows. After that I clicked the Open button to OK the adjustment. This updated the Smart Object copy layer. Finally, I added a layer mask to the copy layer and applied a black to white gradient to create a fade between the two smart object layers.

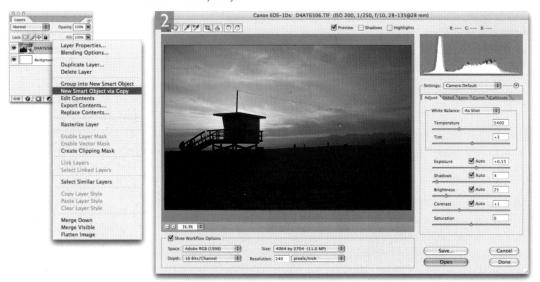

Chapter 11 Digital capture

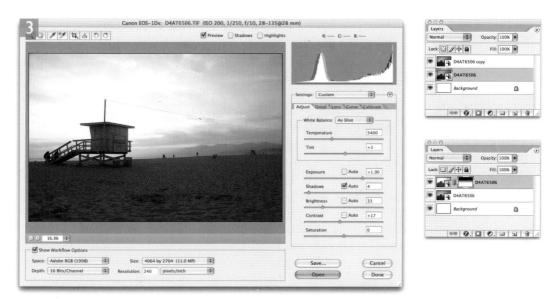

4 This technique can be adapted in various ways. You can use the layer blending options to change the layer blend mode or double-click the layer to open the Layer Style dialog where you can adjust the Blend if: This Layer options to adjust the transition between the two Smart Object layers.

Storage

If you are inclined to get carried away shooting lots of photographs, how are you going to save all the images that you capture and archive them? Let's say each raw capture file is just less than 10 MB in size. That means you can store up to 65 exposures (just less than two rolls of 35 mm film) on a recordable CD disk. The Imacon Ixpress in single shot mode can shoot six raw 16-bit, 96 MB files in less than 10 seconds. But you would need to burn a whole CD to archive those six shots. Even with a ×48 speed CD recorder, it would take at least five minutes to load, write and verify each disk. I typically use DVD media to archive my capture files. DVD disks can store around 4.2 GB of data and it looks like the storage capacity of DVD is going to increase. Although the DVD recorder I use is not as fast as a CD recorder, it is possible to devise a workflow where everything that has been shot in a day can be copied across to a single DVD disk. Even if the process takes half an hour on a standard DVD recorder. this is something that can be done in the background at a suitable time and does not necessitate hanging around the computer swapping a pile of CD disks in and out of the machine. I then keep one copy of the raw files stored on an external hard drive and on DVD as a backup.

Pros and cons of going digital

A really important benefit of digital shooting is increased productivity. When a client commissions a photographer to shoot digitally, they have an opportunity to see the finished results straight away and approve the screen image after seeing corrections. The picture can be transmitted by FTP to the printer (or wherever) and the whole shoot 'signed off' the same day. Because of the capital outlay involved in the purchase and update of a digital camera system, it is not unreasonable for a photographer to charge a digital premium, in the same way as the cost of studio hire is normally charged as an expense item. Digital capture is all too often being promoted as an easy solution and unfortunately there are end clients who view the advantages of digital photography purely on the basis of cost savings: increased productivity, fast turnaround and never mind the creativity. Some clients will look for the material savings to be passed on to them regardless, but I find that nearly all are willing to accept a digital capture fee on top of the day rate. They will still be able to save themselves time and money on the film and processing plus further scanning costs. And as photographers are getting involved in the repro process at the point of origination, there is no reason why you should not consider selling and providing an extra menu of services associated with digital capture, like CMYK conversions, print proofing and image archiving.

Digital photography has become firmly established as the way of the future. But making the transformation from analog to digital can be a scary process. The photographer is rightly anxious to keep their customers happy and often compelled to invest in digital camera equipment because they will otherwise lose that client. Meanwhile clients want to see better, faster and cheaper results. But they also wish to avoid the disasters brought about through digital ignorance. For photographers this is like a replay of the DTP revolution that saw a massive shake-up in the way pages were published. For newcomers, there is a steep learning curve ahead, while for experienced digital pros there is absolutely no going back.

Chapter 12

Resolution

his chapter deals with the issues of digital file resolution. How should you define the resolution of an image and how big a file do you need to make a print at a particular size? When we talk about resolution in photographic terms, we normally refer to the sharpness of the lens or fineness of the emulsion grain. In the digital world, resolution relates to the number of pixels contained in an image. Every digital image contains a finite number of pixel blocks that are used to describe the image, and the more pixels you have, the more detail the image can contain. The pixel dimensions are an absolute value: a 2400 × 3000 pixel image could be output as 12" × 15" at 200 pixels per inch and the megabyte file size would be 20.6 MB RGB or 27.5 MB CMYK. A 2500 × 3500 pixel image could reproduce as an A3 or full bleed

The pixel resolution

The pixel dimensions are the surest way of defining the size of a digital file. If we have a digital image where the dimension along one axis is 3000 pixels, these pixels can be output at 10 inches at a resolution of 300 pixels per inch or 12 inches at a resolution of 250 pixels per inch. This can be expressed clearly in the following formula: number of pixels = physical dimension \times (ppi) resolution. In other words, there is a reciprocal relationship between pixel size, the physical dimensions and resolution. If you quote the resolution of an image as being so many pixels by so many pixels, there can be no ambiguity about what you mean.

magazine page printed at the same resolution of 200 pixels per inch and megabyte file size would be about 25 MB RGB (33.4 MB CMYK).

Digital cameras are often classed according to the number of pixels they can capture. If the CCD chip contains 2000 × 3000 pixel elements, it can capture a total of 6 million pixels, and therefore be described as a 6 megapixel camera. If you multiply the 'megapixel' size by three you will get a rough idea of the megabyte size of the RGB image output. In other words, a 6 megapixel camera will yield an 18 MB RGB file. Quoting megabyte sizes is a less reliable method of describing things because document file sizes can also be affected by the number of layers and alpha channels present and whether the file has been compressed or not. Nevertheless, referring to image sizes in megabytes has become a convenient shorthand when describing a standard uncompressed, flattened TIFF file.

Figure 12.1 In this diagram you can see how a digital image that is comprised of a fixed number of pixels can have its output resolution interpreted in different ways. For illustration purposes let's assume that the image is 40 pixels wide. The file can be printed big (and more pixelated) at a resolution of 10 pixels per cm, or it can be printed a quarter of the size at a resolution of 40 pixels per cm.

Figure 12.2 Digital images are constructed of a mosaic of pixels. Because of this a pixel-based digital image always has a fixed resolution and is said to be 'resolution-dependent'. If you enlarge such an image beyond the size at which it is meant to be printed, the pixel structure will soon become evident, as can be seen in the left-hand close-up below. But suppose the picture shown opposite was created not as a photograph, but as an illustration in a program like Adobe Illustrator. If the picture is drawn using vector paths, the image will be resolution-independent. The mathematical numbers used to describe the path outlines shown in the bottom right example can be scaled to reproduce at any size: from a postage stamp to a billboard poster.

'Stalkers' by The Wrong Size. Photograph: Eric Richmond.

Photoshop as a vector program

Photoshop is mainly regarded as a pixelbased graphics program, but it does have the capability to be a combined vector and pixel-editing program because it also contains a number of vector-based features that can be used to generate images such as custom shapes and layer clipping paths. This raises some interesting possibilities, because you can create various graphical elements like type, shape layers and layer clipping paths in Photoshop and these are all resolution-independent. These 'vector' elements can be scaled up in size in Photoshop without any loss of detail, just as you can with an Illustrator graphic.

Pixels versus vectors

Digital photographs are constructed with pixels and as such are resolution-dependent. You can scale up a pixel image, but as you do so, the finite information can only be stretched so far before the underlying pixel structure becomes apparent. Objects created in a program like Adobe Illustrator are defined mathematically, so if you draw a rectangle, the proportions of the rectangle edges, the relative placement on the page and the color it is filled with can all be described using mathematical expressions. An object defined using vectors can be output at any resolution. It does not matter if the image is displayed on a computer screen, or as a huge poster, it will always be rendered with the same amount of detail (see Figure 12.2).

Terminology

Before proceeding further let me help clarify a few of the confusing terms used and their correct usage when describing resolution.

ppi: pixels per inch. This describes the digital, pixel resolution of an image. But you will notice the term dpi is often inappropriately used to describe the digital resolution of film scanners. This is an incorrect use of the term 'dpi' because input devices like scanners produce pixels. They don't produce dots. Only printers can do that! However, it's become quite common now for scanner manufacturers to use the term dpi when they really mean ppi and unfortunately this has only added to the confusion, because you often hear people describing the resolution of an image as having so many dpi. But if you look carefully, Photoshop always refers to the input resolution as being in pixels per inch or pixels per centimeter. So if you have an image that has been captured on a digital camera scanned from a photograph, or displayed in Photoshop, it is always made up of pixels. The pixel resolution (ppi) is the number of pixels per inch in the input digital image.

Ipi: lines per inch. This is the number of halftone lines or 'cells' in an inch, also described as the screen ruling. The origins of this term go back way before the days of digital desktop publishing. To produce a halftone plate, the film exposure was made through a finely etched criss-cross screen of evenly spaced lines on a glass plate. When a continuous tone photographic image was exposed this way, dark areas formed heavy halftone dots and the light areas, smaller dots, which when viewed from a normal distance gave the impression of a continuous tone image on the page. The line screen resolution (lpi) is therefore the frequency of halftone dots or cells per inch.

dpi: dots per inch. This refers to the resolution of a printing device. An output device such as an imagesetter is able to produce tiny 100% black dots at a specified resolution. Let's say we have an imagesetter capable of printing at a resolution of 2450 dots per inch and the printer wished to use a screen ruling of 150 lines per inch. If you divide the dpi of 2450 by the lpi of 150, you get a figure of 16. Within a matrix of 16×16 printer dots, an imagesetter can generate a halftone dot varying in size from 0 to 255, which is 256 print dots. It is this variation in halftone cell size (constructed from the combined smaller dots) which gives the impression of tonal shading when viewed from a distance.

Desktop inkjet printers correctly use the term dpi to describe the resolution of the printer head. Inkjet printers produce an output made up of small dots at resolutions of between 360 and 2880 dots per inch. The inkjet output is not the same as the reprographic process – the screening method used is quite different.

Confusing terminology

You can see from these descriptions where the term 'lines per inch' originated. In today's digital world of imagesetters, the definition is somewhat archaic, but is nonetheless commonly used. You may hear people refer to the halftone output as dpi instead of lpi, as in the number of 'halftone' dots per inch, and the imagesetter resolution be referred to as having so many spi, or spots per inch. Whatever the terminology I think we can all logically agree on the correct use of the term pixels per inch, but I am afraid there is no clear definitive answer to the mixed use of the terms dpi, lpi and spi, It is an example of how the two separate disciplines of traditional repro and those who developed the digital technology chose to apply different meanings to these same terms.

Desktop printer resolution

Inkjet printers use the term 'dots per inch' to describe the output resolution of the printer. The dpi output of a typical inkjet will range from 360 to 2880 dpi. And although this is a correct usage of dpi, in this context the dpi means something else yet again. Most inkjet printers lay down a scattered pattern of tiny dots of ink that accumulate to give the impression of different shades of tone, depending on either the number of dots, the varied size of the dots, or both. The principle is roughly similar to the halftone process, but not quite the same. If you select a finer print resolution such as 1440 or 2880 dpi, you should see smoother print outputs when viewed close up.

The optimum pixel resolution should ideally be the printer dpi divisible by a whole number. So if an inkjet printer head has a resolution of 2880 dpi, the following pixel resolutions could be used: 144, 160, 180, 240, 288, 320, 360. To make large inkjet prints for viewing at a greater distance, use a low pixel resolution. For smaller sized portfolio prints I normally use a 240 or 300 ppi pixel resolution. I doubt very much you will notice any improvement in print quality if you choose a resolution that is higher than this.

Repro considerations

The structure of the final print output appearance bears no relationship to the pixel structure of a digital image. A pixel in a digital image does not equal a cell of halftone dots on the page. To explain this, if we analyze a CMYK cell or rosette, each color plate prints the screen of dots at a slightly different angle, typically: Yellow at 0 or 90 degrees, Black: 45 degrees, Cyan: 105 degrees and Magenta: 75 degrees. If the Black screen is at a 45 degree angle (which is normally the case), the (narrowest) horizontal width of the black dot is 1.41 (square root of 2) times shorter than the width of the Yellow screen (widest). If we extend the width of the data creating the halftone cell, then multiplying the pixel sample by a factor of 1.41 would mean that there was at least a 1 pixel width of

1 The halftone screen shown here is angled at zero degrees. If the pixel resolution were calculated at ×2 the line screen resolution, the RIP would use four pixels to calculate each halftone dot.

4 Each halftone dot is rendered by a PostScript RIP from the pixel data and output to a device called an imagesetter. The halftone dot illustrated here is plotted using a 16×16 dot matrix. This matrix can therefore reproduce a total of 256 shades of gray. The dpi resolution of the image setter, divided by 16, will equal the line screen resolution. 2400 dpi divided by 16 = 150 lpi screen

resolution.

2 To reproduce a CMYK print output, four plates are used, of which only the yellow plate is actually angled at zero degrees. The black plate is normally angled at 45 degrees and the cyan and magenta plates at less sharp angles. Overlay the same pixel resolution of ×2 the line screen and you will notice that there is no direct relationship between the pixel and line screen resolutions.

3 There is no single empirical formula that can be used to determine the ideal 'half toning factor'. Should it be $\times 2$ or $\times 1.5$? The black plate is the widest at 45 degrees and the black plate information is usually more prominent than the three color plates. If a half toning factor of $\times 1.41$ (the square root of 2) were used, the pixel resolution will be more synchronized with this angled halftone screen. There is no right or wrong half toning factor - the RIP will process pixel data at any resolution. If there are too few pixels, print quality will be poor. But having more than the optimum number does not necessarily equate to better output, it is just more pixels.

The relationship between ppi and lpi

Determining output image size

Image size is determined by the final output requirements and at the beginning of a digital job, the most important information you need to know is:

- How large will the picture appear on the page, poster etc.?
- What is the screen frequency being used by the printer – how many Ipi?
- What is the preferred halftone factor used to determine the output resolution?
- Will the designer need to allow for page bleed, or want to crop your image?

But we always use 300 ppi!

There is a common misconception in the design industry that everything must be supplied at 300 pixels per inch. This crops up all the time when you are contacting clients to ask what resolution you should supply your image files at. Somehow the idea has got around the industry that everything from a picture in a newspaper to a 48-sheet poster must be reproduced from a 300 ppi file. It does not always hurt to supply your files at a higher resolution than is necessary, but it can get quite ridiculous when you are asked to supply a 370 MB file in order to produce a 30" x 36" print! information with which to generate the black plate. The spacing of the pixels in relation to the spacing of the 45 degree rotated black plate is thereby more synchronized.

For this reason, you will find that the image output resolution asked for by printers is usually at least 1.41 times the halftone screen frequency used, i.e. multiples of $\times 1.41$, $\times 1.5$ or $\times 2$. This multiplication is also known as the 'halftone factor', but which is best? Ask the printer what they prefer you to supply and some will say that the 1.41:1 or 1.5:1 multiplication produces crisper detail than the higher ratio of 2:1. There are other factors which they may have to take into account such as the screening method used. It is claimed that Stochastic or FM screening permits a more flexible choice of ratios ranging from 1:1 to 2:1.

Ideally this information needs to be known before the image is scanned (or captured digitally). Because if you calculate that only 10 MB worth of RGB data will actually be required, there may be no point in capturing more image data than is absolutely necessary. If the printer's specification is not available to you, then the only alternative is to scan or shoot at the highest practical resolution and resample the image later. The downside of this is that large image files consume extra disk space and take longer to process on the computer. If a print job does not require the images to be larger than 10 MB, then you'll want to know this in advance rather than waste time and space working on unnecessarily large files. On the other hand, designers like to have the freedom to take a supplied image and scale it in the design layout program to suit their requirements. So it may seem contrary for me to state that I normally supply my files using a $\times 2$ halftone factor, because that way I know there will always be enough data in the supplied file to allow for a 20% scaling without adversely compromising the final print quality.

Creating a new document

If you want to create a new document in Photoshop with a blank canvas, go to the File menu and choose New ... This will open the dialog shown in Figure 12.3, where you can select a preset setting from the Preset pop-up menu or manually enter the new document dimensions and resolution in the fields below. When you choose a preset setting, the resolution will adjust automatically depending on whether it is a preset used for print or computer screen type work. You can change the default resolution settings for print and screen in the Units & Rulers Photoshop preferences dialog. The Advanced section lets you do extra things like choose a specific profiled color space. After you have entered custom settings in the New Document dialog these can be saved by clicking on the Save Preset... button. In the New Document Preset dialog shown below you will notice that the options will allow you to select which attributes will be included in the saved preset.

	Name:	Untitled-1			ОК
Preset: (8 × 10		•		Cancel
	Width:	8	inches	•	Save Preset
	Height:	10	inches	\$	Delete Preset
	Resolution:	300	pixels/inch	\$	
	Color Mode:	RGB Color 🛟	16 bit	•	
Backgro	Background Contents: White				Image Size: 41.2M
Pixel	Aspect Ratio:		ment Preset	•	
Pr	eset Name: 8.	25 in X 11.5 in		- 6	ок
	Include In Sa Resolution Mode	ved Settings:	0		Cancel

Figure 12.3 The New document and New Document Preset dialogs.

Pixel Aspect Ratio

The Pixel Aspect Ratio is there to aid multimedia designers who work in stretched screen formats. So, if a 'non-square' pixel setting is selected, Photoshop will create a scaled document which will preview how a normal 'square' pixel Photoshop document will actually display on a stretched wide screen. And the title bar will add [scaled] to the end of the file name to remind you are working in this special preview mode. When you create a non-square pixel document the scaled preview can be switched on or off by selecting the Pixel Aspect Correction item in the View menu.

Custom	
Clipboard	
Default Photoshop	Size
Letter	
Legal	
Tabloid	
2 × 3	
4 x 6	
5 x 7	
8 × 10	
640 x 480	
800 x 600	
1024 x 768	
A4	
A3	
85	
84	
B3	
NTSC DV 720 x 48	
NTSC DV Widescre	en, 720 x 480 (with guides)
NTSC D1 720 x 48	
	ix, 720 x 540 (with guides)
PAL D1/DV, 720 x	
	Pix, 768 x 576 (with guides)
PAL D1/DV Widese	creen, 720 x 576 (with guides)
HDV, 1280 x 720	(with guides)
HDV, 1440 x 1080) anamorphic (with guides)
HDV, 1920 x 1080) (with guides)
D4	
Cineon Half	
Film (2K)	
D16	
Cineon Full	
Untitled-1	

Altering the image size

The image size dimensions and resolution can be adjusted using the Image Size dialog. The dialog will normally open with the Resample Image box checked. This means that as you enter new pixel dimension values, measurement values or adjust the resolution, the overall image size will adjust accordingly. As you adjust one set of units you will see the others adjust simultaneously. When Resample Image is unchecked, the pixel dimensions will be grayed out and any adjustment made to the image will not alter the total pixel dimensions, only the relationship between the measurement units and the resolution. Remember the rule I mentioned earlier: the number of pixels = physical dimension \times (ppi) resolution. You can put that rule to the test here and use the Image Size dialog as a training tool to better understand the relationship between the number of pixels, the dimensions and the resolution. The Constrain Proportions checkbox links the horizontal and vertical dimensions, so that any adjustment is automatically scaled to both axis. Only uncheck this box if you wish to squash or stretch the image while adjusting the image size.

	Image Size
Auto Resolution Screen: 133 lines/inch ; OK Quality Cancel	Pixel Dimensions: 49.4M (was 62.9M) Width: 3604 pixels Height: 2397 pixels Width: 34.41 cm Height: 22.89 cm Width: 22.89 cm Width: 34.41 cm Wid
O Draft O Good O Best	Resolution: 266 pixels/inch Scale Styles Constrain Proportic Resample Image: Resample Image: Scubic Smoother Bicubic Sharper

Figure 12.4 To change the image output dimensions but retain the resolution, leave the Resample box checked. To change the image output dimensions with a corresponding change in resolution, leave the Resample box unchecked. Click on the Auto button to open the Auto resolution dialog. This will help you pick the ideal pixel resolution for repro work based on the line screen resolution.

Image interpolation

Image resampling is also known as interpolation and Photoshop can use one of five methods when assigning approximated values for any new pixels that are generated. The interpolation options are located next to the Resample Image checkbox.

Nearest Neighbor is the simplest interpolation method, yet I use this quite a lot, such as when I want to enlarge a screen grab of a dialog box for this book by 200% and I don't want the sharp edges of the dialog boxes to appear fuzzy.

Bilinear interpolation will calculate new pixels by reading the horizontal and vertical neighboring pixels. It is fast, and perhaps that was an important consideration in the early days of Photoshop, but I don't see there is much reason to use it now.

Bicubic interpolation provides better image quality when resampling continuous tone images. Photoshop will read the values of neighboring pixels, vertically, horizontally and diagonally to calculate a weighted approximation of each new pixel value. Photoshop intelligently guesses the new pixel values, by referencing the surrounding pixels.

When to interpolate?

I consider 'interpolating up' an image in Photoshop to be preferable to the interpolation methods found in basic scanner software. Digital files captured from a scanning back or multishot digital camera are extremely clean, and because there is no grain present, it is usually possible to magnify a digitally captured image much more than you would to a scanned image of equivalent size. There are other third-party programs that claim to offer improved interpolation, but there appears to be little evidence that you will actually gain any major improvements in image quality over and above what you can achieve using Photoshop.

Resize Image Assistant	1	Resize Image Assistant
What is the desired size of your Image? Width: 21 cm 🔅 Height: 13.97 cm 🔅	000	Which halftone screen (LPI) will be used to print your angle? 65 9 133 150 200 Other: Description Appropriate for web printing, weekly magazine, etc.
 Cancel Back Next		Cancel Back Next

Figure 12.5 If Image Size is proving too confusing, the Resize Image assistant is on hand to help guide you. This wizard is located in the Help menu and can be used to resize images both for print and for the Web.

Planning ahead

Once an image has been scanned at a particular resolution and manipulated there is no going back. A digital file prepared for advertising usages may never be used to produce anything bigger than a 35 MB CMYK separation, but you never know. It is safer to err on the side of caution and better to sample down than have to interpolate up. It also depends on the manipulation work being done. Some styles of retouching work are best done at a magnified size and then reduced. Suppose you wanted to blend a small element into a detailed scene. To do such work convincingly, you need to have enough pixels to work with to be able to see what you are doing. For this reason some professional retouchers will edit a master file that is around 100 MB RGB or bigger even. Another advantage of working with large file sizes is that you can always guarantee being able to meet clients' constantly changing demands. Although the actual resolution required to illustrate a glossy magazine double-page full-bleed spread is probably only around 40-60 MB RGB or 55-80 MB CMYK. Some advertising posters may even require smaller files than this, because the print screen on a billboard poster is that much coarser. When you are trying to calculate the optimum resolution you cannot rely on being fully provided with the right advice from every printer. Sometimes it will be necessary to anticipate the required resolution by referring to the table in Figure 12.7. This shows some sample file size guides for different types of print job.

The Photoshop bicubic interpolations are improved and more accurate than before, especially with regard to the downsampling of images. And if you need to apply an extreme image resize either up or down in size, I suggest that you consider using the Bicubic Sharper or Bicubic Smoother interpolation methods.

Bicubic Smoother is the ideal choice if you wish to make an image bigger.

Bicubic Sharper should be used when you want to reduce the pixel resolution more accurately. For example, if you have a high resolution digital capture of detailed machinery and want to make a duplicate copy but at a much lower pixel resolution. If you reduce the image size using Bicubic Sharper the scaled down image will retain more detail and sharpness.

Step interpolation

Some people might be familiar with the step interpolation technique, where you gradually increase or decrease the image size by small percentages. This is not really necessary now because you can use Bicubic Sharper or Bicubic Smoother to increase or decrease the image size in a single step. Some people argue that for really extreme image size changes they prefer to use a 50% step method.

Unsharp masking should always be applied last as the file is being prepared for print. This is because interpolating after sharpening will enhance the image artifacts introduced by the sharpening process.

Practical conclusions

When I have been able to scan an original image, I like to end up with an image which when converted to 8 bits per channel will be around 75 MB in size. If I am working from a digital capture, I will convert the data at the maximum uninterpolated resolution in Camera Raw. I would estimate that the majority of pictures you see published in books and magazines are probably printed

				Inches	Centimeters	inches	Centimeters
Pixel size	Megapixels	MB (RGB)	МВ (СМҮК)	200 ppi	80 ppc	300 ppi	120 ppc
1600 x 1200	2	6	7.5	8 x 6	20 x 15	5.5 x 4	13.5 x 10
2400 x 1800	4.3	12.5	16.5	12 x 9	30 x 22.5	8 x 6	20 x 15
3000 x 2000	6	17.5	23.5	15 x 10	37.5 x 25	10 x 6.5	25 x 17
3500 x 2500	8.75	25	33.5	17.5 x 12.5	44 x 31	11.5 x 8.5	29 x 21
4000 x 2850	11.4	32.5	43.5	20 x 14	50 x 36	13.5 x 9.5	33.5 x 24
4500 x 3200	14.4	41	54.5	22.5 x 16	56 x 40	15 x 10.5	37.5 x 27
5000 x 4000	20	57	76	25 x 20	62.5 x 50	16.5 x 13.5	42 x 33.5

Figure 12.6 The above table shows a comparison of pixel resolution, megapixels, megabyte file size and output dimensions at different resolutions, both in inches and in centimeters.

Output use	Screen ruling	x1.5 Output resolution	MB Grayscale	МВ Смук	x 2 Output resolution	MB Grayscale	MB CMYK
A3 Newspaper single page	85 lpi	130 ppi	3	12.5	170 ppi	5.5	21.5
A3 Newspaper single page	120 Ipi	180 ppi	6	24	240 ppi	10.5	42.5
A4 Magazine mono single page	120 lpi	180 ppi	3	na	240 ppi	5.3	na
A4 Magazine mono double page	120 lpi	180 ppi	6	na	240 ppi	10.6	na
A4 Magazine single page	133 lpi	200 ppi	3.7	14.8	266 ppi	6.5	26.1
A4 Magazine double page	133 lpi	200 ppi	8	29.6	266 ppi	13	52.2
A4 Magazine single page	150 lpi	225 ppi	4.7	18.7	300 ppi	8.3	33.2
A4 Magazine double page	150 lpi	225 ppi	9.4	37.4	300 ppi	17	66.4

Figure 12.7 Here is a rough guide to the sort of file sizes required to reproduce either a mono or CMYK file for printed use. The table contains file size information for output at multiples of x1.5 the screen ruling and x2 the screen ruling.

Resolution and viewing distance

In theory the larger a picture is printed, the further away it is meant to be viewed and the pixel resolution does not have to alter in order to achieve the same perception of sharpness. There are limits though below which the quality will never be sharp enough at normal viewing distance (except at the smallest of print sizes). It also depends on the image subject matter - a picture containing a lot of mechanical detail will need more pixels to do the subject justice and be reproduced successfully. If you had a picture of a softly lit cloudy landscape, you could guite easily get away with enlarging a small image through interpolation, beyond the normal constraints.

using 20 MB of RGB data or less. You can be sure that in any magazine publication you care to look at, it does not matter how large the original scans or digital captures were, the same amount of digital information was eventually used to make the halftone separations on each page you are looking at. There are photographers and also clients who insist nothing less than a high resolution scan from a 5×4 or 10×8 sheet of film will provide good enough quality for advertising work. I do believe an overobsession with 'pixel correctness' gets in the way of appreciating just how good the technical output quality can be from smaller format cameras or what can be created on a modern computer desktop setup in the hands of a talented artist.

An enormous industry was based around photographers supplying films to clients, who made positional scans for layout purposes. They in turn then sent the film for repro scanning at the bureau to make the final separations. Along comes a photographer armed with Photoshop, offering to cut out a large chunk of the repro process, supplying repro quality digital files themselves. Tread on somebody's toes once and they won't like you very much. Stamp all over them and they begin to squeal (loudly), especially if they believe you don't have a clue what you are talking about. Obviously, the printers should know best when it comes to getting the best results from their machinery, but remember some still have a vested interest in keeping the likes of you out of the equation. This leads to occasional 'spoiling' tactics, designed to make you look foolish in front of the end client, such as requests to supply poster size files at 300 ppi. Companies with attitudes like these are dying out now. The smart businesses recognize the digital revolution will continue apace with or without them and they have to continually adapt to the pace of modern technology and all its implications. Besides, printing companies have been getting into the supply of digital photography themselves and the boundaries between our industries are constantly blurring.

Chapter 13

Color Management

hotoshop 5.0 was justifiably praised as a ground-breaking upgrade when it was released in the summer of 1998. The changes made to the color management setup were less well received in some quarters. This was because the revised system was perceived to be extremely complex and unnecessary. Some color professionals felt we already had reliable methods of matching color and you did not need ICC profiles and the whole kaboodle of Photoshop ICC color management to achieve this. The aim of this chapter is to start off by introducing the basic concepts of color management. The first part will help you to understand the principles of why color management is necessary. And then we shall be looking at the color management settings.

The need for color management

An advertising agency art buyer was once invited to address a meeting of photographers. The chair, Mike Laye, suggested we could ask him anything we wanted, except 'Would you like to see my book?' And if he had already seen your book, we couldn't ask him why he hadn't called it back in again. And if he had called it in again we were not allowed to ask why we didn't get the job. And finally, if we did get the job we were absolutely forbidden to ask him why the color in the printed ad looked nothing like our original photograph!

That in a nutshell is a problem which has bugged us all our working lives. And it is one which will be familiar to anyone who has ever experienced the difficulty of matching colors on a computer system with the original or a printed output. Figure 13.1 has two versions of the same photograph. One shows how the Photoshop image is previewed on the monitor and the other is an example of how a printer might interpret and reproduce those same colors when no attempt is made to color manage the image.

So why is there sometimes such a marked difference between what is seen on the screen and the actual printed result? Digital images are nothing more than just bunches of numbers and good color management is all about making sense of those numbers and translating them into meaningful colors at the various stages of the image making process.

The way things were

Twelve years ago, most photographers only used their computers to do basic administration work and there were absolutely no digital imaging devices to be found in a photographer's studio (unless you counted the photocopier). If you needed a color print made from a chrome transparency, you gave the original to the printer at a photographic lab and they matched the print visually to your original. Professional photographers would also supply chrome transparencies or prints to the client and the photographs then went to the printer to be digitized

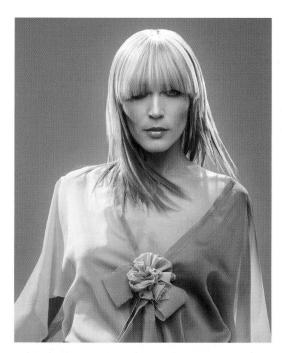

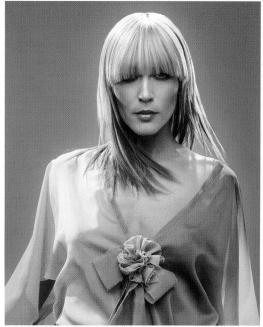

using a high-end drum scanner to produce a CMYK file. The scanner would be configured to produce a CMYK file ready to insert in a specific publication. And that was the limit of the photographer's responsibilities. If color corrections were required, the scanner operators would carry this out themselves on the output file.

These days a significant number of photographers, illustrators and artists are now originating their own files from digital cameras, desktop scanners or directly within Photoshop. This effectively removes the repro expert who previously did all the scanning and matching of the colors on the press. Therefore, there is no getting away from the fact that if you supply digital images to a printer, you will be deemed responsible should any problems occur in the printing. This may seem like a daunting task, but with Photoshop it is not hard to color manage your images with confidence.

Figure 13.1 The picture on the left shows how you would see the Photoshop image on your screen and the one on the right represents how that same image might print if sent directly to a printer without applying any form of color management. This is an actual simulation of what happens when raw RGB data is sent without any form of compensation being applied to balance the output to what is seen on the screen. You might think it is merely a matter of making the output color less blue in order to successfully match the original. Yes, that would get the colors closer, but when trying to match color between different digital devices, the story is actually a lot more complex than that. The color management system that was first introduced in Photoshop 5.0 will enable you to make use of ICC profiles and match these colors from the scanner to the screen and to the printer with extreme accuracy.

Client: Russell Eaton. Model: Lidia @ M&P.

Why not all RGB spaces are the same

Go into any TV showroom and you will probably see rows of televisions all tuned to the same broadcast source but each displaying the picture quite differently. This is a known problem that affects all digital imaging devices, be they digital cameras, scanners, monitors or printers. Each digital imaging device has its own unique characteristics. And unless you are able to quantify what those individual device characteristics are, you won't be able to communicate effectively with other device components and programs in your own computer setup, let alone anyone working outside your system color loop.

Some computer monitors will have manual controls that allow you to adjust the brightness and contrast (and in some cases the RGB color as well), so we have some element of basic control there. And the desktop printer driver software will also probably allow you to make color balance adjustments, but is this really enough though? And if you are able to get the monitor and your printer to match, will the colors you are seeing in the image appear the same on another person's monitor?

Figure 13.2 All digital devices have individual output characteristics, even if they look identical on the outside. In a TV showroom you will typically notice each television displaying a different colored image.

RGB devices

Successful color management relies on the use of profiles to describe the characteristics of each device such as a scanner or a printer and using a color management system to successfully translate the profile data between each device in the chain. Consider for a moment the scale of the color management task. We wish to capture a full color original subject, digitize it with a scanner or digital camera, examine the resulting image via a computer screen and finally reproduce it in print. It is possible with today's technology to simulate the expected print output of a digitized image on the display with remarkable accuracy. Nevertheless, one should not underestimate the huge difference between the mechanics of all the various bits of equipment used in the above production process. Most digital devices are RGB devices and just like musical instruments, they all possess unique color tonal properties, such that no two devices are always identical or will be able to reproduce color exactly the same way as another device can. Nor is it always possible to match in print all the colors which are visible to the human eye. Converting light into electrical signals via a device such as a CCD chip is not the same as projecting pixels onto a computer screen or reproducing a photograph with colored ink on paper.

The versatility of RGB

A major advantage of working in RGB is that you can access all the bells and whistles of Photoshop which would otherwise be hidden or grayed out in CMYK mode. And these days there is also no telling how many ways a final image may end up being reproduced. A photograph may get used in a variety of ways, with multiple CMYK separations made to suit several types of publications, each requiring a slightly different CMYK conversion because CMYK is not a 'one size fits all' color space. High-end retouching for advertising usage is usually done in RGB mode and a large format transparency output produced. That transparency can be used as an original to be scanned again and converted to CMYK but the usual practice is to use the transparency output for client approval only. The CMYK conversions and film separations are produced working directly from the digital file to suit the various media usages.

Photographers are mainly involved in the RGB capture end of the business. The proliferation of Photoshop, plus the advent of high quality desktop scanner and digital cameras, means that more images than ever before are starting out in and staying in RGB color. This is an important factor that makes color management so necessary and also one of the reasons why I devote so much attention to the managing of RGB color, here and elsewhere in the book. But if professional photographers are more likely to supply a digital file at the end of a job, how will this fit in with existing repro press workflows that are based on the use of CMYK color? Although digital capture has clearly taken off, the RGB to CMYK issue has to be resolved. If the work you create is intended for print, the conversion of RGB to CMYK must be addressed at some point and so we will be looking at CMYK color conversions later on in this chapter.

Color management references

If your main area of business revolves around the preparation of CMYK separations for print, then I do recommend you invest in a training course or book that deals with CMYK repro issues. I highly recommend the following books: 'Real World Color Management' by Bruce Fraser, Chris Murphy and Fred Bunting. 'Color Management for Photographers' by Andrew Rodney and 'Getting Colour Right, The Complete Guide to Digital Colour Correction' by Neil Barstow and Michael Walker.

Color vision trickery

They say that seeing is believing, but nothing could be further from the truth, since there are many interesting quirks and surprises in the way we humans perceive vision. There is an interesting book on this subject titled 'Why We See What We Do', by Dale Purves and R. Beau Lotto (Sinauer Associates, Inc). And also a website at www.purveslab.net, where you can have a lot of fun playing with the interactive visual tests, to discover how easily our eyes can be deceived. What you learn from studies like this is that color can never be properly described in absolute mathematical terms. How we perceive a color can also be greatly influenced by the other colors that surround it. This is a factor that designers use when designing a product or a page layout. You do it too every time you evaluate a photograph, probably without even being aware of it.

Interpreting the color data

One of the main reasons why people have problems reproducing color correctly from digital files is because of a lack of effective communication between the different devices used in a typical Photoshop workstation setup or between one Photoshop user and another. Most of the pieces of equipment you are working with are RGB devices and each of these devices has its own individual way of interpreting or portraying color. As I said in the opening introduction, digital files are nothing more than bunches of numbers. As these files are passed from one device to another the numbers will always reproduce as different colors on different devices, unless of course they are somehow properly managed.

In the old days, people were inclined to solve this problem by adjusting the monitor settings to make the monitor display match the printed output. This 'mess up the monitor to look like the print' approach was seriously flawed, yet we still do hear of people trying to advocate this approach. In Daniel Defoe's book, Robinson Crusoe faced something of a furniture management problem. He tried to make the legs of his table stay level by sawing bits off some of the legs. As soon as he had managed to even up two or more of the legs, he found that one of the others would then be too long. And the more he attempted to fix the problem with his saw, the shorter the table became. A similar thing happens when you try to color manage an image in Photoshop by adjusting the monitor colors. You may be able to obtain a good match for one set of colors, such as the skin tones, but if your subject is wearing a blue suit, the color might be way off and if you then compensate successfully for the blue clothing, the skin tones will no longer be true or some other color will reproduce incorrectly. It is not a simple matter of making the screen a little more red to match the reddish print. Color managing your images in this way can be about as successful as hammering a square peg into a round hole! You will never be able to achieve consistently matching results using this method of color management.

Output-centric color management

Printers who work in the repro industry naturally tend to have an 'output-centric' view of color management. Their main concern is getting the CMYK color to look right on a CMYK press. Accordingly, you will hear an argument that suggests you don't need ICC profiles to get accurate CMYK color. And they will go on to argue that if you know your numbers, you don't even need a color monitor to judge color either. In some respects you can say they are right. These proven techniques have served the printing industry well for many years. If your production workflow is limited to working with the one high-end scanner and a known press output, then the number of variables in your workflow is quite limited and it would not be difficult to synchronize everything in-house. But this is not everyone's experience. Photographers who use Photoshop quite often have to handle digital files sourced from many different types of RGB devices such as: digital cameras, desktop scanners, or from picture libraries, other photographers etc. If we all worked with the same few digital capture devices (like in the old days when there were only a handful of high-end scanner devices) the problem would be not so bad. But in the last decade or so the number of different scanners and cameras has grown enormously. When you take into account all the different monitors that are in existence and other Photoshop users who supply you with files of unknown provenance... well, you get the picture. Since the explosion of new desktop scanners and digital cameras arriving on the market, the publishing industry has been turned on its head. The old way of doing things no longer holds all the answers when it comes to synchronizing color between so many unknown users and digital devices. On top of this our clients may expect us to output to digital proofing devices, Lambda printers, Pictrographs, Iris printers, web pages, and ultimately a four-color press. An appreciation of CMYK printing is important, but in addition to this, you will possibly have to control the input and output between many different RGB color devices before a file is ready to go to press.

Working in isolation

There are those who remain critical of the introduction of ICC-based color management in Photoshop. They look at the needs of their own setup and figure that what works well for them has got to be right for everyone else. I travel guite a lot and once I was driving off the normal tourist track and needed to find a decent road map, but couldn't find any local gas stations that sold one. When I enquired why, I was told 'Because we all know where everything is around here!' It seemed the locals had no need to accommodate lost strangers around those parts. You could say the same of some bureaux and printers. because they work exclusively at the final stage of the print process and are less accustomed to the difficulty photographers face in managing so many different types of incoming and outgoing files.

Beyond CMYK

There are other types of output to consider. not just CMYK. Hexachrome is a six-color ink printing process that extends the range of color depth attainable beyond conventional limitations of CMYK. This advanced printing process is currently available only through specialist print shops and is suitable for high quality design print jobs. Millions have been invested in the four-color presses currently used to print magazines and brochures, so expect four-color printing to still be around for a long time to come, but Hexachrome will open the way for improved color reproduction from RGB originals. Photoshop supports six-color channel output conversions from RGB, but you will need to buy a separate plug-in utility like HexWrench. Spot color channels can be added and previewed on screen: spot color files can be saved in DCS 2.0 or TIFF format. Multimedia publishing is able to take advantage of the full depth of the RGB color range. If you are working in a screenbased environment for CD, DVD and web publishing RGB is ideal, and with today's browsers color management can be turned on to take advantage of the enhanced color control they now offer.

But the printer can color correct a CMYK image 'by the numbers' if they wish. Take a look at the photograph of the young model in Figure 13.3. Her Caucasian flesh tones should at least contain equal amounts of magenta and yellow ink with maybe a slightly greater amount of yellow, while the cyan ink should be a quarter to a third of the magenta. This rule will hold true for most CMYK press conditions. The accompanying table compares the CMYK and RGB space measurements of a flesh tone color. However, you will notice there are no similar formulae that can be used to describe the RGB pixel values of a flesh tone. If you were to write down the flesh tone numbers for every RGB device color space, you could in theory build an RGB color space reference table. And from this you could feasibly construct a system that would assign meaning to these RGB numbers for any given RGB space. This is basically what an ICC profile does except an ICC profile may contain several hundred color reference points. These can then be read and interpreted automatically by the Photoshop software and give meaning to the color numbers.

CMYK in
Euroscale
3M Match
US Web u
Generic Ja
RGB pixe
Adobe RC
Pictrograp
Lambda
Epson 900

	CMYK ink values	Cyan	Magenta	Yellow	Black
	Euroscale Coated v2	09	28	33	0
	3M Matchprint Euroscale	07	25	30	0
	US Web uncoated (SWOP)	08	23	29	0
,	Generic Japan pos proofing	07	28	33	0
1					
	RGB pixel values	Red	Green	Blue	
	Adobe RGB	220	190	165	
	Pictrograph 3000	231	174	146	
	Lambda	230	184	158	
	Epson 9000 RGB	231	179	123	

Figure 13.3 The tables shown here record the color readings in RGB and CMYK color spaces of a typical Caucasian flesh tone. As is explained in the text, while the CMYK readings are all fairly consistent, this is not the case when you try to compare the RGB values.

Profiled color management

The objective of profiled color management is to use the measured characteristics of everything involved in the image editing workflow from capture to print and to reliably translate the color at every stage. In a normal Photoshop workflow, the color management process begins with reading the profiled RGB color data from the incoming file and if necessary converting it to the current Photoshop RGB work space. While the image is being edited in Photoshop the RGB work space image data is sent to the computer display and converted on-the-fly to the profiled monitor space so that the colors are viewed correctly. When the image is finally output as a print, the RGB work space data is converted to the profile space of the printer. Or, you might carry out an RGB to CMYK conversion to the CMYK profile of a known proof printer.

A profile is therefore a useful piece of information that can be embedded in an image file. When a profile is read by Photoshop and color management is switched on, Photoshop is automatically able to find out everything it needs to know in order to manage the color correctly from there on. Note that this will also be dependent on you calibrating your monitor, but essentially all you have to do apart from that is to open the Photoshop Color Settings from the Edit menu and select a suitable preset such as the US Prepress Default setting. Do this and you are all set to start working in an ICC color managed workflow.

Think of a profile as being like a postcode (or ZIP code) for images. For example, the address label shown in Figure 13.4 was rather optimistically sent to me at 'Flat 14, London', but thanks to the postcode it arrived safely! Some labs and printers have been known to argue that profiles cause color management problems. This I am afraid is like a courier company explaining that the late delivery of your package was due to you including a ZIP code in the delivery address. A profile can be read or it can be ignored. What is harmful in these circumstances is an operator who refuses to use an ICC workflow. If you feel you are getting the runaround treatment, it is time to change your lab.

Figure 13.4 Even if you have never been to London before, you know it's a fairly big place and 'Flat 14, London' was not going to help the postman much to locate my proper address. However, the all-important ZIP code or postcode was able to help identify exactly where the letter should have been delivered. An image profile is just like a ZIP code, it can tell Photoshop everything it needs to know about a file's provenance.

Making sense of the data

One way to comprehend the importance of giving meaning to the numbers in a digital file is to make a comparison with what happens when language loses its meaning. There is an excellent book by Lynne Truss called 'Eats, Shoots & Leaves: The Zero Tolerance Approach to Punctuation'. It is partly a rant against poor punctuation, but also stresses the importance of using punctuation to assign exact meaning to the words we read. Remove the punctuation and words will easily lose their true intended meaning. Another good example is the way some words have different meanings in other languages. So a word viewed out of context can be meaningless unless you know the language that it belongs to. For example, the word 'cane' in English means 'dog' in Italian.

Color Management Modules

The International Color Consortium (ICC) is an industry body that represents the leading manufacturers of imaging hardware and software, The ICC grew out of the original Color Consortium that was establishd in 1993 and has been responsible for extending and developing the original ColorSync architecture to produce the standardized ICC format which enables profiles created by different vendors to work together. All ICC systems are basically able to translate the color gamut of a source space via a reference space (the Profile Connection Space) and accurately convert these colors to the gamut of the destination space. At the heart of any ICC system is the Color Management Module, or CMM, which carries out all the profile conversion software processing. Although the ICC format specification is standardized, this is one area where there are some subtle differences in the way each CMM will handle the data. In Photoshop you have a choice of three CMMs: Adobe Color Engine (ACE), Apple ColorSync or Apple CMM. And there are other brands of CMM that you can use as well. But this really need not concern most Photoshop users. The default CMM used in Photoshop is Adobe (ACE) and I recommend that you leave this as set.

The Profile Connection Space

If the CMM is the engine that drives color management, then the Profile Connection Space, or PCS, is at the hub of any color management system. The PCS is the translator that can interpret the colors from a profiled space and define them using either a CIE XYZ or CIE LAB color space. The Profile Connection Space is an interim space. It uses unambiguous numerical values to describe color values using a color model that matches the way we humans observe color. You can think of the PCS as being like the color management equivalent of a multilingual dictionary that can translate a language into any other language.

If an ICC profile is embedded in the file, Photoshop will recognize this and know how to correctly interpret the color data. The same thing applies to profiled CMYK files as well. Photoshop uses the monitor display profile information to render a color correct preview on the monitor screen. It helps to understand here that in an ICC color managed workflow in Photoshop, what you see on the monitor is always a color corrected preview and you are not viewing the actual file data. So when the RGB image you are editing is in an RGB work space such as Adobe RGB and color management is switched on, what you see on the screen is an RGB preview that has been converted from Adobe RGB to your profiled monitor RGB via the PCS. The same thing happens when Photoshop previews CMYK data on the screen. The Photoshop color management system calculates a conversion from the file CMYK space to the monitor space. Photoshop therefore carries out all its color calculations in a virtual color space. So in a sense, it does not really matter which RGB work space you edit with. It does not have to be exactly the same as the work space set on another user's Photoshop system. If you are both viewing the same file, and your displays are correctly calibrated and profiled, a color image should look near enough the same on both monitors.

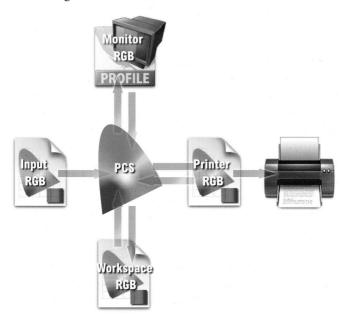

Figure 13.5 A color management system is able to read the profile information from an incoming RGB file and behind the scenes it will build a table that correlates the source RGB information with the Profile Connecting Space values.

Figure 13.6 Photoshop can read or make use of the profile information of an incoming RGB file and translate the data via the Profile Connecting Space and make an RGB to RGB conversion to the current RGB work space in Photoshop. As you work in RGB mode, the image data is converted via the PCS using the monitor profile to send a profile-corrected signal to the monitor display. When you make a print the image data is then converted from the work space RGB to the printer RGB via the PCS.

Figure 13.7 The CD-ROM accompanying this book contains a short movie which helps to explain the RGB space issue by graphically comparing some of the main RGB spaces.

Figure 13.8 A CMYK color space is mostly smaller than the monitor RGB color space. Not all CMYK colors can be displayed accurately due to the physical display limitations of the average computer monitor. This screen shot shows a continuous spectrum going through shades of cyan, magenta and yellow. The image was then deliberately posterized in Photoshop. Notice how the posterized steps grow wider in the Yellow and Cyan portions of the areas of the CMYK spectrum which fall outside the gamut of a typical CRT monitor.

Choosing an RGB work space

Although I highly recommended that you switch on the color management settings in Photoshop, you cannot assume that everyone else will. There are many other Photoshop users and color labs from the Jurassic era who are running outputs from files with Photoshop color management switched off and are not bothering to calibrate their displays properly either.

If you are using Photoshop 6.0 or later it matters less individually which RGB color space you choose in the RGB setup, as long as you stick to using the same space for all your work. RGB to RGB conversions are not as destructive as RGB to CMYK conversions, but the space you plump for does matter. Once chosen you should not really change it. And whichever color work space you select in the RGB color settings, you will have to be conscious of how your profiled Photoshop RGB files may appear on a non-ICC savvy Photoshop system. What follows is a guide to the listed RGB choices.

Apple RGB

This is the old Apple 13" monitor standard. In the early days of Photoshop this was used as the default RGB editing space where the editing space was the same as the monitor space. If you have legacy images created in Photoshop on a Macintosh computer using a gamma of 1.8, you can assume Apple RGB to be the missing profile space.

sRGB IEC-61966-2.1

sRGB was conceived as a multipurpose color space standard that consumer digital devices could all standardize to. It is essentially a compromise color space that provides a uniform color space which all digital cameras and inkjet printers and monitors are able to match. sRGB aims to match the color gamut of a typical 2.2 gamma PC monitor. Therefore if you are opening a file from a consumer digital camera or scanner and there is no profile embedded, you can assume that the missing profile should be sRGB. It is an ideal color space for web design but unsuitable for photography or serious print work. This is mainly because the sRGB space clips the CMYK gamut quite severely and you will never achieve more than 75%–85% cyan in your CMYK separations.

ColorMatch RGB

ColorMatch is an open standard monitor RGB space that was implemented by Radius. ColorMatch has a gamma of 1.8 and is favored by some Macintosh users as their preferred RGB working space. Although not much larger than the gamut of a typical monitor space, it is at least a known standard and more compatible with legacy, 1.8 gamma Macintosh files.

ProPhoto RGB

This is a large gamut RGB space that is suited for image editing that is intended for output to photographic materials such as transparency emulsion or a photo quality inkjet printer. It is also useful if you wish to take full advantage of the gamut of your raw capture files when initially converting the raw data to RGB. Any further wide gamut editing should ideally be done using 16 bits per channel mode (until you convert to a smaller gamut RGB space).

Adobe RGB (1998)

Adobe RGB (1998) has become established as the recommended RGB editing space for RGB files that are destined to be converted to CMYK. For example, the Photoshop prepress color settings all use Adobe RGB as the RGB working space. Adobe RGB was initially labeled as SMPTE-240M which was a color gamut proposed for HDTV production. As it happens, the coordinates Adobe used did not exactly match the actual SMPTE-240M specification. Nevertheless, it proved popular as an editing space for repro work and soon became known as Adobe RGB (1998). I have adopted Adobe RGB as my preferred RGB working space, since it has a larger color gamut and is particularly suited for RGB to CMYK color conversions.

The ideal RGB working space

If you select an RGB work space that is the same size as the monitor space, you are not using Photoshop to its full potential and more importantly you are probably clipping parts of the CMYK gamut. Select too wide a space, like Wide Gamut RGB, and there will be large gaps in color tone between one data point and the next, as each color channel can only represent up to 256 data points. Although you can safely use a wide gamut RGB space as long as you are editing mostly throughout in 16 bits per channel mode. And since 16-bit editing is now widely supported in Photoshop CS and Photoshop CS2, there is now no reason why you cannot under these circumstances adopt a wide gamut RGB space for all your Photoshop editing work. But for most 24-bit image editing I advise you don't use anything larger than Adobe RGB.

Martin Evening Adobe Photoshop CS2 for Photographers

Figure 13.9 Good color management is very much dependent on having your display calibrated and profiled. This should ideally be done using a hardware calibration device like the Gretag MacBeth Eye-One system.

Profiling the display

The first step to making color management work in Photoshop is to calibrate and profile the screen display. It is by far the most important and essential first link in the color management chain. You can live without scanner profiling and it is not the end of the world if you can't profile every printer/paper combination. But you simply must have a well-calibrated and profiled display. It is after all the instrument you most use to make color editing decisions with.

In Chapter 3 I described the basic, visual methods for calibrating and building a profile for your monitor. But the problem with these visual calibration methods is that because our eyes are so good at adapting to light, your eyes are poor instruments to use when calibrating a device like a monitor display. I would strongly urge you to purchase a proper measuring instrument and use this to calibrate with instead. A hardware calibration device combined with a dedicated software utility is the only way to guarantee getting good color from your system. This will enable you to precisely calibrate your display and build an accurate monitor profile. At the time of writing, I found four basic monitor profiling packages, which include a colorimeter and basic software program, all for under \$300. Highly recommended is the basICColor Display and Squid combination. Then there is the Gretag MacBeth Eye-One Display that comes with Eye-One Match 2 software, the Monaco Optix XR system and lastly the LaCie BlueEye 2 Vision Calibrator. Of these I would probably recommend the Gretag MacBeth Eye-One Display, since I am very familiar with the more expensive Eye-One spectrophotometer system, which I use to calibrate and profile the display in my office. It is also an emissive spectrophotometer so I can also use it to build custom printer profiles. The units I listed above are all colorimeters so these can only be used for building monitor profiles. But they are often regarded as being just as good as more expensive spectrophotometers for this type of task.

Calibration and profiling

Profiling devices are attached to the screen via rubber suckers to a CRT, or hung over the edge of an LCD display using a counter weight that gently rests the calibrator against the surface. Don't use a calibrating device with suckers on an LCD as this will easily damage the delicate surface.

The software packages used will vary in appearance but they essentially all do the same thing. If you are using a CRT monitor it must be switched on for at least half and hour before you attempt to calibrate and profile it. The first stage is to calibrate the display to optimize the contrast and brightness. You should end up with a display luminance of around 85-110 cd/m². Most CRT monitors will allow you to manually adjust the individual color guns to help neutralize the screen. But on an LCD display all you can adjust is usually the brightness. Once this has been done you will want to lock down the hardware controls so they cannot be accidentally adjusted. This should be done before performing the calibration in which a series of colors will be sent to the screen and the measurements used to adjust the video card settings which will fine-tune the display to achieve optimum neutralization.

The second part is the profiling process. Once the screen has been calibrated a longer sequence of color patches will be sent to the screen and measured to build a profile describing how the neutralized screen displays these known colors. This data is collected together to build the profile. At the end you will be asked to name the profile and it should be automatically saved to the correct folder location and assigned as the new default monitor profile.

Some CRT monitor displays such as the Sony Artisan or Barco have built-in internal calibration mechanisms. You literally just switch them on and they self-calibrate to provide optimized performance. This takes a lot of the guesswork out of the calibration process.

Do remember that the performance of the display will fluctuate over time (especially a CRT display). It is therefore important to check and calibrate the monitor at regular intervals, like once a week.

Locating the display profile

On the Macintosh, the profile should automatically be saved in the Library/ ColorSync/Profiles/Displays folder. On a PC, save to the Windows/System32/Spool/ Drivers/Color folder.

Monitor profile creation settings

Before you build a profile there are several option settings you have to decide upon. First there is the gamma space which I recommend should always be 2.2, even if it says somewhere that Macintosh users should use 1.8. The white point should be set to 6500 K. You may see 5000 K as the recommended setting, but your display will perform much better at 6500 K and is also closer to the native white point of most LCD displays (where possible select the native white point of your LCD). Select a small profile size for CRT profiles and large profile size for LCD profiles.

LCD hardware calibration

Some high-end LCD displays are beginning to feature hardware-level calibration such as Eizo Coloredge and Mitsubishi Spectraview.

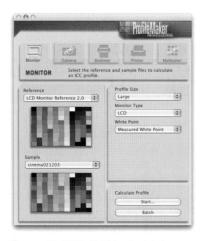

Figure 13.10 ProfileMaker Pro interface.

Camera Raw profiling

As was explained in Chapter 11, the Camera Raw plug-in uses data accumulated from two sets of profiles which have been produced using daylight balanced and tungsten balanced lighting. This method of profiling works surprisingly well with most normal color temperature settings, but the data gathered is based on a small sample of cameras (sometimes just one!) and so cannot be regarded as offering absolute accuracy. It may be helpful to follow the calibrate procedure (described in the same chapter) to obtain improved color.

Profiling the input

Input profiling is possible but it is easier to do with a scanner than it is with a digital camera. To profile a scanner you need to scan a film or print target and use profile creation software such as Gretag MacBeth's ProfileMaker Pro program to read the data and build a custom profile based on readings taken from the scanned target. The target measurements are then used to build a profile that describes the characteristics of the scanner. This profile should be saved to the Macintosh Library/ColorSync/Profiles folder. Or on a PC, save to the Windows/System32/Spool/Drivers/ Color folder. It can then be incorporated into your color managed workflow to describe the image data coming into Photoshop (refer back to Figure 13.6). This can be done by selecting the profile in the scanner software or by assigning the profile in Photoshop as the file is opened.

Camera profiling is a lot trickier to do and few photographers feel it is something worth bothering with. This is because the camera sensor will respond differently under different lighting conditions and you would therefore need to build a new profile every time the light changed. This is not necessarily a problem if you are using a digital camera in a studio setup with a consistent strobe lighting setup. In these circumstances it is probably very desirable that you photograph a color checker chart and take measurements that can be used to create a custom input profile for the camera. The Gretag MacBeth Eye-One Photo system will soon be able to offer camera profiling for such photographers.

Overall, I would not stress too much about input profiles unless it is critical to your workflow that you have absolute color control from start to finish. For example, a museum photographer who is charged with photographing important works of art would absolutely want to profile their camera. But is it always necessary or desirable? The most important thing is to trust what you see on your monitor display and obtain good color management between the image displayed on the screen and what you see in the print.

Figure 13.11 Here are three photographs taken on and around the London Eye wheel. These pictures have each been processed using an incorrect white balance setting. In these examples, input color management becomes irrelevant. But it matters more how consistent the appearance is between the computer display and the print output.

Profiling the output

Successful color management also relies on having accurate profiles for each type of media paper used with your printer. The printer you buy will come with a driver on a CD (or you can download one) and the installation procedure should install a set of canned profiles that will work when using the proprietary inks designed to be used in this device and with a limited range of branded papers. These tend to be OK in quality and will be enough to get you started. To get the best quality results I will use a test target like the one shown in Figure 13.12 and make a test print without color managing it. Once the test print has been allowed to stabilize the target is measured the following day using the Gretag MacBeth Eye-One spectrophotometer (see Figure 13.13). The patch measurement results are then used to build a color profile for the printer. The other alternative is to take advantage of Neil Barstow's remote profiling service special offer which is available to readers of this book (see the Appendix).

If using custom printer profiles, you need one to be built for each printer/media combination. I believe it is well worth the expense since it is possible to achieve really excellent results. If you read through to the next chapter on print output, you will see that you can use a profiled printer to achieve good CMYK proofing even from a modestly priced printer, which comes close to matching the quality of a recognized contract proof printer.

Figure 13.12 This Kodak color target can be used to construct a color ICC profile. Neil Barstow of www.colourmanagement.net, is offering a special discount rate to readers of this book (see Appendix for more details). A profile service company will normally supply you with instructions on how to print it out. When they receive your prints, they can measure these and email the custom ICC profile back to you. For more information on printing a profile test target, refer to Chapter 14.

Figure 13.13 Once a print profile has been printed out, the color patches can be read using a spectrophotometer and the measurements are used to build an ICC profile.

Martin Evening Adobe Photoshop CS2 for Photographers

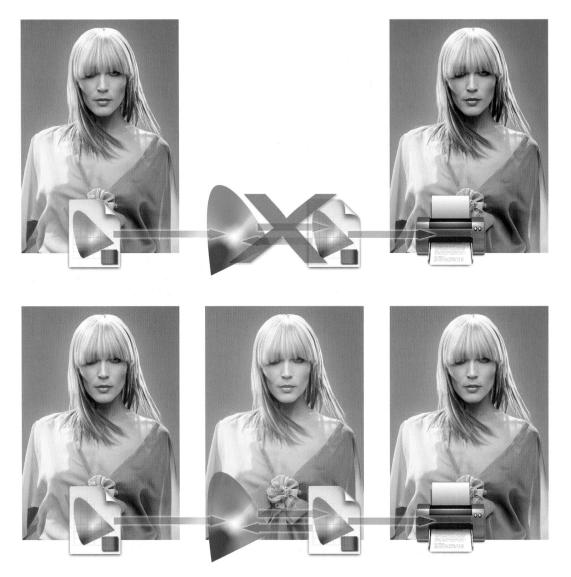

Figure 13.14 Here we are reexamining the problem encountered at the beginning of this chapter where the skin tones in the original image printed too blue. In the upper workflow no printer profile is used and the image data is sent directly to the printer with no adjustment made to the image data. In the lower example we show how a profile managed workflow works. The profile created for this particular printer is used to convert the image data to that of the printer's color space before being sent to the printer. The (normally hidden) color shifting which occurs during the profile conversion process will compensate by making the skin tone colors more red, but apply less color compensation to other colors. The result is an output that more closely matches the original. This is a simple illustration of the ICC-based color management system at work. All color can be managed this way in Photoshop from capture source to the monitor display and the final proof.

495

Photoshop color management interface

By now you should be acquainted with the basic principles of Photoshop ICC color management. It has become relatively easy to configure the Photoshop system. At the most simple level all you have to do is calibrate and profile your display and then go to the Photoshop Color Settings and select an appropriate prepress setting. This will switch on the Photoshop color management policies and be enough to get you up and running without the need to read any further. But if you are ready to discover more, then do read on.

Color Settings

.

1

1

\$

+)

-

For more information on color settings, search for "setting up color management" in Help. This term is searchable from any Creative Suite application.

- Settings: North America General Purpose 2

RGB: sRGB IEC61966-2.1

Gray: Dot Gain 20%

Spot: Dot Gain 20%

CMYK: U.S. Web Coated (SWOP) v2

RGB: Preserve Embedded Profiles

Cray: Preserve Embedded Profiles
Profile Mismatches: Ask When Opening Ask When
Missing Profiles: Ask When Opening

CMYK: Preserve Embedded Profiles

North America General Purpose 2: General-purpose color se

Working Spaces

Description

Color Management Policies

	Preview	area be which v
		Photos
Pasting		unerer
ttings for screen		

OK

Cancel

Load.

Save...

More Options

Figure 13.15 All the Photoshop color settings can be managed from within the Photoshop Color Settings dialog. Photoshop conveniently ships with various preset settings that are suited to different Photoshop workflows. As you move the cursor pointer around the Color Settings dialog, help messages are provided in the Description box area below – these provide useful information which will help you learn more about the Photoshop color management settings and the different color space options.

The Color Settings

The Color Settings are located in the Edit menu. Figure 13.15 shows the basic dialog controls and options. The first item you will come across is the Settings pop-up menu. Photoshop provides a range of preset configurations for the color management system and these can be edited to meet your own specific requirements. In basic mode, the default setting will be some sort of General Purpose setting and the exact naming and subsequent settings list will vary depending on the region where you live.

Other
Monitor Color
North America General Purpose 2
North America Prepress 2
North America Web/Internet

Custom

Figure 13.16 The default settings are just defaults. I advise changing the setting to one of the prepress settings as this will configure Photoshop to use Adobe RGB as your RGB work space and switch on the Profile Mismatch and Missing Profiles alert warnings.

✓ Custom

Other

Monitor Color North America General Purpose 2 North America Prepress 2 North America Web/Internet Trento-medium-2005 Treto-max-2005

Color Management Off	
ColorSync Workflow	
Emulate Acrobat 4	
Emulate Photoshop 4	
Europe General Purpose 2	
Europe General Purpose Defaul	ts
Europe Prepress 2	
Europe Prepress Defaults	
Europe Web/Internet	
Japan Color for Newspaper	
Japan Color Prepress	
Japan General Purpose 2	
Japan General Purpose Defaults	
Japan Magazine Advertisement	Color
Japan Prepress 2	
Japan Prepress Defaults	
Japan Web/Internet	
Monitor Color	
North America General Purpose	4
North America General Purpose	Defaults
North America Prepress	
North America Web/Internet	
Phase One Workflow	
Photoshop 5 Default Spaces	
U.S. Prepress Defaults	
Web Graphics Defaults	

Figure 13.17 Here is a full list of the preset settings (as seen when the More Options is selected). The General Purpose presets will preserve RGB profiles, but use sRGB as the RGB work space instead of Adobe RGB. And CMYK color management will be switched off. This is a little better than the previous Web Graphics default yet may help avoid confusion among novice users. In the basic Fewer Options mode, the choice will be restricted so that all you see will be the color settings for your geographical area.

RGB:	Preserve Embedded Profiles
CMYK:	Preserve Embedded Profiles
Gray:	Preserve Embedded Profiles
	Ask When Opening 🗹 Ask When Pasting
Missing Profiles:	Ask When Opening

Figure 13.18 The Color Management Policies, with the Profile Mismatch and Missing Profile checkboxes checked.

I would recommend that you follow the advice in Figure 13.16 and change this default to one of the Prepress settings. So if Photoshop was installed on a European computer, you would select the Europe Prepress Default setting from this list. If a preset color setting says 'prepress', this will be the ideal starting point for any type of color managed workflow, especially if you are a photographer. That is all you need to concern yourself with initially, but if you wish to make customized adjustments, then you can select custom settings in the Working Spaces section below. For help selecting an ideal RGB work space, refer back to the section on RGB spaces on pages 488–489. The CMYK and Grayscale settings will be covered later.

Color management policies

The first thing Photoshop does when a document is opened, is check to see if an ICC profile is present. The default policy is to preserve the embedded profile information. So whether the document has originated in sRGB, Adobe RGB or ColorMatch RGB, it will open in that RGB color space and after editing be saved as such. This means you can have several files open at once and each can be in an entirely different color space. A good tip here is to set the Status box to show 'Document profile' (on the Mac this is at the bottom left of the image window; on a PC it is at the bottom of the system screen palette). Or, you can configure the Info palette to provide such information. This will allow you to see each individual document's color space profile.

Profile mismatches and missing profiles

When there is a profile mismatch, Photoshop will warn you with one of the dialogs shown in Figure 13.19. Which of these you see will depend on the Color Settings. If you have a prepress setting selected, the Profile Mismatch and Missing Profile boxes will automatically be checked and the dialog that is shown when there is a profile mismatch will offer you a chance to convert the document colors to the current work space or discard the profile.

Preserve embedded profiles

The default policy of Preserve Embedded Profiles allows you to use the ICC color management system straight away, without too much difficulty. So long as there is a profile tag embedded in any file you open, Photoshop will give you the option to open that file without converting it. So if you are given an Apple RGB file to open, the default option is to open it in Apple RGB and save using the same Apple RGB color space. This is despite the fact that your default RGB work space might be Adobe RGB or some other RGB color space. The same policy rules apply to CMYK and grayscale files. Whenever Preserve Embedded Profiles is selected, Photoshop will read the CMYK or Grayscale profile, preserve the numeric data and not convert the colors. And the image will remain in the tagged color space. This is always going to be the preferred option when editing incoming CMYK files because a CMYK file may already be targeted for a specific press output and you don't really want to alter those numeric color values.

	The document "DSC00334.JPC" has an embedded color profil that does not match the current RGB working space. The embedded profile will be used instead of the working space. Embedded: sRGB IEC61966-2.1
	Working: Adobe RGB (1998)
	Don't show again Cancel OK
Δ	Embedded Profile Mismatch The document "DSC00334.JPG" has an embedded color profile that does not match the current RGB working space
A	
A	The document "DSC00334,JPC" has an embedded color profile that does not match the current RGB working space.
4	The document "DSC00334.JPG" has an embedded color profile that does not match the current RGB working space. Embedded: sRGB IEC61966-2.1
<u>A</u>	The document "DSC00334.JPG" has an embedded color profile that does not match the current RGB working space. Embedded: sRGB IEC61966–2.1 Working: Adobe RGB (1998)
1	The document "DSC00334.JPG" has an embedded color profile that does not match the current RGB working space. Embedded: sRGB IEC61966-2.1 Working: Adobe RGB (1998)

Making color management easier

A newcomer does not necessarily have to fully understand how Photoshop color management works in order to use it successfully. When Preserve Embedded Profiles is selected this will make the Photoshop color management system quite foolproof. The color management system is adaptable enough to suit the needs of all Photoshop users, regardless of their skill levels. Whichever option you select – convert or don't convert – the saved file will always be correctly tagged.

Figure 13.19 If the Preserve Embedded Profiles color management policy is selected, the upper dialog will appear whenever there is a profile mismatch between the image you are opening and the current working space. When you see this dialog, click OK to open the image in its embedded color space. Click Don't show again if you don't wish to be reminded each time this occurs.

If the Ask When Opening box is checked in the Profile Mismatches section (see Figure 13.18) then you will see a slightly different dialog like the lower one shown here. If the Ask When Opening option is checked, you can make a choice on opening to use the embedded profile, or override the policy and convert to the working space or discard the embedded profile.

Whatever you do, select one of these options and click OK, because if you click Cancel you will cancel opening the file completely.

Include a 'Read Me' file

When you save a profiled RGB file, enclose a Read Me file on the disk to remind the person who receives the image that they must not ignore the profile information – it is there for a reason! If you are designing images for screen display such as on the Web, then convert your images to the sRGB profile using Edit \Rightarrow Convert to Profile.

Figure 13.20 If the Convert to Working RGB color management policy is selected, the upper dialog will appear whenever there is a profile mismatch between the image you are opening and the current working space. When you see this dialog, click OK to convert the document colors to the current color working space. Click Don't show again if you don't wish to be reminded each time this occurs.

If the Ask When Opening box is checked in the Profile Mismatches section you will see the lower dialog shown here. You can make a choice on opening to convert to the working space, use the embedded profile, or override the policy and discard the embedded profile.

Convert to Working space

If you select the Convert to Working space policy, Photoshop will automatically convert everything to your current RGB or CMYK work space. If the incoming profile does not match the work space, then the default option will be to carry out a profile conversion from the embedded profile space to the current work space. And when the incoming profile matches the current RGB, CMYK or grayscale work space, there is of course no need to convert the colors. Preserve Embedded Profiles is usually the safer option because you can't go wrong if you just click OK to everything. Convert to Working space can be a useful option for RGB mode because you may wish to convert all RGB images to your working space, but not for CMYK. For batch processing work I sometimes prefer to temporarily use a Convert to Working space RGB setting because this will allow me to apply a batch operation to a mixture of files in which all the images end up in the current RGB work space.

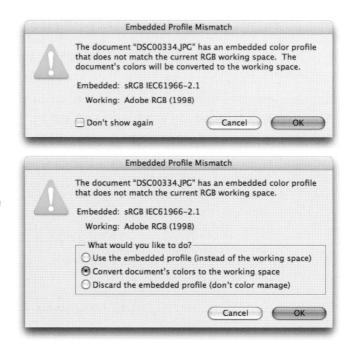

Color Management Off

The other option is to choose Color Management: Off. When this option is selected Photoshop will not attempt to color manage incoming documents. It will assume the default RGB or CMYK work space to be the source. If there is no profile embedded, then the document will stay that way. If there is a profile mismatch between the source and work space, the profile will be removed (with an alert warning pointing out that the embedded profile information is about to be deleted). If the source profile matches the work space, there is no need to remove the profile, so in this instance the profile tag will not be removed (even so, you can still remove the ICC profile at the saving stage).

Turning the color management off is not recommended for general Photoshop work. So check the Color Settings to make sure you are not using one of the Web/Internet preset settings which will disable Photoshop's color management.

	Embedded Profile Mismatch		
	The document "DSC00334.JPG" has an embedded color profile that does not match the current RCB working space. The current RGB color management policy is to discard profiles tha do not match the working space.		
	Embedded: sRGB IEC61966-2.1		
	Working: Adobe RGB (1998)		
	Don't show again Cancel OK		
	Embedded Profile Mismatch		
Λ	The document "DSC00334.JPC" has an embedded color profile that does not match the current RGB working space.		
<u> </u>	Embedded: sRGB IEC61966-2.1		
	Working: Adobe RGB (1998)		
	O Use the embedded profile (instead of the working space)		
	O Convert document's colors to the working space		

When it is good to 'turn off'

Sometimes it is desirable to discard a profile. For example, you may be aware that the image you are about to open has an incorrect profile and it is therefore a good thing to discard it and assign the correct profile later in Photoshop. I would not recommend choosing Off as the default setting though. Just make sure you have the Color Management Policies set to Ask When Opening and you can easily intervene manually to discard the profile when using either of the other color management policy settings.

Figure 13.21 If the Color Management Off policy is selected, the upper dialog will appear whenever there is a profile mismatch between the image you are opening and the current working space. When you see this dialog, click OK to discard the embedded profile. Click Don't show again if you don't wish to be reminded each time this occurs.

If the Ask When Opening box is checked in the Profile Mismatches section you will see the lower dialog shown here. You can make a choice on opening to discard the embedded profile, use the embedded profile or convert to the working space.

Profile conversions

As you gain more experience you will be able to customize and create your own color settings. The minimum you need to know is which of these listed color settings will be appropriate for the work you are doing. And to help in this decision making, you can read the text descriptions that appear in the Description box at the bottom of the Color Settings dialog. For example, you might want to start by loading one of the presets present in the Color Settings menu and customize the CMYK settings to match the conditions of your repro output.

Convert to Profile

Even if you choose to preserve the embedded profile on opening, it is useful to have the means to convert nonwork space files to your current work space after opening. This is where the Convert to Profile command comes in, because you don't have to worry about remembering to convert the image on opening. The profile conversion can take place at any time, such as at the end of a retouch session, just before saving. Let's suppose we want to open an RGB image that is in sRGB and the current working space is Adobe RGB. If the Preserve Embedded Profile option is selected then the default behavior would be to open the file and keep it in sRGB without converting. We could carry on editing the image in the sRGB color space up until the point where it is desirable to carry out a conversion to another color space such as Adobe RGB.

To make a profile conversion, go to the Edit menu and choose Convert to Profile... This will open the dialog box shown in Figure 13.22. The Source space shows the current profile space. The Destination Space contains a pop-up menu that will list all of the profiles available on your computer system (depending on how many profiles you have installed). The list of available profiles will be divided into several sections that are separated by dividers. The first section starts with the default RGB, CMYK and Grayscale profiles. Below that are all the other available RGB profiles followed by the CMYK and lastly the Grayscale spaces.

RGB to RGB conversion warning

A Convert to Profile is just like any other image mode change in Photoshop, such as converting from RGB to Grayscale mode, and it is much safer to use than the old Profile to Profile command in Photoshop 5.0. However, be careful if you use Convert to Profile to produce targeted RGB outputs that overwrite the original RGB master. Any version of Photoshop since version 6.0 will have no problem reading the embedded profiles and displaying the image correctly; and will recognize any profile mismatch (and know how to convert back to the original work space). But as always, customized RGB files such as this may easily confuse other non-ICC savvy Photoshop users. Not everyone is using Photoshop, nor does everyone have their color management configured correctly. Some RGB to RGB conversions can produce RGB images that look fine on a correctly configured system, but look very odd on one that is not.

The Convert to Profile command is also useful when you wish to create an output file to send to a printer for which you have a custom-built profile but the print driver does not recognize ICC profiles. For example, one of the printers I use a lot is the Fuji Pictrograph. I have built a custom profile for this printer, but unfortunately there is no facility within the File Export driver to utilize the output profile. Therefore, I use the Convert to Profile command to convert the color data to match the space of the output device just prior to sending the image data to the printer to make a print.

Whenever you make a profile conversion the image data will end up in a different color space and you might see a slight change in the on-screen color appearance. This is because the profile space you are converting to has a smaller gamut than the one you are converting from. If the profile conversion produces an image in a non-working space color space Photoshop attaches a warning asterisk (*) after the color mode in the title bar.

Convert to Profile	
Source Space Profile: sRGB IEC61966-2.1	OK
Destination Space Profile: Working RGB - Adobe RGB (1998)	Preview
Conversion Options Engine: Adobe (ACE)	
Intent: Relative Colorimetric	
Use Black Point Compensation	
🗹 Use Dither	
Flatten Image	

Figure 13.22 Convert to Profile is similar to the old Profile to Profile command in Photoshop 5.0. The color management system in Photoshop 6.0 or later is different in that you don't need to carry out a profile conversion in order to correctly preview a file in Photoshop. It is nevertheless an essential command for when you wish to convert color data from one profile color space to another profiled space, such as when you want to convert a file to the profiled color space of a specific output device.

Incorrect sRGB profile tags

Some digital cameras don't embed a profile in the JPEG capture files, yet the EXIF metadata will misleadingly say the file is in sRGB color mode. This can be resolved by going to the Photoshop menu and choosing: Preferences ⇒ File Handling... If you check the Ignore EXIF Profile tag, Photoshop will always ignore the specified camera profile in the EXIF metadata and only rely on the actual profile (where present) when determining the color space the data should be in.

Figure 13.23 The Assign Profile command is available from the Edit menu in Photoshop (it has been moved from Image \Rightarrow Mode). Edit \Rightarrow Assign Profile can be used to assign a new, correct profile to an image or remove an existing profile.

Assign Profile

The Assign Profile command can be used to correct mistakes by assigning a profile to an image if one is missing, or removing an incorrect profile. When an image is missing its profile or has the wrong profile information embedded then the numbers are meaningless. The Assign Profile command allows you to assign correct meaning to what the colors in the image should be. So, for example, if you know the profile of an opened file to be wrong, then you can use the Edit \Rightarrow Assign Profile command to rectify the situation. Let's suppose you have opened an untagged RGB file and for some reason decided not to color manage the file when opening. The colors don't look right and you have reason to believe that the file had originated from the Apple RGB color space. Yet, it is being edited in your current Adobe RGB work space as if it were an Adobe RGB image. By assigning an Apple RGB profile, we can tell Photoshop that this is not an Adobe RGB image and that these colors should be considered as being in the Apple RGB color space. You can also use Assign Profile to remove a profile by clicking on the Don't Color Manage This Document button, which will allow you to strip a file of its profile. But you can also do this by choosing File \Rightarrow Save As... and deselecting the Embed Profile checkbox in the Save options.

Assign Pr	ofile:	 (au
O Don't Co	olor Manage This Document	COK
	RGB: Adobe RGB (1998)	Cancel
Profile:	sRGB IEC61966-2.1	Preview

Profile mismatches

One problem with having images with multiple color spaces open at once concerns the copying and pasting of color data from one file to another. Whenever you copy and paste image data, or copy drag an image with the move tool, it is possible that a profile mismatch may occur. When this happens you will see the dialog shown in Figure 13.24. This will ask if you wish to convert the color data to preserve the color appearance when it is pasted into the new destination document. If the Profile Mismatch: Ask When Pasting box is checked in the Color Settings, then you will see instead the dialog box shown in Figure 13.25. This dialog offers you the choice to convert or not convert the data. If you select Convert, the appearance of the colors will be maintained when you paste the data. If you choose Don't Convert the color appearance will change but the numbers will be preserved.

A	Are you sure you want to convert cole a color profile that does not match th	
		ie current Rub working space:
	Source: Adobe RGB (1998)	
	Destination: sRGB IEC61966-2.1	
	Working: Adobe RGB (1998)	
	Don't show again	Cancel OK
	Paste Profile Mism	natch
Λ	Paste Profile Mism You are pasting content copied from profile.	
Ŷ	You are pasting content copied from	
V	You are pasting content copied from profile.	a document with a different colo
1	You are pasting content copied from profile.	a document with a different colo
\$	You are pasting content copied from profile. Source: sRGB IEC61966-2.1 Destination: Working RGB - Adobe R	a document with a different colo

Figure 13.24 If you attempt to paste image data from a document whose color space does not match the destination space, this dialog warning will appear, alerting you to the fact that there is a profile mismatch between the source and destination documents. If you click OK, Photoshop will convert the data and preserve the color appearance of the image data.

Figure 13.25 If the Profile Mismatch: Ask When Pasting box is checked in the Color Settings dialog and you attempt to paste image data from a document whose color space does not match the destination space, this dialog warning will give you the option to Convert the colors (as in Figure 13.24 above), or Don't Convert and preserve the numbers instead.

Color Settings save location

On Mac OS X, if Photoshop CS2 is installed for multi-users, the most likely path to save your settings is to: Library/ Application Support/Adobe/Color/Settings folder. On a PC, save your settings to: Program Files/Common Files/Adobe/ Color/Settings folder. The file will be appended with a .csf suffix.

Saving a Color Setting

If you have configured the settings to suit a particular workflow, you can click on the Save... button to save these as a custom setting that will appear in the Color Settings menu the next time you visit the Color Settings dialog. When you save a setting you can enter any relevant comments or notes about the setting you are saving in the text box (see Figure 13.26). This information will then appear in the Color Settings dialog text box at the bottom. You might name the setting something like 'Internal annual report' and so you might want to write a short descriptive note to accompany the setting.

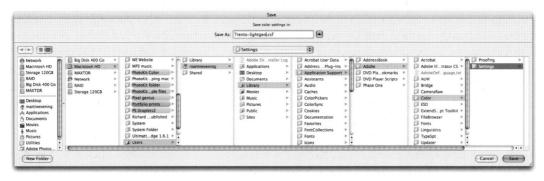

Figure 13.26 Custom color settings can be loaded or saved via the Color Settings dialog. The relevant folder will be located in the Username Library/Application Support/Adobe/ Color/Settings folder (Mac OS X) or Program Files/Common Files/Adobe/Color/Settings folder (PC). When you save a custom setting it must be saved to this location and will automatically be appended with the '.csf' suffix. When you save a color setting you have the opportunity to include a brief text description in the accompanying dialog. A Color Settings file can be shared between some Adobe applications and with other Photoshop users. The Mac OS X location can be 'user' specific, in which case the route would be: Users/ Username/Library/Application Support/Adobe/ Color/Settings folder.

Reducing the opportunities for error

When you adopt an RGB space such as Adobe RGB as the preferred work space for all your image editing, you have to take into account that this might cause confusion when exchanging RGB files between your machine operating in a color managed workflow and that of someone who is using Photoshop with the color management switched off. When sending image files to other Photoshop users, the presence of a profile will help them to read the image data correctly. So as long as they have the Photoshop color settings configured to preserve embedded profiles (or convert to the working space) and their monitor display is calibrated correctly, they will see your photographs on their system almost exactly the way you intended them to be seen. The only variables will be the accuracy of their display calibration and profile, the color gamut limitations of the display and the environment it is being viewed in. Configuring the Color Settings correctly is not difficult to do, but the recipient does have to be as conscientious as you are about ensuring their monitor display is set up correctly. The situation has not been helped either by the way the default color settings have shifted about over the last six versions of the program. The default settings in Photoshop CS2 uses: Preserve Embedded Profiles, but prior to that we had settings like 'Web Graphics' in which color management was switched off. Consequently, there are a lot of Photoshop users out there who have unwittingly been using sRGB as their default RGB work space and with color management switched off. And even when people do have the color management switched on, the monitors they are using may not have been profiled in months or are being viewed in a brightly lit room!

It is important to be aware of these potential problems because it is all too easy for the color management to fail once an image file has left your hands and been passed on to another Photoshop user. With this in mind, here are some useful tips to help avoid misunderstandings over color. The most obvious way to communicate what the colors are supposed to look like is to supply a printed

Playing detective

How you deliver your files will very much depend on who you are supplying them to. I often get emails from readers who have been given the runaround by their color lab. One typically finds that the lab may be using a photo printer such as the Fuji Frontiera which is calibrated to receive sRGB files. And if the color lab operator has Photoshop color management switched off, they will not know how to handle anything other than an incoming file that is in sRGB color. So if you supply them with an Adobe RGB file they won't read the profile and the colors will end up looking different in the final print. And then they blame the customer!

It helps to do a little detective work to ascertain the skill level of the recipient. The first thing you need to know is the color settings they are using. That will help you determine which RGB space they are using and whether the color management is switched on or off. The other thing to ask is 'do you have your monitor display calibrated and profiled?' And if the answer is yes, then ask how often they calibrate and profile their display. The answers to these questions will tell you quite a bit about the other person's system, how you should supply your files and also how accurately they should be able to judge the color on their monitor display.

Martin Evening Adobe Photoshop CS2 for Photographers

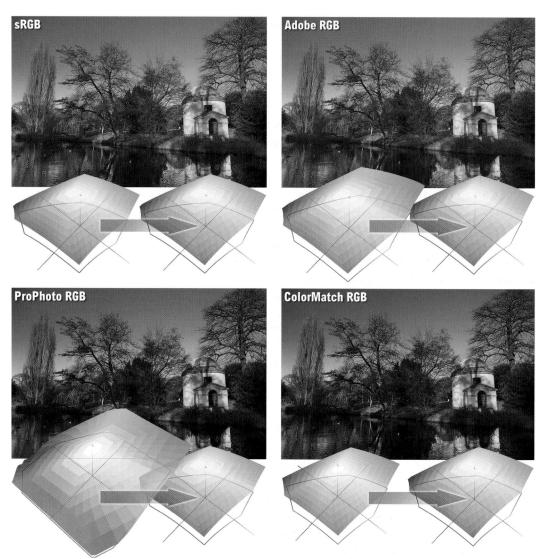

Figure 13.27 The purpose of this illustration is to show what would happen if you submitted an RGB file to a Photoshop user who had their Photoshop system configured using sRGB as their RGB work space and with the color management policies set to ignore incoming profiles. The top left picture is the correct version and shows how the image would look if I supplied the image converted to the sRGB color space, anticipating that the other user was using this as their default RGB space. The remaining examples show how the same picture would look if I had supplied the same picture using different RGB spaces and the person receiving the file ignored the embedded profile. If the picture was delivered as an Adobe RGB file, the gamma would match but because Adobe RGB has a larger gamut than sRGB and the colors would appear slightly desaturated. ProPhoto RGB has a much larger color gamut than Adobe RGB so the colors would appear even more muted when brought into sRGB without any color management. And lastly, if I supplied a ColorMatch RGB file, sRGB would interpret this as a darker image because ColorMatch has a lower gamma of 1.8.

output that shows what the photograph should look like. In fact this is considered routine when supplying images to a printer. If you are sending a file for CMYK repro printing then the file should be targeted to the CMYK output. Don't worry too much about what that means just yet, we will be covering this topic in the following chapter. But supplying a print is an unambiguous visual reference, which if done properly can form the basis of a contract between yourself, the client and the printer.

If the person you are supplying the file to is in the same building or you are in regular contact with them, then you probably have a clear idea of how their system is set up. If they have Photoshop color management switched on, they can read any file you send them in any color space and it will be color managed successfully. But you cannot always make too many assumptions about the people you are sending image files to and so you should sometimes adopt a more cautious approach. I am often asked to supply RGB files as large JPEGs for initial approval by the client before making a finished print. In these situations I find it safer to supply a profiled sRGB image. I do this by choosing Edit \Rightarrow Convert to Profile... and selecting sRGB as the destination space. If the recipient is color management savvy, then Photoshop will read the sRGB profile and handle the colors correctly. If the recipient has not bothered to configure their color management settings then one can be almost certain that they are using sRGB as their default RGB work space. So in these instances, targeting the RGB colors to sRGB is probably the safer option. Figure 13.27 shows a comparison of how a single image that was edited using different RGB work spaces would look on a Photoshop system configured using a (non-color managed) Web Graphics default setting. In this example, the version that was converted to sRGB was the only one that stood a chance of being displayed correctly. I am certainly not advocating you use sRGB as your standard RGB work space, because it is still a poor space to use for photographic work. But it can be a useful 'dumbed down' space to use when communicating with unknown users.

Grayscale for screen display

If you intend creating grayscale images to be seen on the Internet or in multimedia presentations, choose the Default Web Graphics color setting. The Grayscale work space will then be set to a 2.2 gamma space, which is the same gamma used by the majority of PC computer screens. The truth is, you can never be 100% sure how anybody who views your work will have their monitor calibrated, but you can at least assume that the majority of Internet users will have a PC monitor set to a 2.2 gamma.

Macintosh gamma

The Macintosh 1.8 gamma setting should really be relegated to ancient history. The reason it exists at all is because in the very early days of the Macintosh computer and before ICC color management, a 1.8 gamma monitor space most closely matched the dot gain of the Apple monochrome laser printer.

Custom Gray space settings

Figure 13.35 shows a range of dot gain values that can be used as a guide for different types of press settings. This is a rough guide as to which dot gain setting you should use on any given job. When the Advanced color settings option is checked you can enter a custom gamma value or dot gain curve setting (see 'Dot gain' on pages 515–516).

Working with Grayscale

Grayscale image files can also be managed via the Color Settings dialog. The color management policy can be set to either Preserve Embedded Profiles or Convert to Grayscale work space and again the Ask When Opening box should be checked. If the profile of the incoming grayscale file does not match the current Gray work space, you will be asked whether you wish to use the tagged grayscale space profile, or convert to the current grayscale work space. If there is no profile embedded, you will be asked to either: 'Leave as is' (don't color manage), assign the current Gray work space or choose a Gray work space to assign to the file (and, if you wish, convert to the Gray work space).

If you examine the Gray work space options, you will see that it contains a list of dot gain percentages and monitor gamma values. If you are preparing grayscale images for display on a monitor such as on a website or in a multimedia presentation then you will want to select an appropriate monitor space setting such as Gamma 2.2 (see the sidebar: Grayscale for screen display). If you want to know how any existing prepress grayscale image will look like on the Web as a grayscale image, select the View \Rightarrow Proof Setup and choose Windows RGB or Macintosh RGB. You can then select Image \Rightarrow Adjust \Rightarrow Levels and adjust the gamma slider accordingly to obtain the right brightness for a typical Windows or Macintosh display.

For prepress work you should select the dot gain percentage that most closely matches the anticipated dot gain of the press. It is important to note that the Gray work space setting is independent of the CMYK work space. If you want the Gray work space dot gain value to match the black plate of the current CMYK setting, then mouse down on the Gray setting and choose Load Gray... Now go to the Profiles folder which will be in the Library/Application Support/Adobe/Color/Settings folder on a Mac and in the Program Files/Common Files/Adobe/Color/Settings folder on a PC. Select the same CMYK space as you are using for the CMYK color separations and click the Load button.

Advanced Color Settings

The advanced settings will normally remain hidden. If you click on the More Options button, you will be able to see the expanded Color Settings dialog shown in Figure 13.28. These advanced settings unleash full control over the Photoshop color management system. But do not attempt to adjust any of these expert settings until you have fully understood the intricacies of customizing the RGB, CMYK, Gray and Spot color spaces. I would suggest that you read through the remaining section of this chapter first before you consider customizing some of these settings.

		C	olor Settings		
	Help. This term		rch for "setting up co ble from any Creative		OK
ttings: Nort	h America P	repress	2	- (\$	
Working Spaces -					Load
RGB:	Adobe RGB (19	98)			Save
CMYK:	U.S. Web Coate	d (SWOP) v2	2	•	
Gray:	Dot Gain 20%			;	More Option
Spot:	Dot Gain 20%				Preview
Color Managemer	t Policies				
RGB:	Preserve Ember	ided Profile	15 🛟		
CMYK:	Preserve Ember	Ided Profile	15		
Gray:	Preserve Ember	ided Profile	15		
Profile Mismatches: Missing Profiles:	\sim		Ask When Pasting		
Conversion Optio	ns				
Engine:	Adobe (ACE)		•		
intent:	Relative Colorin	netric	•		
	Use Black Po	oint Comper	nsation		
	Use Dither (8-bit/chanr	nel images)		
Advanced Control	s				
Desaturate Moni	tor Colors By:	20	%		
	s Using Gamma:	1.00			
Blend RGB Color					
Blend RGB Color Description					

Black Point and Proof printing

You will want to choose to use Black Point Compensation when separating an RGB image to a press CMYK color space. However, in the case of a conversion from a CMYK proofing space to an inkjet profile space, we must preserve the (grayish) black of the press and not scale the image (because this would improve the blacks). It is for these reasons that the Black Point Compensation is disabled in the Print with Preview dialog when making a proof print to simulate the black ink.

Conversion options

You have a choice of three Color Management Modules (CMMs): Adobe Color Engine (ACE), Apple ColorSync or Apple CMM. The Adobe color engine is reckoned to be superior for all RGB to CMYK conversions because the Adobe engine uses 20-bit per channel bit-depth calculations to calculate its color space conversions.

Black Point Compensation

This will map the darkest neutral color of the source RGB color space to the darkest neutrals of the destination color space. Black Point Compensation plays a vital role in translating the blacks in your images so that they reproduced as black when printed. As was explained in Chapter 4, there is no need to get hung up on setting the shadow point to anything other than zero RGB. It is not necessary to apply any shadow compensation at the image editing stage, because the color management will automatically take care of this for you and apply a black point compensation obtained from the output profile used in the mode or profile conversion. If you disable the Black Point Compensation you may obtain deeper blacks, but you will get truer blacks if you leave it switched on.

Use Dither (8-bit per channel images)

Banding may occasionally occur when you separate to CMYK, particularly where there is gentle tonal gradation in bright saturated areas. Banding which appears on screen does not necessarily always show in print and much will depend on the coarseness of the screen used in the printing process. However, the dither option will help reduce the risks of banding when converting between color spaces.

Rendering intents

The rendering intent will influence the way the data is translated from the source to the destination space. The rendering intent is like a rule that describes the way the translation is calculated. We will be looking at rendering intents in more detail on pages 520–523.

Blend RGB colors using gamma

This item provides you with the potential to the override the default color blending behavior. There used to be an option in Photoshop 2.5 for applying blend color gamma compensation. This allowed you to blend colors with a gamma of 1.0, which some experts argued was a purer way of doing things, because at any higher gamma value than this you would see edge darkening occur between contrasting colors. Some users found the phenomenon of these edge artifacts to be a desirable trapping effect. But Photoshop users complained that they noticed light halos appearing around objects when blending colors at a gamma of 1.0. Consequently, gamma compensated blending was removed at the time of the version 2.5.1 update. But if you understand the implications of adjusting this particular gamma setting, you can switch it back on if you wish. Figure 13.29 illustrates the difference between blending colors at a gamma of 2.2 and 1.0.

Desaturate monitor colors

The desaturate monitor colors option enables you to visualize and make comparisons between color gamut spaces where one or more gamut space is larger than the monitor RGB space. Color spaces such as Adobe RGB and Wide Gamut RGB both have a gamut that is larger than the monitor space is able to show. So turning down the monitor colors saturation will allow you to make a comparative evaluation between these two different color spaces.

Figure 13.29 In this test we have a pure RGB green soft-edged brush stroke that is on a layer above a pure red background layer. The version on the left shows the combined layers using the normal default blending. And the image on the right shows what happens if you check the 1.0 checkbox. The darkening around the edges where the contrasting colors meet will disappear.

Customizing the RGB and work space gamma

Expert users may wish to use an alternative custom RGB work space instead of one of the listed RGB spaces. If you know what you are doing and wish to create a customized RGB color space, you can go to the Custom... option in the pop-up menu and enter the information for the White Point, gamma and color primaries coordinates. My advice is to leave these expert settings well alone. And do avoid falling into the trap of thinking that the RGB work space gamma should be the same as the monitor gamma setting. The RGB work space is not a monitor space.

Adobe RGB is a good choice as an RGB work space because its 2.2 gamma provides a more balanced, even distribution of tones between the shadows and highlights. These are the important considerations for an RGB editing space. Remember, you do not actually 'see' Adobe RGB. The Adobe RGB gamma has no impact on how the colors are displayed on the screen, so long as Photoshop ICC color management is switched on. In any case, these advanced custom color space settings are safely tucked away in Photoshop and you are less likely to be confused by this apparent discrepancy between monitor gamma and the RGB work space gamma.

C	initial (And	Oustom RG8	(
Custom RCB Name: Bruce RCB Camma Gamma: Gamma: 2.20 White Point: 6500° K (D65) X Y White: 0.3127 0.3290 Primaries: Custom \$ X Y Red: 0.6400 0.3300 Creen: 0.2800 0.6500 Blue: 0.1500	OK Cancel Sate application Settings: Nort Working Spaces RGR CMWK Gray: Color Management Color Management RGR CMWK Gray: Profile Mismaches Masing Profiles	Coner Montor RCB Cinema3Dinch-201204.icc Colorsync RCBsRCB IEC61966-2.1 Adobe RCB (1998) Apple RCB ColorMatch RCB SKCB IEC51966-2.1 1290 I-RAC 190304.icc 1290 I-RAC 190304.icc 1290 I-RAC 190304.icc 1290 I-RAC 0303.icc 1290 I-RAC 0303.icc 7600-Hrag-matte-19004.icc 1290 I-RAC matter I-Print.icc 7600-Hrag-matter I-Print.icc	OK Cancel Load Save Fewer Optic
igure 13.30 The Custom RGB dialog. Use is option to create a custom RGB work space. he settings shown here have been named ruce RGB', after Bruce Fraser who devised is color space as an ideal prepress space for notoshop.	Missing Profiles Conversion Optio Engine: Intent: Advanced Contro Desaturate Mon Bland RCB Color	cinema30-monaco-171104.cc cinema30-monaco-171104.cc cinema31-05-04.cc e-sRCB BFSON Stylus Photo 1290 360dpi Ink Jet Paper BFSON Stylus Photo 1290 Goldot.ffe P.P. BFSON Stylus Photo 1290 Moto Paper BFSON Stylus Photo 1290 Photo Paper BFSON Stylus Photo 1290 Photo Paper BFSON Stylus Photo 1290 Photo Qailiy Ink Jet Paper BFSON Stylus Photo 1290 Findurd	

RGB to CMYK

Digital scans and captures all originate in RGB but professional images are nearly always reproduced in CMYK. Since the conversion from RGB to CMYK has to happen at some stage, the question is, at what point should this take place and who should be responsible for the conversion? If you have decided to take on this responsibility yourself then you need to know something more about the CMYK settings. Because when it comes to four-color print reproduction, it is important to know as much as possible about the intended press conditions that will be used at the printing stage and use this information to create a customized CMYK setup.

CMYK setup

If you examine the US prepress default setting, the CMYK space says U.S. Web Coated (SWOP). This setting is by no means a precise setting for every US prepress SWOP coated print job, because there can be many flavors of SWOP, but it does at least bring you a little closer to the type of specification a printer in the US might require for printing on coated paper with a web press setup. If you mouse down on the CMYK setup pop-up list, you will see there are also US options for web uncoated and sheetfed press setups. Under the European prepress default setting, there is a choice between coated and uncoated paper stocks, plus a new ISO coated FOGRA27 setting. And then there is Custom CMYK... where you can create and save your custom CMYK profile settings.

Creating a custom CMYK setting

Figure 13.31 shows the Custom CMYK dialog. This is better known as the familiar 'Classic' Photoshop CMYK setup. You can enter here all the relevant CMYK separation information for your specific print job. Ideally you will want to save each purpose-built CMYK configuration as a separate color setting for future use and label it with a description of the print job it was built for.

Photoshop CMYK myths

There are some people who will tell you that in their 'expert opinion', Photoshop does a poor job of separating to CMYK. And I bet if you ask them how they know this to be the case, they will be stumped to provide you with a coherent answer. Don't let anyone try to convince you otherwise. Professional quality CMYK separations can be achieved in Photoshop, you can avoid gamut clipping and you can customize a separation to meet the demands of any type of press output. The fact is that Photoshop will make lousy CMYK separations if the Photoshop operator who is carrying out the conversion has a limited knowledge of how to configure the Photoshop CMYK settings. For example, a wider gamut RGB space such as Adobe RGB is better able to encompass the gamut of CMYK and yield CMYK separations that do not suffer from gamut clipping. This is one big strike in favor of the Photoshop color management system. But CMYK is not a one-size-fitsall color space. CMYK needs to be tailormade for each and every job.

Saving custom CMYK settings

The custom CMYK settings should be saved using the following locations: Library/ColorSync/Profiles/Recommended folder (Mac OS X). Windows/System32/Spool/Drivers/Color folder (PC).

CMYK previews in Proof Setup

Once the CMYK setup has been configured, you can use View \Rightarrow Proof Setup \Rightarrow Working CMYK to apply a CMYK preview of what the image will look like after converting while you are still editing the image in RGB mode. Once you have configured a new CMYK work space setting, this will become the new default CMYK work space that is used when you convert an image to CMYK mode. Altering the CMYK setup settings will have no effect on the on-screen appearance of an already-converted CMYK file (unless there is no profile embedded) because the CMYK separation setup settings must be established first before you carry out the conversion.

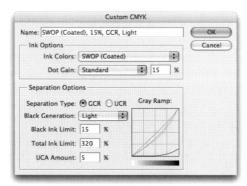

Figure 13.31 When you select the Custom CMYK... option at the top of the pop-up menu list, this opens the dialog box shown above, where you can enter the specific CMYK setup information to build a custom targeted CMYK setting. If you have clicked on the More Options button, you will have a wider range of preloaded CMYK profile settings to choose from.

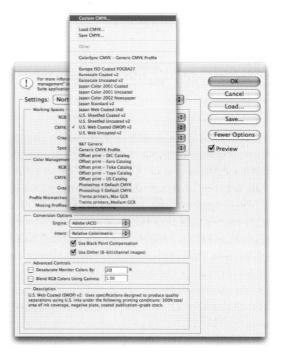

Ink Colors

If you click on the Ink Colors menu, you can select one of the preset Ink Colors settings that are suggested for different types of printing. For example, European Photoshop users can choose from Eurostandard (coated), (uncoated), or (newsprint). These are just generic ink sets. If your printer can supply you with a custom ink color setting, then select Custom... from the Ink Colors menu. This will open the dialog shown in Figure 13.32.

	Y	x	У		(OK)
C:	26.25	0.1673	0.2328		Cancel
M:	14.50	0.4845	0.2396		
Y:	71.20	0.4357	0.5013]	
MY:	14.09	0.6075	0.3191		
CY:	19.25	0.2271	0.5513		
CM:	2.98	0.2052	0.1245		1
CMY:	2.79	0.3227	0.2962		
W:	83.02	0.3149	0.3321]
К:	0.82	0.3202	0.3241		
L*a	*b* Coord	linates			

Figure 13.32 Here is a screen shot of the Custom Ink Colors dialog. For special print jobs such as where non-standard ink sets are used or the printing is being done on colored paper, you can enter the measured readings of the color patches (listed here) taken from a printed sample on the actual stock that is to be used. You could measure these printed patches with a device such as the Gretag MacBeth Eye-One and use this information to create a custom Ink Colors setting for an individual CMYK press setup.

Dot gain

Dot gain refers to an accumulation of factors during the repro process that will make a dot printed on the page appear darker than expected. Among other things, dot gain is dependent on the type of press and the paper stock being used. The dot gain value entered in the CMYK setup will determine how light or dark the separation needs to be. If a high dot gain is encountered, the separated CMYK films will need to be less dense so that the plates produced will lay down less ink on the paper and produce the correct sized printed halftone dot for that particular type of press setup.

You can see for yourself how this works by converting an image to CMYK using two different dot gain values and inspecting the individual CMYK channels afterwards and compare their appearance. Although the dot gain value will affect the lightness of the individual channels, the composite CMYK channel image will always be displayed correctly on the screen to show how the final printed image should look.

If you select the Dot Gain Curves option, you can enter custom settings for the composite or individual color plates. In the preparation of this book I was provided with precise dot gain information for the 40% and 80% ink values (these are shown in Figure 13.33). Figure 13.33 If you select Dot Gain: Curves... from the CMYK setup shown in Figure 13.31, you will open the Custom Dot Gain dialog shown above. If your printer is able to provide dot gain values at certain percentages, then you can enter these here. Dot gain may vary on each ink plate. If you deselect the All Same box, you can enter the dot gain for each individual plate. Note that when you select Custom Dot Gain... from the Gravscale work space menu, a similar dialog appears. If you are preparing to save a color setting designed for separating prepress CMYK and grayscale files, you will want to check that the black plate dot gain setting is consistent (see page 510). Note that dot gain can vary for each plate and that the black plate dot gain may be slightly different.

Advanced CMYK settings

There is not a lot you can do with the standard CMYK settings: you can make a choice from a handful of generic CMYK profile settings or choose Custom CMYK... If you check the More options box, you will readily be able to select from a more comprehensive list of CMYK profile settings in the extended menu, depending on what profiles are already in your ColorSync folder.

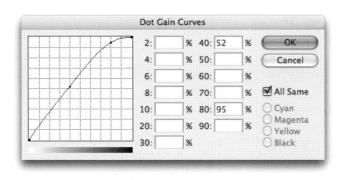

Gray Component Replacement (GCR)

The default Photoshop setting is GCR, Black Generation: Medium, Black Ink Limit 100%, Total Ink Limit 300%, UCA Amount 0%. If you ask your printer what separation settings they use and you are quoted the above figures, you know they are just reading the default settings to you from an unconfigured Photoshop setup and they either don't know or don't want to give you an answer. If you are creating a custom CMYK setting it is more likely you will want to refer to the table in Figure 13.35 for guidance. Or if you prefer, stick to using the prepress Adobe CMYK setting that most closely matches the output (such as: US Sheetfed/Web Coated/Uncoated, or European Pre-Press/ Sheetfed/Web/Coated/Uncoated).

Undercolor Removal (UCR)

The UCR (Undercolor Removal) separation method replaces the cyan, magenta and yellow ink in just the neutral areas with black ink. The UCR setting is also favored as a means of keeping the total ink percentage down on high-speed presses, although it is not necessarily suited for every job.

Undercolor Addition (UCA)

Low key subjects and high quality print jobs are more suited to the use of GCR (Gray Component Replacement) with a small amount of UCA (Undercolor Addition). GCR separations remove more of the cyan, magenta and yellow ink where all three inks are used to produce a color, replacing the overlapping color with black ink. The use of UCA will add a small amount of color back into the shadows and is useful where the shadow detail would otherwise look too flat and lifeless. The percentage of black ink used is determined by the black generation setting (see below). When making conversions, you are better off sticking with the default GCR, a light to medium black generation with 0–10% UCA. This will produce a longer black curve and improved image contrast.

Black generation

This determines how much black ink will be used to produce the black and gray tonal information. A light or medium black generation setting is going to be best for most photographic images. I would advise leaving it set to Medium and only change the black generation if you know what you are doing.

You may be interested to know that I specifically used a maximum black generation setting to separate all the dialog boxes that appear printed in this book. Figure 13.34 shows a view of the Channels palette after I had separated the screen grab shown in Figure 13.32 using a Maximum black generation CMYK separation. With this separation method only the black plate is used to render the neutral gray colors. Consequently, this means that any color shift at the printing stage will have no impact whatsoever on the neutrality of the gray content. I cheekily suggest you inspect other Photoshop books and judge if their palette and dialog box screen shots have reproduced as well as the ones shown in this book!

Figure 13.34 Here is a view of the Channels palette showing the four CMYK channels after I separated the screen grab shown in Figure 13.31 using a Maximum black generation CMYK separation. Notice how all the neutral gray information is contained in the black channel only. This is a good separation method to use for screen grabs, but not so for any other type of image.

Martin Evening

Adobe Photoshop CS2 for Photographers

Separation settings	ink colors	Separation method	Dot gain	Black generation	Black ink limit	Total ink limit	UCA
US printing							
Sheetfed (coated)	SWOP coated	GCR	10—15%	Light/Medium	95%	320350%	0—10%
Sheetfed (uncoated)	SWOP uncoated	GCR	15—25%	Light/Medium	95%	260–300%	0–10%
Web press (coated)	SWOP coated	GCR	15—20%	Light/Medium	95%	300–320%	0–10%
Web press (uncoated)	SWOP uncoated	GCR	20–30%	Light/Medium	95%	260300%	0–10%
Web press (newsprint)	SWOP newsprint	GCR	30-40%	Medium	85–95%	260-280%	0–10%
European printing							
Sheetfed (coated)	Eurostandard coated	GCR	9—15%	Light/Medium	95%	320350%	0–10%
Sheetfed (uncoated)	Eurostandard uncoated	GCR	15—25%	Light/Medium	95%	260-300%	0–10%
Web press (coated)	Eurostandard coated	GCR	15—20%	Light/Medium	95%	300320%	0–10%
Web press (uncoated)	Eurostandard uncoated	GCR	20-30%	Light/Medium	95%	260-300%	0–10%
Web press (newsprint)	Eurostandard newsprint	GCR	30-40%	Medium	85—95%	260-280%	0–10%
Asian printing							
Sheetfed (coated)	Toyo Inks coated	GCR	8–15%	Light/Medium	95%	320350%	0–10%
Sheetfed (uncoated)	Toyo Inks uncoated	GCR	15—25%	Light/Medium	95%	260-300%	0–10%
Web press (coated)	Toyo Inks coated web offset	GCR	12-20%	Light/Medium	95%	300-320%	0—10%
Web press (uncoated)	Toyo Inks uncoated	GCR	20–30%	Light/Medium	95%	260-300%	0–10%
Web press (newsprint)	Toyo Inks uncoated	GCR	30-40%	Medium	85–95%	260280%	0–10%

Figure 13.35 These separation guidelines reflect a typical range of settings one might use for each type of press output. These are guidelines only and reflect the settings you will already find in Photoshop. For precise settings, always consult your printer.

Choosing a suitable RGB work space

The RGB space you choose to edit with can certainly influence the outcome of your CMYK conversions, which is why you should choose your RGB work space wisely. The default sRGB color space is widely regarded as an unsuitable space for photographic work because the color gamut of sRGB is in some ways smaller than the color gamut of CMYK and most inkjet printers. If you choose a color space like Adobe RGB to edit in, you will be working with a color space that can adequately convert from RGB to CMYK without any significant clipping of the CMYK colors. Figure 13.36 below, highlights the deficiencies of editing with sRGB.

6		A B C				A B C	
1		Ac	lobe RGB	1			sRGB
CMYK Info (Adobe RGB)	A	B	C	CMYK Info (sRGB)	A	В	C
Cyan	97	75	95	Cyan	84	72	75
Magenta	10	6	9	Magenta	18	7	10
Yellow	96	8	5	Yellow	80	8	6
Black	0	0	0	Black	1	0	0

Figure 13.36 For the purposes of demonstrating the difference between two RGB color spaces. This example illustrates a Lab mode color image that was converted to CMYK once via Adobe RGB and once via sRGB. The color gradient was chosen to highlight the differences between these two RGB color spaces. The master image was converted to Adobe RGB and then to CMYK. A duplicate of the master was also converted to sRGB, and then to CMYK. As you can see, if you compare the separations shown above, the sRGB version is weaker at handling cyans and greens and there is also a slight boost in warmth to the skin tones.

Which rendering intent is best?

If you are converting photographic images from one color space to another, then you should mostly use the Relative Colorimetric or Perceptual rendering intents. Relative Colorimetric has always been the default Photoshop rendering intent and is still the best choice for most image conversions. I do also recommend that you use the Soft proofing method, described in the following chapter, to preview the outcome of any profile conversion and check to see if a Relative Colorimetric or Perceptual rendering will produce a better result.

Rendering intents

When you make a profile conversion such as one going from RGB to CMYK, not all of the colors in the original source space can be expected to have a direct equivalent in the destination space. RGB is mostly bigger than CMYK and therefore those RGB colors that are regarded as 'out of gamut' will have to be translated to their nearest equivalent in the destination space. The way this translation is calculated is determined by the rendering intent. A rendering intent can be selected in the Color Settings to become the default rendering intent used in all color mode conversions. But you can override this setting and choose a different rendering intent when using Edit \Rightarrow Convert to Profile, or View \Rightarrow Proof Setup \Rightarrow Custom.

Perceptual

Perceptual (Images) rendering is an all-round rendering method that can also be used for photographic images. Perceptual rendering compresses the out-of-gamut colors into the gamut of the target space in a rather generalized way, while preserving the visual relationship between those colors, so they do not become clipped. More compression occurs with the out-of-gamut colors, smoothly ramping to no compression for the in-gamut colors. Perceptual rendering provides a best guess method for converting out-of-gamut colors where it is important to preserve tonal separation. But Perceptual rendering is less suitable for images where there are fewer out-of-gamut colors.

Saturation (Graphics)

The Saturation rendering intent preserves the saturation of out-of-gamut colors at the expense of hue and lightness. Saturation rendering will preserve the saturation of colors making them appear as vivid as possible after the conversion. This is a rendering intent best suited to the conversion of business graphic presentations where retaining bright, bold colors is of prime importance.

Relative Colorimetric

Relative Colorimetric is the default rendering intent utilized in the Photoshop color settings. Relative Colorimetric rendering maps the colors that are out of gamut in the source color space (relative to the target space) to the nearest 'in-gamut' equivalent in the target space. When doing an RGB to CMYK conversion, an out-of-gamut blue will be rendered the same CMYK value as a 'just-in-gamut' blue. Out-of-gamut RGB colors will therefore be clipped. This can be a problem when attempting to convert the more extreme range of out-of-gamut RGB colors to CMYK color. But if you using the View \Rightarrow Proof Setup \Rightarrow Custom to call up the Customize Proof Condition dialog, you can check to see if this potential gamut clipping will cause the loss of any important image detail when converting to CMYK with a Relative Colorimetric conversion.

Absolute Colorimetric

Absolute Colorimetric maps in-gamut colors exactly from one space to another with no adjustment made to the white and black points. This rendering intent can be used when you convert specific 'signature colors' and need to keep the exact hue saturation and brightness, like the colors in a commercial logo design. This rendering intent is seemingly more relevant to the working needs of designers than photographers. However, you can use the Absolute Colorimetric rendering intent as a means of simulating a target CMYK output on a proofing device. Let's say you make a conversion from RGB to CMYK using either the Relative Colorimetric or Perceptual CMM and the target CMYK output is a newspaper color supplement printed on uncoated paper. If you use the Absolute Colorimetric rendering intent to convert these 'targeted' CMYK colors to the color space of the proofing device, the proofer will reproduce a simulation of what the printed output on that stock will look like. For more about targeted proofing, see the following chapter on output for print.

Conversion Options				
Engine:	Adobe (ACE)			
Intent:	Relative Colorimetri	ic 🚯		
	Use Black Point	Compensation		
	Use Dither (8-bi	t/channel images)		
	Convert to	Profile	<u>dellerere</u>	
- Source Space				
Profile: sRGB IEC6	1966-2.1			
	•			
Profile: Working		8 (1008)		
Prome. Working	KGB - Adobe KG	9 (1998)		
 Conversion Optic 	ons			
Engine: Adobe (A		B)		
Engine: Adobe (A	CE)	9		
Engine: Adobe (A Intent: Relative C	CE)	9		
Engine: Adobe (A Intent: Relative C SUse Black Point	CE)	0		
Engine: Adobe (A Intent: Relative (Use Black Point Use Dither	CE)	0		
Engine: Adobe (A Intent: Relative C	CE)	0		
Engine: Adobe (A Intent: Relative (Use Black Point Use Dither	CE)	9		
Engine: Adobe (A Intent: Relative (Use Black Point Use Dither	CE)	oof Condition		
Engine: Adobe (A Intent: Relative C Use Black Point Use Dither Flatten Image	CE) : Colorimetric : Compensation Customize Pr	oof Condition	61	
Engine: Adobe (A Intent: Relative C Use Black Point Use Dither Flatten Image	CE) : Colorimetric : Compensation Customize Pr	oof Condition	3)	
Engine: Adobe (A Intent: Relative C Use Black Point Use Dither Flatten Image	CE) : Colorimetric : Compensation Customize Pr		3)	
Engine: Adobe (A Intent: Relative C Use Black Point Use Dither Flatten Image	CE) : Colorimetric : Compensation Customize Pn Custom	ted v2		•
Engine: Adobe (A Intent: Relative C Suse Black Point Lise Dither Flatten Image	CE) Compensation	ted v2	9	•
Engine: Adobe (A Intent: Relative C Suse Black Point Lise Dither Flatten Image ustom Proof Conditions Device to Simulate:	CE) : Colorimetric : Compensation Customize Pr Custom (U.S. Sheetfed Coa Preserve Number	ted v2 trs tric		
Engine: Adobe (A Intent: Relative C Suse Black Point Lise Dither Flatten Image ustom Proof Conditions Device to Simulate:	CE) Colorimetric Compensation Customize Pr Custom Custom U.S. Sheetfed Coa Preserve Numbe Relative Colorimet Stack Point Con- Screen)	ted v2 trs tric	3	

Figure 13.37 The default rendering intent is set by choosing More Options in the Color Settings dialog and mousing down on the Intent menu in the Conversion Options. This default setting can be overridden when using the Convert to Profile command. You can also change the rendering intent in the Custom Proof dialog. This allows you to preview a simulated conversion without actually converting the RGB data. This rendering intent can then be picked up in the Print with Preview dialog to produce a simulated CMYK proof print. Adobe Photoshop CS2 for Photographers

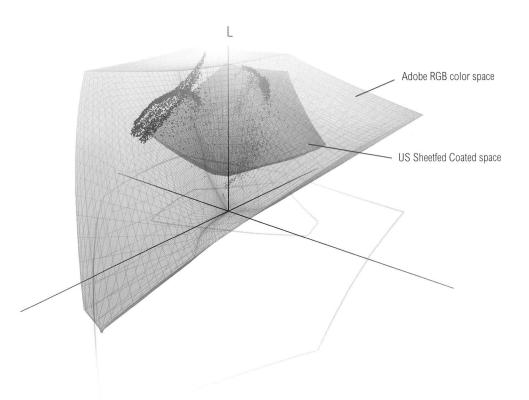

Figure 13.38 To illustrate how the rendering intent can influence the outcome of a color mode or profile conversion I used Chromix ColorThink 2.1.2 to help me create the diagrams shown on these two pages. The above diagram shows the Adobe RGB color space overlaying a US Sheetfed Coated CMYK color space. As you can see, Adobe RGB is able to contain all the colors that will be squeezed into this smaller CMYK space. The photograph opposite has been plotted on this diagram so that the dots represent the distribution of RGB image colors within the Adobe RGB space.

When the colors in this image scene are converted to CMYK, the rendering intent will determine how the RGB colors that are outside the gamut limits of the CMYK space will be assigned a new color value. If you look now at the two diagrams on the opposite page you will notice the subtle differences between a relative colorimetric and a perceptual rendering. And I have highlighted a single blue color in each to point out these differences. The upper example shows a relative colorimetric rendering. You will notice that the out-of-gamut blue colors are all rendered to the nearest in-gamut, CMYK equivalent. Compare this with the perceptually rendered diagram below and you will see that these same colors are squeezed in further. This rendering method will preserve the relationship between the out-of-gamut colors but at the expense of producing a less vibrant separation.

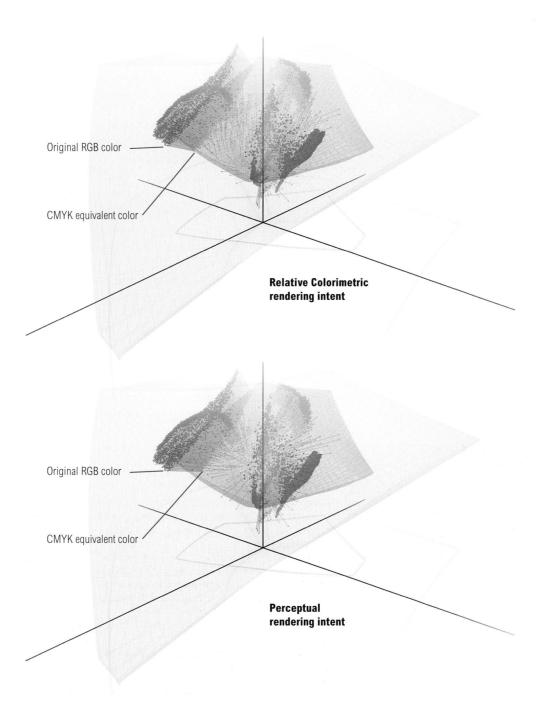

CMYK to CMYK

It is not ideal for CMYK files to be converted to RGB and then converted back to CMYK. This is a sure-fire way to lose data fast! I always prefer to keep an RGB master of the image and convert to CMYK using a custom conversion to suit each individual print output. Converting from one CMYK space to another is not really recommended either, but in the absence of an RGB master, this will be the only option you have available. Just specify the CMYK profile you wish to convert to in the Convert to Profile dialog box. Remember, the Preserve Embedded Profiles policy will ensure that tagged incoming CMYK files can always be opened without converting them to your default CMYK space (because that would be a bad thing to do). This means that the numbers in the incoming CMYK files will always be preserved, while providing you with an accurate display of the colors on the screen.

Lab Color

The Lab Color mode is available as a color mode to convert to via the Image \Rightarrow Mode menu and the Convert to Profile command but does not use embedded profiles. Lab Color mode is assumed to be a universally understood color space, and it is argued by some that saving in Lab mode is one way of surmounting all the problems of mismatching RGB color spaces. You could make this work, so long as you didn't actually do anything to edit the image while it was in Lab. But overall, I would not really advise it. In fact, these days I see little reason to use the Lab Color mode for anything in Photoshop. I know some people like to sharpen in Lab mode, but a luminosity fade (as described in Chapter 4) is a much better method. You can also convert a color image to Lab mode and use the Luminosity channel to make a black and white conversion. But does this really give you any better control over a black and white conversion than you get using the Channel Mixer? The one thing I have found Lab mode useful for is making unusual color cross-processing distortions, as described in Chapter 8.

Info palette

Given the deficiencies of the color display on a monitor, such as its limited dynamic range and inability to reproduce colors like pure yellow on the screen, color professionals will often rely on the numeric information to assess an image. Certainly when it comes to getting the correct output of neutral tones, it is possible to predict with greater accuracy the neutrality of a gray tone by measuring the color values with the eyedropper tool. If the RGB numbers are all even, it is unquestionably gray (in a standard/linearized RGB editing space such as Adobe RGB). Interpreting the CMYK ink values is not so straightforward. A neutral CMYK gray is not made up of an even amount of cyan, yellow and magenta. If you compare the color readout values between the RGB and CMYK Info palette readouts, there will always be more cyan ink used in the neutral tones, compared with the yellow and magenta inks. If the CMY values were even, you would see a color cast. This is due to the fact that the process cyan ink is less able to absorb its complementary color - red - compared to the way magenta and yellow absorb their complementary colors. This also explains why a CMY black will look reddish/brown, without the help of the black plate to add depth and neutrality.

Keeping it simple

Congratulations on making it through to the end of this chapter! Your head may be reeling from all this information about Photoshop color management. But successful color management does not have to be complex. Firstly, you need to set the Color Settings to the prepress setting for your geographic region. This single step will configure the color management system with the best defaults for photographic work. The other thing you must do is to calibrate and profile the monitor. As I said before, if you want to do this right, you owe it to yourself to purchase a decent colorimeter device and ensure the monitor display is profiled regularly. Do these few things and you are most of the way there to achieving reliable color management.

Figure 13.39 When you are editing an RGB image, the Info palette readings can help you determine the neutrality of a color. If the RGB values are all equal, and the RGB color space you are editing in is one of the standard, linear spaces, such as Adobe RGB, sRGB or ProPhoto RGB etc., then the even RGB numbers will equal gray. But notice how the corresponding CMY numbers are not all even. A greater proportion of cyan ink is required to balance out with the magenta and yellow inks to produce a neutral gray color in print.

Chapter 14

Output for Print

he preceding chapter considered the issues of color management and how to maintain color consistency between digital devices. This chapter will deal with the process of making prints from your images. The standard of output available from digital continuous tone and inkjet printers has improved enormously over the last decade. There are so many print methods and printer models to choose from, so it is therefore important to understand what the strengths and weaknesses are of each. To start with you need to consider your main print output requirements. Are you looking for speed, volume printing or a high quality final art finish? And do you require your print output to form the basis of a repro contract print?

RGB output to transparency and print

Many photographers prefer to work in RGB throughout and supply an RGB output as the final art, the same way as one would normally supply a transparency or print.

RGB continuous tone output

Writing to transparency film is a slow, not to mention quite an expensive, process, but is one means of presenting work to a client where money is no object. Such an output can either be scanned again or used as a reference for the printer to work from the digital file. A CMYK proof is usually regarded as a better reference but nevertheless the transparency output is one that some photographers may feel more at home with.

Transparency writers use a scanning laser beam or LEDs to expose the light sensitive silver emulsion and the same technology is employed to make continuous tone RGB photographic prints, particularly large blowups for exhibition display, using print writers such as the Durst Lambda and CSI Light Jet 5000. As with the transparency writers, these machines are intended to be installed in labs and bureaux, where they can replace the traditional enlarger darkroom.

Pictrography

The Fuji Pictrography printers are capable of producing a true photographic print finish. A single pass exposure (as opposed to the three or four passes involved with dye-sublimation) is made with a thermal laser diode onto silver halide donor paper, followed by a thermal development transfer to the receiving print. This, Fuji claim, has all the permanence of a conventional color photograph. Some photographers like using Pictrograph outputs because they are easy to produce and the workflow is very similar to supplying C-type prints made from color negatives. I myself have owned a 3000 Pictrograph printer for many years and can vouch for the benefits of superb color and speed of print output at under two minutes. The machine prints at resolutions from 200 to 400 ppi in sizes ranging

Photo lab print services

Before sending a Photoshop file for printing, check with the lab for any specific compatibility problems. Most photo labs and bureaux like you to send them a flattened TIFF file with an ICC profile embedded.

Speedy photographic printing

Pictrographs are beautiful as portfolio prints or as substitutes for conventional color photographic prints. I consider the Pictrograph to be like having a mini lab in the studio. It particularly suits the way I work because I often have to contend with print orders from clients who want me to provide them with 10 x 8 glossy prints. It takes me less than 2 minutes to make each print, so the Pictrograph is an ideal printer for these types of orders. from A6 to A4 bleed (A3 on the Pictrography 4000). The results are very crisp and the smooth glossy surface will cause no problem when scanned from again and the only chemical solution required is purified water! The more recent models have print drivers that are able to recognize ICC color space profiles and the US and European machines have different specifications, but if you can get a custom ICC profile built for your machine you will see a dramatic improvement in the quality of color output produced. Use the Edit \Rightarrow Convert to Profile command and convert from your current RGB space to that of the Fuji Pictrograph profile prior to printing and make sure you switch off the color matching option in the driver dialog.

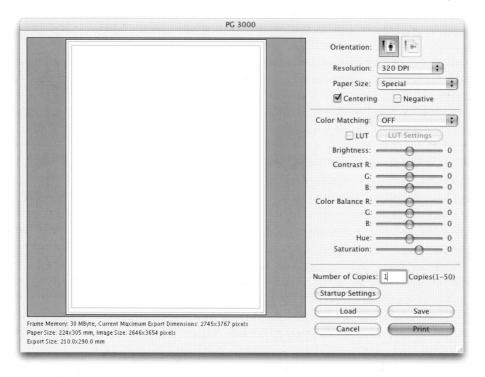

Figure 14.1 The Fuji Pictrograph driver interface. If you are using a custombuilt profile, you should first convert your images to the Pictrograph profile color space and the ColorMatch option in this dialog must be set to 'Off'.

Inkjet printers

Inkjet printers now dominate the printing market and are especially popular with photographers who are using Photoshop. Inkjet printers come in all shapes and sizes from small desktop devices to huge banner poster printers that are the width of a studio.

Inkjet printers work by spraying very fine droplets of ink as the head travels back and forth across the receiving media/paper. The different tonal densities are generally created by varying the number of evenly sized individual droplets and dithering their distribution. Hence the illusion of a lighter tone is represented using sparsely scattered ink dots. The more recent printers are also able to produce variable sized droplets. The Epson Stylus Photo models use six color inks and these are capable of producing an even smoother continuous tone output. The six color inkjets use additional light cyan and light magenta inks to render the paler color tones. The print output is still CMYK (or CcMmYK to be more accurate), but looks smoother because you have less noticeable dot dithering in the lighter areas. But the print times are also slower than the non-Stylus Photo models.

Inkjet printers are used for all sorts of printing purposes. An entry-level inkjet can cost as little as \$150 and is suitable for anything from office letter printing to outputting photographs from Photoshop. And you don't have to spend much more than a few hundred dollars to buy an A4 or A3 printer that is capable of producing photorealistic prints. Later on in this chapter I will discuss how it is possible to use a printer like this to produce acceptable press proofs for CMYK press color matching.

Although inkjets are CMYK or CcMmYK color devices, they work best when they are fed RGB data. This is because a lot of these printers use Quartz rendering (Mac) or GD (PC) drivers as opposed to PostScript. These print drivers can't understand CMYK. So if you send CMYK data to the driver it will convert the data from some form of generic CMYK to RGB before converting the data again to its own proprietary CMYK or CcMmYK.

Inkjet origins

The first inkjet devices were manufactured by IRIS and designed for commercial CMYK proof printing on a limited range of paper stocks. It was largely due to the experimentation of country rock musician and photographer Graham Nash that the IRIS evolved to become an inkiet printing device suitable for producing fine art prints. This costly venture began in the early nineties and was to revolutionize the world of fine art printing thanks to these pioneering efforts. The IRIS printer stopped production in 2000 and its successor is the IXIA from Improved Technologies. The IRIS/IXIA is still favored by many artists, but in the last decade companies like Epson, Hewlett-Packard (HP) and Roland have developed high guality wide-format inkjet printers that are suitable for large format printing, including fine artwork applications.

The revolution in inkjet technology began at the high-end with expensive wide-format printers, but the technology soon diffused down to the desktop. Epson was one of the first companies to produce affordable, high-quality desktop printers. And Epson have retained their lead in printer and consumables technology, always coming out with new and better printers, inks and papers. Although companies like Canon and Hewlett-Packard, who have been making inkjets longer, are now beginning to regain their slices of the printer market with printers to rival Epson's continuing dominance.

Branded consumables

The inkjet manufacturers like to sell their printers cheaply and then make their profit through the sales of proprietary inks designed for their printers. If you care to read the small print, using anything but the manufacturer's own inks may void the manufacturer's guarantee. But this should not necessarily discourage you from experimenting with other ink and paper combinations and apparently this situation is being legally challenged in the USA. Although it has to be said that the number of ink and paper products you can buy these days is quite bewildering. If you perform the color management in Photoshop and disable the printer color management, it is also possible to produce what is known as a cross-rendered CMYK proof from an RGB file, using the Proof Setup dialog to specify a CMYK space to proof with.

The ideal inkjet

Your first consideration will probably be the print size and how big you need your prints to be. Most desktop inkjet printers are able to print up to A3+ (13" × 19"), while the Epson 4000 can print up to A2 (16.5" × 23.5") size. The wide-format printers like the Epson 9600 and 10600 can print up to 44" wide and the HP printers as wide as 96". The bigger printers are designed to be freestanding and therefore require a lot of office space. Wide-format printers are suitable for all commercial purposes and are particularly popular with fine art photographers who need to produce extra large, exhibition-quality art prints.

Photographic print quality

Almost any inkjet printer can give you acceptable print quality, but some printers are definitely more suited to photographic quality printing than others. The Epson Stylus Photo range of printers are marketed as a good choice for photographic print output because they use specially formulated inks and print with six or more ink colors which can yield superb results. Printers like these and others can also be adapted to take third-party inks that are specially formulated for black and white or archival printing. The Epson 2100/2200 Ultrachrome printers are suitable for archival printing and have an extra light black ink which also makes this an almost ideal printer for black and white work, although there are still some issues with an illuminant metameric gray balance shift. It is worth noting that the tolerance and color consistency of the Ultrachrome printers is far superior compared to some of the older Epson printers.

Image permanence

The permanence of an inkjet print will be determined by a variety of factors. Mostly it is down to the environment in which a print is kept or displayed and whether it has been specially treated to prevent fading, followed by the combination of inks and media that are used to produce the print. Light remains the biggest enemy though. If prints are intended for long-term exhibition, then you have to make sure that you use a suitable ink and paper combination, that the prints are displayed behind UV filtered glass and sited so they are not exposed to direct sunlight every day.

Inks and media

To start with I recommend that you explore using the proprietary inks and papers that are 'officially' designated for use with your printer. Firstly, it should be pointed out that the manufacturing engineers have designed these ink and paper products expressly for their printers and secondly, the printer companies will usually supply canned profiles, which although not perfect, can be very useful at getting you an approximately matching print (providing you use their ink and paper of course). And thirdly, if you stick to using proprietary inks and papers at the beginning there are fewer variables for you to worry about when you are learning how to print from Photoshop.

There are two types of inks used in inkjet printers. Dye inks are the most popular because they are capable of producing the purest colors. But the dye molecules in such inks are also known to lack stability. This means they are prone to deteriorate and fade when exposed to prolonged, intense light exposure, high humidity or reactive chemicals. Pigment-based inks have a more complex molecular structure and as a result are less prone to fading. But pigmented inks have traditionally been considered less vivid than dye inks and have a restricted color palette (the color gamut is smaller). Some modern inks use a hybrid combination of dyes and pigments. The latest Epson Ultrachrome ink printers (2100, 2200, 7600, 9600) are the only range so far to offer photo-quality

Third-party delays

As new printers come to market it can take a while for third-party companies to devise their own ink sets. One reason for this is the way that recent inkjets have smart chips fitted to the ink cartridges. These are meant to alert the print driver when they are low on ink, but they are also harder to copy. Third-party manufacturers have to devise a way to reverse-engineer their cartridges so as to work with the newer printers.

Wilhelm Imaging Research

Henry Wilhelm has conducted much research into the various factors that affect the permanence of inkjet prints. The Wilhelm Imaging Research website contains print permanence reports for several printers. Henry has also co-authored a book: 'The Permanence and Care of Color Photographs: Traditional and Digital Color Prints, Color Negatives, Slides, and Motion Pictures', which offers a definitive account on the subject. For more information go to: www.wilhelmresearch.com.

Inkjet economies

Ink cartridges don't come cheap and once you get into serious print making, you will soon get through a lot of expensive cartridges. I don't recommend you economize by buying ink refill kits as these are very messy to use. A better solution is to invest in a continuous inkflow system (CIS). These can be bought as kits which you use to modify your printer. In place of the normal ink cartridges, you have a special cartridge that links to separate ink reservoirs that can feed a continuous flow of ink to the printer head. The advantages are that you don't have to keep replacing ink cartridges and such a system is more efficient and economical to run. Companies supplying continuous inkflow systems include: Lyson, NoMoreCarts CIS, MIS Cobra CFS, Camel Ink Systems CRS and MediaStreet Niagra II Continuous Ink Flow System.

Optimizing the printer

Neil Barstow is a UK-based color management consultant who offers a CD containing a manual and test files to help you optimize your printer settings. For more information on this and his UKbased color consultation services, go to: www.colourmanagement.net.

Neil is able to offer an introductory discount on his consultancy services to readers (see the special offers section in the Appendix). printing using specially formulated pigment-based ink and paper combinations that will produce bright prints which also have exceptional image permanence. When using the correct paper and inks, the life expectancy is predicted to be over 100 years and maybe as long as 200 years with certain paper combinations.

Third-party inks

These are mostly designed for the Epson printers and even then you will find that not all printer models are supported. Lyson make a range of inks for both color and black and white printing. The Lyson Fotonic color inks are designed to provide increased image permanence and in some instances actually have a slightly larger gamut than the standard Epson inks. Whenever third-party inks are used, you will almost certainly want to have custom profiles made for each ink and paper combination. To work with third-party inks and papers a user must first optimize the printer settings.

A lot of photographers like to use the special black ink sets such as the Lyson Quad Black and Small Gamut (SG) inks, MIS Quadtones, MIS Variable Mix (VM) Quadtones and Lumijet Monochrome Plus monochrome inks. These black ink sets can be used with four- or six-color printers in place of the usual color inks. They print overlaying inks of varying gray lightness in place of the usual CMYK inks and have the potential to make rich-toned fine art prints with good image permanence on a variety of paper surfaces. When ordering ink supplies you need to make sure that the cartridges are compatible with the printer and, if using a custom profile, are of the same type. But the paper can be equally critical. The premium glossy and semigloss paper is a popular choice for photographers as these papers match the quality of a normal photographic print surface and the print longevity when used with Epson 4000 is estimated to be up to 60 years. A lot of photographers and artists have enjoyed experimenting with various fine art paper stocks. When combined with the right types of ink, it is possible to produce prints that can be expected to last even longer.

Making a print

There are five Print menu items in Photoshop: the Page Setup, the 'System' Print dialog, Print with Preview, Print One Copy and Print Online... The **HP** *ctrl* **P** shortcut will open the traditional System Print dialog and **HCP** *ctrl alt* **P** will open the Print with Preview dialog (which is the one I will be using throughout in this chapter). If you prefer this behavior to be reversed, you can easily switch these key settings in the keyboard shortcuts. The Print One Copy command is there should you wish to make a print using the current configuration for a particular image, but wish to bypass the print dialogs.

Online printing

To launch Online printing, choose File \Rightarrow Print Online... and follow the dialog instructions to create yourself an account with one of the online print services available through Adobe. Selected images in Bridge can then be uploaded to your account folder with Ofoto. From there on you can explore the various print options and finally place an order to have a print made and delivered. Online print services have become very popular in recent years, mainly due to the speed and popularity of broadband Internet services making it easier to upload large image files. An online printing service can prove useful if you need to make enlargements bigger than your own printer can handle or if you wish to produce multiple print copies at a reasonable cost.

900		-		
Welcome to Adobe Photoshop S	ervices			149 6000
Provided by Ofoto, A Kodek Company				Adobe an-tensor
Get Rodak prints directly from your Adaba software. Conserve and the software of the software and the software of the software of the software for the	Create Account First Name * Email Address * (6 character min) Confine Password *	0 68 68 66	Already a reender? Sign is Remember my asseed Sed in special offers and new from Offers and special means one in formation and denrices.	
	* Indicates a required fiel	4		
			🕄 Cancel	-

Figure 14.2 Before making a print ensure that the correct printer is selected. On Mac OS X go to the Applications folder, open the Utilities and launch the Print Center application (Print Center is copied permanently to the dock in Mac OS X if you have a range of printers). On a PC, choose File \Rightarrow Print and click on the Setup button to select the printer driver.

Figure 14.3 The online print services dialog.

Output options

Note that you must be using a PostScript print driver to apply some of the Output options mentioned here and you should also allow enough border space surrounding the print area to print these extra items.

Print with Preview: Output settings

I prefer to always use the Print with Preview dialog because it shows me how the Photoshop document will print in relation to the page size and set the all-important color management options. But first we shall look at the Output settings. When the Center Image box is deselected, you can position the image anywhere you like, by dragging the preview with the cursor, although there are some issues over the accuracy of the preview placement when

	Print		
t	Position Top: 1.8 Left: 1.76 Scaled Print Size Scale: 100% Height: 28.61 Width: 43.004	cm ienter Image	Print Cancel Done Page Setup Fewer Options
Output Color Management Screen Border Transfer Bleed Interpolation Include Vector Data Encoding: ASCII		rks 🔄 Labels rks 🔄 Emulsion Down	

Figure 14.4 The Print with Preview dialog. This dialog interface allows you among other things to accurately position the image on a page and alter the scale at which it will be printed. Deselect the Center Image checkbox and you can enter precise measurements in the Top and Left edge boxes. When the Bounding box is made visible, you can drag the box and box handles to visually arrange the page position and scale. If a selection is active before you select Print Options and Print Selected Area is checked, the selected area only will be printed. When the Output options is selected, you can add print information such as calibration bars, captions and crop marks. And when the Include Vector Data option is unchecked, it will rasterize the vector layer information, such as type at the image file resolution. However, if it is checked, it will rasterize the vector information such as type much crisper at the full printer resolution, provided that you are outputting a PostScript RIP.

using Mac OS X. Or, you can position and resize within the specified media chosen, using the boxes at the top. You cannot alter the actual number of pixels via this Print dialog. Any changes you make to the dimensions or scaling will always be constrained to the proportions of the image. In the Output options below, you can click on the Background... button to print with a background color other than paper white. For example, when sending the output to a film writer, you would choose black as the background color. Click on the Border button to set the width for a black border, if desired. But be aware that setting the border width can be an unpredictable business. If you set too narrow a width, the border may print with an uneven width on one or more sides of the image.

On the right, you can select any extra items you wish to see printed outside the image area. The Calibration Bars will print an 11-step grayscale wedge on the left and a smooth gray ramp on the right. If you are printing CMYK separations, tint bars can be printed for each plate color and the Registration Marks will help a printer align the separate plates. The Corner and Center Crop Marks will indicate where to trim the image and the Bleed button option lets you set how much to indent these crop marks by. Checking the Description box will print any text that was entered in the File \Rightarrow File Info box Description field and check the Labels box to have the file name printed below the picture.

Print with Preview: Color Management

The Print with Preview dialogs reproduced on the following pages show how to use the Color Management options. The following dialogs include the Mac and PC instructions for the Epson 1290 inkjet printer settings. The Epson interface and main controls will be fairly similar for other makes of inkjet printers, but not identical. This first series of dialogs show how I would go about making a print from an RGB image in Photoshop using one of the Epson 1290 printer profiles that were automatically loaded when I installed the printer driver on my computer.

Figure 14.6 The Bleed option will work in conjunction with the Corner Crop Marks option and determine how far to position them from the edge of the printed image.

Page Setup

	Page Setup
Settings:	Page Attributes
Format for:	Stylus Photo 1290
Paper Size:	EPSON SP 1290 (1,1)
Faper Size.	32.89 cm x 48.30 cm
Orientation:	
Scale:	100 %
0	(Cancel) (OK)
U	

age Setup	?×	Page Setup
	Annual and an annual annua	Printer Name: EPSON Stylus Photo 1290 Y Properties
	A month of consequences and a month of the second of the s	Status: Ready Type: EPSON Stylus Photo 1290 Where: LPT1: Comment:
Paper	A3 297 x 420 mm	Network OK Cancel
Source:	Sheet Feeder	
- Orientation	Margins (millimeters)	
OPortrait	Left: 0 Right 0	
○ Landscap	De Top: 0 Bottom: 0,01	
	OK Cancel Printer	

1 The first thing you need to do is go to the Page Setup dialog and make sure the right printer is selected (you may have to do this each time in Mac OS X). Now choose a paper size that matches the paper you are about to print with and choose the right orientation: either portrait or landscape. There is no need to adjust the scaling percentage here as this can be accomplished more elegantly in the Print with Preview dialog coming up next. On a PC you need to click on the Printer... button to select the printer model.

Chapter 14 Output for print

Print with Preview

		Left: 2.79	cm 🔅 cm 🛟 nter Image		Print Cancel Done Page Setup	
	н	Scaled Print Size Scale: 100% eight: 40.005 Width: 26.67 Show	Cm Cm Bounding Box	9 - 8	Fewer Options	
Color Management		🔄 Print S	Options	C inter	face	
	le: Adobe RCB (1998)) le: N/A)		Printer Profile:	EPSON Styl	hop Determine Colors lus Photo 1290	
Options Color Handling:	Let Photoshop Determine	Colors 🛟 🕕	Rendering Intent:	Working CM	1YK	Black Point Compensation
Printer Profile:	EPSON Stylus Photo 1290	Pre 🛟				
Rendering Intent: Proof Setup Preset:	Relative Colorimetric	€ Bla	ick Point Compensat	ion		
Description	ance, Photoshop will perform any nec			,		

2 If you choose File \Rightarrow Print, you will jump straight to the dialog shown in step 3. But I recommend that you always start by choosing File \Rightarrow Print with Preview because this will enable you to configure how the color is handled. Most of the features have already been covered in Figure 14.4. The dialog shown here is displaying the Color Management options. At this stage you have little choice but to leave the Print space as is, with the Document button selected, which is the right setting to use here (we will be looking at the Proof option later). In this example the source space of the profiled RGB file is Adobe RGB.

Next we come on to the Options section. The default option will say: Let Printer Determine Colors. You could choose this option and check the ColorSync button in the Color Settings, but you can achieve more control and adopt a more consistent workflow that can utilize custom printer profiles by selecting the Let Photoshop Determine Colors option, as shown here.

If you mouse down on the Printer Profile menu a long list of profiles will appear. A set of canned printer profiles should have been installed in your System profiles folder at the same time as you installed the print driver for your printer. If you are using Mac OS X, select the printer profile that most closely matches the paper you are about to print with. But if you are using an Epson printer with a PC, the canned printer profiles are not available to Photoshop at the operating system level; they can only be accessed via the Printer driver. So if you are using a PC with an Epson printer, select the name of your printer from the Printer Profile menu. But if you have custom printer profiles available to use, then you can select these in the Printer Profile menu, just as you would on a Mac. The rendering intent can be set to Perceptual or Relative Colorimetric and with Use Black Point Compensation switched on.

Presets:	Standard		
	Copies & Pages	•	
Copies:	And and a second		
Pages:	From: 1 to: 1		

Print dialog settings

Printer		
Name:	EPSON Stylus Photo 1290	Properties
Status:	Ready	
Туре:	EPSON Stylus Photo 1290	
Where:	LPT1:	
Comment:		Print to file
Print range		Copies
⊙ All		Number of copies: 1 🤤
🔿 Pages	from: to:	
🔿 Selecti	on	112233 Collat

3 Click the Print... button in Print with Preview and you will be taken to one of the Print dialogs shown here. No preset settings have been saved yet. In Mac OS X, mouse down on the Copies and Pages pop-up menu and choose 'Print Settings'. On a PC, click on the Properties... button.

Princ	- EPSON Stylus Photo 1290 Properties ?
Printer: Stylus Photo 1290 Presets: Standard Print Settings Page Setup: Standard Media Type: Premium Glossy Photo Paper Ink: Color Mode: O Atomatic Custom Mode: O Atomatic Settings Print Quality: Photo - 1440dpi MicroWeave MicroWe	EPSON Stylus Photo 1290 Properties
	Photo - 1440dpi No Color Adjustment MicroWeave: On High Speed: On EPSON Version 5.22/P
	OK Cancel Help

4 In this section you need to select a media type that matches the paper you are going to be using. In this example I am printing with the Epson Premium Photo Glossy paper. If you are printing in color, make sure the Color ink button is checked. In Mac OS X, click on the Advanced Settings button and choose a print resolution (1440 dpi will produce nice smooth results). A higher print resolution will produce marginally better looking prints, but take longer to print. The High Speed option will enable the print head to print in both directions. Some people prefer to disable this option when making fine quality prints. On a PC, first select the Media Type, click on the Custom button in the Printer Properties dialog and then click on the Advanced... button to proceed to the next step.

Color Black	Color Management Color Controls PhotoEnhance4 No Color Adjustment sRGB IDM	
Settings	OK Cancel	Help
	Print	
Stylus Photo	1290	
	•	
	jement s	
	Color Black dpi	e Settings Stylus Photo 1290 Standard Color Management Color Color Controls Print Color Adjustment Print Color Adjustment Color Adjustment Color Adjustment Color Adjustment Color Management Colo

Save	
Save As	
Rename	ters and a second second
Delete	
	Save Preset
1971 - The La Sector Sector 11 71 1172	
Save Preset As:	

Figure 14.7 Once you have established the print settings shown here for a particular printing setup, it makes sense to save these settings as a preset that can easily be accessed every time you want to make a print using the same printer and paper combination. It is also the only way for the settings to remain 'sticky'.

5 In the Advanced section on a PC you can now set the print resolution quality. And in the Color Management section click on the No Color Adjustment button. This is because you do not need to make any further color adjustments. The steps carried out at stage 4 will have established the Printer Profile setting in the PC print dialog. Plus, at stage 1 we asked Photoshop to determine the print colors. If using Mac OS X, go to the Color Management print settings option and click on the No Color Adjustment button. All you have to do now is click on the Print button at the bottom and wait for your image to print.

Martin Evening Adobe Photoshop CS2 for Photographers

Figure 14.8 This is an example of a Gretag MacBeth color target which is used to construct a color ICC profile. Each file must be opened in Photoshop without any color conversion and the file is sent directly to the printer, again without any color modification and the print dimensions must remain exact. If it is necessary to resize the ppi resolution, make sure that the Nearest Neighbor interpolation mode is selected. The print outputs are then measured using an emissive spectrophotometer and a profile built from these measurements. All you have to do is make a neutral path print, as shown on the following pages. A third party profiling service such as Neil Barstow's (see the Special Offers page in the Appendix), will be able to supply you with the test chart and printing instructions. You mail him the print and he will email the printer profile back to you.

Building a custom printer profile

If you followed the previous steps carefully, then you should be getting the colors to match near enough what you are seeing on the monitor. And if not, then I suggest you check the calibration of your display and rebuild the monitor profile, although it is never possible to create a complete match between the display and the print, even under ideal light viewing conditions. But if you want to take your color management one step further, why not consider having a custom profile built for your favorite ink and paper combinations? Most of the canned inkjet printer profiles that I have come across are not that bad. They are able to get the colors to reproduce fairly well in print, but some do have a tendency to clog up the shadow detail. I would imagine that this is done deliberately to help improve the appearance of poorer quality images. But if you want to obtain the best results from your printer and have profiles made for non-regular ink and paper combinations then you need to have some custom printer profiles made.

If you don't have the necessary profiling kit and software, the most obvious thing to do is to contract the work out to a specialist service provider. Pixl in Denmark are offering a special coupon to readers of this book that will entitle you to a discount on their remote printer profiling services. More details are in the back of this book and on the CD.

Printing a printer test target

The next series of screen shots lead you through the steps to follow when printing out a target like the one shown in Figure 14.8. The important points to bear in mind here are that you must not color manage the target image. The idea is to produce a print in which the pixel values are sent directly to the printer without any color management being applied. The patch readings are then used to build a profile that will later be able to convert the image data to produce the correct-looking colors. The remaining Print dialog settings should be saved so that the same print settings can be applied as when you printed the test target.

Λ	The RGB document profile.	"TC9.18 RGB A3 i1.tif" does not have an embedded colo	r
6	- How do you wan	t to proceed?	
	• Leave as is (dor	n't color manage)	
	O Assign working	RGB: Adobe RGB (1998)	
	O Assign profile:	sRGB IEC61966-2.1	\$
		and then convert document to working RGB	

1 Begin by opening the test chart file like the one shown in Figure 14.8. This will be included as part of any print profiling package or supplied to you by the profile building service provider. This file will have no embedded profile and it is essential that it is opened without making any conversions and always printed at the exact same print size dimensions.

IKCOC		Position Top:	3.6	cm 😯	Print Cancel
0.73	12.63	Left:		Center Image	Done
100			Print Size		Page Setur
No.	8 6 6	Scale:		Scale to Fit Media	
613		Width:		cm 🔅 –	
1	Storied,		🗹 Sh	ow Bounding Box nt Selected Area	
O Proof (Profi	ile: Untagged RGB) ile: N/A)				
•					
O Proof (Profi		ıt		D	
Options Color Handling:	ile: N/A)			D	
Proof (Profi Options Color Handling: Printer Profile:	ile: N/A)	e RGB (19		D Black Point Compensation	
Proof (Profi Options Color Handling: Printer Profile:	No Color Managemer	e RGB (19			
Proof (Profi Options Color Handling: Printer Profile: Rendering Intent:	No Color Managemer	≥ RGB (19	•	Black Point Compensation	
Proof (Profi Options Color Handling: Printer Profile: Rendering Intent:	Ile: N/A) No Color Managemer Working RCB - Adobe Relative Colorimetric	≥ RGB (19	•	Black Point Compensation	
Proof (Profi Options Color Handling: Printer Profile: Rendering Intent: Proof Setup Preset: Description	Ile: N/A) No Color Managemer Working RCB - Adobe Relative Colorimetric	≥ RGB (19., or	•	Black Point Compensation	

2 Configure the Page Setup as shown in the previous step-by-step example and choose File \Rightarrow Print with Preview with the Color Management options visible as shown here. The Print space should say Document: (Profile: Untagged RGB). The idea here is that you want to create a print output of the unprofiled data without applying any printer color management. In the Options section, select the No Color Management option. Do not adjust the scale as it is very important this remains at 100%. When you have done this click Print...

	Print	
Printer	: Stylus Photo 1290	•
Presets	: Standard	•
	Print Settings	
Page Setup:	Standard	
Media Type:	Matte Paper – Heavyweight	•
Ink:	Color	
Mode:	Automatic	
184	 Custom Advanced Settings 	
- Cor		1440dpi 🛟
	MicroWeave	11100p.
	High Speed	
	Flip Horizontal	
		Help
(?) (Preview) (5	
(?) (Preview) (Save As PDF) Fax	Cancel Print
SA EDSON St.	lus Photo 1290 Properties	2X
Main 🕼	Paper 💮 Layout 🚱 Utility	y
A3 297 x 420	Media Type	Contraction of the second s

3 In Mac OS X, choose the appropriate media type and the desired print resolution in the Print settings section. In this example, I was building a profile for the Hahnemuhle Fine Art Rag paper, so I selected the Matte Paper – Heavyweight media setting. On a PC, click on the Custom button, choose the media type and click on the Advanced button.

	Advanced	
	Media Type Matte Paper - Heavyweight	Color Management Color Controls PhotoEnhance4 No Color Adjustment SGB ICM
	☆ IF High Speed 立 IF Flip Horizontal 滋 IF Finest Detail 泉 IF Smooth Edge	
Printer: Presets:		OK Cancel Help Save Preset
Color Controls ColorSync No Color Adjustrr	Color Management	Save Preset As: HMrag-E1290-1440 Cancel OK
Preview) (S	ave As PDF) Fax	Help Print

4 In the Advanced section on a PC, select the printer resolution. In the color management section you can select 'No Color Adjustments' as before. The main thing to remember here is that whichever route you follow, you should now save and name the print settings used in the Print dialog (which in this example I named as 'HMrag-E1290-1440'). The same setting should be used whenever you print using the custom profile. On the Mac, go to the Presets menu, mouse down and choose Save... On a PC, click on the Save Settings... button. We are now ready to print the test target.

			Print			
		- Positio	on			Print.
MAUE		Top:	4.27	cm	•	Cancel
ALL MAR		Left:	3.46	cm	•	Done
Star 4			Ø	Center Image		
12/15		- Scaled	Print Size			Page Setup
	81-		100%	Scale to	Fit Media -	Fewer Options
12/201	all a		37.994			
	GAL A			cm		
		Width:	25.329	cm		
			1 - 121 - 14 - 14 - 14 - 14 - 14 - 14 -	w Bounding Bo		
			U Prin	Selected Area	K - [
<u> </u>	ile: Adobe RGB (1998 ile: N/A)	3))				
Print Document (Prof	ile: Adobe RCB (1998	8))				
Print Document (Prof Proof (Prof Options	ile: Adobe RCB (1998		rs 🕻 🛈			
Print Document (Prof Proof (Prof Options Color Handling:	ile: Adobe RCB (1998 ile: N/A)	ermine Color	rs 🗘 🛈			
Print Document (Prof Proof (Prof Options Color Handling: Printer Profile:	ile: Adobe RGB (1998 ile: N/A) Let Photoshop Dete	ermine Color 4.icc 2	•	llack Point Con	npensation	
Print Document (Prof Proof (Prof Options Color Handling: Printer Profile:	ile: Adobe RCB (1998 ile: N/A) Let Photoshop Dete (1290 HRAG 190304	ermine Color 4.icc 2	•		npensation	
Print Document (Prof Proof (Prof Options Color Handling: Printer Profile: Rendering Intent:	ile: Adobe RCB (1998 ile: N/A) Let Photoshop Dete (1290 HRAG 190304	ermine Color 4.icc 2 ic		llack Point Con	npensation	
Print Document (Prof Proof (Prof Options Color Handling: Printer Profile: Rendering Intent:	lle: Adobe RCB (1998 lle: N/A) Let Photoshop Dete 1290 HRAG 190304 Relative Colorimetri	ermine Color 4.icc 2 ic		llack Point Con	npensation	
Print Oruge Proof (Proof (Proof	lle: Adobe RCB (1998 lle: N/A) Let Photoshop Dete 1290 HRAG 190304 Relative Colorimetri	ermine Color 4.icc 2 ic olor Sin	iiiiiiiiiiiiiiiiiiiiiiiiiiiiiiiiiiiiii	llack Point Con k Ink		
Print Document (Prof Proof (Prof Options Color Handling: Printer Profile: Rendering Intent: Proof Setup Preset: Description To preserv appear	ile: Adobe RGB (1998 ile: N/A) Let Photoshop Dete 1290 HRAG 190304 Relative Colorimetri Simulate Paper Co	ermine Color 4.icc 2 ic olor Sin	iiiiiiiiiiiiiiiiiiiiiiiiiiiiiiiiiiiiii	llack Point Con k Ink		

5 The print should be allowed to stabilize for at least 24 hours before it can be measured and a profile built. This profile will be applicable for use with your printer, using the same ink sets and with the same media/paper type and print settings as used to generate the printed target. The custom printer profile must be installed in the appropriate operating system ColorSync profiles folder (see page opposite). When you go to Print with Preview choose Let Photoshop Determine Colors and choose the custom profile as the Printer Profile. And if you are using a PC the instructions are now exactly the same as for a Mac if you are selecting a custom profile.

Print	Print	?×
Printer: Stylus Photo 1290	Printer Name: HMrag-E1290-1440 Status: Ready	Properties
Copies:	Type: EPSON Stylus Photo 1290 Where: LPT1: Comment:	Print to file
Pages: All Prom: 1 to: 1 (?) Preview Save As PDF) Fax Cancel Print	Print range	Copies Number of copies:
		OK Cancel

6 When you go to the Print dialog make sure you select the same preset setting that you saved when creating the target print. And that's it. Once you have established and saved the print settings and installed the printer profile correctly you only need to follow the two steps shown on this page each time you want to make a print.

Getting the most from your printer profiles

There is no such thing as a perfect color management workflow. There will always be a small margin for error, but if you follow the guidelines carefully you should be attaining impressive results even from a modest desktop printer. And to fully appreciate the fruits of your labors you really need a calibrated light viewing box to view the prints correctly. All inkjet prints take a while to dry after they come off the printer. A print produced using the Epson 1290 inks can at first look quite green in the shadows, but after a few hours you will notice how the ink colors stabilize and the green cast eventually disappears. This is why you are advised to wait at least 24 hours before measuring your printed target prints. Then there is the issue of what is commonly referred to as 'metamerism'. This refers to the phenomenon where when viewing under different lighting conditions, the ink dye/pigment colors will respond differently. This problem can be particularly noticeable when a monochrome image is printed using color inks. Although the color management can appear to be working fine when a print is viewed under studio lighting, if this environment is changed, and the print is viewed in daylight from a window, the print can appear to have a green cast. There was an example of this with the early Epson Ultrachrome 2000 printer where the pigmentbased ink suffered from this green shift in daylight problem. The later Ultrachrome printers have almost managed to resolve this.

Even despite your best efforts to produce a perfect profile, you may just find that a specific color on the display does not match exactly. I sometimes see this happening with the skin tones in a portrait. Although I usually obtain a perfect match with a specific ink and paper profile combination, sometimes the printed result is just a fraction out on an item of clothing or the skin tones, but every other color looks just fine. If you know what you are doing it is possible to tweak profiles using a program like Gretag MacBeth's ProfileMaker Pro. But I often just add a temporary hue/saturation adjustment layer using this

Installing custom printer profiles

The custom printer profiles should be saved using the following locations: Library/ColorSync/Profiles folder (Mac OS X), WinNT/System32/Color folder (NT/2000), Windows/System/Color folder (PC).

Inkjet papers

The optical brighteners contained in many of today's inkjet papers can also bring about quite a noticeable shift in the way a print is perceived under different lighting conditions. If there is a high amount of UV light present the whites will look much brighter, but also bluer compared to a print that has been made using a paper stock such as the Tecco/Best Remote Proof 9180 or Tecco/Best Proof 9150 papers, which are ideally suited for CMYK proof printing and viewed using controlled lighting with a color temperature of 5000 K. to make a minor correction by targeting, say, the reds of the skin tones and shifting them to become 2-3% more yellow. But another more obvious reason why there may be a difference in the colors seen is that the color gamut of the printer is not the same as the gamut of the display on which you are viewing the image. This is where soft proofing can sometimes help you get more predictable results.

Soft proofing via the display

When you carry out a color mode conversion or a Convert to Profile command, the color data is converted to the destination/device color space. When the file is in this new space, Photoshop will continue to color manage the image. If you are converting an RGB master to the working CMYK space, Photoshop will simulate the CMYK print output appearance on the monitor after the file has been converted to CMYK. This is known as 'soft proofing' (a real proof is a hard copy print produced by a contract standard proof printer). Soft proofing is a term that is applied to using the monitor as a proofing device. The monitor will never be as accurate when it comes to showing how every CMYK color will reproduce, but it is usually close enough for carrying out all the preparation work, before reaching the stage where a final contract proof is demanded. Good quality displays such as the Apple Cinema display or Sony Artisan CRT monitor have larger color gamuts than most other monitors and are therefore more suited for soft proofing CMYK colors on the screen.

If you are editing an RGB master and go to the View ⇒ Proof Setup menu and select Working CMYK (which is the default setting), you can create a preview of how the colors would look if you converted from RGB to the working CMYK color space using the default rendering intent. If you choose the Custom... option you can select any profile space you want from the pop-up list in the Customize Proof Condition dialog and select different rendering intents. You can also name and save a custom proof setting

Cancel Save

\$

Where: Droofing

Chapter 14 **Output for print**

as a '.psf' file in the Users\Username\Library\Application Support\Adobe\Color\Proofing folder (Mac OS X), or the Program Files\Common Files\Adobe\Color\Proofing folder (PC). This saved proof setting will then be appended to the bottom of the list in the Customize Proof Condition dialog.

You don't have to keep returning to the Customize Proof Condition dialog. Once you have established a custom proof setting you can preview the colors in this space by simply choosing View \Rightarrow Proof Colors, or use the keyboard shortcut **H** Y *ctrl* Y to toggle the preview on and off. This keyboard shortcut makes it very easy for you to switch from normal to proof viewing mode. The document window title bar will also display the name of the proofing space after the color mode: RGB/Working CMYK.

Proof Setup	Custom	t the device you wish to soft pr	
Proof Colors 業Y Gamut Warning 企業Y Pixel Aspect Ratio Correction 32-bit Preview Options	Working CMYK Working Cyan Plate Working Magenta Plate Proof Conditi	with, whenever the Proof Colors command ()) () () () () () () () () () () () ()	
Zoom In 第+ Zoom Out 第- Fit on Screen 第0	Working Black Plate example, I sel	r or CMYK print output. In this lected a custom CMYK setting ok printers. Checking the Prese	
Actual Pixels て第0 Print Size	Windows RGB print if the dat	will preview how the image we ta was sent to the printer witho	
Screen Mode	any conversion	on being applied.	
✓ Extras #H Show ►	Customize Proof Con	dition	
	Custom Proof Condition: Custom	СК	
Rulers #R	Proof Conditions Device to Simulate: Trento printers_Medium GCR	Cancel	
✔ Snap 企業;	Preserve Numbers	Load	
Snap To 🕨	Rendering Intent: Relative Colorimetric	Save	
Lock Guides て第; Clear Guides New Guide	Black Point Compensation Display Options (On-Screen) Simulate Paper Color Simulate Black Ink	Treview	
Lock Slices Clear Slices	Sa	ve	
	Save prool	f setup in:	

Proofing other output spaces

The Proof Setup is not just limited to CMYK output. You can use the Proof Setup to preview RGB conversions to RGB output devices or do things like preview how a prepress grayscale file will appear on a Macintosh or Windows RGB monitor. And you can load a custom profile for your printer to gain a more accurate preview of how an image will print. Each new window view can preview a different proofing setup. So, for example, you can create several new window views of the same document and compare the results of outputting to various types of press output directly on the display.

and the second second	Customize Pro
Custom Proof Condition:	Custom
- Proof Conditions	
Device to Simulate:	Working CMYK - Europe
	Preserve Numbers
Rendering Intent:	Relative Colorimetric
	Black Point Compensat
Display Options (On-	-Screen)
Sinulate Paper Cold	or
Simulate Black Ink	

Figure 14.10 The Display Options in the Customize Proof Condition dialog allow you to achieve more authentic on-screen previews that take into account the density of the black in the final output being less black than the maximum black you see on the computer screen. When the Paper Color option is selected the screen image will simulate both the color of the paper stock and the black ink color. It is important to note here that the Proof Condition settings for the rendering intent and Black Point Compensation can have a bearing on a proof print output, but the Simulate Paper Color and Black Ink options will only affect the screen preview.

Display simulation options

When you select the Proof Colors option from the View menu, Photoshop takes the current display view and converts it on-the-fly to the destination color space selected in the Proof Setup. The data is then converted back to the RGB monitor space to form a preview using the relative colorimetric rendering intent and with black point compensation switched on. In simpler terms, the image you see on the display is effectively filtered by the printer profile color space.

The Proof Colors view provides you with an advanced indication of how a file might reproduce after it has been converted to CMYK (or any other print output space) and printed. The Proof Colors view may well produce a more muted image on the display, but it will more accurately reflect the appearance of the final print output. But even though the out-of-gamut colors will appear more muted, the image you are looking at on the screen will still be optimized to the full contrast range of the display. The Simulate Paper Color and Black Ink options enable you to achieve a more accurate simulation, one that takes into account the black ink density and the color of the paper.

The Simulate: Black Ink option will simulate on screen the actual black density of the printing press by turning off the black point compensation.

Simulate: Paper Color will simulate how the whites in the image will appear by simulating the color of the paper on the screen. Simulate: Paper Color uses an absolute colorimetric rendering to convert the proof color space data to the monitor space, simulates both the color of the paper and the black ink color density. However, the Paper Color simulation only works if the CMYK profile used is made on the actual paper stock to be used for printing, and only if this paper doesn't have too much optical brightener in it (otherwise the results will look bluish on screen). It is rather disappointing to see the display preview image deteriorate in front of your eyes in this way, so I follow Bruce Fraser's advice and try looking away from the display just prior to checking these press simulation settings.

Color proofing for press output

If you are supplying digital files for repro, then you will want to obtain as much relevant information as you can about the press, paper stock and print process that will be used to print a job. If the person running the printing press is cooperative and understands what you are asking for, they may be able to supply you with a suitable proofing standard ICC profile, or they can provide you with information about the printing inks and other specifications used for the press. Go to the Edit \Rightarrow Color Settings \Rightarrow Working Space \Rightarrow CMYK \Rightarrow Custom CMYK dialog, and enter these settings as described in Chapter 13. Once you have saved this as a CMYK setting you can convert your RGB image to this custom CMYK color space and save as a TIFF or EPS file.

A CMYK file on its own is not enough to inform the printer how it should be printed. It is standard procedure to supply a targeted CMYK print proof along with the image, which will provide a guide as to how you expect the picture to reproduce in print within the gamut of the specific CMYK print process. The term contract proof is used to describe a CMYK proof that has been reproduced using an approved proofing device. These include the Rainbow, the Epson 5000 inkjet (with RIP) and prepress bureau service proofs like the Dupont Cromalin, 3M Matchprint and many others. Inkjet printers are essentially taking over the proofing industry, as many press houses move to Computer to Plate (CTP) technology, thus eliminating the need for film at the proofing stage. The contract proofing devices benefit from having industrywide recognition. It is safer to supply a digital file together with a proof that has such a seal of approval. The printer receiving it knows that the colors reproduced on the proof originated from a contract device and were printed from the attached file. Their job is to match the proof, knowing that the colors in the proof are achievable on the press.

Realistic proofs

When you supply a CMYK proof you are aiming to show the printer how you envisage the picture should look in print. A proof should be produced using the same color gamut constraints as the halftone CMYK process. That way the printer will have an indication of what colors they should realistically be able to achieve.

Supplying RGB files

You could supply an RGB file tagged with an ICC profile, and some people are doing this. But be warned, this will only work if there is a clear, agreed understanding that the recipient will be carrying out the conversion to CMYK and using the CMYK proof as a guide. If you send RGB files to a client, be careful to label them as RGB folders and make every effort to avoid any potential confusion down the line.

Contract proof versus aim print

The term 'aim' print most justly describes the appropriateness of a standard, profiled inkjet output, when used as a guide for the printer who is determining how to reproduce your image using CMYK inks on the actual press.

Proof Setup presets

The complexities of configuring the Print with Preview dialog can be made easier if you choose to save the Customize Proof Condition settings as a preset. That way you can establish the settings used for normal RGB printing and those used to produce a cross-rendered proof and quickly access these as separate custom settings.

Figure 14.11 This shows you the Print with Preview settings to use to simulate a CMYK proof via an inkjet printer. The source document is in RGB mode, but the Proof button is selected so that the current CMYK Customize Proof Condition color space is effectively used as the Print source space. The color handling is set to Let Photoshop Determine Colors and the Printer Profile uses a custom profile I created for Epson Semi-Gloss paper printed on the Epson 1290 printer. When Proof is selected as the source space, the Rendering Intent will always be grayed out and the Black Point Compensation automatically switched off. You use the two checkboxes below to decide to what extent you wish to simulate the press conditions, using: Simulate Paper Color and Simulate Black Ink. I then hit the Print... button and selected the Print preset setting that was saved at the time I created the custom print profile (see page 543).

CMYK proofing with an inkjet

You don't have to rely on using expensive proofing devices or proofing services. Even a humble inkjet printer is capable of producing excellent quality 'targeted' CMYK prints that can be used as an 'aim' print or even a contract proof by the printer. It is possible to simulate the restricted CMYK gamut of the press via the Print with Preview dialog.

Figure 14.11 shows the Print with Preview dialog for an Adobe RGB image that is currently being soft proofed with the Custom Proof Setup using a 'Europe ISO Coated FOGRA27' color space profile. When the Proof option is selected as the Print space, the current CMYK preview becomes the designated Print space. In the Options, the Color Handling is again set to Let Photoshop Determine Colors. The Printer Profile should use the custom profile for the paper you are about to print on. But note that the rendering intent will be grayed out. The Proof Setup Preset will let you confirm using the current Custom setup as the print space, or you can mouse down and select from any other presaved Custom Proof preset.

			Print			
		Positio	n			Print
		Top:	4.66	[(cm		Cancel
-		Left:	0.95](cm	\$	Done
sh though	*		Ø	Center Image		Page Setup
1 the	* * * *	Scaled	Print Size			
- Alerande	had an a first	Scale:	100%	Scale t	o Fit Media 🚽	Fewer Optio
1985 . 38	ESP/LENniller	Height:	16.581) cm	- a	
the local	Contraction of the local division of the loc	Width:	18 38	(cm		
- Commencement of the local distance of the	Construction of the local division of the lo	wiett.		w Bounding		
				nt Selected Ar		
Options	ile: Europe ISO Coat				·····	
	1290-EpsonSG-21					
	Relative Colorimet			Black Point C		
	Current Custom Se			Mack Point C	unpensation	
roor setup rreset.	Simulate Paper C			·k lnk		
Description	Communite raper v		manual bags			

Simulation and rendering intents

The aim here is to produce a print that simulates the output of a CMYK proof printer. We are configuring the Print with Preview settings to utilize the Customize Proof Condition settings (which will already include the Device to Simulate and the Rendering Intent) and then applying a further profile conversion from this proof setup space to the printer profile space. Photoshop CS2 makes it easy for you to select the right options so that you don't have to do anything more than decide whether you wish to simulate the black ink appearance only or simulate the paper color, in which case the simulate black ink will be checked automatically anyway. So by clicking on one or more of these buttons at the bottom, you can instruct Photoshop to work out for you how the data should be converted and sent to the printer to achieve the desired press simulation.

When Simulate Paper Color is selected, the whites may appear duller than expected. This does not mean the proof is wrong, rather it is the presence of a brighter white border that leads to the viewer regarding the result as looking inferior. To get around this try adding a white border to the outside image you are about to print. When the print is done, trim away the outer paper white border so that the eye does not get a chance to compare the dull whites of the print with the brighter white of the printing paper used.

Proof simulation using Photoshop CS or older

Photoshop CS2 makes it easier for you to get the simulation printing right, but it is perhaps worth me mentioning here how you would go about producing a proof simulation the old way. It is useful to know this should you ever need to achieve the same type of print processing on an older version of Photoshop. Firstly, you will need to deselect the Black Point Compensation. This setting will enable you to successfully simulate the actual black of the print press. And then you need to choose a rendering intent (see sidebar). This will determine how the proof space colors are reproduced in the proof print.

Color Handling:	Let Photoshop Determine Colors	:(0
Printer Profile:	1290-EpsonSG-210904.icc	4	\cup
Rendering Intent:	Relative Colorimetric	*)	

Figure 14.12 When you choose the Let Photoshop Determine Colors option, a little exclamation mark will appear next to this item in the dialog. When you hover over this, a description will appear at the bottom, reminding you that when you have this option selected, you must remember to disable the Color Management options in the system print dialog settings that follow (see pages 539 and 543).

Proofing in Photoshop CS or older

If using Photoshop CS or older, the Black Point Compensation will have to be switched off if you wish to simulate the actual black ink. If Relative Colorimetric is used as the rendering intent, the proof setup to printer space profile conversion will map the whitest point of the proof profile space to the whitest point of the printing paper (as defined by the printer profile). This rendering intent will produce a restricted gamut proof print with possibly brighter whites than will actually be reproduceable on the actual paper stock.

If you select the Absolute Colorimetric rendering intent, the proof setup to printer space profile conversion will map the whitest point of the proof profile space to the true paper white color of the target press, producing a Paper Color simulation.

PostScript printers

There are many desktop PostScript printers to choose from for less than \$10,000. Which one you should go for depends on the type of color work you do. Laser printers are useful to graphic designers where the low cost of consumables such as paper and toners is a major consideration. A setup including a laser printer and dedicated RIP server is ideal for low cost proofing and short run color laser printing. I am thinking here of a color laser printer such as a Canon copier or the recent QMS MagiColor 330GX. The ProofMaster Adesso RIP is a reasonably priced software RIP for Mac OS X only. The ProofMaster Folio is a software RIP available on all platforms and works on around 90 types of inkiet printers: www. proofmaster.net.

PostScript printing

When you print a document, graphic or photograph, the data has to be converted into a digital language that the printer can understand. Printing images directly from Photoshop is a fairly easy process. If you try to print anything directly from a page layout program, the printer will reproduce the screen image only. The text will be nice and crisp and TIFF images will print fine, but placed EPS images will print using the pixelated preview. This is why you sometimes need PostScript, which is a page description language developed by Adobe. When proofing a page layout via a PostScript printer, the image and text data in the layout are processed separately by a Raster Image Processor (RIP) which is either on the same machine or a remote computer. Once the data has been fully read and processed it is sent as an integrated pixel map (raster) file to print in one smooth operation. For example, you'll notice many proofing printers come supplied with PostScript (Level 3 or later). Normally a prepared CMYK image is embedded in the PostScript file of a page layout program and then converted in the RIP. The RIP takes the PostScript information and creates the series of dots for each separation to be output to film or plate. The Photoshop image data is likely to be in either TIFF or encapsulated PostScript (EPS) form in the file created by the page layout program and it is this which is passed along with the original vector images and fonts to be rasterized. And many recent RIPs are able to handle PDF files directly. Printing speed is dependent on the type of print driver software the printer uses and the amount of RAM memory installed in the server machine. Too little memory and either the document will take ages to process or won't print at all.

Printing via a RIP

In the studio office where I work, we use an Epson 7600 Ultrachrome printer for all the large format printing. I have custom profiles built for printing directly from Photoshop but am also able to use a dedicated RIP with this printer, such as ImagePrint 5.6 from ColorByte software. ImagePrint is a visual RIP, which means it displays how the document will print the same as when in Photoshop, you use the Custom proof setup to create an adjusted preview on the screen. The Epson Ultrachrome printers are very consistent in output quality. So the paper profiles that are part of the software package will work on any machine. The RIP software is being used as a replacement for the printer driver used by Photoshop and communicates directly with the printer hardware, which means that the RIP is not constrained by what might be considered as limitations of the manufacturer's print driver defaults. For example, the ImagePrint program has its own way of controlling the inkjet printer heads to produce subtle tonal coloring in black and white prints.

Figure 14.13 The Epson Ultrachrome printers have proved popular with photographers who wish to produce enlarged prints or posters. The Epson 7600 shown here is reasonably priced but takes up a lot of space in the office. The paper can be fed into the printer either from rolls or as single sheets and is as simple to set up and manage as a normal desktop printer. This particular machine is connected to a print server Macintosh computer running the ImagePrint 5.6 by ColorByte Software. The ImagePrint interface is shown in Figure 14.14.

Figure 14.14 This is a screen shot of the ImagePrint 5.5 interface. ImagePrint is a visual RIP. You set up the page size and position the image to be printed on the page, When you select the paper type profile in the Color Management dialog, the document window will display a color managed preview of what the printed output will look like.

Client: Errol Douglas. Model: Vicky Kiernon @ Take Two.

Quantity printing

If you are faced with a large print order there are some bureau solutions to consider. The Sienna printing process supplied by the photographic company Marrutt can produce low cost C-type prints in large quantities and at a reasonable cost. The aforementioned laser light writers such as the Lambda process are always going to be that bit more expensive. Beyond that, one should look at repro type solutions. The technologies to watch are computer to plate (CTP) or direct digital printing: Chromapress, Xericon and Indigo. These are geared to repro guality printing from page layout documents, containing images and text. They make short print runs an economic possibility.

Repro considerations

Color management plays an important role in ensuring that all the prepress activity comes together as smoothly as possible. For this reason, the profiling of RGB devices as described in the preceding chapter is very important. In today's rapidly changing industry, a digital file may take a very convoluted trip through the world of prepress. The aim of Photoshop ICC color management is to maintain consistency through this part of the process. In an 'alldigital' environment this is eminently doable. But once a digital file has been separated and converted to make the plates, it is down to the printer who is running the press to successfully complete the process.

Color management (even non-ICC profiled color management) is controllable and should be maintained within the digital domain, but once you leave that digital world and enter the press room, the operation takes a completely new direction. Fretting over how a proof print may have faded 0.3% in the last month is kind of out of balance to the bigger picture. The printer may be satisfied to keep the whole print job to within a 5% tolerance, although many manage to keep within even tighter tolerances. Imagine, for example, a large volume magazine print run. A printer may use up paper stocks from 17 different sources and make 'on-the-fly changes' to the press to accommodate for changing dot gain and other shifts which may occur during the run. The proof is like the printer's map and compass. Successful repro is as much dependent on the printer exerting their skills as it is reliant on the supplier of the digital file getting their side of the job right. Good communication can be achieved through the use of an accepted color proof standard. It is a mistake to think that one can accurately profile the final press output. The best we can hope to achieve is to maintain as accurate an RGB workflow as is possible and to this end accurate profiling is very important. Once a file has been accurately proofed to a CMYK proofer that is the best we can do, because what happens next is generally out of our hands.

I have had a fair amount of experience producing this series of books on Photoshop. I will usually supply aim prints to the printer that have been printed using a desktop Epson printer and targeted using the custom profile based on the supplied press settings. We rarely have much trouble getting the colors right and the first proof sheets I get back from the printers are usually not that far out. After that I don't get to personally check every book of course, but I do get to see a fair sample of books and over a period of time, there are fluctuations in the color reproduction and that is to be expected. But they are well within an acceptable tolerance. If you want to learn more about printing from Photoshop, I can recommend some further reading: 'Mastering Digital Printing' by Harald Johnson is a comprehensive title that does a good job of covering the subject of printing in extensive detail. 'Real World Color Management' by Bruce Fraser, Chris Murphy and Fred Bunting and 'Real World Photoshop CS2' by Bruce Fraser and David Blatner are the industry bibles on the subject of color management and printing.

File formats

Photoshop supports nearly all current image file formats. And for those that are not, you will find some specialized file format plug-ins are supplied as extras on the Photoshop application CD. Choosing which format to output your images to should be determined by what you want to do with that file and the list can then be further narrowed down to a handful of recognized formats that are appropriate to your needs. You may want to choose a format that is intended for prepress output, or screen-based publishing, or maybe you wish to use a format that is suitable for image archiving only.

Adobe InDesign and Adobe GoLive enable you to share Photoshop format files between these separate applications and see changes made to a Photoshop file be automatically updated in the other program. This modular approach means that many Adobe graphics programs are able to integrate with each other more easily.

While an image is open in Photoshop, it can be manipulated without being limited by the range of features supported in the original source format. If you open a JPEG format image in Photoshop and simply adjust the levels and save it, Photoshop will overwrite the original. But you can also edit the same JPEG image in Photoshop, adding features such as layers or adjustment layers. When you come to save, you will be shown the Save dialog shown in Figure 14.15. This reminds you that the file contains features that are not supported by the JPEG file format and alerts you to the fact that if you click Save now, not all the components in the image (i.e. layers) will be fully saved. This is because while you can save the file as a JPEG, the JPEG format does not support layers and the document will therefore be saved in a flattened state. If I were to choose the native Photoshop file format to save in, the Layers box will automatically be checked and it will become possible for me to now save this version of the image in the native Photoshop format and preserve the layer features.

Figure 14.15 The Photoshop Save dialog box. If the file you are editing contains elements that are no longer compatible with the file format it started out life in, you will be obliged to save using a file format that can recognize such elements, such as TIFF or PSD. If you wish to force Photoshop to save the file in its original file format then the troubling components will appear deselected and with a warning triangle informing you that this image will be saved as a copy.

	As a Copy	Аппо
	Alpha Channels	Spot
	▲ _ Layers	
Color:	Use Proof Setup: W	orking CM
	Embed Color Profile	e: Adobe R

Photoshop native file format

The Photoshop file format is a universal file format and therefore a logical choice when saving and archiving your master files since the Photoshop (PSD) format will recognize and contain all known Photoshop features. But so to will the TIFF and PDF file formats. However, there are several reasons why I find it preferable to save the master images using the PSD format. Firstly, it helps me to distinguish the master, layered files from the flattened output files which I usually save as TIFFs. But more importantly, when you have layered images, saving with the PSD format is faster and in most instances will compact the data more efficiently compared to using TIFF.

Maximum compatibility

Only the Photoshop, PDF, PSB and TIFF formats are capable of supporting all the Photoshop features such as vector masks and image adjustment layers. Saving in the native Photoshop format should result in a more compact file size, except when you save a layered Photoshop file with the Maximize Backwards Compatibility checked in the preferences. Figure 14.24 at the end of this chapter contains a summary of file format compatibility with the various Photoshop features.

TIFF image compression options

An uncompressed TIFF is about the same size as shown in the Image Size dialog box. The TIFF format in Photoshop offers several compression options. LZW is a lossless compression option. Data is compacted and the file size reduced without any image detail being lost. Saving and opening will take longer when LZW is utilized, so some bureaux will request that you do not use it. ZIP is another lossless compression encoding that like LZW is most effective where you have images that contain large areas of a single color. JPEG compression is a lossy compression method and is described more fully in Chapter 15.

Save Image Pyramid

The Save Image Pyramid option will save a pyramid structure of scaled-down versions of the full-resolution image. TIFF pyramid-savvy DTP applications (there are none I know of yet) will then be able to display a good quality TIFF preview, but without having to load the whole file.

PSB (Large Document Format)

The PSB file format is provided as a special format for those who need to save files that exceed the normal 30,000 \times 30,000 pixel dimensions limit in Photoshop. The PSB format does have to be enabled first in the Photoshop preferences, but once enabled you can save image files with dimensions of up to $300,000 \times 300,000$ pixels. This implies that you can create huge-sized files. But the only photographic application I can think of where you might need such a large file, would be if you were creating a long panoramic image. Even so, a lot of applications and printer RIPs cannot handle files greater than 2 GB. But there are exceptions, such as ColorByte's ImagePrint and Onyx's PosterShop. For this reason the $30,000 \times 30,000$ limit has been retained for all existing file formats in Photoshop, where the TIFF specification is limited to 4 GB and the native Photoshop PSD format, 2 GB maximum size. You also have to bear in mind that only Photoshop CS and Photoshop CS2 are capable of reading the PSB format.

TIFF (Tagged Image File Format)

The main formats used for publishing work are TIFF and EPS (and also the native Photoshop file format in an Adobe InDesign or Illustrator workflow, where Maximize Backwards Compatibility must be switched on). Of these, TIFF is the most universally recognized, industry-standard image format, but this does not necessarily imply that it is better. The PDF file format is also gaining popularity for DTP (desktop publishing) work. TIFF files can readily be placed in QuarkXpress, InDesign and any other DTP or word processing document. The TIFF format is more open though and unlike the EPS format, you can make adjustments within the DTP program as to the way a TIFF image will appear in print.

Labs and output bureaux generally request that you save your output image as a TIFF, as this can be read by most other imaging computer systems. If you are distributing a file for output as a print or transparency, or for someone else to continue editing your master file, it will usually be safer to supply the image using this format. TIFFs saved using Photoshop 7.0, CS and CS2 will support alpha channels, paths, image transparency and all the extras that can normally be saved using the native PSD and PDF formats. Labs that receive TIFF files for direct output will normally request that a TIFF file is flattened and saved with the alpha channels and other extra items removed. For example, earlier versions of Quark Xpress had a nasty habit of interpreting any path that was present in the image file as a clipping path.

TIFF Options	
Image Compression MONE	ОК
OLZW	Cancel
OZIP	
O JPEG	
Quality: Maximum \$	
Pixel Order Interleaved (RCBRGB) Per Channel (RRGGBB)]
- Byte Order	
O IBM PC	
Macintosh	
Save Image Pyramid	
Save Transparency	
Layer Compression	
 RLE (faster saves, bigger files) 	
O ZIP (slower saves, smaller files)	
O Discard Layers and Save a Copy	

Figure 14.16 The TIFF save options can be customized. If an open image contains alpha channels or layers, the Save dialog in Figure 14.15 will indicate this and you can keep the necessary options checked to preserve these in a TIFF save. If the File Saving preferences have Ask Before Saving Layered TIFF Files switched on a further alert dialog will warn you after clicking OK to the TIFF options the first time you save an image as a layered TIFF.

Pixel order

The Photoshop TIFF format has traditionally saved the pixel values in an interleaved order. So if you were saving an RGB image, the pixel values would be saved as clusters of RGB values like the following sequence: RGBRGBRGB. All TIFF readers are able to interpret this pixel order. The per channel pixel order option will save the pixel values in channel order. All the red pixel values are saved first, followed by the green, then the blue. So the sequence is more like: RRRGGGBBB. Using the Per Channel order can provide faster read/write speeds and better compression. Most third-party TIFF readers should support per channel pixel ordering. But there is a very slim chance that some TIFF readers won't.

Byte order

The byte order can be made to match the computer system platform the file is being read on. But there is no need to worry about this since I know of no examples where this can cause compatibility problems.

Layer compression

If there are layers present in the image, compression options can be applied separately to the layers. RLE stands for Run Length Encoding and provides the same type of lossless compression as LZW. The ZIP compression is another form of lossless compression. When Maximize Backwards Compatibility is switched on these compression options will help keep the overall saved file size down.

	Can	
	Can	el)
ent		
in a start		
	ent	ent

Figure 14.17 The Photoshop EPS Save dialog.

EPS

The EPS (Encapsulated PostScript) format is another format for placing large color separated files within a page layout document. The EPS file format uses a low resolution preview to display the image on screen, while the image data is written in the PostScript language used to build the output on a PostScript device. The image data is 'encapsulated' which means it cannot be altered within the desktop layout program (i.e. you need a program like Photoshop to edit the image data). The saving options include:

Preview display: This is a low resolution preview for viewing in the page layout. The choice is between None, a 1-bit/8-bit TIFF preview which is supported on both platforms, or a 1-bit /8-bit/JPEG Macintosh preview. I recommend the 8-bit preview mode or JPEG Macintosh preview if working on the Mac.

Encoding: ASCII encoding generates large files and is mainly suited to PC platforms only. Binary encoded files are half the size of ASCII encoded files and can therefore be processed more quickly. Binary encoding is compatible with Mac and PC. JPEG coding produces the smallest sized, compressed files. Only use JPEG if you are sending the job to a Level 3 PostScript printer. Bear in mind that image quality will become significantly degraded whenever you select a lower quality JPEG compression setting.

Include Halftone Screen and Include Transfer Functions:

For certain subjects, the images will print better if you are able to override the default screen used on a print job. The Transfer function is like a Curves image adjustment that is applied to the image during the Photoshop to print output process. The Transfer function does not alter the appearance of the image on the monitor, it is merely an adjustment designed to accommodate for the dot gain output. Check these boxes if you want to override any of the default printer settings. But with today's color management systems there is little reason to use the transfer functions. The best advice is not to adjust anything here unless you are absolutely sure you know what you are doing.

PostScript Color Management: This will enable PostScript Level 2 devices or higher to read the Grayscale, RGB or Lab profiles embedded in Photoshop and convert as necessary. But I believe it is better to let Photoshop handle the color management and conversions.

Include Vector Data: If there is vector data present in the document this can be interpreted such that the vector information will be rasterized in the EPS file. As usual, clipping paths can be saved in an EPS. A clipping path will act as an outline mask when the EPS file is placed into a page layout program. If you have a work path saved in the Paths palette it can be specified to be used as the clipping path from within Photoshop.

Image Interpolation: This is applicable if you have low resolution screen capture images. The Image Interpolation option will attempt to smooth out the pixels on-the-fly as the data is sent to the printer. It is otherwise best to leave this option deselected.

DCS

Quark Xpress also uses a version of the EPS format known as DCS (which stands for Desktop Color Separations). The DCS 1.0 Format generates five separate files: one preview composite and four-color separation files. It can be difficult to manage all these individual color plate files, especially when there are a lot of images in a folder. The DCS 2.0 Format is a self-contained file containing the preview and separations. Crucially, DCS 2.0 supports more than four color channels, i.e. spot colors and HiFi color.

EPS pros and cons

The downside of using EPS is that all the PostScript image data must be processed by the RIP every time you make an output, even if only a smaller amount of data is required to produce a proof and EPS files can take longer to process than a TIFF. However, you get an almost instantaneous rendering of the image preview when editing a DTP document on a computer screen.

	DCS 2.0 Format
Preview:	Macintosh (JPEG)
DCS:	Single File with Color Composite (72 pixel/inch)
Encoding:	Binary
Include	Halftone Screen
🗌 Include	Transfer Function
Include	Vector Data
Image l	nterpolation

Figure 14.18 The DCS 2.0 Format options dialog box.

PDF versatility

The PDF format in Photoshop is particularly useful for sending Photoshop images to people who don't have Photoshop, but do have Adobe ReaderTM on their computer. If they have a full version of Adobe Acrobat they will even be able to conduct a limited amount of editing, such as changing a text layer slightly. Photoshop is also able to import or append annotations from Adobe Acrobat.

Photoshop PDF

The PDF (Portable Document Format) is a cross-platform file format that was initially designed to provide an electronic publishing medium for distributing documents without requiring the recipient to have a copy of the program that originated the document. Acrobat enables others to view documents the way they are meant to be seen, even though they may not have the fonts used to compile that document. All they need is the free Adobe Reader program.

Adobe PDF has now gained far wider acceptance as a reliable and compact method of supplying pages to printers, due to its ability to embed fonts, compress images and its color management features. It is now almost the native format for Illustrator and other programs such as Photoshop, because it can preserve everything that a Photoshop (PSD) file can. Adobe Reader and its predecessor Acrobat Reader are free, and easily obtained from the Adobe Website. Adobe Acrobat can be used to reproduce pages designed in InDesign or Illustrator to be viewed as self-contained documents. Best of all, Acrobat documents are small in size and can be printed at high resolution. I can create a document in InDesign and export it as an Acrobat PDF using the Export command. Anyone who has installed the Adobe Reader program can open the PDF document I supply and see the layout just as I intended it to be seen, with the pictures in full color plus text displayed using the correct fonts. The Photoshop PDF format (see Figures 14.19–14.22) can save all Photoshop features such as layers, with either JPEG or lossless ZIP compression and is backwards compatible in as much as it will save a flattened composite for viewing within programs that are unable to fully interpret the Photoshop CS2 layer information.

		Save Adobe PDF
Adobe PDF Preset:	[[High Quality	Print]]
Standard:	None	Compatibility: Acrobat 4 (PDF 1.3)
General	General	
Compression Output Security Summary	Description:	Use these settings to create Adobe PDF documents for quality printing on desktop printers and proofers. Created PDF documents can be opened with Acrobat and Adobe Reader 5.0 and later.
	Embed F	Photoshop Editing Capabilities age Thumbnails e for Fast Web Preview F After Saving
-		
Save Preset		Cancel Save PDF

Figure 14.19 You can start by selecting a PDF preset setting before you save, or configure the settings, starting with the General options. In most situations you will want to preserve the ability to edit the saved PDF image again in Photoshop and improve the performance of PDFs on web servers. If you want to preview the PDF in Adobe Acrobat afterwards, then check View PDF After Saving.

	Sa	ve Adobe PDF		
Adobe PDF Preset:	[[High Quality Print]]			
Standard:	None	Compatibility:	Acrobat 4 (PDF 1.3)	
General	Compression			
Compression Output	- Options			
Security	Bicubic Downsampling To	\$ 300	pixels/inch	
Summary	for imag	ges above: 450	pixels/inch	
	Compression: JPEG		Tile Size: 0	
	Image Quality: High	•		
Save Preset)			Cancel	Save PDF

Figure 14.20 The Compression options allow you to decide which compression method (if any) should be used.

	ve Adobe PDF	Sa					
•		[[High Quality Print]]	Adobe PDF Preset:				
	Compatibility: Acrobat 4 (PDF 1.3)	None	Standard: (
		Output Color	General Compression Output				
•	No Conversion	Color Conversion: (Security				
	N/A	Destination:	Summary				
	Include Destination Profile	Profile Inclusion Policy:					
•		Output Intent Profile Name: Output Condition: Output Condition Identifier: Registry Name:					
		Description					
	Cancel	Registry Name:	Save Preset)				

Figure 14.21 The Output options allow you to set document level color management policies. So, for example, you could save an RGB file with a Convert to Destination policy and set the destination space below.

		Save Adobe PDF	
Adobe PDF Preset:	[[High Quality Print]] (Modified)	
Standard:	None	Compatibility: Acrobat 4 (PDF 1.3)	en an
General Compression Output	Security Encryption Level: Low (40-bi	t RC4) - Compatible with Acrobat 3 and Later	
Security	- Document Open Password	1	
Summary	Require a password to o	pen the document	
		Document Open Password:	
		ct printing, editing and other tasks Permissions Password: word is required to open the document in PDF editing applications.	
	P	rinting Allowed: None	•
	C	nanges Allowed: None	
		, images and other content screen reader devices for the visually impaired data	

Figure 14.22 The Security options will be linked to the version compatibility you have selected, but essentially allow you to restrict access by requiring a password to open the document and have a separate password to restrict edit changes or document printing.

PDF security

The PDF security options allow you to restrict file access to authorized users only. This means that a password will have to be entered before an image can be opened in either Acrobat or Photoshop. And you can also introduce a secondary password for permission to print or modify the PDF file in Acrobat. Note that this level of security only applies when reading the file in Acrobat. You can only password protect the opening of a PDF file in Photoshop. Once opened in Photoshop, it will be fully editable. Even so, this is still a very useful feature. The PDF security allows you to prevent some unauthorized first level access to your images. There are two security options: 40-bit RC4 for lower-level security and compatibility with versions 3 and 4 of Acrobat and 128-bit RC4, for higher security using Acrobat versions 5-7. However, because the PDF specification is an open-source standard, some other PDF readers are able to by-pass these security features and quite easily open a password-protected image! So the security features are not totally infallible, but marginally better than using no security at all.

Placing PDF files

The Photoshop Parser plug-ins enable Photoshop to import any Adobe Illustrator, EPS or generic single/multi-page PDF file. Using File \Rightarrow Place, you can select individual pages or ranges of pages from a generic PDF file, rasterize them and saving to a destination folder. Use File \Rightarrow Place to extract all or individual image/vector graphic files contained within a PDF document as separate image files (see Figure 14.23).

Figure 14.23 If you try to open a generic Acrobat PDF from within Photoshop by choosing File \Rightarrow Open or File \Rightarrow Place, you will see the Place PDF dialog shown here. This will allow you to select individual or multiple pages or picture elements to be placed within a new Photoshop document.

PICT

PICT is primarily a Macintosh file format which, while it can be read by PC versions of Photoshop, is not a format for DTP work, although it has some uses in certain multimedia authoring applications. The PICT format utilizes lossless Run Length Encoding compression. Areas of contiguous colors (i.e. subjects against plain color backgrounds) compress more efficiently without any image degradation, although files can be compressed using various levels of JPEG compression. There is nothing about PICT which the native Photoshop file format cannot do better and there are also some pixel size limitations with the PICT format.

File format	RGB	СМҮК	Indexed Color	Grayscale	Layers	Alpha Channels	Paths	ICC profiles	Annotations
Adobe Photoshop	•	•	•	•	•	•	•	•	•
Adobe Photoshop 2.0	•	•	•	•		•	•	•	
FlashPix	÷ •;-			•			•		
CompuServe GIF			•						
JPEG	•	•		•			•	•	
Photoshop EPS	•	•	•	•			•	•	
Photoshop DCS 1.0		•					•	•	
Photoshop DCS 2.0	•	•		•		•	•	•	
Photoshop PDF	•	•	•	•	•	•	•	•	•
PICT	•		•	•			٠	•	
PNG-8			•	•		•	•		
PNG-24	•			•		•	•		
Scitex CT	•	•		•			٠		
TIFF	•	•	•	•	•			•	•

Figure 14.24 File format saving options showing which Photoshop features can be saved in the listed formats. Those indicated with a red dot are savable on the Mac OS only. This list includes file formats used to save for web output (which are discussed in the following chapter).

Chapter 15

Output for the Web

he Internet is something most of us use every day and having the means to transmit images has become extremely important. There is the well-known saying 'a picture is worth a thousand words'. And it is so true, pictures allow us to communicate visually with clients, friends and family, in ways that words alone cannot. The most obvious advantage of sending or displaying images via the Web is its immediacy. Pictures can be sent around the world almost instantly and it is quick and easy to prepare an image to be distributed. The downsides are that, unlike producing a finished print, you have little or no control over the way the image is viewed by the recipient and the people you want to see your photographs must obviously have access to the Internet.

Sending multiple images by email

Email programs can accept single or multiple attachments of any format, but not as a folder, unless it is compressed as an archive. And if the recipient is using an AOL account, do not send more than one image per email. Aladdin Software make the ubiquitous Stuffit program which is great for compressing files in his way. Although this originated for the Mac it is available to Windows and handles ZIP compression as well as using its own proprietary format. It uses lossless compression and avoids the problem of Mac files appearing on Windows machines as two identically named files which contain the data and resource forks that constitute a Mac file.

A Stuffit archive will have a .sit extension, which requires expansion by Stuffit (which is incorporated into the Mac OS), but this can also be saved as a self-extracting archive. In this instance, the archive will bear the .sea extension and either WinZip or Stuffit can expand such Mac created archives. If the pictures in the source folder are JPEGs, then you will probably not notice a big difference in the final file size. But don't worry, this compression will not compromise the quality of the JPEG images any further.

Sending images over the Internet

Let's look at the ways you can distribute images over the Web. In the past, people relied heavily on ISDN. But these days a fast Internet connection is all that most people need.

Email attachments

With the increasing popularity of Broadband, cable and ADSL connections, you can effectively use a fast connection to the Internet to transmit and receive large files. The easiest way to do this is to send the files as attachments in an email. Email programs may differ, but most should let you simply drag a file from a folder on your computer into the body text area of an email. Click Send and you're done - the attached document will be distributed along with the text message in the email. It's relatively easy to do, but not completely flawless. There is no reliable way of knowing if the recipient's email program will be able to decode an attachment that has been sent from your email program. If you communicate using email this way, then you must remember to keep the attachments small. As a rule, I keep all attachments under 500 kilobytes (assuming the recipient also has a broadband type connection). I do like to check firstly, before sending anything bigger to see if they mind receiving an attachment bigger than this. The Internet suffers quite enough already with bandwidth being consumed by unwanted junk emails. So don't add to the problem by sending large, unsolicited attachments. But if it is OK to send a big file, ask the recipient if there is a limit in place for the size of files they can receive in a single email, because if you exceed this, the email will only bounce back.

As long as you are aware of the parameters and restrictions of email programs and the possible limitations of the recipient's server, email can be an effective way to transfer smallish documents. Lots of people use email this way to share photographs. And the advanced email programs are also capable of displaying image file attachments within the body text area. But remember, this is by no means a foolproof way to send large images.

Uploading to a server

With email you are sending a message that has the image embedded in it. Another alternative is to upload the image file to a server. You can then send an email that contains a clickable link that launches the recipient's web browser and this will take them directly to a page from where they can download the file. The advantage of this is that the email you send is small, as it only contains a text link to the server. There will be less risk of the email being rejected and if the person you are sending the email to needs to share the image with someone else, they only have to forward the message. They don't have to forward the entire image attachment all over again. But first you need to know how to upload to a server. If you connect to the Internet using a subscription service your Internet Service Provider (ISP) will most likely have provided you with a limited amount of server space that you can use to host your own website and upload files for others to download from in the way I described. If you don't have a subscription service or your ISP doesn't provide enough adequate server space, then you can always rent space from a company that maintains a dedicated server and provides web hosting. I use Image Access at www.image-access.net to host my websites and they provide me with all the server space that I require.

In Figure 15.1 I have provided some screen shots that show how I normally go about making an FTP connection to a server using the Fetch program on Macintosh OS X. To avoid having to reenter the information each time you connect, it should be possible to save this information (along with the password if you wish) as a shortcut so that logging on to the server becomes almost as easy as opening a folder on your hard disk. I typically use the FTP software on a regular basis to upload image documents and Web Photo Galleries created in Photoshop. To give you an example of how I do this, I will create a document and make a connection to the server. The connection window opens, and this is like any other hierarchically structured folder. The main connection window will display the

FTP software for Mac and PC

You will need File Transfer Protocol (FTP) software to upload documents to the server space. If using a Macintosh, I recommend using Fetch: www.fetchsoftworks.com. If you are working on a PC, try using WS_FTP Pro www.ipswitch.com or Flash FXP www.flashfxp.com. All FTP software is more or less the same. To establish a connection you need to provide a link address to connect to the server. Next you need to enter your user ID and finally your password. If you are familiar with the steps required to configure your email account, you should already have the username and password information to hand. You may need to enter a subdirectory folder as well. If you have trouble configuring the connection, speak to your ISP. They are the best people to help you in these instances.

Macintosh iDisk

Another option available to Macintosh users is iDisk. This is a Macintosh utility that has been enhanced for Mac OS X 10.3. iDisk is an online server space that you can use for off site backup storage or as a space to place publicly accessible files and folders.

Adobe Photoshop CS2 for Photographers

i meveni	ing 🛟				Status Connected.
الالمحر ومورد الجام المحاصية لتحصر وفحات المتحود وكمكر فحزور وكالمكام معادها تحز ومركز فلتراخط وتحاج فالتكاف ف	Kind	Size	Date		
photoshop7	folder	-	26/11/2002	6	
portraits	folder	-	30/11/2003	110	File
private.asp	.asp document	1K	19/03/2003	115	evening.pdf
put_away	folder	-	07/02/2003	11	Binary Data 61,238 bytes
review	folder		22/12/2004	0	
safety	folder		19/05/2004	-	Transfer 61.238 bytes
show.asp	.asp document	17K	17/02/2003	4	15,309 bytes/s
Snaps	folder	-	17/12/2004		
of 03/01/2005 06:13 pm			40) items	
Get) Mode: Automatic 🛟	Put Files	;orm	at: Automatic	•	

Figure 15.1 The Fetch 4.0 FTP software interface, showing a new server connection being made.

Make a new	connection to this FTP account:		
Host:	www.photoshop4photographers.com		
User ID:	adnin2		
Password:			
	Add to Keychain		
•			
Shortcuts:	Help Cancel OK		

Download a sample image file

I have uploaded a photograph to my server which you can access by typing in the following URL address in your web browser: www.martinevening.com/portraits/ evening.pdf. This image document was saved as a Photoshop PDF file. You will probably be asked if you want to save the file to the desktop. Click Save and the file will start to download. The reason I saved this image as a Photoshop PDF was to demonstrate the security features that are available when using this format. To open the PDF file you will need to enter the password 'evening' when prompted. website documents and subfolders. In here, I have created new subfolders with names like 'Locations', 'Travel' and 'Review'. I use these specific folders to upload the Web Gallery folders to so that they do not get mixed up with the folder structure of the main website. I will then double-click on a folder such as 'Review' to reveal the subfolder contents and then drag the Internet-ready file or folder across into this window. And that's it. The time this takes to accomplish will depend on the size of your file and Internet connection speed. To access these files, all you have to do is to supply people with a weblink such as the one in the accompanying sidebar. When they click on the link you give them the file should start to download automatically to their computer.

File formats for the Web

Now that we have covered the fundamentals of how to access a server and administer your allocated server space, let's look at preparing images to be displayed on the Web and take a look at the different file formats you can use and which are the best ones to choose in any given situation.

JPEG

The JPEG (Joint Photographic Experts Group) format provides the most dramatic way to compress continuous tone image files. The JPEG format uses what is known as a 'lossy' compression method. The heavier the compression, the more the image becomes irreversibly degraded. If you open a moderately compressed JPEG file and examine the structure of the image at 200%, you will probably notice that the picture contains a discernible checkered pattern of 8×8 pixel squares. This mosaic pattern will easily be visible at actual pixels viewing when using the heavier JPEG settings. The compression is more effective if the image contains soft tonal gradations as detailed images do not compress quite so efficiently and the JPEG artifacts will be more apparent. The JPEG format is mostly used for web design work, because a medium to heavy amount of JPEG compression can make most photographs small enough to download quickly over the Internet. Image quality is less of an issue here when the main object is simply to reduce the download times.

Photoshop compresses images on a scale of 0–12. A setting of 12 will apply the least amount of compression and give the highest image quality, while a setting of 0 will apply the greatest amount of compression and be the most lossy. When you choose to save as a JPEG, the document window preview will change to reflect how the compressed JPEG will look after it is reopened as a JPEG. The JPEG Options dialog box will also indicate the compressed file size in kilobytes and provide an estimated modem download time. This feedback information can be quite helpful. If you save a master file as a JPEG and then decide the file needs further compression, you can safely

Keeping it small

Only one thing matters when you publish images on the Web and that is to keep the total file size of your pages as small as possible. The JPEG format is the most effective way to achieve file compression for continuous tone images. But graphics that contain fewer, distinct blocks of color should be saved using the GIF format. Some web servers are case sensitive and will not recognize capitalized file names. Go to Edit menu and select Preferences ⇒ Saving Files and make sure the Use Lower Case Extensions box is checked.

Figure 15.2 Two JPEG images: both have the same pixel resolution and both have been saved using the same JPEG quality setting. Yet the Sahara desert image will compress to just 21 kilobytes, while the gas works picture is over three times bigger at 74 kilobytes. This is because it contains so much extra detail. The more contrasting sharp lines there are in an image, the larger the file size will be after compression. For this reason it is best not to apply too much unsharp masking to an image before you save it as a JPEG. If you are editing an image that is intended to go on a web page, you can deliberately apply blur to some of the less critical portions of an image to remove distracting detail and thereby reduce the JPEG size (check out the new Surface Blur filter shown in Chapter 10).

overwrite the last saved JPEG using a lower JPEG setting. It is possible to repeat saving in the JPEG format this way. For as long as the image is open in Photoshop, all data is held in Photoshop memory and only the version saved on the disk is degraded.

Once an image has been compressed using the JPEG format, it is not a good idea to repeatedly resave it as a JPEG, because this will only compound the damage already done to the image structure. Unlike some programs, the JPEG compressor used in Photoshop converges, so that after repeated expansions and compressions using the same settings and without modifying the pixels, the data loss will be less and less with every save, to the point where there will be little or no

further loss. Your main uses for the JPEG format should be primarily to create smaller file size copies to conserve disk space, to ensure visitors to your website receive speedy downloads, and smaller email attachments. You normally want to compact a file in this way for inclusion on a web page, for faster electronic distribution, or saving a large file to a restricted amount of disk space. For example, an 18 MB, $10" \times 8"$ file at 300 ppi resolution can be reduced in size to around 1 MB with hardly any degradation to the image quality. Some purists will argue that JPEG compression should never be used under any circumstances when saving a photographic image. It is true that if an EPS or TIFF file is saved with JPEG file compression there are some rare instances where this can cause problems when sending the file to some older PostScript devices. But otherwise, the image degradation is barely noticeable at the higher quality compression settings, even when the image is viewed on the screen in close-up at actual pixels viewing, never mind when it is seen as a printed output.

Choosing the right compression type

As you can see Figure 15.5, JPEG compression is a most effective way to reduce file size, but this is achieved at the expense of throwing away some of the image data. JPEG is therefore known as a 'lossy' format. At the highest quality setting, the image is barely degraded and the JPEG file size is just 70 kilobytes, or 12% of its original size. If we use a medium quality setting the size is reduced further to just 18 kilobytes. This is probably about the right amount of compression to use for a photograph that is intended to be included in a typical web page layout. The lowest compression setting will squeeze the original 586 kilobytes down to under 7 kilobytes, but at this level the picture will appear extremely 'mushy' and it is best avoided.

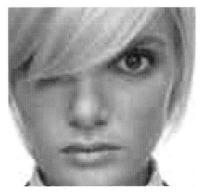

Figure 15.4 The JPEG Options save dialog box. Baseline ('Standard') is the most universally understood JPEG format option and one that most web browsers will be able to recognize. Baseline Optimized will often yield a slightly more compressed sized file than the standard JPEG format and most (but not all) web browsers are able to read this correctly. The Progressive option creates a JPEG file that will download in an interlaced fashion, the same way you can encode a GIF file.

JPEG Options			
Matte: None Image Options Quality: 6 Medium Iarge file Iarge file	OK Cancel Preview		
Format Options Baseline ("Standard") Baseline Optimized Progressive Scans: 3 \$			
-222.86K / 39.37s @ 56.6Kbps +			

Client: Clipso. Model: Bianca at Nevs.

	Q- everywhere	
Name	Date Modified	Size 1
TIFF-uncompressed.tif	5 Mar 2002, 18:15	616 KB
PSD-native.psd	5 Mar 2002, 18:22	292 KB
PICT-32bit.pct	5 Mar 2002, 18:23	288 KB
TIFF-LZW.tif	5 Mar 2002, 18:16	212 KB
clipso.tif-ZIP	5 Mar 2002, 18:17	196 KB
PNG.png	5 Mar 2002, 18:24	192 KB
TIFF-compressed.tif	5 Mar 2002, 18:19	144 KB
JPEG-12.jpg	5 Mar 2002, 18:26	116 KB
GIF-S4W.gif	5 Mar 2002, 18:42	56 KB
JPEG-6.jpg	5 Mar 2002, 18:45	52 KB
JPEG-0.jpg	5 Mar 2002, 18:45	44 KB

Figure 15.5 Here we have one image, but saved eleven different ways and each method producing a different file size. The opened image measures 500 × 400 pixels and the true file size is exactly 586 kilobytes. The native Photoshop format is usually the most efficient format to save in because large areas of contiguous color such as the white background are recorded using a method of compression that does not degrade the image quality. An uncompressed TIFF format doggedly records every pixel value and is therefore larger in size. A compressed TIFF can be made smaller, but the save times are longer. Below that are the JPEG and GIF format versions, which as you can see, offer the most dramatic methods of compression.

JPEG 2000

JPEG 2000 has more extensive features than a normal JPEG format. For example, you can save a 16-bit per channel image, which you can't do with an ordinary JPEG and you can save alpha channels and paths, plus choose to preserve the camera EXIF and all other metadata when you save an image using this format. At one time it was thought that JPEG 2000 might be a better format for storing digital captures, but the advantages of shooting raw have clearly overtaken the JPEG 2000 specification. It is primarily a format that could be used for saving processed image files.

JPEG 2000 compatibility

The JPEG 2000 plug-in is only available from the Bridge plug-ins folder. For instructions on how to use it in Photoshop CS2, refer to page 120. Only another Photoshop CS/CS2 user (or someone with the JPEG 2000 plug-in) can read files encoded in this format. Other programs may support it in the future, but for the time being, use with caution.

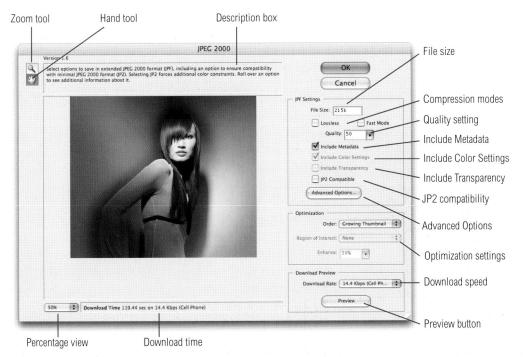

Figure 15.6 The main controls are over on the right, starting with the File Size box. This displays the current projected file size of the compressed JPEG file, but you can also type in the desired file size and Photoshop will calculate a custom file compression to meet this target figure. Below that is the Lossless compression mode button which if checked will render a larger file size, but non-lossy JPEG. The Quality setting can be set anywhere between 1 and 100%, with 100% being the highest quality image setting. JPEG 2000 does not support layers, but if the base layer is a non-background layer and contains transparent pixels, checking the Include Transparency box will preserve the transparency. This will one day be useful for web designers when web browsers are able to recognize JPEG 2000 files. The Optimization settings are identical to those found in the Save for Web dialog (see page 577). The Description box provides a commentary on the function of the other dialog items as you mouse over them.

Martin Evening Adobe Photoshop CS2 for Photographers

Figure 15.7 The GIF file format is mostly used for saving graphic logos and typography. The picture shown here is one that was used for the cover design of an earlier edition of this book. But this is also a good example to illustrate the type of image that would be suitable for saving in the GIF format for use on a web page design. Note that the image contains a large amount of solid red and few other colors. This photograph was reduced in size to around 350 x 300 pixels. I then converted the image to Index Color mode using a palette of 16 colors. When the image was saved as a GIF it measured a mere 19 kilobytes.

GIF

The GIF (Graphics Interchange Format) is normally used for publishing graphic type images such as logos. Some people pronounce GIF with a soft G (as in George) and others use a hard G (as in garage). Neither is right or wrong as both forms of pronunciation are commonly used. To prepare an image as a GIF, the color mode must be set to Indexed Color. This is an 8-bit color display mode where specific colors are 'indexed' to each of the 256 (or fewer) numeric values. You can select a palette of indexed colors that are saved with the file and choose to save as a CompuServe GIF. The file is then ready to be placed in a web page and viewed by web browsers on all computer platforms.

Photoshop contains special features to help web designers improve the quality of their GIF outputs, such as the ability to preview Indexed mode colors whilst in the Index Color mode change dialog box and an option to keep matching colors non-dithered. This feature will help you improve the appearance of GIF images and reduce the risks of banding or posterization. Be aware that when the Preview is switched on and you are editing a large image, it may take a while for the document window preview to take effect, so make sure that you resize the image to the final pixel size first. You will find that when designing graphic images to be converted to a GIF, those with horizontal detail compress better than those with vertical detail. This is due to the GIF format using Run Length Encoding (RLE) compression.

Chapter 15 Output for the Web

Save for Web

The Save for Web option is in the Save section of the File menu. This comprehensive dialog interface gives you complete control over how an image can be optimized for web use, offering a choice of JPEG, GIF, PNG-8 or PNG-24 formats. The preview display options include: Original, Optimized, 2-up and 4-up views. Figure 15.8 shows the dialog window in 2-up mode display. With Save for Web you can preview the original version of the image plus up to three variations using different web format settings. In the annotation area below each preview, you are able

Save for Web tools Optimize settings Optimize menu Preview display options Preview menu Output settings Save For Web - Powered By ImageReady Original Optimized 2-Up 4-Up * Sav Cancel 9 Done IPEG H • Va JPEG \$ After DarlAfter Dar High Quality: 60 DO Progressive 1 ICC Profile . Color Table Image Size Original Size Width:737 pixels Height:1000 pixels w Size Width: 442 pixels pixels Height: 600 cent: 59.97 Constrain Pre Bicu Original: "AC_london010.jpg" 2.11M Apply 60 quality JPEG 72.11K 27 sec @ 28.8 Kbps 1 of 1 G 128 129 0. Edit in ImageReady Zoom level Color information Select browser menu Browser preview button Modify JPEG quality

Figure 15.8 The Save for Web interface.

Figure 15.9 When a browser window preview is selected (see Figure 15.11), the default web browser program is launched and a temporary page will be created, like the one illustrated above. This will allow you to preview the Save for Web processed image as it will appear on the final web page. This is especially useful for checking if the RGB editing space used will be recognized differently by the browser. If you are relying on embedded ICC profiles to regulate the color appearance on screen, you can check to see if the profile is indeed being recognized by the selected web browser program.

to make comparative judgements as to which format and compression setting will give the best payoff between image quality and file size, and also determine how long it will take to download at a specific modem speed. Use the Preview menu to select from a list of modem and Internet connections on which these download times are based. You can also use the Preview menu list to select a preview setting and simulate how the web output will display on either a Macintosh display, a PC Windows display or with Photoshop compensation. The Select Browser menu allows you to select which web browser application to use when you want to preview a document that has been optimized for the Web (see Figure 15.9).

Photoshop provides an option for Progressive JPEG formatting. Most Netscape and Internet Explorer browsers support this enhancement, whereby JPEGs can be made to download progressively the way interlaced GIFs do. The optimized format (see the checkbox below the Optimize menu) can apply more efficient compression, but again is not generally compatible with older web browser programs. The quality setting can be set as Low, Medium, High, Maximum or it can be set more precisely as a value between 1 and 100%. Custom Save for Web output settings can be saved via the Optimize menu. And the Blur control will allow you to soften an oversharpened original and obtain further file compression when using the JPEG format.

Next to the Quality setting is a small selection mask icon. Click on this icon to open the Modify Quality Settings. In the JPEG mode Save for Web dialog you can set zone optimized levels of compression based on the text layer/vector layer content or an alpha channel stored in the master document (see Figure 15.10), so that areas of important detail can have less JPEG compression applied to them. You can adjust the sliders to establish the range of JPEG compression from the total mask to no mask areas, and vary the softness of this transition. In Figure 15.10, the All Text Layers option is checked and you can see a preview of the mask based on the text layer in the Modify Quality settings dialog. A higher quality JPEG

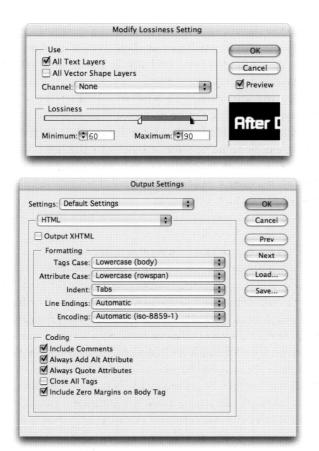

compression will therefore be applied to the text in the final JPEG output. In the Save for Web GIF format mode (discussed next), an alpha channel can also be used to zone optimize the color reduction and modify the dither settings.

The Save for Web dialog lets you save as: HTML and Images, Images only, or HTML only. The output settings let you determine the various characteristics of the Save for Web output files such as: the default naming structure of the image files and slices; the HTML coding layout; and whether you wish to save a background file to an HTML page output. Figure 15.9 shows an example of a temporary document window generated with the HTML code generated by Save for Web along with the HTML code in the format specified in the output settings. **Figure 15.10** The Save for Web interface. Click on the button next to the Quality setting to open the Modify Quality Setting dialog. This will allow you to use an alpha channel to zone optimize the JPEG compression range or as shown above you can check the All Text Layers box to apply a higher quality compression setting to the text areas and a lower compression to the remaining image.

Figure 15.11 The HTML section of the Optimize Settings found in the Save for Web dialog. Other menu options include Background, Saving, and Slices. Click on the Generate CSS button to create cascading style sheets based on the current image slicing.

Figure 15.12 From the Optimize menu you can open the Optimize To File Size dialog and specify the optimum number of kilobytes you want the file to compress to.

The Image Size options are fairly similar to those found in the Image \Rightarrow Image Size dialog box. Just simply enter a new percentage to scale the image to and check what impact this will have on the file size (this will change the file size in all the optimized windows). An alternative approach is to select Optimize To File Size from the Optimize menu (see Figure 15.12). Use this to target the optimized file to match a specific kilobyte file size output and if you wish have Photoshop automatically determine whether it is better to save as a GIF or JPEG.

GIF Save for Web

The GIF Save for Web options are also very extensive. You have the same control over the image size and you can preview how the resulting GIF will appear on other operating systems and browsers – the remaining options all deal with the compression, transparency and color table settings that are specific to the GIF format. The choice of color reduction algorithms will allow you to select the most suitable 256 maximum color palette to save the GIF in. This includes the 8-bit palettes for the Macintosh and Windows systems. These are fine for platform specific work, but such GIF files may display differently on the other system's palette. The Web palette contains the 216 colors common to both platforms and is therefore a good choice for web publishing if viewers are limited to looking at the image on an 8-bit color monitor display. Now to be honest, restricting your colors to a Web palette should not really be that necessary these days, but the option is still there. However, the Web Snap slider will let you modify the Color table by selecting those colors that are close to being 'browser safe' and making them snap to these precise color values. The Web Snap slider determines the amount of tolerance and you can see the composition of the Color table being transformed as you make an adjustment. The Interlace option will add slightly to the file size, but is worth selecting – the image will appear to download progressively in slices. The Perceptual setting produces a customized table with colors to which the eye is

Figure 15.13 The Save for Web interface showing GIF settings.

Design: Rod Wynne-Powell.

more sensitive. The default Selective setting is similar to the Perceptual table, but more orientated to the selection of web safe colors. This is perhaps the best compromise solution to opt for now as even the most basic PC setup sold these days is well able to display 24-bit color. The Adaptive table palette samples the colors which most commonly recur in the image. In an image with a limited color range, this type of palette can produce the smoothest representation using a limited number of colors.

Adobe Photoshop CS2 for Photographers

Figure 15.14 The color table with Color palette fly-out menu shown.

A: Maps the selected color to transparency.

B: Shifts/unshifts selected colors to the Web palette.

C: Locks the color to the palette to avoid deletion.

D: Adds a eyedropper-selected color to the palette

The Lossy option allows you to reduce the GIF file size by introducing file compression. This can be helpful if you have an overlarge GIF file. But too much compression will noticeably degrade the image until it looks like a badly tuned TV screen. The diffusion dithering algorithm is effective at creating the impression of greater color depth and reducing any image banding and the Dither slider allows you to control the amount of diffusion dithering. The Pattern and Noise options have no dither control. If the image to be saved has a transparent background, the Transparency option can be kept checked in order to preserve the image transparency in the saved GIF. To introduce transparency in an image you can select the color to make transparent using the evedropper tool and then click inside the image preview area. The color chosen will appear selected in the color table. Select one or more colors and click on the Map Selected Colors to Transparent button in the Color table. You can apply a diffusion, pattern or noise dither to the transparent areas, which will help create a smoother transparent blend in your GIF.

ZoomView Export

The ZoomView plug-in is made by Viewpoint: www. viewpoint.com. There is a ZoomView Export option in the File menu with which you can create an output folder containing all the necessary components to produce a zoomable image web page. Visitors to these pages will need to have installed the freeware Viewpoint Media Player (VMP) which is compatible with many (but not all) web browsers. The ZoomView format is ideal for portfolio presentations and commerce websites, where customers can easily view large images in close-up, downloading these views as tiled JPEGs.

Viewpoint ZoomView¹⁴

 Template:
 Plain

 Output Location
 Cancel

 Folder....
 Base Name (ED030137

 Base Name (ED030137
 Load...

 Path To Broadcast License File
 URL:

 Image Tile Options
 Get License

 Tile Size:
 128 @ 256

 Quality:
 Bight 40

 small file
 upp file

 Stowster Options
 Width:

 Width:
 1000

 Ø Optimize Tables
 Forware

 Ø Optimize Tables
 Monoster for a trademark of Viewpoint Corporation. Plase and the monotime or to date: a trademark of Viewpoint Corporation. Plase and the monotime or to date: a trademark of Viewpoint Corporation. Plase and the monotime or to date: a trademark of Viewpoint Corporation. Plase and the monotime or to date: a trademark of Viewpoint Corporation. Plase and the monotime or to date: a trademark of Viewpoint Corporation. Plase and the monotime or to date: a trademark of Viewpoint.

Figure 15.15 Here is the ZoomView Export dialog box. The output will be a folder that contains all the necessary components to display a zoomable image. Once created, all you have to do is upload the folder to your website and add /foldername/basename.htm/ to the usual URL weblink (note that the Base Name is based on the image's file name). Visitors to your website will be reminded that they must have a Viewpoint Media Player plug-in installed for their web browser in order to see ZoomView images (unless it is already installed). Once the page has been accessed, visitors can left mouse-click on an area of interest to zoom in and *errol* right mouse-click to zoom out. Licensing is free for non-commercial purposes. Commercial users must pay a license fee to Viewpoint.

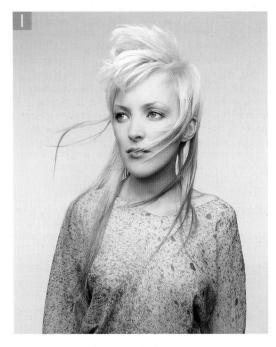

2 Before adding a copyright symbol, choose Rulers from the View menu, double-click either ruler and set the ruler units to Percentage. Drag two guides out to intersect at 50%. Now select the type tool, choose centered type alignment and click on the center point. Nearly all typefaces will produce a copyright symbol when you type **C** *ctr alt C*. To adjust the font size use Edit ⇒ Free Transform and hold down the **C** *alt* key and drag a corner handle to enlarge from the center, then click OK.

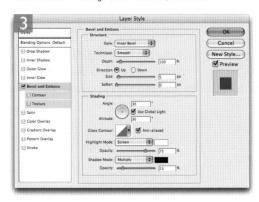

Adding a copyright watermark

1 The following steps are based on a tutorial I wrote a few years ago for PEI magazine, which showed you how to add a copyright symbol as a watermark. It is worth reproducing the tutorial here because it illustrates an approach to watermarking images that makes use of the limited security features of the Adobe Acrobat PDF format.

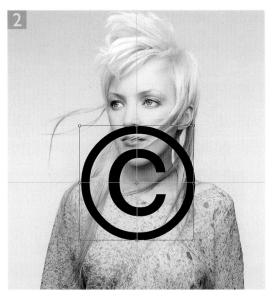

3 You could at this point choose Layer \Rightarrow Type \Rightarrow Convert to Shape. This will save the copyright symbol as a custom shape saved to the Shapes presets folder, where it can easily be accessed again for future use. It does not really matter about the color of the type at this stage. Go to the Layers palette and set the Fill opacity to zero percent. The logo disappears. But if you add an effects layer such as Bevel and Emboss, the effect will become visible. The only adjustment I made in the Layer Style dialog was to reduce the Multiply opacity to 15%.

Layers			
Normal		Opacity:	50%
Lock:]/40	Fill:	ж 🕨
	6		9-
	Effects Bevel ar	nd Emboss	
•	8ackground		6
88 1	0. 0 0.		3/

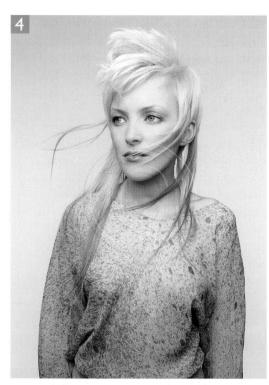

Client: Rainbow Room. Model: Greta at FM.

4 If you follow my advice about saving the copyright symbol as a custom shape, you can quite easily record a Photoshop action using the steps described so far. But you could consider loading the copyright symbol as a custom shape rather than typing it in. This way, you can record an action that will always produce a correctly scaled symbol regardless of the image pixel dimensions.

Lastly, I saved the image as a PDF using the PDF security options to make the image password protected. To open the image in Photoshop, the recipient will need to know the relevant passwords. Once a user has successfully entered a password they will see the image in its layered form and can delete the watermark layer. Other copies made from this master file can serve as proof copies for use in page layouts or as a JPEG version on a website.

Adobe PDF Preset:	[[High Quality Print]] (Modified)		10		
Standard:	None Compat	ibility: Acrobat 5 (PDF 1.4)	10		
General	Security				
Compression Output	Encryption Level: High (128-bit RC4) - Comp	atible with Acrobat 5 and Later			
Security	- Document Open Password				
Summary	Require a password to open the docume	nt			
	Document Open Password:				
		ng and other tasks missions Password: ****** In the document in PDF editing applications.			
	Printing Allowed:	Low Resolution (150 dpl)			
	Changes Allowed:	None			
	Enable copying of text, images and otl Enable text access of screen reader de Enable plaintext metadata				

PNG (Portable Network Graphics)

This file format can be used for the display and distribution of RGB color files online and also available as a file format option in Save for Web. PNG (pronounced 'ping') features improved image compression and enables alpha mask channels (for creating transparency) to be saved with the image. Other advantages over JPEG and GIF are higher color bit depths, support for channels and limited built-in gamma correction recognition, so you can view an image at the gamma setting intended for your monitor. Newer versions of Netscape Navigator and Microsoft Internet Explorer web browsers will support the PNG format, as does Apple's Safari web browser program.

Adding type and Photoshop actions

When you record an action that includes adding a type layer, you will want to include recording a step in which you go to the Image ⇒ Image Size dialog, and set the resolution of the image to a pre-determined pixel resolution (with the Resample image box left unchecked), before you record adding a type layer. This will ensure that the type size is applied consistently.

Web Photo Gallery

The Web Photo Gallery feature can be used to process a folder of images and automatically generate all the HTML code needed to build a website complete with thumbnail images, individual gallery pages and navigable link buttons. This Photoshop feature can save you many hours of repetitious work. I use the Web Photo Gallery all the time, and it is an essential tool in my daily production workflow. Imagine you have a set of Photoshop images that need forwarding to a client or colleague. When you build a self-contained web photo gallery in Photoshop, the processed images and HTML pages are output to a destination folder. You can then upload this processed folder to your web server and simply pass the URL link on to the person who needs to see the photographs. For a quick reminder of how to do this, refer back to Figure 15.1. Drag the Web Photo Gallery processed folder across to the Server window and pass on the URL link via email. In the Figure 15.17 example, I decided to call the destination folder 'i3forum' and place it inside a folder called 'portraits' on my server. I therefore appended '/portraits/ i3forum/' to my normal website URL as the full URL for the recipient to follow. It is necessary to add a forward slash at the end of the URL link, because this indicates that 'i3forum' is a folder containing a directory of files, but there is no need to add 'index.htm' after the forward slash because a web browser will by default always look for a file called 'index.htm' or 'index.html'.

The source can be any folder of images, regardless of whether they are in RGB or CMYK color mode. But if it is a really critical job, you might wish to make duplicates of all the source images and convert these to sRGB color first. You can also access the Photoshop Web Photo Gallery directly from the Tools menu in Bridge. For example, you can make a selection of images within Bridge and use: Tools \Rightarrow Photoshop \Rightarrow Web Photo Gallery to create a gallery based on your selection. The image order can be changed by simply dragging the thumbnails in the Bridge window. When the Include all Subfolders box is checked

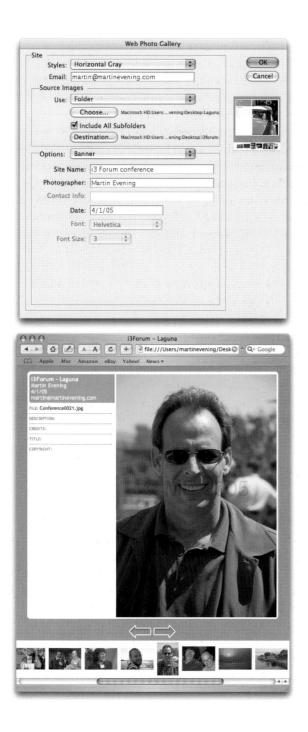

Figure 15.16 The Photoshop Web Photo Gallery will let you save extra information such as contact details and an active link to your email address. The security feature will enable you to apply a visible watermark to the gallery images that are created. This can be based on file data such as the file name, caption information, or alternatively you can enter some customized text.

Figure 15.17 Once the web gallery has been completed, it will automatically launch the completed pages in your default web browser, so you can preview the resulting pages offline before uploading them to the server.

i3 Forum

The i3 Forum is a unique conference where leading figures from the world of digital imaging working in 2D, 3D design and movie making, including software engineers, authors and artists, gather together to share new ideas. To find out more, visit: www.i3forum.com.

Designing your own templates

If you want to be really adventurous, then search the Adobe Photoshop Help database for information listed under: Customizing Web Photo Gallery Styles and using tokens in Web Photo Gallery styles. This will provide tips and instructions on how to write the HTML code from scratch. After you have completed the template output folder, you can further enhance the appearance of your gallery pages by importing them into a separate website editing program such as Adobe GoLive. the subsets of folders can be processed too. It is not essential that you resize them to the exact viewing size, as the Web Photo Gallery options allow you to precisely scale the gallery images and thumbnails down in size while they are being processed.

There are now a choice of 20 template styles to choose from in Photoshop CS2, a few of which are shown in Figure 15.18. Some of these templates have a simple HTML table design, while others utilize frames and basic JavaScript. These gallery styles can be customized to some extent by adjusting the Options settings, as described on the following pages. Because these templates vary a lot in their design, not all of the options settings will be recognized when you come to build a gallery. If you process a folder of images and are not sure about the look of the chosen layout, then try adjusting the Options settings or selecting an alternative Web Photo Gallery style. It is worth pointing out that if you have to redo a Web Photo Gallery because the banner title was incorrect or you want to change the contact details, make sure the 'Add Width and Height Attributes for Images' option is checked in the General settings. Photoshop will not need to reprocess all the image data and will instead recode the HTML. After a web gallery has been processed the settings used will be remembered the next time you use the Web Photo Gallery.

You can also create your own layout templates. Go to the Photoshop CS2/Presets/Web Photo Gallery folder and use the folders in there as a guide for designing your own customized HTML templates. One easy way of doing this is to make a copy of an existing WPG template, take a peek inside the template's images folder and open the various graphic elements in Photoshop. You can then create your own alternative graphic designs for things like the buttons and background patterns and save these, overwriting the previous image files, using the exact same file names. Give the modified template a new name and the next time you run the WPG, it will appear in the Styles pop-up menu.

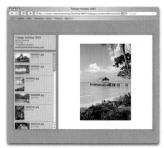

Centered Frame 1 Basic

Centered Frame 2 Feedback

Horizontal Feedback

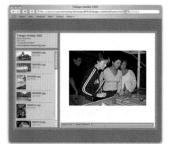

Centered Frame 1 Feedback

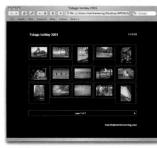

Dotted Border - White on Black

Horizontal Neutral

Figure 15.18 This shows you a few examples of the Web Photo Gallery templates in Photoshop CS2. These screen shots will give you a better impression of what the individual templates will look like rather than the tiny thumbnail displayed in the Web Photo Gallery dialog. These pages were mostly created using the default Web Photo Gallery color settings, so there is plenty of scope for you to produce your own customized Web Photo Gallery pages. The feedback templates allow visitors to mark favorite images, submit comments on individual photographs and send these back to you in the form of an email.

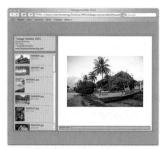

Centered Frame 1 Info Only

 $\mathsf{Flash}-\mathsf{Gallery}\ 2$

Horizontal Slideshow

Table 2

General

The Use UTF 8 Encoding option will apply to the URL only. If the Add Width and Height Attributes for Images is checked, Photoshop will be forced to reprocess every image every time you regenerate a web photo gallery, even if all you do is to change the Banner title. I prefer to uncheck this option. The Preserve all metadata option will ensure that the metadata is not stripped out of the image files you create, but at the expense of making the gallery images bigger in size.

Options:	General
Extension:	(.htm 🛟
	Use UTF 8 Encoding for URL Add Width and Height Attributes for Images
	Preserve all metadata

Banner

Enter the name of your site in the Site Name field. The text entered here will appear in both the title bar and as a bold heading on the gallery pages. Type your name below, or to be more specific type something like 'Photography by:' followed by your name. Type in your contact details below, although only the Centered Frame, Horizontal Feedback and Horizontal Slideshow templates will use this data. Today's date will automatically appear in the Date Field and lastly you can customize the font type and font size used.

Site Name:	i3 Forum conference
Photographer:	Martin Evening
Contact Info:	
Date:	4/1/05
Font:	Helvetica 🛟
Font Size:	3

Large Images

This lets you control the size and appearance of the main gallery images. You can determine whether the images need to be resized or not, the pixel dimension limits and the JPEG quality setting to use. Plus you can specify the number of pixels to add as a border. Many of the templates are capable of displaying image file metadata such as the Description (used to be Caption) and Copyright metadata. If the checkbox is enabled (and checked), this information is capable of appearing alongside or underneath each gallery image.

Options: Large Ir	nages		
Add Numeric Li	nks		
Resize Images:	Custom	500	pixels
Constrain:	Both	•	-
JPEG Quality:	Medium	5	7
File Size:	small	lar	ge
Border Size:	0 pixels		
Titles Use:	Filename Description Credits		tle opyright
Font:	Helvetica	۵)	

Size:	Large	•	100	pixels
Columns:	5	Rows:	3]
Border Size:	0	pixels		
Titles Use:	🗌 Des	name cription	Co	le pyright
	C.	dian		
Font:	Cre	dits etica 🛟		
Font: Font Size:	Helv			

Options: Custom Colors

Text:

Link:

Background:

Thumbnails

The thumbnails are smaller versions of the main image files that are used as a visual aid to navigation. The thumbnail size and appearance can be adjusted to suit your requirements. Obviously, the smaller the thumbnail size, the faster the gallery pages will load. Although there is a range of title options, you can normally have only the file name appear beneath a thumbnail.

Custom Colors

\$

Banner:

Active Link:

Visited Link:

The Web Photo Gallery templates mostly use neutral color schemes. If you want to go more colorful, you can choose any colors you like for the background, banner headers and text. The link colors can also be changed so that they override the default colors used in some of the templates.

Custom Text: Font:	© ME 2005	
Font	and the second s	
FOIL.	Helvetica	•
Font Size:	36 pt 💌	
Color:	Black	Opacity: 10 P
Position:	Centered	
Rotate:	None	•
Rotate:	None	•

Security

These settings let you place watermarks on the gallery images. If you select the Copyright setting, any copyright notice contained in the IPTC file info will automatically be used to watermark the image. Or you can select another type of text source from the Content pop-up menu, or enter custom text. Choosing the right font size will depend on the pixel width dimensions of your gallery images. A little testing is usually required here. If you check out the sample gallery page I created, the copyright notice opacity was set to 10%.

Client feedback

Clients can use the feedback gallery interfaces to make image selections, add comments even and forward these as an email. At present, only the file names are used in the email to reference the selected photos, but the system still works a lot better than having someone write the image file names or model details down by hand and call you up on the telephone with their comments.

Information and feedback

The feedback Web Photo Gallery templates utilize a JavaScript which means that once a gallery has been built and uploaded to your server, visitors can use the website to send feedback comments back to you. For this to work you must remember to enter your email address in the main Web Photo Gallery dialog (see Figure 15.16). Whenever I conduct a model casting, I take digital shots and input the model's name and agency in the Description field of the IPTC Metadata pane in Bridge. This metadata information is then automatically stored in either the file header or an .xmp sidecar file. When I build a Web Photo Gallery and check the Description box under the options for Large Images, the model name and information will appear alongside each image in the final gallery.

	Feedback from Jane Mitchell
5 (Send Chat At	A Contraction A Contraction Address Fonts Colors Save As Draft
To:	Martin Evening 🔊
	edback from Jane Mitchell
_F2F0451.jpg ~ Approved ~~	-
Comments: Definitely the lo	bok we are going for. Check sizes with the Stylist
D4AT1140.jpg - Approved	
Comments: Can you check	to see if free on the 21st ~~
D4AT7410.jpg - Approved	ANY
D4AT2971.jpg Approved ~~	
Comments: Will be free to s	shoot on both dates. ~~~
D4AT2934.jpg Approved ~~~	
*********	ANY

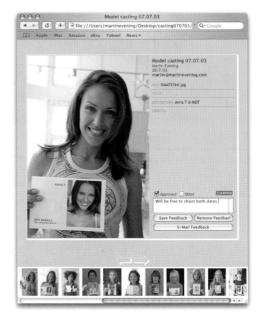

Figure 15.19 Here is an example of a Web Photo Gallery created using one of the Feedback templates. I find these templates to be particularly useful when posting a collection of photographs taken from a model casting, or when I want to show a set of retouched photographs that require comments from a client. In this example, a client can visit my web gallery page, make a selection of the approved models, add a few comments and click on the Save Feedback button. Sending these comments as an email couldn't be simpler. All the client has to do is click on the Email Feedback button and enter their name. After that, Photoshop will launch the default email program and complete the email. All the client has to then do is click 'Send'.

Chapt Output for the

Adobe ImageReady CS2

Adobe ImageReady CS2 is bundled with Adobe Photoshop CS2. This supplementary program primarily meets the needs of web designers who use Photoshop. And PSD documents created for the Web in Photoshop or ImageReady can integrate better with Adobe GoLive (you can output GoLive compatible HTML code or drop PSD files directly into GoLive). I have provided information in this book that is mainly about the photographic uses of Photoshop and web design is really a separate skill. Nevertheless, ImageReady deserves a brief mention here because it is still an important component of the Photoshop program.

Figure 15.20 The ImageReady CS2 Tools palette, showing the keyboard shortcuts. Note that the Tools palette fly-outs can be torn off and converted into stand-alone palettes.

The ImageReady interface

Many of the ImageReady features and tools are identical to those found in Photoshop and Figure 15.20 provides you with an overview of the Tools palette layout and the keyboard shortcuts. ImageReady-specific options include: the ability to add image maps; toggle the visibility of image maps; a rollover preview; toggle slice visibility; and preview in a default web browser. And there are palettes in ImageReady designed to aid the management of a website and building things like rollovers and animations.

ImageReady layers

You can add layers in ImageReady just as you do in Photoshop. The layer features are shared between the two programs, so when you transfer a Photoshop image into ImageReady, all the layers, layer masks and layer effects will be preserved. You can add as many layers as you want and organize these using layer sets and the new Layer Comp palette feature. While adjustment layers can only be edited in Photoshop, the adjustment will be previewed in ImageReady. Gradient map and fill layers can be edited though. Using layers in ImageReady, you can construct a sophisticated web page with dynamic content such as rollover buttons and animations, which in turn can be linked, because the HTML code associated to the images can be generated upon saving.

Jump to application

When you click on the Jump to button at the bottom of the Tools palette you are able to switch the editing of a document between two different editing programs. The Jump to command from Photoshop will enable you to switch to editing in ImageReady or (if specified) any another Adobe Creative Suite program. The Jump to command in ImageReady will also allow you to switch between other HTML editing programs, such as Adobe GoLive. To specify additional programs to jump to, place an alias of the application (Mac) or shortcut (PC) in the Adobe Photoshop $CS2 \Rightarrow$ Helpers \Rightarrow Jump To Graphics Editor folder. Place curly brackets ({}) around an application to jump to from Photoshop and straight brackets ([]) around an application to jump to from ImageReady. In ImageReady CS2 you can choose either File \Rightarrow Jump to \Rightarrow Graphics Editor or File \Rightarrow Jump to \Rightarrow HTML Editor. The auto-updating of documents between the separate applications will happen in the background. This means that the jump tos between ImageReady and Photoshop are relatively smooth and fast. The image is displayed in each program in its own document window and the window preview will be dimmed in whichever application is inactive.

Image slicing

Slicing an image is a further example of how you can use Photoshop and ImageReady in tandem to create and design dynamic web pages that will download efficiently and also produce HTML output files that can be further edited in a program like Adobe GoLive CS2. Slicing makes it easy to specify what type of content will appear in a slice and how the image content in a slice shall be optimized.

Select the slice tool and you will notice the first slice (01) is assigned to the entire image. There are several ways to slice an image. Choose Slice \Rightarrow Divide Slice(s) and this will open a dialog box allowing you to divide an existing slice vertically or horizontally. This is perhaps only useful where slice symmetry is vital. When you drag

Figure 15.21 This layered image was created in Photoshop and contains shape button layers, type layers and image content layers. The image was sliced up using the Slice tool and brought into ImageReady. The Web Content palette provides a display of the web content, such as the rollover down states associated with each slice. In this example, we can see the expanded view of the Salons button, showing the 'Over' button state.

with the slice tool inside the document, you are creating what is known as a 'user-slice'. As you add a user-slice, 'auto-slices' are automatically generated every time you add or edit a user-slice. User-slices can be created by dragging with the slice tool, but they can also be based on a selection, layer bounds (Layer \Rightarrow Create Slice From Layer), or guides (Slices \Rightarrow Create Slices From Guides). Note that when you create a user-slice from a layer, the slice will automatically adjust to any changes made to the layer, such as when you add an outer glow layer effect.

You can modify a slice by selecting the slice select tool and clicking on the slice you wish to edit (all slices but the active slice will appear dimmed) and using *Shift*-click to select multiple slices. You can also use the slice select tool to move a slice or resize it by dragging on one of the corner

Compression options

Different compression or format options can be applied to individual slices such that areas where image detail matters most, less JPEG compression is applied.

Linked slices

Linking slices allows you to share the optimization settings between linked slices, choose Link Slices from the Slices menu.

D	1111		D	1	1
	Π	-			
					۴
				٨	
					1

handles. A solid line border indicates that it is a user-slice and a dotted line that it is an auto-slice. It is possible to promote auto-slices to user-slices (Slices \Rightarrow Promote To User-Slice). Doing so will prevent it from being altered whenever a regeneration takes place. Slices can also be merged together by choosing Slices \Rightarrow Combine Slices.

Slice content and optimization

The default behavior when slicing images is to create image content slices; however, you can create no-image slices that can have text or even solid color fills. The Background Color option will fill a no-image slice with a solid color or fill the transparent areas of an image content slice. No-image slices can also be created within the Save for Web dialog in Photoshop. HTML text can be added to a no-image type content slice via the Slice palette text box. A URL web link can also be added in the Slice palette URL text box. These slice content modifications cannot be seen directly in the ImageReady document window, so you will only be able to preview these in a web browser or other web page editing program.

The ImageReady Optimize controls can be accessed at any time via the Optimize palette and the normal image window layout can be changed to show the optimized version, 2-up or 4-up displays. When working with the

Figure 15.22 This is an ImageReady document that has a button shape layer to which a rollover style has been added from the Styles palette. If you look at the Layers palette you can see the list of effects that have been added and in the Web Content palette you can see that these are the effects that will be used to generate the Standard rollover image state. If the Down state in the Web Content palette is selected, a different set of effects will be used to generate the down state version of this button.

optimized display, the optimized version will want to regenerate a new preview after each editing action. To stop this happening you can deselect the Auto Regenerate option in the Optimize palette fly-out menu. If you do this, after the image is modified, a small warning triangle ((A)) will appear in the bottom right corner. To manually regenerate an optimized view, click on this warning symbol.

Animation

Both Photoshop CS2 and ImageReady can also be used to construct self-contained animated image files, such as animated GIFs or Quicktime movies which can be incorporated into a web page or multimedia presentation. As with rollovers, animations are created by moving and modifying the layers in an image and the animation steps are controlled by the Animation palette. To add a frame, click on the New Frame button (you should always edit the animation frames using the original view, not optimized). You can modify various aspects of the image document such as color, layer opacity or the position of a layer for each frame. Now edit the frames by selecting them in the Animation palette and making adjustments. *Shift*-click to select contiguous frames, **(H)** *ctrl*-click to select discontiguous frames.

After you have produced a sequence of frames, you can then alter the time delay between each. The tweening feature will automatically add extra in-between frames and is a simple method with which to produce smoother looking animations. Tweening can be applied to individual frames or all frames and it can also be applied to specific animation layers only and/or can be applied to specific layer attributes such as layer position, opacity and layer effects. Frames can easily be reordered by dragging within the palette. They can be copied and pasted using the Animation palette fly-out menu to copy and paste frames. Click the Animation palette Play button to preview the completed animation, or use the File \Rightarrow Preview In Command to preview them in a web browser program.

Figure 15.23 When the document preview tool is selected in the Tools palette, you can hover the mouse over the rollover buttons and mouse down, to preview how they will respond to mouse behavior in the final web page design.

1 This is a logo that I designed for the Pixel Genius PhotoKit Sharpener plug-in for Photoshop. The master document was designed as a page layout graphic. I made a duplicate, smaller version that retained the original layers and could be modified to produce an animated GIF.

2 This was a complicated animation to produce, as it contained a total of 13 frames that showed the magnifying glass move from left to right across the 'Sharpener' logo lettering. In the final animation, as the glass moves over the blurred letters they are magnified by the lens and brought into focus. Here you can see the Layers palette with the prepared layers of the various magnified lettering stages organized into separate layer sets. But notice also how the Layers palette displays the frame unify controls whenever the Animation palette is open in Photoshop.

3	0			
24	er Comps			
	Last Document State			
	Layer Comp 1			
_	Layer Comp 2			
	Layer Comp 3			
	Layer Comp 4			
	Layer Comp 5			
	Layer Comp 6			
—	Layer Comp 7			
-	Layer Comp 8			
	Layer Comp 9			
	Layer Comp 10			
	Layer Comp 11			
	Laver Comp 12			
	Layer Comp 13			

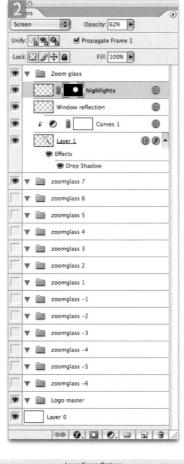

Name: Layer Comp 11	ОК
Apply To Layers: 🗹 Visibility	Cancel
Position	
Appearance (Layer Style	
Comment:	

3 To create the individual animation frames, I needed to display one layer set at a time and simultaneously move the magnifying glass in register. The Layer Comps palette is ideally suited for this type of task since it allows you to effectively take snapshots of different layer arrangement layouts in a single document and recall these later.

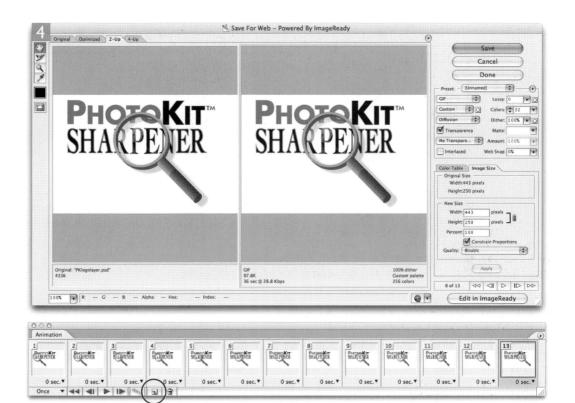

4 I then chose File \Rightarrow Save for Web... By selecting the 2-up display mode, we can see the original and optimized documents next to each other and make decisions about the ideal GIF output settings. I then went to the View menu and brought the Animation palette into view. I clicked on the 'Layer comp 1' icon in the left-most palette column (click on the layer comp icon, not the layer comp name) to display the magnifying glass on the left. This established the start frame. I then clicked on the Add Animation frame button (circled) in the Animation palette to add a new frame and selected the Layer 2 comp. This created the second frame and so on, until all the layer comps had been used to create all 13 animation frames. Once this exercise has been completed the animation can be tested by clicking on the Play button in the Animation palette. If a frame requires any editing, just select it and the corresponding Layer Comp will also be selected and you can then modify the layer arrangement and possibly the selected layer content as well, so long as changing the layer content changes a layer that is only visible when this frame is active. When your work is complete, the animation can be saved as an animated GIF or jump to ImageReady and choose Export to create a Macromedia Flash movie.

Chapter 16

Image Management

ne of the consequences of working with digital images in Photoshop is that you will soon find yourself struggling to cope with an ever-growing collection of image files, which if you are not careful will consume all the remaining space on your computer's hard disk. Most people find it necessary to store their image files on separate CD or DVD disks. And the smart photographers will take care to catalog these disks and possibly create an image library database, so that pictures can be organized by categories and retrieved more quickly.

I know of a photographer who was asked to 'go digital' by his main client. So he bought all the necessary kit, investing a small fortune in digital hardware. However, after a few months, the client said he wanted to go back to the old days, when he had piles of pictures to flip through. This was all because the client had a hard time tracking down specific images from the growing pile of CD-ROMs. This anecdote highlights a great potential weakness in professional digital capture workflow. If you don't manage your images efficiently, you will find it incredibly difficult to track them down later from your growing digital archives. Sifting through a disorganized pile of film images is not an ideal solution either of course, but at the end of the day, the pictures must be archived. But the argument can be made that once you do put in the effort to archive and manage your digital files properly, the rewards are great, and you will find you can retrieve your pictures far more easily, using varied search criteria, than you can using a conventional film-based archive.

If you are looking for a sophisticated archival retrieval system then consider purchasing an image database program. There are several popular programs that you can buy and I will be discussing these later, but the Bridge program that comes with Photoshop CS2 now boasts a number of powerful new features with which to manage your image files.

The Bridge program

To launch Bridge you need to click on the Go to Bridge button icon which is always present in the Photoshop CS2 Options bar palette. Clicking this button will launch Bridge and open a window displaying the contents of the folder you last visited, like the view shown in Figure 16.1. You can also launch Bridge by choosing File \Rightarrow Browse... and also by using the $\textcircled{} \bigcirc \emph{ottl} \emph{alt} \bigcirc$ or $\textcircled{} \bigcirc \emph{ctrl} \emph{Shift} \bigcirc$ shortcuts. To open an image, simply double-click the thumbnail or image preview in a Bridge window and the image will open in Photoshop. If you want the Bridge window to close as you open the image, then hold down the $\fbox{} @ \emph{alt}$ key as you doubleclick. Now if you refer back to the chapter on image capture and the section on pages 434–439, you will note how opening Camera Raw files can vary depending on how

Keeping track of your data

If you use a computer regularly you will already appreciate the importance of keeping track of all your office work files by saving things to their correct folders just as you would keep everything tidy inside the filing cabinet. The task is made slightly easier on the computer inasmuch as it is possible to contain all your word processing documents on the one drive (and a single backup drive). Digital files are by comparison too large to store on a single disk and need to be archived on many separate disks or tapes. One disk looks pretty much like another and without diligent marking, cataloging and storing, in a year or two it will take forever to trace a particular picture. I only have to look at my collection of video tapes to appreciate the wisdom of indexing - I know there are movie masterpieces in there somewhere, but am damned if I can find them when I want to.

Bridge and Camera Raw

Bridge integrates smoothly with the Adobe Camera Raw plug-in, to let you work directly with your raw image files within Photoshop (assuming the Camera Raw file format is one of those supported).

Return to Photoshop

The same command you use to go to Bridge, **H C** *O ctrl alt O*, can be used when you wish to return to Photoshop.

Adobe Photoshop CS2 for Photographers

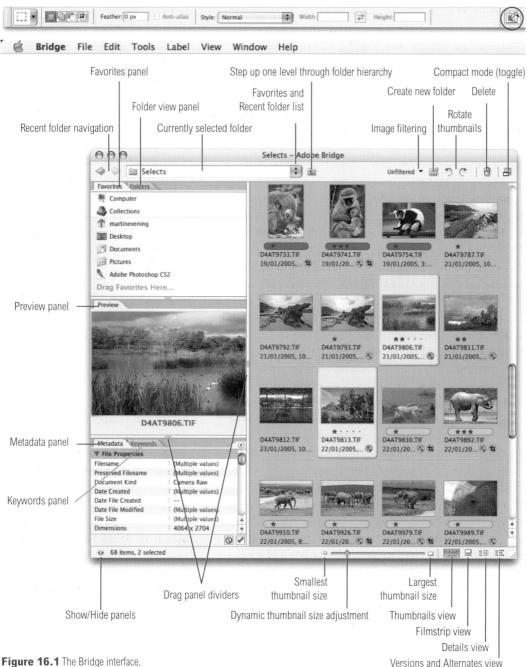

Versions and Alternates view

the preferences are configured. When you double-click on a raw camera file thumbnail, or multiple thumbnails in Bridge, this will normally open the image(s) via the Adobe Camera Raw dialog hosted in Photoshop. And if you go to the File menu in Bridge and choose Open in Camera Raw... (or use the $\mathbb{H} R$ *ctrl* R shortcut) the image(s) will open via the Camera Raw dialog hosted in Bridge. The subtle distinctions between which application hosts Adobe Camera Raw are elaborated in Chapter 11, and if you wish to refresh your memory, then I suggest you revisit those pages I mentioned. But essentially a double-click will open a raw file via the camera raw plug-in in Photoshop almost the same way as you did using the File Browser in Photoshop CS. And if you hold down the *Shift* key as you double-click, you can open a raw image by-passing the Camera Raw dialog.

If you have the entire Creative Suite installed on your computer, then you will be able to access the Bridge Center, which offers a potentially useful starting point from which to access recently opened images and folders. You can also create and access collections of images, and then there is the new Adobe Stock Photos library service from which you can search, access and purchase images online.

But let's now look at the Bridge program interface in more detail. The Bridge program menu will appear at the top of the screen and the main window interface controls are all itemized in Figure 16.1 on the page opposite.

Rotating the thumbnails and preview

You can apply 90° rotations via the rotate commands in the Bridge Edit menu or use the following keyboard shortcuts: **H**[*ctrl*] will rotate a thumbnail anti-clockwise and **H**[*ctrl*] will rotate a thumbnail clockwise. Alternatively, you could use the Rotate buttons at the top of the Bridge menu. Note that it is the thumbnail and preview images that are rotated, and that the rotation of the image only takes place when you come to open the image.

Bridge history

The File Browser made its first appearance in Photoshop 7.0. The File Browser in Photoshop CS addressed a lot of its earlier shortcomings. But the Bridge program that comes with Photoshop CS2 is now more like the tool we always wanted, and in my view is a compelling reason why a photographer should upgrade to Photoshop CS2. Bridge is like an open dialog on steroids. It is a central component of the Photoshop interface that allows you to guickly inspect and compare images at a full screen resolution, make picture selection edits, sort images using different criteria and conduct image searches based on things like the file name or metadata content (more of which later).

Open anything

Well almost anything... The key thing about Bridge is that it's an open dialog for all the programs in the Adobe Creative Suite. And you are not just limited to opening documents in the CS2 Adobe Suite. For example, Bridge is able open InDesign documents in InDesign CS. You can even open things like Word documents in the Word program via Bridge. And you can drag and drop documents from the Bridge window to an external folder or vice versa.

Deleting contents

The *Delete* button can be used to delete selected images. This action will remove the thumbnail from the Bridge window and send the original file to the Trash (Mac) or Recycle bin (PC). You need have no fear of deleting files in Bridge, as you cannot delete a file permanently from within Photoshop, this can only be effected by deleting the contents of the Trash (Mac)/Recycle bin (PC) at the operating system level. Also, you can only delete a folder that is empty, when you use the Delete button (the Trash can) within Bridge.

Figure 16.2 A Bridge window can be compacted by clicking on the Switch to Compact Mode button. The Bridge window will then shrink in size. Click on the button again to restore the window to the original view mode and size. If you click on the button to the left, you can compact a window to Ultra-Compact mode. Note that a Compact mode Bridge window will always remain in the foreground, in front of any documents or other programs, by default. This behavior can be altered via the compact Bridge fly-out menu, by deselecting 'Compact Window Always on Top'.

Arranging the Bridge contents

The Bridge window contains thumbnails in an expandable view area, which can be made to fill the full window, plus five tabbed panels. The contents can be customized to suit your individual requirements. If, for example, you want to use Bridge to make a picture edit selection, you can drag the browser window dividers so that the Folders, Keywords and Metadata panels are collapsed and the Preview panel is expanded to fill as much of the window area as possible. In Figure 16.3, the Preview panel has been expanded in this way. A customized arrangement like this will make it easier to check for small details when sorting through a large number of images in a folder, such as when you return from a location shoot and wish to create a short-list selection of pictures. You can also rearrange the thumbnails in the content area by dragging them with the mouse. This too makes the Bridge experience more analogous to editing slides on a lightbox.

My preferred way of working is to expand the preview panel as shown in Figure 16.3, to make it as big as possible. I then use the right and left keyboard arrow keys to progress forward or reverse through the image folder contents and if I see a picture I like, I then use the cumulative method of rating, described on page 621, to mark the shots I like the most and then use the image filtering menu to display the marked images only (personally, I rarely find the need to rate images any higher than three stars). The image filtering menu will then let me decide how to display these selections, such that one can choose to display all images with more than one star, more than two stars, and so on.

As you can see, the Bridge window is able to provide you with lots of information. One might say there is almost too much information displayed here. But you can customize the Bridge window layout to best suit the way you work, and save the layout as a Custom work space setting. Using the option to save a hotkey, you can switch quickly between work space settings.

Chapter 16 Image management

Figure 16.3 The panel arrangements within Bridge can all be customized to suit your own way of working. The thumbnails can be moved around within the content area (as indicated by the arrow), as if you were editing photographs on a lightbox. If you doubleclick on a panel tab, such as I have done here with the Metadata panel, this will collapse the panel, hiding its contents. The panel sizes can be adjusted by dragging on the vertical and horizontal dividers, and if you double-click on the divider bar (circled) you can toggle showing and hiding the left-hand panels. In this example, the Preview panel has been expanded so that we get to see a large preview of the selected thumbnails. Note that whenever you save a work space setting, you are also able to save a customized Bridge configuration.

Adding new folders

New folders can be added by choosing New Folder from the File menu in Bridge (# Shift N ctrl Shift N or ctrl right mouse-cliick in the Content area and choose New Folder from the contextual menu.

Name:	Workspace 1				Save
Keybo	ard Shortcut:	X +	None	•	Cancel

Figure 16.4 You can save a named Work space and assign it a keyboard shortcut.

Thumbnails only

You can use the **(B)** *ctrl keyboard* shortcut to toggle hiding and showing the text information that appears below the image thumbnails in the content area.

Customizing the panels and content area

But first, let's take a look at the way the Bridge window is structured. A Bridge window can be imagined as having two distinct zones. The panels are all contained in the area on the left (which I have colored pink in Figure 16.5 below). You can customize which panels are displayed by selecting or deselecting them via the View menu in Bridge. And within the panel area you can drag the dividers to adjust the respective heights of each panel.

The content area is on the right (which I have shaded blue) and this section of the Bridge window can be customized by selecting a view mode for the content area from the View mode, or by clicking on one of the corresponding View mode buttons at the bottom of the Bridge window. The combination of the panel area arrangement and the content area View mode can be saved as a combined work space setting.

Figure 16.5 A Bridge window can be imagined as having two distinct areas. The first is the panel area on the left (colored pink). Here you can customize which panels are displayed by selecting or deselecting them via the View menu in Bridge. And within the panel area you can drag the dividers to adjust the respective heights of each panel. The content area on the right (shaded blue) is used to display the contents of a folder that is selected in the Favorites or Folders panels.

Figure 16.6 The Details view mode displays the image thumbnails in a list, and this is accompanied with basic metadata information.

Figure 16.7 The filmstrip mode displays a large preview with a strip of thumbnails. You can click on the switch content button to switch from the default horizontal filmstrip mode to display using the vertical filmstrip mode shown here.

Custom work spaces

The preset workspace keyboard shortcuts range from **ℜ ctr/+F1** to **F5**. You can customize the Bridge layout to suit your own way of working, create your own custom work space settings and assign these shortcuts. Choose Window ⇒ Workspace ⇒ Save Workspace... The saved setting will then appear in the Workspace menu.

Selecting a Bridge work space

Photoshop CS2 ships with several preset work space settings that can be accessed by going to the Window ⇒ Workspace menu. The Lightbox and Filmstrip work spaces are illustrated in Figures 16.8–16.10. While in filmstrip mode you can switch between the vertical and horizontal display modes by clicking on the switch filmstrip orientation icon. These work spaces provide nice simplified Bridge layouts that are ideal for navigating images. The File Navigator and Metadata Focus work spaces incorporate the metadata and folder panel views and offer more focus on the folder navigation and file information data.

Figure 16.9 The horizontal filmstrip work space, which fills the window using the horizontal filmstrip view mode.

000		Selects - Adobe Bridge		
🗇 🌳 🛅 Selea	cts		Unfiltered	- 2 C 8 8
Favorites		* D4AT11026.TIF	D4AT101052.TIF	D4AT101053.TIF
ige Center		24/01/2005, 2:06:42 pm	23/01/2005, 10:32:25	23/01/2005, 10:32:34
Computer				25/01/2003/10.52.54
Adobe Stock Photo	DS .			and the provide state of the state of
Version Cue				
Collections		· ·	Landston and the second	and the second state of th
Metadata	=		1	BUTIER Carried
V Flie Properties			and the second second	AND ADDRESS AND ADDRESS ADDRES
Filename	D4AT101057.TIF		Contraction of the second s	11 (1) (1) (1)
Preserved Filename	D4AT10157.TIF	and all the state of the state of the	Provide States	
Document Kind	Camera Raw			
Date Created	23/01/2005, 10:32:53 am	D4AT1010506.TIF	D4AT101057.TIF	DSC00569JPG
Date File Created	:	23/01/2005, 10:32:50	23/01/2005, 10:32:53	08/01/2005, 1:22:46 pm
Date File Modified	23/01/2005, 10:33:00 am	10101110001 10:01100) 00/01/0003, 1101/10 pm
File Size	3.65 MB			
Dimensions	: 4064 x 2704			
Resolution	: 240 dpi	A Northern St. M. C.	m	
Rit Depth	16			A DECEMBER OF
	0		SH I	A STATE OF STATE
Keywords		·	565	
Assigned Keywords:		the second se	720_>	1.2.2
		we Create State of the		
▼ Agencies		DSC00588.JPG	* DSC00638.JPC	* testl.jpg
EM Models		08/01/2005, 1:32:36 pm	16/01/2005, 4:16:53 pm	20/01/2005, 9:43:30 am
4 69 items, 1 select	ted	0		
CONTRACTOR OF A DECEMBER OF A	No search y Charles I you and an a second	COLUMN TRANSPORTATION OF A DESCRIPTION O		CONTRACTOR OF TAXABLE PARTY IN CONTRACTOR OF TAXABLE PARTY.

Figure 16.10 The Metadata focus work space setting.

Working with multiple windows

Another big difference with Bridge is that you can have multiple window views open at once, which means you can now access more than one folder of images at a time, without having to use the Folders panel or window navigational buttons to navigate back and forth between different image collections. Having multiple windows also makes it easier to make comparative editing decisions when reviewing a collection of images (see Figure 16.11 below).

Figure 16.11 Bridge will let you to have multiple Bridge windows open at once. In the arrangement shown here, I pointed both windows at the same source folder of images. But I configured them differently so that the first window focused on displaying a favorite image nice and big in the Preview panel, while the second window was configured using the Filmstrip Focus preset work space (choose Window \Rightarrow Workspace \Rightarrow Filmstrip Focus or use **(File Configure)** with the filmstrip set to display vertically. I was then able to navigate through the image thumbnails and compare alternative shots with the one displayed in the first window.

The Bridge Slideshow feature could be considered a useful tool for making neat-looking presentations. But I think you will find that the Slideshow viewing mode offers a very suitable, clear interface in which to edit your pictures, devoid of all the clutter of the Bridge window. In Figure 16.12, the Bridge Slideshow is displayed within a window, but you can switch display modes to run it in full screen mode should you wish. What I love most is that you have access to all the usual image rating controls, so one can sit back to review and edit a collection of pictures and use just the arrow keys () to progress through the shots, and use the . key to increase the star rating and use the apostrophe key can be used to both add or subtract a rating.

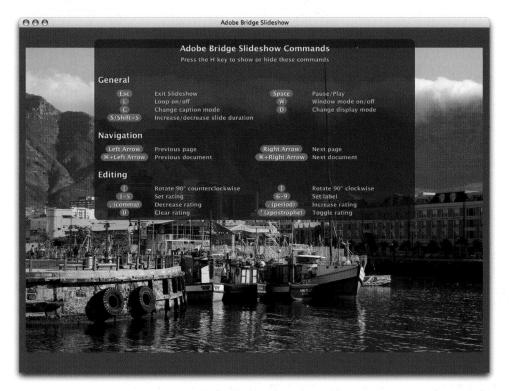

Figure 16.12 The Bridge window contents can be previewed in Slideshow mode by choosing View ⇒ Slideshow (第)(4) @//(4).

Figure 16.13 The Folders panel displays a complete list view of all the folders in your main hard drive and any mounted disks. Bridge will allow you to drag and drop folders with ease within the Content area and Folders panel areas, as well as drag directly to external folders.

Cache building routines

When you point Bridge at a folder of images it will speedily generate low-res thumbnails, and when that is done, a second pass will add higher resolution data.

Favorites		
	Computer	
Alla .	Collections	
3	Version Cue	
1	martinevening	
	Desktop	
Ē	Documents	
Ē	Pictures	
0	Adobe Photoshop CS2	
Dra	ag Favorites Here	

Figure 16.14 The Favorites panel contains a list of starting points to ease Bridge navigation. If you have installed the full Creative Suite, you will see an item called Bridge Center in this list.

Folders panel

The Folders panel displays a folder list view of the computer contents plus any other disks currently mounted. The Folders panel is used to navigate the folder hierarchy. Folders can be expanded or collapsed. Should a CD/DVD/external drive or other removable volume fail to appear, you may need to refresh the Folders panel contents which can be done by using the fly-out menu or *ctrl* right mouse-clicking and selecting 'Refresh', or by using the **F5** keyboard shortcut. When you highlight a folder in the Folders panel, all the files in that folder will be displayed as icons in the content area on the right. Note that Photoshop will only be able to create a preview of image files it already understands or has a file import plug-in for. As this is happening, Photoshop will write a folder cache of all the image thumbnails and previews, which will be stored in a central folder located on the hard disk. The saved cache will save time displaying the thumbnails whenever you revisit that folder. Incidentally, it can be considered advantageous to switch on the backward compatibility option in the main Photoshop Preferences, as this will speed up the writing of the thumbnail cache file. The cache options are in the Tools \Rightarrow Cache menu (see page 618). You can choose Export Cache, so that a cache is also saved in the same folder hierarchy. This is useful if you are preparing a folder of images to burn to a CD/ DVD disk, because the exported cache can then be read by another Photoshop CS2 user. If a disk contains a cache that was exported from Photoshop 7.0, Photoshop CS2 will be able to read it, but earlier versions of Photoshop will not be able to interpret Bridge cache files.

Favorites panel

The Favorites panel offers an alternative navigational starting point and it is usually nested behind the Folders panel. The items that appear in Favorites can be edited via the Bridge preferences and as you can see, you can add your own Favorites by dragging a folder over to the bottom of the Favorites list.

Keywords panel

Keywording provides a way of grouping and organizing images within Photoshop. On page 623 I demonstrate how the Find command could be used to locate all the models who were named Sarah from within a large collection of model casting photographs. But supposing we wanted to conduct a search restricted to looking for models belonging to a specific model agency? Or perhaps we might want to categorize photographs in other ways as well, separating them according to the location where they were shot? We can achieve all this by applying specific keywords to groups of images. Figure 16.15 shows the Keywords panel. To add new keywords, click inside an existing Keyword set or create a new one and then click on the New Keyword button at the bottom of the panel. To assign keywords to one or more images, you need to make your image thumbnail selection from within the Bridge and then go to the Keyword panel and click on the empty square to the left of the desired keyword to assign one or more keywords from a Keyword set. This will allow you to apply keywords to multiple images at once. Keywording can help you search and retrieve images and the keywords will also be recognized by other image database programs such as Adobe Photoshop Album (PC only).

Image metadata

Several times now, I have referred to the term 'metadata' in this chapter. Metadata is usually defined as being 'data about data'. The concept of metadata is one you should be quite familiar with. Librarians use metadata to classify and catalog books in a library. In the old days, one would be accustomed to using index cards to do a search by an author's name or by the book's title. Everything is now computerized of course and with a computerized system it is possible to record so much more information about a file and use this information to carry out sophisticated searches and cross-reference one file with another.

Figure 16.15 The Keywords panel can be used to assign keywords to one or more images at a time. It can also provide feedback on the keywords already assigned. In the example shown here I have highlighted an image and I can see that it has been assigned three keywords telling me that it is a model casting photograph, shot in London and that the model agency is called M&P.

Metadata everywhere

The most commonplace use of metadata these days is the Internet. Use a search engine and within a matter of seconds web links will appear on the screen. offering lots of suggestions for what vou are looking for. Web designers add metadata tags to the headers of websites to enable search engines to catalog them more effectively. Parents and schools use metadata to filter out the web content that children can access. MP3 players use metadata to categorize your music collections. Metadata is used in all sorts of ways and if anything, we seem to have too much metadata out there! Web search engines often offer you thousands of possible links, when you would rather have your choice narrowed down to a smaller selection. The trick is for distributors to provide metadata that is useful and for retrieval systems to intelligently sort through the metadata.

Figure 16.16 The File Info dialog is shown here displaying the Description information. To save you time when filling out the editable sections of File Info dialog, you can mouse down on the little fly-out menu buttons next to each field entry and select from a list of previously entered metadata entries.

File Info metadata

The File Info dialog shown in Figure 16.16 has been around since the early days of Photoshop, but until just recently, few people have bothered using it. The File Info dialog is designed to enable you to edit the image metadata relating to picture content. Photoshop has always supported the information standard developed by International Press Telecommunications Council (IPTC), which was designed to help classify and label images and text files using metadata. In previous versions of Photoshop, you could access the File Info via the File menu and use it to title an image, add the name of the author, add keywords and inspect the camera capture metadata. File Info is still in the Photoshop File menu, but can also now be accessed via the File menu in the Bridge, or by using the default keyboard shortcut: # Shift | ctrl alt Shift |. The File Info dialog will appear as a sheet that drops down from the title bar of the Bridge window containing the highlighted image. The File Info dialog contains seven sections, some of which are editable, such as the Description section shown in Figure 16.18, and some that provide information

-18	30	NEIT	tington-PR TIFFs - Adobe Bridge	6
1	Description	Description		
fo	Cemera Data 1 Camera Data 2 Categories History IPTC Contact IPTC Contact IPTC Contact IPTC Contact IPTC Status Adobe Stock Photos Origin Advanced	Document Title:	Remington	
		Author:	Martin Evening	
		Author Title:		•
		Description:	Remington PR shots	E
4				
		Description Writer:		
Not Loc Not Not Not Life		Keywords:	Fashion, PR, London	Travel South Afric
			1 Commas can be used to separate keywords	Elephants Gardens UK
1	1000	Copyright Status:	Copyrighted	London
Col Col Cre Cre Cre Cre Cre		Copyright Notice:	© Martin Evening 2004	Portraits
		Copyright Info URL:	www.martinevening.com	
			Co	To URL
ne re		Created: 20/8/0 Modified: 20/8/0		
18 18 63	xmp.	Application: Adobe Format: image/	Photoshop CS Macintosh tiff	
es TR			Cancel	ОК
C.)		01		
6	235 items, 1 selected (Get)	trg "DAD40478.22" preview)	o o	

only, such as the camera EXIF metadata. You can use File Info with single or multiple image selections to add your name as the author, mark the image(s) as being copyrighted, add a copyright notice and a URL to your website. Marking an image as being copyrighted in the File Info has the extra advantage of adding a copyright symbol to the title bar of your image window whenever it is opened in Photoshop by you or any other user who opens the image.

You can also configure the File Info to create a metadata template. One could begin by selecting an image and entering some basic custom metadata such as author name, copyright tag etc. and follow this by mousing down on the File Info fly-out menu and choosing Save Metadata Template... This template can then be used to apply your author details to images singly or in batches to other images, without having to keep typing in the same data over and over again. In the Figure 16.17 example I named the template 'London studio work' and clicked Save. Once I have saved a custom metadata template in this way, I can select other images and add or replace the metadata by making an image selection in a Bridge window and choose a pre-saved template from the Append Metadata or Replace Metadata in the Tools menu.

Interpreting the metadata

Metadata comes in many forms. In the early days of digital camera development, the manufacturers jointly came up with the EXIF metadata scheme for cataloging camera information. You may find it interesting to read the EXIF metadata that is contained in your digital camera files. It will tell you things like what lens setting was used when a photo was taken and the serial number of the camera. This could be useful if you were trying to prove which camera was used to take a photograph when there were a lot of other photographers nearby trying to grab the same shot and also claiming authorship. The EXIF metadata can describe everything about the camera's settings, but the EXIF schema could not be adapted to describe the

Figure 16.17 You can configure the File Info dialog to create a custom metadata template containing metadata items you might wish to apply regularly to collections of images. If you go to the File Info options (circled in Figure 16.16) you can choose Save Metadata Template... and name the template as shown here. Once you have done this you will be able to apply this template to other images by choosing this template from the Tools menu. Replace Metadata will substitute all pre-existing metadata with that in the template. Append metadata is the safer option since it will only add to the metadata that is already embedded in the image file.

Future uses of metadata

It is quite scary to consider the number of freely distributed digital images out there that contain no information about the contact details of the person who created it. Imagine a scenario in the future where metadata can be used to embed important information about usage rights. Imagine also that a third party developer could service a web site that allowed interested purchasers to instantly discover what specific exclusive usages were currently available for a particular image? You could even embed a self-generating invoice in the image file. If someone tried to strip out the metadata, you could even use an encrypted key embedded in the file to re-import the removed metadata, and/or update specific metadata information. I predict that the use of metadata will offer tremendously powerful advantage to individual image creators who wish to distribute their creative work more securely over the Internet and profit from legitimate image rights purchases.

information that interests you. In 2001, Adobe announced XMP (eXtensible Metadata Platform), which to quote Adobe: 'established a common metadata framework to standardize the creation, processing and interchange of document metadata across publishing work flows'. Adobe has already integrated the XMP framework into Acrobat, InDesign Illustrator and Photoshop. XMP is based on XML (eXtensible Markup Language) that is the basic universal format for using metadata and structuring information on the Web. Adobe has also made XMP available as an open-source license, so it can be integrated into any other system or application. Adobe's enormous influence in this arena means that XMP will doubtlessly become a common standard in the publishing and imaging industry. Adobe and also third-party companies are now able to exploit the potential of XMP to aid file management on a general level and for specific needs such as scientific and forensic work.

Metadata in use

Since version 6.0, Photoshop has been able to preserve any metadata that is written into a file. The use of metadata will play an extremely important role in the future of digital photography and the way images are managed. In a lot of cases this will happen automatically, thus saving end users' time and money, when cataloging their image databases. The Pixel Genius company I belong to have produced a freeware plug-in for Photoshop called MetaReader, which you can download from the Pixel Genius website: www. pixelgenius.com. The plug-in will display and export to text files any industry standard metadata embedded in the file. This allows photographers and artists to use the exported metadata in a variety of common database programs.

Metadata panel

Now let's take a look at the Metadata panel. The metadata information is divided into sections. The File Properties and IPTC sections duplicate the File Info dialog contents. Below that is the EXIF camera data, followed by Camera Raw data, GPS information and the Edit History log.

As with File Info, the IPTC metadata can be edited, to do so, mouse-click the field next to the metadata heading (the pencil icons indicate which metadata items are editable). As I mentioned earlier, the amount of information displayed here is vast and more than you really need to know. If you open the Metadata preferences (shown in Figure 16.19) you can control how much metadata is displayed in the panel. Each metadata item has a checkbox against it. This allows you to show or hide individual items. If the Hide Empty Fields box is checked, the checked items will only be displayed in the Metadata panel if there is an accompanying data entry.

General	Metadata	
Metadata Labels File Type Associations Advanced Adobe Stock Photos	✓ File Properties ✓ File Properties ✓ Preserved Filename ✓ Document Kind ✓ Application ✓ Date Created ✓ Date File Modified ✓ Date File Modified ✓ File Size ✓ Dimensions ✓ File Size ✓ Dimensions ✓ Resolution ✓ Bit Depth ✓ Color Mode ✓ Color Mode ✓ Color Profile Label Rating ✓ Jobs Name ✓ Notes ✓ Supports XMP ▼ IPTC (IM, legacy) Document Title Headline Keywords Description Description	
Powered By	Hide Empty Fields	

Figure 16.19 If you mouse down on the Metadata panel options (circled in Figure 16.18), you can open the Bridge preference dialog that governs the Metadata display content. Since it is unlikely that you will really want to see or use all the metadata items listed here, you can deselect those that you don't need.

Metadata		1
File Properties		~
Filename	: D4AT10078.TIF	
Preserved Filename	D4AT10178.TIF	
Document Kind	: Camera Raw	
Date Created	: 24/01/2005, 2:52:41 pm	
Date File Created		
Date File Modified	24/01/2005, 2:52:46 pm	
File Size	: 11.31 MB	
Dimensions	: 4064 x 2704	
Resolution	: 240 dpi	
Bit Depth	: 16	
V IPTC Core		
Creator	Martin Evening	A
Creator: Job Title		2
Creator: Email(s)		A
Creator: Website(s)		9
Headline	:	A
Description	Addo Bational Elephant Park	2
IPTC Subject Code		0
Description Writer	[]:[2
Date Created	: 24/01/2005, 2:52:41 pm	2
Title	:	2
Job Identifier	:	2
Copyright Notice	: © Martin Evening 2005	9
Rights Usage Terms	:	2
V Camera Data (Exif)		
Exposure	1/400 s at f/4.5	
Exposure Program	Normal	
ISO Speed Ratings	: 200	
Focal Length	: 145 mm	
Lens	70.0-200.0 mm	
Artist	- Martin Evening	
Date Time	: 24/01/2005, 2:52:41 pm	
Date Time Original	: 24/01/2005, 2:52:41 pm	
Flash	Did not fire	
Metering Mode	Pattern	
Orientation	: Normal	
Make	Canon	
Model	Canon EOS-1DS	
Serial Number	: 107498	
V Camera Raw		
Raw Filename	D4AT10078.TIF	
White Balance	As Shot	
Temperature	: 5250 °K	
Tint	÷ +12	
Exposure	-0.10	
Shadows	Auto (6)	
Brightness	Auto (68)	
Contrast		
Contrast Saturation	: Auto (+13) : 0	
	: 25	
Sharpness		
Luminance Smoothing	: 0	

Figure 16.18 The Metadata panel is able to display all the metadata contained in an image file. The metadata sections can be compacted to make viewing easier and those fields in the IPTC section can be edited. You can increase the font size in the Metadata panel via the panel fly-out menu. This will make it easier for typing into the metadata and for locating existing entries more accurately.

Metadata

Edit History
2005-02-19T17:42:47Z File D4AT9962.TIF opened
Open Big Disk 400 Go:Master Images:Personal:South Africa:
Addo-Safari:D4AT9962.TIF
As: Camera Raw

Shadow/Highlight Shadow/Highlight Shadow: Parameters Amount: 45% Tone Width: 29% Radius: 28 Highlight: Parameters Amount: 4% Tone Width: 50% Radius: 30 Black Clip: 0.01 Black Clip: 0.01 Color Correction: 20

Unsharp Mask Unsharp Mask Amount: 120% Radius: 0.7 pixels Threshold: 0

8 Bits/Channel Convert Mode Depth: 8

New Gradient Fill Layer Make fill layer Using: fill layer Type: gradient: With Dither With Dither Gradient: gradient Angle: 90° Type: linear Gradient: gradient Name: - Custom" Form: custom stops Interpolation: 4096 Colors: color stop list color: RGB color RGB color RGB color RGB color Blue: 179.996 Type: user specified color Location: 0 Blue: 19.996 Golor: RGB color Type: user specified color Location: 0 Blue: 255 Type: user specified color Location: 4096 Midpoint: 50 Color: top Safety: 100% Location: 0 Midpoint: 50 Color: 50 Color: 50 Color: 50 Color: 50 Midpoint: 50 Color: 50 Co

Figure 16.20 The history log options must be configured in the Photoshop General Preferences. The history log content can record: sessions only (such as the time a file was opened and closed); a concise log listing of what was done in Photoshop; or as shown here, a detailed log, will include a comprehensive list of the settings applied at every step. If you choose to embed the history log in the file metadata, the Edit History log can be viewed in the Bridge Metadata panel.

01

Edit history log

If the history log options are enabled in the General Preferences, an edit history can be recorded in either the file metadata, or as a separate text file log, or both. The Edit history has many potential uses. A log file will record how much time was spent working on a photograph and could be used as a means of calculating how much to bill. In the world of forensics, the history log could be used to verify how much (or how little) work was done to manipulate an image in Photoshop. And the same arguments can apply to validating images that are used to present scientific evidence.

Image cache management

From the moment you open an image folder in Bridge, the program sets to work, building thumbnails to display in the content area, reading in the image file metadata as it does so, taking into account things like: Camera Raw information, image rotation instructions, file rating and labeling.

This is quite a lot of information that Bridge has to process. If it is your intention to use Bridge to manage large collections of images, especially large numbers of raw files, you really do need a fast computer, or Bridge will appear frustratingly slow. The information that is built up during this process is stored in the form of 'cache data'. The Bridge cache has two components: the image metadata and thumbnail cache. Every time you open a folder in Bridge it will check to see if there is an image cache located somewhere, such as the Application Support\ Adobe\Bridge\Photoshop CS2 folder. If a cache is present, the inspected folder will display the archived thumbnails, previews and metadata instantaneously. This works fine so long as the folder is being inspected on the computer that created it and the folder name has not changed since the cache was created. If these two conditions are not met, then Bridge will have to start all over again and build a new cache. Now if you are editing a bunch of raw files, the information you added before, such as the rotation, image rating and Camera Raw adjustments, will not have

been saved in the image files because most raw file formats cannot be edited (an exception being the new Adobe DNG format). So obviously, it is very useful to preserve the cache information wherever possible.

If you open the Bridge Preferences (**H** K ctrl K) and go to the Advanced section, you can set the Cache preferences so that Bridge will distribute the cache files whenever possible. Bridge will then automatically update the cache by adding two cache data files within the same image folder. The advantage of doing this is that it does not matter how you may rename the folder later, the folder image cache will still be recognized. This is especially important if you are about to share a folder of images you have edited in Bridge with another Bridge (a Bridge cache will not be recognized by the older Photoshop File Browser), or you are about to archive the pictures you have edited to a CD or DVD disk. This ensures that the cache data will always be preserved. You can still export the cache manually by going to the Tools menu and choosing Cache \Rightarrow Export Cache. The Build Cache for Subfolders option enables you to force Bridge to prioritize building a cache for not just the current folder, but a collection of subfolders without having to visit them each in turn.

Interferent Contention Contention Contention	
General Metadata Labels File Type Associations Advanced	Advanced Miscellaneous Do not process files larger than: 200 MB Number of Recently Visited Folders to Display in the Look In Popup: 10 Double-click edits Camera Raw settings in Bridge Language: English Changes to the language settings will take effect the next time the application is launched. Cache When Saving the Cache: Use a Centralized Cache File @ Use Distributed Cache File @ Use Distributed Cache Files When Possible Centralized Cache Location: /Users/martinevening/Library/App/Adobe/Bridge/Cache/Thumbnalis/ Choose

Figure 16.23 The Advanced Bridge Preferences.

Sidecar and non-image files

The Parse XMP Metadata from Non-Image Files is something I'll come onto shortly, but basically you want to keep this checked as it will enable Photoshop to read in the metadata from non-image files such as camera metadata files, also referred to as 'sidecar' files. The reasons for creating these sidecar files were explained earlier in Chapter 11. But basically, sidecar files are a mechanism for storing essential, edited metadata information that for various reasons cannot otherwise be embedded in the original file. Sidecar files are linked to specific images. It is a good thing to keep this option checked. It means that whenever you move a file about from one folder location to another, the associated sidecar file travels with it.

_H4I0391.CR2

_H4I0391.xmp

Figure 16.21 If the Camera Raw Preferences are set to save .xmp files as sidecar files, you will see sidecar files like this appear alongside a raw image file that has been modified via Bridge.

Adobe Bridge Cache.bc

Adobe Bridge Cache.bct

Figure 16.22 If the Bridge Preferences are configured to use a distributed cache, cache files like the two shown here will automatically be added as Bridge inspects each folder.

GPS metadata

It is interesting to conjecture how one day it might be possible to use the Global Positioning Satellite (GPS) metadata to automatically complete the location metadata fields. To explain what I mean by this, it is possible with some setups to record a GPS reading at the time of capture and embed this information in the image file. Take a look at the Metadata panel contents and you will see that there is already provision to display the GPS data. Now imagine that there was an online database (similar in principle to the one iTunes references) that could read in the GPS data and translate this into meaningful location information. It is interesting to speculate that one day in the future there might be an online database that would be able to automatically calculate the name of the area you took the photograph in and then be able to update the image file metadata accordingly.

Managing images in Bridge

I began this chapter with an anecdote about a photographer who had been left stranded by a client who was unable to manage his digital image files. Whether you are a professional or amateur photographer, it should be clear that you must plan to manage your pictures or else you too will become just as frustrated. The Bridge tools are designed to make it easier for you to catalog and locate images but you may also want to consider using a separate stand-alone image library program to administer your image collections. Mac OS X users have iPhoto as standard on their computers, which is an Apple only application. Adobe produced a program called Photoshop Album (PC only), which integrates nicely with the Bridge in Photoshop, recognizing and using the Keyword and metadata structure used in Photoshop CS and CS2.

File management is commonplace in other aspects of computer work. For example, if you want to manage your music files, a program like iTunes will update your music database automatically. When a CD is inserted, iTunes will query an online database, downloading the album title, artist, track listings and genre of music. This is an example of metadata in action, and is used to help you manage your music collections as easily as possible. When you are converting music files to an MP3 format, the cataloging is effortless because it can happen in the background automatically. But when you want to catalog image files, you have to input the metadata yourself. I have described in this chapter some of the ways you can go about updating the metadata in Bridge, but in many ways you will be better off using a dedicated image library software program.

Image rating and labeling

One of the main tasks you will want to carry out in Bridge is to rate the images, to select those you like best, or sort them into groups. The Bridge program provides two main ways of categorizing images. If you go to the Label menu you will notice that you can apply ratings to an image in the form of stars going from one to five, or you can apply colored labels. You can see the color labels being put to use in Figure 16.1, where the monkey pictures are all labeled using a violet color and the elephant park photographs are labeled using yellow. It is a simple matter of selecting the individual or multiple images you would like to label and then choosing a color from the list in the Label menu. And you will note that there are keyboard shortcuts ranging from \mathbb{H} 6 ctrl 6 to \mathbb{H} 9 ctrl 9 that you can use to assign a label color without going to the Label menu. You can also *ctrl* right mouse down on an image in Bridge to apply label colors via a contextual menu.

The image rating system is useful as a cumulative system for flagging the images you like. And in fact the Bridge rating is an extension of the flag control that existed in Photoshop CS. So if you were to visit a folder where you had flagged specific images using Photoshop CS, you will now see those images marked with a single star rating. Plus you can still use the \mathbb{H} *ctrl* +' (apostrophe) keyboard shortcut to add or remove a single star rating to an image. The official way to apply ratings in Bridge is to use **H** • *ctrl* • to increase the rating by one star and use **H** otrease the rating by one star. What I love about this system is that it is now really easy to focus all your attention on the images as you use the 🔄 🤿 arrow keys to progress from one image to the next and use the above rating keyboard shortcuts to mark the shots you like most using **H** ctrl to cumulatively add more stars and use **H** *ctrl*, to cumulatively subtract stars. To my mind, these are the only keys you need, but you can also apply specific star ratings from one to five using the (**H**) *ctrl* key plus the desired rating number.

	Rating	
	No Rating	₩0
V	*	#1
	**	₩2
	***	₩3
	****	₩4
	****	₩5
	Decrease Rating	₩,
	Increase Rating	ж.
	Label	
	No Label	
	Red	Ж6
v	Yellow	Ж7
	Green	#8
	Blue	% 9
	Purple	

Figure 16.24 Image rating and labeling can be applied via the Label menu in Bridge, or by using the keyboard shortcuts indicated here.

Turning off the labeling

You can turn off the labeling by selecting No Label from the Label menu in Bridge. But the labeling keyboard shortcuts also have a toggle action. You can turn the labeling off for an image or group of images by applying the same keystroke as you used to label the images in the first place.

Universal rating methods

You are not limited to using the rating controls just within Bridge. The rating keyboard shortcuts described here work equally well when you are reviewing your images in the Camera Raw dialog or when using the Slideshow viewing mode.

Filtering Bridge window results

Once you have assigned the desired rating and labeling of the images, you can go to the image filtering at the top of the Bridge window and select a filtering option from the drop-down menu.

Show All Items	₹#A
Show Unrated Items O	nly
Show 1 or More Stars	飞第1
Show 2 or More Stars	元第2
Show 3 or More Stars	飞第3
Show 4 or More Stars	飞 第4
Show 5 Stars	\%5
Show Labeled Items O	nly
Show Unlabeled Items	Only
Show Red Label	飞第6
Show Yellow Label	て第7
Show Green Label	て第8
Show Blue Label	7#9
Show Purple Label	

Figure 16.25 Here is a list of viewing options that can be selected from the image filtering drop-down menu in a Bridge window.

Refreshing the view

The Refresh item at the bottom of the View menu is really useful to know about. If you alter the contents of a volume or folder at the System level, outside of Bridge, then the Bridge Folder panel and Content Area won't always know to update the revised volume or folder contents. If you ever need to refresh the view in Bridge, use this menu item or the **F5** keyboard shortcut.

Filtering and sorting images in Bridge

Once this has been applied you can use the image rating and labeling to filter and sort the images in a Bridge window. As you mouse down on the Filtering options menu at the top of the Bridge window you can choose one of the options shown in Figure 16.25 to narrow the selection of images shown in the Bridge window. Meanwhile in the View menu you can select various options to determine which types of files will be made visible in a Bridge window. So if you want to exclude all non-graphics files, you can select the Show Graphics Files Only option. The Sort menu allows you to choose a method of determining the order in which the image files are displayed. When you combine the Bridge window level filtering with the program level Sort options, Bridge is perfect for organizing and presenting your images just the way you want them.

Compact Mode Slide Show	¥≁ KΓ	
✓ As Thumbnails As Filmstrip As Details As Versions and Alterna	ates	
 ✓ Favorites Panel ✓ Folders Panel Preview Panel ✓ Metadata Panel Keywords Panel 		
Sort	Þ	✓ Ascending Order
Show Thumbnail Only	ЖТ	By Filename
Show Hidden Files ✓ Show Folders		By Document Kind By Date Created By Date File Modified
✓ Show All Files Show Graphic Files Onl Show Camera Raw Files Show Vector Files Only Refresh	Only	By File Size By Dimensions By Resolution By Color Profile By Copyright By Label By Rating By Purchase State
		By Version Cue Status Manually

Figure 16.26 The Sort menu options allow you to arrange the displayed thumbnail images by ascending or descending order using any of the criteria listed in the menu. Normally this is left at the default Filename setting. If, for example, you selected By Date Modified the images would be displayed in the order of which was most recently edited.

Chapter 16

Image management

Image searches

Bridge has the power to perform image searches based on selected criteria. Although Bridge is not trying to be an image database program it is feasible to use it as such. For example, in my line of work we regularly hold model castings and we add the details of the name of the model and the agency into the Description metadata field in the Metadata panel. Over the course of several months we build up many hundreds of model images. If I need to conduct a search for a specific model, I go to the Edit menu in Bridge and choose Find... (#) F. I can select Description under the Criteria section, type the name of the model in the text field and click the Find button. Bridge will conduct a filtered search and can display the search results in a new Bridge window, as shown in Figure 16.27. If no results match the search criteria, there will be a warning message displayed in a new Bridge window.

Source		Find
Look in: TaylorP070405	Browse	Cancel
Include All Subfolders Find All Files Criteria	Search Past Versions of Version Cue Files	
Description	sarah 🕘 🟵	
Match: If any criteria are met		

Search criteria

The search criteria can be almost anything you want. The source folder will default to the folder you are viewing in the front most Bridge window. But you can select other folders to look in and in some cases it will be necessary to select a folder that contains a lot of subfolders and make sure that the Include All Subfolders option is checked. The search criteria can be adapted in many ways to search for images that meet or don't meet specific criteria.

Figure 16.27 In this example I chose Find... from the Bridge Edit menu and entered the first name of the model I was looking for in the Description field under the Criteria section. The Find dialog settings used here displayed all the images that matched this criteria in a separate new Bridge window.

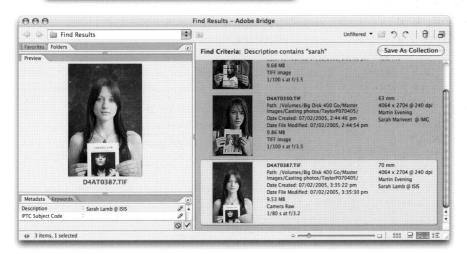

Figure 16.28 The Bridge Automate menu.

Renaming schemes

The renaming scheme you use can be anything you choose. There are no hard and fast rules. But whatever method you decide to use, it should be done with a view to the future and avoid the possibility of you creating file names that overlap with other files. The naming scheme I describe here was designed to be simple yet versatile as it lets me catalog up to 10,000 images per year per client.

Bridge automation

The Photoshop Automate features can all be accessed directly in Bridge by choosing Tools \Rightarrow Photoshop and selecting one of the options from the submenu. To apply a Photoshop action to a group of images, make a selection of images in Bridge, choose Tools \Rightarrow Photoshop \Rightarrow Batch... and configure the dialog to run a batch action processing routine on the selected photos. If I want to create a web gallery from a selection of images in Bridge, I would make a filtered selection of images in Bridge, and perhaps I would also rearrange the order I wanted the pictures to appear in, and then choose the Web Photo Gallery option from the Tools \Rightarrow Photoshop menu. You can read more about this and all the other automation features in the following chapter on automating Photoshop.

Renaming images

To rename an image in Bridge, just double-click the file name and enter a new one. To batch rename a selection of images, choose Batch Rename... from the Tools menu. This will open the Batch Rename dialog shown in Figure 16.29. You can rename the files in the same folder or rename or move them to a new (specified) folder. Notice how you can define the new file name structure, by clicking on the plus buttons next to a field entry to add more components to the New Filename section and how within each component you have multiple choices, which all told will provide you with a comprehensive file renaming tool. In the example shown here, the first field was set as a Text entry, in which I entered two letters as a shorthand for the job client name. This was followed by a Date entry that I configured so that it added just the last two digits of the current year. This was followed by a serial number that started with the number '1' and consisted of four digits (if I had wanted the serial number to begin at a number other than 0001, I could enter a new number to start the sequence from). Note there is now no need to enter a file extension at the end, Bridge will do so automatically. And I suggest that if you are a Mac user, you check for Windows compatibility.

		Ba	tch R	ename		
Destination Folder Rename in same fo Move to other folde Copy to other folde Browse	er					Cance
New Filenames						
Text	•	CO	matter		\odot \odot	
Date	•	Today	:	YY :	\odot \odot	
Sequence Number	•	1		Four Digits	⊕ ⊕	
Options Preserve current fil Compatibility: 🗹 Win						
Preview First selec D4AT2				First new filename CO050001.TIF		

Figure 16.29 The new Batch Rename dialog will now let you copy the files to another folder as you rename them. The New Filename options can be configured to accommodate pretty much any method of renaming you could wish for.

✓ Text	CO		00
New Extension Current Filename	Today 🛟	YY	• •
Preserved Filename Sequence Number Sequence Letter Date	9	Four Digits	• • •
EXIF Metadata	me in XMP Metadata		

Figure 16.30 Lots of extra options become available as you mouse down on the pop-up menus. Selecting the Preserved Filename will restore the original file name, providing the box circled in Figure 16.29 is checked.

Applying Camera Raw settings

In Photoshop CS2, the Adobe Camera Raw dialog has come more into its own and the best way to apply the Camera Raw settings is via the single or multiple Camera Raw dialog, where you can precisely control how these are applied (see page 456). But you can use the Edit \Rightarrow Apply Camera Raw Settings menu in Bridge to apply a saved preset setting or choose Previous Conversion, to apply the last used Camera Raw setting across all the selected images. The other thing you can do is to copy and paste settings from one file to another, or better still use the keyboard shortcuts: use \Re C ctrl alt C to copy a setting and \Re C ctrl alt V to paste.

Editing the Batch renaming fields

The Batch Rename dialog has been completely revised in Photoshop CS2 and Bridge, so that we now have a versatile set of renaming options at our disposal. The default mode settings are configured to do nothing at all, but once you start editing the pop-up menus, you will discover that the renaming options are quite extensive. You can select items such as Text, where you can enter your own text data. You can also incorporate the original file name in parts of the new name, which will make a lot of people I know very happy.

Undoing a Batch Rename

If you inspect the Batch Rename options closely you will notice there is an option to preserve the original file name. So if you do slip up for some reason, Bridge and Photoshop CS2 are able to locate and reassign the original name to the file. But, and it's a big but, this will only be possible if you remember to check the box that says: Preserve current filename in XMP Metadata.

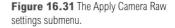

Figure 16.32 If you are using the entire CS2 Creative Suite, you will have access to the Bridge Center (shown below) in which you can click on the Suite Color Settings button to synchronize the color settings across all the programs in the Creative Suite.

Figure 16.33 The Bridge Center is available via the Favorites panel. As was mentioned above, it is only installed and accessible in Bridge if you have purchased the entire Adobe CS2 Creative Suite.

Photoshop Services

The Tools \Rightarrow Photoshop Services submenu will take you to an online ordering service for which you have to register. An example of the Online Print Services dialog is shown on page 533.

Bridge extras

Photoshop CS2 can be purchased as a stand-alone program or as part of the CS2 Creative Suite package. Bridge is included with both, but you will only get to see certain extra items, such as the Color Management Suite synchronization and the Bridge Center if you purchase the CS2 Suite package. But everyone can access the Adobe Stock Photos from the Bridge Center as well as from the Bridge Edit menu. Adobe Stock Photos is an online library service offering access via Bridge to royalty-free images. Personally, this is not something that I am interested in promoting, but it's there in Bridge.

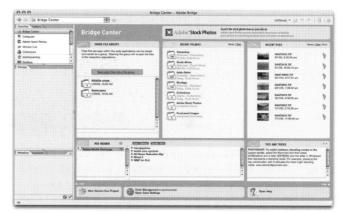

The digital lightbox experience

Let's now look at the process as a whole of bringing digital images into Photoshop and how you can manage them successfully with a view to maintaining a digital image archive. The following steps show how I use Bridge when I am either in the studio or on location. I typically use Bridge to manage my photographs, automating the process as much as possible and at the same time maintaining a backup of all the raw data on a separate hard drive. When adding new images to a collection of captures throughout the day, I use the Batch Rename function to renumber the new images I am adding to a folder. But I always remember to set the numbering so as to follow on from the last image in the previous batch.

1 The process begins with the digital captures which are always shot using Raw mode being copied from the media card to the computer. All media cards are vulnerable to damage, but so too are computer hard drives. Initially I copy the files across to a laptop computer in the studio, copying the files across to a LaCie FireWire pocket drive. This is the simplest way to get the files off the card without having to worry if they are in the right folder or not, which is important when you are in a hurry.

Name	Date Modified	Size	Kind	(11)12
🃁 Camera transfer files	Today, 19:10		Folder	
_H4I0548.CR2	2 January 2005, 20:52	18.1 MB	CRAW2	
_H4I0549.CR2	2 January 2005, 20:54	18.4 MB	CRAW2	
_H4I0550.CR2	2 January 2005, 20:54	22 MB	CRAW2	
_H4I0551.CR2	2 January 2005, 20:54	18.8 MB	CRAW2	
H4I0552.CR2	2 January 2005, 20:56	16.1 MB	CRAW2	
_H4I0553.CR2	2 January 2005, 20:56	18.7 MB	CRAW2	
_H4I0554.CR2	2 January 2005, 20:59	21.5 MB	CRAW2	
_H4I0555.CR2	2 January 2005, 20:59	19.2 MB	CRAW2	
H4I0556.CR2	2 January 2005, 20:59	18 MB	CRAW2	

2 Next, I will make a backup of these files to a designated folder on the main computer hard disk. At this point it is now safe to delete all the files off the card so that it can be reused. And at this point I recommend you reformat the card before shooting with it again.

20	TP1_Selects - Adobe Br	idge		
TP1_Selects		Bat	ch Rename	
Roders Vasentes ♥ Computer ♥ ag bick 400 Co ₩ adola scans 5.1.05 ♥ Master Images Master Images		Destination Folder Rename in same folder Move to other folder Copy to other folder Browse		Canc
-	TP040006.tif 19/04/2004, 10:3	New Filenames Text Date Sequence Number 1	CONTRACTOR OF A	
1 th	* TP040012.tif 19/04/2004, 10:5	⊂ Options Ø Preserve current filename in XMP Metadata Compatibility: Ø Windows Ø Mac OS □ Unix		
TP040008.tif		Preview First selected filename _H410548.CR2 20 files will be ren	First new filename TP050001.CR2	
266 items, 1 selected				

3 I will then open a new window in Bridge and select the camera file folder on the main computer hard disk (not the one on the pocket drive) and once the thumbnails have been generated, I will choose Select All (#A ctrl(A)) from the Bridge Edit menu. To deselect, use **B** Shift A ctrl Shift A (note that **B D** ctrl **D** will duplicate). This is followed by Batch Rename from the Tools menu. You can use any identification/numbering system you like. The method shown here is the one described on page 625.

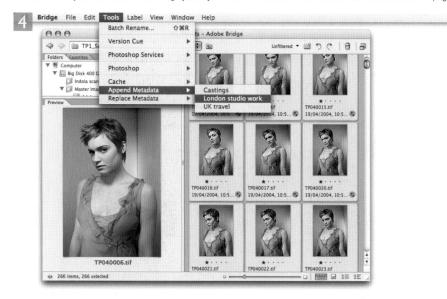

4 The Canon camera has a neat feature whereby I can program it to automatically embed my name as the author whenever I shoot a capture. But I can also make sure every photograph I process in Photoshop is copyright marked with my name again plus any other details by using the Append Metadata command as described on page 615.

5 At this stage the photographs will be ready for editing. Bridge should be regarded as the digital equivalent of a photographer's lightbox. I like having the ability to move the dividers around so that the preview image can fill the screen as much as possible. You may find it easier to create and save a custom Workspace setting for making edit selections where the Preview panel is maximized to fill as much of the screen area as possible.

6 I can now navigate from one image to the next using the keyboard arrow keys, and rate favorite pictures using the **B C C C C** keyboard shortcut. The favorite images rated with one star can be viewed in isolation by filtering the Bridge window contents to display the one star or more images only. At this point I can make a selection of pictures to automatically generate a contact sheet for review by the client.

DVD as an alternative to CD

Recordable DVD drives have become increasingly popular and are often supplied as standard with some computer models. Recordable DVD disks are capable of storing 4.7 GB of data. But again, to be realistic, I would knock that figure down to something more like 4.2 GB as the actual amount of data you can store on a disk. Early DVD drives were x1 speed and painfully slow to work with. But you can now get x4 speed DVD drives, which from my point of view make an appreciable difference to the time it takes to archive my data. I typically shoot around 300-400 raw captures during a day's shoot and usually I am able to back up these raw files to a single DVD drive. The only problem with a CD or DVD disk is that if it gets damaged you lose everything and that might mean losing a hefty chunk of valuable data. So make an extra backup copy of important data and archive this separately. Recordable disks also have a finite life span. And who is to say if CD or DVD will not be superseded by some other form of recordable media? Furthermore, if you archive raw camera files, will you always have the software to interpret these? In this industry a lot can happen in a matter of just a few years.

Storage Media

The biggest bottleneck in the digital management process right now is the time it takes to archive data to a storage medium. Over the years we have seen many types of storage media systems come and go. But the most popular media these days are recordable CDs and DVDs. Just about every computer sold today will have a built-in CD drive that is capable of reading and writing disks. Some CD disks can theoretically hold up to 700 MB of data, although 650 MB is probably a more realistic upper limit to aim for. Not so long ago, 650 MB used to be considered an enormous amount of storage space, but these days it won't go very far. My layered master images often exceed 200 MB and if storing to CD, I would therefore have to separate my files into two or more folders before burning the disks, taking care that none exceeds the capacity of the CDR media. A colleague of mine, Seth Resnick, has adopted a very thorough approach to working with digital captures and I have learned a lot from attending his seminars on managing the digital workflow. Seth argues that it makes sense to process all the selected favorites as 16-bit TIFFs and archive these on an actual hard drive as well as a CD or DVD. A 500 GB external hard drive is not too expensive and if you accumulate around 25 GB worth of data for each job, then it only costs a twentieth of the cost of a hard drive to store all the files from each shoot you do. He also points out that in all the years he has been working with computers that hard drives are the one standard that has survived all the various types of recordable media. For example, does anyone now remember Syquest disks?

Image protection

Anyone who fully understands the implications of images being sold and transferred in digital form will appreciate the increased risks posed by piracy and copyright infringement. The music industry has for a long time battled against pirates duplicating original disks, stealing music and video sales. Digital music recordings on CD made this problem even more difficult to control when it became possible to replicate the original flawlessly. The issue of piracy is not new to photographers and image makers, but the current scale of exposure to this risk is. It includes not just us Photoshop geeks, but also anyone who has their work published or is interested in the picture library market.

To combat this problem, the first line of defense had been to limit the usefulness of images disseminated electronically by (a) making them too small in size to be of use other than viewing on a screen and (b) including a visible watermark which both identified the copyright owner and made it very difficult to steal and not worth the bother of retouching out. The combination of this two pronged attack is certainly effective but has not been widely adopted. The World Wide Web contains millions of screen sized images few of which are protected to this level. The argument goes that these pictures are so small and degraded due to heavy JPEG compression, what possible good are they for print publishing? One could get a better pirated copy by scanning an image from a magazine on a cheap flatbed scanner. Shopping is now replacing sex as the main focus of interest on the Internet, so screen sized web images therefore do now have an important commercial value in their own right. Furthermore, the future success of digital imaging and marketing will be linked to the ability to transmit image data. The technology already exists for us to send large image files across the world at speeds faster than ISDN. Once implemented, people will want to send ever larger files by telecommunications. The issue of security will then be of the utmost importance.

Fingerprint plug-ins

Software solutions have been developed to provide better data protection and security, giving suppliers of electronic data the means to identify and trace the usage of their intellectual property. These systems apply an invisible 'fingerprint' or encrypted code that does not spoil the appearance of the image but can be read by the detection software. The code must be robust enough to work at all usage sizes: from screen size to high resolution. They must withstand resizing, image adjustments and cropping. A warning message should be displayed whenever an image is opened up alerting the viewer to the fact that this picture is the property of the artist and a readable code embedded from which to trace the artist and negotiate a purchase.

Two companies have produced such encryption/detection systems: SureSign by Signum Technology and Digimarc by the Digimarc Corporation. Both work as plugins for Photoshop. They will detect any encrypted images you open in Photoshop and display a copyright detection symbol in the status bar alongside the file name. You have to pay an annual usage fee to Digimarc to register your individual ID (check to see if free trial period offers are in operation). Anyone wishing to trace you as the author, using the Photoshop Digimarc reader plug-in, will contact their website, input the code and from there read off your name and contact number. SureSign provide a unique author code plus transaction number. In my opinion, the latter is a more adaptable system.

Chapter 17

Automating Photoshop

etting to know the basics of Photoshop takes a few months, learning how to become fluent takes a little longer. There are a great many ways that you can speed up the way you work in Photoshop and this chapter aims to introduce you to some of the various automation features that can be found in Photoshop. This chapter will hopefully expand your knowledge of Photoshop and show you the many ways you can save yourself time by automating much of the routine image processing that you do in Photoshop.

Keyboard shortcuts

One way you can speed up your Photoshop work is by learning how to use many of the keyboard shortcuts. There are a lot of them in the program and so it is best to learn these shortcuts a few at a time, and not try to absorb everything at once. Throughout this book I have always indicated the Mac and PC key combinations for the shortcuts you can use in place of navigating through the menus in Photoshop. And I have probably covered nearly all the keyboard shortcuts one might use on a regular basis. But there are even more shortcuts you can learn! Most of these are listed in the Keyboard Shortcuts dialog and the other way is to open up the Shortcuts table PDF on the CD that comes with the book and print it out.

Custom keyboard shortcuts

The default keyboard shortcuts in Photoshop utilize just about every key combination that is available on a standard English language computer keyboard. The toolbox uses every letter of the alphabet to perform a function, then you have the \mathfrak{H} *ctrl* keys plus a letter, number or keyboard symbol, followed by the \mathfrak{H} *Shift ctrl Shift* key combinations, the \mathfrak{H} *ctrl alt* combinations, and finally, a few key combinations that combine three modifier keys, such as \mathfrak{H} *Shift ctrl alt Shift*.

Non-English language computer keyboards will differ. For example, keyboards produced for the Scandinavian countries will assign different special language symbols in place of the ones found on a US or British keyboard. In the past, this presented problems for non-English language Photoshop users, as things like the tilde key (~) wouldn't exist on some keyboards. But the shortage of spare keyboard shortcuts also limited the number of Photoshop functions that could have a keyboard shortcut.

When you use Photoshop CS or CS2, you can customize the keyboard shortcuts to suit your own way of working. Shortcuts you find redundant can be reassigned to execute functions that are more useful to you. Modified

Table of Shortcuts

In previous editions of this book I published a table that showed all the keyboard shortcuts in Photoshop. That table is still there, but it is now published as a PDF document on the CD. There are two reasons for this. One is that Photoshop allows you to print your own summary of the keyboard shortcuts directly from the Keyboard Shortcuts manager dialog. But more importantly, there was so much new information that needed to be covered in this edition, we had to use all the space available to cover what is new in Photoshop CS2. This is why we decided to place the Shortcuts tables on the CD instead.

Contextual menus

A good many shortcuts are just a mouseclick away. Contextual menus are available throughout Photoshop. On a Macintosh you use *ettri*-click and on the PC use a right mouse-click to open a contextual menu in an image document window or a Photoshop palette such as the Layers, Channels or Paths palette. For example, you can *ettri* right mouse-click in the document window to access a list of all the menu options associated with the currently selected tool.

Keyboard shortcuts tip

The shortcut for Keyboard Shortcuts is: Shift K ctrl all Shift K The shortcut for Custom Menus is: Shift M ctrl all Shift M. shortcuts can then be saved as custom sets. But to start with, go to the Edit menu and choose Keyboard Shortcuts... This will open the dialog shown in Figure 17.1, where you can select a preset setting such as 'Working with Type' or customize the current Shortcuts settings and create your own custom configuration.

The Palette shortcuts are grouped into: Application menus, Palette menus and Tools. The Application and palette menu sets contain subsets of items with expandable views.

Figure 17.1 The Keyboard Shortcuts dialog.

To create a new keyboard shortcut, click in the Shortcuts column next to the menu item you wish to customize and hold down the keyboard key combination exactly as you would if you were using the keyboard shortcut. The key combination will then appear in the Shortcut column field you are editing. You can also create more than one shortcut for each item. To do this, select an item in the list and click on the Add Shortcut button. Enter the secondary shortcut as usual. When you are done, click on the Create New Set button. This will open the Save dialog box shown in Figure 17.2. Give the new set a name and save the new set to the Keyboard Shortcuts folder.

You can Access the Custom Menu dialog by clicking on the Menu tab behind Keyboard Shortcuts. The menu customization is something I have covered elsewhere in the book. For more information on menu customization, please refer to pages 14–15.

oplication Menu Command	Shortcut		Accept
Lock All Layers		6	Undo
Link/Unlink Layers			Use Default
Select Linked Layers			Cost bendan
Merge Layers	ж+Е		Add Shortcut
Merge Visible	Shift+#+E		Delete Shortcut
Flatten Image	Opt+Shift+第+E		
Matting>		D	Summarize
Defringe			
Remove Black Matte		Ţ	
Opt+Shift+#+E is alread the target layer if accept layers into the target laye layers into the target laye	y in use and will be removed from "Mer ed. You cannot assign a different short r [*] .	ge a copy of all vis cut to "Merge a co	ible layers into py of all visible

Save As:	Photoshop Custom 1.kys	
Where:	Keyboard Shortcuts	 9

Figure 17.2 The Keyboard Shortcuts Save set dialog. The default location for saving sets is the Keyboard Shortcuts folder in the Adobe Photoshop CS application folder.

Generating a shortcut summary

If you click on the Summarize... button, this will generate a document in an HTML format that summarizes all the shortcuts in this set. This summary can be printed out and used as a reference guide to all the available shortcuts.

Figure 17.3 As you edit the keyboard shortcuts, you will come up against the same problem that has long bugged the Photoshop engineers, and discover that many of the key combinations are already in use. When this happens, an alert message will appear at the bottom of the dialog telling you that the shortcut is already in use elsewhere. You can either undo the change or choose Accept. When you change the assigned shortcut the old shortcut will be removed from this set. If the Palette menu shortcut is also shared as a menu item, the changes will take place in both locations.

Sourcing readymade actions

You will find several Actions are already loaded and made available when you install Photoshop. And there are many more that are freely available on the Internet. A useful starting point is the Adobe Studio Exchange site at: http:// share.studio.adobe.com. This site contains a comprehensive list of actions, plug-ins and scripts etc. Another is the Elated site: www.elated.com/actionkits/. Both these sites offer ready prepared actions or sets of actions with examples of the types of effects achieved with them for you to freely download for use in Photoshop.

Volatile actions

One thing you have to be aware of is that although actions will remain stored in the Actions palette after you quit Photoshop, a newly installed or created action can easily become lost if Photoshop crashes before you quit. And remember that if you ever uninstall Photoshop it is always a good idea to take the precaution of saving out all the action sets in the Actions palette first, so you don't lose them!

Working with Actions

Photoshop is able to record many of Photoshop's operations in a sequence and save them as an action. These actions can then be replayed on other images and shared with other Photoshop users so that they can repeat this sequence of Photoshop steps on their computer. Actions can save you the bother of laboriously repeating the same steps over and over again on subsequent images.

Playing an action

The Actions palette already contains a set of prerecorded actions called Default Actions.atn. And if you go to the Actions palette fly-out menu you can load other sets from the menu list such as: Frames and Image Effects. To test these out, open an image, select an action from the menu and press the Play button. Photoshop will then apply the recorded sequence of commands to the selected image. If the number of steps in a complex action exceeds the number of available histories, there will be no way of completely undoing all the commands when the action has completed. So as a precaution, either take a Snapshot via the History palette or save the document before executing an action. If you are not happy with the result of the action, you can fill from the saved snapshot in History or revert to the last saved version. Photoshop Actions are normally appended with the .atn file extension and saved by default to the Photoshop Actions folder, inside the Photoshop Application Presets folder. But you can store them anywhere you like. And if you want to install an action you have downloaded or someone has sent to you, all you have to do is double-click it and Photoshop will automatically load the action into the Actions palette (and launch Photoshop in the process if the program is not already running at the time).

Recording actions

To record an action, open up a test image to work with. You may at this stage want to create a new action set to contain new actions. Next click on the New Action button icon at the bottom of the Actions palette. This will add a new action to the set. Give the action a name and then press the Record button. At this stage you can also assign a custom key combination using a combination of Function keys (**F1**-**F5**) with the **Shift** and **H ctl** keys. You can then simply use the key combination to initiate running the action. Now carry out the Photoshop steps you wish to record and when finished click the Stop button.

Watch out for recording commands that rely on the use of named layers or channels that may be present in your test file, as these will not be recognized when the action is applied to a new image. Also try to make sure that your actions will not always be conditional on starting in one color mode only, or being of a certain size. If you intend recording a complex action, the best approach is to carefully plan in advance the sequence of Photoshop steps you intend to record. A break can be included in an action. This will always open a message dialog at a certain point during playback. It can include a memo to yourself (or another user replaying the action), reminding you of what needs to be done at a certain stage. Or if the action is to be used as a training aid, the message could include a teaching tip or comment. Actions are always created within sets and if you want to save an action, it has to be saved as a set. So if you want to separate an action to save on its own, click on the New Set button in the Actions palette to create a new set, drag the action to the new set, name the set and choose Save Actions... from the Actions palette flyout menu (an action set must be highlighted, not an action). If you hold down the $\Re \simeq ctrl alt$ keys as you choose Save Actions... this will save the text descriptions of the action steps for every Photoshop action currently in the Actions palette. The following example demonstrates how to record a basic action.

Limitations when recording actions

Most Photoshop operations can be recorded within an action such as image adjustments, History palette steps, filters, and most tool operations in Photoshop. Tools such as the marguee and gradient fills are recorded based on the currently set ruler unit coordinates. Where relative positioning is required, choose the Percent units in Units & Rulers preferences before you begin recording. Avoid using commands which as yet cannot be recorded with an action. Certain operations like brush strokes (or any of the other painting tools) cannot be recorded as this goes beyond the scope of what can be scripted.

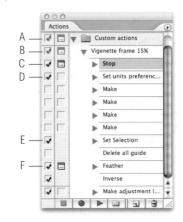

Figure 17.4 Actions palette column icons.

A: The Set contains inactive operations.

- B: The Action contains inactive operations.
- C: Indicates the Action step is active and contains a Stop.
- D: An active operation that has a dialog box.
- E: An active operation with no dialog box.
- F: An active operation with a Stop, opening the dialog box.

1 The Actions palette has been expanded here to list all the steps that make up an action I have named Vignette frame 15%. As a first step, I chose Show Rulers from the View menu. I crr/ right mouse-clicked a ruler and set the units to 'Percent'. By doing this, all positions were recorded, measured as a percentage of the document's dimensions. The recorded action will work effectively, whatever the size or proportions of an image.

2 I dragged ruler guides out from the rulers, placing four guides at 15% in from the edge. I then used these guides as a reference to draw a rectangular marquee and then cleared the guides afterwards to delete them. To create the vignette effect, I chose Feather from the select menu and feathered the selection by 100 pixels, followed by an Inverse Selection.

3 I then clicked on the Add Adjustment layer button in the Layers palette and chose Levels. This step added an adjustment layer, automatically adding a layer mask at the same time, based on the current selection. So as I darkened the adjustment by dragging the Gamma slider to the right in Levels, only the outer areas were affected.

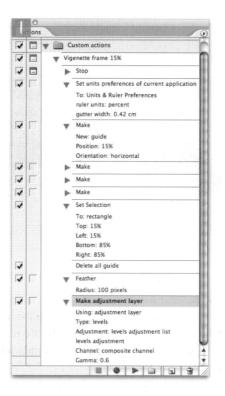

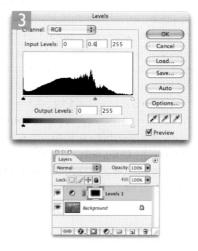

4 When the recording is complete, you need to remember to click on the Stop button in the Actions palette. The action is now ready for testing. And when you have fine-tuned the actions as necessary, it is ready for use to apply as a single action or as part of a batch process operation.

Troubleshooting actions

Check that the image to be processed is in the correct color mode. Many actions, such as those that use certain Photoshop filters, are written to operate in RGB color mode only. Color adjustment commands will not work properly if the starting image is in CMYK and not at all if in Grayscale. Some pre-written actions require that the start image fits certain criteria. For example, the Photoshop supplied Text Effect Actions require that you begin with images that already contain layered text. If you have just recorded an action and are having trouble getting it to replay, you can inspect it command by command. Open a test image and expand the Actions palette to display all the items. Hold down the **R** *ctrl* key and click on the Play button. This will play the first command only. If there is a problem, double-click the command item in the list to rerecord it. Hold down the 🔀 *ctrl* key again and click on the Play button to continue. To replace an item completely, press Record and perform a new step, then click Stop. This will delete the old step and replace it with the one you have just recorded.

Actions only record changed settings

One of the problems you commonly face when preparing and recording an action, is what to do if certain settings are already as you want them to be. Actions will only record a setting as part of an action if it actually changes. So, for example, you are recording an image size adjustment where you want the image resolution to end up at 300 pixels per inch, but the image is already defined in the Image Size dialog as 300 pixels per inch. In these situations, Photoshop does not record anything. To resolve these potential problems, you have to deliberately make the image size something else before you record the step, and then when you change the pixel resolution, this will get recorded.

Stop and pause

When editing an action, you can insert what is known as a Stop, which will allow you to halt the action process to display an alert message. This could be a useful warning like the one shown in Figure 17.5, which is displayed at the beginning of the action playback. If you want to display a dialog setting during playback, insert a Pause by clicking in the blank space to the left of the action step (see Figure 17.4).

Action recording tips

Action recordings should be as unambiguous as possible. For example, if you record a step in which a named layer is brought forward in the layer stack, on playback the action will look for a layer with that name. Therefore, when adding a layer include naming the layer as part of the action. Do not use Layer 1, Layer 2 etc. This can only cause confusion with Photoshop's default naming of layers. And use the main Layer menu or Layer key command shortcuts to reorder the layer positioning. Doing so will make your action more universally recognized.

Inserting menu items

There are some things which can be included as part of a Photoshop action that can only be included by forcing the insertion of a menu item. For example, Photoshop will not record zoom tool or View menu zoom instructions. But if you select Insert Menu Item from the Actions palette fly-out menu, as you record, you will see the dialog in Figure 17.6. The Menu Item dialog will initially say None Selected. If at this stage I choose a zoom command from the View menu, the instruction will now be recorded as part of the action. Although frustratingly, the image won't actually zoom in or out until you replay the action. I also use the Insert Menu Item to record opening dialogs that I regularly access, like the Web Photo Gallery. This saves me always having to navigate the File menu.

Message:		(OK)
Make sure the image you RGB mode.	are about to process is in	Cancel
Allow Continue		

Figure 17.5 The Record Stop dialog.

Menu Item: View:Zoom Out	ОК
To record a menu item, select a menu item using the mouse.	Cancel

Figure 17.6 The Insert Menu Item dialog will initially say None Selected. Select a menu item such as Window \Rightarrow Tile and click OK. When the Action is replayed the instruction will be included.

Batch processing actions

One of the great advantages of Actions is having the ability to batch process files. The Batch dialog can be accessed via the File \Rightarrow Automate menu. And it can also be accessed via the Bridge Tools \Rightarrow Photoshop menu. You will need to select an Action Set and Action from the Play section. Then you need to select a Source and Destination. The Source can be all currently open images, selected images in the Bridge window or a designated folder, in which case, you need to click on the Choose... button below and select a folder of images. If you check the Override Action 'Open' commands checkbox, Photoshop will only open and process images if the Action includes an Open command. And check the Include All Subfolders option only if you want to process all the subfolders within the selected folder.

Checking the Suppress Color Profile Warnings option will prevent the missing profile and profile mismatch dialogs appearing when you batch process images. If there

Play			OK
Set: Custom acti	ons		
Action: Save as JPEG			Cance
Source: Folder	•		
Choose)			
Override Action "Oper	" Commands		
Include All Subfolders			
Suppress File Open Op			
Suppress Color Profile	Warnings		
Destination: Folder			
Chaose Macintor	h HD:Users:martinevening:Desktop:JPI	C folder:	
Override Action "Save	As" Commands		
File Naming Example: Bookimage_1	01_230205.gif		
	01_230205.gif + 2 Digit Serial Number	* +	
Example: Bookimage_1		\$ + \$ +	
Example: Bookimage_1	+ 2 Digit Serial Number		
Example: Bookimage_1 Bookimage_ [_] [extension	+ 2 Digit Serial Number + ddmmyy (date)	+	
Example: Bookimage_1 Bookimage_ 	+ 2 Digit Serial Number + ddmmyy (date)	+	
Example: Bookimage_1 Bookimage_ 	+ 2 Digit Serial Number + Iddmmyy (date) + +	+	

Figure 17.7 An example of the Batch Action dialog set to apply a prerecorded action. You can write your own fields. I have created a batch process where the image will be renamed 'Bookimage_' followed by a two digit serial number, followed by an underscore '_' the date expressed as: day; month; and year, followed by a lower case extension. Note that the numbering has been set to start at '101'. So in this example the file name structure will be something like: Bookimage_101_230205.gif. Note also that the .gif extension is just there as an example to show that there will be an extension appended to the file name. It won't actually be saved as a GIF. And the Windows box has been checked to ensure file naming compatibility with PC systems.

✓ Document Name document name DOCUMENT NAME 1 Digit Serial Number 2 Digit Serial Number **3 Digit Serial Number** 4 Digit Serial Number Serial Letter (a, b, c...) Serial Letter (A, B, C ...) mmddyy (date) mmdd (date) yyyymmdd (date) yymmdd (date) yyddmm (date) ddmmyy (date) ddmm (date) extension **EXTENSION** None

Figure 17.8 The Batch interface naming and numbering options.

is a profile mismatch, Photoshop will check what you did previously. If you previously chose to keep the image in its own profile space, then this is how the images will be batch processed. If there is no profile present, Photoshop will check to see if your previous preference was set to: Ignore, Assign a profile, or Assign and convert to the working space, and act accordingly.

The action you are using for the batch process may contain a Save or Save As command that uses a specific file format and format settings. This action step will also have recorded a Save destination. Now it might so happen that the Save destination is an important part of the action. But if the destination folder no longer exists, the action will fail to work. And besides, you can specify a destination folder within the Batch dialog. So in the majority of instances, if the action contains a Save instruction, I recommend you check the Override Action: 'Save As' Commands checkbox. And if the action does not contain a Save or Save As command, leave it unchecked.

The file naming options let you define the precise naming and numbering structure of the batch processed files. For example, the existing file document name can be made capitalized or use lower case type. Figure 17.8 shows the complete list of naming and numbering options (these are also used in the Create Droplet dialog). If a folder is selected as the destination, you have six editable fields at your disposal. You can use any combination you like, but the file extension must always go at the end. As you edit the fields, you will see an example of how the naming will work on a nominal image called MyFile.gif.

Creating a droplet

A Photoshop action can be converted into a self-contained application, known as a droplet, that can be saved outside of Photoshop to somewhere useful, like the desktop. When you drag a document or a folder on top of a droplet icon it will launch Photoshop (if the program is not already running) and initiate a specific action sequence.

To make a droplet, go to the File \Rightarrow Automate menu and choose Create Droplet... Figure 17.9 shows the Create Droplet interface (the Create Droplet options are identical to those found in the Batch Actions dialog). Choose a location to save the droplet to and choose a destination folder for the droplet processed files. When you are finished, click OK. Droplets can play a useful role in any production workflow. They are effectively selfcontained Photoshop batch processing routines. I have got into the habit of keeping a folder located on the desktop specifically designed to contain Photoshop droplets and their associated destination folders.

	Create Droplet	
- Save Droplet In		OK
Choose) Macintos	h HD:PS Droplets2:Vignette frame	15% Cano
Play		
Set: Custom acti	ons 🗘	
Action: Vigenette fra	ame 15%	
Override Action "Oper	" Commands	
Include All Subfolders		
Suppress File Open Op		
Suppress Color Profile	Warnings	
Destination: Folder	•	
Choose):vignett	e frame folder:	
Override Action "Save File Naming Example: MyFile.gif		
Document Name	+ extension	• +
	+	+
	+	
Starting serial#: 1		
Compatibility: Wind	ows Mac OS Unix	
Errors: Stop For Errors		
Save As		
344C PR5		

Cross platform droplets

You can name a droplet anything you like, but to be PC compatible you should add a .exe extension. If someone sends you a droplet that was created using a PC, it can be made Mac compatible by dragging it over once to the Photoshop application icon.

Figure 17.10 When you drag and drop an image file on top of a droplet, this will launch Photoshop and perform a single or batch processing operation within the program. Droplets can perform Save and Close operations or save the processed results to an accompanying folder. I have an easily accessed folder on my main hard drive that contains dozens of droplets with their associated droplet folders.

Destination:	
/Volumes/Big Disk 400 (Browse)	Run
File Name Prefix:	Cancel
Web-layout	
Visible Layers Only	
- File Type:	
TIFF	
Include ICC Profile	
- TIFF Options:	1
Image Compression: None	Antra-
Quality: 8	
	1 Contraction
Please specify the format and location for	saving each

Figure 17.11 An example of the Export Layers to Files Script dialog from the Scripts menu in Photoshop.

Figure 17.12 The Script Event Manager is located in the File \Rightarrow Scripts menu. The dialog shown here is configured to trigger running a script that displays the name of the camera make whenever I open a Camera Raw file in Photoshop.

1	Canon, Canon EOS-1Ds Mark II, was used to shoot this file!	
	(ok	

Scripting

One of the most neglected aspects of Photoshop has been the ability to write scripts to automate the program and do more than you can with Actions alone. For most of us, the prospect of writing scripts is quite scary, and I freely confess I am one of those who has looked at the scripting manuals and simply shuddered at the prospect of learning how to do such computer programming. But steps have been taken to make this stuff more accessible to the general user. You can start by referring to the Photoshop Scripting Guide and other PDF documents about scripting that can all be found in the Photoshop CS2/Scripting Guide folder. You can also download pre-made scripts from the Adobe Studio Exchange website: http://share.studio.adobe.com.

But to start with, go to the Scripts menu in the Photoshop File menu. There are a few sample Scripts here to experiment with. Among these is a script that will generate a Web Photo Gallery from the Layer Comps in a file. And in Figure 17.11 I have shown the interface for the Export Layers to Files Script.

Script Event Manager

The Script Event Manager can be configured to trigger a Javascript or an action in Photoshop whenever a particular operation is performed. Below is a simple example of what can be done using scripting.

	Script Events Manager	
Enable Ev	ents to Run Scripts/Actions:	Done
Open Docun	nent: Display Camera Maker.jsx	Remove Remove All
Photoshop		Add
Script:	Display Camera Maker.jsx Manage your events by adding and removing. Select different javaScript files to get detailed descriptions.	

Image Processor

The Image Processor is located in the File \Rightarrow Scripts menu in Photoshop and can also be accessed via the Tools \Rightarrow Photoshop menu in Bridge. The Image Processor is a fine example of what Scripts can do when presented via an easy-to-use interface. The Image Processor basically allows you to select a folder of images (or use all open images) to process and select a location to save the processed files to. The Image Processor can then be configured to run a Photoshop action (if required) and save the processed files using either the JPEG, PSD or TIFF file formats. But it will also allow you to simultaneously process and save the files to more than one format at a time. So it is very handy if you wish to produce, say, a TIFF version at high resolution and a JPEG version ready to place in a web page design

		Image Pr	ocessor			
O Select	the images OUse Op	to process en Images				Run
O	· · · ·	ect Folder) No ir			oeen selecte	d
0.01.0				5		_ Load
Select		save processed imag Same Location	jes			Save
S.	• Sel	ect Folder)ge	process	or fo	lder	
File T	ype					—
	Save as	JPEG	🗹 Re	size	to Fit	
	Quality:	8	W:	450	рх	
	Conv	vert Profile to sRGB	H:	450	рх	
	Save as	PSD	Re	size	to Fit	
	Maxi	mize Compatibility	W:		рх	
			H:		рх	
	Save as	TIFF	🖂 Re	size	to Fit	
	LZW	Compression	W:		рх	
			H:		рх	
O Prefer	ences					
	n Action: ight Info:	Default Actions © Martin Evening 2	ment	sic w	orkspaces	Ð
	lude ICC Pr					

Preparing JPEGs for the Web

When you are preparing images that are destined to be shared by email or published via the Web, the Image Processor is a handy tool to use because you can not only resize the images as part of the image processing, but you can instruct the Image Processor to convert the image from its current profile space to sRGB, which is an ideal RGB space for general purpose web viewing.

Figure 17.13 The Image Processor (formerly known as Dr Russell Brown's Image Processor). This scripting dialog can be configured to process single or multiple images, applying a Photoshop action, with the ability to add copyright info and save the files to a designated folder location in one or more of the following file formats: JPEG, PSD or TIFF. The destination folder will contain the processed images and these will be separated into folders named according to the file format used.

Once configured, you can click on the Save... button to save the settings and load them again at a future date.

Martin Evening Adobe Photoshop CS2 for Photographers

Figure 17.14 The Crop and Straighten Photos plug-in can be used to extract scanned photos that need to be rotated and cropped.

Fi	t Image	
Constrain Within -		7
Width: 2173	pixels	(OK
Height: 2173	pixels	Cancel

Figure 17.15 The Fit Image dialog.

Automated plug-ins

The Automation features described in this section are all examples of Automated plug-ins. What distinguishes these from normal plug-ins is that they enable Photoshop to perform a complex set of procedures based on simple user input. Some Automated plug-ins are like 'wizards' that feature a step-by-step interface to guide you through various options and help you produce the desired result. Adobe have made Automated plug-ins 'open source' which means it is possible for third-party developers to have the means to build their own Automated plug-ins for Photoshop. I believe that Pixel Genius (of which I am a cofounder) are so far the only company who have made use of this feature in Photoshop to produce the PhotoKit, PhotoKit Sharpener and PhotoKit Color Automated plug-ins.

Crop and Straighten Photos

This Automated plug-in is very straightforward to use, if you have scanned images that need to be rotated and cropped. Gang up several images on your scanner, scan the pictures in as one image and choose Crop and Straighten Photos from the Automate submenu (note, this option is not available in Bridge). Photoshop will then create a rotated and cropped copy version of each picture. It kind of works, but only if the background has an absolutely solid color. Crop and Straighten therefore works best when processing scans of chrome transparencies and the border is deep black. But otherwise it sometimes helps if you make a selection around an individual image first.

Fit Image

Fit Image... is a very simple Automated plug-in that bypasses the Image \Rightarrow Image Size menu item. It is well suited for the preparation of screen-based design work. Enter the pixel dimensions you want the image to fit to, by specifying the maximum pixel height or width.

Contact Sheet II

The Contact Sheet II is able to take a folder of images or a selection of pictures from Bridge (or selected via the File \Rightarrow Automate menu in Photoshop) and combine them into a contact sheet. If there are more images in the folder than will fit a single page layout, then extra contact sheets will be produced. The Contact Sheet II dialog is shown in Figure 17.16. In the Document section you can define the contact sheet page size, color mode and pixel resolution. Below that is the Thumbnails section where you can set the number of rows and columns to be used in the layout. When the 'Use Auto-Spacing' box is checked, Photoshop will position the contact sheet images as closely together as possible. But bearing in mind that some images may be in landscape and others in portrait mode, there will still be some gaps between each image. If the Rotate For Best Fit box is checked, Photoshop will ignore the orientation of images and lay them out to achieve the best fit on the page. This means you will end up with something that looks more like a normal film contact sheet.

Adding captions to the contacts

Check the Use Filename As Caption checkbox if you want the file name to appear below each picture. There is a small selection of fonts to choose from in point sizes going from 4 point up to 72 point.

Source Image Use:	s Folder		ОК
	Choose		Cancel
		Il Subfolders	
Document			
Units:	Cm		
Width:	21		
Height:	29		Page 1 of 8
Resolution:	240	pixels/inch	9 of 69 Images W: 6.9 cm
Mode:	RGB Color		H: 9.1 cm
🗹 Flatten Al	I Layers		Press the ESC key t Cancel
Thumbnails -			processir images
Place:	across fi	Use Auto-Spacing	
Columns:	3	Vertical: 0.036 cm	
Rows:	3	Horizontal: 0.036 cm	
🗌 Rotate Fo	r Best Fit		
🗹 Use Filenar	ne As Captio	n	
		Font Size: 12 pt	

Contact Choot II

Figure 17.16 With the Contact Sheet II feature you can automatically produce contact sheet prints that make the best use of the space on the page.

Picture Package

The Picture Package can automatically produce a picture package page layout based on one or more images. Figure 17.17 shows how you could have a combination of a single 5×7 , with four smaller 2.5×3.5 sized images all oriented to fit within a single 10×8 print area.

Picture Package will normally generate a layout based on the frontmost image that is open in Photoshop. You can also select a specific file as the source or a folder, in which case a Picture Package will be created of every image in the folder, but this might take a long while to process.

If you double-click on any of the images displayed in the Picture Package layout preview, this will pop a Browse file dialog which will allow you to select an alternative image to replace one of the repeated images.

The Label section is useful if you wish to add, say, the file name or have the caption appear within the image area. For example, you could enter custom text, choose a low opacity and have it appear in the center of each image as a watermark (such as a copyright message). This labeling feature is still very limited as you cannot place the label outside of the image area (for example, just below each image). But you can now edit the layouts more easily.

The Picture Package Edit Layout dialog is shown in Figure 17.18. If you click on a template zone in the preview area an eight handle bounding box will appear around the selected template zone, allowing you to edit the size and positioning of each zone. You also have the ability to delete or add more zones, and create templates using different page sizes. If you check the Snap To box in the Grid section this will display a grid, which will make it easy to ensure that the zones you place are all neatly aligned.

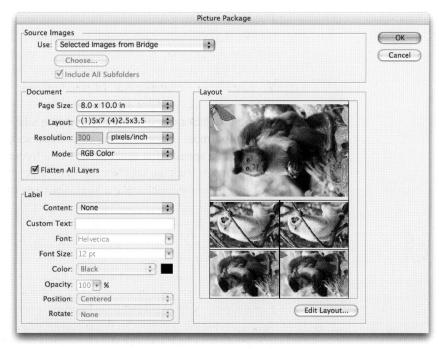

Figure 17.17 The Picture Package dialog box.

	ure Package Edit Layout
Layout Name: (1)5×7 (4)2.5×3.5 Page Size: Custom Width: 21 cm Height: 29.7 cm Units: cm Size: Add Zone Bize: Add Zone Delete Zone Delete All Position: X: 5.08 cm Y: 11.43 cm Crid: Size: 1.27 cm	Save Cancel

Figure 17.18 The Picture Package layout editor.

Photomerge

Photomerge is mainly used to stitch photographs together to create panoramic compositions. It's not a unique feature as there are other programs out there that can accomplish the same types of results with varying degrees of success. I would consider the Photomerge plug-in to be a fairly sophisticated tool and it is one I enjoy using myself whenever I want to capture a view that is wider than the lens on my camera will allow.

If you are planning to create a panoramic scene, then here are a few words of advice. You need to make sure that all the images overlap sufficiently, by at least 15%, and as you take your series of pictures, rotate the camera

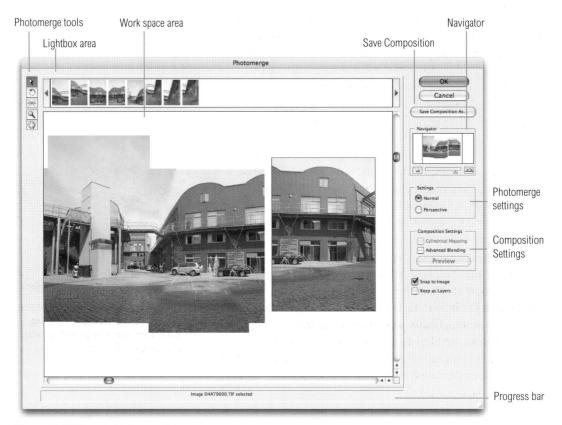

Figure 17.19 The main Photomerge dialog.

in gradual steps aiming to pivot the rotation around the center of the lens. And try to prevent the camera lens axis shifting about too much. You can do this by handholding the camera, but to get the best results, you could consider using a tripod head like the Pan head from Manfrotto, which when used with the angle bracket clamp, will enable you to capture images that align more easily in Phtomerge, because the center of rotation can be positioned accurately around the center of the lens axis.

You will generally get good results if you start with a simple composition that stitches together just a few shots rather than bombarding it with too many images. And before you shoot the photographs, set the exposure setting to manual so that the exposures are all consistent. And if you are shooting digitally, make sure that the white balance setting also remains the same (although if you shoot raw, you can apply a single white balance in the Camera Raw processing). The focal length must remain constant as well; do not attempt to zoom in or out as you are taking photographs. Wide angle shots are more tricky to stitch together, so try to use a focal length that is equivalent to a 35 mm lens on a 35 mm camera, or longer.

There are two ways you can use Photomerge. The easiest way is to use Bridge to select the images you want to merge and choose Tools \Rightarrow Photoshop \Rightarrow Photomerge. The other way is to launch Photomerge from the File \Rightarrow Automate menu, and click on the Browse button in the introductory dialog to select a folder of images, or browse through the folders on your computer to add specific individual files you wish to merge together, or select the Open Files, if they are already open in Photoshop. If you then check the box at the bottom, Photomerge will always attempt to automatically join images together.

If you have an already pre-saved Photomerge composition, you can click the Load Composition... button. This will load the saved composition data and locate the associated source files.

Use:	✓ Files			
	Folder Open Files		Browse)	
	D4AT9674.TIF D4AT9672.TIF D4AT9670.TIF		(Remove)	
	Open Compos	ition		

Figure 17.20 The Photomerge opening dialog. If you wish to load a pre-saved composition, there must be no images loaded in this dialog. Start with an empty dialog and click on the Open Composition button.

1 Gather together a selection of images that you wish to build a panoramic image with. I find that the best approach is to make an edited selection of photographs via Bridge and choose Photomerge... from the Bridge Tools ⇒ Photoshop menu.

2 As Photomerge launches it will open all of the images in sequence and attempt to auto stitch the pictures together. As you can see here, Photomerge was able to work out how to assemble six of the eight shots in the work area all by itself. The two shots that wouldn't auto match are held in the Lightbox area above. You can use the Navigator controls to zoom in and out of the work space area and scroll around the composition.

3 If you want to merge the remaining images held in the lightbox area, make sure the Select Image tool is active and the Snap to Image box is checked. Click on one of the above images, drag it into the work area. The image will appear semitransparent where it overlaps the underlying composition. This will enable you to judge where to position it so that the image registers as closely as possible to the rest of the composition. If the image does not appear to match too well, select the rotate image tool and rotate it slightly until it does.

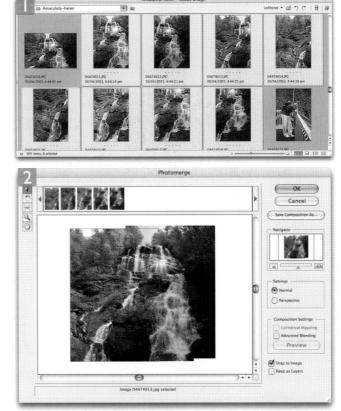

n - Adobe Bridge

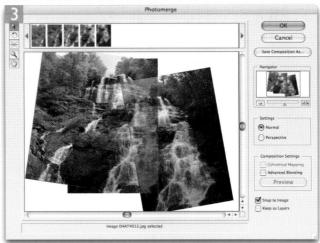

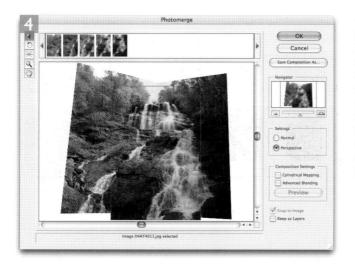

4 Once all the image components are in place, you can try making further improvements. If you click on the Perspective button in the dialog settings, Photomerge will adjust the composition preview, transforming each image component in order to achieve an improved composition perspective, centered around the currently active image, which will be the one outlined in red. If the perspective needs adjusting, select the set vanishing point tool and click in the work area to set a new vanishing point.

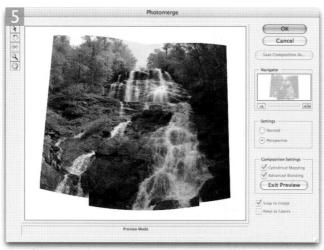

Save As:	amacalola.pmg	
Where:	Desktop	•
		Cancel Save

5 If the perspective correction produces a rather extreme looking composite image, check the Cylindrical Mapping button. This will implement the perspective correction to blend the images better, but the composite image will be rendered 'flatter'. If you check the Advanced Blending box, you can preview how the image will look using the improved blending mode. When Advanced Blending is selected. Photomerge will aim to produce the smoothest tonal transition possible between the composite images. I normally use this mode all the time. Click the Save Composition button if all you want to do for now is save the composition settings. To load a Photomerge setting, choose Photomerge from the Photoshop (not Bridge) File \Rightarrow Automate menu (see Figure 17.20) and click on the Load Composition button in the opening dialog. Photomerge settings can be saved anywhere, but they may fail to work if the source folder name is changed. Click OK to process the images and create a blended panorama. The Keep all Layers option will produce a layered file with the elements in register, as they appear in the composition.

Using Photomerge to align images

Photomerge can also be used to align the images in a photo composite. The example here illustrates how this feature might be applied to a typical job. This technique may prove particularly useful if you need to combine two or more shots from a group photo series, replacing people in a shot and aligning them with other consistent elements in the picture. You could also use this feature to combine a scanned negative or chrome with a print of the same picture.

1 In this example, I had four images shot from an identical viewpoint that I wanted to combine to make a single image composite. I selected the images in Bridge and opened them up in Photomerge with the Automatically Arrange Images option turned off.

2 I then dragged the images one by one into the work space area. Photomerge will attempt to align points of similarity in the images if the Snap to Image option is checked. The composition might look a bit weird, since Photomerge will be attempting to blend the images as if you were intending to stitch them together.

3 If you click the Keep as Layers checkbox and Click OK, Photomerge will align the images and convert them to a layered image, without any blending. In this example, I added layer masks to each of the layers in order to cut out each of the shots.

lvanced Blen

Snap to Image Keep as Layers

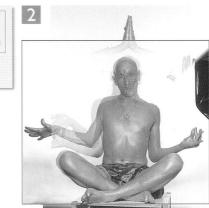

Automating Photoshop

Chapter 17

PDF Presentation

This Photoshop feature enables you to produce a multipage document or a slideshow presentation in a PDF format. PDF files can be read by various programs, including Adobe Acrobat and Adobe Reader. PDF Presentation is useful if you want to produce a portfolio slideshow, or a self-contained document containing a series of images that are going to be sent to a client. A feature like this should have great potential for the professional market, but its usefulness in this implementation of Photoshop is still disappointingly limited. Hopefully the interface design will be improved in the future to enable fuller control over the creation of PDF presentations.

> Figure 17.21 The PDF Presentation automation feature is capable of producing PDF documents from selected images. You can click on the Browse... button to select single or Shift select multiple images. Or check the Add Open Files box to select all files that are currently open in Photoshop. If you are using Bridge, you can make an image selection there and choose PDF Presentation from the Tools ⇒ Photoshop menu. You can choose to generate either a multi-page PDF document or a PDF Presentation slideshow. Both can be opened in any application that can read the PDF format, including Adobe Reader.

PDF Presentation can read files in RGB or CMYK color that are either layered or flattened. But there is no option in the PDF Presentation dialog to resize the files to fit within specific pixel dimensions. If you select a folder of master images to process, the image pixel dimensions will remain unchanged.

If all you want to produce is a compact slideshow that will fit specific pixel dimensions, you must carefully resize each image beforehand. The transition effects can be very pretty, but only version 6.0 or later of Adobe Acrobat or Adobe Reader are capable of rendering these on the screen.

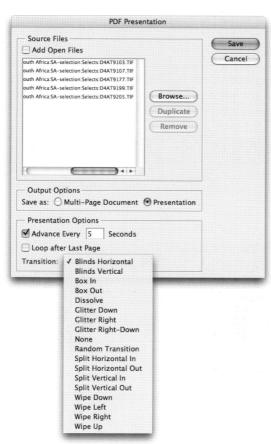

Figure 17.22 The Photoshop Help Center can be accessed from the Photoshop Help menu and it is able to offer cross application support for all the Adobe Creative CS2 Suite programs you have currently installed on your computer. The search feature is able to conduct a search based on words that are similar. So, for example, a search using the word 'grain', would return a list of possible topics ranging from Photoshop grain filters to how to remove noise and grain in Camera Raw.

Photoshop Help

When you find yourself stuck in Photoshop and in need of a quick and concise explanation of what a feature does, the Help menu in Photoshop is a good place to head to. The Photoshop Help Center shown in figure 17.22 has been revised and can now conduct contextual searches.

How To help files

This feature was first introduced in Photoshop CS. It is all very well having books like mine to help you understand the program, but there are times when you want quick answers and solutions without having to flick through manuals. The How To menus can be found in the Help menu. A selection of How Tos are included already with the program and these cover a variety of subjects. The How To format can also be adapted and used by anyone who wishes to write and publish their own How To help files. These can be shared or published in the same way Actions and other Photoshop settings can be distributed between fellow users.

Figure 17.23 The How To shown here was created by Rod Wynne-Powell, who is the technical editor of this book.

Chapter 17 Automating Photoshop

Export Transparent Image and Resize Image

These last two Automation plug-ins are located in the Help menu. The Export Transparent Image interface starts by asking you whether the purpose of the final image is for print or online use. For example, if you want to make a transparent GIF and there is no selection currently active, it will tell you to cancel and make a selection first. From there on it will duplicate the current image and ask clearly put questions about the intended final output and guide you towards that desired goal. The Resize Image Automation plug-in also has a clearly designed interface and takes the user step by step through the process of sizing an image for reprographic or online use (see Figure 17.25).

Resize Image Assistant

What is the desired size of your image?

inches 🛟

inches 🛟

Figure 17.24 The Resize Image Assistant can help you resize your images to the optimum resolution for multimedia or print output, based on the resolution of the print screen used. A warning may appear if the image is too small to be enlarged for print, which will suggest the image may need to be rescanned.

Figure 17.25 The Export Transparent Image Assistant will require the image to be either: against a transparent background, or you need to make a selection first of the area to be made transparent. The Export Transparency Assistant will then guide you to make a transparent GIF or PNG format image for the Web or a transparent image for print.

Width: 8

Height: 4.9

Let Photoshop take the strain

If Photoshop can do something quickly and effectively, it makes sense to do it on the computer rather than waste time in the studio when you could be more productive and creative attending to other important things. The Automation tips and tools discussed in this chapter should go a long way to reducing the time you spend huddled over the computer, when you could be doing something more relaxing instead! Furthermore, I hope the tips and techniques demonstrated throughout have helped you understand more about the power of Photoshop as a professional quality image editor.

Don't forget that the CD that comes with this book contains a PDF of all the Photoshop shortcuts and features some of the tutorials as movies. There is also a website for the book: www.photoshopforphotographers.com. This contains an FAQ section and email support links to help people who are experiencing problems running the CD movies.

And lastly, I want to thank you for buying this book and if you liked it, then let myself, or my publishers know. And do tell us what other things you would like to see covered in future editions. Working with Photoshop has proven for me to be a fascinating and rewarding experience. It literally changed my life and the way I work and opened up many new avenues to explore!

Appendix

ost of the photographs you see in this book were taken by myself. Some were from commissioned assignments, others are personal shots. I also asked friends and colleagues to include work too, all of whom are professional photographers. Here then is some biographical information on the other contributors whose work has been featured. This is followed by a double page spread with special offers that have been specially arranged just for readers of this book.

Davis Cairns

A partnership specializing in fashion accessory still-life photography with clients who include Red or Dead Ltd and Paul Smith. Davis Cairns are currently moving into more portrait and fashion-based work with an emphasis in portraying creative textiles. I have worked on all the Davis Cairns computer retouching work and a number of these commissioned and personal images were used in this book.

Email: sara@daviscairns.demon.co.uk

Laurie Evans

Laurie Evans was born in Scotland in 1955. Having studied photography at art school he spent two or three years as a rock and roll photographer before coming to London to seek his fortune. Transferring his interests to still life, and always a passionate cook, he quickly found that he could combine work with pleasure as he discovered the joys of food photography. He works extensively in the advertising and design industry and contributes to a broad range of magazines in the UK and abroad, and has also illustrated more than 40 cookbooks. He is married, has two sons and lives and works in London.

Tel: +44 (0)20 7284 2140 Email: Laurieevans@btconnect.com

Thomas Fahey

Originally from Oklahoma, he opened his Atlanta studio in 1990. His photography takes him from New York to Miami and occasionally overseas to London and Milan. He is a regular cover and feature photographer for Atlanta magazine, among others, and his pictures have appeared in numerous advertising campaigns. Formerly, Thomas trained and worked as an archival photographic printer and worked as a photojournalist. Today, he enjoys a diversified client base and relies on his Mamiya RZ, Pentax 6x7, Norman light control and an indispensible G4 workstation. Tel: 001 404 355 5948

Email: faheystudio@bellsouth.net Web: www.thomasfahey.com

Peter Hince

Peter Hince is an advertising photographer specializing in people/lifestyle. He works mainly on location throughout the world and is very experienced with big productions and 'round the globe' projects. He also has a unique style of underwater work and produces toned and textured black and white shots for his 'Ocean Images' collection. His work has won many advertising and photographic awards. Tel: +44 (0)20 7386 0244 Email: peter.hince@btinternet.com

Eric Richmond

Eric Richmond is an American born resident of London, specialising in arts-based photography. His clients include the Royal Ballet, English National Ballet and Birmingham Royal Ballet. Other commissions include posters for West End theatre productions, CD covers, publicity photos for various orchestras, actors, singers and musicians. He might not have gone to all this trouble if he had been a better guitar player.

Tel: +44 (0)20 8880 6909

Email: eric@ericrichmond.net Web: www.ericrichmond.net

Jeff Schewe

Jeff Schewe is an award winning veteran advertising and commercial photographer based in Chicago. Jeff is a leading pioneer in digital imaging – his first assignment digitally imaged was in 1984. He's been a Photoshop alpha tester since version 4.0 and is also a member of Canon's Explorer of Light program and an Epson Stylist Pro. Jeff is a founding partner of PixelGenius Software and led development of the original PhotoKit. Tel: 312-951-6334

Web: www.schewephoto.com

Rod Wynne-Powell

Once again Rod has provided valued support in the checking of what has gone into this book, verifying that what has been written works as indicated, and offering ideas for inclusion and expansion. He continues to work as a beta tester, and latterly a late alpha tester of Photoshop.

For those who avail themselves of his services, this time spent working alongside other testers worldwide provides sound in-depth knowledge of the program; the ways in which it can improve workflow and techniques it offers when creating images, and generally extracting the most out of digital imagery.

His earlier experience of professional photography, his time with a central london colour laboratory, and his extensive knowledge of Mac operating systems and hardware, all combine to create a very valuable resource. And he can still be found contributing to other subscribers on the ProDIG List.

Sitting in the studios of photographers in the UK (and even the south of France), has allowed his clients to gain some useful insights into how Photoshop can extend creative control over their images. There are probably readers of these paragraphs nodding their heads in agreement. He enjoys the challenges and the satisfaction that his work brings to theirs, whether he is there to train or retouch. He speaks the same language and feels the relationship is aptly described by a word in common currency – Synergy.

Tel: +44 (0) 1582-725065 Email: rod@solphoto.co.uk Mobile: +44 (0) 7836-248126 Skype name: rodders63

SOLUTIONS photographic

In the last of its teenage years 'SOLUTIONS photographic' is a mature, but very much up-to-date, consultancy within the digital photographic market.

Non-trivial retouching is still a strong forté, with catalogues and annual reports continuing to feature unseen creative help.

The variety of clients and differing styles of work range from multi-nationals, direct clients and Design Groups to individual photographers and designers. Mostly obtained by word of mouth, this has been a powerful advertising medium.

Due to continuing adoption of broadband, much of the work can be handled remotely. There are even those whose guidance through complicated techniques is done via the telephone, with conversations that clients initiate, and begin with the words: 'Good morning, start the clock...' This has been known affectionately as Rod's 'Flying Doctor' service – the beauty of this sort of involvement is immediacy – nothing beats a calm and patient guide when you are in the midst of a crisis!

colourmanagement.net: neil barstow

Remote profiling for RGB printers

You have just been reading one of the best digital imaging books in the marketplace. Now you'll probably want to be sure your colour is as good as it can be, without too much back and forth when printing. Lots of print testing to achieve expected colour really does use up the ink and paper, but, more importantly it uses up the creative spirit. We'd like to offer you a deal on a printer profile. Just download the profiling kit from: www.colourmanagement.net/profiling_inkjets.html.

The kit contains a detailed manual and color charts. We ask you to print the charts twice, so we can compare the sets to check printer continuity. You post them to us.

We will measure both sets of charts using a professional auto scanning spectrophotometer. This result is then used within high-end profiling software to produce a 'printer characterisation' or ICC profile which you will use when printing. Comprehensive instructions for use are included.

You can read a few comments from some of our clients at: www.colourmanagement.net/about.html.

Remote RGB profiles cost £95 plus VAT. For readers of 'Adobe Photoshop CS2 for Photographers', we are offering a special price of £60 plus VAT. If our price has changed when you visit the site, then we will give you 20 percent off.

Coupon code: MEPCSFP401

We sell Display Profiling equipment etc. too.

Consultancy services

Neil Barstow, color management and imaging specialist, of www.colourmanagement.net, offers readers of this fine book a discount of 12.5% on a whole or half day booking for consultancy. Subject to availability and normal conditions.

Coupon code: MEPCSFP402.

Please note that the above coupons will expire upon next revision of Adobe Photoshop for Photographers. E&OE.

Pixel Genius PhotoKit plug-in discounts www.pixelgenius.com

PhotoKit

Analog Effects for Photoshop

This Photoshop compatible plug-in is designed to provide photographers accurate digital replications of common analog photographic effects. PhotoKit is quick and simple and allows for a greatly enhanced workflow. Priced at \$49.95.

PhotoKit SHARPENER

A complete Sharpening Work flow for Photoshop

Other products may provide useful sharpening tools, but only PhotoKit SHARPENER provides a complete image "Sharpening Workflow". From capture to output, PhotoKit SHARPENER intelligently produces the optimum sharpness on any image, from any source, reproduced on any output device. But PhotoKit SHARPENER also provides the creative controls to address the requirements of individual images and the individual tastes of users. PhotoKit SHARPENER is priced at \$99.95.

PhotoKit Color

Creative color effects for Photoshop

PhotoKit Color applies precise color corrections, automatic color balancing and creative coloring effects. This plug-in also provides a comprehensive suite of effects that lets you recreate creative effects like black and white split toning and cross processing. PhotoKit Color is priced at \$99.95.

Pixel Genius is offering a 10% discount on any whole order, which must be placed from the Pixel Genius store at: www.pixelgenius.com. This is a one-time discount per email address for any order made from Pixel Genius. This coupon will not work on affiliate sites. Also it cannot be combined with other discounts or programs except for certain cross-sell items. Please note that this coupon will expire upon next revision of 'Adobe Photoshop for Photographers'.

Coupon ID: PSFPCS2ME

PHOFOKIT SHARPENER

Index

Symbols

16-bit editing 164–165, 410–413 color space selection 165 32-bit editing 9, 166–170 64-bit processing 95

A

Absolute Colorimetric 521, 551 Acrobat format (PDF) 562 notes 89 Actions 49, 636-642 Batch Actions 641 creating droplets 643 editing an action 639 including text 639 inserting a Stop 640 inserting menu items 640 inserting menu items 640 limitations 637 playing an action 636 recording 637, 640 sourcing actions 636 stop and pause 640 troubleshooting 639 Activation 22 Actual pixels viewing 91 Adaptive Web palette 581 Adding a border 351 Adding a layer mask 275 Adding glows 364 Adding shadows 364 Add noise to a layer 250 Adjustment layers 50 change layer content 278 cumulative adjustments 160 Adobe Gamma 105-107 Adobe GoLive 593, 594 Adobe Help Center 18 Adobe Illustrator 558

Adobe ImageReady CS 593-597 Adobe InDesign 558 Adobe PageMaker 558 Adobe PDF 562 Adobe Photoshop Album 613, 620 Adobe Reader 655 Adobe RGB 489 Adobe Stock Photos 603, 626 Adobe Transient Witticisms 55 ADSL Internnet 568 Advanced color settings 509 Advanced layer blending 290 Agfa 407 Aim prints (for proofing) 550 Aligning images 654 Aligning layers 64, 300 Align layers 64 Alpha channels 52, 261 AltiVec 97 Animated GIFs 598 Animation palette 18, 599 Annotation tools 89 Anti-aliasing 266 Anti-aliasing filter 425 Appending file names 114 Apple Cinema display 546 Apple Display Calibrator 105-107 Apple RGB 488 Apply Image 314 Arbitrary map mode (curves) 204 Arrow heads 88 Artifacts 474 Art history brush 76 Assigning shadows and highlights 142 Assign Profile 502 Auto-update documents 112 Automatic Levels 140 Automatic masking 320 Automation 17 Automation plug-ins 641, 646

Auto Color 196 Auto contrast 196 Auto Levels 196 Auto select layer 64

В

Background eraser find edges mode 78 Background printing color 535 Backwards compatibility 114, 128 Banding 250 use dither option 510 Barco Calibrator monitor 98, 100, 491 Barstow, Neil xxviii, 481, 532, 662 Batch processing 641 Batch renaming 624-625, 628 Bayer pattern 418 Beauty retouching 252-256 Betterlight camera 427 Bibble 430 Bicubic interpolation 112, 473 Bicubic Sharper interpolation 474 Bicubic Smoother interpolation 474 Big data 67.177 Bilinear interpolation 473 Binuscan 407 Bitmapped images 410 Bit depth 410 Black and white from color 326 Black generation 517 Black Point Compensation 140, 510, 537 Blatner, David 555 Blending modes 161, 285, 285-289 Color 195, 240, 247, 289, 329 Color Burn 286 Color Dodge 286 Darken 255, 285, 305, 352 Difference 288, 290 Dissolve 285 Exclusion 289

Hard Light 287 Hard Mix 288 Hue 289 Lighten 255, 286 Linear Burn 286 Linear Dodge 287 Linear Light 288 Luminosity 163, 188, 247, 289, 339 Multiply 161-162, 285, 351 Normal 285 Overlay 237, 287 Pin Light 288 Saturation 289 Screen 161, 162, 286, 337 Soft Light 240, 287, 346 Vivid Light 287 Blend interior effects 290 Blurring along a path 251 Blur filters 374-376 Blur tool 84,251 Border effects 351 Box Blur filter 378 Bridge 2,21-22, 434, 601-629 adding new folders 606 Apply Camera Raw settings 625 Batch Rename 624-625 Bridge preferences 127, 619 Bridge work spaces 608 cache 129, 618-619 cache building routines 612 cache updates 129 compact mode 604 content area 606-607 custom views 605 custom work spaces 608 deleting contents 604 Details view mode 607 Edit History log 617 Export Cache 612 Favorites panel 612 File Info 614 File Navigator work space 608 filmstrip mode 607

Filtering images 622 Folders panel 612 folder cache 612 horizontal filmstrip work space 609 image cache 618 image rating 2,621 image rotation 603 image searches 623 Keywords panel 612-613 Labeling 621 launch options 113 Lightbox work space 608 managing images 620 Metadata Focus work space 608 multiple windows 610 Preview panel 604-605 refreshing the view 622 renaming schemes 624 search criteria 623 sidecar files 619 Slideshow 4, 25, 611 Sort menu 622 Tools automation 624, 641 undoing a Batch Rename 625 Bridge and Camera Raw 434, 601 Bridge Center 626 Bridge history 603 Broadband cable 568 Broback, Steve xxviii Broncolor 426 Brown, Russell xxviii, 17, 222, 248, 328.645 Browser preview 578 Browser safe colors 580 Bruno, Andrea xxviii Brushes 43 Shape dynamics 46 Brushes palette 44, 239 Brush attributes 44 Brush blending modes 252 Brush controls 254 Brush cursor 117

Brush cursor options 117 Brush tool 70 Building a printer profile 540 Bunting, Fred 481, 555 Bureau scans 413 Burning in a photo 244–245 Burn tool 85,244 Bus connection 97 Byte order 559

C

Cable Internet 568 Cache memory 96 Cairns, Davis 660 Calibration 99-101, 490 Calibration bars 535 Camel Ink Systems CRS 532 Camera chip performance 422 Camera exposure 134 Camera Raw 4-5, 26, 425, 434-461, 601 Adjust panel controls 442-443 Auto Settings 443 black and white conversions 457 Calibrate panel controls 451-454 Camera Raw profiling 492 Camera Raw settings 455-456 Camera Raw tools 436 Chromatic Aberration 448 compatibility 434 cropping 458 Curve panel 459-460 Custom configuration 455 deleting images 440 Detail panel controls 446-447 Exposure controls 442-443 General controls 436-439 image browsing 440-441 Lens panel controls 448–449 Lens settings 448 multiple raw conversions 459-461 opening multiple files 439 Panel previews 446

removing a crop 458 Save options 439 Save settings 455-456, 458 Save Settings Subset 457 shadow and highlight clipping 443 Smart Objects 459 straighten tool 458 vianette control 449 white balance 442 camera response times 425 canned profiles 531 Canon EOS 1D 425 EOS 1Ds 417 EOS 1Ds MkII 405, 418 injet printers 529 Canvas canvas size 176 changing color 83 Caplin, Steve xxviii Capture One 430 Cascading Style Sheets 579 CCD cameras 416-417 CCD scanners 407 **CD-ROM** 110 CD recorders 462 Channels 52, 259 Channels palette make new channel 260 make selection 261 Channel Mixer 278, 330 Character palette 42, 87, 370 Chip acceleration 96 Chip speed 97 Chromapress 554 Chromatic aberration 10, 388 Cintig input device 110 Classic Photoshop CMYK setup 513 Cleaning camera chips 425 Cleanup tool 320 Cleanup tool (Extract command) 322 Clear guides 33 Clipboard 112 Clipping masks 318–319

Clipping paths 146, 324, 561 Clone stamp 70 Clone stamp tool 219-221, 239 Cloning 70, 219-221 CMMs 486 CMOS cameras 417 CMYK CMYK conversions 513 CMYK myths 513 CMYK settings advanced 516 CMYK setup 513-514 CMYK to CMYK conversions 524 gamut 38 proof 549 separation setup 514 CMYK proofing 550 CMYK separation guidelines 518 CMYK skin tones 215 ColorByte 553 Coloring a black and white 252 Colorize hue/saturation 210 Colourmanagement.net 662 ColorMatch RGB 489 ColorVision 103 Color Balance 195 Color blend mode 289 Color Burn blend mode 286 Color Dodge blend mode 286 Color management 109 Color Management Modules 486-487 Color management off 499 Color monochrome filters 326 Color overlays 346 Color palette 47 Color Picker 81, 92, 112, 260 Color policies 496 Color proofing 549 Color Range 214 Color Replacement brush 212-213 Color sampler tool 90, 202 Color settings 109, 495 advanced color settings 509

ask when pasting 503 Color settings files 504 saving color settings 504 Color temperature 205, 442 Color toning 329 Color vision trickery 482 Color wheel 193 colourmanagement.net 532 Compact Flash 424 Computer mail order 111 system maintenance 131-132 Connor, Kevin xxviii Contact Sheet II 647 Contax 420 Contextual menus 57, 633 Contiguous selections 59 Continuous inkflow system 532 Continuous tone prints 527 Contours 366 Contour editor 367 Contract proofing 549 Convert to Profile 498, 500-501, 524, 528, 546 Convert to Shape 584 Convert to Working space 498 Corrupt files 26 Cox. Chris xxviii Create droplet 643 Create Layers 362 Create New Brush 43 Creating a new document 471 Crop and Straighten Photos 646 Crop tool 66 Cross-processing 339-343 CSI Lightjet 527 CTP 549, 554 Curves 150, 200-204 color correction 200-203 Customizing RGB color 512 Custom brushes 44 Custom CMYK 513, 549 Custom gradients 81 Custom ink colors 515

Custom shapes 372 Cutout images 146

D

Darken blend mode 285 Data Rescue program 132 Dean Allen, Sheri xxviii Debevec, Paul 166 Deficiencies of grayscale 334 Define custom shape 372 Delete preferences 112 Denley, Margaret xxviii Density range 405 Desaturate monitor colors 511 Desaturate with sponge tool 85 Determining output size 470 Dicomed 416 Difference blend mode 288 Digimarc 631 Digital cameras 416-418 dust removal 425 multishot exposures 422 Digital exposure 444-445 Digitizing pad 110 Direct selection tool 269 Disk Doctor 132 Disk performance 123 Disk Warrior 132 Displace filter 386-387 Display 97 gamma 100 Display & Cursors 117 **Display calibration** 99 **Display Calibration Assistant** 106 **Display profiles** 491 Dissolve blend mode 285 Distribute layers 64 Distribute linked layers 300 DNG file format 4, 431-433 Document profile 31, 496 Document window 30 Dodge tool 85, 244 Dodging a photo 244-245

Donaldson, Christina xxviii Dots per inch 467 Dot gain 515 Dot gain curves 516 Droplets 643 Drum scanners 406 Duotones 334 Duotone options 335 Duplicate an image state 72 Dupont Cromalin 549 Durst Lambda 527 DVD 110-111.630 DVD recorders 462 Dynamic Color Sliders 113 Dynamic fill layers 160 Dynamic range 422

Е

Easter eggs 55 Edge highlighter tool 321 Edge touchup tool 320 Edit history 113, 617 Edit menu fade command 337 Keyboard Shortcuts 634 Efficiency 31, 123 Eismann, Katrin xxviii Electronic publishing 562-565 eMac computer 95 Email attachments 568 Endpoints setting them in Levels 142 Epson 10600 530 2100/2200 530 5000 549 7600 531,553 9600 530 Epson 4000 532 Photo Stylus 1290 535 Stylus Photo 529, 530 Ultrachrome printers 553 Epson inkjet printers 529

Eraser tool 77 Erase to history 77 Evans, Laurie xxviii, 660 Exchange foreground/background 92 Exclusion blend mode 289 EXIF metadata 436, 575, 615 Export Clipboard 112 Export image cache 612 Export Transparent Image 657 Exposure 137 ExtendScript Toolkit 127 Extensis Mask Pro 3.0 302 Extract command 79, 304, 320-323 smart highlighting 79 Eye-One 103, 490, 493 Eye-One Display 104 Evedropper tool 90, 142 Eye retouching 236-238

F

Fade command 188 Fahey, Thomas xxviii, 660 Fibers filter 399 File extensions 114 File formats 556-560 CompuServe GIF 576 DCS 561 DNG 431-433 EPS 53, 560 Encoding 560 Image Interpolation 561 Include Halftone Screen 560 Include Transfer Functions 560 Include Vector Data 561 PostScript Color Management 561 Preview display 560 for the Web 571 GIF 114, 576 GIF transparency 582 JPEG 114, 571, 645 baseline optimized 574 baseline standard 574 optimized JPEG 578

JPEG 2000 575 JPEG compression 558 Lossy GIF format 582 Maximum compatibility 557 PDF 370, 562-565, 570 Photoshop 557 PICT 566 PNG 585 PSB 116, 558 Raw Binary 115 Save options 566 TIFF 115, 125, 558 compression 558 File Handling 114 File header information 27 File Info 614 File menu Automate 641 preferences 112 plug-ins 120 scratch disk 120 File ompression LZW compression 558 File Transfer Protocol 569 Fill layers 47 Filter Gallery 385 Filter menu Blur Average Blur 376 Box Blur 12, 378 Gaussian Blur 246-247, 312, 374 Lens Blur 380-383 Motion Blur 376 Radial Blur 301, 374 Sampled Blur 378 Shape Blur 13 Smart Blur 376 Surface Blur 12, 378 Distort Displace 386-387 Fade filter 378 Lens Correction 388-389 Liquify 390-396

bloat tool 390 freeze/thaw 393 freeze tool 390 pucker tool 390 reconstruct tool 390 reflection tool 390 shift pixels tool 390, 395, 397, 399 thaw tool 390 turbulence tool 396 twirl clockwise tool 390 warp tool 390 Noise add noise 250 dust & scratches 222-223 median 376 reduce noise 248-249 Other high pass filter 191 maximum 316 minimum 309 Pattern Maker 233, 384 Photo Filter 205 Render 3D transform 399 clouds 402 fibers 399 lens flare 403 lighting and rendering 399 lighting effects 399-401 .Sharpen Smart Sharpen 189 Unsharp mask filter 182 Fine art inkjets 532 Finger painting 84, 251, 631 FireWire 110.123 FireWire out 19 Fit image 646 Fit to screen view 32, 91 Flash FXP 569 Flash memory 424 Flatbed scanners 407 Flat panel LCD displays 98 Flextight CCD scanner 407

Floating windows 98 FM screening 470 Font Size custom UI font size 112 Foreground/background 92 FotoStation 430 Foveon X3 CMOS chip 417, 418, 420 Fractional widths 370 Fraser, Bruce xxviii, 188, 451, 481, 548.555 Freehand lasso tool 60 Free Transform 296, 299, 315 fsck disk checking 132 fsck repair instructions 132 FTP software 569 Fuii 424 Lanovia 407 Pictrography 527 S602 417 Super CCD 417

G

G5 Macintosh 95 Galbraith, Rob 424 Gamma 104 Gamut warning 214 Gaussian Blur filter 374 Gauthier, Karen xxviii GCR separations 516 General preferences 112 General Purpose presets 496 GIF file format 576 Gorman, Greg xxviii GPS metadata 620 Gradients noise gradients 350 Gradient banding 250 Gradient Fill 80 Gradient Map coloring 350 Gradient tool 80, 319 transparency stops 81 Graphic tablet 68

Grayscale color management 508 Grayscale conversions 326 Grayscale management 508 Grayscale mode 410 Grayscale proofing on screen 335 Gretag Macbeth 103, 348, 490 color target 540 Eye-One 490, 493 ProfileMaker Pro 492, 493, 545 Grid 33, 120, 174 Group Layers 281 Guides 120 adding new guides 33

H

Hair retouching 239 Halftone factor 469 Hamburg, Mark xxviii, 75 Hand coloring 348 Hand tool 91 Hard drives 123 Hard Light blend mode 287 Hard Mix blend mode 288 Hasselblad 420 HDR conversion 169 Healing brush 69, 219, 224-227 Heidelberg 407 Help Center 18 Help menu 656 Hewlett Packard printers 529 Hexachrome 484 Hexadecimal web colors 47 HexWrench 484 Hide crop 177 Hiding the palettes 93 HiFi color 561 Highlight detail how to preserve 146 High Dynamic Range imaging 9, 166 High Pass edge sharpening 191 Hill, Brian 131 Hince, Peter xxviii, 660 Histogram 134

Histogram palette 39, 149 History 28, 65 memory usage 73 non-linear history 310 History brush 71-72, 222 History log 618 History palette 49 Holm, Thomas xxviii, 246, Hooper, Marie xxviii Horwich. Ed xxviii Hot mirror filters 426 How To files 656 HSB color model 210 **HTML 593** Hue/Saturation 210-211 Hue blend mode 289 Hyphenation 370

I

i3 Forum 587 IBM Microdrive 424 ICC color management 485-486 Ideal RGB space 489 iDisk 569 Illegal colours 38 Imacon xxviii FlexColor 3.6 409 Flexframe 4040 423 Flextight 646 407 Flextight 848 407 Flextight Photo 407 Flextight scanners 408 Ixpress 384 423, 425, 427 ImagePrint 553, 558 ImagePrint 5.6 553 ImageReady 593 animation 597 Animation palette 599 auto regenerate 597 document preview tool 597 image slicing 594 layers 594

linking slices 596 rollovers 595, 596 slice content 596 slice tool 595 styles 596 ImageReady CS2 593-597 Image Access (ISP) 569 Image adjustments Arbitary map curves 333 Auto Color 196 Auto Contrast 196 Auto Levels 142, 196 Brightness/Contrast 148 Channel Mixer 327, 330, 344-345 Color Balance 195, 329 Curves 150, 200-204 Exposure 137 Hue/Saturation 210-211, 326, 328 Levels 138, 140, 194, 198-199 Match Color 206-209 Replace Color 215 Selective Color 216 Shadow/Highlight 154 Amount 154 CMYK mode 157 Color Correction 157 Midtone Contrast 157 Radius 155 Tonal Width 154 Variations 193 Image cache 122, 125, 612 Image cache management 618 Image interpolation 473 Image Processor 645 Image security 631 Image Size 472 Image window 28 Indiao 554 Info palette 15, 38, 198, 524-525 infrared simulation 336-338 Inkjet media 531 Inkjet papers 545 Inkjet printers 529

Ink Colors 514 Input profiling 492 Interlaced GIFs 580 International Color Consortium 486 Internet Service Providers 569 Interpolation 421, 473 Iomega Zip 110 iPhoto 620 IPTC Metadata 592, 614 IRIS/IXIA printer 529 iTunes 620 iView MediaPro 430

J

JavaScript 588 Jitter 46 Johnson, Carol xxviii Johnson, Harald 555 Johnson, Stephen 427 Johnston, Gwilym xxviii JPEG 2000 file format 120, 575 JPEG compression 572, 573 JPEG file format 571 JPEG noise removal 249 Jump To application 93,112, 594 Justification (type) 370

K

Kennedy, Georgia xxviii Keyboard shortcuts 65, 217, 633–635 Keystone correction 174 Keywording 613 Knockout blending 290 Knockout layers shallow knockout 291 Knoll, John 373 Knoll, Thomas xxviii, 373 Kodak DCS ProBack 423 DCS ProBack 423 DCS Pro 14n 417, 418 Photo CD 414 Picture CD 415

L

Lab color conversions 326, 524 Lab color effects 339, 342-343 LaCie Electron BlueEye 101 pocket drive 627 Lambda printer 527, 554 Lasso tool 56, 60 Lave, Mike xxviii, 478 Layers 50, 300 adjustment layers 272 clipping paths 324 deleting multiple layers 271 fill opacity 363 group linked 318 group with previous layer 310 image layers 271 layer linking 283 layer locking 284 layer mask removing 276 layer masks 276 Layer styles 347 linking layers 282 linking layer masks 283 masking layers 275-278 matting defringe 304 multiple lavers 279 new layer/copy layer 271 shape layers 272 text layers 272 vector masks 277 Layers palette 16 Laver arrange menu 300 Layer comps 51, 598 Layer effects 47, 87, 354-365 Bevel and Emboss 358, 366 Color Overlav 360 Create Layers 362 Drop Shadow 355, 366 Gradient Overlay 359 Inner Glow 357

Inner Shadow 356 on image layers 362-363 Outer Glow 357, 364 Pattern Overlay 360 Satin 359 scale effects 362 Stroke 361 Laver effect contours 366 Layer groups 279-281 lock all layers 281 moving layers in a group 279 Laver group blending Pass Through mode 291 Laver locking 284 Layer masks 309 Layer number limits 271 Laver selection 64 Layer visibility 271 LCD hardware calibration 491 Legacy Serial Number 121 Lens Blur filter 380-383 Lens Correction filter 10, 388-389 Lens Flare filter 403 Levels 137-138,194 color correction 198-199 threshold mode 138 Lighten blend mode 286 Lighting and rendering 399-403 Lighting effects 400-401 Lightprobe images 166 Linear Burn mode 286 Linear Dodge mode 287 Linear Light mode 288 Lines per inch 467 Linoscan 407 Linotype 407 Liquify filter 390 Lock guides 33 Lock image pixels 284 Lomas-Walker, Lucy xxviii Lossy compression 571, 573 Lotto, R. Beau 482 Lumijet inks

Monochrome Plus 532 Luminance sharpening 188 Lyson Fotonic inks 532 Quad Black 532 Small Gamut 532 LZW compression 558

Μ

Macaroni 131 Macbeth, Gretag xxviii Macintosh gamma 508 Macromedia Flash 599 Mac Janitor 131 Mac maintenance programs 131 Mac OS X 112, 130-131 print center 533 Magic eraser 77 Magic wand 56, 59, 264 Magnetic lasso 56, 60, 63 Magnetic pen tool 86 Managing your images 620 Map GIF Colors to transparent 582 Marguee tool 56 Marrutt 554 Masking hair 312 Mask channels 260 Mastering Digital Printing 555 Matchlight software 302 Match Color 206-209 Match Location 91 Match Zoom 91 Maximize backward compatibility 114, 557 Measure tool 90, 175 Median Noise filter 376 MediaStreet Niagra II 532 Megapixels 464 Megapixel limits 420 Memory 15 clearing the memory 124 Memory & Image Cache 125 Memory cards 424

Memory management 122 Memory Sticks 424 Menu customization 14, 217, 635 Menu font size 14 Merge to HDR 9, 166-169 Merlin 55 Metadata 613-617 preferences 127 Metadata palette 617 Metaframer script 17 Metallic layer effects 366 Metamerism 545 MetaReader[™] 616 Microtek 407 Missing profiles 496 MIS Cobra CFS 532 MIS inks Quadtones 532 Variable mix 532 Mitsubishi SpectraView 101 MMX 97 Modifier keys 57-58 Moiré patterns 246-247 Monaco Optix XR 490 Monaco Systems 103 Monitor calibration 99 Monitor display 97 Monitor gamma (PC) 508 Monitor profile creation settings 491 Monitor Spyder 103 Montages 302-323 Motion Blur filter 301, 376 Move tool 64 Multiple undos 71 Multiply blend mode 285 Murphy, Chris 481, 555

Ν

Nack, John xxviii Nash, Graham 529 National Air and Space Museum 306 Navigator palette 37, 91 Nearest Neighbor interpolation 473 Nested layer groups 279 Neutral gray tones 198, 525 Neutral RGB color 198 Nikon 407, 421 D1H 425 LS4000 408 LS8000 408 Noise gradients 80 Noise Reduction filter 11 NoMoreCarts CIS 532 Nonlinear history 74 Norton Utilities 132 Numeric transform 64,299

0

Olympus 424 E-1 421 Four thirds system 420 Online print services 533 Onyx 131 PosterShop 558 Opening images 26 OpenType fonts 370 OptiCal software 103 Optimize save for web settings 579 Optimize to file size 580 Options bar 40, 54 Output profiling 493 Out of gamut colors 216 Overlay blend mode 287

Ρ

Page Setup 533,536 Paint bucket 83 pattern fill mode 83 Palettes 34 Palette docking 35 Palette well docking 40 Paragraph palette 42, 87, 370 Parse XMP Metadata 619 Pass through blending 290 Patch tool 69, 229–231, 235 Paths 86, 267–270, 268

convert path to a selection 269 drawing pen paths 268 make path 267 Paths palette 53 shape layers mode 267 stroke path/sub path 251 text on a path 371 Pattern Maker 233-234, 384 Pattern presets 384 Pattern stamp tool 70 Pawliger, Marc xxviii Paynter, Herb xxviii PC monitor caibration 105 PDF file format 19, 562-565 PDF security 565, 585 PDF Presentation 655 PEI magazine 584 Pencil 70 Pentax 420 Pentium processors 95 Pen tool 86, 251, 268, 307 curved segment 269 pointer 269 Rubber Band option 270 Perceptual rendering 520 Perspective cropping 174 Phase One 416, 430 Capture One 430 H20 423 H25 420 PhotoCal 103 PhotoKit Color 196-197, 346 PhotoKit Sharpener 188, 598 Photomerge 650-654 Photomultiplier 406 Photoshop Help Center 656 Photoshop preferences 112 image cache 122 preference file 112 saving preferences 121 Photoshop Services 626 Photo CD 414-415 Photo Filter 205

Photo Lab prints 527 Pictrograph 527 SCSI cards for 130 Picture CD 415 Picture Package 646, 648 Piezo crystals 422 Pigment inks 531 Pillow emboss 358 Pin Light blend mode 288 Pixels per inch 466 Pixel Aspect Ratio 471 Pixel doubling display option 117 Pixel Genius 188, 598, 616 PhotoKit Sharpener 188 Pixel Mafia 55 Pixel resolution 464-465 Plug-ins third party 373 Plug-ins folder preferences 121 PNG file format 585 Polaroid 407 Polygon lasso tool 56, 60 Polygon shape tool 88 PostScript 370, 560 PostScript printing 552 PostScript RIP 469 Preserve Embedded Profiles 497-499. 524 Preserving image luminosity 339 Presets 361 Patterns 234 Preset Manager 48 Preview box options 30 Primary scratch disk 121, 132 Printers Chromapress 554 custom profiles 540 Fuji Pictrography 527 Indigo 554 inkjet 529 Lambda 554 laser 552 PostScript 552

Rainbow proofer 549 Sienna/Marrutt 554 Wide-format inkjet 530 Xericon 554 Printer profiles 540 custom printer profiles 545 Printer Properties 538 Printing via a RIP 553 Print Center (Mac OS X) 533 Print dialog 538 color management 539 simulate black ink 551 simulate paper color 551 Print Properties (PC) 538 Print registration marks 535 Print Selected Area 534 Print size viewing 91 Print stabilization 545 Print with Preview 19, 533-534, 537, 550 ProfileMaker Pro 103, 492-493, 545 Profile Connection Space 486-487 Profile conversions 500 Profile Mismatch 496, 503 ask when pasting 503 Profiling the display 490 Progressive JPEG 574, 578 ProofMaster Adesso RIP 552 Folio RIP 552 Proof Setup 335, 514, 546-548 gravscale 508 Proof simulation 551 ProPhoto RGB 489 Purge history 74 Purge memory 124 Purves, Dale 482 pyramid cache structure 125

Q

QMS MagiColor 552

Quadtones 334 Quantum Mechanic 418, 425 QuarkXPress 324, 559, 561 Quartz rendering 529 Quick Mask 92, 260

R

Radial Blur filter 374 RAID hard drives 124 RAM memory 122-123 RAM memory settings 123 Rasterized type 370 Raster Image Processing 552 rawformat.com 432 Raw conversions 430 Raw processing comparisons 450 Raw versus JPEG 429 Read Me files 498 Real World Camera Raw 451 Real World Color Management 555 Real World Photoshop CS2 481, 555 Recent File list 116 Red eve tool 13.257 Refresh list tree view 612 Relative canvas size 176 Relative Colorimetric 521, 551 Reloading selections 261 Remove matte color 304-305 Removing noise 246-247 Removing wrinkles 256 Rendering intents 510, 520-523 Absolute Colorimetric 521 Perceptual 520 Relative Colorimetric 521 Saturation (Graphics) 520 Repair Disk Permissions 132 Replace color 215 Repro printing 554-555 Reset palette locations 36 Reset tool settings 115 Resize image 657 Resize windows to fit 91 Resnick, Seth xxviii, 630

Resolution film 463 output resolution 468-470 pixels 463 reciprocal formula 464 screen resolution 119 terminology 466-467 Reveal All 67, 177 Reveal Scripts in Finder 127 RGB printers 527 RGB work spaces 488, 512 Richmond, Eric xxviii, 660 Ring flash effect 364 Rodney, Andrew xxviii, 481 Roff. Addy xxviii Roland printers 529 Roots coloring 240 Rosettes (halftones) 468 Rotate canvas arbitrary 175 Rotate image 175 RSA Gray Balance 197 Rubber Band option 270 Rubylith mode 276 Rulers 33 Ruler units 119 Run Length Encoding 576 Run Length Encoding compression 566

S

Sampled Blur filter 378 Saturate with sponge tool 85 Saturation mode 289 Saturation rendering 520 Save Image Pyramid 558 Save dialog 557 Save for Web 577, 579 GIF format 580, 581 JPEG format 577 Save palette locations 113 Save Workspace 608 Saving 556

previews 114 Saving HTML code 579 Saving images 26 Scaled laver effects 362 Scanning bit depth 409 drum scanners 406 dynamic range 409 noise 414 resolution 408, 470 scanning backs 426 scanning software 413 scanning speed 413 scans from films 405 Schewe, Becky xxviii Schewe, Jeff xxviii, 75, 660 Scratch disks 121-122 size 31 usage 73 Screen angles 468 Screen blend mode 286 Screen redraw times 160 Scripting 17 Scripts 644-645 Export Layers to Files 644 Image Processor 645 Script Event Manager 644 Scroll Wheel settings 113 SCSI compatibility 130 Secure Digital cards 424 Selections 259 modifying 261 selections to paths 267 selection cropping 173 Selective sharpening 187 Select menu Color Range 56, 214, 304 deselect 260 feather 245, 266 grow selection 59, 264-265 modify border 265 expand/contract 265

smooth selection 264-265 reselect 260 select similar 265 Shapes 372 Shape layer 366 Sharpening 178-191 auto sharpening 181 Camera Raw 180 capture sharpening 180 edge sharpening 185 high pass edge sharpening 191 luminance sharpening 188 output sharpening 181 selective sharpening 187 sharpening plug-ins 188 Sharpen filter 182 Sharpen More filter 182 Smart Sharpen filter 189-190 Unsharp Mask filter 182 Amount 182 Radius 183 Threshold 183 Sharpen tool 84 Shortcuts 65, 635 Shortcut summaries 635 Show Grid 33 Show Layer Edges 16 Show Tool Tips 112 Sidecar .xmp files 128, 455-456, 619 Sienna printing 554 Sigma SD9 camera 417, 420 Signum Technologies 631 Simulated CMYK proofs 550 Simulate paper white 548 Sinar 54, 420 Skurski, Mike xxviii Slice tools 68, 594 SmartMedia cards 424 Smart Guides 16, 33 Smart highlighting (Extract command) 320 Smart Objects 8, 292-295, 459

Edit Contents 293 placing a raw file 295 Smart Sharpen filter 12,189–190 Smooth selection options 56 SMPTE-240M 489 Smudge tool 84, 251 finger painting 251 Snapshot 72,636 Snap To 33, 67 Snap to Edge 174 Snyder, Steve xxviii Soft focus effect 352 Soft Light 287 Soft proofing 546 Solarization 331-333 SOLUTIONS photographic 661 Sonv Memory Stick 424 Sony Artisan 98, 100, 546 Sound annotations 89 Sourcing actions 636 Space Monkey 55 Spectrophotometer 493 Specular highlights 144-145 Spell checking 371 SpherocamHDR camera 423 Spirit of St Louis 306 Sponge tool 85, 214 Spot color channels 52, 368-369, 484 Spot healing brush 14, 228 sRGB IEC-61966-2.1 488 incorrect tags 502 Step interpolation 474 Stitching panoramas 650 Stochastic screening 470 Storage 462 Storage media 630 Stuffit 568 Styles 47, 87, 354-357 Stylus pressure options 68 Sunnybrook Technologies 99, 165 Super CCD 417 SureSign 631

Surface Blur filter 378 Swatches palette 47 SWOP print settings 513 Syquest 630 System Info 132

Т

Table of Shortcuts 633 Targeted CMYK prints 550 Target brightness assigning in Levels 143 Target Gamma 107 Tebbutt, Lisa xxviii Tecco Best Proof papers 545 TechTool Pro 132 Thumbnail image cache 612 Timina 31 Title bar proxy icons 30 Tolerance settings 264 Tools palette 54 Tool options 40 Tool Presets 41, 239, 371 Tool switching behavior 55 Tool tips 93, 127 Tool tips info 54 Transfer functions 560 Transform command 296-301, 300 numeric transforms 299 transforming paths 299 transforming selections 299 transforming selections and paths 299 transform again 299 via the move tool 64 Transparency 118 checkerboard 118 Transparency & Gamut 118 Transparency output 527 Transparent GIFs 582 Transparent gradients 80 Trim image 67 Tritones 334

TWAIN 413 Type 370 anti-aliasing 371 warping 87 Type preferences 126 Type selections 370 Type tool 87

U

UCA separations 517 UCR separations 516 Ultimatte Advantedge 302 Ultrachrome inks 531, 553 Umax 407 Units & Rulers 119 Unsharp masking 180, 184, 474 amount 182 radius 183 selective channels 184, 188, 189, 190, 191 threshold 183, 184 Uploading to a server 569 USB devices 110 User interface font size 112 Use all layers 219 Use Dither 510 Use lower case extensions 572 UTF 8 Encoding 590

V

Vander Houwen, Greg 304, 363 Vanishing Point 6, 241–243 Variations 193 Vector masks 277 Vector output 370 Vector paths 306 Vector to pixels 263 Version Cue 28, 116 Vertical palette docking 35 Video cards 99 Viewing distance 476 Viewpoint ZoomView plug-in 583 View menu fit to window 171 gamut warning 118, 214 hide edges 214 new view 32 proof setup 546 Vignettes adding a vignette 244 Vignetting 388 Virtual memory 122 Vivid Light mode 287

W

Wacom 14, 45, 77, 110, 239 Walker, Michael 481 Warping 7 Warping text 87, 370 Warp command 397-398 Warp Transforms 296 WebDAV 30 Webster, Paul 660 Web Graphics color 508 Web Photo Gallery 18, 586 banner settings 590 custom colors settings 591 feedback 592 feedback forms 592 general settings 590 large images settings 590 security settings 591 template styles 588 thumbnails settings 591 Web safe colors 92, 581 Web snap slider 580 Weisberg, Gwyn xxviii White balance 430 White point 104, 108 Wilhelm, Henry 531 Wilhelm Imaging Research 531 Williams, Russell xxviii Williford, Mark xxviii Windows Disk Defragmenter 132 Windows XP 131

System reverts 131 Window menu cascade windows 32 reset palette locations 36 tile windows 32 WinZip 568 Wizards in Photoshop 646 Woolfitt, Adam xxviii, 431 Workgroups 116 Work spaces Save Workspace 15 Work space menu 217 Work space Settings 36 Work Group Server 30 WS_FTP Pro 569 Wynne-Powell, Rod xxviii, 661 WYSIWYG menus 126

X

X-Rite 103 xD SmartMedia cards 424 XML 616 XMP 455, 616 XMP Metadata 619

Z

ZIP compression 558 Zone optimization 579 ZoomView Export 583 Zoom Blur filter 374 Zoom percentage info 30 Zoom shortcuts 65 Zoom tool 91